W9-ASR-635

The Museum of Modern Art, New York

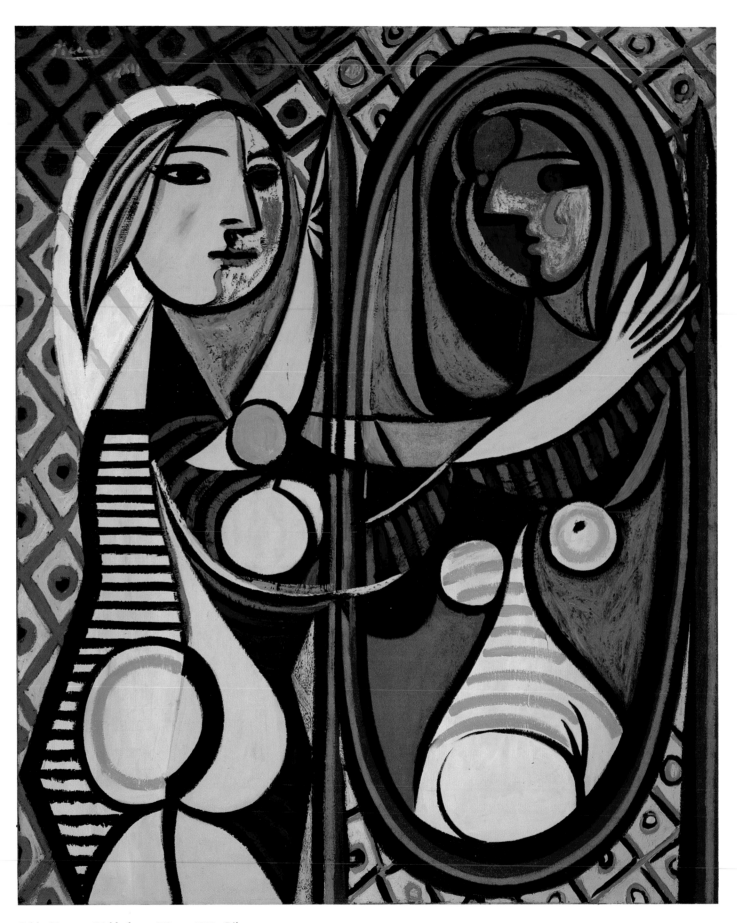

Pablo Picasso. *Girl before a Mirror*. 1932. Oil on canvas

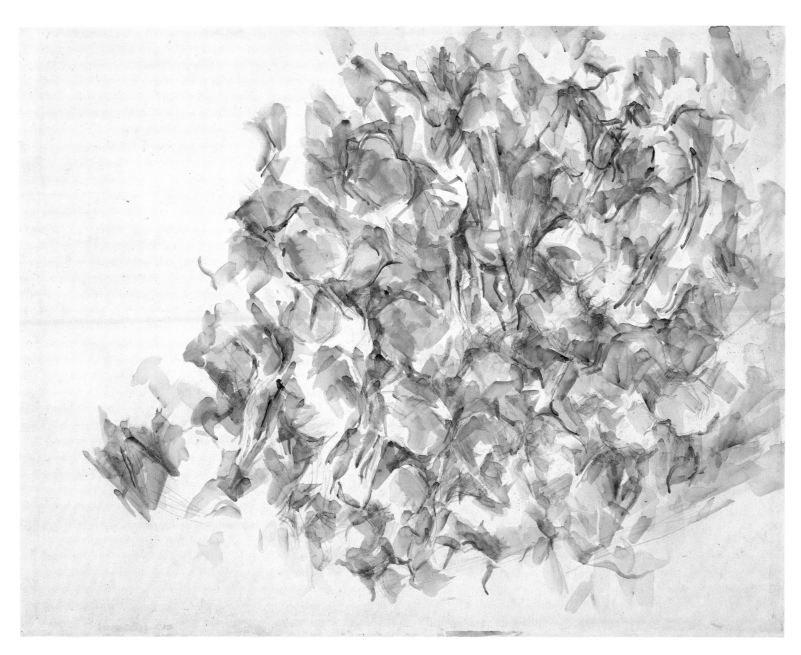

Paul Cézanne. *Foliage.* 1895–1900. Watercolor and pencil on paper

Jasper Johns. *Decoy II*. 1971–73. Lithograph, printed in color

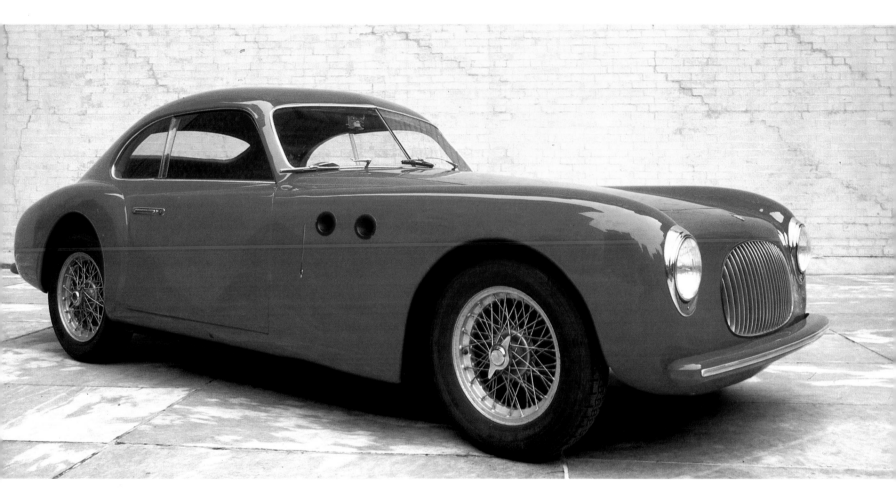

Pinin Farina. Cisitalia "202" GT Car. 1946. Aluminum body

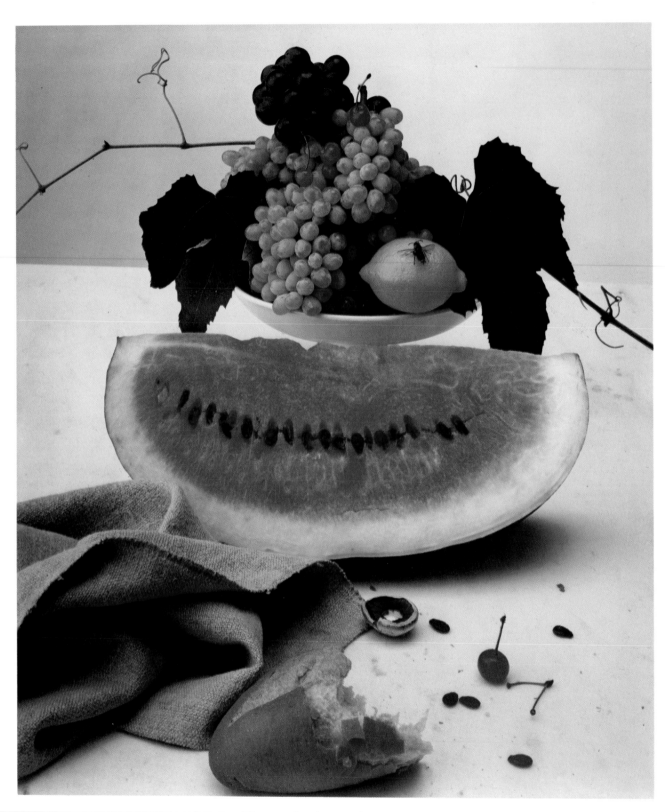

Irving Penn. *Still Life with Watermelon.* 1947. Photograph—dye-transfer print

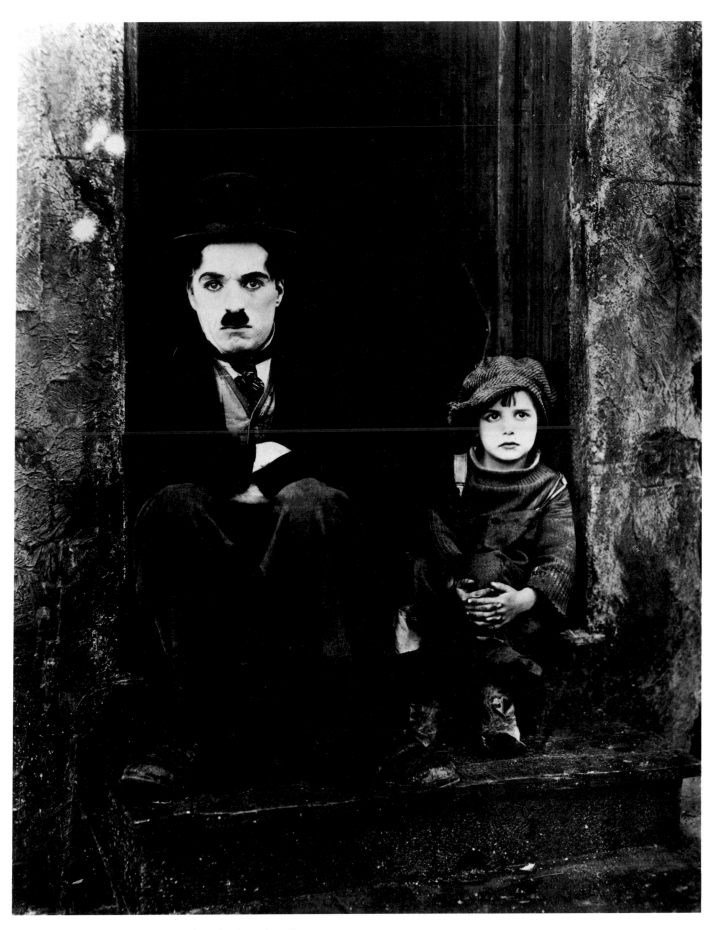

Charles Chaplin. *The Kid.* 1921. Black-and-white silent film

The Museum of

ABRADALE PRESS/HARRY N. ABRAMS, INC., PUBLISHERS,

Modern Art, New York

The History and the Collection

INTRODUCTION BY SAM HUNTER

IN ASSOCIATION WITH THE MUSEUM OF MODERN ART, NEW YORK

The Library of Congress has cataloged the Abrams edition as follows:
Main entry under title:

The Museum of Modern Art, New York.
 Includes index.
 1. Museum of Modern Art (New York, N.Y.)
1. Hunter, Sam, 1923– II. Museum of Modern Art
(New York, N.Y.)
N620.M9M8 1984 709'.04'007401471 83–15769
ISBN 0–8109–1308–9
Abradale ISBN 0–8109–8187–4

Harry N. Abrams, Inc.
100 Fifth Avenue
New York, N.Y. 10011
www.abramsbooks.com

Contents

Prefaces

PREFACE TO THE ABRADALE EDITION

The Museum of Modern Art is pleased to continue its collaboration with Harry N. Abrams, Inc., in making this volume on the Museum's history and collection available in an Abradale edition some thirteen years after its initial publication. First issued in 1984, the book has had a long life without any significant changes in its contents and has had eight printings.

Although many changes have occurred at the Museum and its collection has grown significantly in the intervening years, this book remains a valuable overview of the guiding principles, growth, and scope of one of the world's greatest museums. It will remain an important record in the years ahead as the Museum prepares to enter the twenty-first century with new publications on its collection.

Richard E. Oldenburg, under whose aegis this book was created, retired from the directorship of the Museum in 1995. As his successor, I am pleased to enable this volume to reach an even broader audience than it has up to now. To that end, minimal alterations have been admitted, principally in the index—to record artists now deceased—and including a current list of the Museum's trustees and the change of the name of the film department to the Department of Film and Video. The acknowledgments below continue to credit those principally responsible for the first edition.

Glenn D. Lowry
Director
The Museum of Modern Art

PREFACE TO THE FIRST EDITION

It is appropriate and pleasing that this book should be published at a time when newly expanded gallery spaces make it possible to exhibit more of the Museum's collection than ever before. As indicated in the Introduction, the Museum carries on many other activities in addition to building and displaying its collection. Through scholarship supported by its unrivaled library, through publishing and educational programs, through special exhibitions in this country and abroad, the Museum serves an extended public far beyond its walls in New York. Important as these functions are, the core of the Museum's purpose and definition is indeed its collection, and this is the primary focus of this book.

The collection is an entity greater than the sum of its parts. As envisioned by Alfred H. Barr, Jr., the founding director of the Museum, the collection represents the modern spirit and imagination in all the visual arts. In doing so, it offers not only an unparalleled overview of the modern movement in art, but also a deeper understanding of its meanings through their manifestations in diverse mediums. The interrelationship of all parts of the collection is one of its most stimulating qualities, and it should not be obscured by the administrative necessity of assigning responsibility for various mediums to distinct departments. I hope that this synoptic aspect of the collection will still be apparent, although the works reproduced in this book are arranged in separate sections for each of the Museum's six curatorial departments: Painting and Sculpture, Drawings, Prints and Illustrated Books, Architecture and Design, Photography, and Film.

Each of these sections is preceded by a brief essay which seeks to explain the guiding principles and historical circumstances which have shaped the development of the part of the collection that follows, producing its strengths and sometimes its weaknesses. The works illustrated are of course only a representative selection from each department. While the majority of the collection's most familiar masterpieces are included, many works of extraordinary quality—some very well known and others less so—have had to be omitted solely for lack of space. It is particularly difficult to represent by a few examples the very large number of works in the care of departments such as Photography, Prints and Illustrated Books, and Architecture and Design.

Given these limitations, great consideration has been given to presenting a selection which fairly reflects the quality, scope, and diversity of the collection. Some less familiar works have been included to suggest the depth and variety which are continually rediscovered in changing exhibitions drawn from the collection. For the installations on view in the galleries are not static. Even in the Museum's enlarged spaces, only a portion of the collection can be exhibited at any given time, and there is frequent rotation of works to show more of the collection in the course of each year. The Museum is also a very generous lender to other institutions, and as these loans are made, other works from the collection take their places in the galleries.

Most important, the collection itself is always changing, both through new acquisitions and through reassessments of the past. This is particularly true of a museum like this one concerned with the art of our own time. If the Museum's curators choose well, future editions of this book may be quite different from this edition, with more recent works supplementing or even replacing those presented here. While we may be reasonably confident that the works illustrated in this book will withstand a further test of time, it is intriguing that we can never be entirely certain. What is certain is the continuing effort to build and refine what is already one of the great museum collections in the world. The success of this effort depends on the creativity of artists and also on the generosity of donors. However, it depends as well on the discrimination and daring of the Museum curators who perform the role which Alfred Barr defined as "the conscientious, continuous, resolute distinction of quality from mediocrity." This book is impressive evidence of their judgment and dedication.

Richard E. Oldenburg
Director, 1972–1995

ACKNOWLEDGMENTS

The preparation of this publication required the collaboration of a great many people, who have given most generously of their time and expertise.

Very prominent among these is Sam Hunter, whose Introduction reflects his long association with the Museum and his close knowledge of its collection. He was assisted by Marcy Freedman, Michael Stanton, and Richard Taylor, Princeton University graduate students; by Richard Sarnoff, whose efforts were supported by a grant from the Spears Fund of the Department of Art and Archaeology; and by Diane Gurien.

Warm gratitude is due all the members of the Museum staff who contributed to this book. Despite many other demands on their time, they accomplished the major tasks of selecting the works to be illustrated and described, researching and writing the texts and captions, arranging for photography, and preparing all of these materials for publication. Great appreciation is extended to the following staff members who participated in this effort: Mary Lea Bandy, Eileen Bowser, Louisa Briccetti, Mikki Carpenter, Riva Castleman, Robert Coates, Mary Corliss, Arthur Drexler, John Elderfield, Louis Estrada, Catherine Evans, Audrey Isselbacher, J. Stewart Johnson, Susan Kismaric, Francis Kloeppel, Carolyn Lanchner, Alicia Legg, Barbara London, Frederic McCabe, Cara McCarty, Robert McDaniel, Kynaston McShine, Ron Magliozzi, John Pultz, Monawee Richards, Rona Roob, Bernice Rose, Barbara Ross, William Rubin, Pamela Sweeney, John Szarkowski, Richard Tooke, and Wendy Weitman.

Two more members of the Museum staff deserve special thanks for particularly crucial roles. Harriet Schoenholz Bee served as the Museum's editor from the inception of this book through publication, guiding and coordinating the work of the many contributors with extraordinary patience and perseverance. Ethel Shein, Assistant to the Director of the Museum, was an early and dedicated champion of this project. Her persuasive conviction of its importance and continuing involvement in furthering its progress were essential to its accomplishment.

Grateful acknowledgment is equally due the skilled professional staff of Harry N. Abrams, Inc., who produced this book on a very tight schedule. Margaret L. Kaplan, Executive Editor, was most helpful in the initial planning, and Sheila Franklin served with great competence as the editor and coordinator of the project through its final editorial and production stages. Sam Antupit was responsible for the design which handsomely accommodates a great variety of images, and Dirk Luykx very ably organized the diverse design elements. Finally, this book could not have been produced without the constant support, encouragement, and direction of Paul Gottlieb, President of Harry N. Abrams, Inc.

R. E. O.

Introduction

FOUNDERS

When The Museum of Modern Art opened its doors on November 7, 1929, the brave new experiment was generally greeted as a cultural event of the first order. Nevertheless, many observers took a guarded view of the enterprise, for an apparent contradiction still existed in some minds between the productions of the modern avant-garde and the historical perspectives and custodial functions associated with traditional art museums. At that time established American museums were only rarely disposed to show late nineteenth- and twentieth-century art, or the work of living artists, and few attempted to collect modern art seriously.

From the beginning, one of the remarkable aspects of The Museum of Modern Art was its success in establishing the modern artist as a cultural figure of stature. The Museum also demonstrated a special talent for mixing demanding intellectual content in a controversial field of knowledge with a decided flair for appealing to the lay public. The Museum's combination of sober art-historical scholarship with evangelical zeal for its subject helped popularize modern art at a moment in its history when it did not enjoy public confidence. Making the most of enlightened patronage and imaginative leadership, the adventurous institution did nothing less than revolutionize the very idea of the art museum in American life.

The Museum came into being because three influential collectors were prepared to challenge the conservative policies of traditional museums and to establish an institution devoted exclusively to modern art. These progressive public-spirited founders of the Museum were Lillie P. Bliss, Mrs. Cornelius J. (Mary Quinn) Sullivan, and Mrs. John D. (Abby Aldrich) Rockefeller, Jr.

Miss Bliss, the daughter of a textile manufacturer who served as Secretary of the Interior under William McKinley, was, by 1929, a recognized collector of Post-Impressionist and contemporary art. She was a close friend of the painter Arthur B. Davies, one of the organizers of the Armory Show of 1913, from which she bought the five paintings and a number of drawings and prints with which she started her collection. Along with Davies, a tireless proponent of the cause of modern art, and several other patrons, Miss Bliss in 1921 persuaded The Metropolitan Museum of Art to hold its first exhibition of modern art, covering the period from the Impressionists through Picasso's pre-Cubist work. Hostile press reactions to even that carefully delimited exhibition discouraged the Metropolitan from further experiments of the kind; its repudiation of progressive currents in art was undoubtedly a factor in the birth of an independent museum in New York devoted exclusively to modern art.

Mrs. Sullivan, the former Mary Quinn, grew up in Indianapolis, and worked as an art teacher in New York before her marriage to Cornelius J. Sullivan, an attorney and collector of rare books and paintings. Sullivan had long been a friend of the adventurous collector of modern art John Quinn (no relation of Mary Quinn), who advised Mrs. Sullivan on the purchase of a number of works from the Armory Show. These works formed the nucleus of her collection. She, too, was a friend of Davies, who thought that the Quinn collection would make an excellent foundation for a museum devoted to modern art; but when Quinn died in 1924, his collection was sold at auction, as was Davies's own collection at his death four years later.

Mrs. Rockefeller had developed an interest in art under the influence of her father, Senator Nelson W. Aldrich of Rhode Island, an avid collector of European art, who introduced her to the galleries of Europe when she traveled with him as a young woman. She later acquired a taste for modern art and became convinced that America required a museum devoted to recent art, especially to that of living artists. Her son Nelson Aldrich Rockefeller, in the introduction to a book on his own collection, later recalled: "Mother

used to illustrate the need for the new museum by citing the tragedy of Vincent van Gogh, one of the great pioneers of Post-Impressionism, who died at age thirty-seven in an institution for the destitute, unable to sell his paintings to buy bread, only to have the greatness of his work recognized years after his death. Mother's objective for the new museum was to reduce dramatically the time lag between the artist's creation of and the public's appreciation of great works of art." Mrs. Rockefeller's concern for the arts of her own time was reflected in her personal collection of paintings, sculpture, and prints by American artists, which was kept in a "gallery" on the top floor of the family mansion on West Fifty-fourth Street. (The house was dismantled and the land was given by her husband in 1937 to be used for the Museum's first sculpture garden.) She later donated her collection to the Museum.

The three art patrons began seriously to exchange ideas on forming a new museum for modern art in the winter of 1928–29 when Mrs. Rockefeller and Miss Bliss met by chance while touring in Egypt. The idea had been discussed for some time by Davies and Miss Bliss. On the return crossing Mrs. Rockefeller discovered a fellow enthusiast in Mrs. Sullivan, also an acquaintance of Miss Bliss, and drew her into the bold scheme. Speaking many years later of the three founders, Nelson Rockefeller wrote: "It was the perfect combination. The three women among them had the resources, the tact, and the knowledge of contemporary art that the situation required. More to the point, they had the courage to advocate the cause of the modern movement in the face of widespread division, ignorance, and a dark suspicion that the whole business was some sort of Bolshevik plot." In May 1929, the three women asked A. Conger Goodyear, a collector and former army officer, to become chairman of a committee to form the proposed museum, and the first step had been taken.

As the president of the Albright Art Gallery in Buffalo, Goodyear had shown a firm commitment to experimental modern art in 1927 by borrowing a portion of Katherine Dreier's avant-garde Société Anonyme collection in spite of sharp criticism. Her collection, which she had started with Marcel Duchamp, was one of the few contemporary collections available at that time for public viewing, but on an irregular basis, since the collection had no permanent home. When Goodyear then proceeded to purchase Picasso's *La Toilette*, a painting of the late Rose Period, for the gallery, his alarmed fellow trustees forced him off the board. Goodyear's principled intransigence appealed to Mrs. Rockefeller, and she later explained in a letter why the women had turned to him: "We did this because we had been told of your efforts in the cause of modern art in Buffalo and that you had resigned the presidency of that museum because the trustees would not go along with you in your desire to show the best things in modern art."

Goodyear shortly thereafter became one of the founding trustees and recruited three others, bringing the number to seven. They were Mrs. W. Murray Crane, who had helped finance New York's most progressive educational experiment, the Dalton School; Frank Crowninshield, the urbane editor of the art-conscious magazine *Vanity Fair;* and the highly regarded academic Paul J. Sachs, whose course in museum connoisseurship at Harvard University's Fogg Museum trained a generation of museum curators and directors.

It was Sachs who recommended his former student, twenty-seven-year-old Alfred Barr, for the post of director of the new museum, and persuaded the founders that despite his inexperience and youth, Barr possessed more than compensating virtues of erudition, strength of character, profound convictions about modern art, and an intense personal drive. He represented Barr to his associates as a man to whom they might entrust the challenge of defining the new museum, and said that if they wanted an older man he would have to think it over. Goodyear later wrote, "We spared him this trouble, and ourselves many troubles, by taking his nominee. Alfred H. Barr, Jr., became our director." Barr

Opposite, above: Lillie P. Bliss, *center:* Mrs. Cornelius J. Sullivan, *below:* Mrs. John D. Rockefeller, Jr.
Above: Alfred H. Barr, Jr., c. 1929–30

proved a most propitious choice, and the Museum's subsequent success often has been attributed to the historical coincidence of an idea whose time had come and the appearance, in the words of Meyer Schapiro, of a "providential man."

As an undergraduate at Princeton University, Barr had been influenced by his studies with the distinguished medievalist Charles Rufus Morey, whose major course, according to Barr, "was a remarkable synthesis of the principal medieval visual arts as a record of a period of civilization: architecture, sculpture, paintings on walls and in books, minor arts and crafts were all included." Barr remained at Princeton another year as a graduate student and then transferred to Harvard, where he took Sachs's museum course. Then he was offered a teaching position at Wellesley College as an associate professor, an unusual distinction for a man of his age. There Barr conceived and taught the first undergraduate course in modern art offered in American higher education. The course not only dealt with twentieth-century painting and sculpture and their late nineteenth-century sources, but also included film, photography, music, theater, architecture, and industrial design. Barr had transposed Morey's medieval arts model into a twentieth-century context. These ideas were reinforced by a lengthy trip to Europe, where Barr made a number of discoveries that solidified his theoretical teachings. He traveled to the Soviet Union, where he met many of the Constructivist artists; to Mondrian's de Stijl circle in the Netherlands; and to the Bauhaus at Dessau, Germany: "A fabulous institution...painting, graphic arts, architecture, the crafts, typography, theater, cinema, photography, industrial design for mass production—all were studied and taught together in a large new modern building." It proved an influential model for his subsequent museum plan.

Upon his appointment as director Barr was asked to submit a design for the Museum. He proved surprisingly well prepared and offered an ambitious multidepartmental plan, based on his twentieth-century art course at Wellesley. He later commented on its shaping influence in his conception of the Museum: "This multidepartmental plan was...simply the subject headings of the Wellesley course....The Plan was radical... because it proposed an active and serious concern with the practical, commercial and popular arts as well as with the so-called 'fine' arts." And of the Bauhaus he said, "Undoubtedly it had an influence not only upon the plan for our Museum...but also upon a number of its exhibitions."

On September 19, 1929, Cornelius Sullivan drew up incorporation papers for the founding trustees, and the Board of Regents of the University of the State of New York, acting on behalf of the State Education Department, granted a provisional charter for "establishing and maintaining in the City of New York, a museum of modern art, encouraging and developing the study of modern arts and the application of such arts to manufacture and practical life, and furnishing popular instruction." Although Barr's multidepartmental plan was not immediately put in force (the Museum initially focused on the exhibition of late nineteenth-century paintings), the Museum, gradually at first, achieved its implementation and became the first in America to integrate twentieth-century fine and applied art.

Over more than half a century, adhering to the general lines of the plan laid down by Barr at the very beginning, the Museum has built an unrivaled multidepartmental collection while at the same time conducting a coherent and adventurous program of exhibitions and related educational activities. As critic John Russell put it: "The Museum of Modern Art as it is today has certain clearly defined characteristics. It is truly international. It covers not only painting and sculpture, but photography, prints and drawings, architecture, design, the decorative arts, typography, stage design, and artists' books. It has its own publishing house, its own movie house, and its own department of film and video. It has a shop in which everyday objects of every kind may be on sale, provided they pass the Museum's standard of design. It is a palace of pleasure, but it is also an un-

structured university. You don't get grades for going there, but in a mysterious, unquantifiable way, you become alert to the energies of modern art."

THE FIRST TEN YEARS

During its first years the Museum experimented with a variety of exhibitions and programs and began to build what was tentatively called a "permanent" collection. The Museum evolved inexorably according to the multidepartmental course Barr had set for it in 1929, as foundations for all the Museum's programs were gradually laid down one by one during the first decade. But all this was not said in the beginning. *A New Art Museum,* a brochure issued by the founders, stated that their "immediate purpose is to hold...exhibitions....The ultimate purpose will be to acquire, from time to time,...the best modern works of art," and that "in time the Museum would expand...to include other phases of modern art."

In late September 1929, the seven founding trustees set about raising a substantial sum of money for the first two years of operations, and found a suitable exhibition space on the twelfth floor of the Heckscher Building at 730 Fifth Avenue, at Fifty-seventh Street. In early October, at the first formal meeting of the board, Goodyear was elected president; Miss Bliss, vice president; Mrs. Rockefeller, treasurer; and Crowninshield, secretary. On October 25, seven additional trustees were elected: William T. Aldrich, Frederick Clay Bartlett, Stephen C. Clark, Chester Dale, Samuel A. Lewisohn, Duncan Phillips, and Mrs. Grace Rainey Rogers.

Plans were quickly made for an opening loan exhibition of the "ancestors" of modern painting, to use Goodyear's term. Goodyear, who was an activist president, went to Europe to secure important loans from dealers, institutions, and private collectors to complement those obtained at home: a glittering array of thirty-five Cézannes, twenty-eight van Goghs, twenty-one Gauguins, and seventeen Seurats, many of them belonging to his fellow trustees. The exhibition, *Cézanne, Gauguin, Seurat, van Gogh,* opened to the public on November 8, 1929—just ten days after the collapse of the American stock market ushered in the Depression. Despite the pervasive atmosphere of public anxiety, the show proved an immediate success, attracting impressive numbers of visitors to the cramped gallery spaces: more than forty-nine thousand in just five weeks, the largest audience to attend an exhibition of modern art since the Armory Show sixteen years earlier. The new museum had clearly touched a public nerve and need, bridging the gap between a few affluent collectors and amateurs who patronized the arts and the new democratic culture with its mass audience eager to unravel the mysteries of modern art.

The Museum's second exhibition, *Paintings by Nineteen Living Americans,* perhaps not surprisingly, drew only half the attendance of the first show of European masters. The inconsistent mix of artists may have been partly responsible. The work had been selected by the trustees; casually thrown together were established modernists such as Marin, O'Keeffe, and Weber, with sentimental favorites like Sloan. But the Museum continued experimenting, and a pattern of representation was established that played American and European art off against each other in an effort to achieve a kind of parity, even though it was a period when Americans of taste and judgment considered School of Paris and European leadership inarguable. Barr also seemed to enjoy contrasting the past and present. Contemporary art was shown immediately after an exhibition of nineteenth-century American "old masters": *Homer, Ryder and Eakins.* There were different exhibitions of European art such as *Daumier and Corot* and *Toulouse-Lautrec and Redon;* exhibitions based on locale such as *Painting in Paris* and *Modern German Painting and Sculpture;* and individual exhibitions for painters and sculptors such as Klee, Matisse, Maillol, Lehmbruck, Rivera, and Weber.

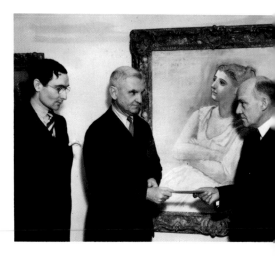

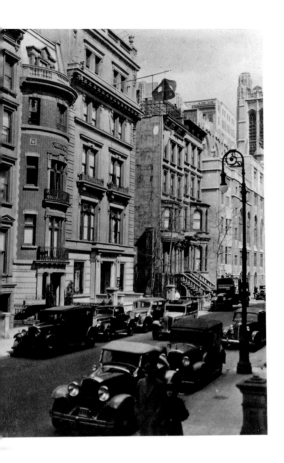

In spite of his crusading spirit in advancing the cause of artistic modernism and his radical plan for a multidepartmental museum, Barr exercised a degree of caution in early exhibitions of painting and sculpture. Gradually, however, and especially in the field of European modernism, his choices manifested an uncompromising boldness. His two great summary exhibitions of 1936—*Cubism and Abstract Art* and *Fantastic Art, Dada, Surrealism*—were, and remain, among the landmark shows of modernism. Barr always made a conscientious effort to preserve an evenhanded approach to the avant-garde, firmly resisting partisan pressures that might limit his options. This meant that for him "a respectful distance" was necessary before attempting to judge contemporary art with any degree of finality. Indeed, by 1936 Cubism was almost thirty years old; Dada, begun twenty years before, had long since spent itself; and Surrealism had passed its tenth birthday. Nevertheless, Barr's choices were truly daring, given the "culture gap" that existed. They must be seen against a background of almost universal condemnation of vanguardism by the American public, and in a context in which critical and art-historical literature was extremely limited.

In 1932, the Museum moved from its temporary quarters at 730 Fifth Avenue to a house leased from John D. Rockefeller, Jr., at 11 West Fifty-third Street, and the question of "determining a fixed policy in the matter of a permanent collection," originally proposed by Barr in 1929, arose again. But again the question was deferred in favor of an active exhibition policy. The trustees did not feel the Museum had been in existence long enough to collect works on a permanent basis—although works had been given to the Museum by that time—and a number still wondered if the idea of permanence and modernism were, in fact, compatible at all. With the deepening of the Depression and the difficulty of raising funds, the prospect of making art purchases seemed incongruous. Lillie P. Bliss had died in 1931 and bequeathed the major part of her magnificent collection to the Museum on the condition that a sizable endowment be raised to maintain it. With a number of successful exhibitions behind him, and riding the crest of a wave of popular enthusiasm for the Museum's programs, Barr began in 1932 to urge the trustees to adopt a policy of forming a collection that would allow the endowment stipulated by Miss Bliss to be raised within the specified three years.

Barr had already formed in his mind the image of the Museum's collection: "The Permanent Collection may be thought of graphically as a *torpedo moving through time*, its nose the ever advancing present, its tail the ever receding past of fifty to a hundred years ago. If painting is taken as an example, the bulk of the collection...would be concentrated in the early years of the twentieth century, tapering off into the nineteenth with a propeller representing 'Background' collections...." And Barr concluded a lengthy, detailed plea for a permanent collection on a note of some urgency: "If such a policy is not inaugurated, the 'Museum of Modern Art' may as well change its name to 'Exhibition Gallery'."

Just three years after the death of Miss Bliss, the trustees met the financial requirements stipulated in her bequest to the Museum of the major portion of her collection. The Lillie P. Bliss Collection was officially deeded to the Museum, and a complete catalogue was published shortly thereafter. When the Museum opened its fifth-anniversary exhibition, *Modern Works of Art*, it was able to boast a significant group of works of art, whose "cornerstone" was the Bliss bequest. The magnificent gift included thirty oils; thirty-six watercolors, drawings, and pastels; and fifty prints. Among these were masterworks by Cézanne, Gauguin, Matisse, Modigliani, Picasso, Seurat, Degas, Derain, Pissarro, Redon, and Renoir. Furthermore, under the generous terms of Miss Bliss's will, the Museum was later able to sell or exchange works from the bequest to acquire other, more needed objects.

Once the Bliss collection was acquired, Barr's program for establishing a permanent

collection became an irreversible reality, and a more promising basis for the development of the Museum seemed assured. By the time of the installation of the Bliss bequest a number of other gifts from a widening circle of friends of the Museum had already been received. The first painting acquired by the Museum was Edward Hopper's *House by the Railroad*, given anonymously in 1930 by Stephen C. Clark; and the first sculpture was Aristide Maillol's *Ile de France*, 1910, given by Goodyear in 1929 (now in The Metropolitan Museum of Art). For its fifth-anniversary exhibition the Museum proudly put on view not only these early gifts and outstanding works from the Bliss bequest, but also a number of new acquisitions from other sources: paintings by Burchfield, Dix, Dufy, and Vuillard and sculptures by Brancusi, Epstein, Lachaise, Lehmbruck, and Maillol. Among the generous donors were Clark, Goodyear, Philip Johnson, Mrs. Saidie A. May, Mrs. John D. Rockefeller, Jr., and Edward M. M. Warburg.

Although Alfred Barr expressed satisfaction with the collection of painting and sculpture on the occasion of the Museum's fifth anniversary, half the collection was then in nineteenth-century art and the other half represented rather conservative choices in early twentieth-century art. In the next five years, however, the collection radically changed character, as Barr for the first time had at his disposal discretionary funds with which he was able to supplement gifts of works of art.

In 1935 Mrs. Rockefeller presented the Museum with 181 works, mainly by American artists, including fine watercolors by Burchfield, Demuth, and Prendergast and oils by Weber, Sheeler, and others. She also specified that a number of works in her gift could be exchanged or sold for purchase funds in order to build the collection, thus continuing Miss Bliss's useful precedent. Within the next year Mrs. Rockefeller presented Barr with his first formal purchase funds, and Barr used the money to acquire abstract and Surrealist works in Europe connected with the two major exhibitions of 1936, *Cubism and Abstract Art* and *Fantastic Art, Dada, Surrealism*. Then in 1938 Mrs. Rockefeller gave the Museum a larger sum for buying works of art, and her son Nelson Rockefeller increased the sum by half in his mother's name.

From the *Fantastic Art* show the Museum acquired three Arp reliefs and paintings by de Chirico, Tanguy, Ernst, and Miró. There were also new acquisitions of works by the French Cubists and pre-Revolutionary Russian avant-garde artists, Rodchenko and Malevich among them.

Many gifts of works of art or money came through the Junior Advisory Committee, formed in 1930 as a means for bringing young collectors close to the Museum's inner circle of policymakers. Many members later assumed important roles in the Museum as trustees and in curatorial positions on the Museum staff. Among the early members were the first chairman, George Howe, who was shortly to be succeeded by Nelson Rockefeller, and Elizabeth Bliss, Sidney Janis, Philip Johnson, Lincoln Kirstein, Mrs. Charles S. Payson, James Thrall Soby, James Johnson Sweeney, Edward M. M. Warburg, and Monroe Wheeler. The early gifts acquired through several of the committee members included paintings by Gris and Léger and Picasso's *The Studio*, 1927–28, the gift of Walter P. Chrysler, Jr.

In the late thirties a most generous patron appeared when Mrs. Simon Guggenheim made the first of numerous major gifts to the collection. She provided funds in 1938 and 1939 for two of the Museum's capital paintings: Picasso's *Girl before a Mirror* and Rousseau's *The Sleeping Gypsy*. And she subsequently made possible the acquisition of nearly forty major modern works of art over a period of some twenty years, the Mrs. Simon Guggenheim Fund being specifically earmarked for the purchase of "masterpieces." The full inventory of acquisitions made with her funds over the years lists seventy-one works.

In 1939 perhaps the Museum's most historically influential painting entered the collection with the purchase of Picasso's *Les Demoiselles d'Avignon*, acquired primarily by

Above: Mrs. Simon Guggenheim
Opposite, above: Installation, *Fantastic Art, Dada, Surrealism*, 1936, *below:* Installation, *Modern Architecture: International Exhibition*, 1932

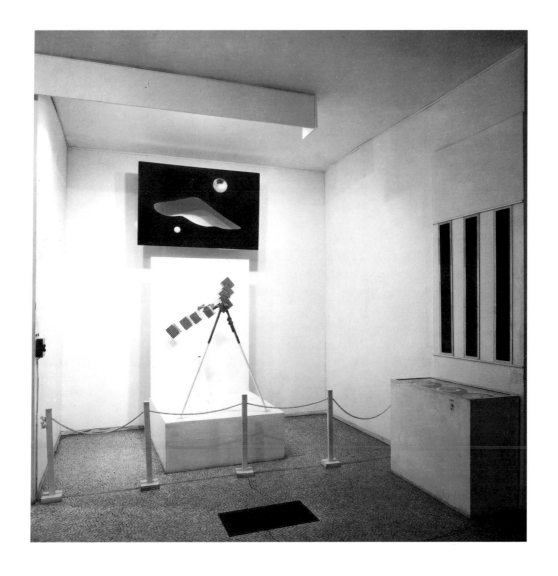

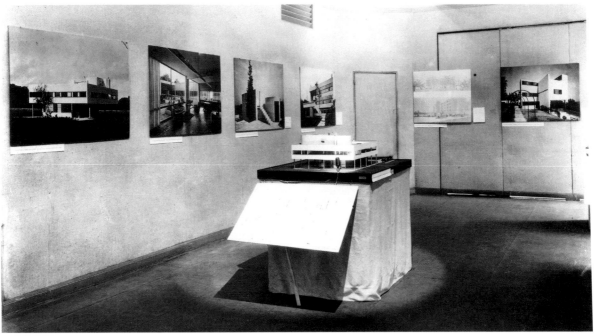

an exchange of a Degas from the Lillie P. Bliss Bequest. Possibly the most innovative and daring painting in the history of modern art, it enjoys a very special identity with the Museum among scholars and public alike. Other notable painting acquisitions that year, the Museum's tenth, were Klee's *Twittering Machine* and *Around the Fish*, Kokoschka's *Hans Tietze and Erica Tietze-Conrat*, and Matisse's *The Blue Window*, a picture that had been branded "degenerate" and discarded by the Nazis. Among the notable acquisitions of sculpture during the thirties were the more radical innovations such as Brancusi's bronze *Bird in Space*, Lehmbruck's *Kneeling Woman*, Giacometti's *The Palace at 4 A.M.*, and Duchamp-Villon's *The Horse*.

Founding trustee Paul J. Sachs was responsible for the Museum's first drawings and prints acquisitions, a field in which he himself was a recognized collector. The month the Museum opened in 1929, he presented it with eight prints and a drawing. The Bliss bequest had brought a significant group of fifty prints to the collection in 1934; other donations in the thirties came from J. B. Neumann and Mrs. Saidie A. May; a large number of illustrated books from Paul Eluard's library were given by Walter P. Chrysler, Jr.; and the most important donor of prints was Mrs. John D. Rockefeller, Jr. In 1931 she gave Barr five hundred dollars, a large amount of money at the time, for the purchase of prints in Paris with the understanding that his selections would eventually go to the Museum.

During the thirties as well as after, many painting exhibitions included a print section. In 1933 *Toulouse-Lautrec Prints and Posters* was the first Museum exhibition to consist solely of prints, and in 1936 Monroe Wheeler directed an influential exhibition of modern illustrated books, *Painters and Sculptors as Illustrators*.

In the Museum's first decade the drawings collection grew impressively, primarily in relation to the painting and sculpture collection. There had been thirty-six drawings, pastels, and watercolors in the Bliss bequest, among them Cézanne's *House among Trees*, Seurat's *At the "Concert Européen,"* and Redon's *Roger and Angelica*.

Mrs. Rockefeller's gift in 1935 included 105 watercolors and pastels by living American artists. Earlier that year she had given Barr money to buy works on paper for the Museum; he acquired several Dada collages by Ernst and works by Masson, Schwitters, and Tanguy that are among the most adventurous early acquisitions in the field of Surrealism. And the nucleus of the Museum's important collection of Russian avant-garde work, in large part consisting of works on paper, was formed following Barr's 1936 trip to the Soviet Union with the acquisition of drawings, illustrated books, and broadsides by Gontcharova, Larionov, Malevich, Rodchenko, and others.

Most of the Museum's early exhibitions of painting and sculpture contained drawings, especially American works on paper. In 1930 it held a show of Burchfield's early watercolors, and in 1936 members of the first generation of American modernists— Marin, Feininger, and Demuth—were given shows consisting entirely or predominantly of works on paper.

Perhaps more radical for its time than Barr's innovative exhibitions and acquisitions in the field of painting, sculpture, drawings, prints, and illustrated books was the fact that he began to implement his plan for a multidepartmental museum with the establishment of independent divisions for architecture and film, and with exhibitions of photography. The latter led directly to the formation of an autonomous department in this specialty. In addition, Barr inaugurated several other important noncuratorial departments that supported the Museum's education and research goals; these were the library, publications department, circulating exhibitions department, and an education program that encompassed an art school for children and adults on the premises of the Museum.

The formation of the Department of Architecture in 1932 followed the success of the influential *Modern Architecture: International Exhibition*, organized that year at the suggestion of Barr by Philip Johnson, who became chairman of the department, in associa-

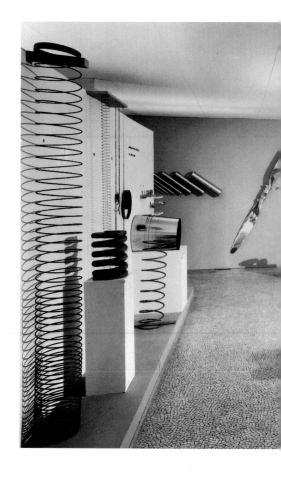

Installation, *Machine Art*, 1934

tion with architectural historian Henry-Russell Hitchcock. The pioneering exhibition consisted of models and related drawings of buildings of various types by architects from Europe and the United States. Among those represented were Gropius, Hood, Howe, Lescaze, Le Corbusier, Mies van der Rohe, Neutra, Oud, and Wright. The impact of the show was amplified by the appearance in the same year of Hitchcock and Johnson's analytical study, of greater length than that found in their catalogue for the exhibition. The book is now the classic text on the International Style.

Then in 1934 Johnson staged the controversial *Machine Art* show, filling three floors of the Museum with examples of industrial engineering and modern design—often by anonymous designers—including "machines, machine parts, scientific instruments and objects useful in ordinary life." The event has been compared with the Armory Show in pointing to new directions in modern design in this country. The core of the design collection was formed when one hundred objects were acquired from the exhibition. Although many traditional museums collected the decorative arts of past historical periods, none focused on modern architecture or on industrial design rather than crafts. And, in 1935, after Johnson had left the Museum, the department was reorganized and its name changed to the Department of Architecture and Industrial Art.

In the late thirties the department presented shows of the architecture of Richardson and Aalto, surveys of modern architecture in England and the United States, posters by Cassandre and Kauffer, a competition for the design of college buildings, surveys of government housing, and an exhibition of rugs designed by American artists, these activities defining the range of the department up to the present time. In 1938 John McAndrew, an architect and teacher who became curator of architecture and industrial art in 1937, launched the first in an important series of exhibitions of industrial design: *Useful Household Objects under Five Dollars.* Although the dollar limit was raised in subsequent shows, the original concept of showing excellent design available at moderate prices was not abandoned.

The major exhibition of this period was a retrospective of the Bauhaus, covering the years from 1919 to 1928. By the time this exhibition was presented in 1939, many of that school's original members, including its founder and first director, Walter Gropius, had settled in the United States. The exhibition was designed by Herbert Bayer with the assistance of other former Bauhaus members in collaboration with McAndrew.

The exhibition of what came to be called the International Style led directly to the establishment of a department devoted to the circulation of exhibitions to other American museums. This resulted from the economic necessity of financing half the cost of the exhibition by leasing it to other museums. Thus began one of the most important and far-reaching educational activities undertaken by the Museum, organized in 1933 by Elodie Courter. By 1938 an exhibition of American painting, sculpture, architecture, and film, along with a small group of prints and photographs, was organized for showing in Paris. It was received with mixed commentary, the most favorable being accorded the architecture and film sections, the harshest being reserved for the paintings. But a beginning had been made in the area of international cooperation in the arts, in which the Museum today, in large part through its International Program, serves as a leader. These early efforts to broaden the Museum's audience were "educational in the broadest, least academic sense," in the words of Alfred Barr, and were a "major factor in increasing interest in modern art throughout the country," and, one might add, throughout the world.

The establishment of a library of modern art, contemplated from the very beginning, became possible once the Museum moved to its quarters on Fifty-third Street, where space was allotted on the top floor and a collection begun with books given by Goodyear. Soon after, in 1933, a library fund was authorized, and Iris Barry was hired as the first librarian. The collection at the end of its first year numbered more than thirteen hundred

volumes. By 1939, when Beaumont Newhall, the second librarian, left that post, after systematizing its holdings, the library was considered the largest in the United States devoted exclusively to modern art. In later years the reputation of the library was greatly enhanced by Bernard Karpel, an indefatigable bibliographer, who was librarian for more than thirty years, during which time, through many resourceful acquisitions, the library became foremost in its field.

Barr's original plan for the Museum included numerous revolutionary suggestions, among them a "library of films," or, as he put it, a "*filmotek.*" In 1929 it was highly unusual to consider films as art or as a medium worth preserving. Nevertheless, the Film Library was established at the Museum a few years later, in 1935, as an independent corporate entity, representing the first film program of its kind in the country.

While the Film Library owed its formation primarily to the efforts of trustee John Hay Whitney, its first president, the moving force behind its program during the first years was its charismatic curator Iris Barry, the film reviewer and cofounder of the Film Society of London, who had come to the Museum as its librarian. Combining an ambitious program of film acquisitions, showings, interpretation, and preservation, Barry and John Abbott, the first director of the department, announced the Film Library's goals: "to trace, catalogue, assemble, exhibit, and circulate a library of film programs so that the motion picture may be studied and enjoyed as any other one of the arts."

Barry and Abbott, with Whitney's help, turned to Hollywood for support for a permanent film archive. When industry officials were made conscious of the elusive and threatened historical heritage of the film, and when they were assured that the Museum would not compete with them commercially, they began to contribute to the Film Library. In 1937 D. W. Griffith donated nineteen films made between 1913 and 1930, including original negatives and prints; and his papers formed the core of what has become the most comprehensive collection on America's pioneer filmmaker. In 1939 the Museum was given a large collection of films produced by the Biograph Company between 1896 and 1916, including Griffith's first four hundred films, and the next year the Museum held the first of three major exhibitions of Griffith's work. The Douglas Fairbanks Collection, also acquired in 1939, included more than two million feet of film, works which Fairbanks produced and in which he starred.

In 1938 the Film Library and its sister institutions in London, Paris, and Berlin formed the Fédération Internationale des Archives du Film (FIAF), which now has affiliates in forty countries and a program of exchange, preservation, and documentation of world cinema. At the end of the thirties the Museum began circulating throughout the United States a collection of film programs, offering key works to students and teachers interested in the study of the new art of the motion picture.

By 1935, when Barry became curator of the Film Library, Beaumont Newhall, a photographer and former student of Sachs at Harvard, had joined the Museum as librarian. Soon after, Barr invited him to organize a comprehensive photography exhibition for the Museum. In 1930 the Museum had been given its first photograph, Walker Evans's *Lehmbruck: Head of Man.* The donor was Lincoln Kirstein, already known in the art world as the founder and editor of the literary magazine *Hound and Horn* at Harvard, who in 1933 directed the Museum's exhibition of Evans's photographs of nineteenth-century houses. The next photography show was without precedent, Newhall's *Photography: 1839–1937,* the first comprehensive photography exhibition ever presented in the United States. It contained more than eight hundred photographs, covering a wide range of techniques and imagery and presented within a historical framework. Included were daguerreotypes and modern prints, abstract formal photography and scientific imagery, news photographs and cinema stills. Attracting more than thirty thousand visitors, the exhibition was the most popular show of 1937. Goodyear wrote, "It must be counted one

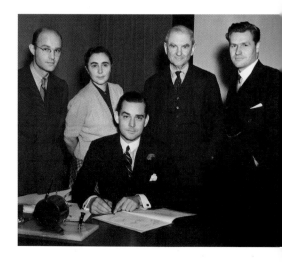

Above: The founding of the Film Library, 1935. John E. Abbott, Iris Barry, John Hay Whitney, A. Conger Goodyear, and Nelson A. Rockefeller
Opposite: Monroe Wheeler

of the most complete and satisfying exhibitions in the Museum's history." Three years later the impact of this important show, and the book that accompanied it, provided the basis for the formation of the photography department, with Newhall its first curator.

In 1937 Barr hired Victor D'Amico, a pioneer in art education, to direct an "education project" at the Museum. He founded the Peoples Art Center, which included an art school for children and adults and encompassed many revolutionary programs that influenced the teaching of art and art appreciation in this country and abroad. Among D'Amico's many students over the years were two who became curators at the Museum and directors of their own departments: Arthur Drexler of architecture and design and William Rubin of painting and sculpture. When D'Amico retired in 1970, the art school came to an end. By then D'Amico's innovative teaching techniques had been adopted by schools all over the country. The division, which ultimately became the Department of Education, continued and expanded its programs associated with public education, including those in the primary and secondary schools, and added a varied program of educational activities coordinated with the Museum's exhibition program.

It is nearly impossible to recount the early history of the Museum's exhibitions and acquisitions without commenting on its extraordinary publishing program. A catalogue accompanied the Museum's very first exhibition of Post-Impressionist painting, and a monthly *Bulletin* was issued for many years beginning in 1933. In 1934, when the Bliss bequest was exhibited in its entirety for the first time, the catalogue that appeared was more thorough and complete than any that had come before, and it marked the beginning of a new kind of art book, both scholarly and attractive, that the Museum was to develop further in the years following. In 1935 the Museum held an exhibition called *The Making of a Museum Publication,* which used the Bliss catalogue to illustrate its theme.

In 1939 the Department of Publications was established under Monroe Wheeler's direction to handle the increasing volume of publications. Wheeler, who had a distinguished reputation as a publisher of fine limited editions in Paris, became a member of the Junior Advisory Committee in 1936 and joined the staff in 1938. He was one of the principal policymakers at the Museum for many years, as director of exhibitions and publications from 1941 to 1967, and as a trustee from 1944. As the Museum's publisher, Wheeler transformed the image of the modern book. A Museum of Modern Art publication came to mean the highest standard of book production.

Among the most influential books produced under the aegis of the painting and sculpture department were two pioneering studies by John Rewald, who also organized a number of important exhibitions for the Museum (and is now an honorary trustee). *The History of Impressionism,* first published in 1946 and reissued in 1955, 1961, and 1973, and *Post-Impressionism: From van Gogh to Gauguin,* first published in 1956 and reissued in 1962 and 1978 remain essential to a comprehension of the history of modern art.

In its first decade the Museum extended its reach in many ways, as we have seen. It pioneered with a number of unusual exhibitions, was openly experimental, and was for most of the decade intimately involved with the government programs in the arts through the Works Progress Administration (WPA). Its unorthodox exhibitions explored areas related to modern art, by way of establishing its foundations and affinities in non-Western and Primitive art. In 1933 and 1935 the Museum held the first exhibitions of pre-Columbian and tribal art as art rather than anthropology: *American Sources of Modern Art (Aztec, Maya, Inca)* and *African Negro Art.* Other exhibition activities were shaped during the Depression by the desperate plight of unemployed American artists, which had induced the government to develop several creative art projects as part of a vast public works program for idle workers in every field of culture and the arts. The Museum was closely allied to these government projects through Holger Cahill, who was acting director of the Museum during a period in which Barr was on leave, and who then assumed, in 1934, the

directorship of the WPA Federal Art Project. Several Museum exhibitions were devoted to work produced under government auspices. Among them was the 1936 exhibition of work by artists on the Project, *New Horizons in American Art*, directed by Dorothy C. Miller, who had joined the staff in 1934 as Barr's assistant and became, the next year, assistant curator of painting and sculpture and Barr's closest associate in the long history of the formation of the painting and sculpture collection. Today historians agree that the government art project under the aegis of the WPA contributed essentially to the later development of the American Abstract Expressionists in the forties by giving them a continuing activity and a new sense of unity. Other collaborations of the Museum with the government during this period included exhibitions of housing programs, of photographs from the Farm Security Administration (in the forties), and of government posters.

By the mid-thirties, the rapid expansion of the Museum's exhibition program, the growing collection, and the increased audience for art put a strain on staff resources and the physical plant. A building program came under discussion, and in 1936, with the Museum's acquisition of four buildings on West Fifty-third Street, the trustees announced plans to construct a new museum. In 1937 John D. Rockefeller, Jr., made a gift to the Museum of land on West Fifty-fourth Street which made it possible to add a sculpture garden to the building plan. The trustees raised a building fund of over a million dollars, a stunning accomplishment for the Depression period. The new building, designed by Philip L. Goodwin and Edward D. Stone, opened on May 10, 1939, with the exhibition *Art in Our Time*, the most effective demonstration to date of the Museum's multidepartmental concept. It included works from all curatorial areas of the Museum. In his introduction to the show's catalogue, Barr observed that the exhibition took cognizance of the main curatorial divisions of the Museum: Painting and Sculpture, Architecture, Industrial Design, and the Film Library. And he noted that some departments "which are not yet formally established" were also represented, photography among them.

The Museum's opening in new quarters coincided with new leadership for the board of trustees. Goodyear resigned as president after ten years in office and was succeeded by Nelson Rockefeller, who had become a trustee in 1932; John Hay Whitney, a trustee since 1930, became vice president. A new post of chairman was created, and Stephen C. Clark was appointed to it.

The unusual building itself attracted considerable attention as a small architectural gem designed in the International Style which the Museum had introduced to the public in its 1932 exhibition. The facade of the six-story building with its light aluminum shell and curved canopied entrance utilized a new translucent material called Thermolux, a sandwich of spun glass between two sheets of clear glass. The first three floors of the building were designed for exhibitions, the fourth floor for the library and print room, the fifth for offices, and the sixth for meeting rooms and a restaurant surrounded by a roofed terrace. There was an auditorium below street level for the film programs. The garden, designed by John McAndrew for the display of sculpture from the collection, quickly became a favorite New York outdoor oasis, gracefully relieving the angular midtown vistas and offering the public an unrivaled urban amenity.

THE WAR AND ITS AFTERMATH

Within two years of the opening of the Museum's new building in 1939, the United States entered World War II. During the war years the Museum modified its program, working in support of the war effort by preparing special programs, posters, films, and exhibitions for the government, the armed forces, and later for veterans. The Museum executed thirty-eight contracts for various governmental agencies, including the Office of War Information, the Library of Congress, and the Office of the Coordinator of Inter-Amer-

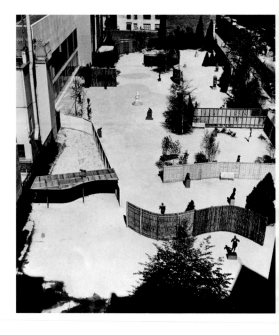

Above: The Museum's first sculpture garden, 1939, designed by John McAndrew
Opposite: The Museum of Modern Art, 1939, designed by Philip L. Goodwin and Edward D. Stone

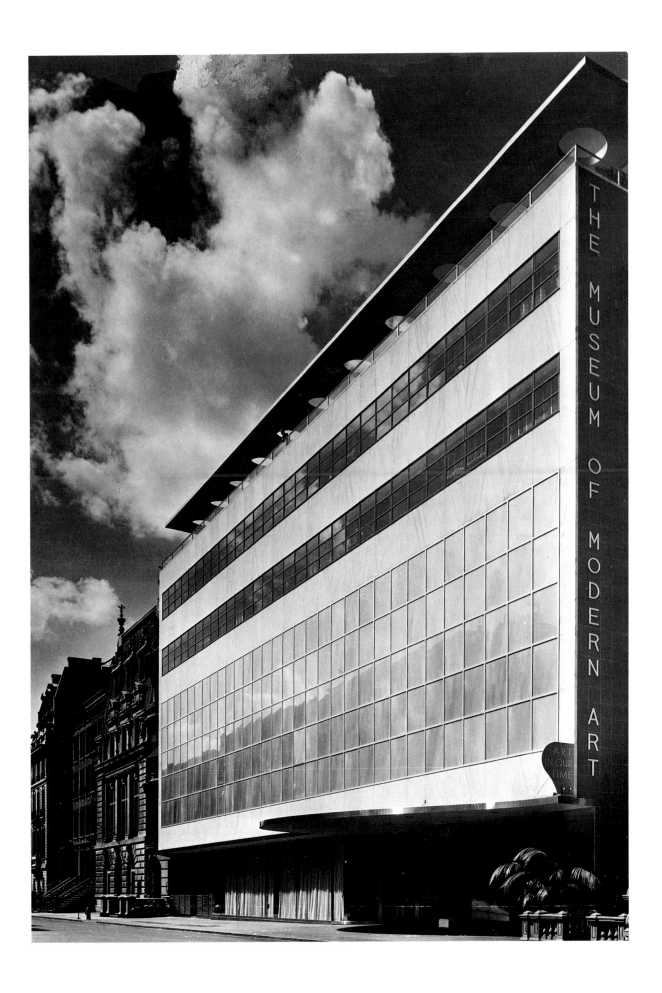

ican Affairs. Nineteen exhibitions were sent abroad and twenty-nine were shown on the premises, all related to the war and the problems and suffering it engendered. The film department analyzed enemy propaganda films. An Armed Services program was established, sending materials and exhibitions to the armed forces and providing therapy programs for disabled veterans. In the garden a canteen for servicemen was installed and became a favorite recreation and entertainment center.

Many changes occurred in the leadership of the Museum during this period. Nelson Rockefeller resigned as president in 1941 to become the government's coordinator of Inter-American affairs, heading an agency designed to further a "good neighbor" policy with Latin America. On the board of trustees John Hay Whitney succeeded Nelson Rockefeller as president but soon left to join the air force; Stephen C. Clark then served as both president and chairman.

Before the war the Museum had expanded its plant, staff, and public commitments, and during the early war years the conflicting duties of executive administration and scholarship began to weigh heavily on Alfred Barr. In 1943 he was abruptly relieved of his administrative duties by Clark. But he would not leave—and so was given a research position in the library. Considerable confusion and dismay among the staff ensued. Barr had become in the art community and in the public mind the intellectual symbol of the Museum, and an internationally recognized museum figure. The first step toward resolving these dramatic difficulties was made the next year when Nelson Rockefeller suggested that René d'Harnoncourt join the Museum staff as an executive administrator with the title of vice president. His relationship with the Museum had begun in 1941 when he organized the exhibition *Indian Art of the United States,* which occupied almost the whole Museum and was a tremendous popular success and first established him as a master of installation. Born in Vienna, d'Harnoncourt emigrated to Mexico, where during the twenties and thirties he organized traveling shows of Indian and folk art for the Mexican government and The Metropolitan Museum of Art. In 1934 he taught at Sarah Lawrence College and became a citizen in 1939. By 1941 he had joined the United States government's Indian Arts and Crafts board in Washington. D'Harnoncourt, quite apart from his connoisseurship in Primitive art and his genius for installation design, was uniquely suited by reason of his generosity of spirit, human sympathy, tact, and organizational skill to reconcile differences and focus the abundant energies of the curatorial staff. Three years after coming to the Museum, and after the reelection of Nelson Rockefeller to the presidency and John Hay Whitney to the chairmanship of the Museum, d'Harnoncourt restored to Barr full curatorial responsibilities as director of Museum Collections, a newly formed cross section of the institution's functions. Barr held this position until his retirement in 1967. In 1949 d'Harnoncourt was named director of the Museum and served in that capacity until his retirement one year after Barr's.

During the time that Barr was without curatorial responsibility, painting and sculpture exhibitions and acquisitions were directed by James Thrall Soby from 1943 to 1945 and by James Johnson Sweeney in 1945 and 1946. Soby, an esteemed critic and collector of contemporary art, known for his lapidary prose style, served the Museum in a variety of capacities during his long association with the institution. An original member of the Junior Advisory Committee and a trustee since 1942, Soby directed the Museum's Armed Services program and organized fourteen exhibitions at the Museum. Despite the brevity of Sweeney's service as director of painting and sculpture, he exercised considerable influence in the Museum and in the art world at large. Before his appointment he had been active at the Museum on the Junior Advisory Committee and directed a number of major exhibitions. He encouraged a broad spectrum of contemporary avant-garde expression and was, in fact, the first museum curator to recognize Pollock's genius.

The dramatic growth of the painting and sculpture, drawings, and print collections

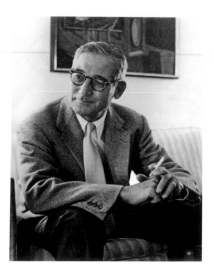

Above: Nelson A. Rockefeller and Stephen C. Clark, 1939, *below:* James Thrall Soby
Opposite, above: James Johnson Sweeney, *below:* Dorothy C. Miller

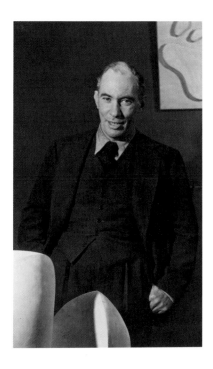

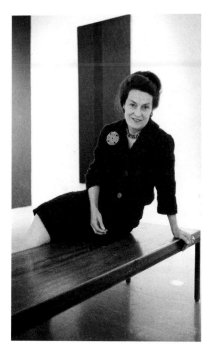

continued in the forties despite the interruption of the war and the changes in staff. Among the paintings acquired during this period were such masterworks as van Gogh's *The Starry Night,* Mondrian's *Broadway Boogie Woogie,* Beckmann's triptych *Departure,* and Matisse's *Piano Lesson* and *The Red Studio.* In 1945 the Museum acquired a group of important European Cubist paintings, among them Braque's *Man with a Guitar,* Picasso's *"Ma Jolie"* and *Card Player,* Léger's *Big Julie,* and Duchamp's *The Passage from Virgin to Bride.*

During the war the feeling grew that the Museum should strongly show its colors as an American museum, and establish a special relationship to the artists of its own country. In the foreword for the Museum's 1942 catalogue of the collection, John Hay Whitney wrote: "It is natural and proper that American artists should be included in greater numbers than those of any other country. But it is equally important in a period when Hitler has made a lurid fetish of nationalism that no fewer than twenty-four nations other than our own should also be represented in the Museum Collection."

With the advent of the postwar avant-garde Abstract Expressionists and their growing international stature, the Museum began to shift its focus toward these American artists. The Museum had bought with discrimination among them in the early and mid-forties, securing such works as Gorky's *Garden in Sochi,* Motherwell's *Pancho-Villa, Dead and Alive,* and Pollock's *The She-Wolf,* all acquired the year after they were completed, and Gottlieb's *Voyager's Return,* acquired the year it was painted.

When Dorothy Miller initiated her prestigious series of group shows of Americans in 1942, the Museum was not fully committed to showing the American avant-garde; beginning in 1946, however, Miller selected growing numbers of vanguard artists for these shows. Among the fourteen artists in the third show in the series held in 1946 were Gorky, Motherwell, Noguchi, Roszak, and Tobey. Six years later the next show in the series, *Fifteen Americans,* put the Museum's stamp of approval on Abstract Expressionism by including Baziotes, Pollock, Rothko, Still, Tomlin, and Ferber. Miller continued to organize group shows at the Museum through 1963, and many important works were acquired for the collection from these exhibitions. She retired in 1969 as senior curator in the department of painting and sculpture.

With the support of Mrs. Rockefeller, who had made the print collection her personal project, space for a print room had been assigned in the new building of 1939, and the following year she gave the Museum her entire collection of prints. However, because of the war the print-room space was converted to use for wartime film programs, and the print collection was put into storage. In spite of this the Museum expanded its holdings during the forties, and Mrs. Rockefeller remained an active force. The Museum's print room opened in 1949, a year after her death, and although she was not able to see it in operation, it recalled her presence by its name: The Abby Aldrich Rockefeller Print Room.

In 1944 Monroe Wheeler directed the influential exhibition *Modern Drawings,* an international survey of modern draftsmanship. It was an exhibition widely admired by specialists in the field, and proved an important basis for further critical and scholarly exploration. The first exhibition devoted to the Museum's drawings was held three years later. At the time the Museum owned only 227 drawings, and 160 of them were hung in the show, *Drawings in the Collection of The Museum of Modern Art.*

The Museum's 1941 exhibition *Organic Design in Home Furnishings* was one of its most influential early design shows, now best remembered for its sponsorship of a competition that produced revolutionary molded plywood chairs by Eero Saarinen and Charles Eames, the first of their kind, subsequently mass-produced. The chairs were manufactured by a method never previously applied to furniture: layers of plastic glue and wood veneer were molded in three-dimensional forms to make a light structural shell.

These chairs probably represented the most innovative development in furniture design since Breuer and others designed tubular-steel furniture at the Bauhaus almost two decades earlier. Other prizewinning designs included textiles, lamps, and integrated room furnishings, all presented in an effort to foster high aesthetic standards.

The first new department to emerge in the forties was that of photography. An extraordinary public response had greeted the Museum's first exhibition featuring photography as art. In 1940 Beaumont Newhall called on photographer Ansel Adams in San Francisco and disclosed to him plans for the new Museum department; only one museum had a photography department at the time, and it happened to be in New York: The Brooklyn Museum. Adams was enthusiastic and appealed to the collector David H. McAlpin for support on Newhall's behalf. McAlpin immediately promised the Museum a contribution to establish the new department.

Upon his appointment as curator of the department Newhall defined the goals of its program: "The Department of Photography will function as a focal center where the aesthetic problems of photography can be evaluated, where the artist who has chosen the camera as his medium can find guidance by example and encouragement and where the vast amateur public can study both the classics and the most recent and significant developments of photography." Newhall's statement must have seemed visionary, for the Museum's collection consisted of only 229 photographs when he assumed his post. However, gifts began to arrive rapidly; among the important early donors were Albert Bender, the Farm Security Administration, Adams, Eliot Porter, James Thrall Soby, Lincoln Kirstein, and David McAlpin, and between 1940 and 1943 the collection grew to more than two thousand photographs.

For its first five years the department focused much of its attention on the war effort. One of its most successful ventures, combining aesthetics with patriotism, was Edward Steichen's 1942 exhibition *Road to Victory*. The theatrical installation marked a new era in photographic presentation, with monumental photomurals of America and its people set off by rousing appeals for sacrifice and dedication in texts by poet Carl Sandburg. It was undoubtedly the most overtly political exhibition held by the Museum during the war years and received enthusiastic notices, often highly emotional in tone, in the major American newspapers. *The New York Times,* for example, called the exhibition "the supreme war contribution" and "the season's most moving experience."

In 1947 Steichen became director of the department, and Newhall left the Museum to become curator at the newly formed museum of photography at George Eastman House in Rochester. During Newhall's tenure the photography department had organized more than thirty exhibitions. His 1937 survey exhibition and the classic book that evolved from it, the formation of the department and the development of its collection, and the example of his scholarship were his major contributions. Steichen said later that they "set a standard for quality [that] continues to be a goal to strive for."

CONSOLIDATION AND GROWTH

René d'Harnoncourt became director in 1949 and retired in 1968, thus presiding over the Museum's years of richest growth. In those nineteen years the Museum flourished, expanding vastly in exhibition space, staff, and the scope of its programs. In the early fifties Dwight Macdonald marveled at the multiple functions of the Museum and d'Harnoncourt's virtuosic managerial skills: "'What is this, a three-ring circus?' a group of artists asked in a manifesto denouncing the Museum of Modern Art. Their rhetoric was thrice too moderate. The Museum is a nine-ring circus, at least. The traditional function of preserving and displaying its own art works takes up only one ring. In addition, it

Opposite, above: René d'Harnoncourt, *below:* The Abby Aldrich Rockefeller Sculpture Garden, 1953, designed by Philip Johnson

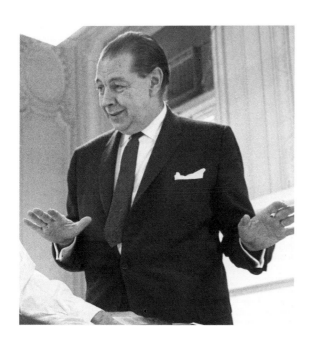

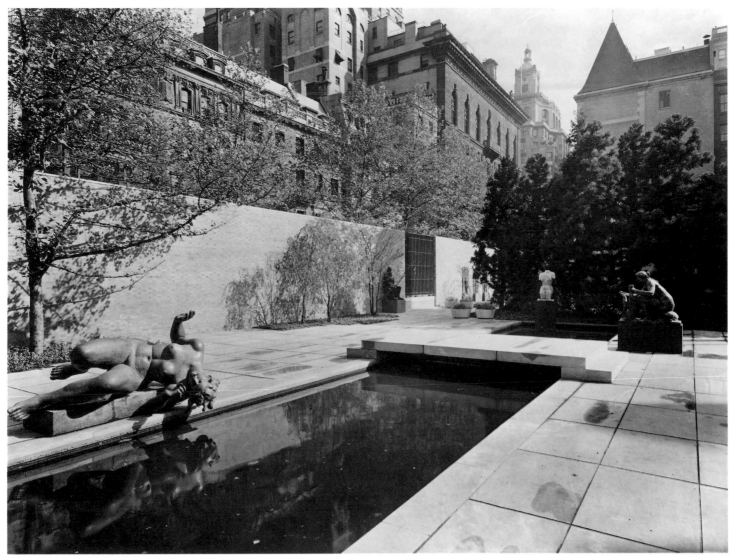

is a community center, a movie theatre, a library, a publishing house, a school, a provider of shows for other institutions, an arbiter of taste in everything from frying pans to country houses, and above all, an impresario that every year puts on some twenty all-new productions, with new lighting and scenery and mostly new casts, borrowed from collectors, dealers, artists, and other museums. As director or ringmaster d'Harnoncourt presides over all nine rings, a task that at times strains even his considerable executive and diplomatic resources."

D'Harnoncourt was also a devoted internationalist, and had conceived an imaginative program for making the Museum an international center of modern art. In 1952 he established a new Museum department, The International Program, under the supervision of Porter McCray, with the principal aim of making modern art in general and recent American art in particular better known around the world. The program was underwritten with an initial five-year grant from the Rockefeller Brothers Fund and backing from The International Council, an organization of art patrons from all over the world, started in 1953 with Mrs. John D. Rockefeller 3rd its first president. It has continued under the directorship of Waldo Rasmussen and with the advice and generous support of the members of the council. Through this program, the Museum has conducted the most extensive private effort yet undertaken in international art exhibitions.

In this period the exhibitions shown at the Museum drew increasingly large and well-informed audiences. In late 1951 a Matisse exhibition included many extraordinary works unfamiliar to the American audience. In the same year Barr's book *Matisse: His Art and His Public,* still mandatory reading for all scholars of Matisse, was published, adding to an impressive list of books by Barr, all published by the Museum.

A cursory listing of exhibitions presented in subsequent years would include *Les Fauves* and *De Stijl* in 1952. In 1953 the Museum's garden was redesigned by Philip Johnson and named The Abby Aldrich Rockefeller Sculpture Garden; it opened with an exhibition, *Sculpture of the Twentieth Century,* directed by Andrew Carnduff Ritchie, after which the area was devoted to sculpture from the collection. Other exhibitions of the fifties included the works of Gris and Miró. Major shows of the sixties included *Mark Rothko; Futurism; The Art of Assemblage; The Last Works of Matisse: Large Cut Gouaches;* exhibitions of the work of Dubuffet, Gorky, Nolde, Rodin, Hofmann, Rosso, Beckmann, Giacometti, Motherwell, Magritte, Turner, Pollock, de Kooning, and Oldenburg; *The School of Paris: Paintings from the Florene May Schoenborn and Samuel A. Marx Collection; The Sculpture of Picasso; Dada, Surrealism, and Their Heritage; The Machine as Seen at the End of the Mechanical Age;* and *Spaces.*

With the Pollock, Balthus, Matta, and David Smith shows of 1956 and 1957, the Museum inaugurated a policy of holding miniretrospectives of "artists in mid-career." (Pollock, however, died four months before his exhibition opened.) In 1958–59, at the request of European museums, The International Council organized a major exhibition devoted specifically to Abstract Expressionism in America: *The New American Painting.* The show was directed by Dorothy Miller and was shown in eight countries, before its last showing in New York. The reception in Europe was sensational, whether enthusiastic or hostile; it was acknowledged that in America a "new" and indigenous kind of painting had appeared, which quickly exerted an influence on artists abroad. In the summer of 1969 the Museum showed an exhibition directed by William Rubin, now director of the painting and sculpture department, called *The New American Painting and Sculpture: The First Generation,* as part of a series of shows that featured different aspects of the collection. In the decade since the earlier exhibition, new art of a very different spirit and character had developed in America; hence the addition of the subtitle. In the effort to follow the development of certain key artists over a period of more than a quarter of a century, a new program of acquisitions was initiated to solicit gifts or commitment toward

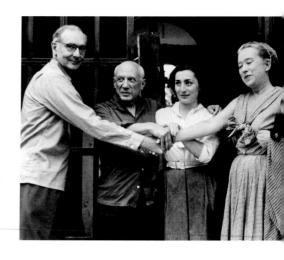

future bequests of works of specific dates or styles that were lacking. Of the sixty-six works published in the checklist of the 1969 show as promised gifts, thirty-two have since been given.

While Barr and Miller directed the new division of Museum Collections, which maintained jurisdiction over all departments' acquisitions by way of a trustee committee that passed on all Museum acquisitions, the exhibitions of painting and sculpture were under the aegis of the Department of Painting and Sculpture Exhibitions. Ritchie held these responsibilities until 1958, when they were shared by Peter Selz and William C. Seitz. The collecting and exhibition functions were not reunited under one administrative head until 1968.

During the fifties and sixties many major gifts were made to the Museum's painting and sculpture collection. The collection's considerable strength in Surrealism was augmented in 1953 by a number of Duchamps acquired from the Katherine S. Dreier Bequest. The gift of ninety-nine works included the bulk of Dreier's personal collection, the Société Anonyme collection having previously been given a home at Yale, and encompassed a group of "valuable and needed works," in Barr's words, by Archipenko, Brancusi, Ernst, Kandinsky, Klee, Léger, Miró, Mondrian, and other masters of twentieth-century art.

The acquisition of Matisse's group of relief sculptures on the theme of The Back, made possible by the Mrs. Simon Guggenheim Fund, and some years later, *Dance*, a gift of Nelson A. Rockefeller in honor of Alfred H. Barr, Jr., enhanced what was already a major Matisse collection. But it was the gift, by Samuel and Florene Marx (now Mrs. Wolfgang Schoenborn) of four masterpieces, *The Moroccans, Woman on a High Stool, Goldfish,* and *Variation on a Still Life by de Heem* that catapulted it into a collection unrivaled in the West, and matched only by the Museum's collection of Picassos for its concentration and quality in the work of a single, great twentieth-century master.

Other significant gifts in this period were the Larry Aldrich Fund for the purchase of recent art; the Kay Sage Tanguy Bequest of Surrealist works; the Mrs. David M. Levy Bequest of European master paintings; the bequest of works from Philip L. Goodwin's collection; and the gift of two late Monets from Mrs. Simon Guggenheim, works of mural scale which were installed in a special gallery bearing her name. To these were added immediate and promised gifts from two trustees, Mrs. Bertram Smith (in European art) and Philip Johnson (in recent American art). Mrs. Smith's superb gifts have included two Picasso sculptures, *Glass of Absinth* and *Pregnant Woman,* and Kandinsky's *Picture with an Archer.* Those from Johnson included paintings and sculptures by Flavin, Jenney, Judd, Morris, Newman, Stella, Oldenburg, and Warhol—forming the basis of the Museum's post–Abstract Expressionist collection.

In sculpture the following purchases were made during this period from the Mrs. Simon Guggenheim Fund: Calder's *Black Widow,* Gonzalez's *Woman Combing Her Hair,* Lachaise's *Standing Woman,* Lipchitz's *Man with a Guitar,* Moore's *Large Torso: Arch,* Picasso's *She-Goat,* Rodin's *St. John the Baptist Preaching,* and David Smith's *History of LeRoy Borton,* all sculptures of masterwork quality; and William A. M. Burden, a trustee since 1944 and later president of the Museum, gave three important gifts: a Brancusi *Bird in Space,* his bronze *Young Bird,* and Arp's *Ptolemy* to complement his other gifts of paintings.

Among artists, Alexander Calder had a long-standing relationship with the Museum, dating back to his 1945 exhibition, and he became an important donor in 1966 when he casually offered Barr thirteen of his sculptures. Soby described the gift as the most consequential one ever made to the Museum by an artist.

The Abby Aldrich Rockefeller Print Room finally opened in 1949, the year d'Harnoncourt became director of the Museum. At that time William S. Lieberman, who

had come to the Museum as Barr's assistant in 1945, was appointed associate curator in charge of prints, and was made curator in 1953. Throughout the fifties, prints, as well as drawings, were considered an integral part of the painting and sculpture department. Within that province, however, Lieberman both refined and greatly enlarged the print collection, making significant acquisitions of large groups of prints by Beckmann, Feininger, Matisse, Morandi, Picasso, Rohlfs, Rouault, and Villon. In less than ten years the print collection doubled in size. During the fifties Lieberman directed a number of exhibitions built around the print collection.

The drawings collection grew in the fifties under the aegis of the painting and sculpture department, and in 1960 Lieberman organized a large survey exhibition called *100 Drawings*. Then, in recognition of the growth of both the collection of drawings and that of prints, a new department, Drawings and Prints, was established, and Lieberman was named its curator; he became director of the department in 1966.

Among the many important acquisitions which made the drawings collection one of unrivaled quality in the sixties, a few may be singled out. John S. Newberry, who had been curator of graphic art at the Detroit Institute of Arts, made it possible for the Museum to acquire 153 drawings, mainly by modern masters. One of the most important gifts of postwar drawings came from an anonymous donor who bought for the Museum Rauschenberg's series of thirty-four drawings illustrating Dante's *Inferno*.

Among print acquisitions there was the nearly complete graphic work of Dubuffet, comprising over three hundred prints and books, the gift of Mr. and Mrs. Ralph F. Colin. And beginning in 1962 the complete production of Universal Limited Art Editions, publisher of lithographs by Johns, Rauschenberg, and others, was presented annually by Celeste and Armand P. Bartos; later the entire production of over three thousand prints of the Tamarind Lithography Workshop (1960–70) was donated by Kleiner, Bell and Co. These two shops encouraged contemporary artists of quality to experiment with serious printmaking.

In the architecture department the d'Harnoncourt era began with the return of Philip Johnson, who had acquired a degree in architecture from Harvard University, and the reunification of the departments of architecture and design under his directorship. In that year, 1949, the first architectural structure was built for public exhibition in the Museum's first sculpture garden. It was a full-scale completely furnished small house designed by Breuer, one of Johnson's teachers at Harvard; the price of each item in the house was carefully labeled and the cost of construction estimated. This exhibition drew a large audience, and a second house was erected in 1950, by California architect Gregory Ain.

Also in 1950 the "service" exhibitions, initiated in 1938 by John McAndrew, were revived and expanded by Edgar Kaufmann, Jr., then curator of design, in a far more ambitious arrangement cosponsored by the Merchandise Mart of Chicago. The idea of the Good Design exhibition series was to familiarize the public with the best-designed products available from the biannual merchandise markets of home furnishings. Although the Good Design series, as such, was discontinued in the middle of the decade, the Museum kept abreast of developments and innovations in modern design by regularly screening submitted work and organizing group and individual exhibitions, from which objects were continually added to the collection.

In 1951 Arthur Drexler joined the department as curator, and when in 1954 Philip Johnson again resigned to devote full time to the practice of architecture, remaining a trustee, it was Drexler who assumed Johnson's administrative duties. Drexler was named director of the department two years later. He directed the exhibition in which another house was erected—the first to appear in the new Abby Aldrich Rockefeller Sculpture Garden, designed in 1953 by Johnson—a new Japanese house based on sixteenth- and seventeenth-century prototypes. All the parts of this building were made in

Above: William S. Lieberman
Opposite: Japanese house exhibited in The Abby Aldrich Rockefeller Sculpture Garden, 1954. René d'Harnoncourt, Prime Minister Shigeru Yoshida, and John D. Rockefeller 3rd

Japan, packed in more than seven hundred crates, and shipped to New York, where, under the architect's supervision, and with the aid of three Japanese craftsmen and a gardener, the house was reassembled in the sculpture garden. Given to the Museum by the American Japan Society of Tokyo, the house was open to the public during the summers of 1954 and 1955; the exhibition was accompanied by an ambitious study, *The Architecture of Japan,* written by Drexler.

During Drexler's directorship, exhibitions in design and architecture multiplied, and the fifties and sixties saw such shows as *The Package, Art Nouveau, Frank Lloyd Wright, Louis I. Kahn, Architecture without Architects,* and *Word and Image.* At this time the design collection of the Museum began to acquire the scope and magnitude that today make it unique among institutional collections.

During the greater part of this period Edward Steichen presided over the photography department, organizing a number of large spectacular exhibitions with broad public appeal. He was most successful with his 1955 exhibition *The Family of Man,* which was seen by more than nine million people in the United States and abroad when it traveled, and which broke all Museum attendance records at home.

In 1950 Georgia O'Keeffe gave the Museum fifty-one Stieglitz photographs, one of the largest and most important gifts during Steichen's directorship. Frequent smaller acquisitions made by Steichen in the United States and Europe gave the photography collection an international scope.

In 1961, the year before he retired, Steichen was encouraged by the trustees to hold a retrospective of his own work. *Steichen the Photographer* traced his career from his earliest romantic days as a "pictorialist" through his World War II days as photographer for the Navy Air Force. With Steichen's retirement in 1962, John Szarkowski, photographer and author of *The Idea of Louis Sullivan* and *The Face of Minnesota,* was appointed director of the department. Since that time the department's exhibition activity has expanded and become more varied. The collection developed steadily, and the number of photography publications increased. All of this reflected not only the energies of the director and his staff, but also the support given the department in response to the dramatically expanding public interest in photography.

Szarkowski's first important theme exhibition, *The Photographer and the American Landscape* in 1963, initiated a number of exhibitions that provided a historical and critical framework for understanding the evolution of a particular photographic tradition. In 1964 Szarkowski directed *The Photographer's Eye,* a large loan exhibition of two hundred photographs from public and private collections. It was an ambitious aesthetic statement, providing a fresh critical and theoretical framework for understanding different styles of photography, and it set a standard for all subsequent exhibitions in the field.

New Documents, in 1967, contained photographs by Arbus, Friedlander, and Winogrand. All three photographers later were given shows at the Museum. Among the major gifts during that time were the Ben Schultz Memorial Collection, the David H. McAlpin Collection, and a gift from Edward Steichen.

In 1950 Richard Griffith succeeded Iris Barry as curator of the Film Library. Griffith was a documentary filmmaker who had worked during the war with Frank Capra, and he built up the Film Library's collection of wartime films and social documentaries. He encouraged historical investigation into the cinema, and in 1957 wrote, with Arthur Mayer, the indispensable history of American film, *The Movies,* recently reissued in an edition updated and enlarged by curator Eileen Bowser. Griffith had expanded the film programs from fewer than five per year to about fifteen when he retired in 1966.

A major breakthrough in film preservation in 1950, the invention of triacetate film stock, which provided a stable alternative to nitrate, made it possible for the Museum to guarantee the long-term survival of film footage—provided there were funds for the

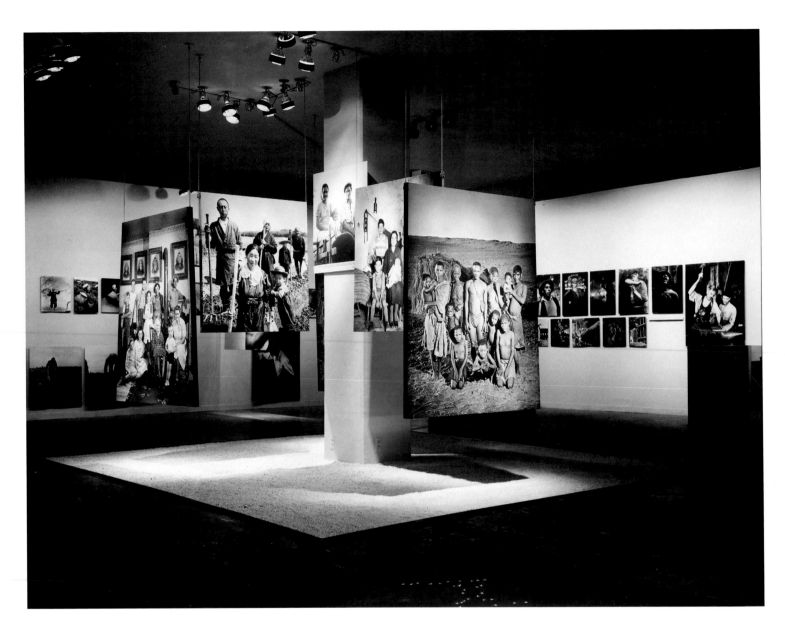

Opposite, above: Installation, *The Family of Man,* 1955, *below:* Edward Steichen
Above: Nelson A. Rockefeller and fireman at the scene of the Museum fire, 1958, *below:* William A. M. Burden and Mrs. John D. Rockefeller 3rd, 1962

expensive duplicating process. During Griffith's tenure the department began work on its extensive film-preservation program.

In 1952 the nucleus of the Film Stills Archive was formed when *Photoplay* magazine donated a large collection of film stills and publicity photographs. Other important gifts were the Stanley Kubrick Collection and the Joseph E. Levine Collection. Kubrick, then a young director, had discovered his cinematic vocation and studied the potentialities of film expression in regular attendance at Museum screenings.

In 1966 filmmaker Willard Van Dyke was appointed director of the Film Library, and as his first official act, changed its name to the Department of Film. He revitalized the department's public programming with several series that continue today. Cineprobe, begun in 1968, gives independent or avant-garde filmmakers an opportunity to present their films and engage in discussion following the screenings. Brakhage, Anger, and Frampton were among the first "new talents" who participated in the series. Van Dyke also introduced the program What's Happening?, featuring contemporary documentary films often with strong social viewpoints, and New Directors/New Films, in collaboration with the Film Society of Lincoln Center. In 1967 the department broadened its holdings of foreign films through the gift of the Janus Films Collection, which included twenty-seven postwar films by Bergman, Antonioni, Ray, Truffaut, and others.

But the Museum's history was not wholly a succession of happy developments. In May 1958 a serious fire broke out while the galleries were undergoing renovation. Fortunately the fire was soon contained and extinguished, but three paintings were destroyed: a large and important work, *Water Lilies,* by Monet; a smaller Monet; and a Cândido Portinari mural. The large late-Impressionist painting was soon after replaced through the purchase of an equally fine Monet of the same period and scale. Umberto Boccioni's masterwork *The City Rises* was badly burned over one-third of its surface, but thanks to the resources of modern-day conservation, the area was faithfully restored. Smoke damage to Pollock's *Number 1, 1948* was also severe, but the soot and grime were successfully removed, as they were from several other works which suffered from the smoke.

A strong show of public sympathy followed the fire. A large group of supporters were clearly concerned with the well-being of the Museum, and the trustees felt encouraged to launch an ambitious fund-raising campaign in the fall of 1958 to enlarge the building and increase the Museum's endowment. At this time Mrs. John D. Rockefeller 3rd succeeded William A. M. Burden as president of the Museum. The chairmanship was held, successively, by Nelson Rockefeller, Henry Allen Moe, and, in 1962, David Rockefeller. By 1962 the money needed had been raised through large private donations, support of the general public, and Museum membership, and construction began on two new wings and other building improvements.

In May 1964 the Museum opened its enlarged galleries with a series of exhibitions, principally from the collection, under the title *Art in a Changing World: 1884–1964.* A new lobby and two new wings, and an addition to the Abby Aldrich Rockefeller Sculpture Garden, had been designed by Philip Johnson. The acquisition of the former Whitney Museum of American Art building at 20 West Fifty-fourth Street, adjoining the new sculpture garden, provided space for a garden restaurant, the library, conservation laboratories, and storage for painting and sculpture; storage areas for the collections of each department were designed as study centers so that scholars and the public could easily view the works not on display in the galleries.

A new garden wing to the east of the Museum was also built to house temporary exhibitions, adding fifty-four hundred square feet of gallery space, uninterrupted by supporting piers. Above this space a terrace was built to connect with the new garden and provide additional space for the exhibition of outdoor sculpture. In the renovated galleries

of the original Museum building, space was reserved for the first time for the permanent display, or changing display, of the collections of the various departments of the Museum. The space thus allocated became the Edward Steichen Photography Center, the Philip L. Goodwin Galleries for architecture and design, and the Paul J. Sachs Galleries for drawings and prints. In addition, a greater proportion of the painting and sculpture collection was now on exhibit. The Museum was thus able to offer the public a larger and more coherent visual documentation of the major mediums of twentieth-century art than had heretofore been possible.

EXPANSION AND A NEW CHALLENGE

Following René d'Harnoncourt's retirement in 1968, there were four years of rapid change and readjustment in the Museum's leadership. Bates Lowry, who had been head of the art department at Brown University, succeeded d'Harnoncourt but served for less than a year as the Museum's director. He also held the directorship of the painting and sculpture department during his brief tenure. At the same time the presidency of the Museum again changed hands with the retirement of Elizabeth Bliss Parkinson (now Mrs. Henry Ives Cobb), who had taken office in 1965 after completion of the Museum's 1964 expansion. William S. Paley, a trustee since 1937, took her place as president, while David Rockefeller continued as chairman of the board. After Lowry's resignation in 1969, the Museum was directed by trustee Walter Bareiss, the Museum's counsel Richard Koch, and director of exhibitions Wilder Green until the trustees chose John B. Hightower, previously head of the New York State Council on the Arts, to be director in 1970. When Hightower resigned in January 1972, Richard E. Oldenburg, head of the Museum's Department of Publications since 1969 and formerly managing editor at The Macmillan Company, was made acting director. Six months later he was elected director of the Museum by the board of trustees. In reporting his appointment, the president cited Oldenburg's "insight into the workings of the Museum, his understanding of its mission, and the extraordinary grasp of its practical affairs he had demonstrated as acting director." In the fall of 1972, William S. Paley became chairman of the Museum and Mrs. John D. Rockefeller 3rd returned to its presidency.

The Museum now faced challenges that had been developing during the preceding years and recognized a need to reassess its functions and purposes in a changing environment. Although a private museum in legal terms, the Museum had always been a public institution in terms of its goals and concerns. In fact, in its proselytizing role on behalf of the modern visual arts, it had worked harder than most public museums to share its collections and to extend its services as widely as possible, nationally and internationally. Nevertheless, the seventies and eighties saw a transition to a still more public character in both philosophical and practical terms.

The very success of the Museum's efforts had altered its own context. Its modest gallery spaces were now crowded by a million visitors and more each year. A large and growing number of collectors of contemporary art had fostered hundreds of commercial galleries in New York and elsewhere. New museums and exhibition spaces for modern art had been founded in cities throughout this country and abroad. They looked to The Museum of Modern Art in New York not only as an example but as a primary resource center for loans, exhibitions, scholarship, and expertise.

The international stature of the institution was underscored in 1975 when the Museum, represented by Oldenburg and William Rubin, concluded a formal agreement with the Ministry of Culture of France, the French national museums, and the Centre National d'Art et de Culture Georges Pompidou in Paris to collaborate on major exhibitions and other projects. The first fruit of this understanding was cooperation on the 1977

Above: East wing and new terrace of The Abby Aldrich Rockefeller Sculpture Garden, 1964, designed by Philip Johnson, *below:* Elizabeth Bliss Parkinson (now Mrs. Henry Ives Cobb), 1965

David Rockefeller

exhibition *Cézanne: The Late Work.* The second collaboration was even more ambitious, the spectacular *Pablo Picasso: A Retrospective,* which filled the entire Museum in 1980 and remains one of the most memorable exhibitions in recent history.

In order to serve its continually expanding public, to respond to new needs and interests of special constituencies, and to care for, extend, and exhibit its growing collections, the Museum had necessarily become a larger and more complex institution than its founders could have foreseen. The costs of maintaining its programs and services had also grown proportionately, producing expenses-over-income too large to be covered as in the past by a few affluent and dedicated patrons. Major efforts were launched to broaden the Museum's base of financial support, and contributions to the Museum's Annual Fund quadrupled in the decade following 1972. Increasingly significant were grants from two sources from which support had been negligible or nonexistent in prior years: government and corporations. Aid from these sources was particularly essential in meeting the rapidly rising costs of special exhibitions. Receiving it, however, implied greater public accountability for the Museum's programs, and also required care to ensure that experimental work was not neglected simply because it was less easily funded.

While efforts to meet expenses remained a continuing necessity, another need was of equal and perhaps even greater concern: the need for space. In the period since the Museum added new buildings in 1964, the inadequacy of its facilities had become increasingly acute. Only a small fraction of its constantly growing collection could be shown at one time in the galleries, and spaces formerly reserved for special exhibitions had to be reallocated for modest representations of recent acquisitions of contemporary art. Lobby areas, elevators, and other public areas were seriously overtaxed by the number of Museum visitors.

In 1976, the Museum announced an imaginative and innovative plan to expand its facilities and develop new funding sources to support them by realizing the value of a frozen asset: the air rights over its prime location in midtown Manhattan. Under the aegis of the Trust for Cultural Resources of the City of New York, the plan was implemented by the sale of the air rights to a private developer to construct a condominium apartment tower over a new Museum wing to the west of its existing buildings. Through the Trust, the Museum receives most of the benefit of the municipal real estate taxes produced by the new apartment building. The approval of this allocation by the administration of the city of New York recognized the importance of the Museum as a primary cultural asset which deserved some support comparable to the direct subsidies given several other major New York museums. An essential element of the plan was a fiftieth-anniversary capital campaign to provide additional endowment funds after construction costs were covered.

With these commitments in place, the Museum proceeded with an architectural plan designed by Cesar Pelli and colleagues to respond to the Museum's primary goals: substantially expanded space for the exhibition of art and for the related service functions; adequate provision for the reception, circulation, and general accommodation of its visitors; and the accomplishment of these aims without the loss of special qualities for which the Museum had been appreciated in the past: the pastoral ease of its sculpture garden in tumultuous midtown Manhattan, and the sense of intimacy with the works on view in galleries of human scale.

The result is a handsome, expanded Museum almost doubled in size. Each department now has its own gallery space for displaying representative portions of its permanent collection and for changing exhibitions. Together the different foci in historical time, mediums, and curatorial tastes have dramatically enriched the pluralistic multidepartmental plan that found its first complete expression in 1964. Today the presentation is far more complexly accented, both in depth and in breadth, given the opportunity to display a much greater portion of the permanent collection. Limited gallery space formerly meant

that some of the most original and interesting minor works usually had to be kept in storage. Now many have joined the company of the assured masterpieces of the collection, offering a more diversified and historically just reading of the evolution of modern art.

The realization of this ambitious and complex expansion is a great tribute to the patience, perseverance, courage, and resourcefulness of Oldenburg and the Museum staff, the board of trustees, and its principal executive officers—William S. Paley, chairman, Mrs. John D. Rockefeller 3rd, president, Donald B. Marron, chairman of the Expansion Committee, and their colleagues.

At the beginning of the post-d'Harnoncourt years the painting and sculpture department was directed by William Lieberman, who also retained supervision of prints and illustrated books and of drawings. At the same time, William Rubin, who had come to the Museum in 1966 to organize the exhibition *Dada, Surrealism, and Their Heritage* (shown in 1968) and was subsequently appointed a curator of the painting and sculpture collection, became its chief curator. His persuasive involvement with the generous donor had helped make possible the announcement in 1967 of the greatest single gift of modern and contemporary art in the Museum's history: The Sidney and Harriet Janis Collection, formally accessioned in 1972. It consisted of 103 paintings and sculptures that immeasurably strengthened the Museum's collection with a veritable anthology of twentieth-century masterworks. In addition to important works by Cubists, Surrealists, and European modernists—including no less than eight Mondrians—the Janis gift enriched the collection with important works by Gorky, Kline, Pollock, de Kooning, Oldenburg, Rosenquist, and Segal. Janis—the author, with his wife Harriet, of a number of scholarly books on modern art—had been closely associated with the Museum in the thirties and forties as a member of the Advisory Committee, and later, when he opened a gallery, organized exhibitions of such quality that Barr remarked ruefully, "Sidney Janis's scholarly attitude was expressed not only in his books and lectures but also in a number of enterprising exhibitions. . . . The Museum was glad to contribute to such shows but was slightly chagrined that a commercial gallery should anticipate by several years both the Museum's *Les Fauves* and *Futurism* exhibitions." Understanding the needs of the Museum, Janis, now an honorary trustee, agreed that the Museum might sell works from his collection to buy others more necessary to the whole of the Museum's collection. In this manner, and with Janis's active help, the Museum was enabled to acquire a number of key works.

By the time the Janis collection had formally entered the Museum's collection, Rubin had been named director of the painting and sculpture department, while a new Department of Drawings had been formed, with responsibility for all works on paper, with Lieberman in charge of the new division.

Building on Barr's foundation, Rubin and his staff enlarged and enriched the painting and sculpture collection, creating a preeminent representation of the work of the Abstract Expressionists and adding a smaller but exemplary group of European masterworks by Picasso, Munch, Klimt, Matisse, Klee, and Miró. Among the most critical historical acquisitions were two haunting images of late Symbolist painting, Munch's *The Storm* and Klimt's *Hope II;* Picasso's first Cubist metal construction of 1912, *Guitar,* and the realization of the heroically scaled construction *Monument to Guillaume Apollinaire,* made about 1972 after a 1928–29 wire maquette (both gifts of the artist), and the monumental plaster *Head of a Woman (Marie-Thérèse Walter)* and a unique plywood construction, *The Bull* (gifts of Picasso's widow, Jacqueline Picasso); two Matisse cutouts of ravishing quality, *The Swimming Pool* and *Memory of Oceania;* and Miró's *The Birth of the World,* whose ambiguous figure/field interaction and free graphic signs prophesied postwar American Abstract Expressionism.

In order to build the collection of American Abstract Expressionism, some of the Janis gifts originally assigned to the Museum were sold to make possible the purchase of

Above: Alfred H. Barr, Jr., with Alexander Calder's *Gibraltar,* 1967, *below:* Alfred H. Barr, Jr., honored by the trustees of the Museum, March 12, 1973 *Opposite, above:* William S. Paley, *center:* Mrs. John D. Rockefeller 3rd, *below:* Richard E. Oldenburg

Pollock's *One (Number 31, 1950)*. Another rare acquisition was Newman's *Vir Heroicus Sublimis,* the gift of Mr. and Mrs. Ben Heller. Rubin also prevailed upon Rothko and his wife to make a gift of five key paintings he had selected, and upon Ad Reinhardt's widow Rita Reinhardt to give five key works. Gottlieb and Motherwell also made generous gifts. More recently, a group of seven important Pollocks was acquired from the estate of the artist, some through purchase, others as a gift of the artist's widow, Lee Krasner. With these additions, in conjunction with other acquisitions systematically made over the past decade, the quality and completeness of the representation of the American Abstract Expressionist collection have redefined the meaning of the modernist past, inevitably shifting the historical center and balance of the collection forward in time.

At this point there came the necessity of relinquishing guardianship of a work that had been strongly, even emotionally, identified with the Museum for four decades. In accordance with the artist's wish, Picasso's mural *Guernica* and its preliminary studies were turned over to Spain in 1981 after an extended loan from the artist dating back to 1939. That year the artist had lent the painting to Barr's exhibition *Picasso: Forty Years of His Art,* and when World War II erupted in Europe, he requested that the Museum keep the painting provisionally with a number of other personal loans in the exhibition. Although the rest of the Picassos were eventually returned to the artist at his request, he stipulated that *Guernica* and its sixty-two studies remain until the end of the Franco regime and the "reestablishment of public liberties" in his native Spain, where he wished the picture ultimately to go. In 1981 Picasso's legal advisor and heirs concluded that a sufficiently democratic civil situation existed in Spain, and the work was sent to the Prado in Madrid.

The departure of *Guernica,* which had been an important and inspiring work to the Abstract Expressionist generation particularly, left a noticeable vacancy in the Museum's presentation of the full range of Picasso's work. But anticipating the loss in 1971, the Museum had taken steps to diminish it by acquiring the stylistically and thematically related painting *The Charnel House,* a powerful grisaille work partly inspired by photographs of Nazi death camps.

In 1979 two bequests by trustees greatly enriched the collection with a number of superlative masterworks in painting. The Nelson A. Rockefeller Bequest brought the long-promised gift of more than a dozen works, among them fine Cubist paintings and collages: Picasso's classic *Girl with a Mandolin (Fanny Tellier),* Braque's collage *Clarinet,* Léger's *Woman with a Book,* and Gris's *The Sideboard.* The James Thrall Soby Bequest added another extraordinary gift, concentrated in eight works by de Chirico, including *The Enigma of a Day* and *The Seer,* and work by the Surrealists, with important examples by Dali and Tanguy as well as Picasso and Miró, and the more recent masters Bacon and Balthus.

In addition, the department continued to collect vigorously in the field of American and European contemporary art, assembling a comprehensive representation of artists such as LeWitt, Rothenberg, Jenney, Kelly, Noland, Caro, Stella, Close, Merz, and Beuys.

Today, the painting and sculpture collection numbers more than thirty-five hundred objects, forming an incomparable treasure of late nineteenth- and twentieth-century works. The world's only synoptic, internationally balanced collection of such scope, it defines the full range of modern art as a coherent historical development while also exploring the byways of individual artists and idiosyncratic groups that have enriched the art of our century.

While the concern of this publication is the presentation of the Museum's collection, it cannot be forgotten that in the recent past, as at the inception of the Museum, its foundation has rested on the series of experimental and often brilliant exhibitions that have

been the primary vehicle for its presentation, and transformation, of the history of modern art. Continuing its original mandate to be educational, the Department of Painting and Sculpture has in the seventies and eighties presented numerous exhibitions, some at very large scale and with important consequences in terms of new forms of support for the arts and of the increasingly large audience for modern art. Among these, notably, were *Cézanne: The Late Work* and *Pablo Picasso: A Retrospective*.

At the start of the period in question the department instituted a series of retrospective exhibitions of the work of younger artists— Oldenburg, Stella, Kelly, Caro, and LeWitt—which were accompanied by exemplary and ambitious catalogues. Much experimental and intermedia work by individual artists was shown on a limited scale in over one hundred Projects exhibitions, and there were several large-scale group exhibitions of the contemporary vanguard of the seventies, notably *Information*, a pioneering view of Conceptual art, organized by Kynaston McShine, senior curator in the department.

In 1971, when an independent Department of Drawings was created at the Museum under William Lieberman's directorship, the term *drawing* was expanded to include all of the Museum's works on paper. Only a decade later, this encompassed a collection of more than six thousand works on paper in a variety of mediums. In earlier years the Museum defined drawings as unique works mainly in black and white, and then the definition was broadened to include works on paper in a variety of mediums; now not all of its drawings are on paper, for the department began to include works drawn directly on walls as well. A collection of theater arts, set and costume designs by artists who are generally recognized as painters and sculptors rather than primarily as designers for the theater, is another division within the department.

Since the formation of the department, its single most important acquisition has been the gift of the Joan and Lester Avnet Collection, 180 sheets dating from 1901 to 1969. The Avnets and Lieberman worked in close collaboration for more than a decade, assembling a collection tailored specifically to Museum needs in four areas: the work of a number of British artists around the Vorticist movement; theater production designs of all periods; an eclectic choice of contemporary American artists; and a special group of fine drawings by European sculptors. There are also examples of superlative quality by major painters and sculptors of the School of Paris; and another area of strength is the representation of German Expressionist masters.

In 1971, the department's first year, an ambitious exhibition of *100 Drawings from the Collection of The Museum of Modern Art* traveled to Japan, Australia, and Europe. Lieberman organized, in 1974, a dazzling exhibition that was at once more extensive (184 works) and more particularized: *Seurat to Matisse: Drawing in France*. It was another of the notable occasions when the Museum was able to assemble an impressive number of works of supreme quality entirely from its own resources.

But the most important use of the resources of the collection was the continuous program of organizing, in the drawings and prints galleries, smaller exhibitions of between eighty and one hundred works to examine various aspects of twentieth-century art through the discipline of drawing. The Department of Drawings at the Museum pioneered the serious study of twentieth-century drawing from both the historical and aesthetic perspectives, and supported its position with temporary loan exhibitions as well as those drawn from its collection.

Lieberman retired from the Museum after an affiliation of thirty-four years, in 1979. The position of director of the drawings department was filled by John Elderfield, a curator in the painting and sculpture department who had organized a major exhibition of Fauve painting and directed *Matisse in the Collection of The Museum of Modern Art*, for which he had written the perceptive and meticulously documented catalogue. In 1981 he directed the first in a new series of drawings exhibitions devoted to contemporary artists,

Above: William Rubin, *below:* Riva Castleman
Opposite, above: John Elderfield, *below:* Arthur Drexler

New Works on Paper 1, which offered a small group of artists, each represented by a number of examples of their work. The second installment in the adventurous series, directed by Bernice Rose, the department's curator, offered a dramatic contrast in works of larger scale and on unconventional supports.

A Century of Modern Drawing, organized for the British Museum and shown in New York in a preview of the new west wing galleries in 1982, and the exhibition *The Modern Drawing: 100 Works on Paper from The Museum of Modern Art,* shown in 1983, were two exhibitions that traced the history of twentieth-century art through drawings; both amply demonstrated the fact that the collection had matured to the point where such an overview was possible.

The size of the print collection had been recognized in 1969 when the Department of Prints and Illustrated Books was formed; when Lieberman became director of the new drawings department in 1971, he was nominally director of prints, but supervision of the collection was assumed by Riva Castleman, who was named curator in 1972 and director of the department in 1976. The department's most inclusive survey of American prints from the Museum's collection was *American Prints: 1913–1963,* directed by Castleman in 1974 and shown also in Europe during America's bicentennial in 1976. The exhibition commemorated the twenty-fifth anniversary of the Abby Aldrich Rockefeller Print Room and included many prints collected by Mrs. Rockefeller. Under Castelman's guidance the department continued the tradition of individual print exhibitions as well as surveys. She directed the most complete exhibition of prints by Picasso held in the United States, *Picasso: Master Printmaker,* and in 1980 organized *Printed Art: A View of Two Decades,* a full-scale survey of contemporary artists' prints. Her catalogue for the exhibition provided a lucid guide to the refractory terminologies and techniques of contemporary printmaking.

The print department in recent years has acquired important works by Picasso and Matisse; a portfolio of works by Schiele; and two historical illustrated books, Malevich's *On New Systems in Art* and a rare edition of *Der Blaue Reiter* with prints by Marc and Kandinsky. Among acquisitions of contemporary work were a number of prints by the Europeans Baselitz, Penck, Clemente, Paladino, and Hodgkin, artists not represented elsewhere in the Museum at the time of the print acquisitions. Contemporary American classics of recent vintage that entered the collection during this period were Johns's *Usuyuki,* Rauschenberg's *Glacial Decoy Series,* and Oldenburg's *Screwarch Bridge.*

The architecture and design collection—drawings, architectural details, furniture, models, manufactured and handmade objects, and posters—was greatly enlarged at the beginning of the current period by the formation of the Mies van der Rohe Archive in 1968, the largest and most important public collection of architectural material on a single twentieth-century master architect. The Archive contains more than twenty thousand drawings of varying scale encompassing the entire range of Mies's architectural oeuvre and his furniture designs. Since its inception, work has proceeded in the cataloguing and scholarly exploration of this material, which the architect wished held as a unified body of work. The Museum also acquired eighty architectural drawings by another master, Louis I. Kahn. Wright's rare drawing of the Millard House and two of his stained-glass windows from the Coonley Playhouse entered the collection; and a teapot with Suprematist geometry on its surface by the Russian Suetin exemplified the department's interest in historical objects. In the contemporary field, architectural drawings by Michael Graves, John Hejduk, James Stirling, and others were added, as well as a telephone by Henning Andreasen, Nikon binoculars, and a Bell Laboratories microcomputer of anonymous design.

Among the department's major exhibitions of the period were the 1972 survey, *Italy: The New Domestic Landscape,* displaying objects for household use and twelve remark-

able environments commissioned by the Museum, and *The Taxi Project,* of 1976, both directed by Emilio Ambasz, then curator of design. The latter exhibition presented five new vehicles, designed to reduce pollution, operate at reasonable cost, and better serve the needs of the taxi industry, drivers, and passengers. *The Architecture of the Ecole des Beaux-Arts,* in 1975, and *Transformations in Modern Architecture,* in 1979, were directed by Arthur Drexler and accompanied by great interest on the part of the architectural community. The Beaux-Arts show seemed a signal of the growing postmodernist disenchantment with the International Style. Like the Museum's 1966 publication, Robert Venturi's *Complexity and Contradiction in Architecture,* the Beaux-Arts exhibition was taken as an iconoclastic gesture directed at the very tenets of modernism that the Museum had done so much to establish. It should further be noted that Philip Johnson, whose scholarship and architectural practice did so much to establish the philosophical and technical rationale of the International Style, later became a leader of the postmodernist movement and a major factor in dismantling modernism's exclusionary aesthetic. Speaking of the Beaux-Arts show in an interview, Drexler said: "The philosophical principles of the modern movement are not only due but overdue for critical reexamination. Whether or not such reexamination takes place, the movement itself must evolve, and that's beginning to happen." *Transformations* was an attempt to expose and document current practice in architecture and the extent to which it had begun to develop in new directions.

In the photography department, three unusual exhibitions of varied character in recent years were the 1976 retrospective of the photographs of Eggleston, the landmark exhibition *Mirrors and Windows,* in 1978, and *Before Photography: Painting and the Invention of Photography,* in 1981. The Eggleston exhibition was one of several shows of color photography, focusing on the artist's personal vision of the rural and suburban south. In *Mirrors and Windows* John Szarkowski assembled a representation of American photography since 1960. *Before Photography* was divided into two sections, one focusing on paintings made within three decades before the invention of the medium. The painting selection suggested that certain types of composition considered inherent to photography had actually been anticipated by painters several decades before photography was discovered.

The 1979 exhibition *Ansel Adams and the West* coincided with a gift from the photographer of eighteen photographs made between 1924 and 1968. The department's acquisitions in recent years have included photographs by Brancusi of his sculpture, important nineteenth-century works such as an untitled photograph of a young girl with attached drawings from an album by Lewis Carroll, George Barnard's *From Lookout Mountain,* twelve photographs by Maxime Du Camp, and the historically important album of 223 collotypes by John Thompson in four volumes, *Illustrations of China and Its People.*

In addition, work by the following contemporary photographers was added to the collection, in some cases for the first time: Callahan, Coniff, Cumming, Eggleston, Friedman, Groover, Meyerowitz, Nixon, Papageorge, Samaras, and Siskind. Some of the major donations of photographs in recent years have come from Mr. and Mrs. Clarence H. White, Jr., Willard Van Dyke, Lee Friedlander, Mrs. Raymond C. Collins, Paul Strand, Ansel Adams, Monroe Wheeler, Dr. Iago Galdston, The James Thrall Soby Bequest, and Robert B. Menschel.

The department's most challenging scholarly undertaking since Szarkowski became director has been the preservation and cataloguing of the Atget collection acquired by the Museum from Berenice Abbott and Julien Levy in 1968. The collection consists of more than five thousand prints plus negatives and duplicates, a single acquisition that almost doubled the size of the photography collection. Szarkowski organized the most significant part of Atget's oeuvre into four categories, which served as the structure for four exhibitions and four volumes of *The Work of Atget,* organized by the Museum beginning

Above: John Szarkowski
Opposite, above: Mary Lea Bandy,
below: Mrs. John D. Rockefeller 3rd and Richard E. Oldenburg accepting an honorary Oscar from Gregory Peck for the Museum's Department of Film, 1979

in 1981: *Old France, The Art of Old Paris, The Ancien Régime,* and *Modern Times.*

Following Willard Van Dyke's retirement in 1973, associate director Margareta Akermark supervised the film department's activities. Head of the Circulating Film Library from the forties until 1978, Akermark promoted the work of young and experimental filmmakers, and oversaw the distribution of thousands of prints to schools throughout the country. As cinema study programs increased rapidly in American schools, the Circulating Film Library provided coverage of the history of the film medium, particularly the classics of the silent period, avant-garde work of the twenties, and experimental and documentary film from all periods.

Ted Perry served as director of the department from 1975 to 1978, following his chairmanship of New York University's Department of Cinema Studies. Under his direction the Looking at Films series was created; and courses such as "The Modernist Aesthetic of Antonioni" combined film screenings with lectures and introduced many filmmakers to Museum audiences. Perry oversaw the renovation of the auditorium, made possible through a major gift from Mr. and Mrs. Roy V. Titus.

In 1978 Mary Lea Bandy was appointed administrator of the department, and was made director in 1980. Formerly an editor, Bandy reactivated a film publishing program, and under her direction the department has initiated complete catalogues of the collection and of the Circulating Film Library, as well as individual books associated with its exhibitions. The computerized cataloguing of the entire film collection was made possible by a gift from Frederick Koch.

The expansion of the department's facilities included construction of a second, smaller theater in the new west wing, made possible by a second grant from Mr. and Mrs. Roy V. Titus; a staff screening room, the gift of the Louis B. Mayer Foundation; and the Preservation Screening Room, the gift of Warner Communications, Inc.

A new study center includes facilities made possible with a gift from the Gottesman Foundation and trustee Celeste Bartos. In addition to serving as a library, the study center has been an active resource for filmmakers to screen and study their own and other films as they prepare new work. A major gift to the Museum of the David O. Selznick Collection was made in 1978 by ABC Pictures International, and the department's American holdings have been strengthened with works by major contemporary directors such as Francis Ford Coppola, Steven Spielberg, and Martin Scorsese.

From the mid-seventies, through grants from the Jerome Foundation and the National Endowment for the Arts, the collection of American avant-garde cinema has expanded with works from the forties to the present day, including films by Brakhage, Noren, Peterson, Snow, Rappaport, Pitt, and Griffin, among others.

Programming directed by Adrienne Mancia and Larry Kardish continued with retrospectives of individual filmmakers such as Michael Powell, John Cassavetes, and Kenji Mizoguchi, and presentations of national cinemas—including *Film India* (with The Asia Society), *Rediscovering French Film,* and *British Cinema* (with the British Film Institute).

In recent years, the film department has expanded its commitment to contemporary film while continuing its historical program. During its more than half a century the Museum has overcome much of the resistance of patrons of the traditional fine arts to this uniquely twentieth-century expression. Now the film collection can boast a virtually exhaustive catalogue of the great achievements of world cinema in all genres, from the rigorously formal and abstract to social documentary and popular narrative films.

The mid-sixties saw the advent of a new artistic medium as a result of the availability of portable video equipment. Video first appeared at the Museum in the 1968 exhibition *The Machine as Seen at the End of the Mechanical Age,* in which two works by Nam June Paik were shown. Since 1974 the Museum's program Projects: Video, through daily showings, has reflected a diverse international output; the series has presented hundreds of vid-

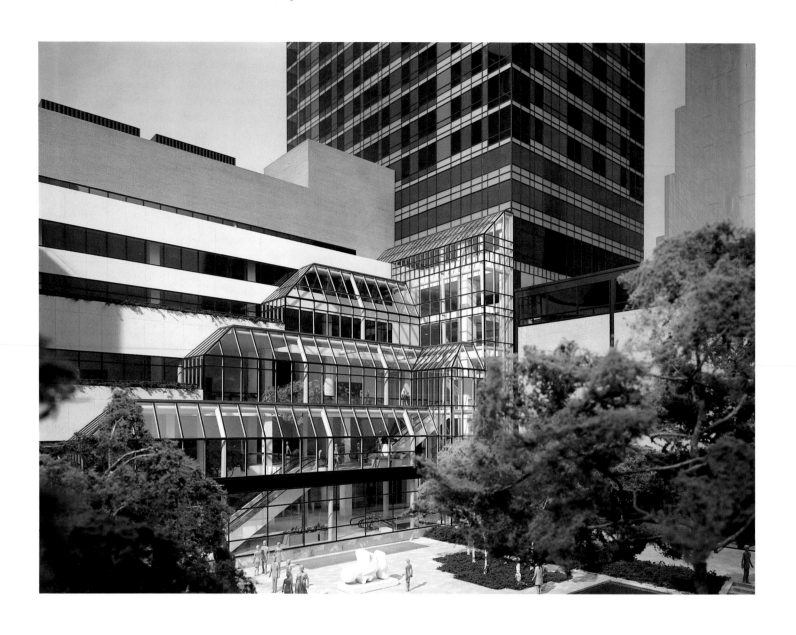

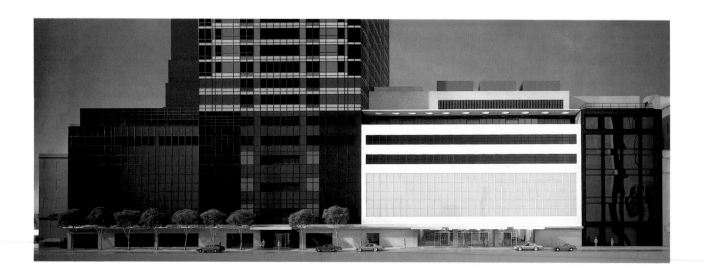

eotapes and installations. With support from the Rockefeller Foundation and individual donors, the collection of video art has expanded to include works by more than sixty artists; work from conventional television, largely devoted to art and artists; and a major installation by Shigeko Kubota, *Nude Descending a Staircase*, of 1976. The collection is eclectic, ranging from independently produced documentaries to the most abstract computer-synthesized works. The scope of the collection has begun to broaden with the addition of more conventional television of high quality and expansion of a fledgling circulating program. Investigation into this new medium has been facilitated by a new video study center and by continuing programs and lecture series with which the Museum covers yet another aspect of contemporary creative endeavor.

THE FUTURE

The renewed and substantially enlarged Museum of Modern Art enters a period when numerous critics and social commentators have observed that the movement of cultural modernism is in crisis. Questions are therefore raised concerning the role of the Museum at a time when the word *modern* is used synonymously with a circumscribed historical episode, with the past rather than the future, and when a distinct and identifiable group of contemporary architects and a less obvious but equally aggressive group of avant-garde artists working in narrative, decorative, and performance genres feel that modernism is exhausted and describe their activities as postmodern. Broad social changes and the proliferation of institutions devoted to modern and contemporary art have also diminished and diffused the Museum's impact on taste. In addition, much art of the past two decades —Earthworks, Conceptual and Performance art, sculpture of monumental scale, or the aurally distracting videotape—is no longer easily exhibitable, if at all, in traditional museum galleries.

Despite the volatile state of the pluralistic art scene, and the attendant confusions in contemporary standards, and despite the loudly proclaimed "crisis" of modernism— which the most resourceful artists and architects today, nevertheless, seem able to overcome inventively, and without necessarily repudiating the basic tenets of historical modernism—the Museum has energetically and responsibly continued to document and interpret contemporary art. The very preeminence of the Museum's historical collection, its brilliant exhibition record, and its responsible scholarship free the Museum to undertake new adventures and as yet undefined risks. After all, the Museum was founded by three extraordinary women whose establishment backgrounds did not limit their interests to traditional art, but, on the contrary, enabled them to embark on a pioneering experiment which directly challenged the prevailing conservative beliefs that had shaped their lives. With the example of the three founders before them, and the profound commitment of its founding director, Alfred Barr, visible on all sides, it seems unlikely that those who guide Museum policy can ever relax into complacency regarding contemporary art.

Perhaps more than any other high-minded declaration from the Museum's legendary past, Paul J. Sachs's statement to the trustees at the formal opening of the new building in 1939 has, through the years, come to symbolize the Museum's continuing sense of mission and its experimental spirit, even for those who admire primarily its unrivaled historical collection and discriminating connoisseurship. "The Museum must continue to take risks," he said. "In the field of modern art, chances must be taken. The Museum should continue to be a pioneer: bold and uncompromising."

Painting and Sculpture

Modern art differs from that of the past in its phenomenal multiplicity of styles—a function of its more individualistic, less collective, less institutional character. Earlier periods of art history were usually dominated by variants of a single style, or of two polar styles (e.g., Romantic and Neo-Classical painting of the early nineteenth century). In twentieth-century art, there are virtually as many distinct styles as there are great and original artists. In the face of this historically unique situation the curator has to deal with special problems and cannot function simply as a connoisseur, as did many curators in the past. Alfred Barr understood that in order to build a comprehensive museum collection for the art of modern times, one would have to adopt a new kind of approach: a position of systematic catholicity. But he was convinced that this could be done without slighting the demands of quality.

Barr understood that modernist variety was not the fruit of sporadic anarchic or revolutionary gestures, as it seemed to many, but that it constituted a series of clearly interrelated and ultimately explainable developments. His view formed the basis for shaping both the collection and exhibition programs of the Department of Painting and Sculpture. Barr saw the nineteenth century as having established certain basic tenets of modernism in relation to which twentieth-century developments could be better understood, and on this basis presented a selection of works from 1880 to 1900 as a kind of introduction to the collection.

Unlike many critics and writers on modern art, Barr did not believe in choosing sides in disputes about contemporary art; such controversy as he created was the inadvertent result of the universality of his approach. When Barr and his colleague James Thrall Soby agreed that the Museum must remain "a respectful distance" behind the artist, they were simply expressing the idea that a minimal perspective was necessary before a definitive judgment could be passed on new work. They saw the task at hand, then, as less to discover the new than to move at a discreet distance behind developing art, not trying to be tastemakers, not creating "instant art history," but putting things together as their contours began to clarify. These principles continue to be followed today—as is Barr's straightforward, realistic guide rule for the acquisition of recent art: that mistakes of commission are more easily remedied than mistakes of omission. In this view, the exhibited collection is, in his words, "the authoritative indication of what the Museum stands for." With this as a base, the temporary exhibitions that the Museum organizes could be "adventurous (and adventitious) sorties into less charted areas."

These less charted areas were not all contemporary, however, for some of the Museum's most adventurous shows were historical. The historical exhibition complements the Museum's collection and enlarges upon an aspect of it while serving the very useful purpose of discovering potential acquisitions for hard-to-fill gaps in the Museum's representation of a particular artist or movement; the contemporary exhibition demonstrates the Museum's commitment to the art of the present day while clarifying—by juxtaposition with the Museum's collection—its relationship to that of the recent and more distant past.

The ratio of historical to contemporary acquisitions has inevitably shifted since the early years. Then, in the effort to build the collection, the acquisition of major historical works was of primary importance. Now, however, thanks largely to the success of that effort, the presence of a remarkably wide and deep synoptic collection makes the painting and sculpture department's activity somewhat different. To be sure, the department continues, through acquisitions, exchanges, and gifts, to fill lacunae in the historical collection and to increase its depth where this seems necessary, but the overwhelming majority of its acquisitions are of contemporary work. And although these permit the representation of only a handful of the many thousands of artists working today, the Museum attempts in its choices to give a sense of the quality and range of current activity. To this extent, its purchases of contemporary art must be considered somewhat "reportorial"; it is not expected that every work—indeed, that the majority of them—will figure in the collection fifty years hence.

The catholicity that characterized the department's acquisitions policy derives directly from Barr's initial conception of the Museum's collection as one made up of all tendencies, weighted according to the significance, quality, and historical importance of various movements and individual artists. Thus, unlike many European museums, whose collections in both older and contemporary art tend to be

predominantly formed from their national schools, this institution saw modern art synoptically as an international movement, none of whose parts could be eliminated without deforming the image of its development, and the whole of which was greater than the sum of its parts.

Barr's vision of a historical collection and of an exhibition program to complement it was, of course, conditioned by practical museological limitations and by the period in which he sought to implement it. Thus, for example, the fact that the Museum's collection begins with Post-Impressionism in the 1880s rather than in the 1860s with Édouard Manet and the emergence of Impressionism, where most art historians would locate the beginning of modernism, has to do with the fact that most of the important masterpieces of the earlier school were either in or committed to major established museums, such as The Metropolitan Museum of Art, by the time Barr began building the collection in the thirties. Moreover, despite the Depression, one needed considerable funds even then to purchase the key nineteenth-century works still available. The funds at Barr's disposal in the thirties were usually slim or nonexistent, and while a little money might go a long way in purchasing a Malevich, Miró, or even a Brancusi, and a certain kind of Picasso, it could have made no dent in the market that obtained in those days for major works by Renoir, Monet, Degas, or Cézanne. The bulk of the Museum's collecting activity had, necessarily, to focus on the pioneering movements of the twentieth century.

Barr's occasional trading and selling of works from the collection established a mobile pattern for acquisition, permitting the Museum to balance out its collection by obtaining key works that it had no hope of getting as gifts. This "tool" of collection building, carefully employed and guided by the multiplicity of professional judgments required for its use, continues to be one of the crucial ways in which the collection is refined and extended, especially in a period when early twentieth-century masterpieces run to many millions of dollars. Sometimes only pictures can buy pictures—as instanced by the recent exchange with The Solomon R. Guggenheim Museum that brought to the Museum two highly needed Kandinskys it could not conceivably have purchased, thus completing the ensemble of four intended by the artist.

As the fulcrum of the Museum's painting and sculpture collection shifted further and further into the twentieth century and the acquisitions focused on works closer to the Museum's own moment in time, the radicality of the new work became too much for certain trustees. The differences between Barr and Stephen C. Clark were not simply related to judgments as to Barr's ability to fulfill at once the duties of an administrative director and a chief curator of the growing institution; they had to do with the self-proclaimed limits of Clark's taste in twentieth-century art—Barr's purchase of a superb group of works by Max Ernst (at what seem today almost laughable prices) particularly incensed him. Nor was it always easy in those days and even later for Barr and colleagues such as Soby and James Johnson Sweeney to get radical work approved by the acquisitions committee. More than once Philip Johnson had to come to the rescue, himself purchasing rejected works, which he later offered to the Museum as gifts.

Barr was a man of genius, and others who played central roles in forming the collection across the years, Soby and Sweeney among them, were truly exceptional connoisseurs and museologists. The collection that they bequeathed to their successors was remarkable for its richness, range, and sheer quality. They had done the hardest thing; they had overcome inertial resistance and had established what was at Barr's retirement by far the world's greatest and most complete collection of twentieth-century art. To the extent that the most difficult work was done, the task of the present generation of curators is easier. They have, as well, the advantage of that additional perspective, fruit of the passage of years, which enables them to make some necessary changes in the editing, adjustment, refinement, and equilibration of the collection. Despite the accomplishments of the first generation, some gaps necessarily remained in the collection's historical panorama at the time of Barr's retirement. These were due to many factors, among them lack of money, the impossibility of obtaining objects (such as Picasso's Cubist constructions), and—the first generation would have had to be gods rather than men were it otherwise—historical misjudgments. The primary instance of the latter was certainly the measure of the Museum's commitment to the major Abstract Expressionist painters. Though it was the

first institution in many cases to buy works by these artists, the Museum never considered the accomplishment of the so-called New York School as equal to that of the major early twentieth-century modern movements. The Abstract Expressionists hotly criticized the Museum for this, and to a certain extent they were right. While this imbalance had to be redressed by subsequent curators—it was the dominant concern of collection building in the later sixties and early seventies—the Museum's first generation of curators nevertheless made remarkably prescient acquisitions of such successors to the Abstract Expressionists as Johns and Stella.

As one surveys the collection today, its most critically weak area is in American painting of the teens, twenties, and thirties. And this is much less a result of misjudgment than of historical and contextual conditions. Although the Museum exhibited and purchased a number of American artists from these periods in the pre–World War II years (its group of Hoppers is especially rich), there was a pervasive feeling among the curators—not wholly wrongheaded, to be sure—that these artists were essentially provincial in relation to the major European masters. Moreover, the fact that funds were extremely limited and that the Whitney Museum and the Metropolitan were both buying American painting—the latter having little or no interest in twentieth-century European art—led to an understanding between Barr and the directors of these other museums that The Museum of Modern Art would concentrate its resources on the European vanguard.

But every great new work of art, as T. S. Eliot observed, changes the art of the past, as well as our sense of the ideal order of those past monuments. Developments in American painting from the late fifties onward have made the American past look different, have annexed it, so to speak, into the mainstream of art history. Demuth's *I See the No. 5 in Gold* (The Metropolitan Museum of Art) looks different to us in the light of Jasper Johns; photography, as well as Photorealist painting, has given a new relevance to earlier American Precisionism. Regrettably, the masterpieces of such painters as Demuth and Hartley that could stand, in their own terms, on an equal footing with the masterpieces of the European modernists the Museum possesses, have long been spoken for. But it has been possible, nevertheless, to strengthen the Museum's representation in that area of the collection by acquiring, for example, additional works by such artists as O'Keeffe, and by obtaining works of artists heretofore unrepresented in the collection, such as Patrick Henry Bruce, Augustus Vincent Tack, and John Storrs.

The glory of the painting and sculpture collection as it now stands is located in the quality and depth of its holdings in the European modernist movements beginning with Cubism and, again, in American Abstract Expressionism. In these areas the depth can be absolutely staggering. The Cubist holdings, if all shown together, could constitute an almost complete survey of the movement in itself. The same would be true on a smaller scale with the Museum's group of Futurist paintings, sculptures, and works on paper; from the minuscule mature oeuvre of its leading figure, Umberto Boccioni, a youthful casualty of World War I, the collection includes a unique group of six oils, two sculptures, and several drawings. Its twenty-one paintings and sculptures by Miró, its sixteen works by Mondrian, sixteen by de Chirico, seven by Malevich, and eighteen by Pollock—to say nothing of the sixty-three Picassos and thirty-six Matisses that form the spine of the collection—suggest just a few of the areas where its combination of quality and depth is unparalleled. Given this kind of richness, the "historical" aspect of the acquisitions program becomes necessarily precise. One needs not *a* Klimt, *a* Kandinsky, or *a* Picasso, but a work of very particular kind and date that fills a lacuna in the sequence —and such works are not likely to turn up on the art market. Today's curators are therefore inevitably caught up in a kind of search and research, one might almost say "detective work," often followed by prolonged negotiations, such as those which recently made possible the acquisition and approval for export from Austria of an Art Nouveau Klimt, the first acquired by any American museum.

With respect to more contemporary art, the department has continued the policy of encouraging trustees and friends to purchase major works that it cannot afford, which will later be bequeathed to the collection. Just as the Museum is today receiving wonderful pictures by earlier masters committed to the Museum thirty or forty years ago, so in the future it will receive major works by important contemporary painters and sculptors.

Given the depth of the collection, it is not surprising that space to show works was, is, and always

will be a problem for the Museum, although the recent doubling of the Museum's gallery space tremendously improved the situation. But another dilemma in contemporary museology involves the creation of works that do not lend themselves to, or even permit, Museum presentation. No museum with a comprehensive collection can possibly commit the space necessary to an Earthwork—even if such endeavors did not look hopelessly artificial when transferred from the natural environment to the interior of a museum. Monumental sculptures, totally at home in the public square, are also problematic, as is a good deal of Conceptual art that lends itself better to display on the pages of an art magazine than on the walls of a museum. In the face of such developments, the Museum has adopted an essentially documentary approach, such as purchasing the photographs, drawings, and diagrams that constitute Dennis Oppenheim's *Highway 20* or acquiring a film of Christo's *Valley Curtain*. But in the end, we have to face the fact that museums are themselves creations of a period when the definition of painting and sculpture revolved largely around the portable easel picture and its sculptural counterpart. That contemporary art has recently become, to a certain extent, a public art should no more lead us to want to put Earthworks in the Museum garden than we would want the mosaics of San Vitale or the Stanze of Raphael to be transferred into a museum.

The fact that the modern tradition has been, until these recent developments, essentially a private one, addressed to a small public of the artist's friends and collectors, has implications for the way in which modern painting up to and through Abstract Expressionism should be shown. The intimacy to which I allude has less to do with the size than with the character of the paintings, and pertains to the wall-size Pollocks and the *Water Lilies* of Monet no less than to the smallest easel painting. Modern pictures were not destined for large public areas such as churches and palaces, but for artists' studios and collectors' homes and apartments; these spaces are their natural habitat. Apartment-size spaces are what Rothko had in mind when he said, "I paint big to be intimate." Whether purposely or not, the galleries of the Museum's 1939 International Style building (which forms its present nucleus) were, as a result of the ceiling heights and the placement of the vertical supports, small-scale, intimate spaces. The bulk of the department's collection looks good in such a context, where the large size of certain Matisses, Picassos, and Pollocks has its intended effect—which is not the case when such pictures are seen in the immense spaces of some other museums. While the new west wing of the Museum has permitted the introduction of a needed variety into the configuration of the painting and sculpture space, including some larger galleries, the intimacy established by the 1939 building—an aspect of what has become, in effect, Museum of Modern Art style—has been largely retained, as has a simplicity in the overall presentation that permits the individual works to speak unimpeded.

Because of the richness of the department's collection and the inevitable limitations of its space, it has an extraordinary body of first-rate work upon which to draw for loans, thereby making possible what may be the most active loan program, in relation to its resources, of any museum in the world. Such loans help the Museum continue to fulfill its original evangelical role of carrying modern art to places that need and want the message. At the same time, it has the practical advantage of building an immense reservoir of goodwill, among museums all over the world, which is necessarily drawn upon when the Museum requires loans for important exhibitions. For these reasons the Museum is one of a very few that could possibly have assembled the pictures that figured in such exhibitions as *Cézanne: The Late Work* and *Pablo Picasso: A Retrospective*.

Although its functions have greatly expanded over the years, the Department of Painting and Sculpture now views its obligations in the areas of acquisitions and exhibitions much as it did in the early days of the Museum. While the evangelical role that the historical circumstances of 1929 conferred upon the Museum no longer obtains in the highly conscious and much proliferated "art world" of today, the Museum still seeks to acquire and present objects of outstanding quality and historical importance balanced by the best of those works that are, necessarily, not yet ratified by time.

1. Paul Cézanne. *The Bather.* c. 1885. Oil on canvas. 50 x 38⅛" (127 x 96.8 cm). Lillie P. Bliss Collection

Cézanne's *Bather* is one of the key pictures in the Museum's Post-Impressionist collection. About this work Alfred Barr wrote: "Cézanne, a very shy man with more than his share of nineteenth-century inhibitions, could rarely endure working directly from the nude model. Furthermore the living model could probably not have endured Cézanne who tyrannically insisted upon even his portrait subjects' keeping as 'still as an apple' through a hundred sittings. So Cézanne sometimes depended upon photographs of professional models. . . . Academically, the drawing is poor, the right knee inexcusable, but seen as a whole the figure stands firm as a stone. In fact, it rises like a colossus who has just bestrode mountains and rivers—for Cézanne, adapting a landscape from another painting, has again fumbled his naturalistic scale while achieving artistic grandeur."

1

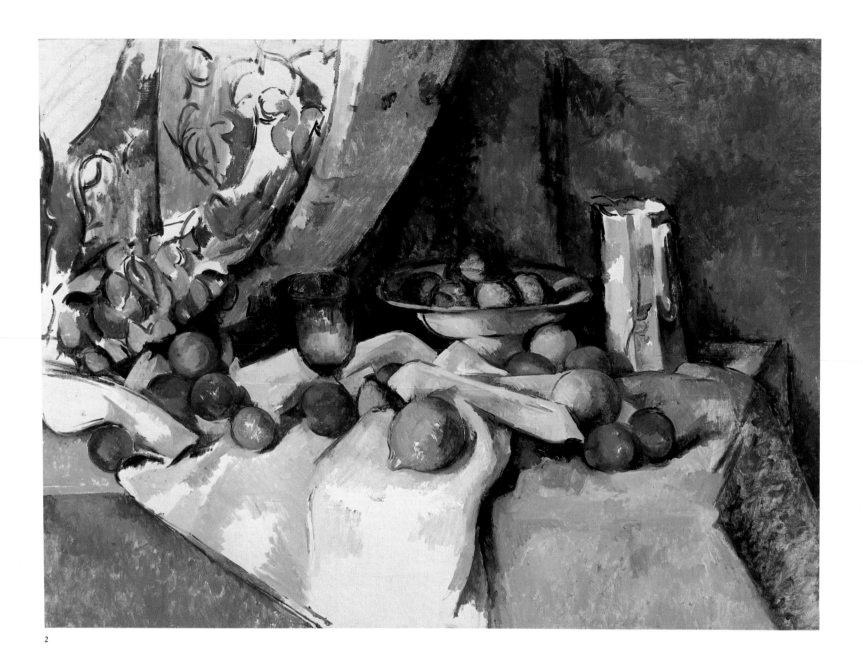

2

2. Paul Cézanne. *Still Life with Apples.* 1895–98. Oil on canvas. 27 x 36½" (68.6 x 92.7 cm). Lillie P. Bliss Collection

The configuration of this painting contains a kind of complexity in the repetition, sequencing, and analogizing of number, shape, and color that was only possible for Cézanne, as William Rubin has observed, in his still lifes. The landscape and the human figure did not provide him with an opportunity to "pre-construct" a composition of multiple small units as he did in setting up this still life in his studio with artificial fruits, crockery, and drapery. Whereas the old masters often bound together their compositional structures by a single overriding geometry, Cézanne accepted as his starting point the notion of dispersal introduced by the Impressionists. But he united these seemingly "random" motifs through an infinitely complex tissue of formal relationships that ultimately endowed the composition with a monumentality and stability, not to say a sense of the ineluctable, which rivals the grandeur of High Renaissance and seventeenth-century composition. Despite appearances the picture is not unfinished; rather, it embodies a new definition of the finished which would influence all subsequent art. In this inner-directed definition, the picture is finished not when its forms obtain a predetermined likeness to external reality, but when the compositional configuration, taken on its own terms, has achieved, in the artist's estimation, its fullest possible meaning.

3. Paul Cézanne. *Boy in a Red Waistcoat.* 1893–95. Oil on canvas. 32 x 25⅝" (81.2 x 65 cm). Fractional gift of David Rockefeller (the donor retaining life interest)

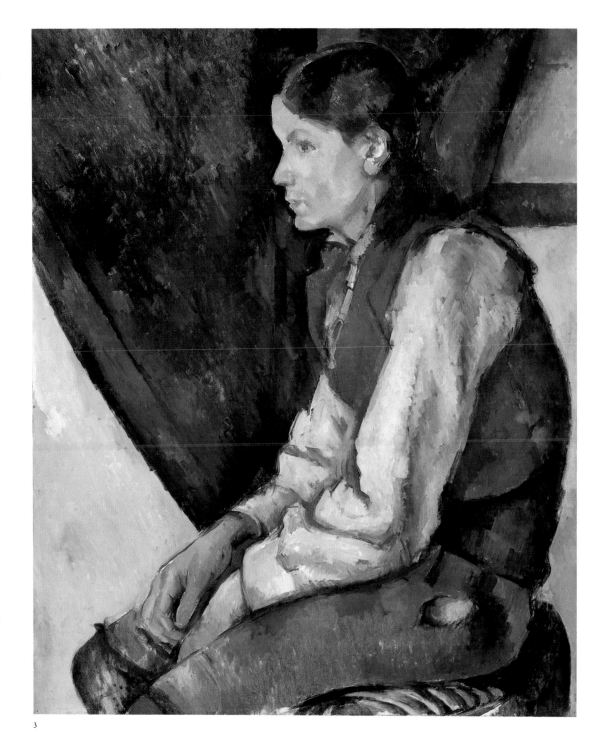

3

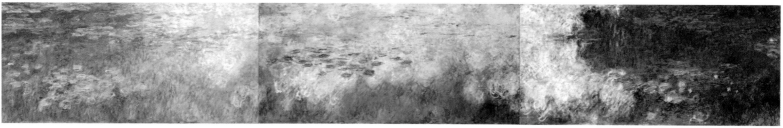

4a–c

5

4a–c. Claude Monet. *Water Lilies.*
c. 1920. Oil on canvas. Triptych, each
section 6′6″ x 14′ (200 x 425 cm). Mrs.
Simon Guggenheim Fund

In the Museum's triptych, as in the
rest of the Nymphéas scenes painted
at Giverny between the early 1890s
and his death in 1926, Monet tried to
create the "illusion" of an endless
whole of water, without horizon or
bank. He intended a new kind of
meditative Symbolist icon designed
to expand the limits of perception by
focusing on an inverted Symbolist
world of water depths and scintillat-
ing light reflections, where visual
flux and interplay could be under-
stood philosophically as a challenge
to current ideas of a stable material
reality.

5. Claude Monet. *Poplars at Giverny,
Sunrise.* 1888. Oil on canvas. 29⅛ x
36½″ (74 x 92.7 cm). The William B.
Jaffe and Evelyn A. J. Hall Collection

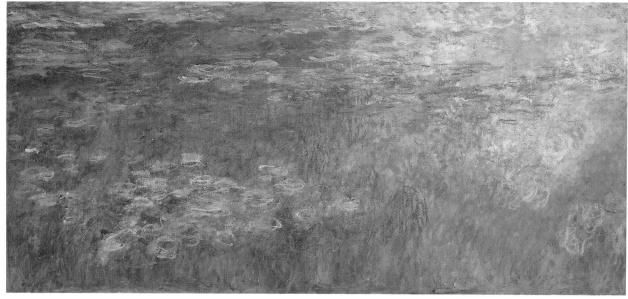

4a

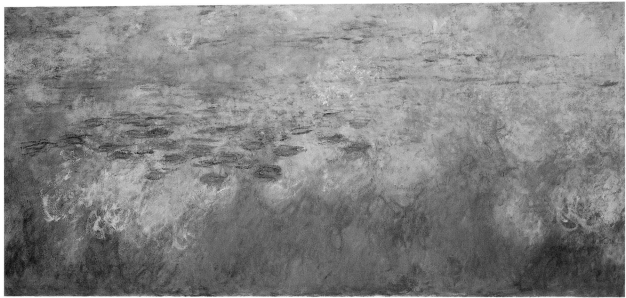

4b

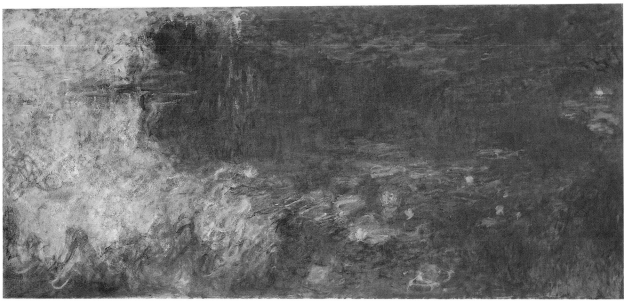

4c

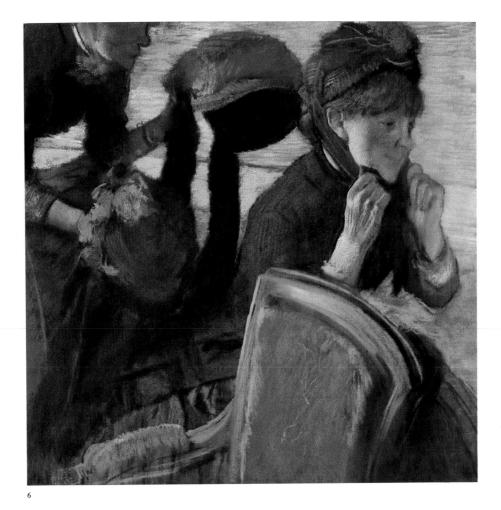

6

6. Hilaire-Germain-Edgar Degas. *At the Milliner's.* c. 1882. Pastel on paper. 27⅝ x 27¾" (70.2 x 70.5 cm). Gift of Mrs. David M. Levy

Temperamentally unique among the members of the Impressionist circle, Degas responded to the visual tempo and imagery of modern life, and managed to find an almost pitilessly exact stylistic formula for a vision that impartially embraced both realism and art for art's sake. Like so many of his compositions, this one is organized along the diagonal in a slow curve enforced by the chair back, with an indication of a high horizon line, which reflects the strong influence of the Japanese print and non-Western perspective. These devices create a tense and shallow space where decorative elements and succinct color shapes can play abstractly in striking patterns. Perhaps Degas's most extraordinary invention here is the subtle interchange and rivalry between the human presence and the accentuated objects: the chair and three bonnets. The picture captures a highly nuanced moment, integrating ideas of pictorial form, fashion, and social hierarchy.

7. Georges-Pierre Seurat. *Port-en-Bessin, Entrance to the Harbor.* 1888. Oil on canvas. 21⅝ x 25⅝" (54.9 x 65.1 cm). Lillie P. Bliss Collection

8. Auguste Rodin. *St. John the Baptist Preaching.* 1878–80. Bronze. 6' 6¾" (200.1 cm) high, at base 37 x 22½" (94 x 57.2 cm) (irregular). Mrs. Simon Guggenheim Fund

7

9. Auguste Rodin. *Naked Balzac with Folded Arms.* 1892–93. Bronze (cast 1966). 29¾ x 12⅛ x 13⅝″ (75.5 x 30.8 x 34.6 cm), at base 15½ x 13⅜″ (39.4 x 34.1 cm). Gift of the B. G. Cantor Art Foundation

10. Auguste Rodin. *Monument to Balzac.* 1897–98. Bronze (cast 1954). 8′10″ (269 cm) high, at base 48¼ x 41″ (122.5 x 104.2 cm). Presented in memory of Curt Valentin by his friends

This sculpture—the distillation of multiple studies and explorations— is Symbolist in mood and radically inventive in form. But, unlike most Symbolist images, *Monument to Balzac* is an exalting and profound affirmation rather than a statement of melancholy or alienation. Almost phallic in form, the figure of the novelist, with his massive head cresting the turbulent swell of his gargantuan cloak, presented an opportunity for Rodin to identify with the writer's demiurge, his colossal creative force.

9

8

10

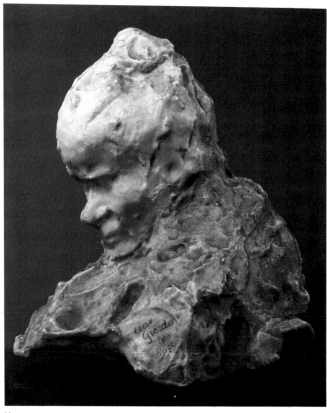

11

11. Medardo Rosso. *The Concierge.*
1883. Wax over plaster. 14½ x 12⅝" (36.8
x 32 cm). Mrs. Wendell T. Bush Fund

12. Medardo Rosso. *The Bookmaker.*
1894. Wax over plaster. 17½ x 13 x 14"
(44.3 x 33 x 35.5 cm). Acquired through
the Lillie P. Bliss Bequest

13. Georges-Pierre Seurat. *The
Channel at Gravelines, Evening.* 1890.
Oil on canvas. 25¾ x 32¼" (65.4 x 81.9
cm). Gift of William A. M. Burden
(the donor and his wife retaining life
interests)

14. Paul Signac. *Against the Enamel of
a Background Rhythmic with Beats and
Angles, Tones and Colors, Portrait of M
Félix Fénéon in 1890.* 1890. Oil on can-
vas. 29⅛ x 38⅝" (73.9 x 98.1 cm). Prom-
ised gift of David Rockefeller

15. Paul Gauguin. *Still Life with Three
Puppies.* 1888. Oil on wood. 36⅛ x 24⅝"
(91.8 x 62.6 cm). Mrs. Simon Guggen-
heim Fund

16. Paul Gauguin. *Portrait of Meyer de
Haan.* 1889. Oil on wood. 31⅜ x 20⅜"
(79.6 x 51.7 cm). Gift of David Rocke-
feller (the donor retaining life interest)

12

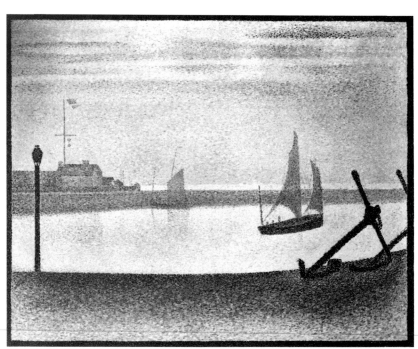

13

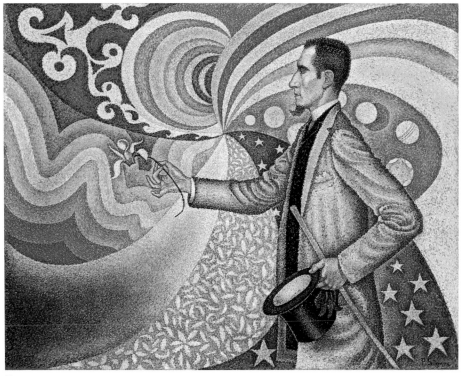

14

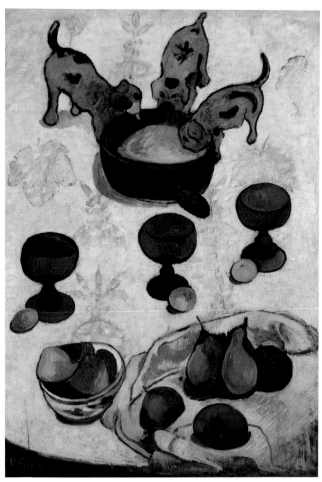

15

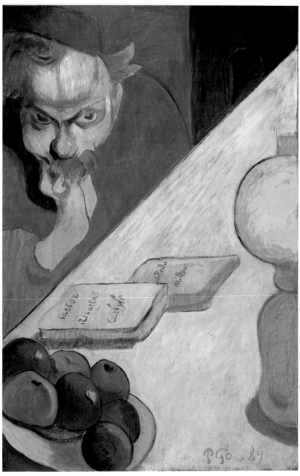

16

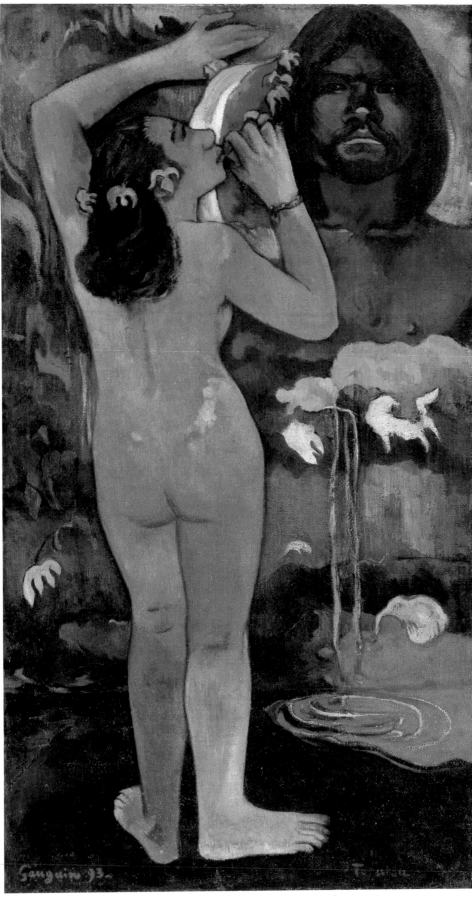

17

17. Paul Gauguin. *The Moon and the Earth*. 1893. Oil on burlap. 45 x 24½" (114.3 x 62.2 cm). Lillie P. Bliss Collection

Abandoning Europe in 1890 for Tahiti, Gauguin discovered that his "earthly paradise" was not all that removed from the corruption of Western civilization. Yet despite ill health, financial problems, and the antagonisms of colonial authorities, he persevered in painting a near-Arcadian vision of island life. *The Moon and the Earth* is based on an enigmatic Tahitian legend and combines the childlike and the mysterious with a new kind of creative spontaneity and invention in the flat patterns of motifs taken from nature.

18. Vincent van Gogh. *The Starry Night*. 1889. Oil on canvas. 29 x 36¼" (73.7 x 92.1 cm). Acquired through the Lillie P. Bliss Bequest

The Starry Night is a powerful example of proto-Expressionist art in the late nineteenth century. One of the Museum's most popular paintings, van Gogh's tumultuous and transcendent vision of nature dramatically opened the path for a new emotionalism and subjective temper in art. The German Expressionists repeatedly acknowledged their debt to van Gogh's "northern spirit," with which they felt profound kinship, when they later explored new areas of pictorial dynamics to convey their own sense of unease and alienation from the natural world—but with little of van Gogh's sense of exaltation.

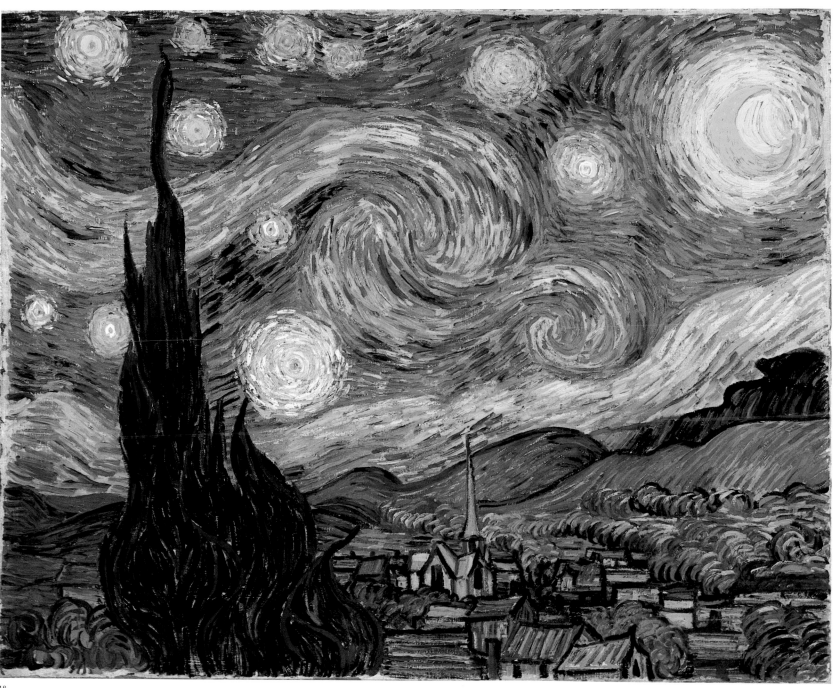

18

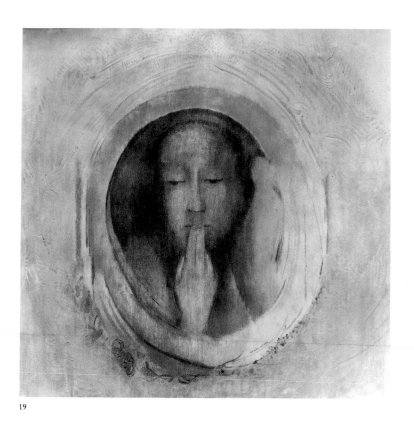

19

19. Odilon Redon. *Silence.* c. 1911. Oil on gesso on paper. 21¼ x 21½" (54 x 54.6 cm). Lillie P. Bliss Collection

20. Aristide Maillol. *Desire.* 1906–08. Tinted plaster relief. 46⅞ x 45" (119.1 x 114.3 cm). Gift of the artist

21. Aristide Maillol. *The River.* c. 1939–43. Lead. 53¾" x 7'6" (136.5 x 228.6 cm), at base 67 x 27¾" (170.1 x 70.4 cm). Mrs. Simon Guggenheim Fund

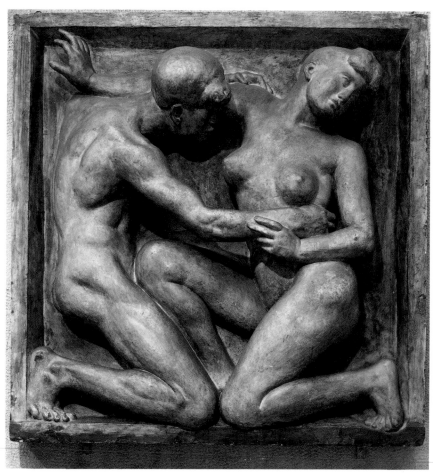

20

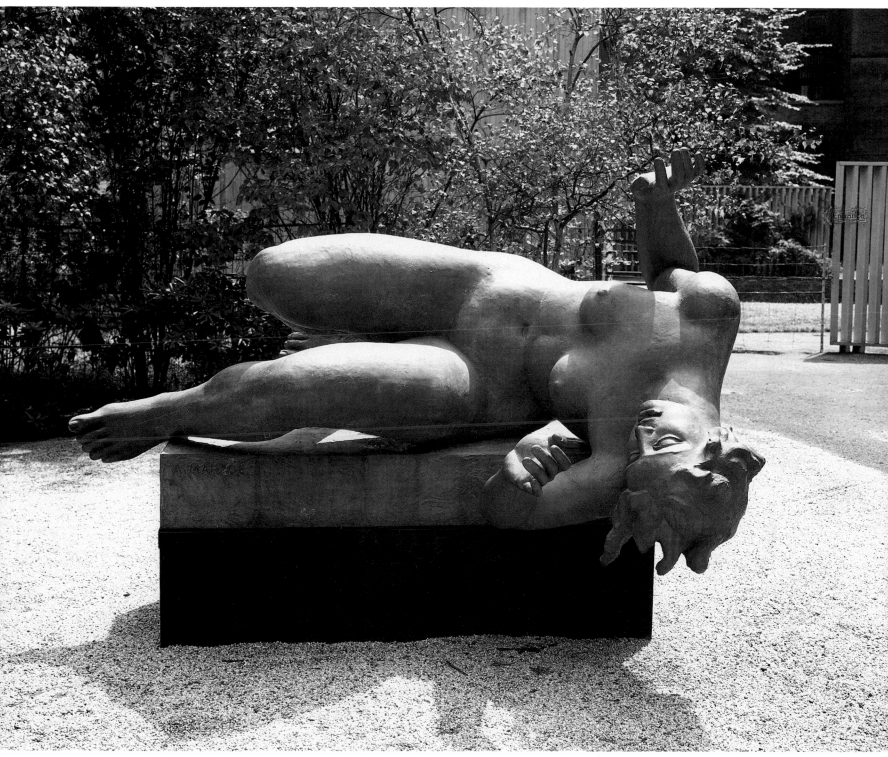

21

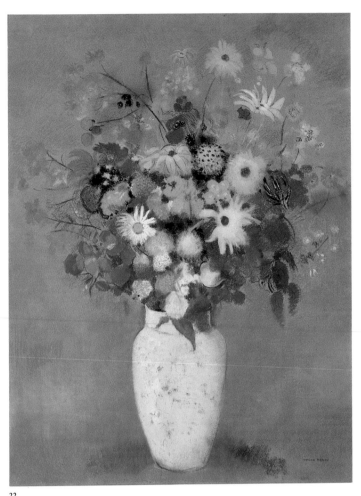

22

23

22. Odilon Redon. *Vase of Flowers.* 1914. Pastel on paper. 28¾ x 21⅛" (73 x 53.7 cm). Gift of William S. Paley

23. Henri de Toulouse-Lautrec. *La Goulue at the Moulin Rouge.* 1891–92. Oil on cardboard. 31¼ x 23¼" (79.4 x 59 cm). Gift of Mrs. David M. Levy

24. James Ensor. *Tribulations of St. Anthony.* 1887. Oil on canvas. 46⅜ x 66" (117.8 x 167.6 cm). Purchase

25. James Ensor. *Masks Confronting Death.* 1888. Oil on canvas. 32 x 39½" (81.3 x 100.3 cm). Mrs. Simon Guggenheim Fund

24

25

26

26. Édouard Vuillard. *The Park*. 1894. Distemper on canvas. 6'11½" x 62¾" (211.8 x 159.8 cm). The William B. Jaffe and Evelyn A. J. Hall Collection (the latter retaining life interest)

27. Edvard Munch. *The Storm*. 1893. Oil on canvas. 36⅛ x 51½" (91.8 x 130.8 cm). Gift of Mr. and Mrs. H. Irgens Larsen and purchased through the Lillie P. Bliss and Abby Aldrich Rockefeller Funds

28. Henri Rousseau. *The Sleeping Gypsy*. 1897. Oil on canvas. 51" x 6'7" (129.5 x 200.7 cm). Gift of Mrs. Simon Guggenheim

29. Henri Rousseau. *The Dream*. 1910. Oil on canvas. 6'8½" x 9'9½" (204.5 x 298.5 cm). Gift of Nelson A. Rockefeller

The Dream is the last painting Rousseau made. The tropical scene is an imaginative evocation of the jungle extrapolated from the Botanical Gardens in Paris that Rousseau frequently visited. A subtle but intense drama results from the startling insertion into the luxuriant flora and fauna of this mysterious jungle-Eden, with its vague menace of moonstruck lions, elephant, and pink serpent, of a female nude on Rousseau's own sofa. The illogical juxtaposition anticipates the later Surrealist version of the "collage principle."

27

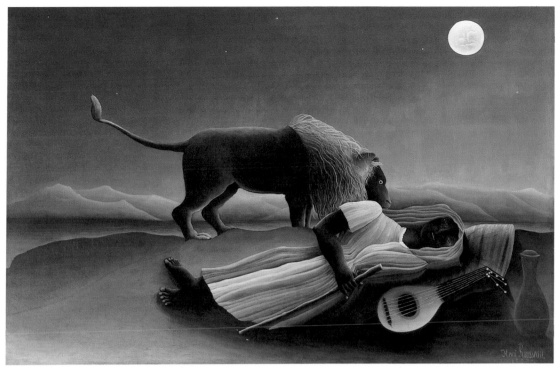

28

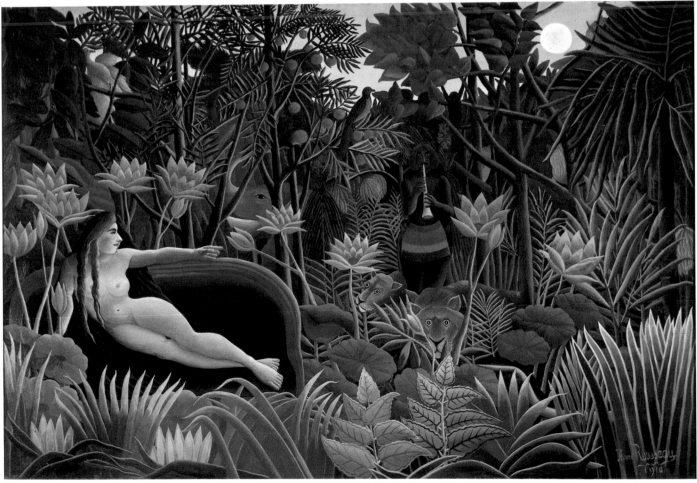

29

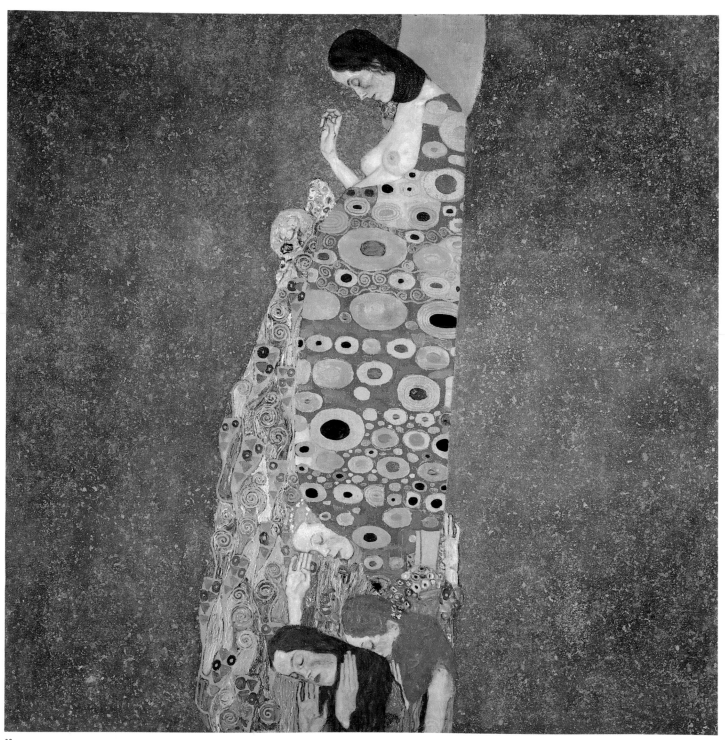

30

30. Gustav Klimt. *Hope II*. 1907–08. Oil and gold paint on canvas. 43½ x 43½″ (110.5 x 110.5 cm). Mr. and Mrs. Ronald S. Lauder and Helen Acheson Funds, Serge Sabarsky

In its mannered eroticism, ornamental stylization, and allegorical con-

tent Klimt's art has virtually come to symbolize turn-of-the-century Vienna. In his figure paintings particularly, Klimt was concerned with the illustration of ideas and drew on sources as diverse as Persian miniatures, the mosaics of Ravenna, Japanese prints, the art of Ferdinand Hodler and Munch, and Byzantine art in the development of his high Jugendstil manner as we see it exemplified here. Painted at the height of his "golden period," *Hope II* is a variation on the theme of love, birth, and death that recurs almost obsessively in his work. As Fritz Navotny has pointed out, the painting is a clear example of Klimt's characteristic "eccentric proportioning of masses... a human column on a square of canvas"—a compositional format that was to have great influence on the young Schiele.

31. Henri Matisse. *Male Model*. 1900. Oil on canvas. 39⅛ x 28⅝″ (99.3 x 72.7 cm). Kay Sage Tanguy and Abby Aldrich Rockefeller Funds

32. Henri Matisse. *The Serf*. 1900–03. Bronze. 37⅜″ (92.3 cm) high, at base 12 x 13″ (30.3 x 33 cm). Mr. and Mrs. Sam Salz Fund

33. Henri Matisse. *Girl Reading (La Lecture)*. 1905–06. Oil on canvas. 29⅝ x 23⅜″ (75.2 x 59.4 cm). Promised gift of David Rockefeller

Girl Reading contains all the attributes of Matisse's painting in his Fauve period, especially its luscious but cool palette of liberated color marks. It shows the artist's daughter Marguerite in the family's Paris apartment on the Quai Saint-Michel. In freely chromatic works of this kind the operative elements of painting themselves become a focus of interest and a rival reality to their depicted imagery. John Elderfield has observed that in this work Matisse's fluid color strokes and hatchings create a kind of chromatic bonfire that incinerates his artistic past: "The interior seems consumed in flames. Only a few sparks of color on the table remain of Matisse's Neo-Impressionist heritage."

31

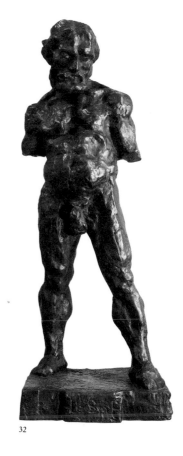

32

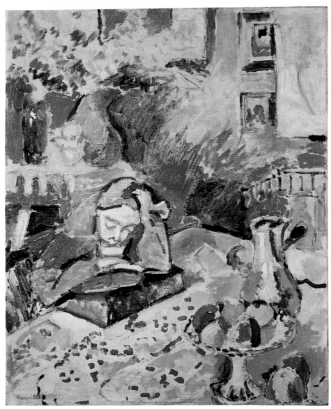

33

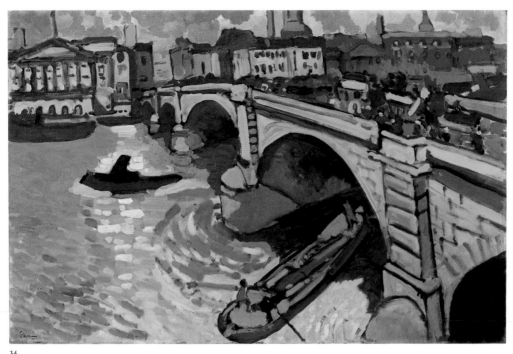

34

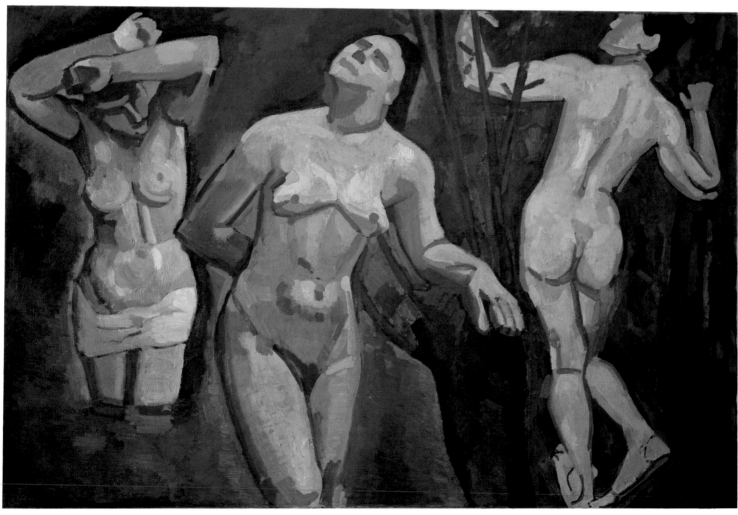

35

34. André Derain. *London Bridge.* 1906. Oil on canvas. 26 x 39" (66 x 99.1 cm). Gift of Mr. & Mrs. Charles Zadok

35. André Derain. *Bathers.* 1907. Oil on canvas. 52" x 6'4¾" (132.1 x 194.8 cm). William S. Paley and Abby Aldrich Rockefeller Funds

Derain's *Bathers* was completed before the Cézanne retrospective of 1907 and before Picasso's *Demoiselles d'Avignon.* It demonstrates, as Elderfield has noted, that although the retrospective did undoubtedly accelerate the movement toward "sculptural" painting, it did not initiate it. The Fauves had always been "premature Cézannists." Cézanne's work had been shown regularly at the Salon d'Automne since 1904. Derain clearly did not need to await the public discovery of Cézanne before tackling a painting of this kind, nor did he have to await the example of Picasso. The central figure in *Bathers* reveals simplifications in the treatment of its head that may indicate an appreciation of African sculpture. But the prevailing complexity and sobriety of its pictorial language mark the dissolution of Fauvism in favor of Cézannism.

36. Georges Braque. *Landscape at La Ciotat.* 1907. Oil on canvas. 28¼ x 23⅜" (71.7 x 59.4 cm). Acquired through the Katherine S. Dreier and Adele R. Levy Bequests

37. Georges Rouault. *Clown.* c. 1907. Oil on paper. 11½ x 12⅞" (29.2 x 32.7 cm). Gift of Vladimir Horowitz

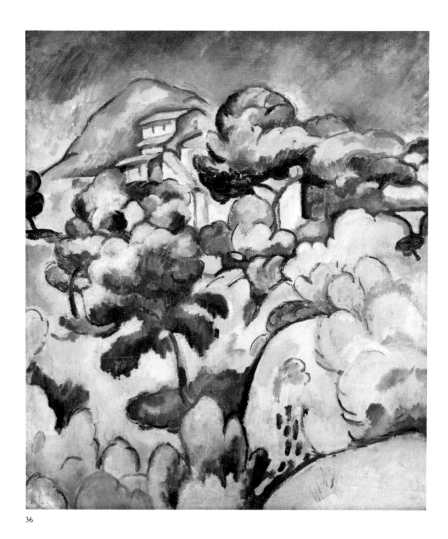

36

37

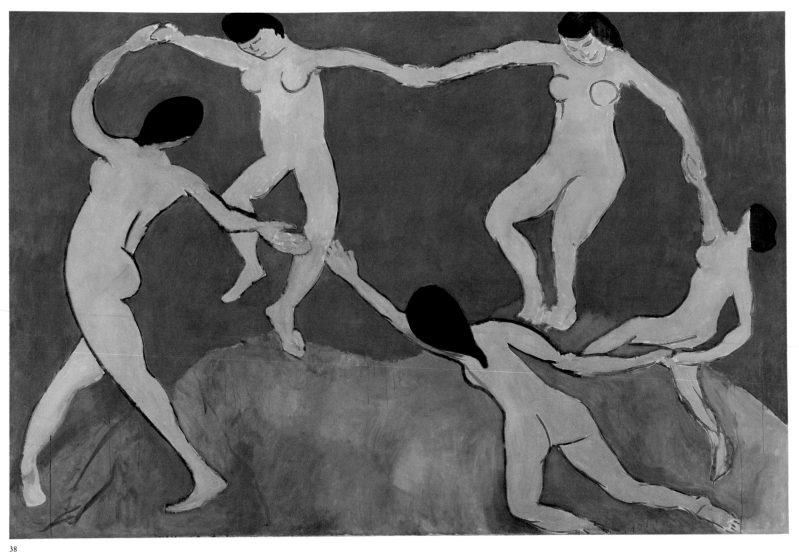

38

38. Henri Matisse. *Dance (first version)*. 1909. Oil on canvas. 8'6½" x 12'9½" (259.7 x 390.1 cm). Gift of Nelson A. Rockefeller in honor of Alfred H. Barr, Jr.

39. Henri Matisse. *The Red Studio*. 1911. Oil on canvas. 71¼ x 7'2¼" (181 x 219.1 cm). Mrs. Simon Guggenheim Fund

The Red Studio combines the pictorial idea of color saturation—its homogeneous overall shade of rusty red—with a more private and intimate theme, a visual inventory of the objects and paintings from Matisse's studio at Issy-les-Moulineaux. The potentially space-creating effects of the perspective lines are shorn of

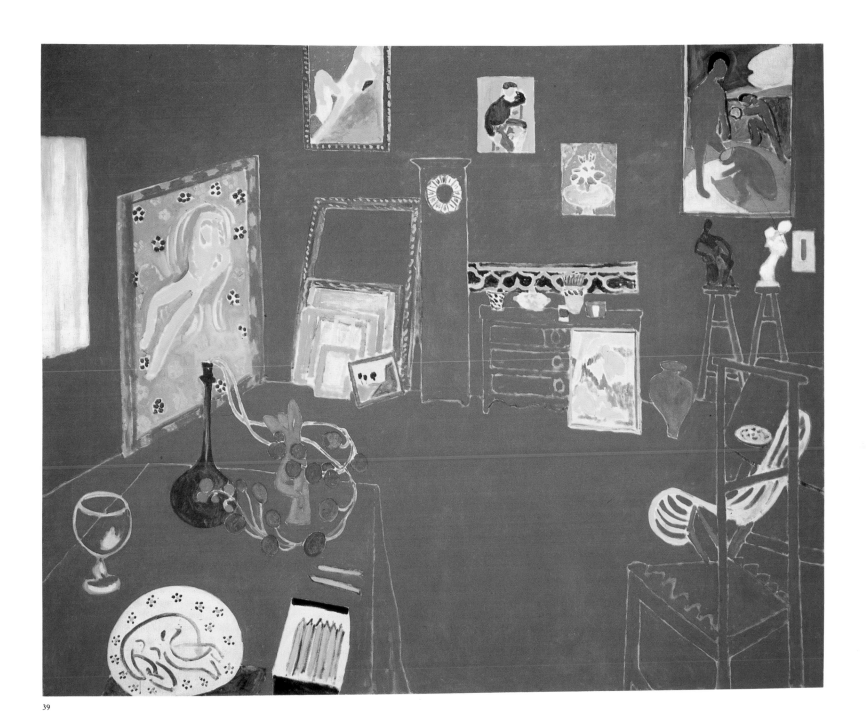

39

their power by not being reinforced with modeling or shading. This tendency is strengthened by the fact that virtually the only objects given local color are those which in themselves are flat (pictures, plates) while the three-dimensional objects (table, chair) are treated only as inscribed contours.

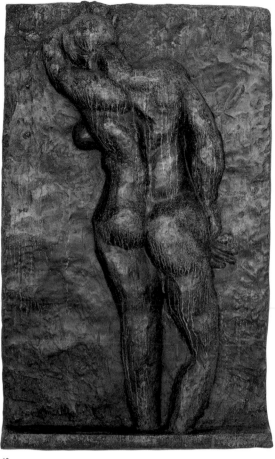

40

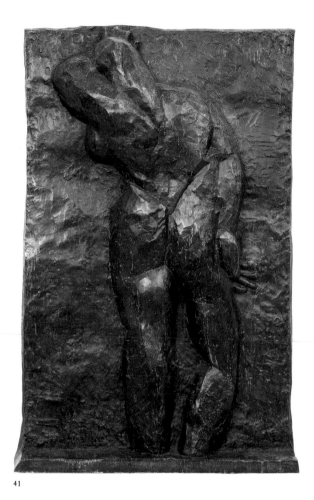

41

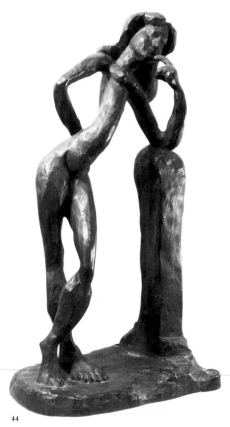

44

40–43. Henri Matisse.
40. *The Back, I*. 1909. Bronze. 6′2⅜″ x 44½″ x 6½″ (188.9 x 113 x 16.5 cm). Mrs. Simon Guggenheim Fund
41. *The Back, II*. 1913. Bronze. 6′2¼″ x 47⅝″ x 6″ (188.5 x 121 x 15.2 cm). Mrs. Simon Guggenheim Fund
42. *The Back, III*. 1916. Bronze. 6′2½″ x 44″ x 6″ (189.2 x 111.8 x 15.2 cm). Mrs. Simon Guggenheim Fund
43. *The Back, IV*. 1931. Bronze. 6′2″ x 44½″ x 6″ (188 x 112.4 x 15.2 cm). Mrs. Simon Guggenheim Fund

The Backs represent Matisse's most ambitious exploration of the monumental possibilities of relief sculpture and correspond to some of his discoveries in the mural-scale paintings made at the time he was painting *Dance*. As the sculptures progressed, the image grew more abstract, coinciding with the large canvases of 1908–18. Although we are now accustomed to seeing the four Backs united, they were actually made at widely spaced intervals

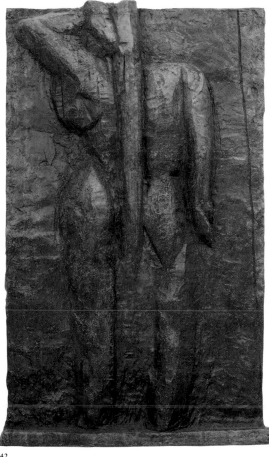

42

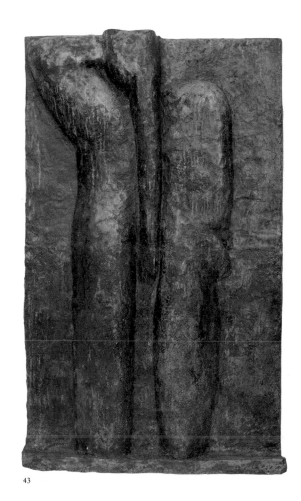

43

between 1909 and 1931, and were never conceived or presented as a series in the artist's lifetime. Nevertheless, the forms are inevitably related as an evolutionary development, and are revealing and powerful in the ensemble.

44. Henri Matisse. *La Serpentine*. 1909. Bronze. 22¼″ (56.5 cm) high, at base 11 x 7½″ (28 x 19 cm). Gift of Abby Aldrich Rockefeller

45. Henri Matisse. *Jeannette, III*. 1911. Bronze. 23¾ x 10¼ x 11″ (60.3 x 26 x 28 cm). Acquired through the Lillie P. Bliss Bequest

46. Henri Matisse. *Jeannette, IV*. 1911. Bronze. 24⅛ x 10¾ x 11¼″ (61.3 x 27.4 x 28.7 cm). Acquired through the Lillie P. Bliss Bequest

47. Henri Matisse. *Jeannette, V*. 1913. Bronze. 22⅞ x 8⅜ x 10⅝″ (58.1 x 21.3 x 27.1 cm). Acquired through the Lillie P. Bliss Bequest

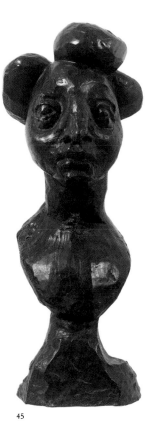

45

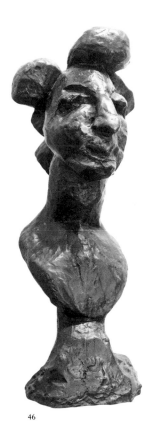

46

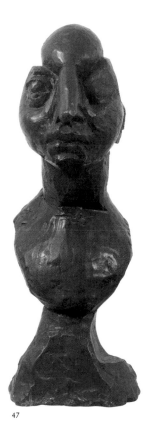

47

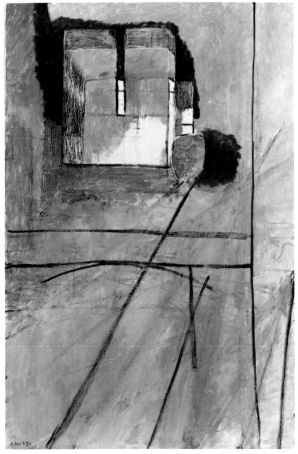

48

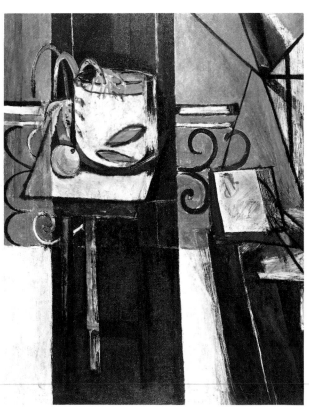

49

48. Henri Matisse. *View of Notre Dame*. 1914. Oil on canvas. 58 x 37⅛" (147.3 x 94.3 cm). Acquired through the Lillie P. Bliss Bequest and the Henry Ittleson, A. Conger Goodyear, Mr. and Mrs. Robert Sinclair Funds, and the Anna Erickson Levene Bequest given in memory of her husband, Dr. Phoebus Aaron Theodor Levene

49. Henri Matisse. *Goldfish*. 1914–15. Oil on canvas. 57¾ x 44¼" (146.5 x 112.4 cm). Gift of Florene M. Schoenborn and Samuel A. Marx

50. Henri Matisse. *Piano Lesson*. 1916. Oil on canvas. 8' ½" x 6'11¾" (245.1 x 212.7 cm). Mrs. Simon Guggenheim Fund

Into the powerful architecture of *Piano Lesson*—as close as Matisse would come to a personal commentary on Cubism—the artist has insinuated a subtle visual argument, conveyed by various forms and objects acting to create multiple polarities. The natural and the artificial interact, with artifice represented by the interior room, and "art" by the symbol of his son Pierre playing the Pleyel piano, his close physical conjunction with an early Matisse sculpture in front of him, and the painting *Woman on a High Stool*, 1913–14 (also in the Museum's collection), on the wall behind him. These passages contrast with the green triangulation leading outdoors, introducing the presence of nature. Other imagery symbolizes contrasts of intellect and instinct, pleasure and artistic discipline—qualities and preoccupations that must have weighed heavily on Matisse as he briefly adopted a very personal version of the reductive, more severe program of Cubism. Yet, even within these sober schemes, color functions vitally through memorable and voluptuous touches of mauve, orange, violet, and magenta.

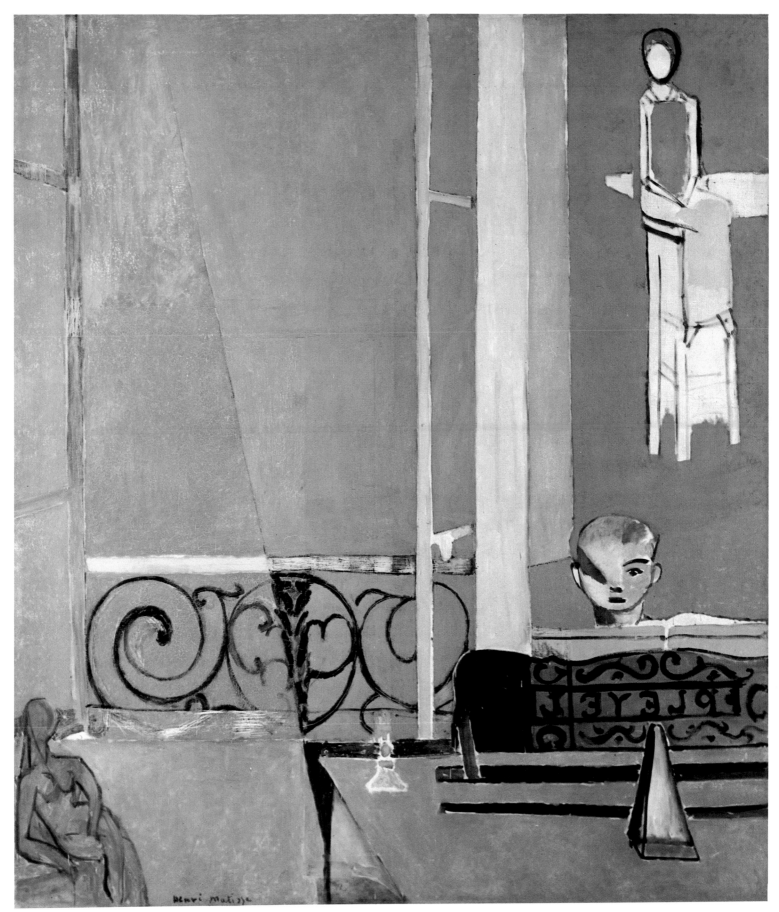

50

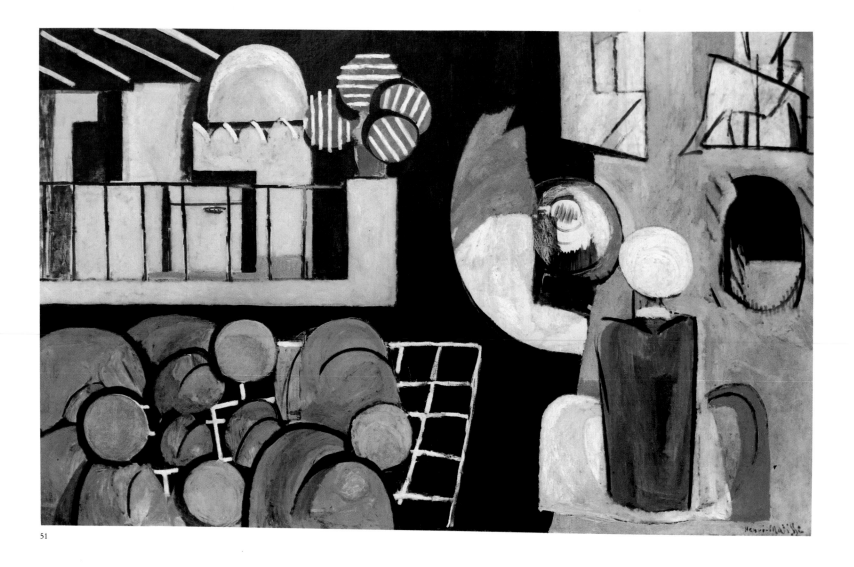

51

51. Henri Matisse. *The Moroccans.* 1916. Oil on canvas. 71⅜" x 9'2" (181.3 x 279.4 cm). Gift of Florene M. Schoenborn and Samuel A. Marx

52. Amedeo Modigliani. *Head.* 1915? Limestone. 22¼ x 5 x 14¾" (56.5 x 12.7 x 37.4 cm). Gift of Abby Aldrich Rockefeller in memory of Mrs. Cornelius J. Sullivan

53. Constantin Brancusi. Left to right: *Fish.* 1930. Gray marble. 21 x 71" (53.3 x 180.3 cm), on three-part pedestal of one marble and two limestone cylinders 29⅛" (74 cm) high. Acquired through the Lillie P. Bliss Bequest; *Magic Bird.* Version I. 1910. White marble. 22" (55.9 cm) high, on three-part limestone pedestal 70" (177.8 cm) high. Katherine S. Dreier Bequest; *Socrates.* 1923. Wood. 51¼" (130 cm) high. Mrs. Simon Guggenheim Fund

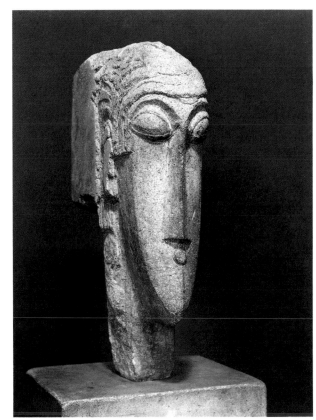

52

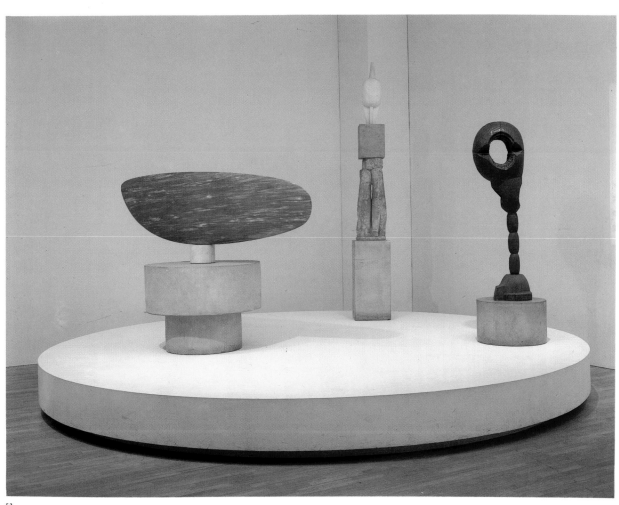

53

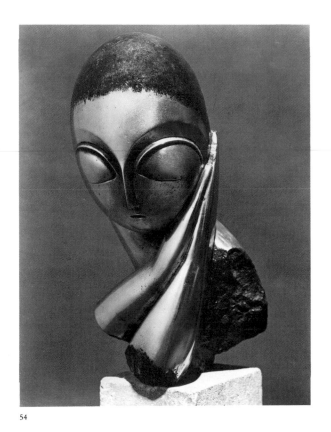

54

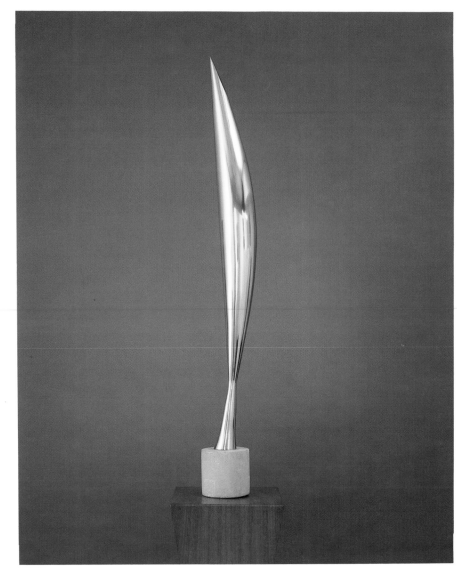

55

54. Constantin Brancusi. *Mlle Pogany.*
Version I. 1913 (after a marble of 1912).
Bronze. 17¼" (43.8 cm) high. Acquired
through the Lillie P. Bliss Bequest

55. Constantin Brancusi. *Bird in Space.*
1928? Bronze (unique cast). 54" (137.2
cm) high. Given anonymously

Though initially inspired by draw-
ings in which the flying bird had
been reduced to a simple V-like
cipher, this sculpture is not intended
so much to represent a bird as to
communicate—through its stream-
lined upward movement and its
highly reflective surface—sensations
associated with flight. While made of

heavy metal and nominally "top-heavy" in its configuration, the sculpture gives an impression of slimness, almost weightlessness, and seems virtually to be lifting off its pedestal. Its contours are smooth, yet its expanding and receding mass embodies surface variations of exceeding subtlety; these become even clearer when this bird is compared to the some sixteen other versions, all similar in conception and yet so utterly different in realization.

56. Amedeo Modigliani. *Anna Zborowska*. 1917. Oil on canvas. 51¼ x 32" (130.2 x 81.3 cm). Lillie P. Bliss Collection

57. Amedeo Modigliani. *Reclining Nude*. c. 1919. Oil on canvas. 28½ x 45⅞" (72.4 x 116.5 cm). Mrs. Simon Guggenheim Fund

This nude was Modigliani's last figure painting, perhaps his greatest, and certainly his most sensual. Of it, James Thrall Soby wrote: "Modigliani's women are not the grown-up cherubs of which the eighteenth century was fond. They are adult, sinuous, carnal and real, the final stage in the sequence leading from Giorgione's *Concert champetre* to Manet's *Dejeuner sur l'herbe* and on to Lautrec and his contemporaries. Yet whereas a certain picturesqueness of evil attaches to Lautrec's works, and indeed to those of many artists from Rops to Pascin, Modigliani's sensuality is clear and delighted, like that of Ingres but less afraid. His nudes are an emphatic answer to his Futurist countrymen who, infatuated with the machine, considered the subject outworn and urged its suppression for a period of ten years."

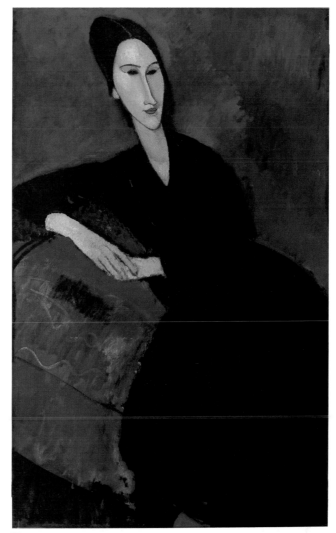

56

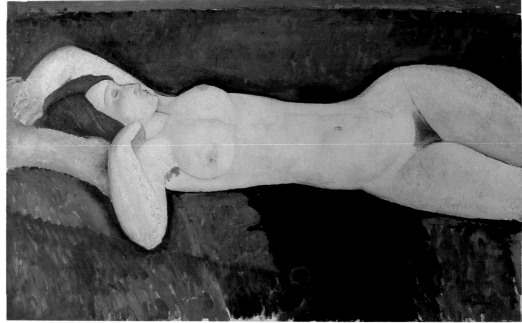

57

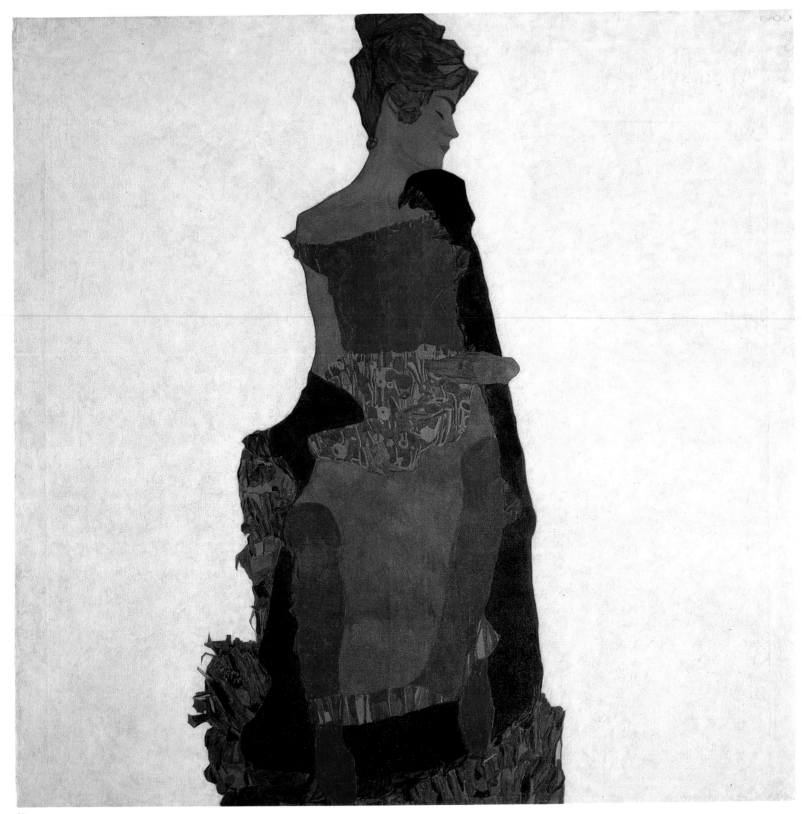

58

58. Egon Schiele. *Portrait of Gerta Schiele*. 1909. Oil, silver and gold-bronze paint, and pencil on canvas. 55 x 55¼″ (139.5 x 140.5 cm). Purchase and partial gift of Ronald S. Lauder

59. Oskar Kokoschka. *Self-Portrait*. 1913. Oil on canvas. 32⅛ x 19½″ (81.6 x 49.5 cm). Purchase

60. Oskar Kokoschka. *Hans Tietze and Erica Tietze-Conrat*. 1909. Oil on canvas. 30⅛ x 53⅝″ (76.5 x 136.2 cm). Abby Aldrich Rockefeller Fund

One of the most important in the series of psychologically penetrating "black portraits," as Kokoschka termed them, this double portrait of well-known art historians seems to bare the souls of his uneasy sitters, who were prominent personages in the social, intellectual, and artistic world of Vienna. The artist felt that his X-ray-like, visionary portraits —executed in oils that have the thinness and transparency of pastels— performed a kind of cathartic act of self-confrontation for his trancelike victim-sitters, which forced them, therapeutically, to surrender what he described as their "closed personalities so full of tension."

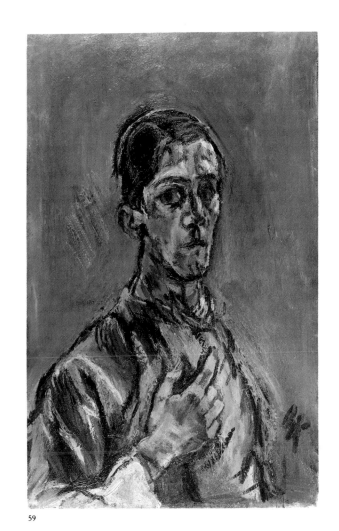

59

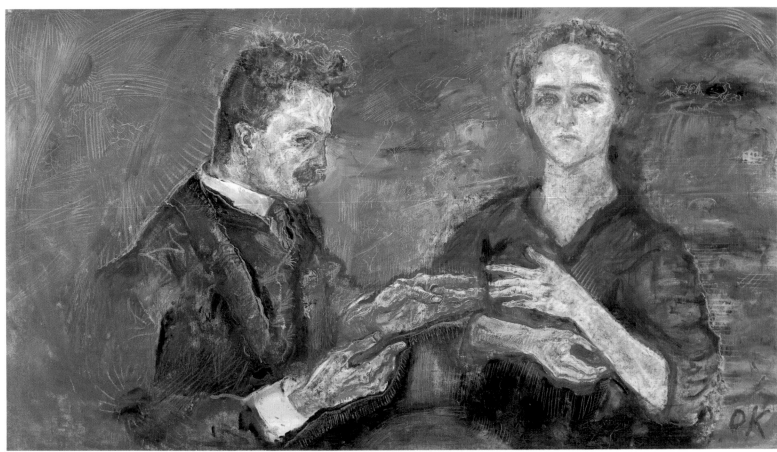

60

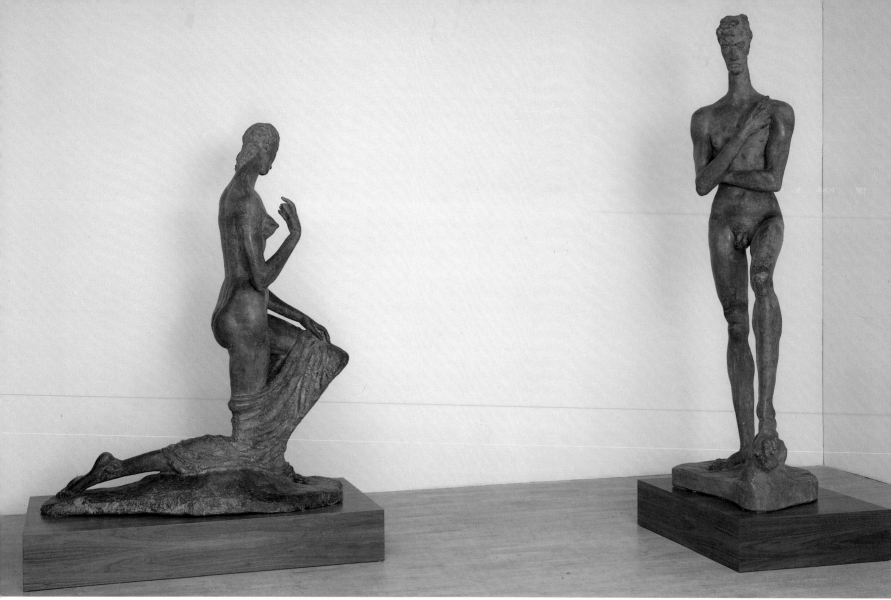

61

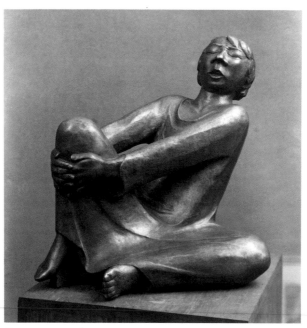

62

61. Wilhelm Lehmbruck. Left: *Kneeling Woman*. 1911. Cast stone. 69½" (176.5 cm) high, at base 56 x 27" (142.2 x 68.6 cm). Abby Aldrich Rockefeller Fund; right: *Standing Youth*. 1913. Cast stone. 7'8" (233.7 cm) high, at base 36 x 26¾" (91.5 x 68 cm). Gift of Abby Aldrich Rockefeller

The figure types of German Expressionist sculpture were polarized, as in Romanesque art, by two extremes of representation. Lehmbruck favored tall, gaunt figures, Barlach squat, compact types. The attenuation of Lehmbruck's personages, the self-enclosing gestures, and the downcast glance of the eyes communicate a sense of alienation characteristic of German Expressionism and anticipate the more radical treatment of those same constituents in the later "existential" figures of Giacometti. The cast stone from which these figures were made is a form of concrete and was used by Lehmbruck because he could not afford bronze. Its friability and softer granular surface nevertheless endow these figures with a sense of vulnerability which Lehmbruck's bronzes never have.

62. Ernst Barlach. *Singing Man*. 1928. Bronze. 19½ x 21⅞ x 14⅛" (49.5 x 55.3 x 35.9 cm). Abby Aldrich Rockefeller Fund

63. Emil Nolde (Emil Hansen). *Christ among the Children*. 1910. Oil on canvas. 34⅛ x 41⅞" (86.8 x 106.4 cm). Gift of Dr. W. R. Valentiner

64. Chaim Soutine. *The Old Mill*. c. 1922–23. Oil on canvas. 26⅛ x 32⅜" (66.4 x 82.2 cm). Vladimir Horowitz and Bernard Davis Funds

63

64

65

66

65. Ernst Ludwig Kirchner. *Street, Dresden.* 1908 (dated on painting 1907). Oil on canvas. 59¼" x 6'6⅞" (150.5 x 200.4 cm). Purchase

Though Kirchner's work resembled that of the Fauves more than did the painting of other members of his German Expressionist group Die Brücke, his *Street, Dresden* of 1908, nevertheless strongly departs from the carefree and joyous mood of its French counterparts. While certain of Kirchner's colors, the pink, for example, resemble the palette of the Fauves, his hot, Munchian orange-red and off-shade greens create a troubled, neurotic effect at odds with the emphasis on the primaries maintained by the French painters. The tilted horizon thrusts the figures closer to us, intensifying the claustrophobic, discomfiting character of the scene.

66. Karl Schmidt-Rottluff. *Houses at Night.* 1912. Oil on canvas. 37⅝ x 34½" (95.6 x 87.4 cm). Gift of Mr. and Mrs. Walter Bareiss

67. Ernst Ludwig Kirchner. *Street, Berlin.* 1913. Oil on canvas. 47½ x 35⅞" (120.6 x 91.1 cm). Purchase

68. Lovis Corinth. *Self-Portrait.* 1924. Oil on canvas. 39⅜ x 31⅝" (100 x 80.3 cm). Gift of Curt Valentin

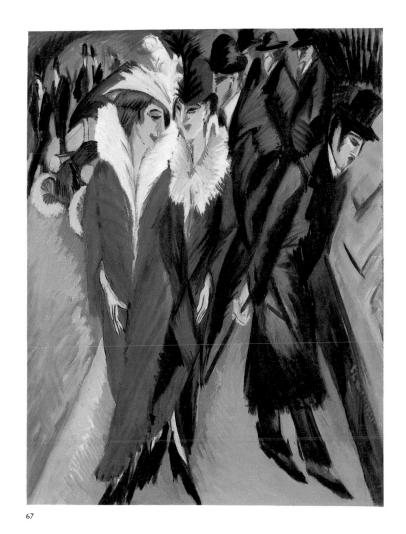

67

68

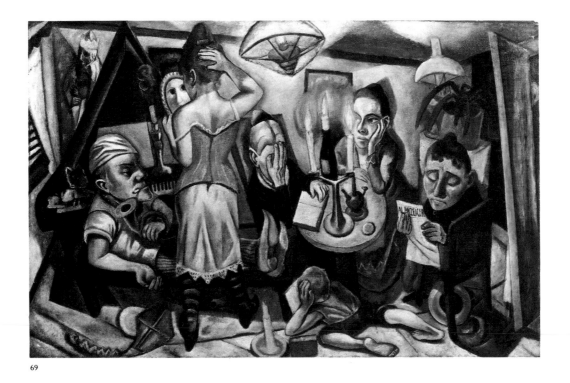

69

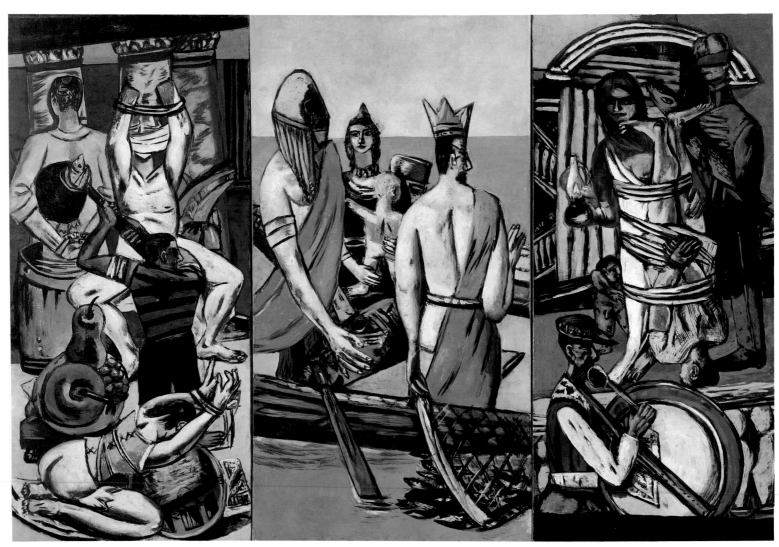

70

69. Max Beckmann. *Family Picture.*
1920. Oil on canvas. 25⅝ x 39¾" (65.1
x 100.9 cm). Gift of Abby Aldrich
Rockefeller

70. Max Beckmann. *Departure.*
1932–33. Oil on canvas. Triptych, center
panel 7'¾" x 45⅜" (215.3 x 115.2 cm),
side panels each 7'¾" x 39¼" (215.3 x
99.7 cm). Given anonymously (by
exchange)

71. Wassily Kandinsky. *Murnau
Landscape.* 1909. Oil on paper. 27¼ x
37" (69.2 x 93.9 cm). Promised gift of
Richard S. Zeisler

72. Wassily Kandinsky. *Picture with an
Archer.* 1909. Oil on canvas. 69 x 57"
(175.2 x 144.7 cm). Fractional gift of
Mrs. Bertram Smith

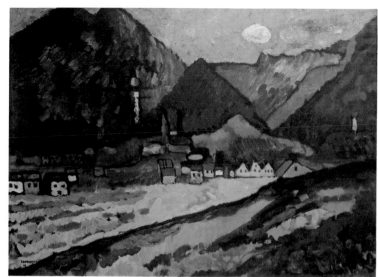

71

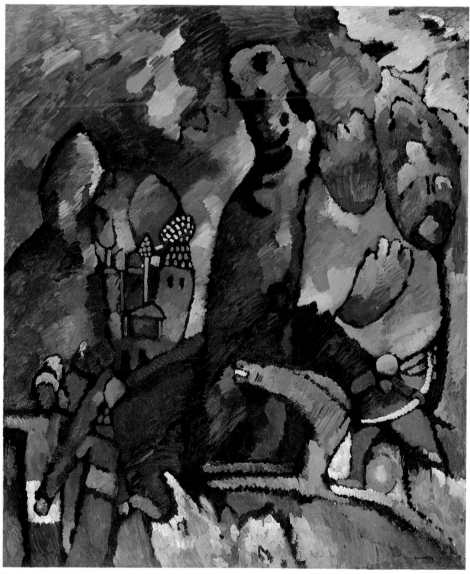

72

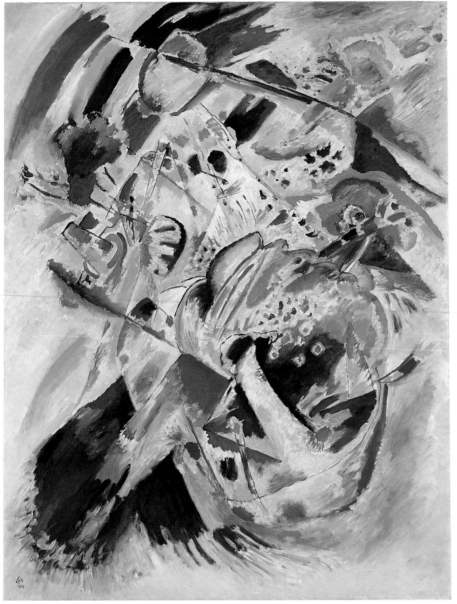

73

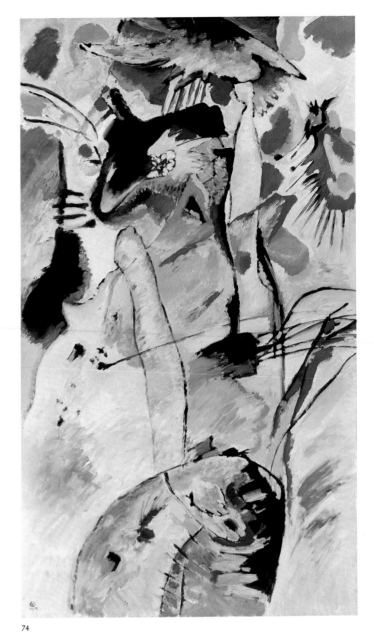

74

73–76. Wassily Kandinsky.

73. *Painting No. 201.* 1914. Oil on canvas. 64¼ x 48¼″ (163 x 123.6 cm). Nelson A. Rockefeller Fund (by exchange)

74. *Painting No. 198.* 1914. Oil on canvas. 64 x 36¼″ (162.5 x 92.1 cm). Mrs. Simon Guggenheim Fund

75. *Painting No. 200.* 1914. Oil on canvas. 64 x 31½″ (162.5 x 80 cm). Mrs. Simon Guggenheim Fund

76. *Painting No. 199.* 1914. Oil on canvas. 64⅛ x 48⅜″ (162.6 x 122.7 cm). Nelson A. Rockefeller Fund (by exchange)

75

76

By means of an exchange with The
Solomon R. Guggenheim Museum
in 1982, the Museum was able to
reunite a historic set of four panels
commissioned by Edwin R. Camp-
bell for his New York apartment in
1914. Together this group of panels,
executed at the height of Kandin-
sky's creative powers, forms one of
modern art's greatest ensembles. The
panels have often been interpreted as
suggesting the four seasons, each of
which is implied by a particular pal-
ette and by an abstract rhythm of
surging color forms and lines.

77

77. Paul Klee. *Actor's Mask*. 1924. Oil on canvas mounted on board. 14½ x 13⅜″ (36.7 x 33.8 cm). The Sidney and Harriet Janis Collection

78. Paul Klee. *Fire in the Evening*. 1929. Oil on cardboard. 13⅜ x 13¼″ (33.8 x 33.4 cm). Mr. and Mrs. Joachim Jean Aberbach Fund

79. Paul Klee. *Around the Fish*. 1926. Oil on canvas. 18⅜ x 25⅛″ (46.7 x 63.8 cm). Abby Aldrich Rockefeller Fund

Around the Fish is a brilliant and characteristic example of Klee's ability to endow a system of veiled private signs with wider meanings. The seemingly submerged fish has an allusively ancestral quality, and echoes the early Christian symbol of the deity; the man to whom the arrow points may represent human consciousness. Other symbols suggest nature, the sun, and the moon in a kind of schematic evolutionary history of man, beginning with zoology and ending with religion.

78

80. Paul Klee. *Cat and Bird.* 1928. Oil and ink on gesso on canvas, mounted on wood. 15 x 21″ (38.1 x 53.2 cm). Sidney and Harriet Janis Collection Fund, and gift of Suzy Prudden and Joan H. Meijer in memory of F. H. Hirschland

Klee's predilection for small-format pictures represents, as William Rubin has observed, the logical consequence of an imagery derived from imagination rather than perception. His art was envisioned on what we might call the "screen" of the mind's eye, which, by nature, feels small. Indeed, this screen *must* be very small, for, as the Gestalt psychologists demonstrated long ago, it is commonly felt to be located just inside the forehead, above the eyes. These considerations are especially relevant to an understanding of *Cat and Bird,* in which Klee relies on our awareness, perhaps subconscious, of where this "screen" is located; otherwise, we would not grasp that the bird represented in the painting is not in front of the cat's head but inside it—quite literally, on his mind. Our apprehension that the bird is a thing imagined rather than seen by the cat is reinforced by Klee's treatment of the pupils of the cat's eyes, which appear unfocused on any exterior object. The obsessional nature of the cat's interest in the bird is further expressed by the rendering of the cat's head so that it almost fills the picture surface. Indeed, the cat's head is pressed so close to the picture plane that its top seems anchored to the upper edge; while at the bottom the cat's whiskers reach out like delicate, seismologically responsive antennae to the corners of the picture.

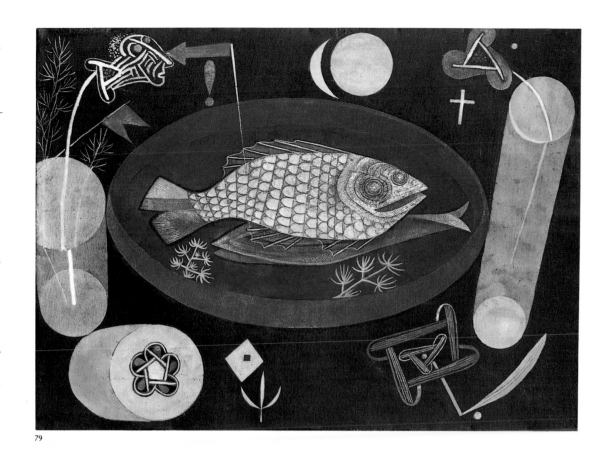

79

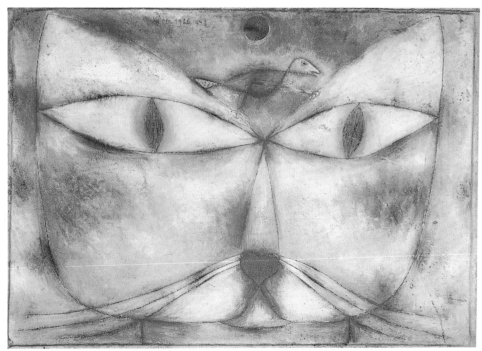

80

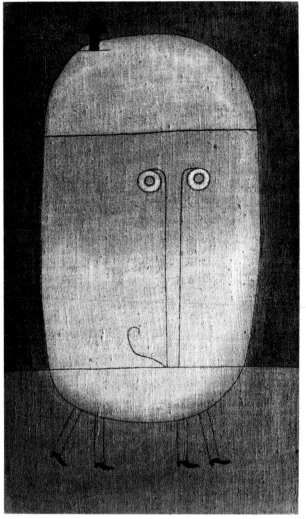

81

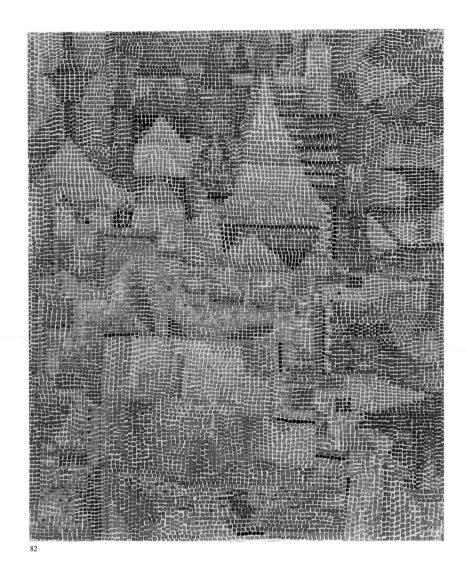

82

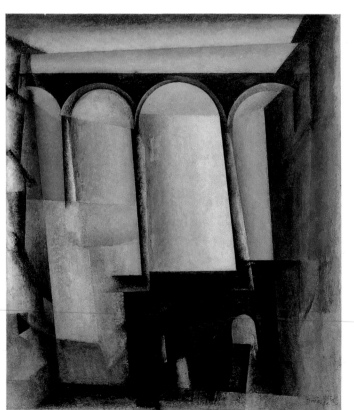

81. Paul Klee. *Mask of Fear.* 1932. Oil on burlap. 39⅝ x 22½" (100.4 x 57.1 cm). Nelson A. Rockefeller Fund

82. Paul Klee. *Castle Garden.* 1931. Oil on canvas. 26½ x 21⅝" (67.2 x 54.9 cm). Sidney and Harriet Janis Collection Fund

This painting is among Klee's most noble and sturdily architectonic works, subtly paraphrasing Cubism in the geometry that emerges from the diaphanous mosaic of color lozenges. The picture epitomizes Klee's divisionist works, which are made up of mosaic-like color tesserae that seem to reconcile in a shimmering envelope of light and atmosphere a softened spatiality with a hard glinting surface.

83

83. Lyonel Feininger. *Viaduct*. 1920. Oil on canvas. 39¾ x 33¾″ (100.9 x 85.7 cm). Acquired through the Lillie P. Bliss Bequest

84. Pablo Picasso. *Boy Leading a Horse*. 1906. Oil on canvas. 7′2¾″ x 51½″ (220.3 x 130.6 cm). Gift of William S. Paley (the donor retaining life interest)

The classical, more sculptural turn that Picasso's art took in the winter of 1905–06 was influenced by Cézanne, thirty-one of whose paintings had been exhibited in the Salon d'Automne of 1904 and ten more at that of 1905. The monumentality of the boy, whose determined stride possesses the earth, the elimination of anecdote, and the multiaccented, overlapping contouring all speak of the master of Aix, and especially of his *Bather*. But Picasso had also been looking at Greek art in the Louvre, and under this influence he showed himself increasingly responsive to the kind of revelatory gesture that is the genius of classical sculpture. Picasso chose a gesture whose sheer authority (there are no reins) seems to compel the horse to follow, and draws attention by analogy, as Meyer Schapiro has pointed out, to the power of the artist's hand. In this picture Picasso makes no concession to charm. The shift of emphasis from the sentimental to the plastic is heralded by a mutation of his earlier rose tonality into one of terra-cotta and gray, which accords well with the sculpture-like character of the boy and horse. The pair is isolated in a kind of nonenvironment, which has been purged not only of anecdotal detail but of all cues to perspectival space. The rear leg of the horse dissolves into the back plane of the picture, and the background is brought up close to the surface by the magnificent scumbling on the upper regions of the canvas.

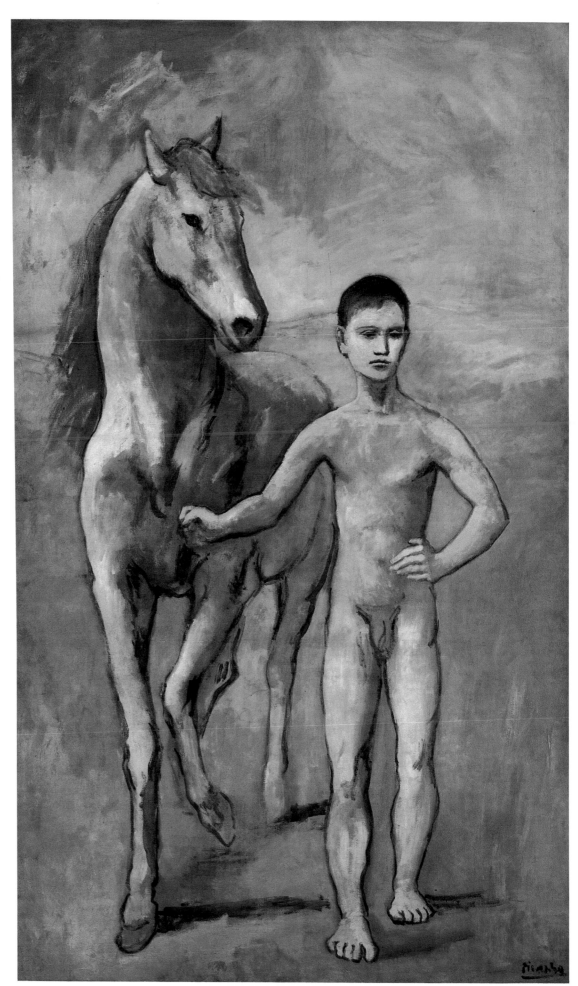

84

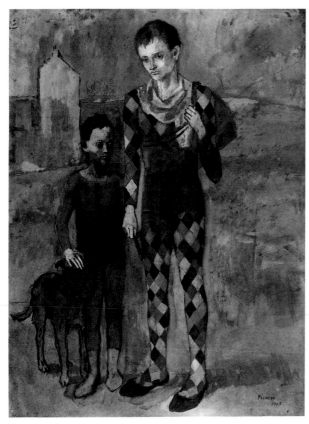

85

86

85. Pablo Picasso. *Two Acrobats with a Dog*. 1905. Gouache on cardboard. 41½ x 29½" (105.5 x 75 cm). Promised gift of William A. M. Burden

86. Pablo Picasso. *Two Nudes*. 1906. Oil on canvas. 59⅝ x 36⅝" (151.3 x 93 cm). Gift of G. David Thompson in honor of Alfred H. Barr, Jr.

87. Pablo Picasso. *Head of a Woman (Fernande)*. 1909. Bronze. 16¼" (41.3 cm) high. Purchase

88. Georges Braque. *Road near L'Estaque*. 1908. Oil on canvas. 23¾ x 19¾" (60.3 x 50.2 cm). Given anonymously (by exchange)

89. Pablo Picasso. *The Reservoir, Horta de Ebro*. 1909. Oil on canvas. 23¾ x 19¾" (60.3 x 50.1 cm). Promised gift of Mr. and Mrs. David Rockefeller

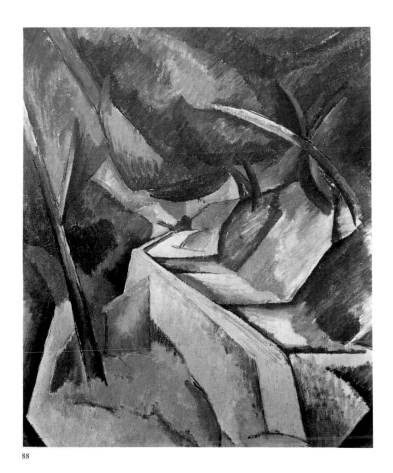

88

87

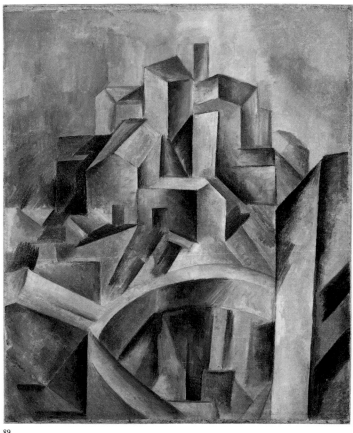

89

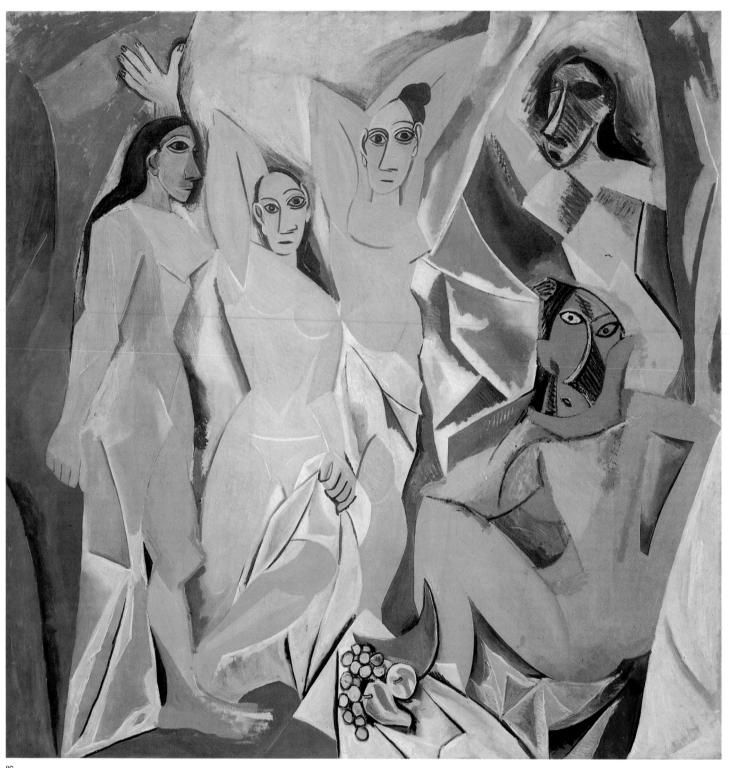

90

90. Pablo Picasso. *Les Demoiselles d'Avignon.* 1907. Oil on canvas. 8′ x 7′8″ (243.9 x 233.7 cm). Acquired through the Lillie P. Bliss Bequest

The first sketches for the *Demoiselles* show that it began as a story-telling picture involving a medical student, a sailor, and five courtesans in a bordello. The evolution of the image to its final state reflected, as William Rubin has noted, a broad progression from the narrative to the "iconic" that characterized Picasso's work during 1905–09. The image's pictorial metamorphosis, as Leo Steinberg has demonstrated, was much less motivated by an interest in abstraction than by Picasso's desire for a more profound and intense projection of his initial concern—his complex and contradictory feelings about women. These spanned sensations of "Dionysian release" and apprehensions of disease and death. In the picture's final form the sailor and medical student have been eliminated along with other anecdotal references, and directly expressionistic components of painting have taken over from narrative, as in the slashing expressionism of the heads on the right, the raw, brash coloring, the violent "attack" of the brushwork, the abstract scalloped shapes of the drapery, and the claustrophobicly compressed space. This painting obliterated the vestiges of nineteenth-century painting still operative in Fauvism, the vanguard style of the immediately preceding years; it is thus, more a "breakaway" painting with respect to late nineteenth-century modernism—and post-medieval Western painting in general—than a "break-through" painting with regard to Cubism. Indeed, though marking the final stage of Picasso's transition from a perceptual to a conceptual way of working, and suggesting something of that shallow relief space which would characterize Cubism, this radically expressionist and primitivist work pointed mostly in directions opposite to Cubism's character and structure.

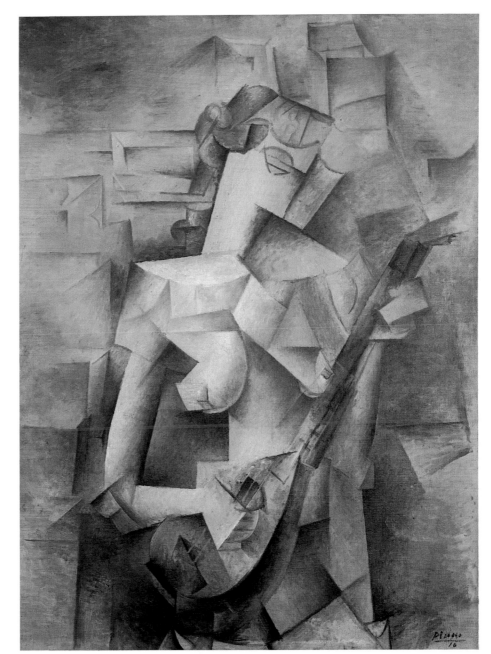

91

91. Pablo Picasso. *Girl with a Mandolin (Fanny Tellier)*. 1910. Oil on canvas. 39½ x 29" (100.3 x 73.6 cm). Nelson A. Rockefeller Bequest

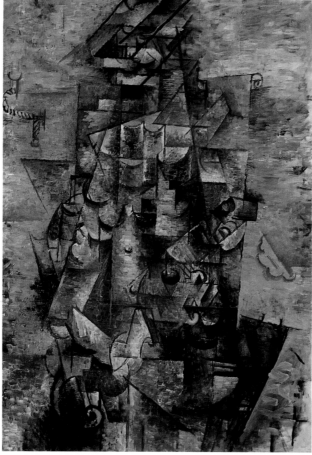

92

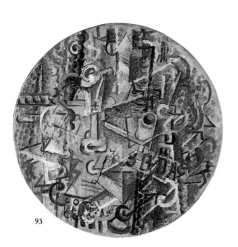

93

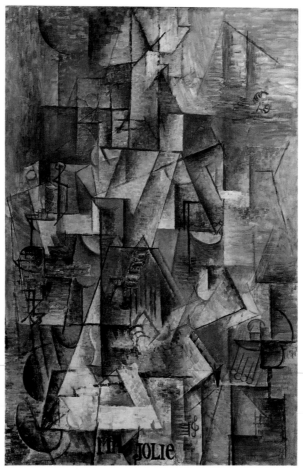

94

92. Georges Braque. *Man with a Guitar.* 1911. Oil on canvas. 45¾ x 31⅞" (116.2 x 80.9 cm). Acquired through the Lillie P. Bliss Bequest

In this picture Braque achieves a more symmetrical and balanced disposition of parts and a firmer sense of the controlling tonality than in his earlier Cubism. A superlative example of the most uncompromising "musical," or "hermetic," phase of Analytic Cubism, *Man with a Guitar* manages to hold in an elegant tension bits of observed or remembered subject matter and more formal invented signs and passages. No matter how fragmentary and remote, references to the human figure, a guitar, and still-life objects are still clearly discernible.

93. Georges Braque. *Soda.* 1911. Oil on canvas. 14¼" (36.2 cm) diameter. Acquired through the Lillie P. Bliss Bequest

94. Pablo Picasso. *"Ma Jolie."* 1911–12. Oil on canvas. 39⅜ x 25¾" (100 x 65.4 cm). Acquired through the Lillie P. Bliss Bequest

High Analytic Cubist paintings, such as this one of 1911–12, are difficult to read, for while they are articulated with planes, lines, space, shading, and other vestiges of the language of illusionistic representation these constituents have been largely abstracted from their former descriptive functions. Their degree of abstraction is about as great as it would ever become in Picasso's work, and though these pictures approach nonfiguration, they maintain tenuous ties with external reality. The fragmented wineglass at the lower left, the passementerie tassels of the chair in the lower right, and the treble clef and musical staff at the bottom of the picture—in combination with the song title "Ma Jolie"— suggest an ambience of informal music-making. Even without the advantage of the picture's subtitle, *Woman with a Zither or Guitar,* we would probably identify the suggestions of a figure in it.

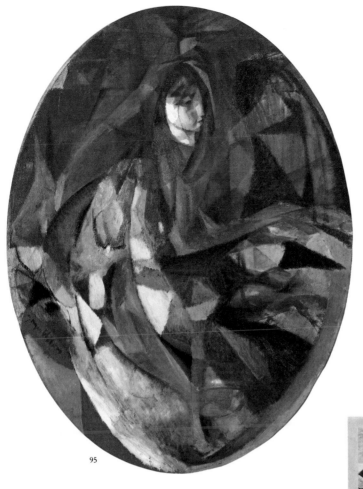

95

95. Jacques Villon. *Little Girl at the Piano*. 1912. Oil on canvas. 51 x 37⅞" (129.2 x 96.4 cm). Bequest of Helen Acheson

96. Juan Gris. *Guitar and Flowers*. 1912. Oil on canvas. 44⅛ x 27⅝" (112.1 x 70.2 cm). Bequest of Anna Erickson Levene in memory of her husband, Dr. Phoebus Aaron Theodor Levene

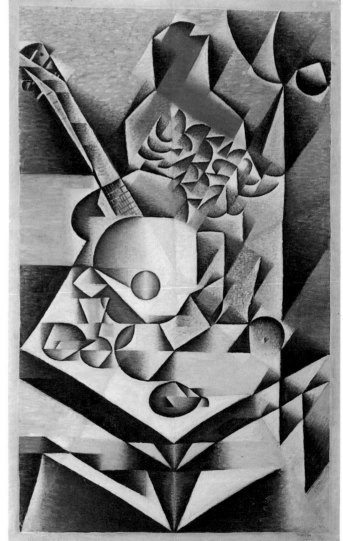

96

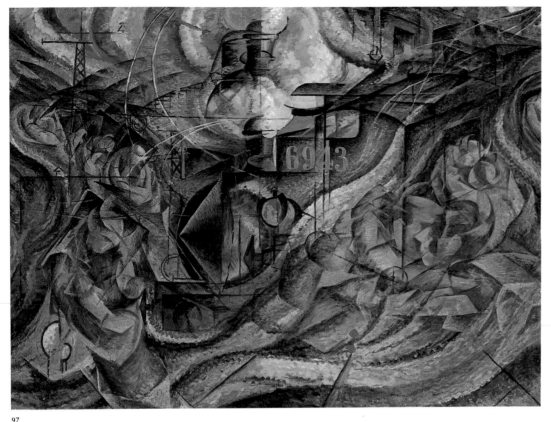

97

97. Umberto Boccioni. *States of Mind: The Farewells.* 1911. Oil on canvas. 27⅞ x 37⅞" (70.7 x 96 cm). Gift of Nelson A. Rockefeller

The Italian Futurists set the Cubist world in motion, substituting, as in this image of a crowd in a railroad station, suggestions of last-minute embraces, chugging trains, and flashing signals for the static and contemplative subjects of their French colleagues. While accepting the dissection of forms into planes and lines, and the gridlike verticals and horizontals of French Cubism, they added to that vocabulary great baroque curves and brighter colors such as those that twist through the space of this picture enhancing the sensation of movement.

98. Giacomo Balla. *Street Light.* 1909. Oil on canvas. 68¾ x 45¼" (174.7 x 114.7 cm). Hillman Periodicals Fund

99. Carlo Carrà. *Funeral of the Anarchist Galli.* 1911. Oil on canvas. 6'6¼" x 8'6" (198.7 x 259.1 cm). Acquired through the Lillie P. Bliss Bequest

100. Umberto Boccioni. *Development of a Bottle in Space.* 1912. Silvered bronze (cast 1931). 15 x 12⅞ x 23¾" (38.1 x 32.7 x 60.3 cm). Aristide Maillol Fund

101. Umberto Boccioni. *Unique Forms of Continuity in Space.* 1913. Bronze (cast 1931). 43⅞ x 34⅞ x 15¾" (111.2 x 88.5 x 40 cm). Acquired through the Lillie P. Bliss Bequest

A powerfully arresting evocation of power and speed, this massively muscled human form is encased in spiraling scallops of metal that reinforce a sense of continuous motion. Boccioni's famous bronze was the climax of a long series of figures in violent motion—riding horseback, cycling, or running—among them the Museum's monumental painting *Dynamism of a Soccer Player* and the charcoal study *Muscular Dynamism.* The Cubists had always represented the figure in repose and emphasized its architectural stability. Boccioni, however, used the structural devices and artifices of Cubism to epitomize

98

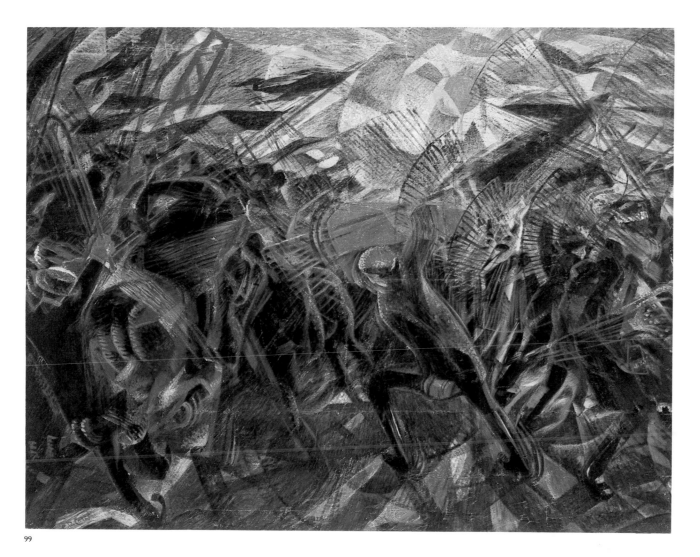

99

the Futurist love of movement and speed. But though the Futurist manifesto saw "a speeding automobile"... as "more beautiful than the Victory of Samothrace," Boccioni's sculpture resembles nothing so much as an abstract version of that celebrated Hellenistic work.

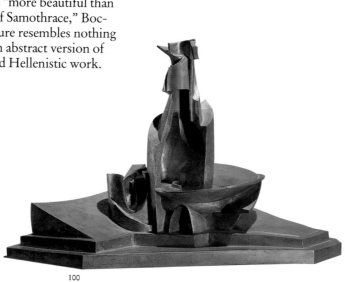

100

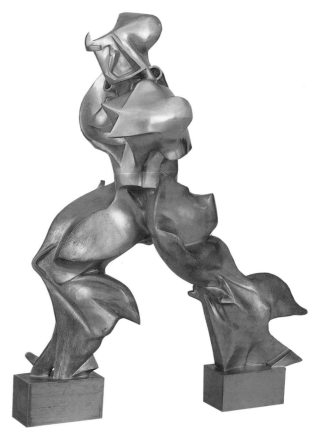

101

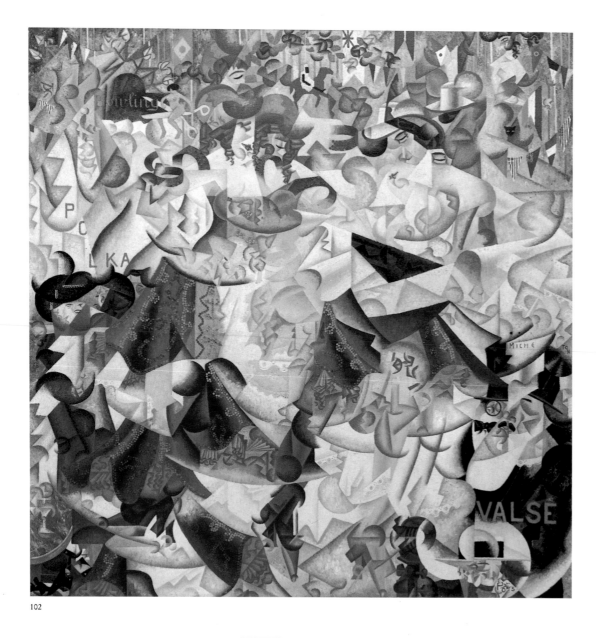

102

103

102. Gino Severini. *Dynamic Hieroglyphic of the Bal Tabarin*. 1912. Oil on canvas, with sequins. 63⅝ x 61½" (161.6 x 156.2 cm). Acquired through the Lillie P. Bliss Bequest

103. Giacomo Balla. *Swifts: Paths of Movement + Dynamic Sequences*. 1913. Oil on canvas. 38⅛ x 47¼" (96.8 x 120 cm). Purchase

104. Umberto Boccioni. *Dynamism of a Soccer Player*. 1913. Oil on canvas. 6'4⅛" x 6'7⅛" (193.2 x 201 cm). The Sidney and Harriet Janis Collection

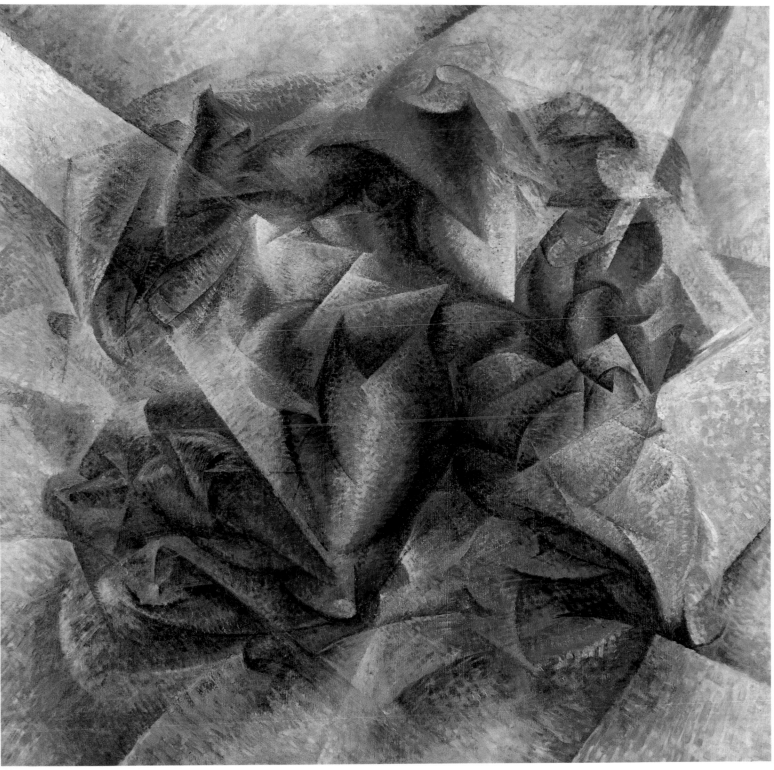

104

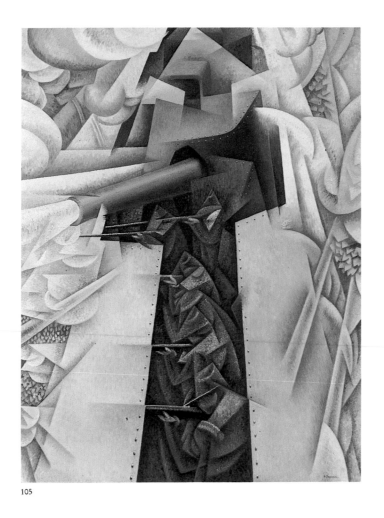

105

105. Gino Severini. *Armored Train in Action*. 1915. Oil on canvas. 46 x 34½" (116.8 x 87.8 cm). Promised gift of Richard S. Zeisler

106. Robert Delaunay. *The Windows*. 1912. Oil on canvas. 51" x 6'5" (129.5 x 195.8 cm). Promised gift of Mr. and Mrs. William A. M. Burden

107. Francis Picabia. *The Spring*. 1912. Oil on canvas. 8'2¼" x 8'2⅛" (249.6 x 249.3 cm). Eugene and Agnes E. Meyer Collection, given by their family

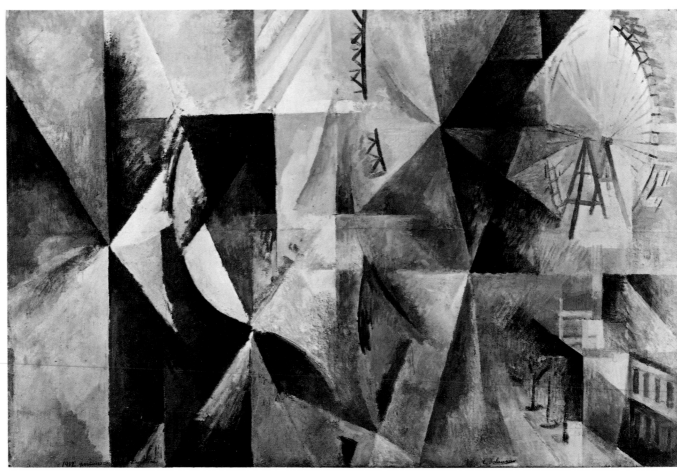

106

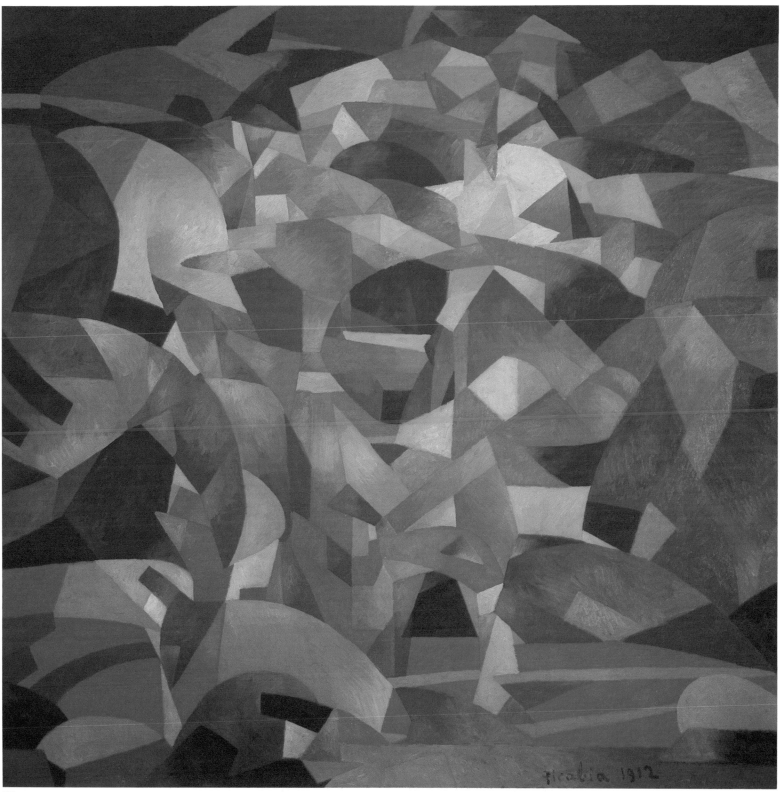

107

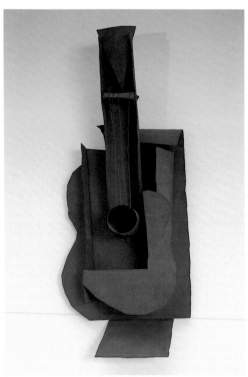

108

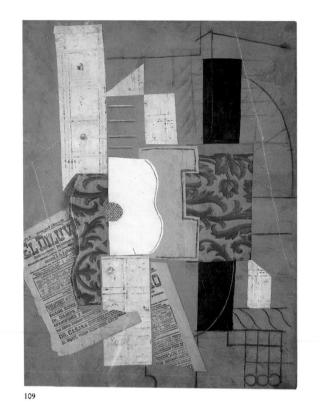

109

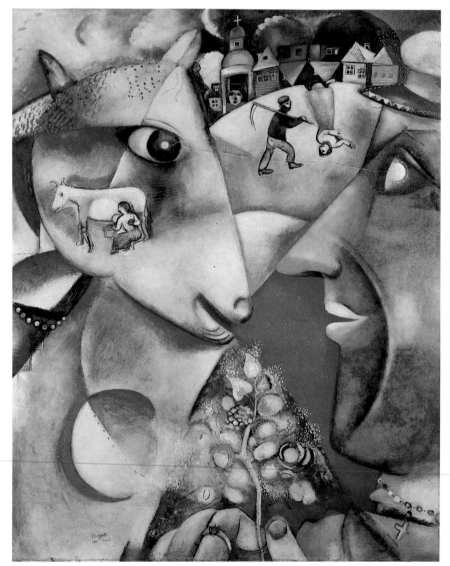

110

108. Pablo Picasso. *Guitar.* 1912. Sheet metal and wire. 30½ x 13¾ x 7⅝" (77.5 x 35 x 19.3 cm). Gift of the artist

This revolutionary metal relief constituted a dramatic rupture with traditional sculpture and led to the birth of a new tradition that replaced modeling and carving with open-work construction. It compounded ideas related to high Analytic Cubism, in which simulated surfaces of objects were dismantled and penetrated, and different views of the object, in plan and elevation, were superimposed, with the opaque planar juxtapositions of collage. In the sheet-metal *Guitar* and its necessarily more freely rendered cardboard maquette (also in the Museum's collection) only certain aspects of the musical instrument as such remain: the vertical strings and the cylinder that represents the sound hole.

109. Pablo Picasso. *Guitar.* 1913. Charcoal, crayon, ink, and pasted paper. 26⅛ x 19½" (66.3 x 49.5 cm). Nelson A. Rockefeller Bequest

110. Marc Chagall. *I and the Village.* 1911. Oil on canvas. 6'3⅝" x 59⅝" (192.1 x 151.4 cm). Mrs. Simon Guggenheim Fund

The "dreamer" in this painting is an improbable but appealing cow that impresses the viewer as both icon and nature spirit. Chagall communicates a highly individual poetry, the inventive syntax of which had been made possible by the displacements, transparencies, and interpenetrations of the Cubist aesthetic. His uninhibited zest stems as much from the liberating character of Cubism and his own ingenious fantasy as from folkloristic memories of his native village of Vitebsk.

111. Marc Chagall. *Calvary.* 1912. Oil on canvas. 68¾" x 6'3¾" (174.6 x 192.4 cm). Acquired through the Lillie P. Bliss Bequest

112. Marc Chagall. *Birthday.* 1915. Oil on cardboard. 31¾ x 39¼" (80.6 x 99.7 cm). Acquired through the Lillie P. Bliss Bequest

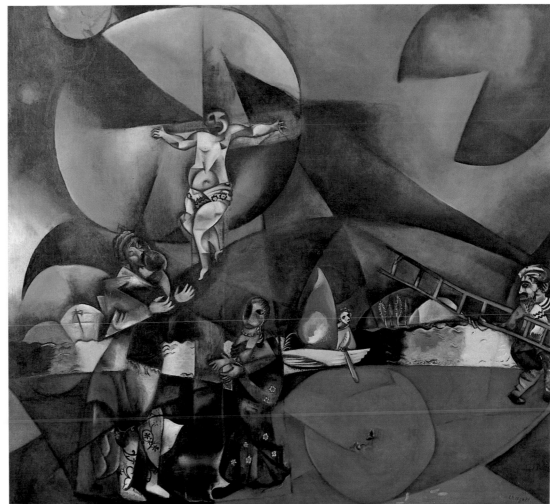

111

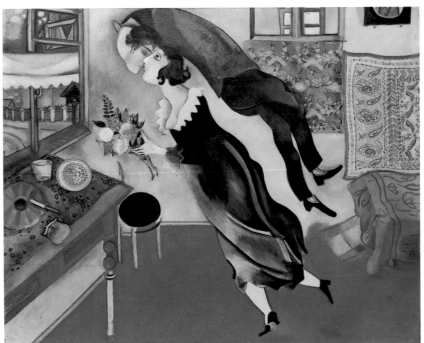

112

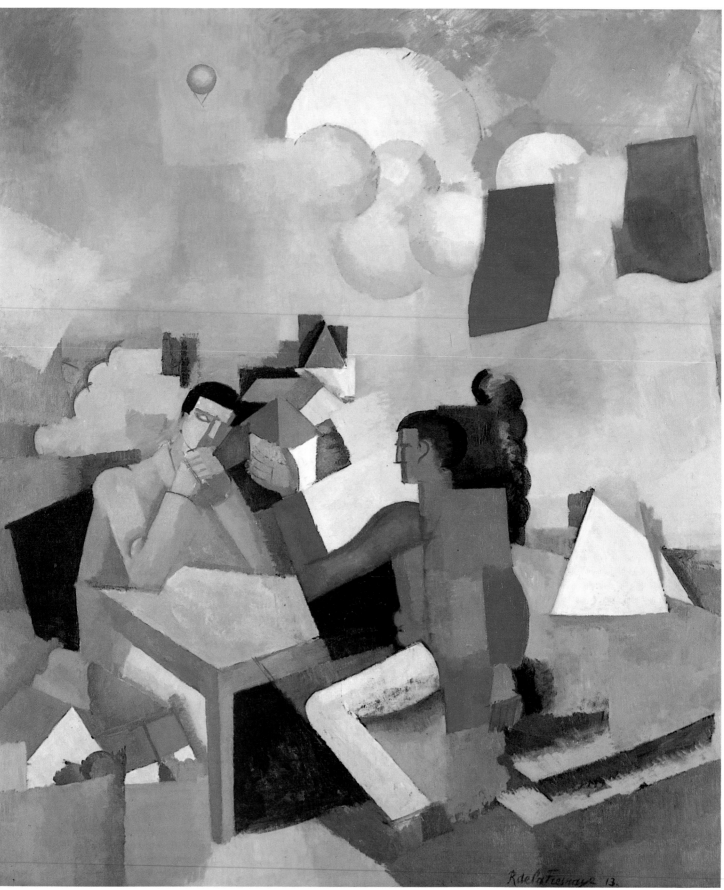

113

113. Roger de La Fresnaye. *The Conquest of the Air.* 1913. Oil on canvas. 7′8⅞″ x 6′5″ (235.9 x 195.6 cm). Mrs. Simon Guggenheim Fund

114. Robert Delaunay. *Simultaneous Contrasts: Sun and Moon.* 1913 (dated on painting 1912). Oil on canvas. 53″ (134.5 cm) diameter. Mrs. Simon Guggenheim Fund

115. Fernand Léger. *Contrast of Forms.* 1913. Oil on canvas. 39½ x 32″ (100.3 x 81.1 cm). The Philip L. Goodwin Collection

114

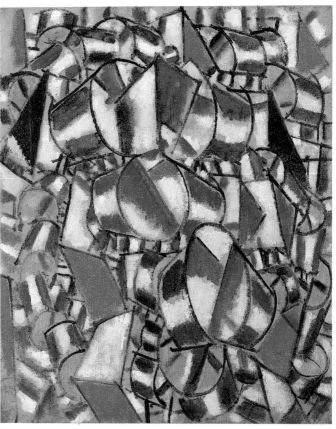

115

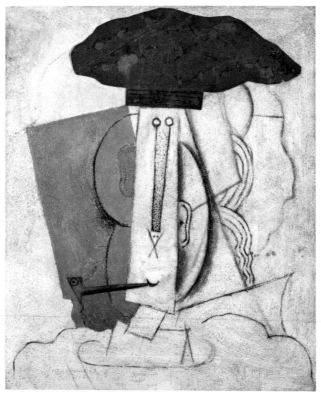

116

116. Pablo Picasso. *Student with Pipe.* 1913–14. Oil, charcoal, pasted paper, and sand on canvas. 28¾ x 23⅛″ (73 x 58.7 cm). Nelson A. Rockefeller Bequest

117. Georges Braque. *Clarinet.* 1913. Pasted papers, charcoal, chalk, and oil on canvas. 37½ x 47⅜″ (95.2 x 120.3 cm). Nelson A. Rockefeller Bequest

118. Pablo Picasso. *Card Player.* 1913–14. Oil on canvas. 42½ x 35¼″ (108 x 89.5 cm). Acquired through the Lillie P. Bliss Bequest

119. Pablo Picasso. *Glass of Absinth.* 1914. Painted bronze with silver sugar strainer. 8½ x 6½″ (21.6 x 16.4 cm), at base 2½″ (6.4 cm) diameter. Gift of Mrs. Bertram Smith

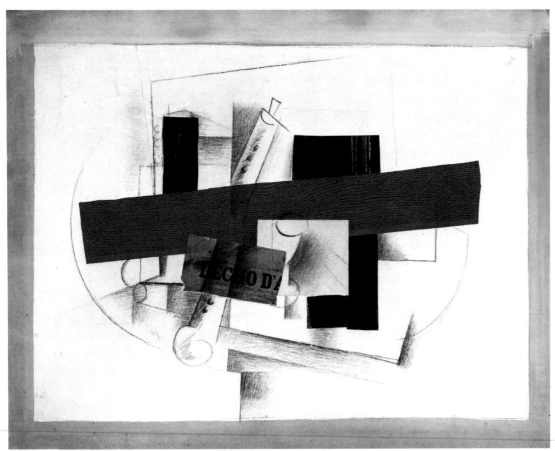

117

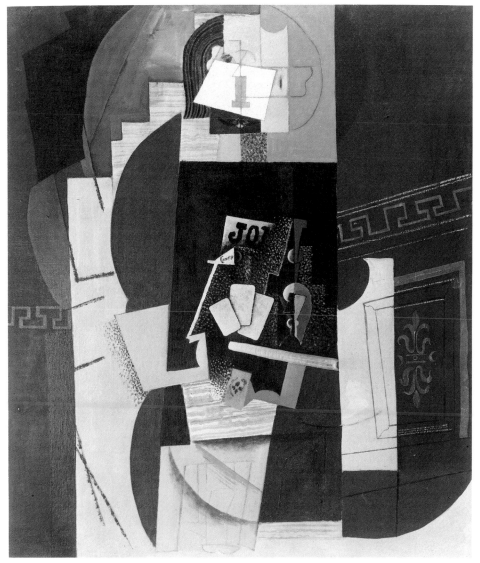

118

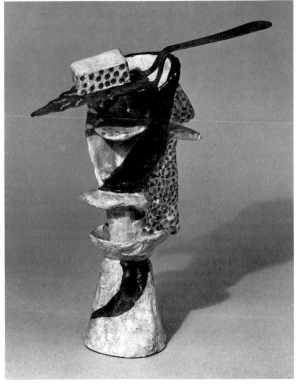

119

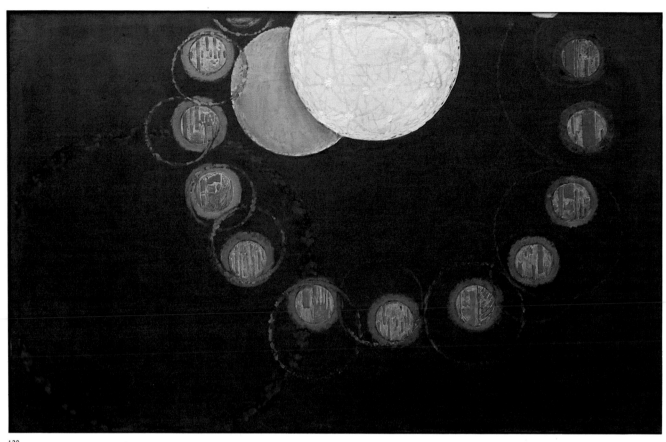

120

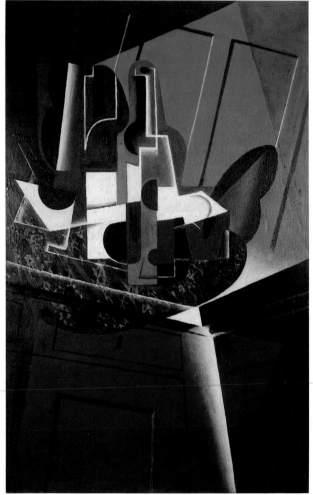

121

120. František Kupka. *The First Step.* 1910–13? (dated on painting 1909). Oil on canvas. 32¾ x 51″ (83.2 x 129.6 cm). Hillman Periodicals Fund

121. Juan Gris. *The Sideboard.* 1917. Oil on plywood. 45⅞ x 28¾″ (116.2 x 93.1 cm). Nelson A. Rockefeller Bequest

By 1912, only a few years after Braque and Picasso had invented the idiom, Gris had developed his own distinctive style of Analytic Cubism. Daniel-Henry Kahnweiler, the pioneer dealer and critic of the major Cubists, described Gris as the "most classical of the Cubists." His highly controlled art was more intellectual and self-conscious than that of Braque and almost totally devoid of the daring, wit, and contradictions of Picasso's Cubism. Here, though there are nuanced passages of both green and russet, the palette and mode of the painting are held in check by its taut and severe geometric order. *The Sideboard,* executed in 1917, has an almost monastic simplicity and asceticism, but it achieves a monumental impact by the reintroduction of perspectival illusion, which gives the monochrome still life, ambiguously floating on its simulated linoleum oval, the effect of towering above us in a shaftlike space. The painting is one of Gris's most unusual and powerful inventions.

122. Vladimir Baranoff-Rossiné. *Symphony Number 1.* 1913. Polychrome wood, cardboard, and crushed eggshells. 63¼ x 28½ x 25″ (161.1 x 72.2 x 63.4 cm). Katia Granoff Fund

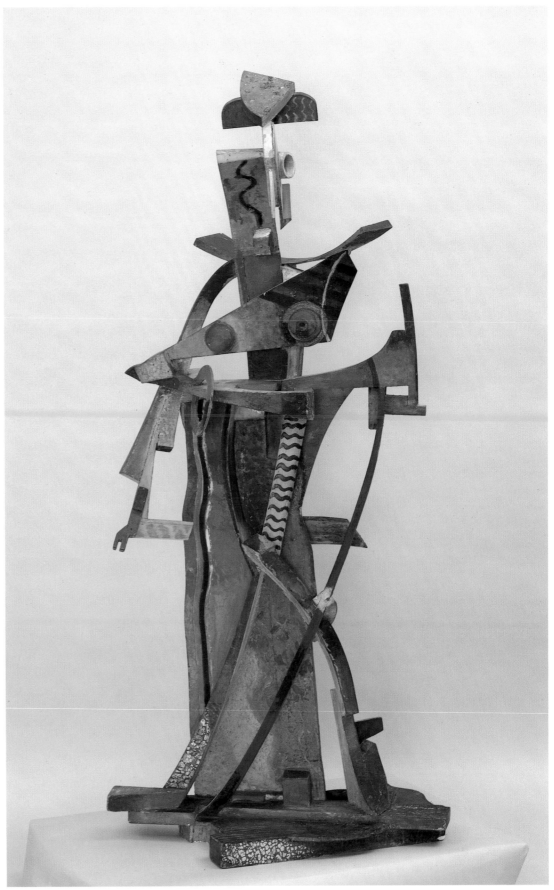

122

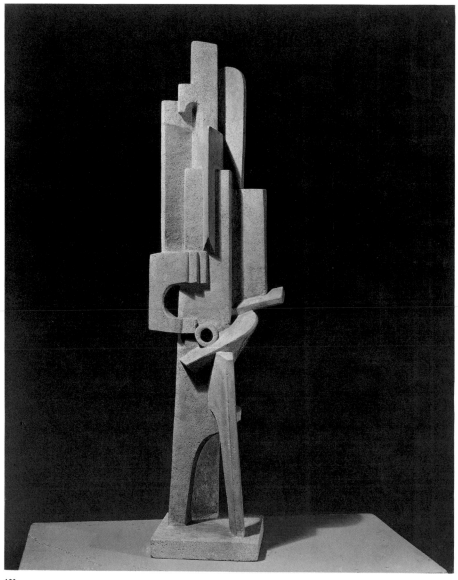

123

123. Jacques Lipchitz. *Man with a Guitar*. 1915. Limestone. 38¼″ (97.2 cm) high, at base 7¾ x 7¾″ (19.7 x 19.7 cm). Mrs. Simon Guggenheim Fund (by exchange)

124. Jacob Epstein. *The Rock Drill*. 1913–14. Bronze (cast 1962). 28 x 26″ (71 x 66 cm), on wood base 12″ (30.5 cm) diameter. Mrs. Simon Guggenheim Fund

125. Raymond Duchamp-Villon. *The Horse*. 1914. Bronze (cast c. 1930–31). 40 x 39½ x 22⅜″ (101.6 x 100.1 x 56.7 cm). Van Gogh Purchase Fund

126. Henri Laurens. *Head*. 1918. Wood construction, painted. 20 x 18¼″ (50.8 x 46.3 cm). Van Gogh Purchase Fund

127. Jacques Lipchitz. *Reclining Nude with Guitar*. 1928. Black marble. 16⅜″ (41.6 cm) high, at base 27⅝ x 13½″ (70.3 x 34.3 cm). Promised gift and extended loan from Mrs. John D. Rockefeller 3rd

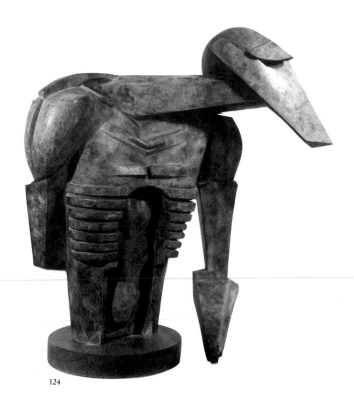

124

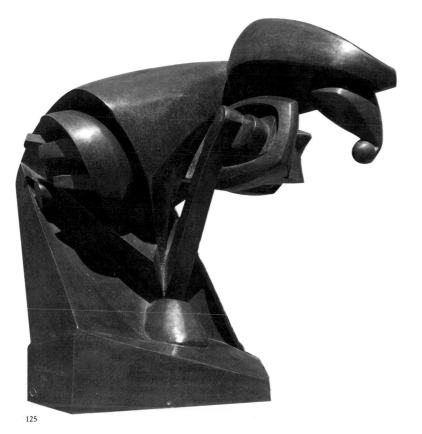

125

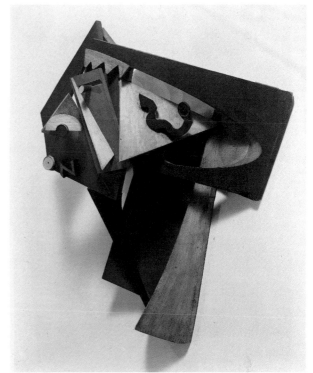

126

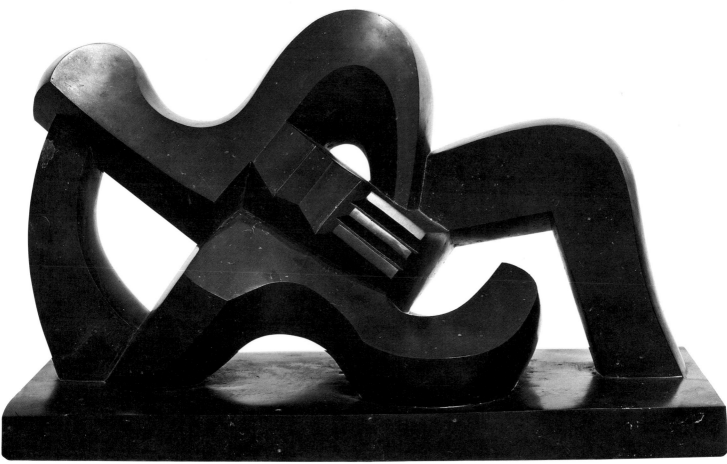

127

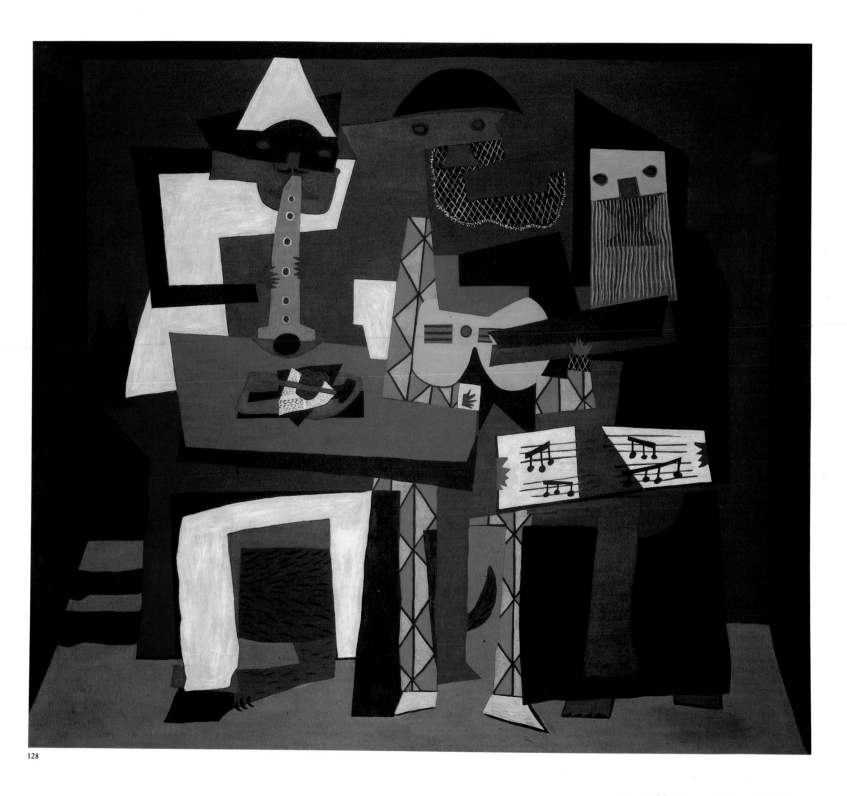

128

128. Pablo Picasso. *Three Musicians.*
1921. Oil on canvas. 6'7" x 7'3¾" (200.7
x 222.9 cm). Mrs. Simon Guggenheim
Fund

This picture constitutes the apogee
of Picasso's Synthetic, or decorative,
Cubism. The carnivalesque figures
recall the iconography of the com-

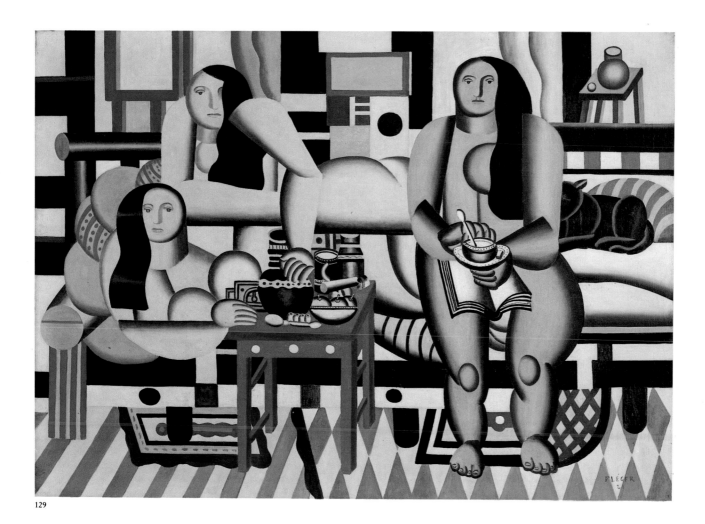

129

media dell'arte, with a Pierrot at the left playing a clarinet; a Harlequin at the center playing a guitar; and a monk at the right, masked like his fellow performers, singing from sheet music in his lap. The figures are presented in a spatial box, or room, the contours of which require our eye to shift from the bright and contrasting colors of the costumes to distinguish subtly nuanced variations of monochromatic brown— the perception of which reveals a dog crouching at the revelers' feet. The flat-out, tripartite simplicity of the presentation is countered by the extraordinary intricacy of a system of interlocking jigsaw-puzzle shapes and colors.

129. Fernand Léger. *Three Women.* 1921. Oil on canvas. 6'¼" x 8'3" (183.5 x 251.5 cm). Mrs. Simon Guggenheim Fund

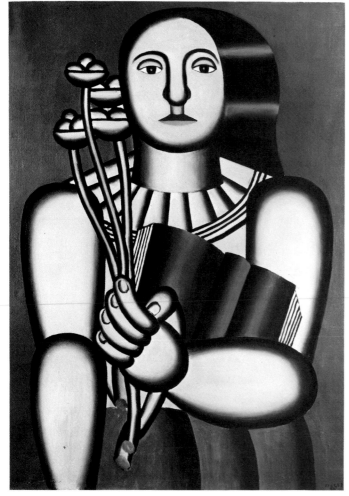

130

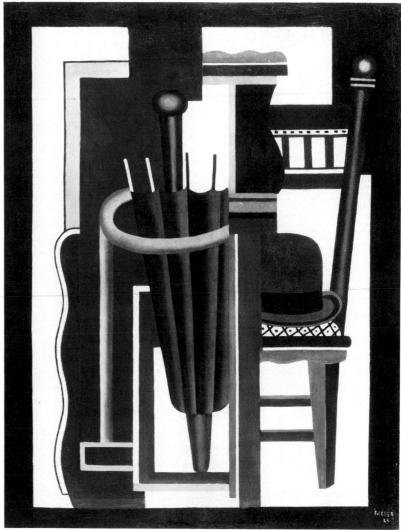

131

130. Fernand Léger. *Woman with a Book*. 1923. Oil on canvas. 45¾ x 32⅛" (116 x 81.4 cm). Nelson A. Rockefeller Bequest

131. Fernand Léger. *Umbrella and Bowler*. 1926. Oil on canvas. 50¼ x 38¾" (130.1 x 98.2 cm). A. Conger Goodyear Fund

132. Le Corbusier (Charles-Édouard Jeanneret). *Still Life*. 1920. Oil on canvas. 31⅞ x 39¼" (80.9 x 99.7 cm). Van Gogh Purchase Fund

133. Amédée Ozenfant. *The Vases*. 1925. Oil on canvas. 51⅜ x 38⅜" (130.5 x 97.5 cm). Acquired through the Lillie P. Bliss Bequest

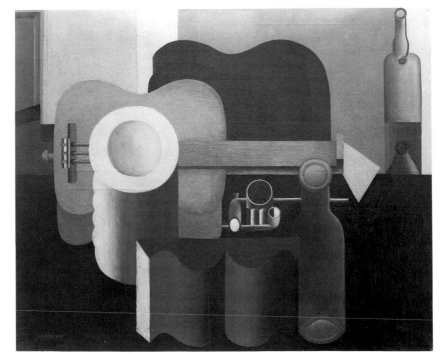

132

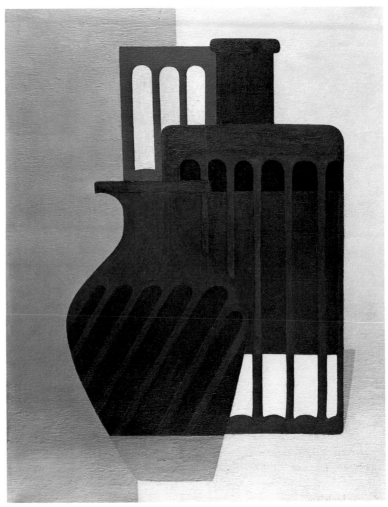

133

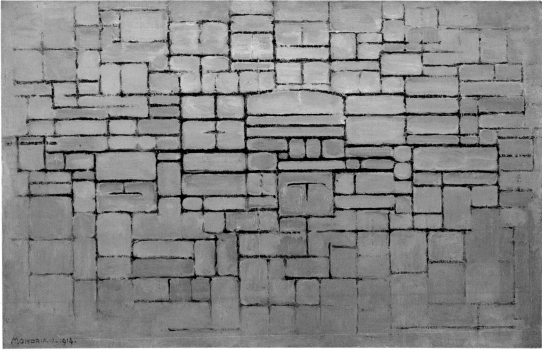

134

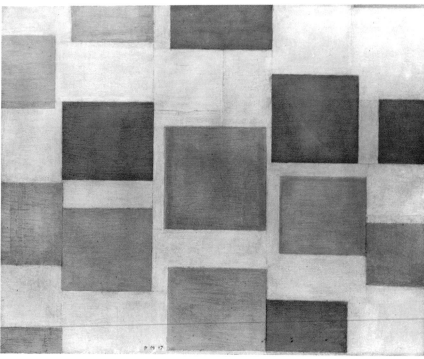

135

134. Piet Mondrian. *Composition, V.* 1914. Oil on canvas. 21⅝ x 33⅝" (54.8 x 85.3 cm). The Sidney and Harriet Janis Collection

During a four-year sojourn in Paris, between 1911 and 1914, Mondrian worked in a modified Cubist manner, but by the end of that time—unlike the pioneer Cubists—he had abandoned even recognizable references to subject matter in favor of a more rectilinear, nonobjective style of his own invention. In *Composition, V* the purist direction his art would take is already clear. The composition retains the Cubist grid and, to a degree, the characteristically limited palette of grays, ochers, and off-whites, but the whites are already being significantly modified by rose and a faint bluish-gray that anticipates the pastel shades of the early de Stijl palette. The composition is elliptically related to a series of church facade pictures that Mondrian executed in Paris from schematic drawings of partially demolished buildings.

135. Piet Mondrian. *Composition with Color Planes, V.* 1917. Oil on canvas. 19⅜ x 24⅛" (49 x 61.2 cm). The Sidney and Harriet Janis Collection

136. Theo van Doesburg (C. E. M. Küpper). *Rhythm of a Russian Dance.* 1918. Oil on canvas. 53½ x 24¼" (135.9 x 61.6 cm). Acquired through the Lillie P. Bliss Bequest

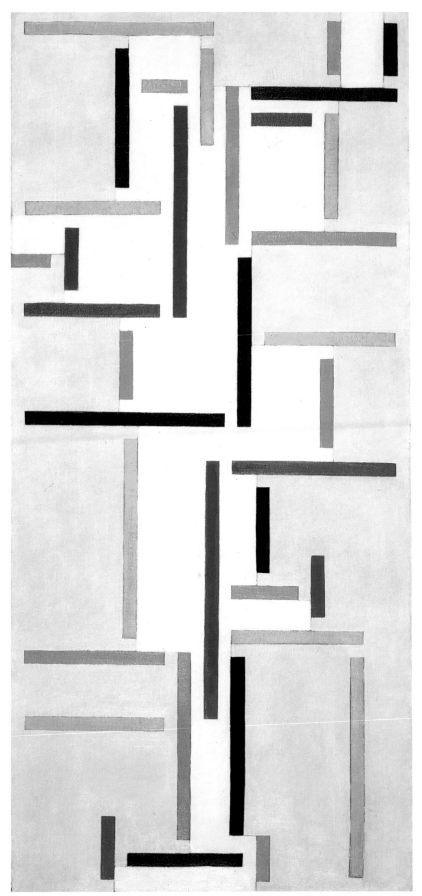

136

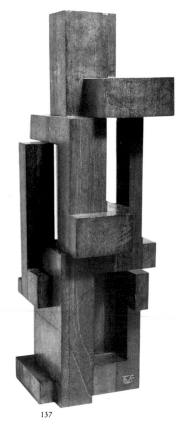

137

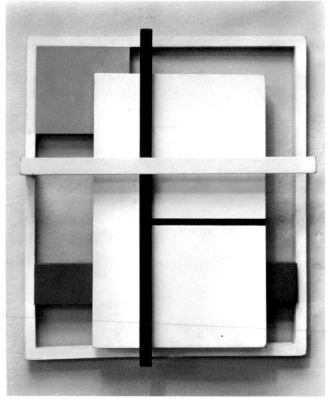

138

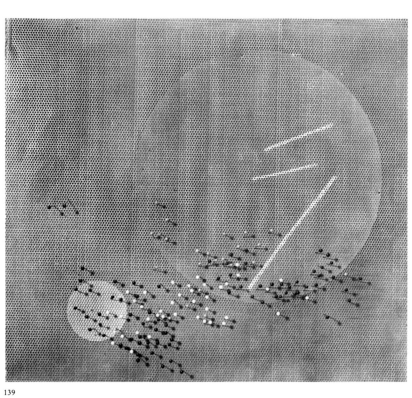

139

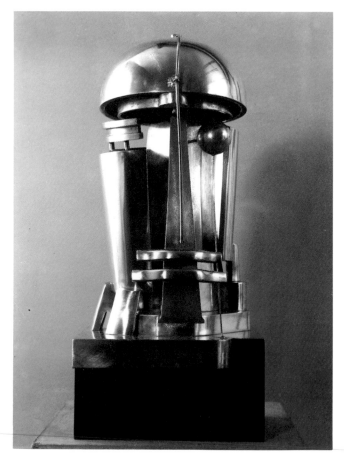

140

137. Georges Vantongerloo. *Construction of Volume Relations.* 1921. Mahogany. 16⅛″ (41 cm) high, at base 4¾ x 4⅛″ (12.1 x 10.3 cm). Gift of Silvia Pizitz

138. Burgoyne Diller. *Construction.* 1938. Painted wood construction. 14⅝ x 12½ x 2⅝″ (37 x 31.9 x 6.7 cm). Gift of Mr. and Mrs. Armand P. Bartos

139. László Moholy-Nagy. *Space Modulator L3.* 1936. Oil on perforated zinc and composition board, with glass-headed pins. 17¼ x 19⅛″ (43.8 x 48.6 cm). Purchase

140. Rudolf Belling. *Sculpture.* 1923. Bronze, partly silvered. 18⅞ x 7¾ x 8½″ (48 x 19.7 x 21.5 cm). A. Conger Goodyear Fund

141. Oskar Schlemmer. *Bauhaus Stairway.* 1932. Oil on canvas. 63⅞ x 45″ (162.3 x 114.3 cm). Gift of Philip Johnson

Schlemmer ran both the theater and ballet workshops at the Bauhaus. He painted its stairway in 1932 from memory in Breslau, three years after he had left the school's faculty, on the basis of some earlier studies. The elegantly tapered, robot-like figures mounting the stairs recall Schlemmer's theater designs, especially his *Triadic Ballet* figures of about 1922.

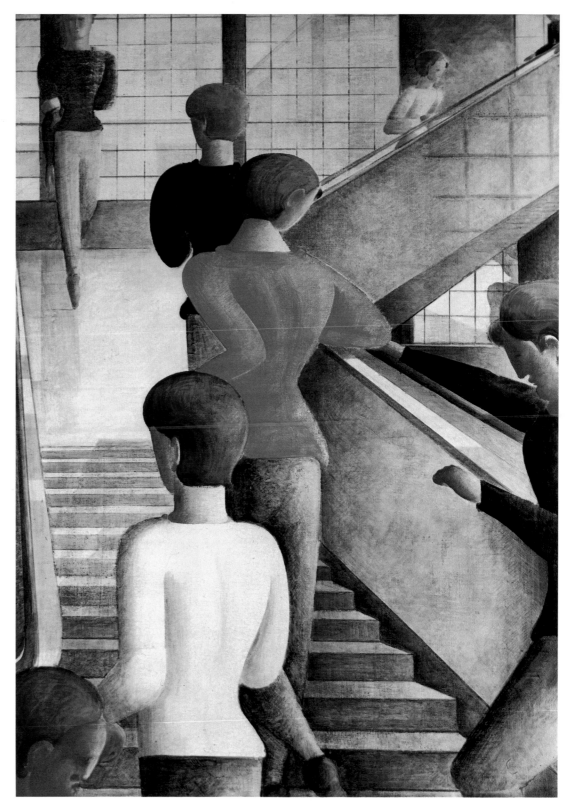

141

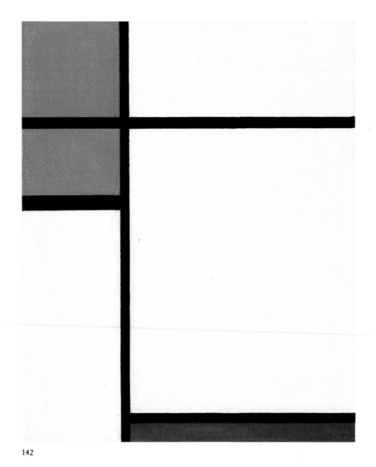

142

142. Piet Mondrian. *Composition*. 1933. Oil on canvas. 16¼ x 13⅛" (41.2 x 33.3 cm). The Sidney and Harriet Janis Collection

143. Theo van Doesburg (C. E. M. Küpper). *Simultaneous Counter-Composition*. 1929–30. Oil on canvas. 19¾ x 19⅝" (50.1 x 49.8 cm). The Sidney and Harriet Janis Collection

144. Piet Mondrian. *Broadway Boogie Woogie*. 1942–43. Oil on canvas. 50 x 50" (127 x 127 cm). Given anonymously

Mondrian's last completed painting, *Broadway Boogie Woogie*, was made in New York during World War II. With it he came very close to achieving one of his lifelong ambitions, the expression of a disembodied, pure rhythm in painting. With its multitude of small, staccato accents, the picture appears far more impressionistic than anything he had done in the intervening years and suggests the character of New York as surely as his Cubist essays reflected the scale, morphology, and atmosphere of Paris. In relation to his imposing achievement of the twenties and thirties, it is to Mondrian's great credit that he was willing to embark on radical new experiments at the very end of his life. He could easily have exploited his earlier solutions, or continued to work within the proven formula of his black-and-white grids and primary colors.

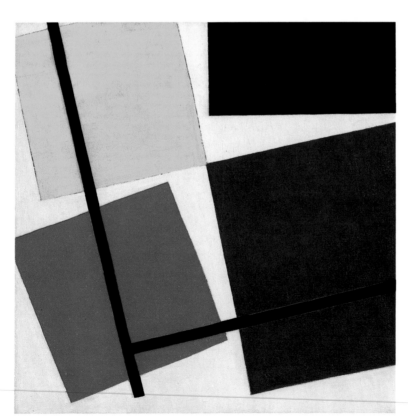

143

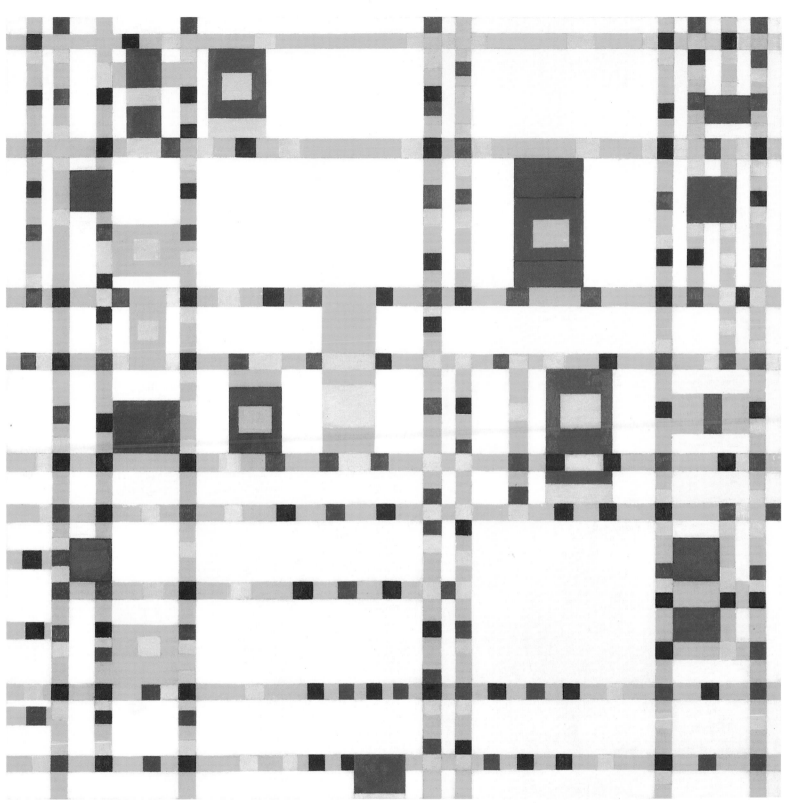

144

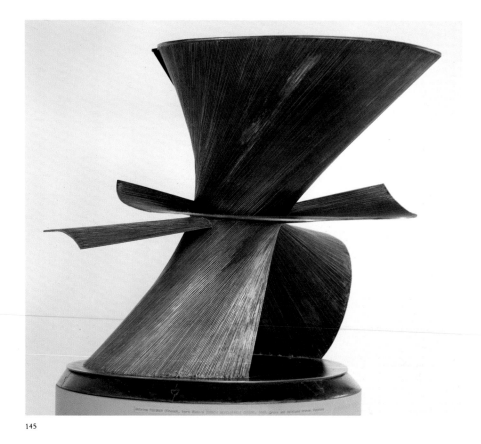

145

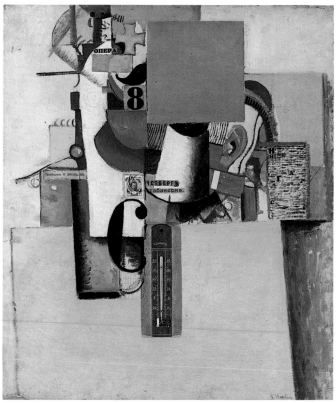

146

147

145. Antoine Pevsner. *Developable Column.* 1942. Brass and oxidized bronze. 20¾" (52.7 cm) high, at base 19⅜" (49.2 cm) diameter. Purchase

Developable Column is a complex organization of curved planes and spaces based on an Einsteinian concept of space-time. Bundles of bronze rods organized in curving sheets define the complicated, intricately interacting planes. Both light, reflected from the metal surfaces, and space play major roles in the total form. The motif of a developing shape relates to ideas of growth and generation, as this architectural form is pulled and twisted into a continuous spatial projection.

146. Kasimir Malevich. *Private of the First Division.* 1914. Oil on canvas with collage of postage stamp, thermometer, etc. 21⅛ x 17⅜" (53.7 x 44.8 cm)

147. Mikhail Larionov. *Rayonist Composition: Domination of Red.* 1912–13 (dated on painting 1911). Oil on canvas. 20¾ x 28½" (52.7 x 72.4 cm). Gift of the artist

148. Kasimir Malevich. *Suprematist Composition: Airplane Flying.* 1914. Oil on canvas. 22⅞ x 19" (58.1 x 48.3 cm). Purchase

Malevich's totally abstract painting is composed of red, black, blue, and yellow rectangles and trapezoids. These simple geometric figures are arranged on a diagonal from lower right to upper left, except for the two counterpoised red bars, one of which intersects the large yellow rectangle, creating an effect suggestive of both flight and spatial depth in its diminished scale. In his eloquent and ecstatic theoretical writing Malevich identified flight—liberation in space— with a release from natural, earthbound existence. For Malevich such forms and sensations symbolized certain philosophical absolutes, plastic relationships, and the spiritual values of a new society, all simultaneously. Although his vocabulary of forms has now become part of a familiar empirical language of international abstract art devoid of philosophical meanings, it was viewed by Malevich in his own time in a different light, as a key to universal knowledge and freedom from the material world.

149. Kasimir Malevich. *Suprematist Composition: White on White.* 1918? Oil on canvas. 31¼ x 31¼" (79.4 x 79.4 cm)

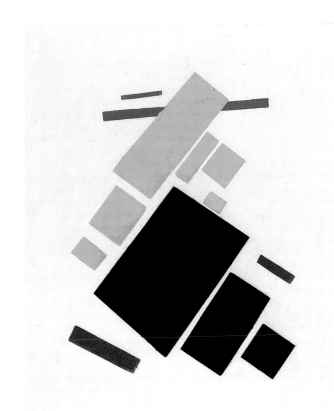

148

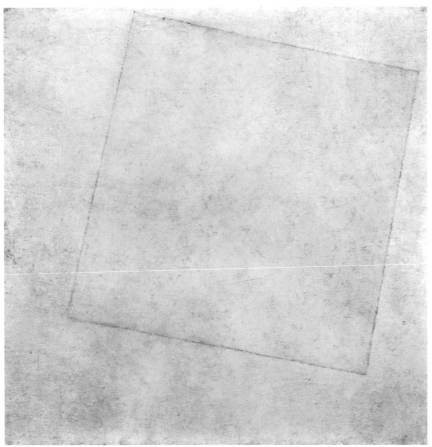

149

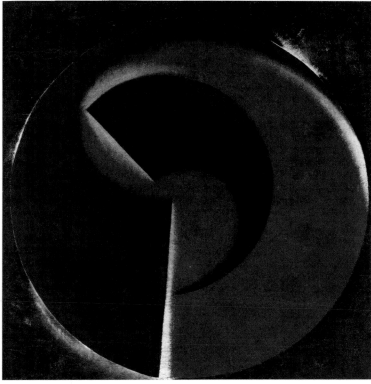

150

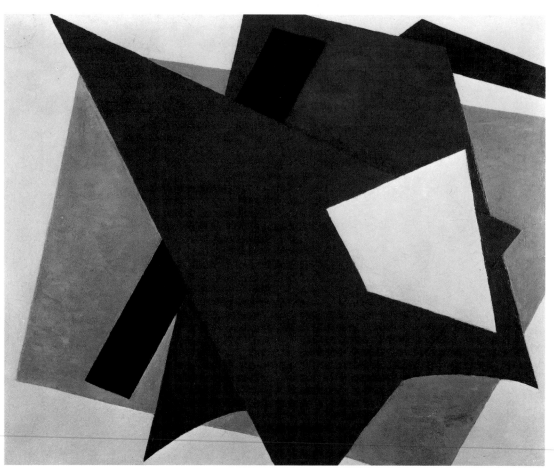

151

150. Alexander Rodchenko. *Non-objective Painting: Black on Black.* 1918. Oil on canvas. 32¼ x 31¼" (81.9 x 79.4 cm). Gift of the artist, through Jay Leyda

151. Lyubov Sergeievna Popova. *Architectonic Painting.* 1917. Oil on canvas. 31½ x 38⅝" (80 x 98 cm). Philip Johnson Fund

152. Naum Gabo. *Head of a Woman.* c. 1917–20 (after a work of 1916). Construction in celluloid and metal. 24½ x 19¼" (62.2 x 48.9 cm). Purchase

Gabo's *Head of a Woman* is an early excursion into abstract form using unorthodox plastic material and an original space definition. Open and closed forms are simultaneously presented by means of a series of connected abstract planes that synthesize into a stereometric image. The construction was heavily influenced by the intersecting and transparent planes of Analytic Cubism, whose color and luminosity are literalized in the brownish plastic.

153. El Lissitzky (Lazar Markovich Lissitzky). *Proun 19D.* 1922? Gesso, oil, collage, etc., on plywood. 38⅜ x 38¼" (97.5 x 97.2 cm). Katherine S. Dreier Bequest

154. Gustav Klutsis. *Radio Announcer* (Maquette for Street Kiosk). 1922. Construction of wood, cardboard, paper, paint, string, and metal brads. 42 x 14¼ x 14¼" (106.5 x 36 x 36 cm). Sidney and Harriet Janis Collection Fund

This construction-sculpture is a maquette for one of Klutsis's "radio announcers," or "screen-tribune-radio-kiosks," developed in 1922 for the Fifth Anniversary of the Russian Revolution and the Fourth Congress of the Comintern. These Constructivist propaganda kiosks were designed to be placed at main intersections for the radio transmission of Lenin's speech of 1922. Formally, the work embodies all of the principal characteristics of Constructivist work in three dimensions. It is a composite of geometric panels, "architectural" supports, and gaily painted loudspeakers, assembled by

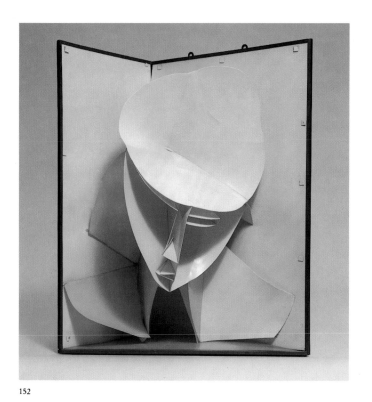

152

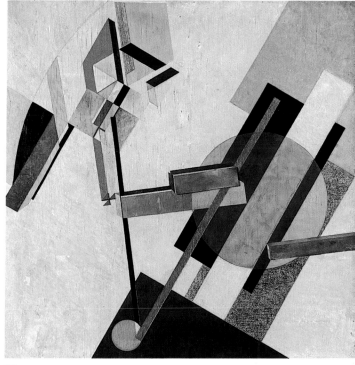

153

means of tension cables which hold the construction together. This piece is not only one of the best examples of Klutsis's work, but also one of the rare original constructions surviving from this period, and the first such three-dimensional work to enter the Museum's collection.

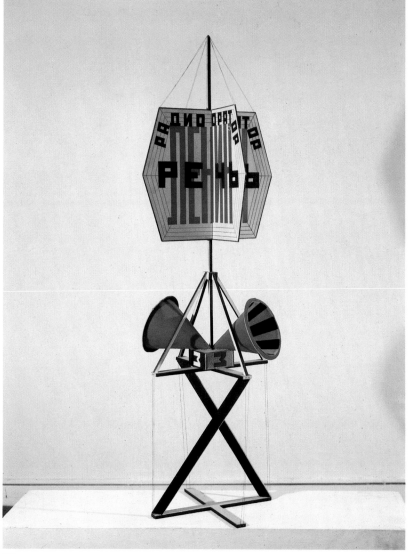

154

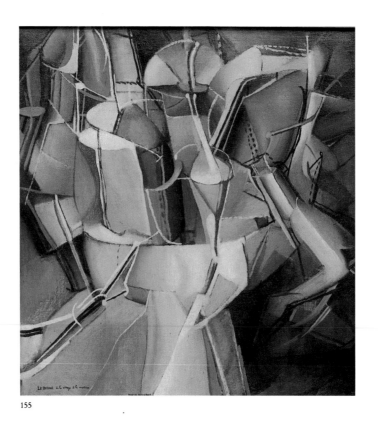

155

155. Marcel Duchamp. *The Passage from Virgin to Bride*. 1912. Oil on canvas. 23⅜ x 21¼" (59.4 x 54 cm). Purchase

While accepting the space, shading, and monochromy of high Analytic Cubism, Duchamp began in this picture a reversal of Cubist propositions that would eventually lead him to create Dada (years before that movement got a name) and finally cause him virtually to cease art-making in any form. In place of the stable "architectural" forms of Cubism, he introduced organic forms that suggest an internalizing vision of the human figure, even to the pink, membranous surfaces he favors. These reversals are entirely logical insofar as, unlike the Cubists, he was concerned with an event in time: the moment of a young lady's defloration.

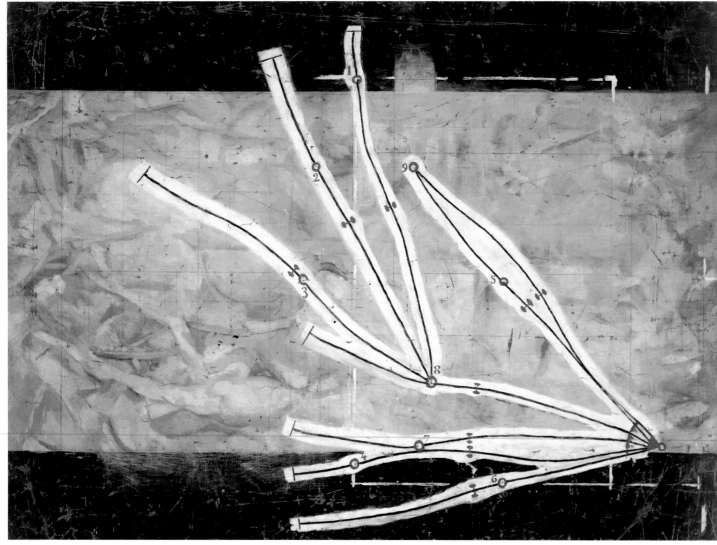

156. Marcel Duchamp. *Network of Stoppages*. 1914. Oil and pencil on canvas. 58⅝" x 6'5⅝" (148.9 x 197.7 cm). Abby Aldrich Rockefeller Fund and gift of Mrs. William Sisler

157. Marcel Duchamp. *To Be Looked At (From the Other Side of the Glass) with One Eye, Close To, for Almost an Hour.* 1918. Oil paint, silver leaf, lead wire, and magnifying lens on glass (cracked). 19½ x 15⅝" (49.5 x 39.7 cm), mounted between two panes of glass in a standing metal frame 20⅛ x 16¼ x 1½" (51 x 41.2 x 3.7 cm), on painted wood base 1⅞ x 17⅞ x 4½" (4.8 x 45.3 x 11.4 cm); overall 22" (55.8 cm) high. Katherine S. Dreier Bequest

158. Marcel Duchamp. *Fresh Widow.* 1920. Miniature French window, painted wood frame, and eight panes of glass covered with black leather. 30½ x 17⅝" (77.5 x 44.8 cm), on wood sill ¾ x 21 x 4" (1.9 x 53.4 x 10.2 cm). Katherine S. Dreier Bequest

159. Marcel Duchamp. *Bicycle Wheel.* 1951 (third version, after lost original of 1913). Assemblage. Metal wheel 25½" (63.8 cm) diameter, mounted on painted wood stool 23¾" (60.2 cm) high; overall 50½" (128.3 cm) high. The Sidney and Harriet Janis Collection

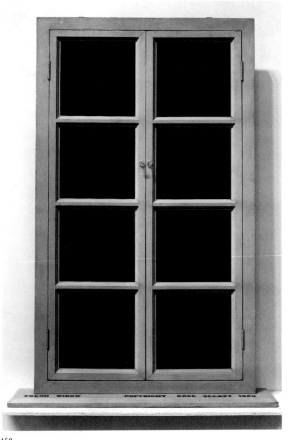

157

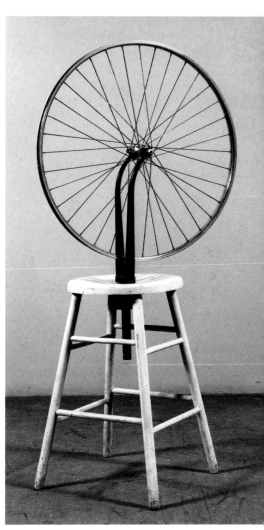

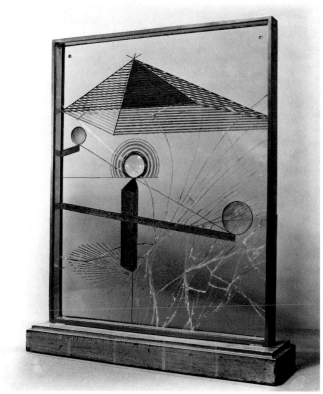

158

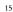

159

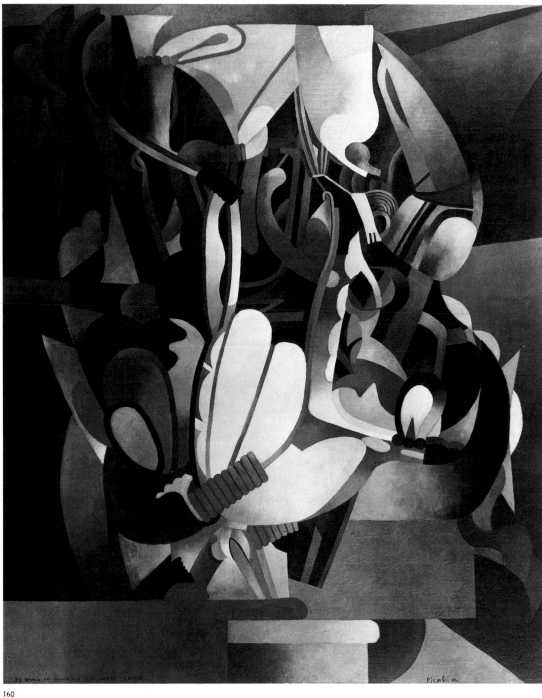

160

160. Francis Picabia. *I See Again in Memory My Dear Udnie.* 1914 (perhaps begun 1913). Oil on canvas. 8'2½" x 6'6¼" (250.2 x 198.8 cm). Hillman Periodicals Fund

161. Francis Picabia. *M'Amenez-y.* 1919–20. Oil on cardboard. 50¾ x 35⅜" (129.2 x 89.8 cm). Helena Rubinstein Fund

162. Man Ray. *Cadeau [Gift].* c. 1958 (replica of 1921 original). Painted flatiron with row of thirteen tacks, heads glued to bottom. 6⅛ x 3⅝ x 4½" (15.3 x 9 x 11.4 cm). James Thrall Soby Fund

163. Man Ray. *The Rope Dancer Accompanies Herself with Her Shadows.* 1916. Oil on canvas. 52" x 6'1⅜" (132.1 x 186.4 cm). Gift of G. David Thompson

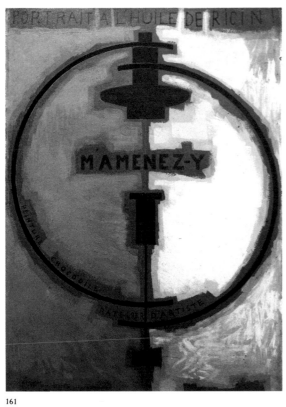

161

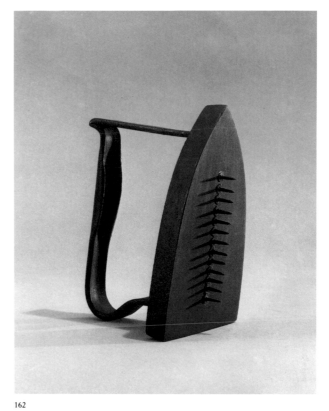

162

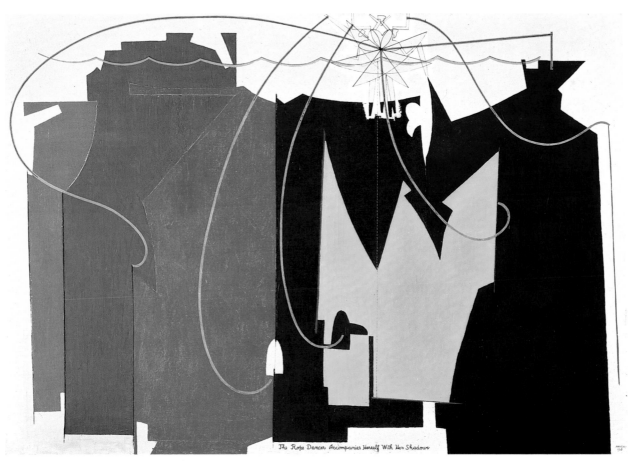

163

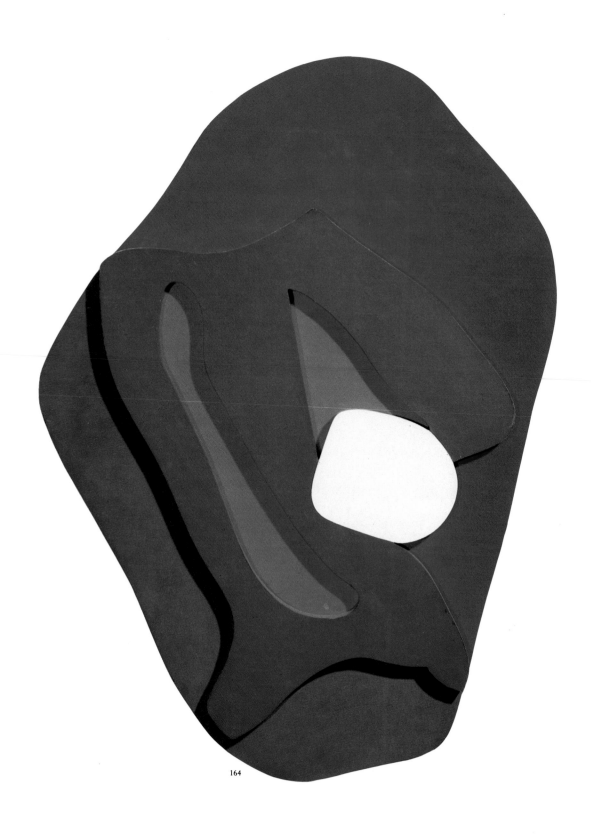

164

164. Jean (Hans) Arp. *Enak's Tears (Terrestrial Forms)*. 1917. Painted wood relief. 34 x 23⅛ x 2⅜" (86.2 x 58.5 x 6 cm). Benjamin Scharps and David Scharps Fund and purchase

In polychrome wood reliefs such as this, Arp was the first to utilize "biomorphic" forms suggesting kidney and amoeba-like shapes to establish a new, counter-Cubist form-language. These organic shapes soon came to represent the most credible alternative to Cubist and Constructivist geometry and inspired artists of the next three decades, from Miró to Gorky.

165. Jean (Hans) Arp. *Mountain, Table, Anchors, Navel*. 1925. Oil on cardboard with cutouts. 29⅝ x 23½" (75.2 x 59.7 cm). Purchase

166. Jean (Hans) Arp. *Bell and Navels*. 1931. Painted wood. 10" (25.4 cm) high, including wood base 1⅝" high x 19⅜" diameter (4.2 x 49.3 cm). Kay Sage Tanguy Fund

167. Jean (Hans) Arp. *Human Concretion*. 1935. Original plaster. 19½ x 18¾" (49.5 x 47.6 cm). Gift of the Advisory Committee

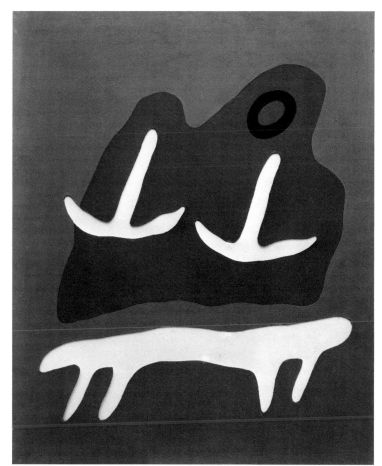

165

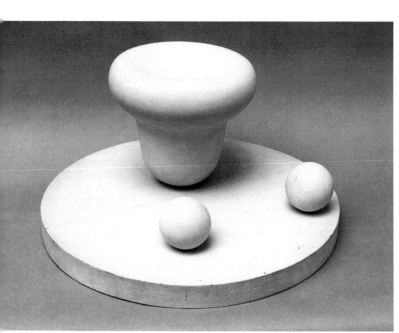

166

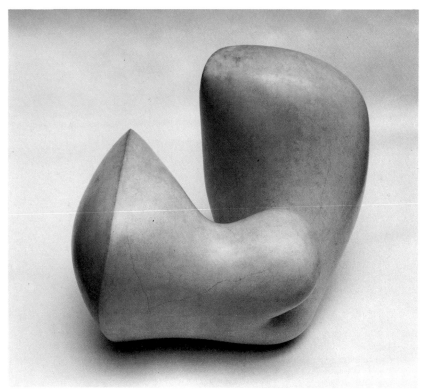

167

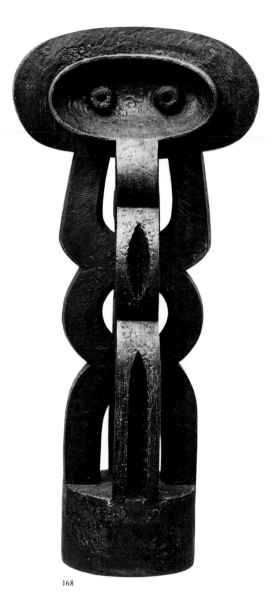

168

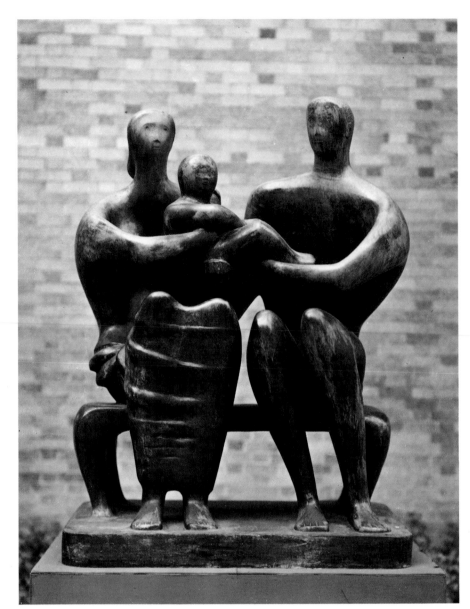

169

168. Jacques Lipchitz. *Figure.* 1926–30. Bronze (cast 1937). 7'1¼" x 38⅝" (216.6 x 98.1 cm). Van Gogh Purchase Fund

169. Henry Moore. *Family Group.* 1948–49. Bronze (cast 1950). 59¼ x 46½" (150.5 x 118 cm), at base 45 x 29⅞" (114.3 x 75.9 cm). A. Conger Goodyear Fund

170. Kurt Schwitters. *Revolving.* 1919. Relief construction of wood, metal, cord, cardboard, wool, wire, leather, and oil on canvas. 48⅜ x 35" (122.7 x 88.7 cm). Advisory Committee Fund

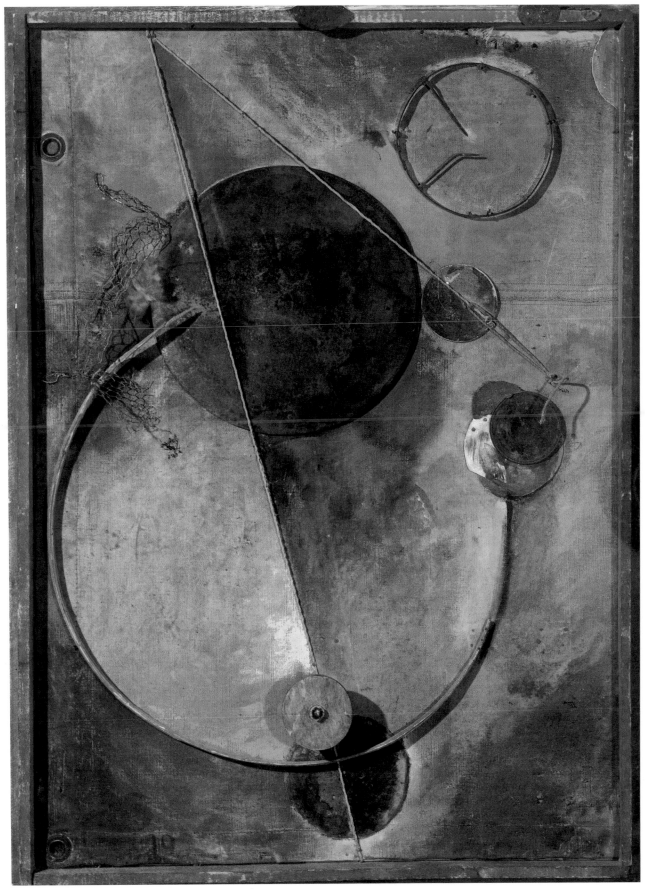

170

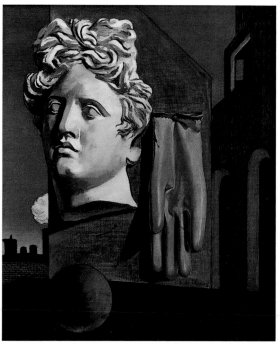

171. Giorgio de Chirico. *The Song of Love.* 1914. Oil on canvas. 28¾ x 23⅜" (73 x 59.1 cm). Nelson A. Rockefeller Bequest

The green croquet ball, fragmentary plaster cast of the Apollo Belvedere, and surgeon's rubber glove set against a background that includes a puffing locomotive and shadowed arcade constitute, as William Rubin has observed, virtually a "symbolic autobiography." While these oneiric images have been interpreted psychologically as signs of the unconscious, and culturally as a confrontation of the heroic past and a mechanistic present, the artist insisted on the visionary meanings of his enigmatic ciphers. For de Chirico they revealed a metaphysical presence in the object world which constituted a second level of existence.

171

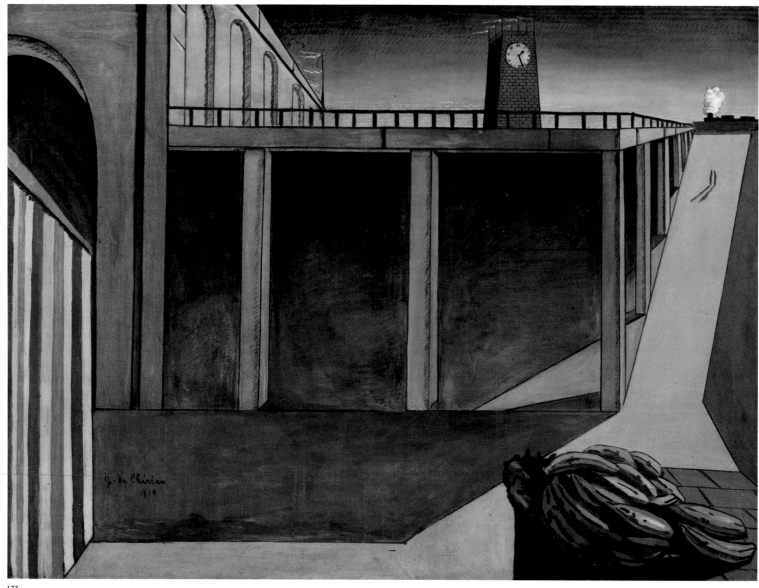

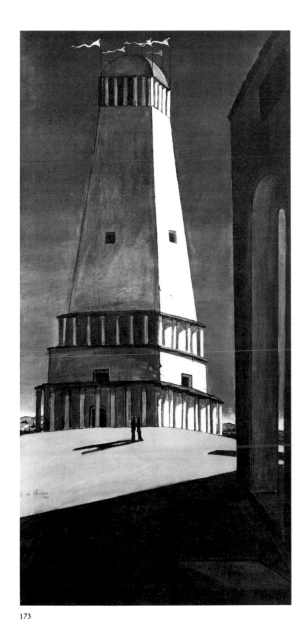

173

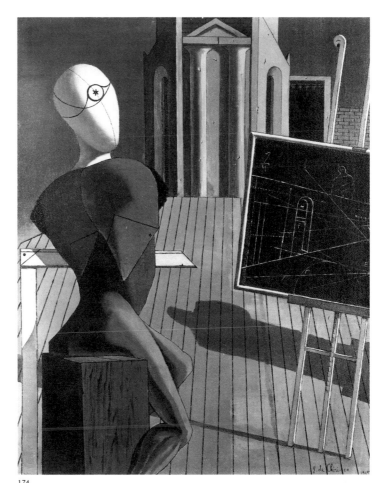

174

172. Giorgio de Chirico. *Gare Montparnasse (The Melancholy of Departure)*. 1914. Oil on canvas. 55⅛" x 6'⅝" (140 x 184.5 cm). James Thrall Soby Bequest

173. Giorgio de Chirico. *The Nostalgia of the Infinite*. 1913–14? (dated on painting 1911). Oil on canvas. 53¼ x 25½" (135.2 x 64.8 cm). Purchase

174. Giorgio de Chirico. *The Seer.* 1915. Oil on canvas. 35½ x 27⅝" (89.6 x 70.1 cm). James Thrall Soby Bequest

175

176

175. Max Ernst. *Two Children Are Threatened by a Nightingale*. 1924. Oil on wood with wood construction. 27½ x 22½ x 4½" (69.8 x 57.1 x 11.4 cm). Purchase

176. Joan Miró. *The Hunter (Catalan Landscape)*. 1923–24. Oil on canvas. 25½ x 39½" (64.8 x 100.3 cm). Purchase

177. Joan Miró. *The Birth of the World*. 1925. Oil on canvas. 8'2¾" x 6'6¾" (250.8 x 200 cm). Acquired through an Anonymous Fund, the Mr. and Mrs. Joseph Slifka and Armand G. Erpf Funds, and by gift of the artist

No other painting made before World War II so clearly anticipates Abstract Expressionism; indeed, André Breton, Surrealism's founder, was to label it "the *Demoiselles d'Avignon* of the '*informel*,'" the latter being the European counterpart of American painting of the fifties. In this picture, Miró used a new method that involved improvisational as well as tightly controlled brushwork, the spilling of thinned-out liquid paint and its blotting with rags, in tandem with "automatic" drawing. Miró has spoken of the picture as "a sort of genesis," and it is one of the first of many Surrealist pictures that would deal metaphorically with the act of artistic creation through an image of the creation of the universe. Miró began his improvisation with the empty canvas—the "void." This was followed by a "chaos" of stains and spots; these, in turn, suggested other forms to him. "One large portion of black in the upper left seemed to need to become bigger," Miró recounted. "I enlarged it and went over it with opaque black paint. It became a triangle to which I added a tail. It might be a bird." The need for an accent of red on the right led Miró to make the precisely painted disk with its yellow streamer, which he later identified as a shooting star. The "personage" with a white head, whose right foot almost touches a spider-like black star, was the last motif to be introduced into this poetically conceived universe.

177

178

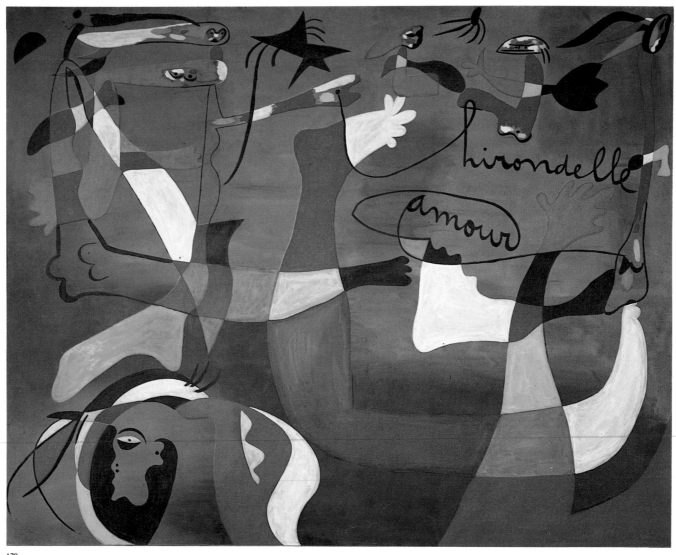

179

178. Joan Miró. *Dutch Interior, I*. 1928. Oil on canvas. 36⅛ x 28¾" (91.8 x 73 cm). Mrs. Simon Guggenheim Fund

179. Joan Miró. *Hirondelle/Amour.* 1933–34. Oil on canvas. 6'6½" x 8'1½" (199.3 x 247.6 cm). Gift of Nelson A. Rockefeller

180. Joan Miró. *Object*. 1936. Assemblage: stuffed parrot on wood perch, stuffed silk stocking with velvet garter and doll's paper shoe suspended in a hollow wood frame, derby hat, hanging cork ball, celluloid fish, and engraved map. 31⅞ x 11⅞ x 10¼" (81 x 30.1 x 26 cm). Gift of Mr. and Mrs. Pierre Matisse

181. Joan Miró. *Self-Portrait*. 1937–38. Pencil, crayon, and oil on canvas. 57½ x 38¼" (146 x 97 cm). James Thrall Soby Bequest

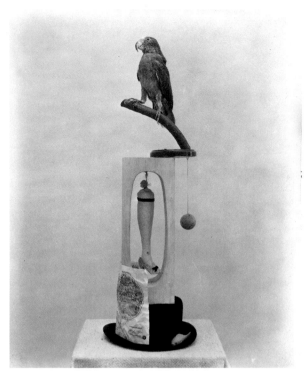

180

181

182

182. André Masson. *Battle of Fishes.* 1926. Sand, gesso, oil, pencil, and charcoal on canvas. 14¼ x 28¾″ (36.2 x 73 cm). Purchase

This is the first of Masson's prophetic series of sand paintings of 1926–27 in which he developed a technique—extrapolated from his practice of automatic drawing—in which paint was applied directly from the tube, glue poured in patches and lines over the surface of the canvas, and sand sprinkled onto the areas of glue. Thus liberated from "the element of resistance represented by the canvas and the preparation of colors," Masson anticipated, albeit in miniature, the later work of Pollock. *Battle of Fishes* established the locus for all of Masson's subsequent sand paintings. Although the human figure is prominent in more than half of the paintings of this series, each is nonetheless

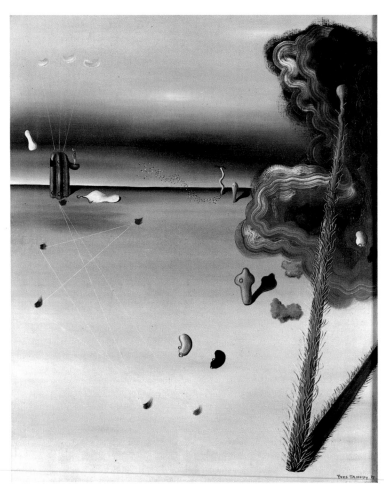

183

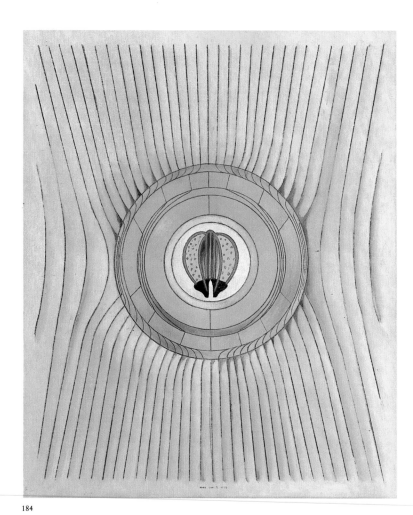

184

unmistakably a marine landscape, poetically equating depiction with physical substance. Conflict is central in nearly all of these works, and their imagery is based on Masson's desire to uncover a kind of primordial eroticism.

183. Yves Tanguy. *Mama, Papa is Wounded!* 1927. Oil on canvas. 36¼ x 28¾" (92.1 x 73 cm). Purchase

After seeing a painting by de Chirico that deeply moved him, Tanguy painted this picture in which some aspects of de Chirico's dream theater are realized in a more academic mode. It represents a visionary recreation of some desolate desert plateau, or ocean floor, where substances are confused and mingled. There are obvious Freudian allusions in the hairy membranous pole, at right, with its bulbous tip and its elongated Chiricoesque shadow. Tanguy's self-taught, academically illusionist style, which reminds one of certain Salon painters of the nineteenth century, may be interpreted as a form of "primitivism," hence revolt, given the pictorial context of modernism. But this "subversive" handling was nevertheless put in the service of a biomorphic form-language borrowed from Arp that is resolutely modern in character.

184. Max Ernst. *The Blind Swimmer.* 1934. Oil on canvas. 36⅜ x 29" (92.3 x 73.5 cm). Gift of Mrs. Pierre Matisse and the Helena Rubinstein Fund

185. Max Ernst. *Lunar Asparagus.* 1935. Plaster. 65¼" (165.7 cm) high. Purchase

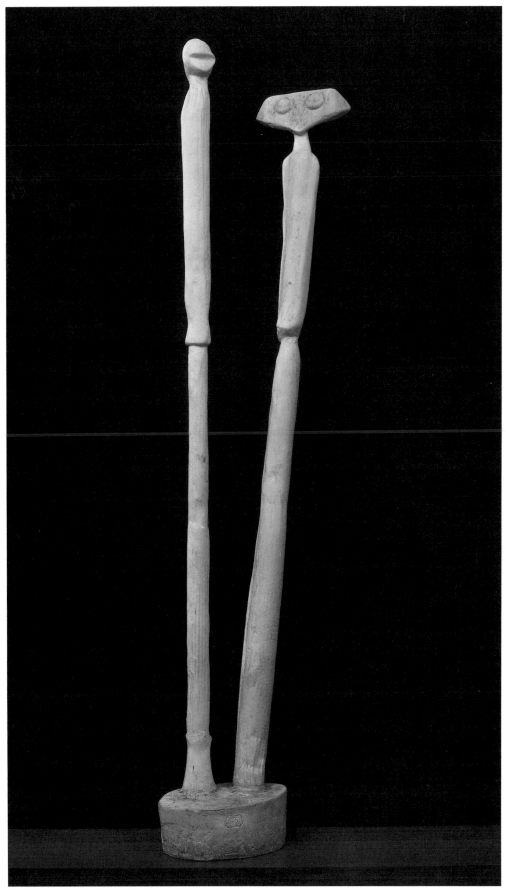

185

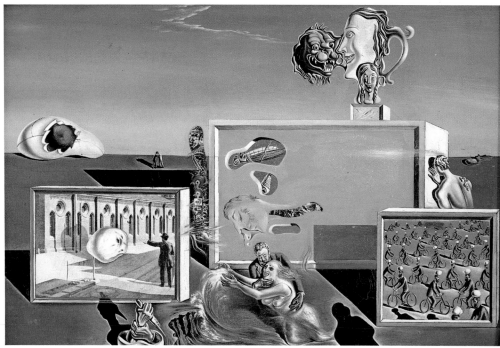

186

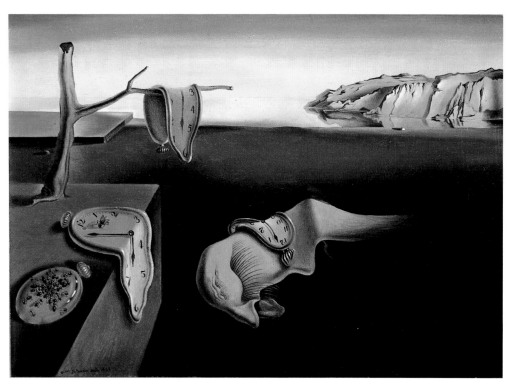

187

186. Salvador Dali. *Illumined Pleasures.* 1929. Oil and collage on composition board. 9⅜ x 13¾" (23.8 x 34.7 cm). The Sidney and Harriet Janis Collection

187. Salvador Dali. *The Persistence of Memory.* 1931. Oil on canvas. 9½ x 13" (24.1 x 33 cm). Given anonymously

Here Dali presents an illogical dreamlike scenario of soft watches, arid landscape, and a slumbering fetal monster that he has identified as a self-portrait. The limp timepieces, both jewel-like and putrescent, reveal the contradictions in material states that the Surrealist exploited to baffle the public. At their best, such paintings encapsulated the anxieties, obsessive eroticism, and magic of a vivid and confounding dream imagery.

188. René Magritte. *The Menaced Assassin.* 1926. Oil on canvas. 59¼" x 6'4⅞" (150.4 x 195.2 cm). Kay Sage Tanguy Fund

189. René Magritte. *The False Mirror.* 1928. Oil on canvas. 21¼ x 31⅞" (54 x 80.9 cm). Purchase

Previously an accomplished abstract painter, Magritte was led to alter his art by a fortuitous encounter with the work of de Chirico that was further abetted by a visit to the Surrealists in Paris. He then began to project visual conundrums and puns in a scrupulously exact and "banal" technique. *The False Mirror* confounds inner vision with the external environment by locating its cloudscape within the eye, thus preserving the Surrealist faith in the "omnipotence of dreams" and the human image-making faculty, which in this case usurps the facts of the real world. It joins what Leonardo noted as the "clarity" with which we see things in dreams with a boldness and simplicity held over from Magritte's abstract paintings.

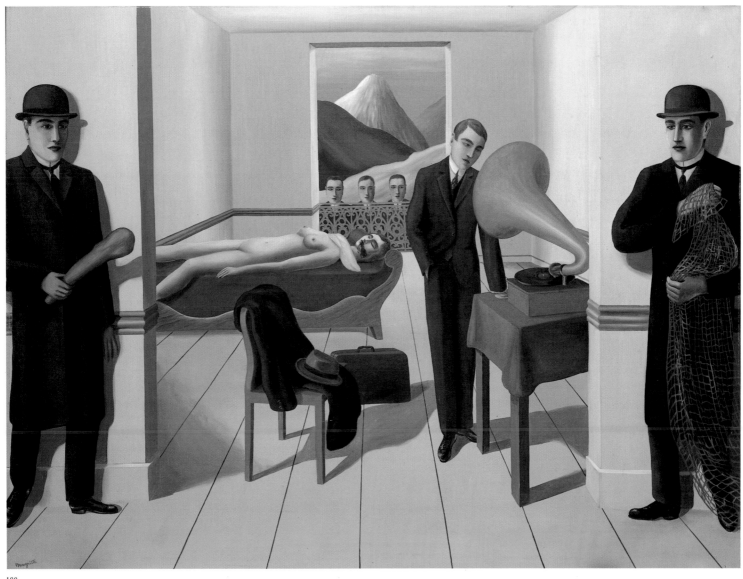

188

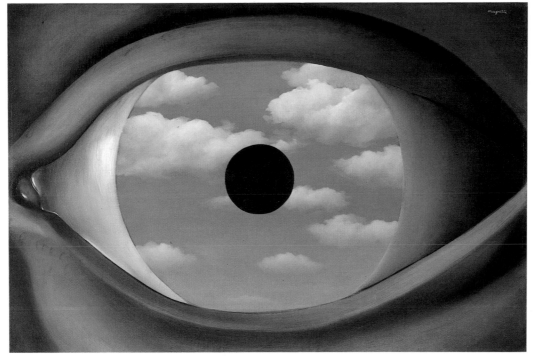

189

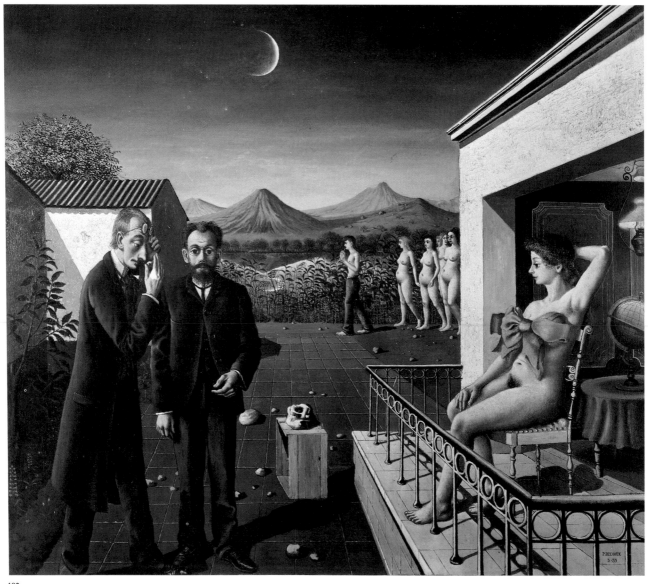

190

191

190. Paul Delvaux. *Phases of the Moon*. 1939. Oil on canvas. 55 x 63" (139.7 x 160 cm). Purchase

191. Meret Oppenheim. *Object*. 1936. Fur-covered cup, saucer, and spoon. Cup 4⅜" (10.9 cm) diameter, saucer 9⅜" (23.7 cm) diameter, spoon 8" (20.2 cm) long; overall 2⅞" (7.3 cm) high. Purchase

192. Hans Bellmer. *The Machine-Gunneress in a State of Grace*. 1937. Construction of wood and metal. 30⅞ x 29¾ x 13⅝" (78.5 x 75.5 x 34.5 cm), on wood base 4¾ x 15¾ x 11⅞" (12 x 40 x 29.9 cm). Advisory Committee Fund

193. Alberto Giacometti. *Woman with Her Throat Cut*. 1932. Bronze (cast 1949). 8 x 34½ x 25" (20.3 x 87.6 x 63.5 cm). Purchase

192

193

194

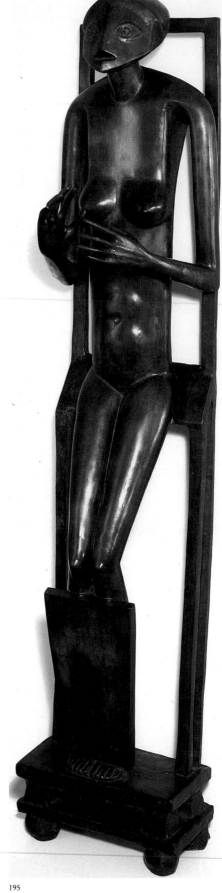

195

194. Alberto Giacometti. *The Palace at 4 A.M.* 1932–33. Construction in wood, glass, wire, and string. 25 x 28¼ x 15¾" (63.5 x 71.8 x 40 cm). Purchase

195. Alberto Giacometti. *The Invisible Object (Hands Holding a Void)*. 1934-35. Bronze. 61" (154.9 cm) high. Promised gift of Mrs. Bertram Smith

Though better known for his later elongated and emaciated "existential" figures, Giacometti made some of his most original works during his Surrealist period. *The Invisible Object* shows an almost primitive figure, bound to an imprisoning armature, emerging fearfully from its confines, and "holding" the void with a strange gesture of the arms and hands. It evokes the poignancy of human yearning and, paradoxically, the hollowness of hope, thus echoing the disenchanted mood which grimly colors so many Surrealist fancies.

196. Max Weber. *The Geranium*. 1911. Oil on canvas. 39⅞ x 32¼" (101.3 x 81.9 cm). Acquired through the Lillie P. Bliss Bequest

197. Joseph Stella. *Battle of Lights*. 1913–14? Oil on canvas mounted on cardboard. 20¼" (51.4 cm) diameter (irregular). Elizabeth Bliss Parkinson Fund

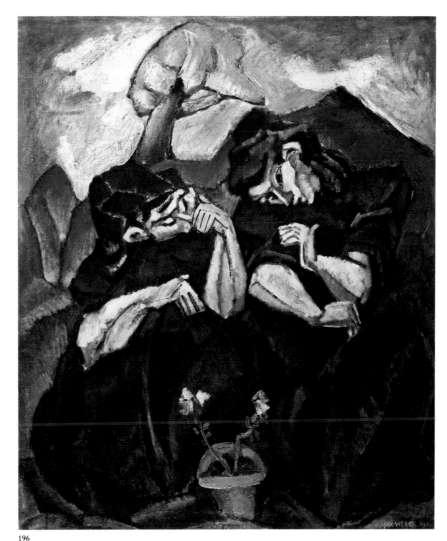

196

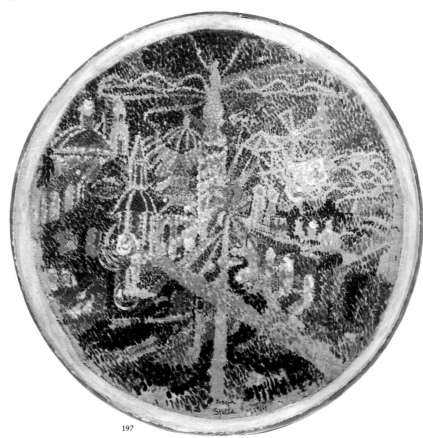

197

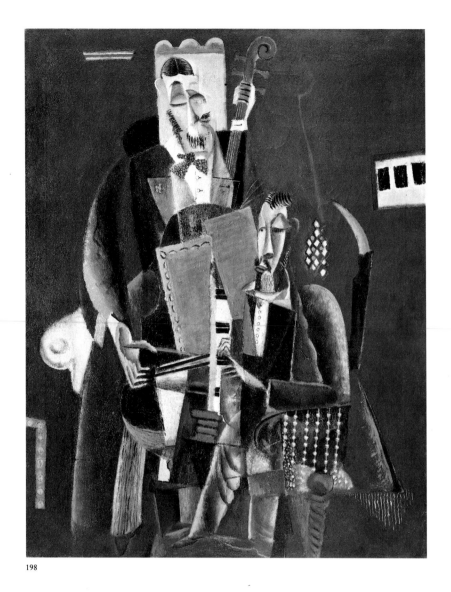

198

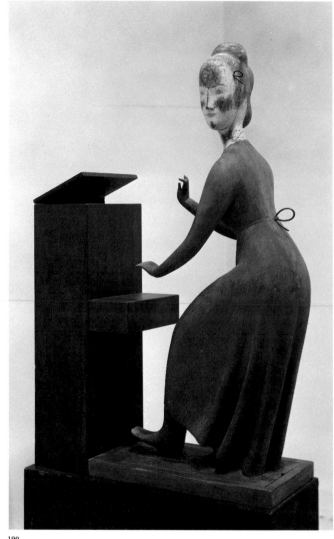

199

198. Max Weber. *The Two Musicians.*
1917. Oil on canvas. 40⅛ x 30⅛″
(101.9 x 76.5 cm). Acquired through
the Richard D. Brixey Bequest

199. Elie Nadelman. *Woman at the
Piano.* c. 1917. Wood, stained and
painted. 35⅛″ (89.2 cm) high, at base,
including piano, 21½ x 8½″ (54.5 x 21.5
cm). The Philip L. Goodwin Collection

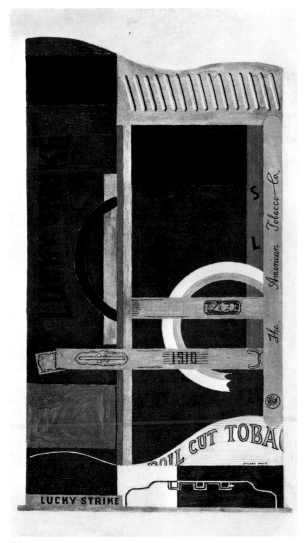

200

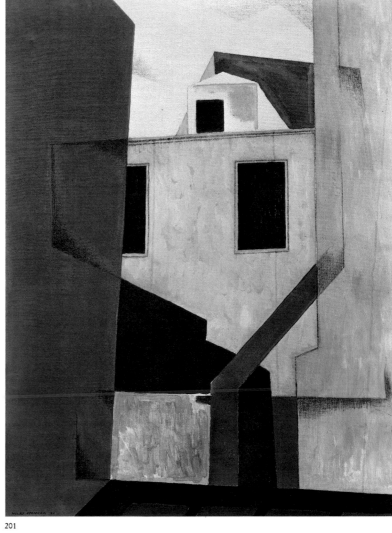

201

200. Stuart Davis. *Lucky Strike*. 1921.
Oil on canvas. 33¼ x 18″ (84.5 x 45.7
cm). Gift of the American Tobacco
Company, Inc.

201. Niles Spencer. *City Walls*. 1921.
Oil on canvas. 39⅜ x 28¾″ (100 x 73
cm). Given anonymously (by exchange)

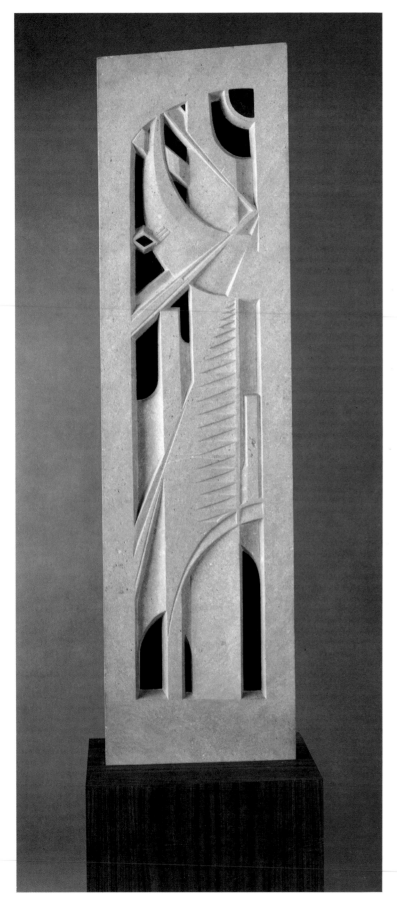

202

203

202. John Storrs. *Stone Panel with Black Marble Inlay.* 1920–21. Cast stone and black marble. 60½ x 15¼ x 1¾" (153.7 x 38.8 x 4.5 cm), with wood base 18½ x 12⅛ x 12⅛" (46.1 x 30.8 x 30.8 cm). Walter J. Reinemann Fund

203. Arthur G. Dove. *Portrait of Alfred Stieglitz.* 1925. Assemblage: camera lens, photographic plate, clock and watch springs, and steel wool on cardboard. 15⅞ x 12⅛" (40.3 x 30.8 cm). Purchase

This "portrait" brings together on a sheet of cardboard a camera lens, photographic plate, watch springs, and a piece of steel wool—associations to Dove's energetic and committed photographer-dealer. Whatever their ideological content, Dove's collages are transformed into an intimate and personal expressive form. Employing fragments of everyday reality, the artist evolved a poetry of the commonplace, distinguished by irony and wit.

204. Georgia O'Keeffe. *Abstraction Blue.* 1927. Oil on canvas. 40¼ x 30" (102.1 x 76 cm). Acquired through the Helen Acheson Bequest

This picture can be read as both an interior vision and a cloudscape, and was probably influenced by the symbolism of her husband Stieglitz's Equivalents, a photographic series of cloud and landscape fragments. O'Keeffe began to isolate and enlarge her natural imagery in the twenties, until individual details were magnified to a point where they ceased to be recognizable as represented objects. In extreme enlargement, filling the canvas, the cloud forms take on the character of an abstract, symbolic emblem—the universe in microcosm.

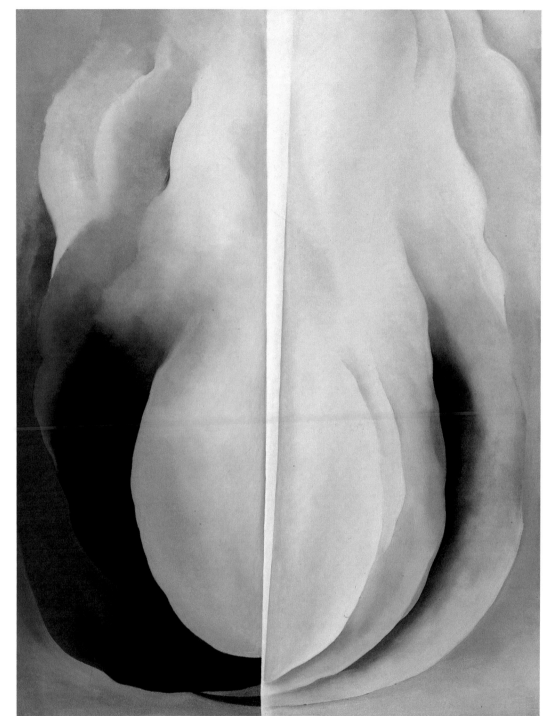

204

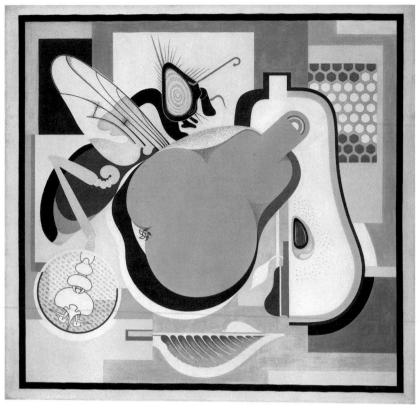

205

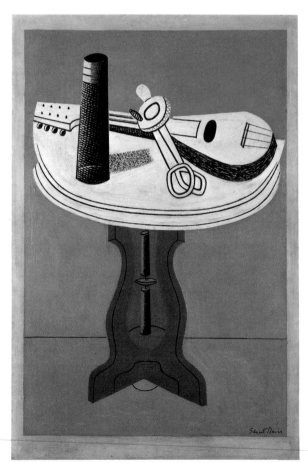

206

205. Gerald Murphy. *Wasp and Pear.*
1927. Oil on canvas. 36¾ x 38⅝"
(93.3 x 97.9 cm). Gift of Archibald
MacLeish

206. Stuart Davis. *Egg Beater, V.* 1930.
Oil on canvas. 50⅛ x 32¼" (127.3 x 81.9
cm). Abby Aldrich Rockefeller Fund

207. Georgia O'Keeffe. *Lake George
Window.* 1929. Oil on canvas. 40 x 30"
(101.6 x 76.2 cm). Acquired through the
Richard D. Brixey Bequest

208. Charles Sheeler. *American
Landscape.* 1930. Oil on canvas. 24 x 31"
(61 x 78.8 cm). Gift of Abby Aldrich
Rockefeller

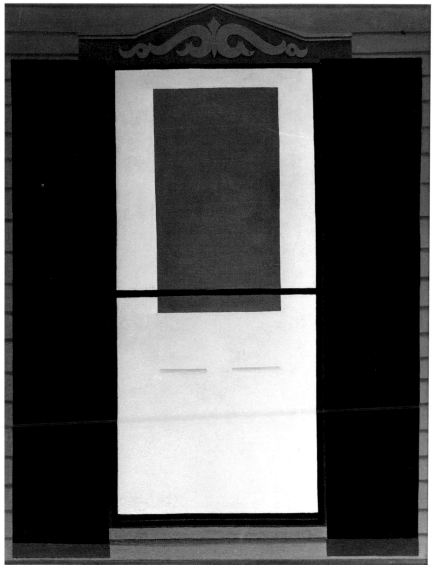

207

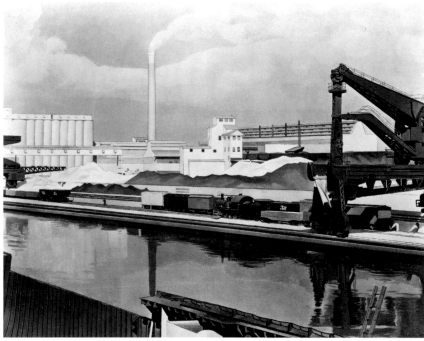

208

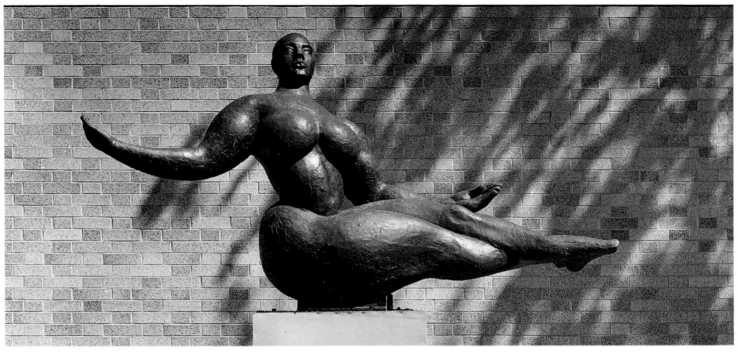

209

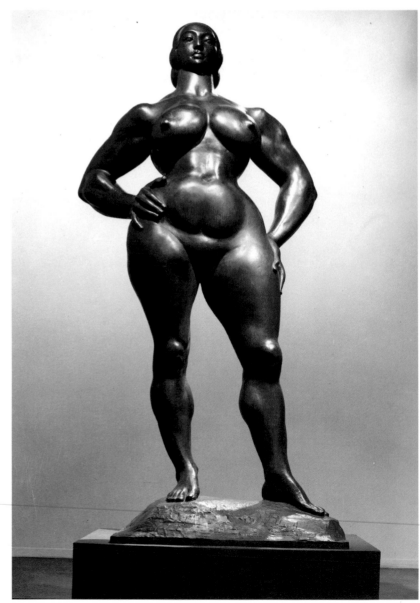

210

209. Gaston Lachaise. *Floating Figure.* 1927. Bronze (cast 1935). 51¾" x 8' x 22" (131.4 x 243.9 x 55.9 cm). Given anonymously in memory of the artist

210. Gaston Lachaise. *Standing Woman.* 1932. Bronze. 7'4" x 41⅛" x 19⅛" (223.6 x 104.3 x 48.4 cm). Mrs. Simon Guggenheim Fund

211. Alexander Calder. *Lobster Trap and Fish Tail.* 1939. Hanging mobile: painted steel wire and sheet aluminum. 8'6" x 9'6" (260 x 290 cm) (variable). Commissioned by the Advisory Committee for the stairwell of the Museum

This mobile, one of the most effective of Calder's early compositions in wire and steel, was commissioned in 1939 by the Advisory Committee of the Museum for the stairwell in which it still hangs. By cutting and shaping various sheet metals into largely abstract forms that nonetheless present tantalizing hints of objects in nature, and then grouping these forms on hanging wires that are set in motion by air currents, Calder achieved one of the most distinctive personal styles in modern sculpture. Mobiles such as these were inspired in part by Arp and the loose articulation of planes and lines in Miró's highly abstract, biomorphic openwork compositions of the late twenties, and are inflected by Calder's love of certain Eskimo masks with their chains of dangling elements and unexpected projections.

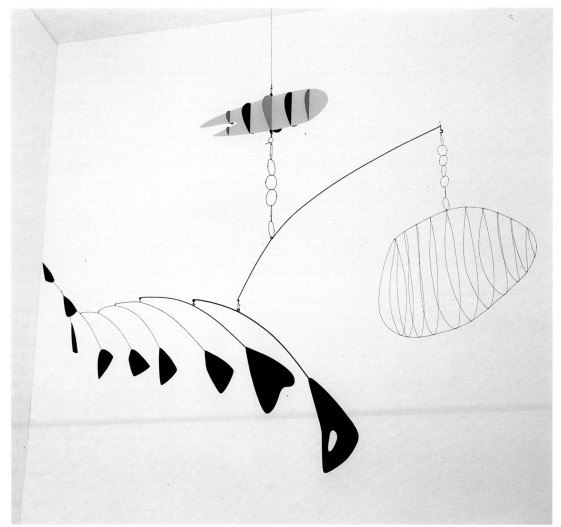

211

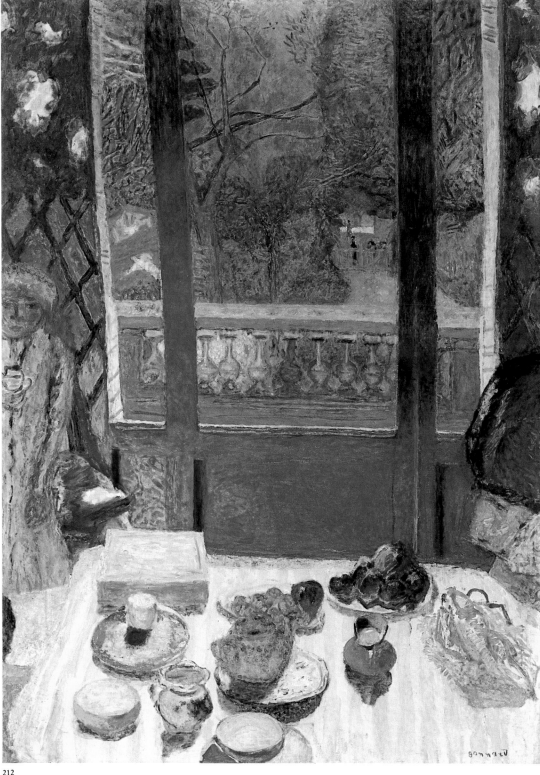

212

212. Pierre Bonnard. *The Breakfast Room*. c. 1930–31. Oil on canvas. 62⅞ x 44⅞″ (159.6 x 113.8 cm). Given anonymously

213. Pablo Picasso. *Three Women at the Spring*. 1921. Oil on canvas. 6′8¼″ x 68½″ (203.9 x 174 cm). Gift of Mr. and Mrs. Allan D. Emil

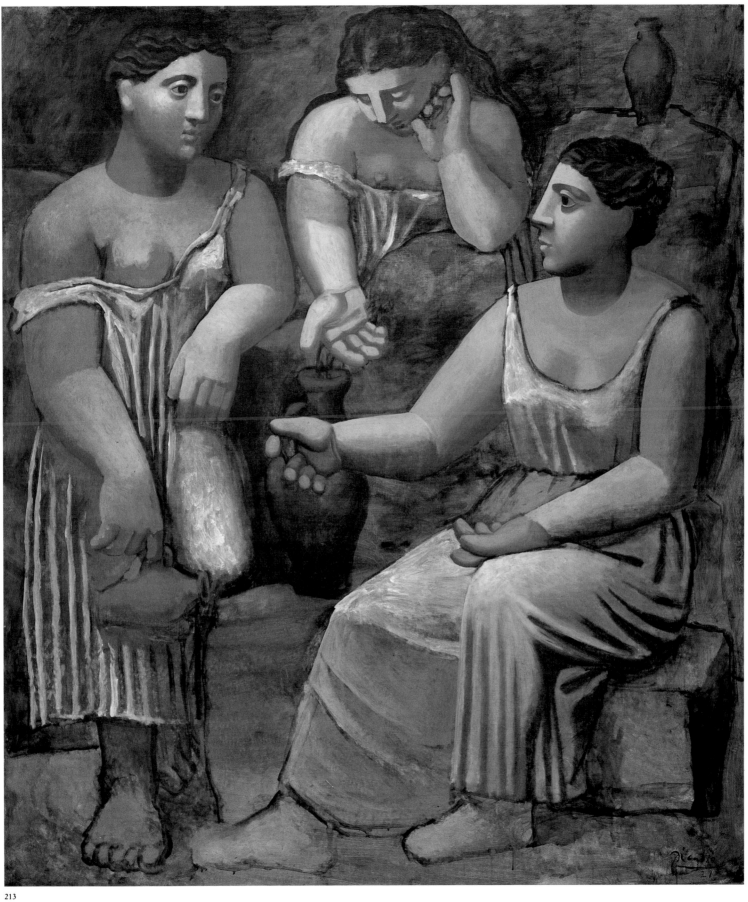

213

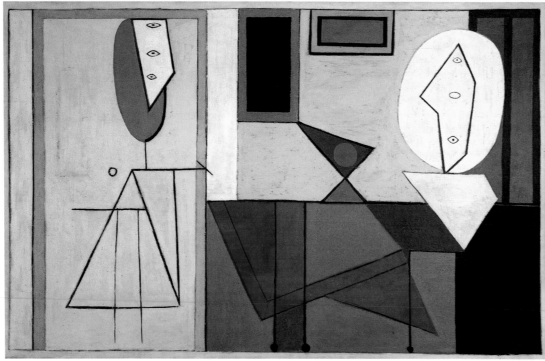

214

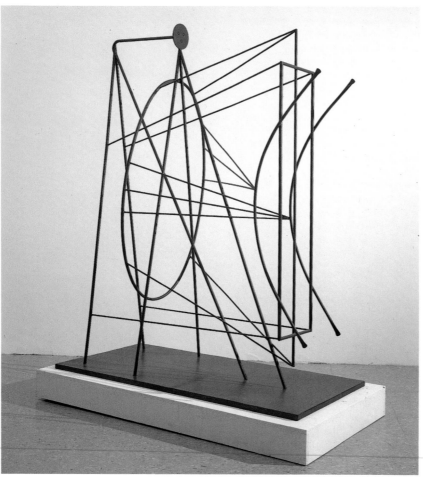

215

214. Pablo Picasso. *The Studio.* 1927–28. Oil on canvas. 59″ x 7′7″ (149.9 x 231.2 cm). Gift of Walter P. Chrysler, Jr.

The Studio is a diagrammatic, almost totally abstract, linear structure of unmodeled planes and straight lines that is nonetheless sharply evocative of the artist's presence and of the still-life objects on an adjoining table. Whatever schematic clues Picasso gives for the spatial relationships of the objects in *The Studio,* he totally eschews perspectival cues and modeling so as not to qualify the insistent flatness of the composition. Although Cubism had been, from the start, an art of straight-edged planes that tended to echo the architecture of the frame, Picasso pushed rectilinearity and economy to radical extremes in this painting. *The Studio* was acquired in 1935, and has been constantly on view at the Museum, where it has served as a beacon for generations of painters.

215. Pablo Picasso. *Project for a Monument to Guillaume Apollinaire* (Intermediate Model). 1962 (enlarged version after 1928–29 original wire maquette). Painted steel rods. 6′6″ x 62⅞″ x 29½″ (198 x 159.4 x 72.3 cm). Gift of the artist

The original 1928 maquette for this sculpture was one of three made for a committee interested in putting up a monument to Apollinaire. Picasso had this version made from that nineteen-inch maquette in 1962 and, ten years later, he authorized the Museum to realize his long-held intention of making a monumental version. This last, in Cor-Ten steel, stands nearly thirteen feet high in the Museum's garden. The original maquette, *Construction in Wire,* is one of only four linear, metal-rod sculptures ever executed by Picasso. The first "drawing-in-air" sculptures, these works represent Picasso's second dramatic and radical reorientation of the art of sculpture— which he had earlier redirected with his first sheet-metal construction, *Guitar* of 1912, which he also gave to the Museum. The committee that

had requested a sculpture from Picasso for the Apollinaire memorial was so shocked by the radical character of his open-work sculpture that no monument to Apollinaire was then erected. To Roland Penrose Picasso said, "What did they expect me to make, a Muse holding a torch?"

216. Pablo Picasso. *Girl before a Mirror.* 1932. Oil on canvas. 64 x 51¼" (162.3 x 130.2 cm). Gift of Mrs. Simon Guggenheim

In *Girl before a Mirror* Picasso proceeds, as Meyer Schapiro has observed, from "his intense feeling for the girl, whom he endowed with a corresponding vitality. He paints the body contemplated, loved and self-contemplating. The vision of another's body becomes an intensely rousing and mysterious process." The painting is extraordinary for its many dualisms: the psychic contrasts of the views of the profile head of the girl—one a frontal, mythic yellow mask, the other a more naturalistic profile, with the further echo of a troubled, internalized image in the mirror reflection. This is counterpointed by the contrast between the sinuous, organic forms of the figure and mirror and the geometric decorativism of the wallpaper background and the girl's costume.

217. Pablo Picasso. *Interior with a Girl Drawing.* 1935. Oil on canvas. 51¼ x 76⅝" (130 x 195 cm). Nelson A. Rockefeller Bequest

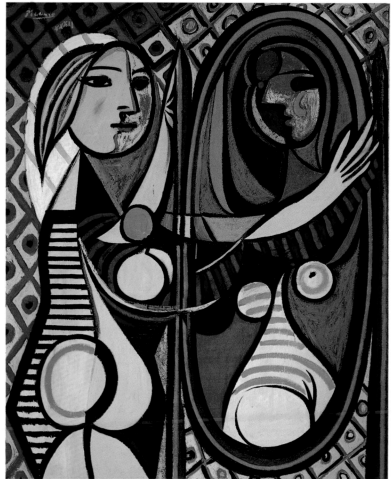

216

217

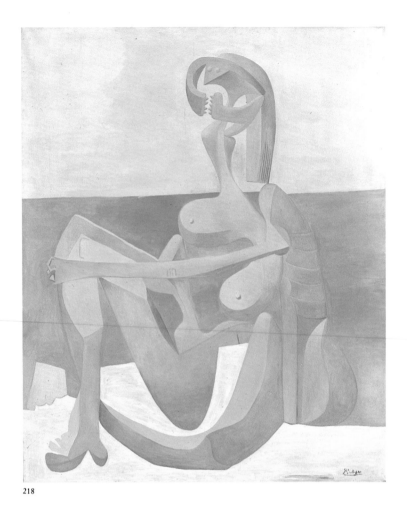

218

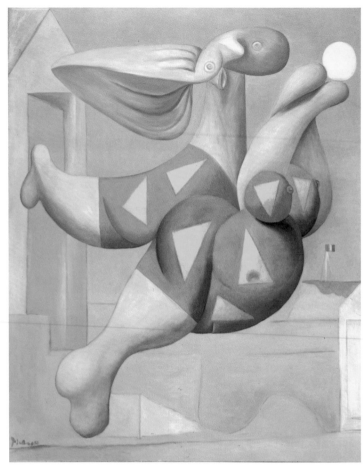

219

218. Pablo Picasso. *Seated Bather.* 1930.
Oil on canvas. 64¼ x 51" (163.2 x 129.5
cm). Mrs. Simon Guggenheim Fund

In *Seated Bather* we are confronted
by a hollowed-out creature whose
hard, bonelike forms are all skeletal
armor. While she sits in a comfort-
able pose against a deceptively placid
sea and sky, the potential violence
that Picasso finds in her is epito-
mized by her mantis-like head,
which combines the themes of sex-
uality and aggression. The praying
mantis, who devours her mate in the
course of the sexual act, had been a
favorite Surrealist symbol; as a num-
ber of Surrealist painters and poets
collected mantises, the insects could
hardly have escaped Picasso's notice.
The menacing nature of the bather is
intensified by her beady eyes and
dagger-like nose, but above all by
her viselike vertical mouth, Picasso's
personal version of a favorite Sur-
realist motif, the *vagina dentata.*

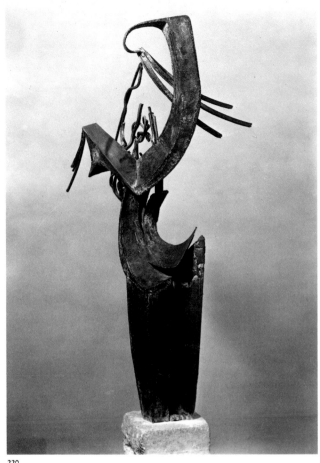

220

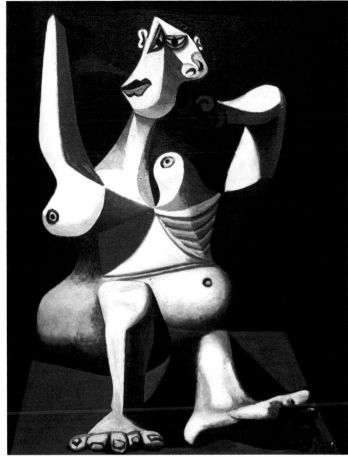

221

219. Pablo Picasso. *Bather with a Beach Ball.* 1932. Oil on canvas. 57⅝ x 45⅛" (146.2 x 114.6 cm). Partial gift of Ronald S. Lauder

220. Julio Gonzalez. *Woman Combing Her Hair.* 1936. Wrought iron. 52 x 23½ x 24⅝" (132.1 x 59.7 x 62.4 cm). Mrs. Simon Guggenheim Fund

221. Pablo Picasso. *Woman Dressing Her Hair.* 1940. Oil on canvas. 51¼ x 38¼" (130.2 x 97 cm). Promised gift of Mrs. Bertram Smith

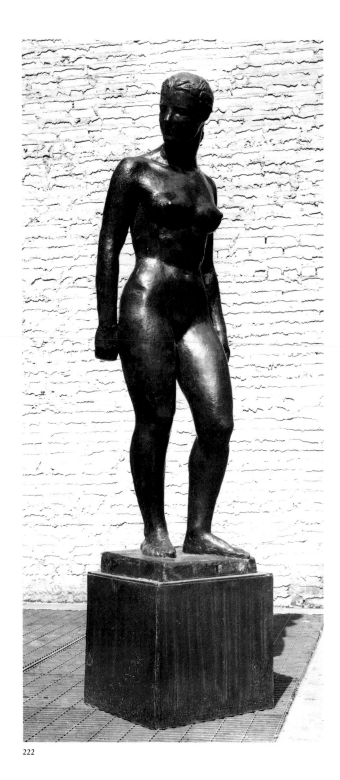

222

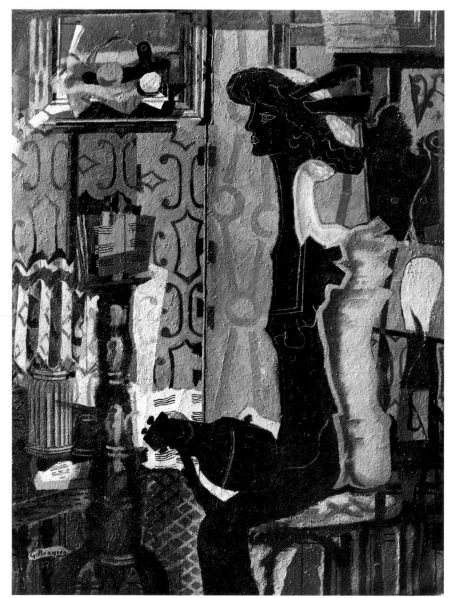

223

222. Charles Despiau. *Assia*. 1938.
Bronze. 6'¾" (184.8 cm) high. Gift of
Mrs. Simon Guggenheim

223. Georges Braque. *Woman with a Mandolin*. 1937. Oil on canvas. 51¼ x
38¼" (130.2 x 97.2 cm). Mrs. Simon
Guggenheim Fund

224. Stuart Davis. *Visa*. 1951. Oil on
canvas. 40 x 52" (101.6 x 132.1 cm). Gift
of Mrs. Gertrud A. Mellon

Partial to jazz and other popular art
forms, Davis sought to inject brisk
new rhythms and an irreverent
gaiety into the Cubist conventions

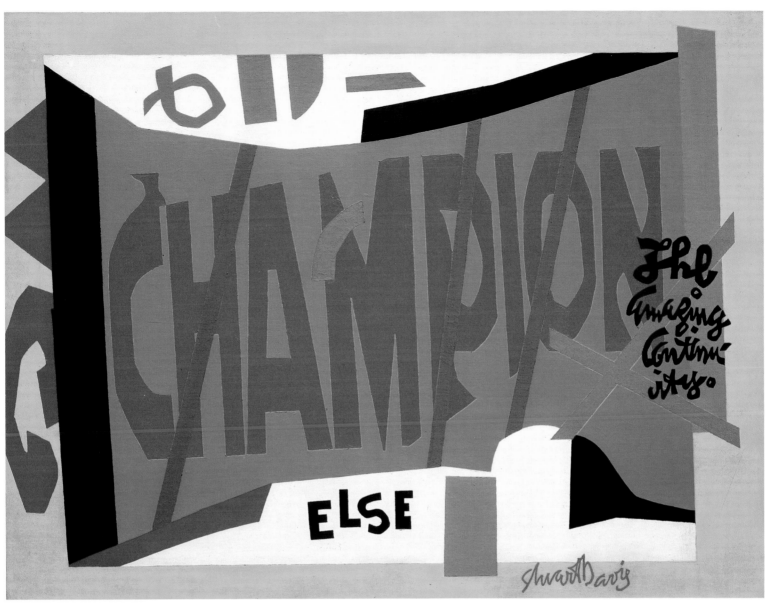

224

he had inherited. In *Visa*, a late work, the matchbook brand name "Champion" and the phrase "The Amazing Continuity" conspire to create a poetic sense of unity, playing against a jarring color scheme. Davis used words in his pictures, he said, "because they are a part of an urban subject matter." A prophetic work, *Visa* distills urban energies and imagery in fragmented form using optically active color contrasts; it thus anticipates both the visual brilliance of Op art and the ironic comment of Pop art.

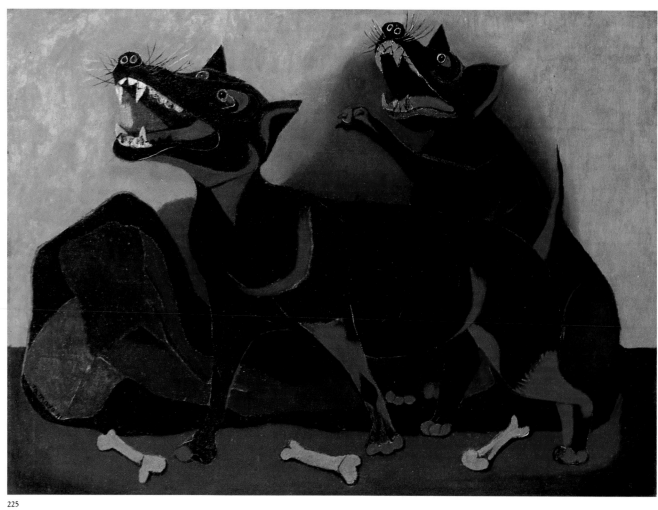

225

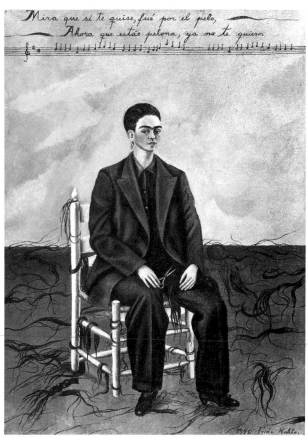

226

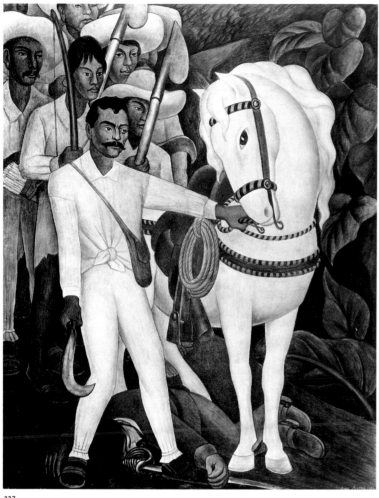

227

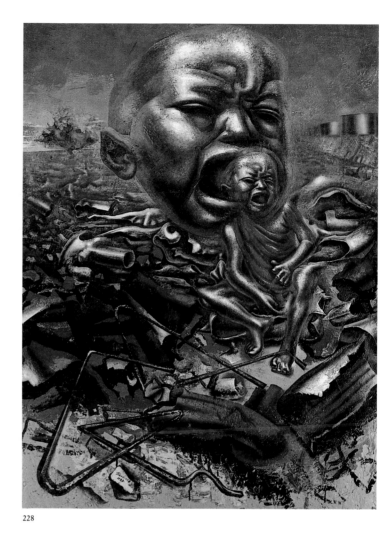

228

225. Rufino Tamayo. *Animals.* 1941.
Oil on canvas. 30⅛ x 40″ (76.5 x 101.6
cm). Inter-American Fund

226. Frida Kahlo. *Self-Portrait with
Cropped Hair.* 1940. Oil on canvas.
15¾ x 11″ (40 x 27.9 cm). Gift of Edgar
Kaufmann, Jr.

227. Diego Rivera. *Agrarian Leader,
Zapata.* 1931. Fresco. 7′9¾″ x 6′2″ (238.1
x 188 cm). Abby Aldrich Rockefeller
Fund

228. David Alfaro Siqueiros. *Echo of a
Scream.* 1937. Duco on wood. 48 x 36″
(121.9 x 91.4 cm). Gift of Edward M. M.
Warburg

229. José Clemente Orozco. *Zapatistas.*
1931. Oil on canvas. 45 x 55″ (114.3 x
139.7 cm). Given anonymously

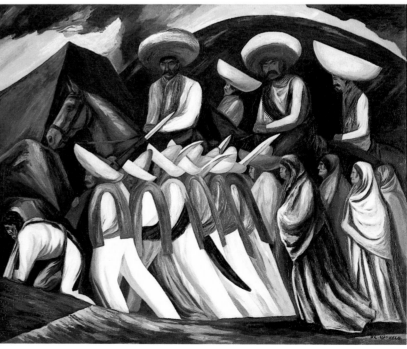

229

230

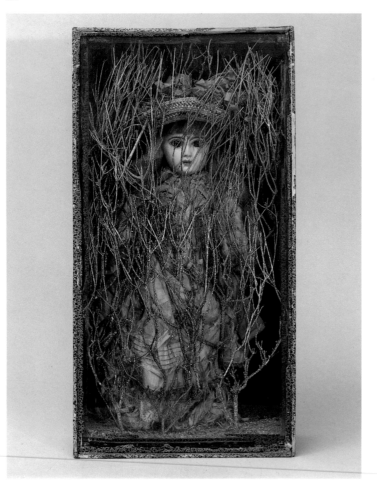

231

230. Joseph Cornell. *Taglioni's Jewel Casket*. 1940. Wood box containing glass cubes, jewelry, etc. 4¾ x 11⅞ x 8¼″ (12 x 30.2 x 21 cm). Gift of James Thrall Soby

231. Joseph Cornell. Untitled (*Bébé Marie*). Early 1940s. Papered and painted cardboard box with glass front containing doll in cloth dress and straw hat with cloth flowers and dried flowers, and twigs, flecked with paint. 23½ x 12⅜ x 5¼″ (59.7 x 31.2 x 13.4 cm). Acquired through the Lillie P. Bliss Bequest

232. Balthus (Baltusz Klossowski de Rola). *The Street*. 1933. Oil on canvas. 6′4¾″ x 7′10½″ (194.9 x 240 cm). James Thrall Soby Bequest

233. Balthus (Baltusz Klossowski de Rola). *The Living Room*. 1942. Oil on canvas. 45 x 57½″ (114.3 x 146.1 cm). Estate of John Hay Whitney

Balthus has become best known for pictures of seemingly everyday bourgeois interiors, often with adolescent girls, in which the artist hints at troubling sexual undercurrents, and *The Living Room* is a major example of this type of work. The implicit eroticism of the picture is partially a function of the posture of reverie of the girl with the guitar case on her lap. But this is subsumed within a revelation of a deeper order that suspends the chance moment in an aura of fixity and timelessness. The latter derives from Balthus's extraordinary powers as a composer of pictures that, in their enigmatic stasis and silent spacing, remind us of Seurat. The more immediate psychosexual implications of such pictures are trivial as compared to their structuring, wherein the mystery lies.

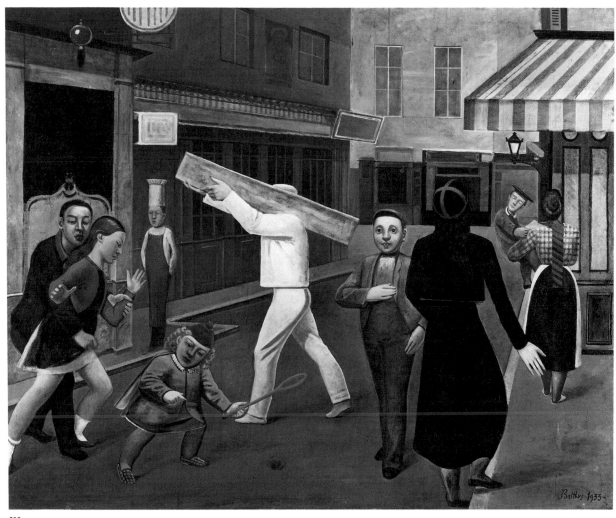

232

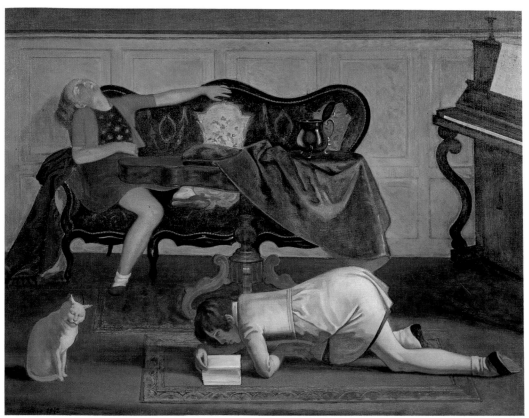

233

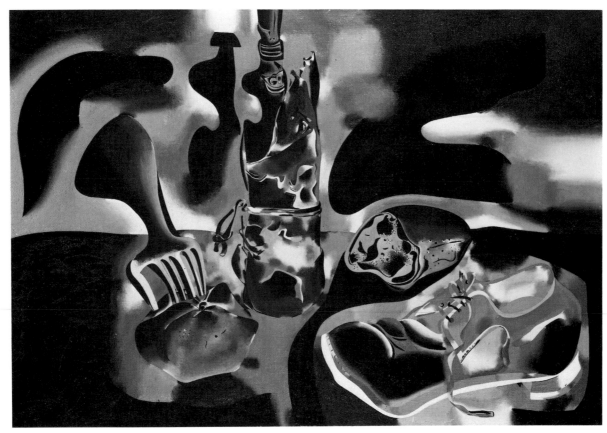

234

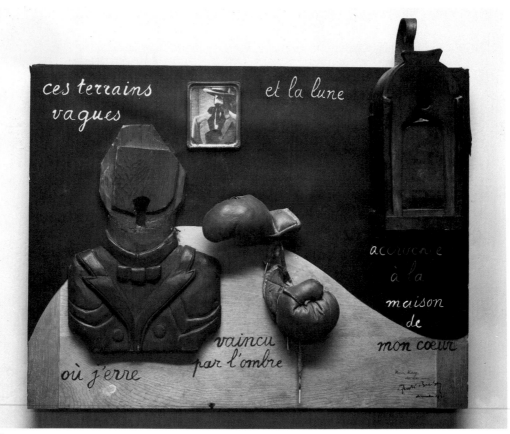

235

234. Joan Miró. *Still Life with Old Shoe*. 1937. Oil on canvas. 32 x 46″ (81.3 x 116.8 cm). James Thrall Soby Bequest

235. André Breton. *Poem-Object*. 1941. Assemblage mounted on drawing board: carved wood bust of man, oil lantern, framed photograph, and toy boxing gloves. 18 x 21 x 4⅜″ (45.8 x 53.2 x 10.9 cm). Kay Sage Tanguy Bequest

236. Ben Nicholson. *Painted Relief*. 1939. Synthetic board mounted on plywood, painted. 32⅞ x 45″ (83.5 x 114.3 cm). Gift of H. S. Ede and the artist (by exchange)

237. Jean Hélion. *Composition*. 1936. Oil on canvas. 39¼ x 31⅞″ (99.7 x 80.9 cm). Gift of the Advisory Committee

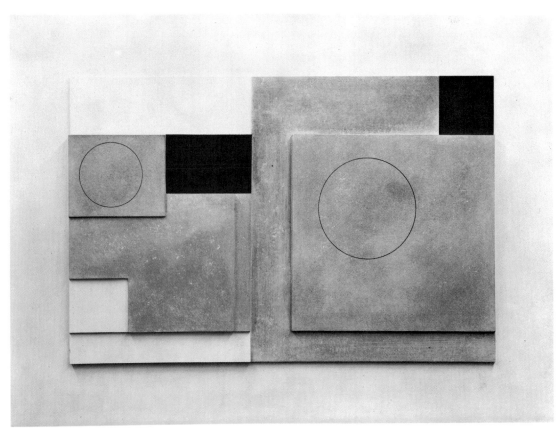

236

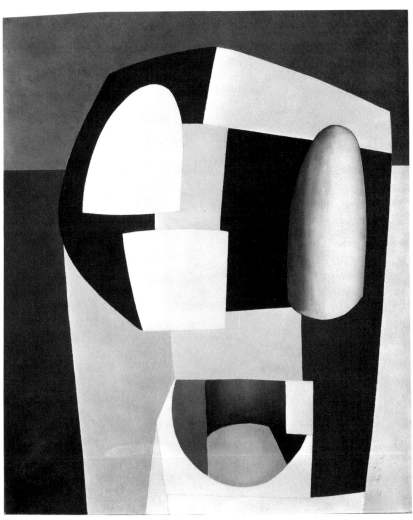

Painting and Sculpture | **171**

237

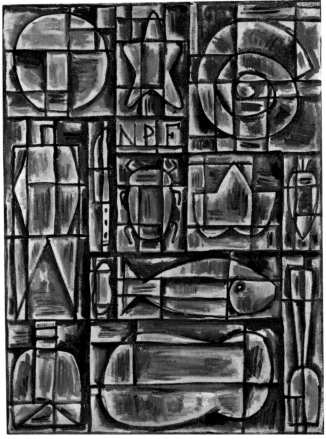

238

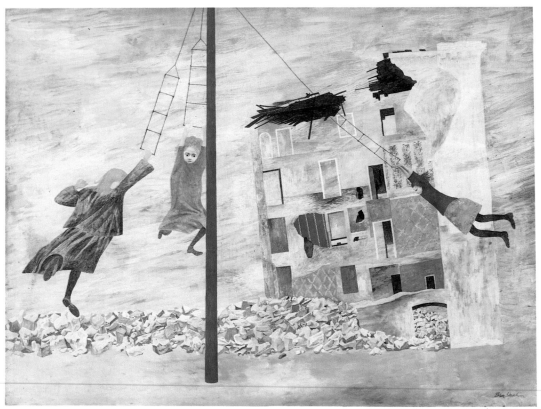

239

238. Joaquín Torres-García. *Constructive Painting*. c. 1931. Oil on canvas. 29⅝ x 21⅞" (75.2 x 55.4 cm). The Sidney and Harriet Janis Collection

239. Ben Shahn. *Liberation*. 1945. Tempera on cardboard, mounted on composition board. 29¾ x 40" (75.6 x 101.4 cm). James Thrall Soby Bequest

This painting may have been inspired by a photograph Shahn had seen after the war; it is very close to one by Cartier-Bresson of children playing in the rubble of a bombed-out area. Shahn himself was a gifted social photographer who had participated in the Farm Security Administration program documenting living conditions among the rural poor, along with Walker Evans, Dorothea Lange, Carl Mydans, and Arthur Rothstein. The painting combines a sense of ironic actuality—the children playing delightedly in a ruin of collapsed buildings—with the formal economy of modern representation.

240. Edward Hopper. *House by the Railroad*. 1925. Oil on canvas. 24 x 29" (61 x 73.7 cm). Given anonymously in 1930 by Stephen C. Clark

No American realist has been able to capture the vacancy and frustration of modern urban existence with more evocative pictorial means than Hopper. *House by the Railroad* isolates and heightens the awkward ugliness of an architectural folly. Yet the anachronistic house gains our sympathy despite its lonely prominence by its romantic lighting and rather exotic color accents.

241. Edward Hopper. *New York Movie*. 1939. Oil on canvas. 32¼ x 40⅛" (81.9 x 101.9 cm). Given anonymously

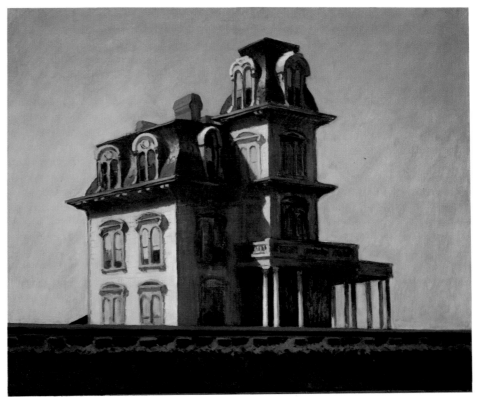

240

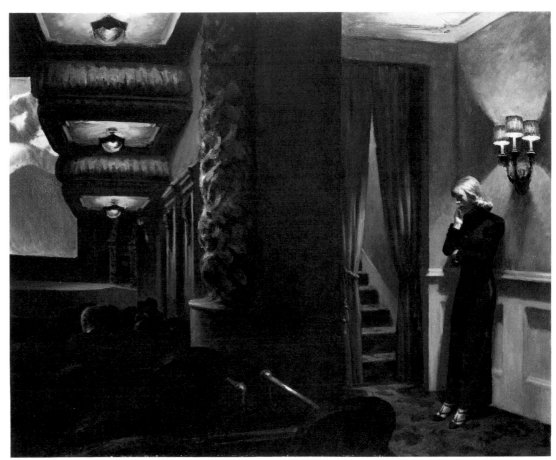

241

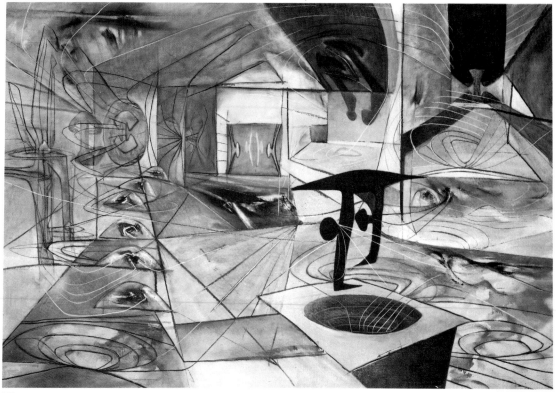

242

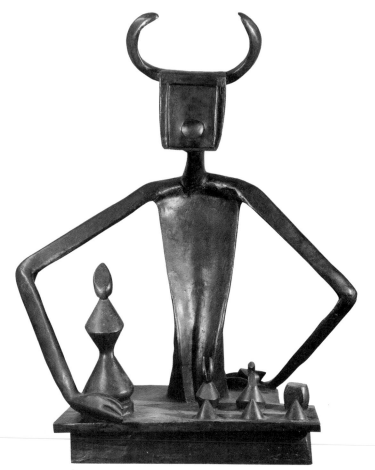

243

242. Matta (Sebastian Antonio Matta Echaurren). *The Onyx of Electra.* 1944. Oil on canvas. 50⅛ x 72″ (127.3 x 182.9 cm). Anonymous Fund

243. Max Ernst. *The King Playing with the Queen.* 1944. Bronze (cast 1954 from original plaster). 38½″ (97.8 cm) high, at base 18¾ x 20½″ (47.7 x 52.1 cm). Gift of Dominique and John de Menil

244. André Masson. *Meditation on an Oak Leaf.* 1942. Tempera, pastel, and sand on canvas. 40 x 33″ (101.6 x 83.8 cm). Given anonymously

245. André Masson. *The Kill.* 1944. Oil on canvas. 21¾ x 26¾″ (55.2 x 67.9 cm). Gift of the artist

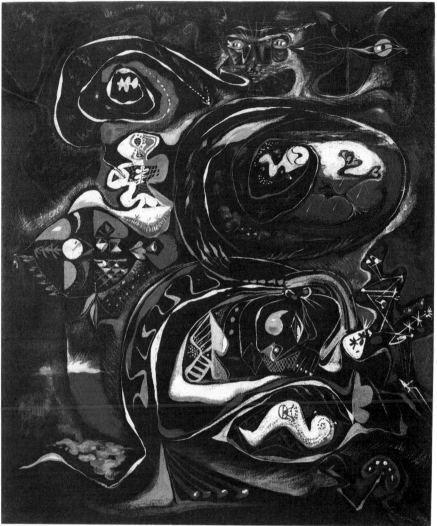

244

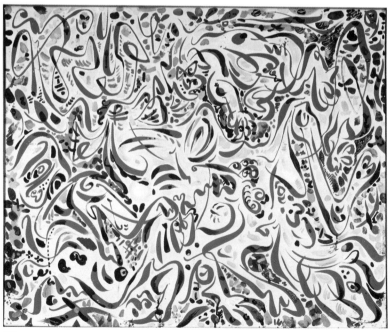

245

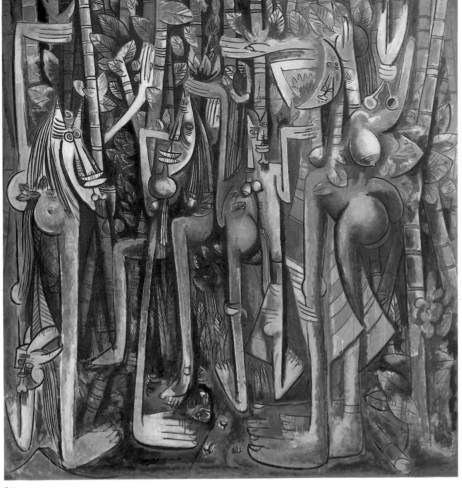

246

246. Wifredo Lam. *The Jungle*. 1943. Gouache on paper mounted on canvas. 7'10¼" x 7'6½" (239.4 x 229.9 cm). Inter-American Fund

247. Matta (Sebastian Antonio Matta Echaurren). *Le Vertige d'Éros*. 1944. Oil on canvas. 6'5" x 8'3" (195.6 x 251.5 cm). Given anonymously

In *Le Vertige d'Éros*, an infinite space is suggested that simultaneously acts as a metaphor for the cosmos and the recesses of the mind. In a mystical world of half-light that seems to emerge from unfathomable depths, we witness the eclosion of a nameless morphology. Unlike other Surrealists such as Dali and Magritte, whose imagery accepts the prosaic and realistic appearance of objects seen in dreams, Matta invents new symbolic shapes. These seem to reach back beyond and behind dream activity to the more latent sources of psychic life.

248. Pavel Tchelitchew. *Hide-and-Seek*. 1940–42. Oil on canvas. 6'6½" x 7'3¾" (199.3 x 215.3 cm). Mrs. Simon Guggenheim Fund

247

248

249

250

249. Yves Tanguy. *Multiplication of the Arcs.* 1954. Oil on canvas. 40 x 60" (101.6 x 152.4 cm). Mrs. Simon Guggenheim Fund

250. Andrew Wyeth. *Christina's World.* 1948. Tempera on gesso panel. 32¼ x 47¾" (81.9 x 121.3 cm). Purchase

251. Peter Blume. *The Eternal City.* 1937. Oil on composition board. 34 x 47⅞" (86.4 x 121.6 cm). Mrs. Simon Guggenheim Fund

252. Jack Levine. *The Feast of Pure Reason.* 1937. Oil on canvas. 42 x 48" (106.7 x 121.9 cm). Extended loan from the United States WPA Art Program

251

252

253

253. Jackson Pollock. *Stenographic Figure*. 1942. Oil on canvas. 40 x 56″ (101.6 x 142.2 cm). Mr. and Mrs. Walter Bareiss Fund

Stenographic Figure is Pollock's "break-away" painting for his "surrealizing" style of the early forties. The reclining figure, part female nude, part animal, reflects the young painter's debt to Picasso, Miró, and Masson, as does the late Cubist layout of the composition. The powerful, rapid, and improvisational execution is of a velocity and sureness matched only by Picasso. And the calligraphic script, with its cryptic letters and numbers that energize the surface, foretells the translation of such automatism into the skeins of Pollock's later poured pictures.

254. Jackson Pollock. *Gothic*. 1944. Oil on canvas. 7′5⅝″ x 56″ (215 x 142.2 cm). Promised gift of Lee Krasner

254

255. Arshile Gorky. *The Leaf of the Artichoke Is an Owl.* 1944. Oil on canvas. 28 x 35⅞" (71.1 x 90.2 cm). Sidney and Harriet Janis Collection Fund

256. Arshile Gorky. *Agony.* 1947. Oil on canvas. 40 x 50½" (101.6 x 128.3 cm). A. Conger Goodyear Fund

The succession of catastrophes that led to Gorky's suicide in 1948 began with the destruction of his paintings and his studio by fire in January 1946, and his operation for cancer in February. During that year he underwent crushing blows to his physique, his personal life, and his art. This tragic and beautiful canvas is an outcome of these pressures. *Agony* was not systematically developed, as William Seitz has observed, from one master drawing but was preceded by several bold studies, each of which, like the final painting, concentrates on the same structure—a fearful hybrid resembling a dentist's chair, an animated machine, a primitive feathered fetish, or a human figure hanging on the rock, its rib cage hollow and its groin adorned with petals. Though Gorky's distinctive form of biomorphism—as opposed to those of Arp, Miró, or Matisse—was derived from landscape studies, the configuration for *Agony* did not derive from landscape but from a furnished interior closed from behind by a partition.

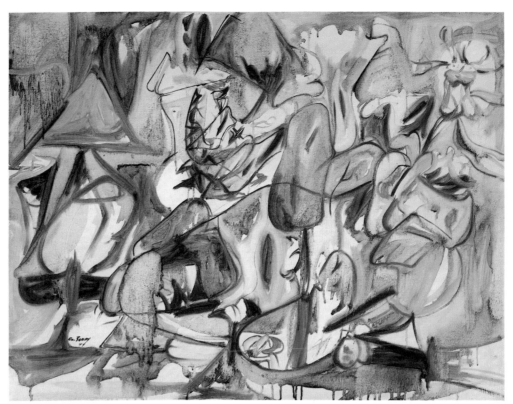

255

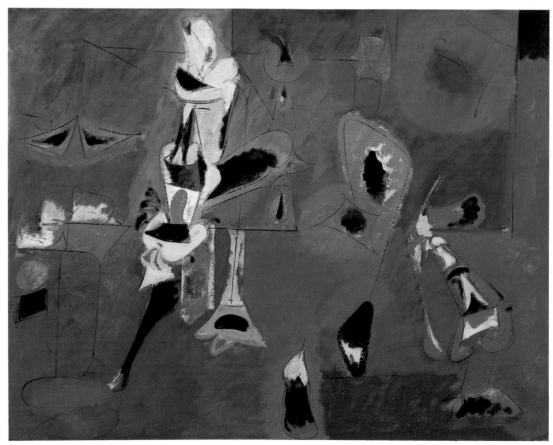

256

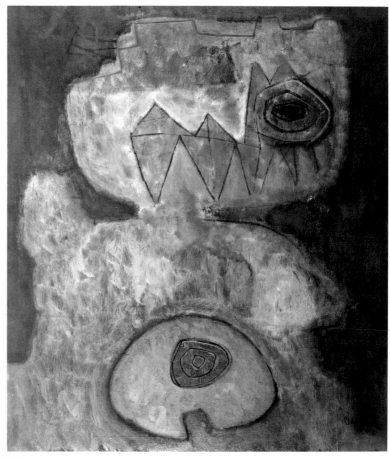

257

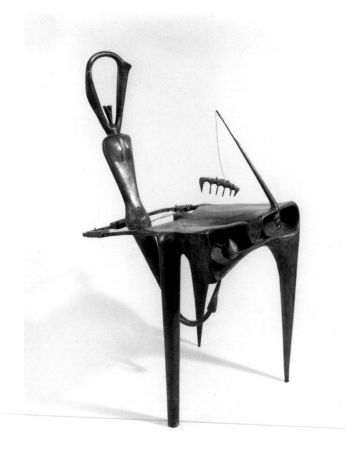

258

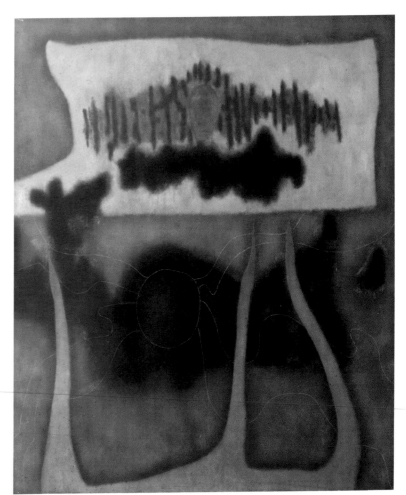

259

257. William Baziotes. *Dwarf.* 1947. Oil on canvas. 42 x 36⅛″ (106.7 x 91.8 cm). A. Conger Goodyear Fund

258. David Hare. *Magician's Game.* 1944. Bronze (cast 1946). 40¼ x 18½ x 25¼″ (102.2 x 47 x 64.1 cm). Given anonymously

259. William Baziotes. *Pompeii.* 1955. Oil on canvas. 60 x 48″ (152.4 x 121.9 cm). Mrs. Bertram Smith Fund

260. Theodoros Stamos. *Sounds in the Rock.* 1946. Oil on composition board. 48⅛ x 28⅜″ (122.2 x 72.1 cm). Gift of Edward W. Root

261. Mark Rothko. *Slow Swirl by the Edge of the Sea.* 1944. Oil on canvas. 6′3⅜″ x 7′¾″ (191.4 x 215.2 cm). Bequest of Mrs. Mark Rothko

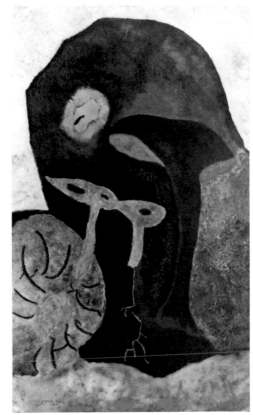

260

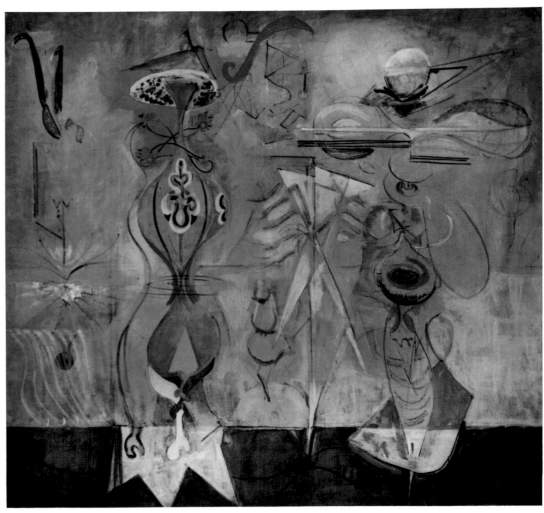

261

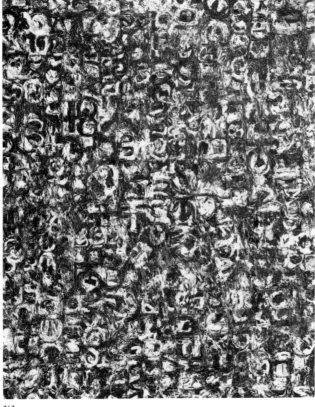

262

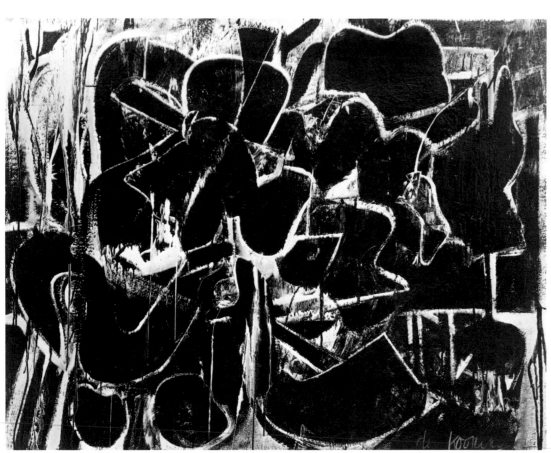

263

262. Lee Krasner. Untitled. 1949. Oil on composition board. 48 x 37" (121.9 x 93.9 cm). Gift of Alfonso A. Ossorio

263. Willem de Kooning. *Painting.* 1948. Enamel and oil on canvas. 42⅝ x 56⅛" (108.3 x 142.5 cm). Purchase

264. Pablo Picasso. *The Charnel House.* 1944–45. Oil and charcoal on canvas. 6'6⅝" x 8'2½" (199.8 x 250.1 cm). Acquired through the Mrs. Sam A. Lewisohn Bequest (by exchange); Mrs. Marya Bernard Fund in memory of her husband, Dr. Bernard Bernard; William Rubin; and Anonymous Funds

The grisaille harmonies of *The Charnel House* distantly echo the black-and-white newspaper photographs of concentration camps, which appeared just after World War II, while establishing the proper key for a requiem. Like *Guernica,* this picture is, as William Rubin has observed, a massacre of the innocents—an evocation of horror and anguish amplified by the spirit of genius. It marks the final act in the drama of which *Guernica*—with which it has affinities of style as well as iconography—may be said to depict the beginning. Both works submit their vocabulary of contorted and truncated expressionistic shapes to a compositional armature derived from Cubism, thus absorbing the violence of the morphology into the silent and immutable architecture of the frame.

265. Pablo Picasso. *The Kitchen.* 1948. Oil on canvas. 68⅞" x 8'2½" (175 x 250 cm). Acquired through the Nelson A. Rockefeller Bequest

Although Picasso was to paint a number of superb pictures later in his career, *The Kitchen* was the last major work which finds him on the cutting edge of vanguard painting. Here Picasso brings to the picture's fulfillment a kind of open-work drawing based on lines and small black circles begun in 1926 in notebook studies that were later published in 1931 as part of the illustrated book *Le Chef d'oeuvre inconnu.* The 1926 drawings had adumbrated his wire sculptures of

1928–29, as the more elaborate configuration of *The Kitchen* anticipates the character of David Smith's "drawing-in-air" sculptures. The motifs, only some of which are readable, derive from a view into Picasso's kitchen from his Rue des Grands Augustins studio. The door and door handle and the ornamental plates hanging on the wall are among the motifs whose ideographic reductions can be clearly read.

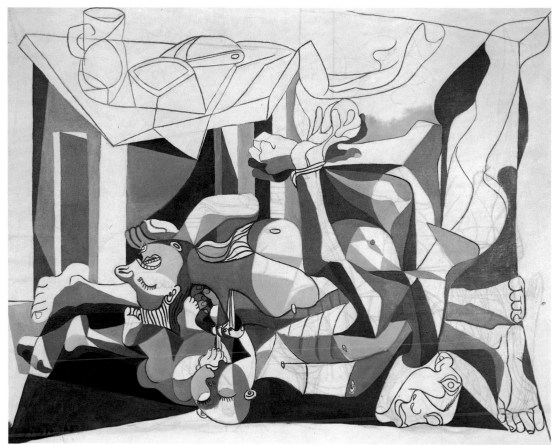

264

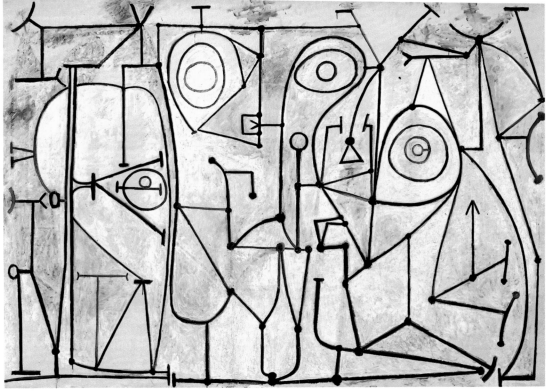

265

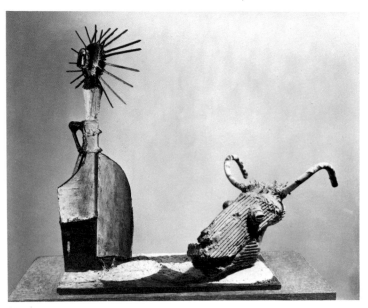

266

266. Pablo Picasso. *Goat Skull and Bottle*. 1951–52. Painted bronze (cast 1954 after found objects). 31 x 37⅝ x 21½" (78.8 x 95.3 x 54.5 cm). Mrs. Simon Guggenheim Fund

267. Joan Miró. *Moonbird*. 1966. Bronze. 7'8⅛" x 6'9¼" x 59⅛" (228.8 x 206.4 x 150.1 cm). Acquired through the Lillie P. Bliss Bequest

268. Alberto Giacometti. *Man Pointing*. 1947. Bronze. 70½" (179 cm) high, at base 12 x 13¼" (30.5 x 33.7 cm). Gift of Mrs. John D. Rockefeller 3rd

269. Alberto Giacometti. *City Square*. 1948. Bronze. 8½ x 25⅜ x 17¼" (21.6 x 64.5 x 43.8 cm). Purchase

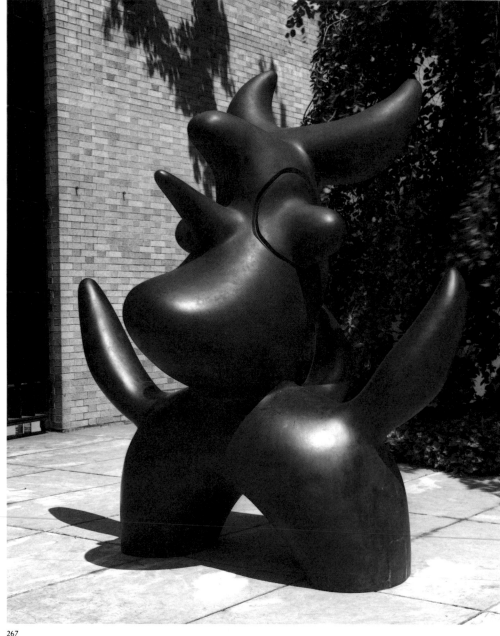

267

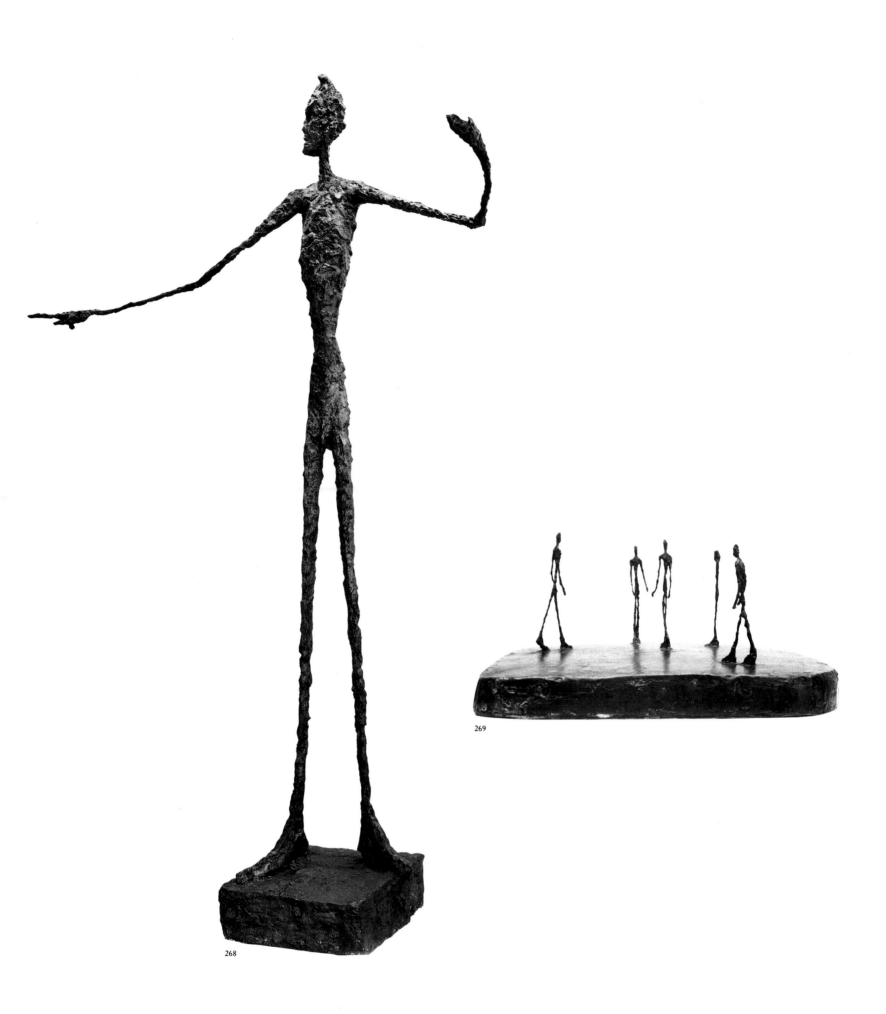

268

269

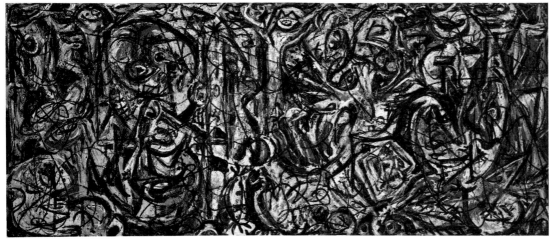

270

The fabric of this picture, remarkably transparent despite the many overlays of paint, breathes in a rhythm determined by the network of poured lines that Pollock controlled through the thickening, thinning, or flooding of the paint medium and the different ways in which it was released onto the canvas from a can or along a brush hardened with paint. The fantastic anatomies and private mythic figures of Pollock's Surrealist-influenced painting of the early forties, and the heavily impastoed textures of the transitional "allover" pictures of autumn 1946, gave way, during the following three years, to Pollock's "classic" style, which came to an astonishing conclusion with a few wall-size paintings on the order of *One.* Here, the poured, blotted, sprinkled, and dripped liquid paint is stained into the white cotton duck so as to become part of the warp and woof of the weave rather than an autonomous film on top of the canvas. The result is an image scintillating with light like a work of late Impressionism, but containing an almost apocalyptic intensity in the celerity of its improvisation. It constitutes a contemporary interpretation of the "sublime" of the late eighteenth and early nineteenth centuries.

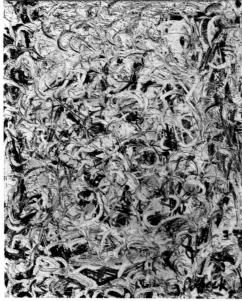

271

272

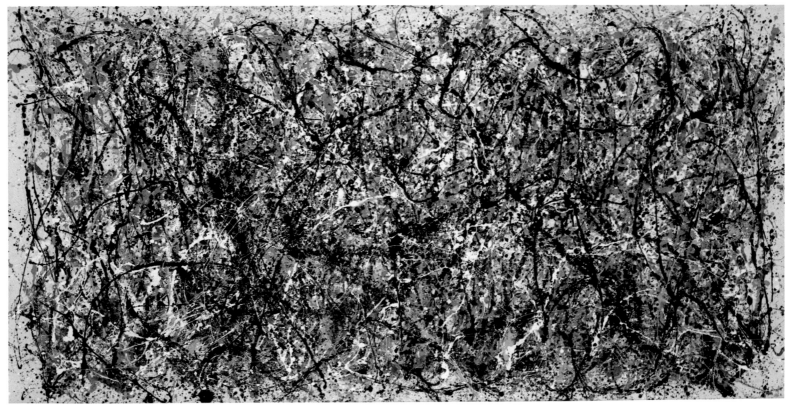

273

274. Jackson Pollock. *Echo (Number 25, 1951)*. 1951. Enamel paint on canvas. 7'7⅞" x 7'2" (233.4 x 218.4 cm). Acquired through the Lillie P. Bliss Bequest and the Mr. and Mrs. David Rockefeller Fund

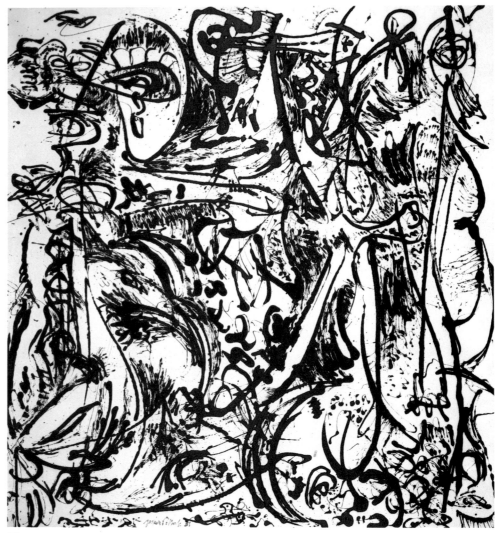

274

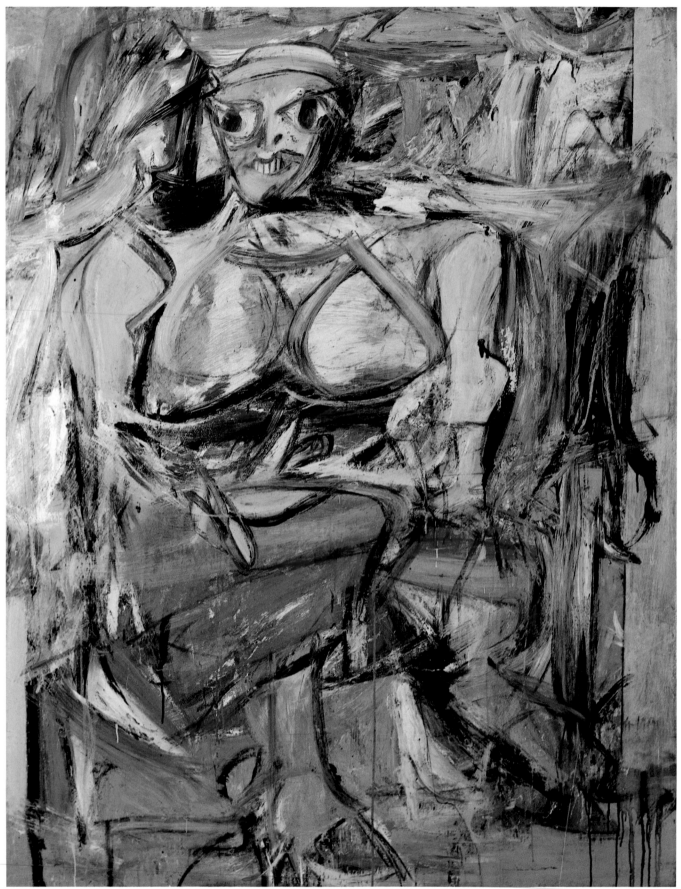

275

275. Willem de Kooning. *Woman, I.*
1950–52. Oil on canvas. 6'3⅞" x 58"
(192.7 x 147.3 cm). Purchase

This painting reveals the artist in a
moment of transition from a figura-
tion reminiscent of Soutine to an
even more fragmented and aggres-
sive painterliness set in a densely
structured, depthless space. The
image of Woman, as de Kooning
portrays her here, is, as Tom Hess
has pointed out, the Black Goddess,
Venus with a touch of the billboard,
and "the idol, hilarious, contempo-
rary and banal." Painted at a time
when rigorous abstraction was con-
sidered by formalist criticism as the
only respectable contemporary
mode, *Woman, I* reflects de Koon-
ing's stubborn insistence on painting
as his impulses dictated. He later
remarked, "It's really absurd to
make an image, like a human image,
with paint, today, when you think
about it It [*Woman, I*] did one
thing for me: it eliminated composi-
tion, arrangement, relationships,
light—all this silly talk about line,
color and form—because that was
the thing I wanted to get hold of. I
put it in the center of the canvas
because there was no reason to put
it a bit on the side. So I thought I
might as well stick to the idea that it's
got two eyes, a nose and mouth and
neck."

276. Willem de Kooning. *A Tree in
Naples.* 1960. Oil on canvas. 6'8¼" x
70⅛" (203.7 x 178.1 cm). The Sidney and
Harriet Janis Collection

277. Willem de Kooning. *Pirate*
(Untitled II). 1981. Oil on canvas. 7'4"
x 6'4¾" (223.4 x 194.4 cm). Sidney and
Harriet Janis Collection Fund

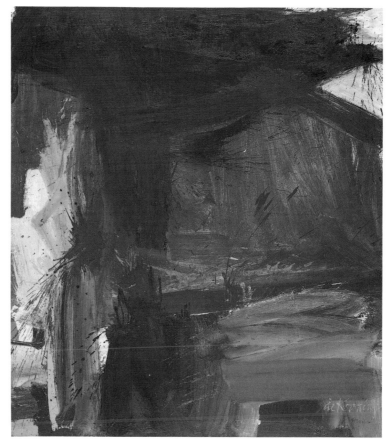

276

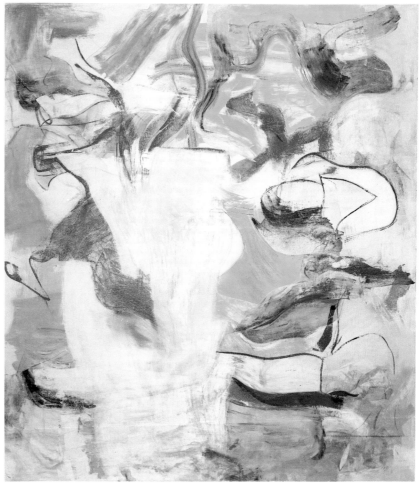

277

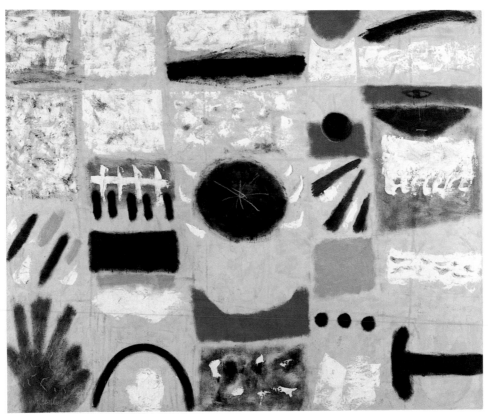

278

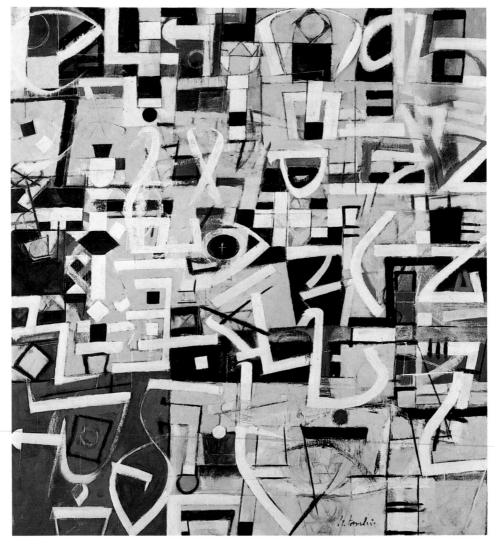

279

278. Adolph Gottlieb. *Tournament.* 1951. Oil on canvas. 60⅛ x 72⅛" (152.6 x 183 cm). Promised gift of Esther Gottlieb

279. Bradley Walker Tomlin. *Number 20.* 1949. Oil on canvas. 7'2" x 6'8¼" (218.5 x 203.9 cm). Gift of Philip Johnson

280. Adolph Gottlieb. *Descending Arrow.* 1956. Oil on canvas. 8 x 6' (243.5 x 182.4 cm). Gift of the artist

In this picture Gottlieb has taken one of the more familiar signs from his earlier pictographic series and presented it as a monumental black form against a terra-cotta background. The boldness of the conceit and the scale of its execution have affinities with the calligraphy—writ large—of Kline's more architectural paintings. But there is also in *Descending Arrow* a subtlety in the transition from terra-cotta to pink and a delicacy in the picture's execution that remind us of Gottlieb's youthful apprenticeship at the altar of Matisse.

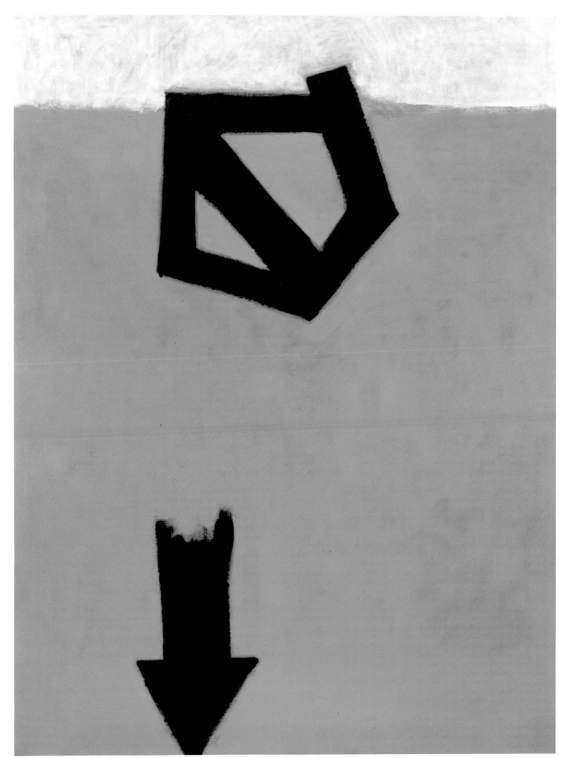

280

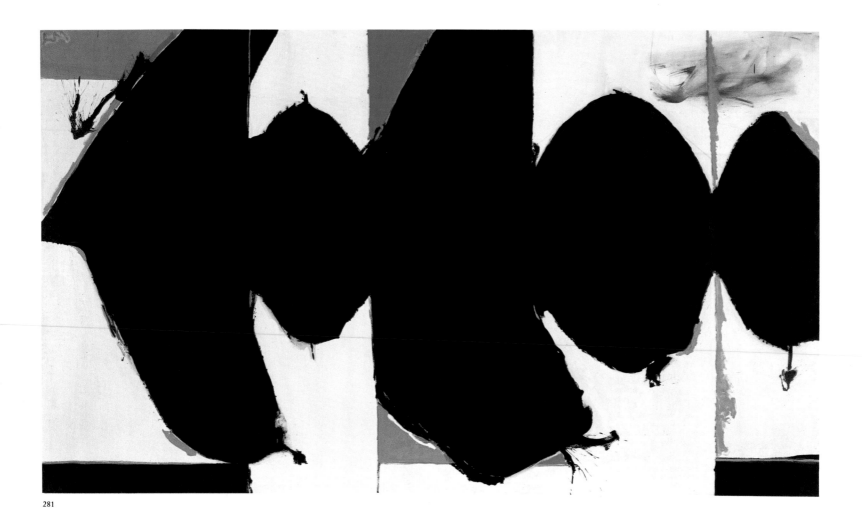

281

281. Robert Motherwell. *Elegy to the Spanish Republic, 108*. 1965–67. Oil on canvas. 6′10″ x 11′6¼″ (208.2 x 351.1 cm). Charles Mergentine Fund

Between 1948 and 1967 Motherwell completed more than a hundred paintings in which the violent ritual of the bullring is evoked in black rectangular and ovoid shapes against white. He has related these forms to the practice of displaying the dead bull's testicles after the corrida. Remarking on Motherwell's relationship with the art of Miró, Matisse, and Picasso, as well as his affinity to color-field abstraction, Irving Sandler wrote, "In sum, *Elegies* are an original synthesis in an immediate and monumental form of all the qualities Motherwell valued in modern art: symbolism, flatness, sensuousness, automatism, biomorphism, and abstraction." In this particular Elegy, the sensuous use of

green and umber, the openness and easy breathing of the composition, and the sense of the laureate hand of the painter combine to produce a détente from the tragedy and economy of earlier Elegies that points to the sunlight and Matissean transparency of Motherwell's later Open series.

282. Philip Guston. *The Clock.* 1956–57. Oil on canvas. 6'4" x 64⅛" (193.1 x 163 cm). Gift of Mrs. Bliss Parkinson

Guston brought to the new Abstract Expressionist style of his day a searching intellect and poetic pictorialism. In this picture, his loaded and slow-moving brushstrokes suspend and visibly prolong the painting gesture, creating strongly felt abstract metaphors for doubt and resolution, disquiet and calm, through sensitive elaboration of the forms. Guston's earliest mature pictures owed more to the Impressionist than to the Expressionist tradition, but by the time he made this work, he was exploring the possibilities of organic associations with color shapes that appear to expand and shrink, with an intimacy and concern for the delicacies of touch that recall Vuillard.

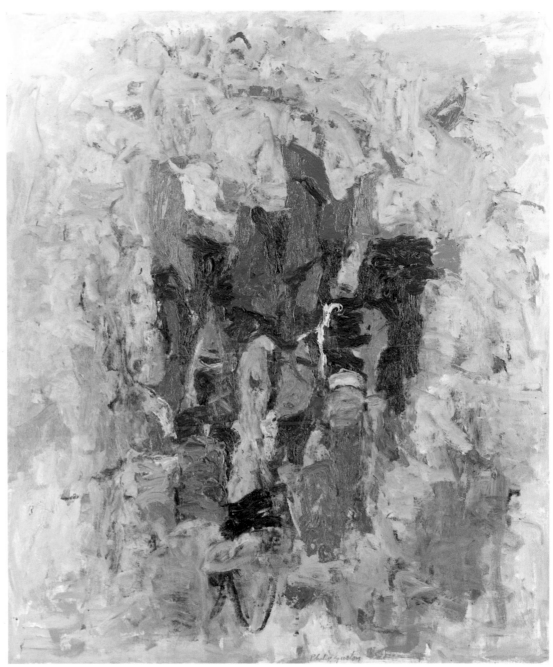

282

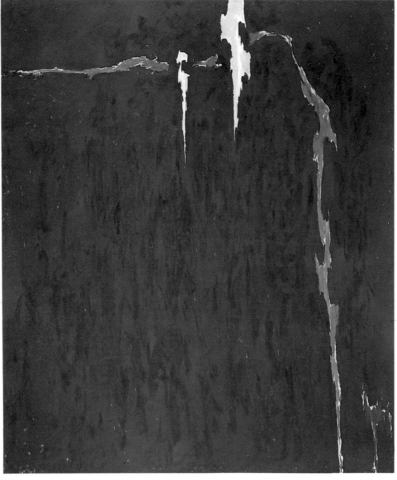

283

283. Clyfford Still. *Painting, 1944.*
Dated by the artist 1944. Oil on canvas.
8'8¼" x 7'3¼" (264.5 x 221.4 cm). The
Sidney and Harriet Janis Collection

Of all the major Abstract Expressionist painters, Still was the one
least directly influenced by Cubist
conceptions of organizing the surface. Like many of Still's other
mature works, this picture has a
roughly applied, almost tarlike surface which, even more than its counterparts in Dubuffet's Mirobolus,
Macadam et Cie series, makes no
concession to received ideas of pictorial beauty. A jagged red line cuts
across this black expanse from the
upper left of the image and slams
downward into the bottom framing
edge like a lightning bolt, itself
deflected by the two jagged, yellow-
white forms that crash through it at
the top center of the image.

284. Clyfford Still. *Painting.* 1951.
Oil on canvas. 7'10" x 6'10" (238.8 x
208.3 cm). Blanchette Rockefeller Fund

285. Franz Kline. *Painting Number 2.*
1954. Oil on canvas. 6'8½" x 8'9"
(204.3 x 271.6 cm). Mr. and Mrs.
Joseph H. Hazen and Mr. and Mrs.
Francis F. Rosenbaum Funds

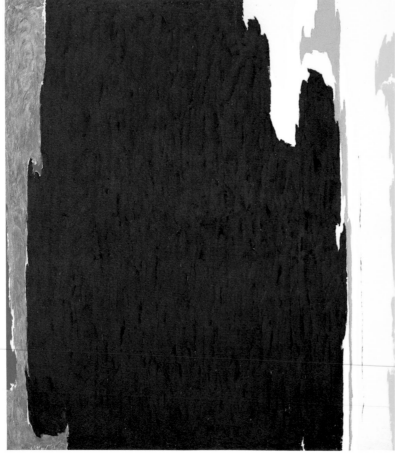

284

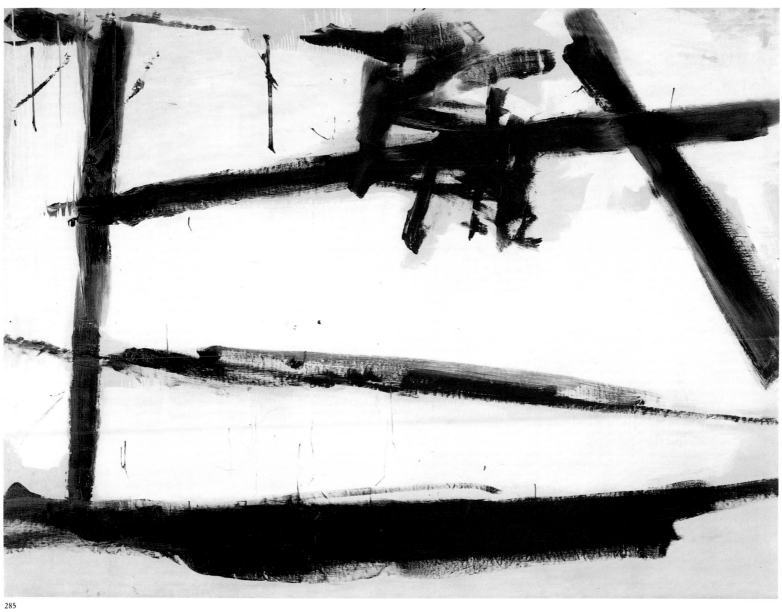

285

286

287

286. David Smith. *Australia*. 1951.
Painted steel. 6'7½" x 8'11⅞" x 16⅛"
(202 x 274 x 41 cm), at base 14 x 14"
(35.6 x 35.6 cm). Gift of William Rubin

Smith quite rightly saw himself as
the traditional heir to Picasso's free-
standing linear sculpture, which
Smith knew only in photographs,
though he was familiar with the
Picasso-inspired sculptures of
Gonzalez. In Smith's linear pieces of
the fifties such as *Australia* the
"drawing" has a range, flexibility,
and power—derived partially from
Smith's training as a welder and his
extraordinary physical strength
—that went beyond the Picasso/
Gonzalez models. His works are
the counterparts of the Abstract
Expressionist painting of his day.
According to Rosalind Krauss, this
sculpture depicts a kangaroo, the
aboriginal totem animal of Aus-
tralia, but in its final form it strikes
us as a lyrical adventure in abstract
drawing.

287. David Smith. *History of LeRoy
Borton*. 1956. Steel. 7'4¼" x 26¾" x 24½"
(224.1 x 67.9 x 62.2 cm). Mrs. Simon
Guggenheim Fund

288. David Smith. *Cubi X*. 1963. Stain-
less steel. 10'1⅜" x 6'6¾" x 24" (308.3 x
199.9 x 61 cm), including steel base 2⅞ x
25 x 23" (7.3 x 63.4 x 58.3 cm). Robert O.
Lord Fund

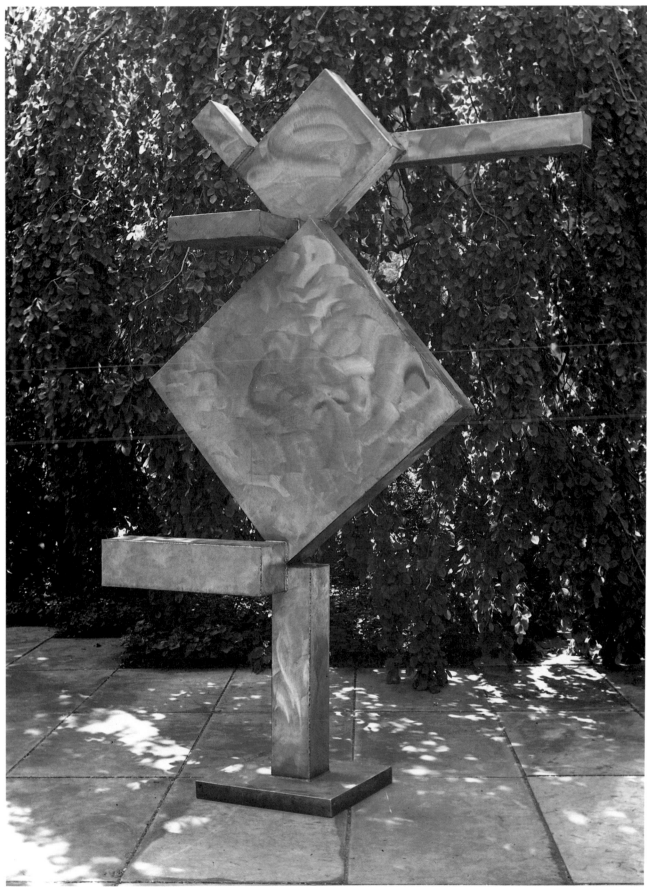

288

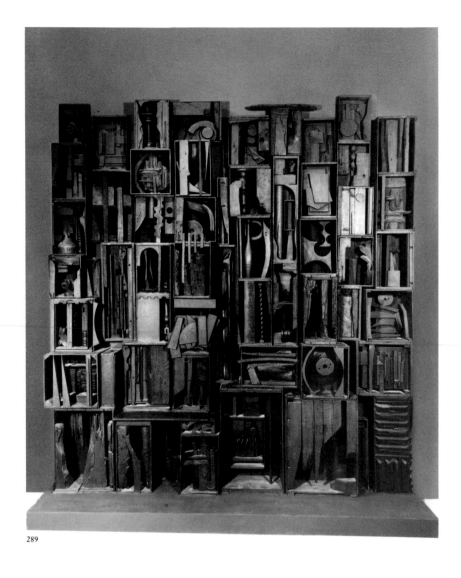

289

289. Louise Nevelson. *Sky Cathedral.* 1958. Assemblage: wood construction painted black. 11′3½″ x 10′¼″ x 18″ (343.9 x 305.4 x 45.7 cm). Gift of Mr. and Mrs. Ben Mildwoff

290. Mark Tobey. *Edge of August.* 1953. Casein on composition board. 48 x 28″ (121.9 x 71.1 cm). Purchase

291. Sam Francis (Samuel Lewis Francis). *Towards Disappearance, II.* 1958. Oil on canvas. 9′1½″ x 10′5⅞″ (275.6 x 319.7 cm). Blanchette Rockefeller Fund

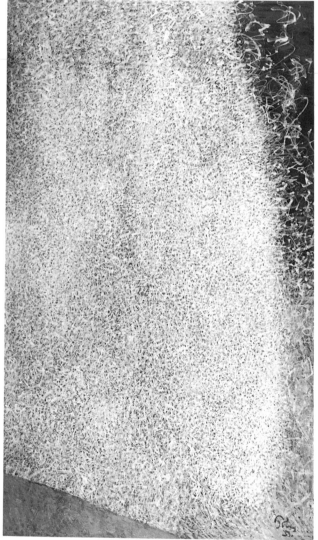

290

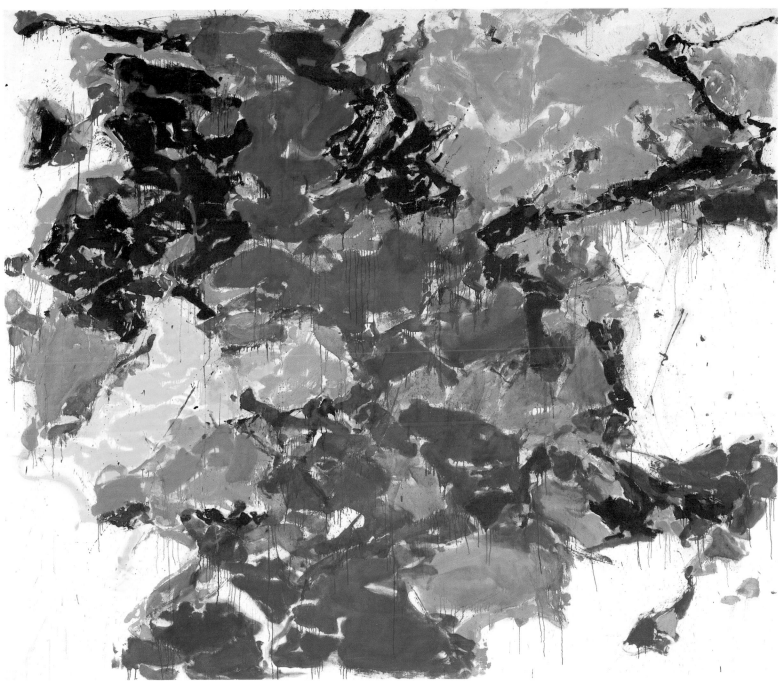

291

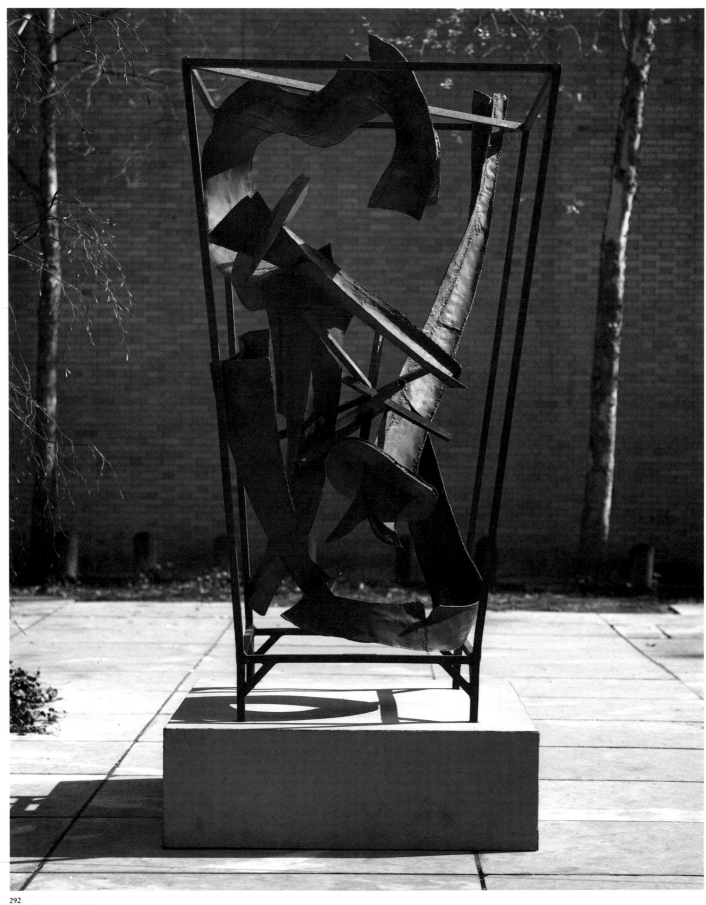

292

292. Herbert Ferber. *Homage to Piranesi, I.* 1962–63. Welded and brazed sheet copper and brass tubing. 7'7¼" x 48¾" x 48" (231.8 x 123.8 x 121.7 cm). Given anonymously

293. Louise Bourgeois. *Sleeping Figure.* 1950. Balsa wood. 6'2½" (189.2 cm) high. Katharine Cornell Fund

294. Isamu Noguchi. *Stone of Spiritual Understanding.* 1962. Bronze suspended on square wood bar set on metal supports. 52¼ x 48 x 16" (132.6 x 121.9 x 40.4 cm). Gift of the artist

295. Seymour Lipton. *Manuscript.* 1961. Brazed bronze on monel metal. 60⅜" x 7'1⅛" x 37⅛" (153.3 x 213.7 x 94.2 cm). Mrs. Simon Guggenheim Fund

293

294

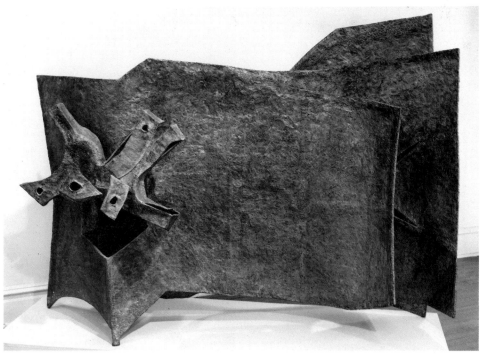

295

296

296. Hans Hofmann. *Cathedral.* 1959. Oil on canvas. 74¼ x 48¼" (188.5 x 123.9 cm). Promised gift of an anonymous donor

297. Hans Hofmann. *Memoria in Aeternum.* 1962. Oil on canvas. 7' x 6' ⅛" (213.3 x 183.2 cm). Gift of the artist

297

298

298. Ad Reinhardt. *Number 107*. 1950.
Oil on canvas. 80 x 36″ (203.2 x 91.4
cm). Gift of Mrs. Ad Reinhardt

299. Ad Reinhardt. *Abstract Painting,
Red*. 1952. Oil on canvas. 9′ x 40″ (274.3
x 101.4 cm). Promised gift of Mr. and
Mrs. Gifford Phillips

299

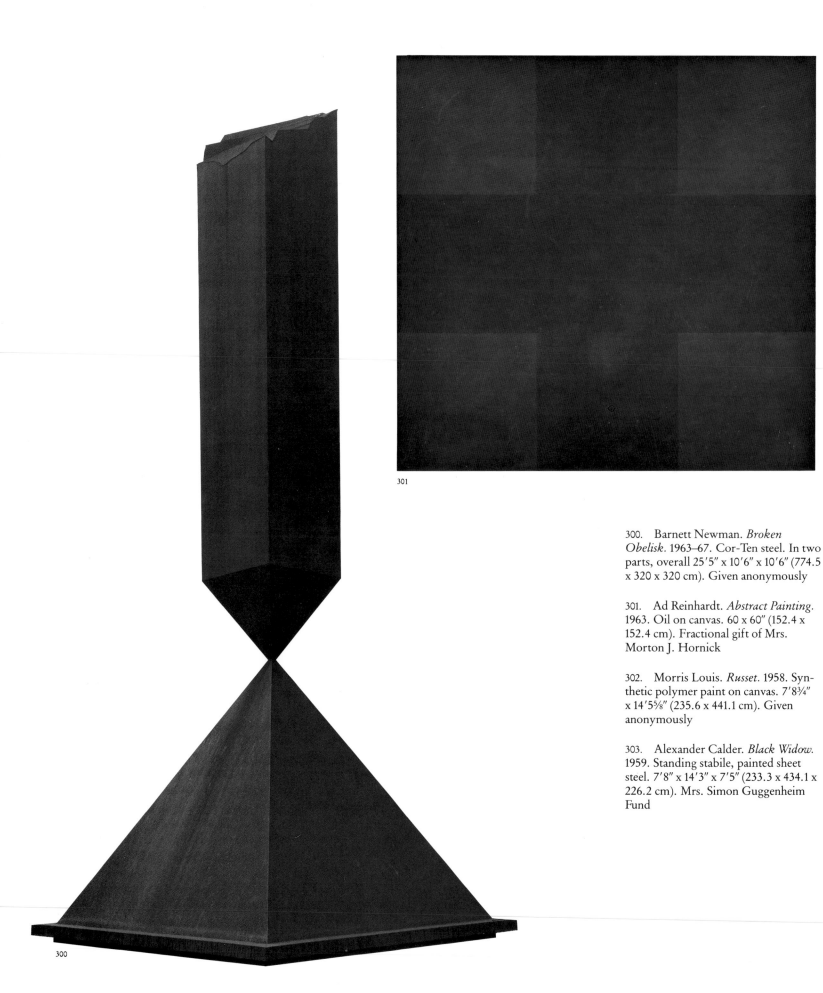

301

300

300. Barnett Newman. *Broken Obelisk*. 1963–67. Cor-Ten steel. In two parts, overall 25′5″ x 10′6″ x 10′6″ (774.5 x 320 x 320 cm). Given anonymously

301. Ad Reinhardt. *Abstract Painting*. 1963. Oil on canvas. 60 x 60″ (152.4 x 152.4 cm). Fractional gift of Mrs. Morton J. Hornick

302. Morris Louis. *Russet*. 1958. Synthetic polymer paint on canvas. 7′8¾″ x 14′5⅝″ (235.6 x 441.1 cm). Given anonymously

303. Alexander Calder. *Black Widow*. 1959. Standing stabile, painted sheet steel. 7′8″ x 14′3″ x 7′5″ (233.3 x 434.1 x 226.2 cm). Mrs. Simon Guggenheim Fund

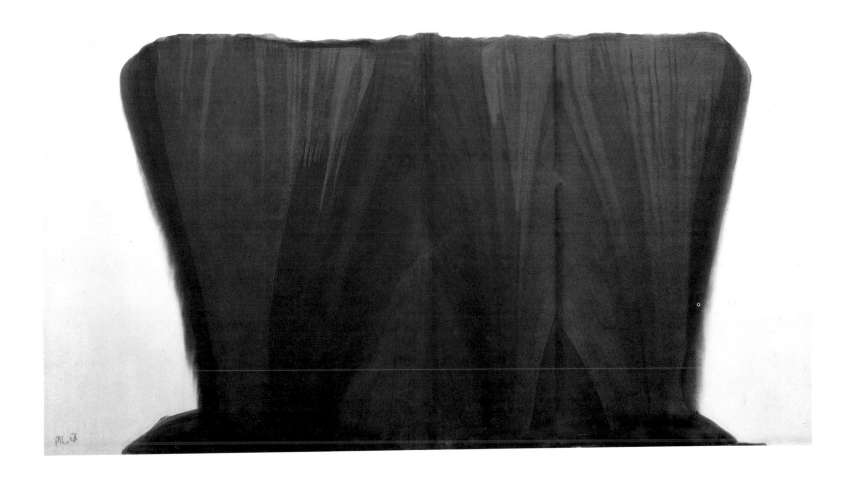

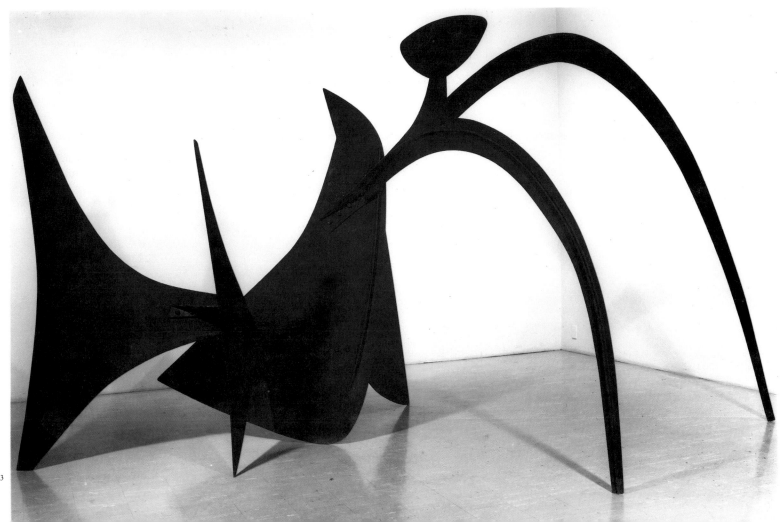

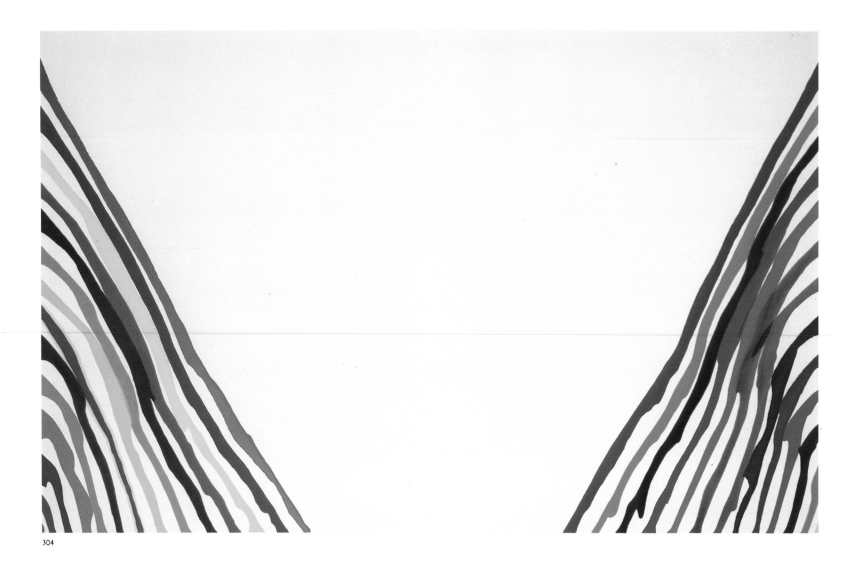

304

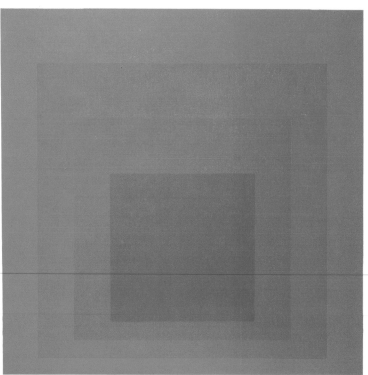

305

304. Morris Louis. *Beta Lambda.* 1960.
Synthetic polymer paint on canvas. 8'7"
x 13'4" (262.6 x 407 cm). Gift of Mrs.
Abner Brenner

Though born in the same year as
Pollock and therefore of the Abstract
Expressionist generation, Louis
emerged in the fifties in conjunction
with a movement away from the
more painterly forms of Abstract
Expressionism in favor of color
fields and more rigorous drawing.
Nevertheless, Louis's shimmering
Veils of the fifties constitute the last
major authentic vision in Abstract
Expressionism's essentially poetic
vein; his Stripes, on the other hand,
belong just as securely to the work

of the younger generation of 1960. *Beta Lambda* is one of a large group of Unfurleds, characterized by loosely spilled woven lines of pure color which move diagonally between the bottom and the sides of the canvas on the left and right. These pictures may be thought of as mediating between the two previously mentioned poles of his development. In their irregular, poured contours these streams of color reach back to Louis's Abstract Expressionist roots, but the manner in which they collectively resonate the large expanse of unpainted canvas daringly left in the center anticipated the radical optical adventures of the younger generation.

305. Josef Albers. *Homage to the Square: Broad Call.* 1967. Oil on composition board. 48 x 48″ (121.9 x 121.9 cm). The Sidney and Harriet Janis Collection

306. Mark Rothko. *Magenta, Black, Green on Orange.* 1949. Oil on canvas. 7′1⅜″ x 65″ (216.5 x 164.8 cm). Bequest of Mrs. Mark Rothko

307. Mark Rothko. *Red, Brown and Black.* 1958. Oil on canvas. 8′10⅝″ x 9′9¼″ (270.8 x 297.8 cm). Mrs. Simon Guggenheim Fund

The soft and luminous, roughly rectangular planes of close-valued dark color in this picture are formed by multiple overlays of turpentine-thinned washes that create a flickering illumination which dematerializes the forms in a mysterious, almost Byzantine manner. Like Pollock's vision in his poured paintings, Rothko's constituted an approach to "the sublime," although for him it was through the poetic and apocalyptic possibilities of monumental color fields rather than by drawing with paint.

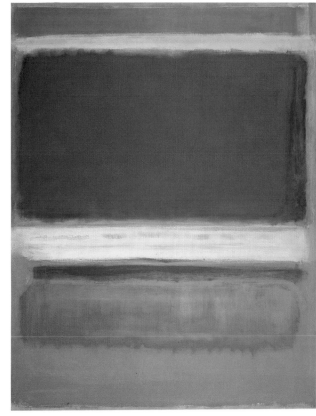

306

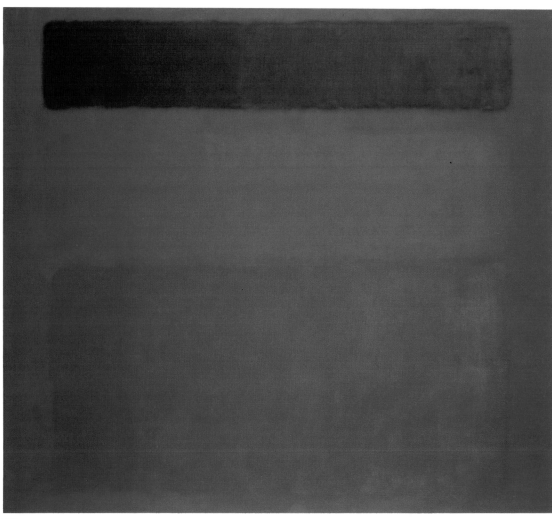

307

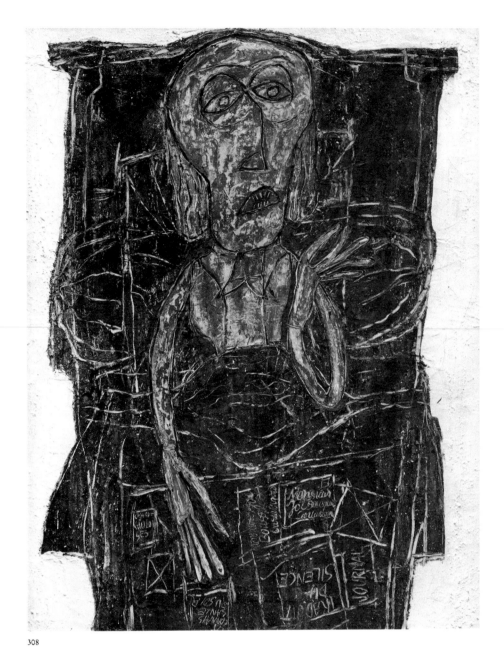

308

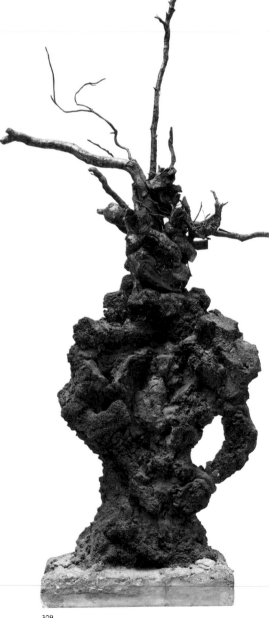

309

308. Jean Dubuffet. *Joë Bousquet in Bed*. 1947. Oil emulsion in water on canvas. 57⅝ x 44⅞" (146.3 x 114 cm). Mrs. Simon Guggenheim Fund

Dubuffet was a seminal figure in the creation of an almost primitivistic representational painting that took place simultaneously with the celebration of a new, totally abstract art on the part of the Abstract Expressionists and early color-field painters. In his often cruel and somehow hilarious portraits of the forties, such as *Joë Bousquet in Bed*, there was an element of sinister farce whose dark psychic undertones found an echo in the inanities and wild caricature of the writings of his friend, the playwright Eugene Ionesco. Dubuffet's strangely vital, gnomic illustration took as its conscious model the art of children, the insane, and the artistically naive, which he himself systematically collected under the rubric *l'art brut*. Whether in wall graffiti, pathological art, or primitivistic expressions, Dubuffet's astonishingly diverse formal explorations took the human situation, rather than the directly expressive possibilities of pure painting, as their point of departure.

309. Jean Dubuffet. *The Magician*. 1954. Slag and roots. 43½" (109.8 cm) high, including slag base 2¾ x 12¾ x 8" (6.8 x 32.2 x 20.2 cm). Gift of Mr. and Mrs. N. Richard Miller, and Mr. and Mrs. Alex L. Hillman and Samuel Girard Funds

310. Jean Dubuffet. *Corps de Dame: La Juive*. 1950. Oil on canvas. 45¾ x 35" (116.2 x 88.7 cm). Gift of Pierre Matisse

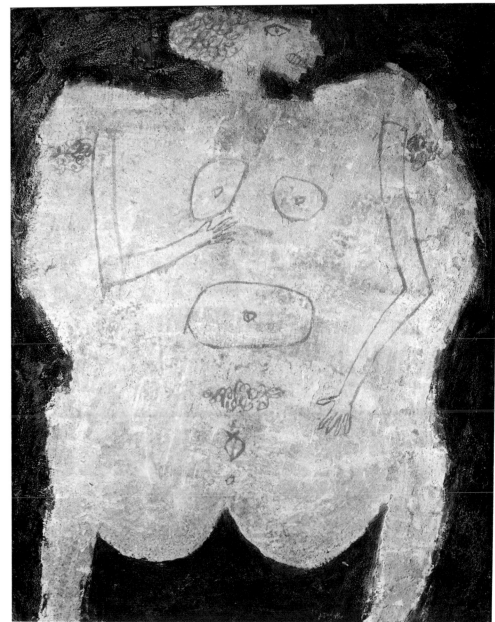

310

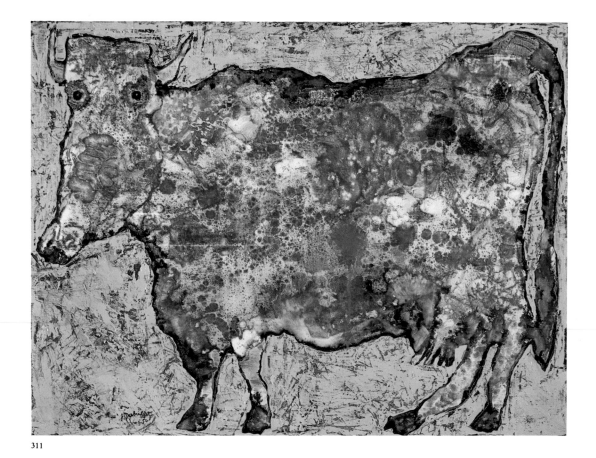

311

312

311. Jean Dubuffet. *The Cow with the Subtile Nose.* 1954. Oil and enamel on canvas. 35 x 45¾" (88.9 x 116.1 cm). Benjamin Scharps and David Scharps Fund

312. Jean Dubuffet. *Texturology.* 1958. Oil on canvas. 35 x 46" (88.9 x 116.8 cm). Promised gift of Richard S. Zeisler

313. Barnett Newman. *Onement, III.* 1949. Oil on canvas. 71⅞ x 33½" (182.5 x 84.9 cm). Gift of Mr. and Mrs. Joseph Slifka

314. Barnett Newman. *Vir Heroicus Sublimis.* 1950–51. Oil on canvas. 7'11⅜" x 17'9¼" (242.2 x 513.6 cm). Gift of Mr. and Mrs. Ben Heller

Newman's significant innovations are vividly experienced in the immense red color field of this painting, a colossal work that deals with pictorial decorum in a radically new way. The familiar agitated spatial movement, flux, and calligraphic signs of Abstract Expressionist painting have given way to a single grand and solemn color field dominated by one high-keyed color "resonated" by five fine vertical bands. The fragile and oscillating stripes play tricks on the eye, as they alternate between intense brightness and a subliminal visibility, producing the effect of ethereal afterimages whose optical flicker subverts the initially geometric sense of the spatial structure.

313

314

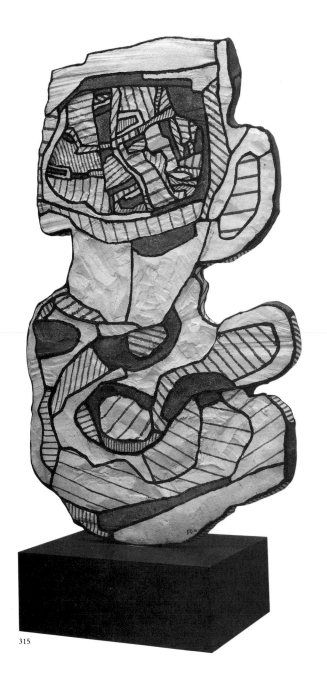

315

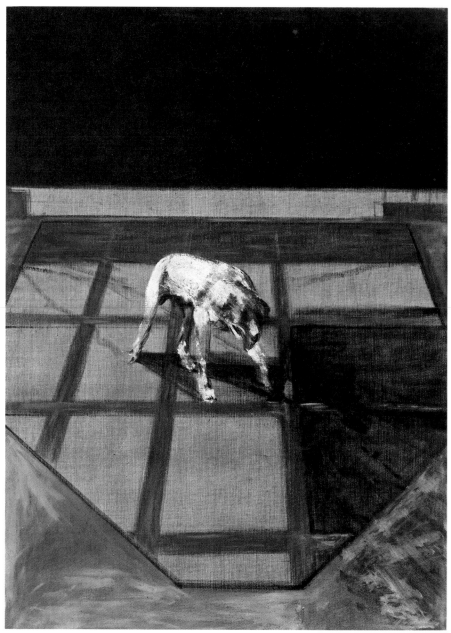

316

315. Jean Dubuffet. *Cup of Tea, II.* 1966. Cast polyester resin and cloth with synthetic polymer paint. 6'5⅞" x 46¼" x 3¾" (197.8 x 117.3 x 9.5 cm). Gift of Mr. and Mrs. Lester Avnet

316. Francis Bacon. *Dog.* 1952. Oil on canvas. 6'6¼" x 54¼" (198.7 x 137.8 cm). William A. M. Burden Fund

317. Francis Bacon. *Number VII from Eight Studies for a Portrait.* 1953. Oil on canvas. 60 x 46⅛" (152.3 x 117 cm). Gift of Mr. and Mrs. William A. M. Burden

318. Wols (Otto Alfred Wolfgang Schulze). *Painting.* 1944–45. Oil on canvas. 31⅞ x 32" (81 x 81.1 cm). Gift of Dominique and John de Menil

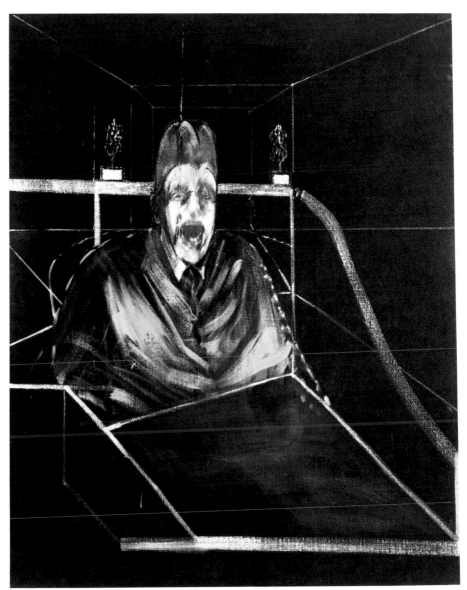

317

318

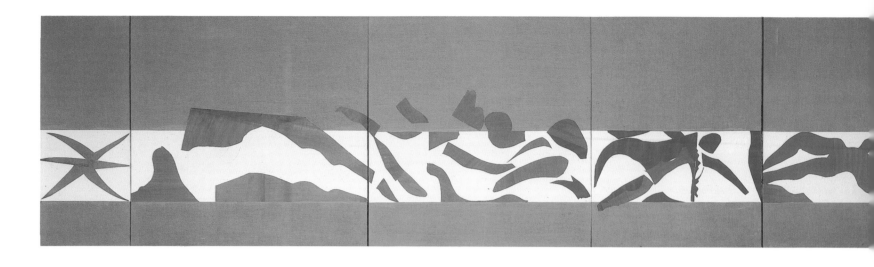

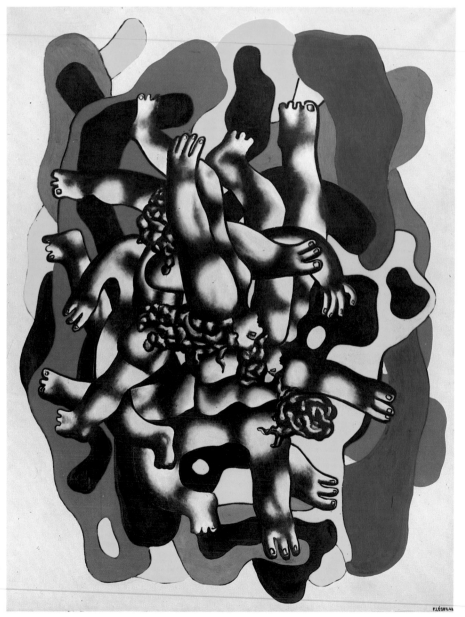

319. Fernand Léger. *The Divers, II*. 1941–42. Oil on canvas. 7'6" x 68" (228.6 x 172.8 cm). Mrs. Simon Guggenheim Fund

With paintings such as this, executed during World War II, Léger initiated a new, relaxed public style. He was consciously seeking a more "intelligible" popular art, but without compromising his formal standards. Léger made a notably successful effort in his paintings of the late thirties and forties to adapt his earlier visual poems to the machine to modern genre themes showing ordinary laborers on construction jobs or on family outings. He portrayed humanity in a more simplistic but nevertheless grave and monumental fashion. Painted while he was in exile in the United States, *The Divers, II* was inspired by an earlier experience of seeing young men diving into the Mediterranean at Marseilles.

319

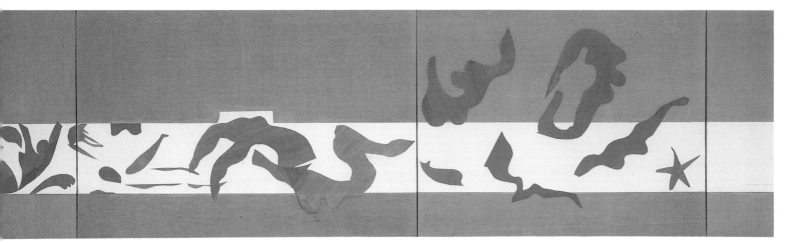

320. Henri Matisse. *The Swimming Pool.* 1952. Gouache on cut-and-pasted paper on burlap. Nine-panel mural in two parts: 7′6⅝″ x 27′9½″ (230.1 x 847.8 cm); 7′6⅝″ x 26′1½″ (230.1 x 796.1 cm). Mrs. Bernard F. Gimbel Fund

The Swimming Pool is one of the largest of Matisse's cutouts and his most ambitious, summarizing major thematic and formal preoccupations of a lifetime. Its personal meaning to the artist was emphasized by the fact that it was not a commission but made for his own pleasure to decorate the dining-room walls in his apartment in Nice, where he spent his last years confined to a wheelchair and bed. The two-part, room-sized frieze is composed of blue gouache on cut paper pasted onto heavy white paper and mounted on burlap (the burlap approximates the effect produced by the beige walls to which the work was initially fixed). Matisse's bold silhouettes create a refreshing effect of splashing water and nubile forms rendered with an extraordinary economy.

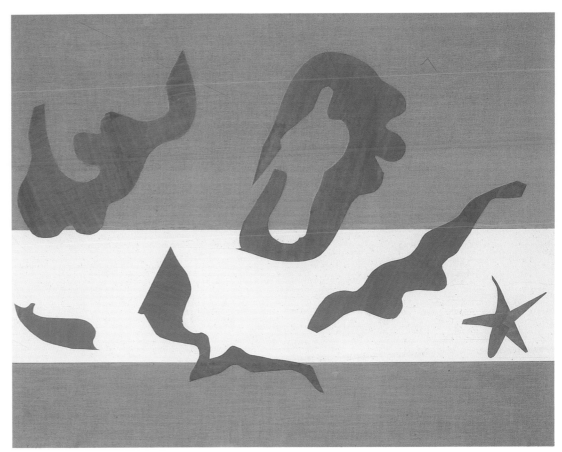

320 (detail)

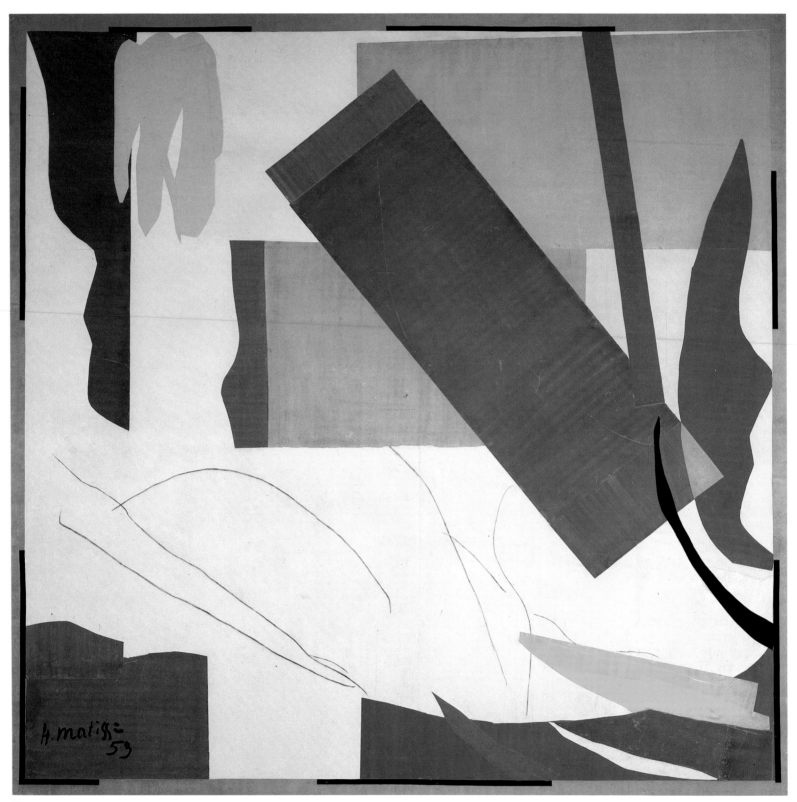

321

321. Henri Matisse. *Memory of Oceania*. 1953. Gouache and crayon on cut-and-pasted paper over canvas. 9'4" x 9'4⅞" (284.4 x 286.4 cm). Mrs. Simon Guggenheim Fund

This monumental paper cutout was completed just a year before the artist's death in 1954. It is more abstract than the Museum's other *découpage, The Swimming Pool,* in its apparently nonreferential shapes. Yet, like Matisse's other abstract forms, its imagery is related to the actual experiences of nature. In particular, it embodies a nostalgic memory of the artist's trip to Tahiti in 1931. It absorbs effects of brilliant light and color into an image of unusual formal rigor and monumentality, thus recalling the structural power of his Cubist-influenced work such as *Piano Lesson.*

322. Joan Miró. *The Song of the Vowels*. 1966. Oil on canvas. 12'1⅛" x 45¼" (336 x 114.8 cm). Mrs. Simon Guggenheim Fund, special contribution in honor of Dorothy C. Miller

This monumental painting is almost unprecedented in format and style in Miró's oeuvre. The title and veiled iconography have been associated with his Dada/Surrealist work of the late twenties when, in a number of related works, his inventions of graphic signs were conceived as the visual equivalents and elaborations of Arthur Rimbaud's poem, "Voyelles." *The Song of the Vowels,* however, has been divested of the pointed psychological meanings or emotional import of his earlier explorations. The forms of detached lines, color marks, and bright lozenge-like color shapes vaguely resemble, at best, shooting stars or a rain of confetti. The generous scale, formal simplicity, and sparseness of the color accents may be seen as an enlargement of ideas in Miró's earlier Constellations and suggest aspects of the postwar American color-field painting of the sixties.

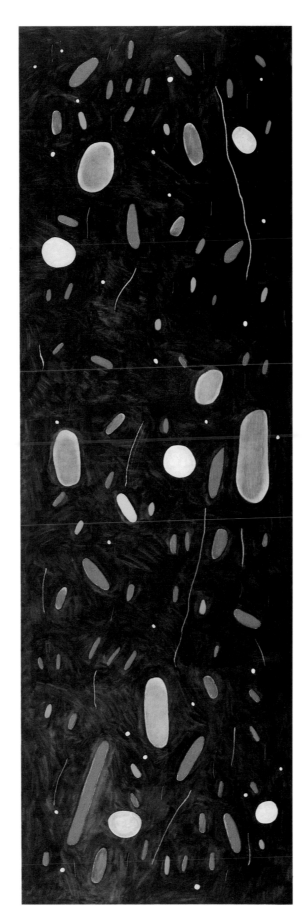

322

323

324

325

323. Nicolas de Staël. *Painting.* 1947. Oil on canvas. 6'5" x 38⅜" (195.6 x 97.5 cm). Gift of Mr. and Mrs. Lee A. Ault

324. Pierre Soulages. *January 10, 1951.* 1951. Oil on burlap. 57½ x 38¼" (146 x 97.2 cm). Acquired through the Lillie P. Bliss Bequest

325. Alberto Burri. *Sackcloth 1953.* 1953. Burlap, sewn, patched, and glued, over canvas. 33⅞ x 39⅜" (86 x 100 cm). Mr. and Mrs. David M. Solinger Fund

326. Georges Mathieu. *Montjoie Saint Denis!* 1954. Oil on canvas. 12'3⅝" x 35½" (375 x 90.2 cm). Gift of Mr. and Mrs. Harold Kaye

327

328

327. Auguste Herbin. *Composition on the word "Vie,"* 2. 1950. Oil on canvas. 57½ x 38¼" (145.8 x 97.1 cm). The Sidney and Harriet Janis Collection

328. Antoní Tàpies Puig. *Gray Relief on Black.* 1959. Latex paint with marble dust on canvas. 6'4⅝" x 67" (194.6 x 170 cm). Gift of G. David Thompson

329. Henry Moore. *Large Torso: Arch.* 1962–63. Bronze. 6'6⅛" x 59⅛" x 51¼" (198.4 x 150.2 x 130.2 cm). Mrs. Simon Guggenheim Fund

After the war Moore continued to develop the abstract reclining figures and stylized family groups that had interested him in the thirties and forties, but he also added a new vocabulary of monumental, abstract forms, combining anatomical and architectural signs and imagery in a novel fashion. Few sculptors have expressed the relationship of hollow cavities to solid form so powerfully or effectively as Moore does in this monumental sculpture. He always had a strong and deeply romantic feeling for the English countryside and for such natural forms as eroded bones and waterworn pebbles, objects shaped by time. *Large Torso: Arch* reflects his abiding concern with human content and natural forms.

329

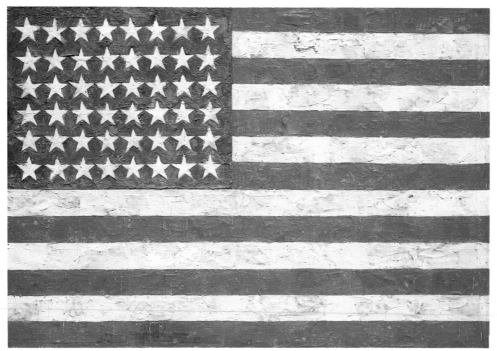

330. Jasper Johns. *Flag*. 1954–55. Encaustic, oil, and collage on fabric mounted on plywood. 42½ x 60⅝" (107.3 x 153.8 cm). Gift of Philip Johnson in honor of Alfred H. Barr, Jr.

In *Flag* Johns transformed the familiar stars-and-stripes image into a quasi-abstract painterly field, thereby confounding our received notions of what is painted illusion and what is reality. Through a complex encaustic-collage technique that absorbs newsprint into the texture of the work, effects of shading and touch force themselves upon the viewer's eye, contradicting his apprehension of the flag-painting as flat, thus reinforcing the play of formal and thematic tensions.

330

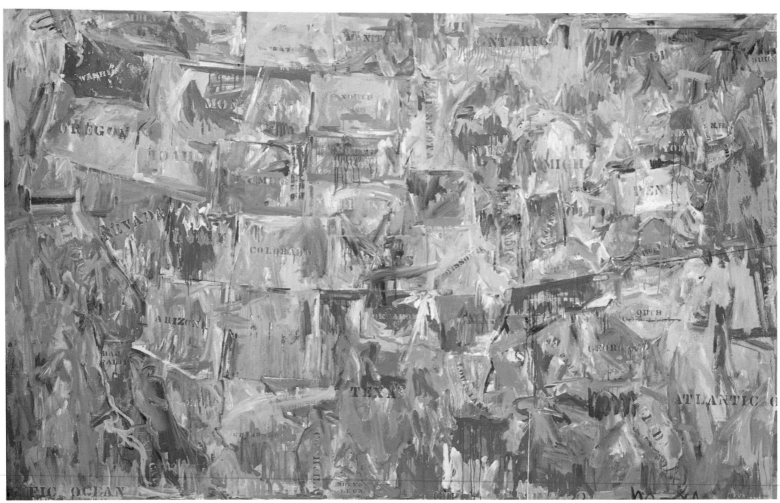

331

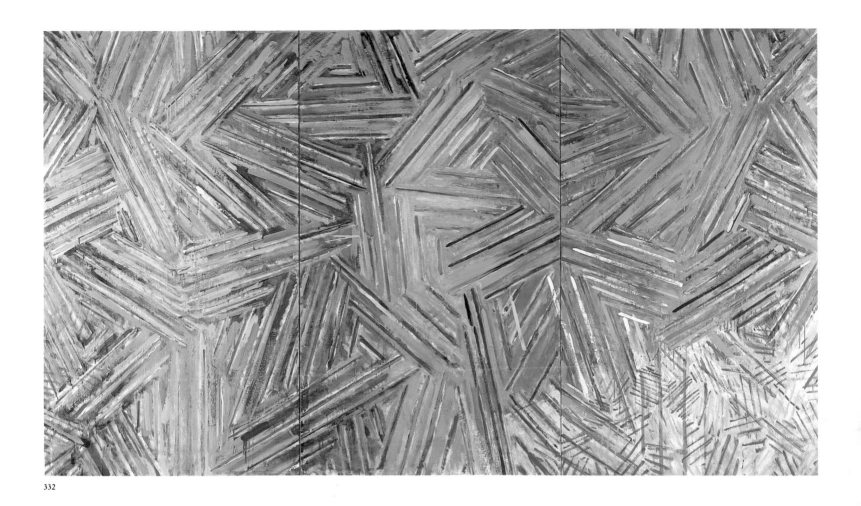

332

331. Jasper Johns. *Map.* 1961. Oil on canvas. 6'6" x 10'3⅛" (198.2 x 307.7 cm). Gift of Mr. and Mrs. Robert C. Scull

332. Jasper Johns. *Between the Clock and the Bed.* 1981. Encaustic on canvas. Three panels, overall 6'1⅛" x 10'6⅜" (183.4 x 302.2 cm); each panel 72⅛ x 42⅛" (183.4 x 107.1 cm). Gift of Agnes Gund

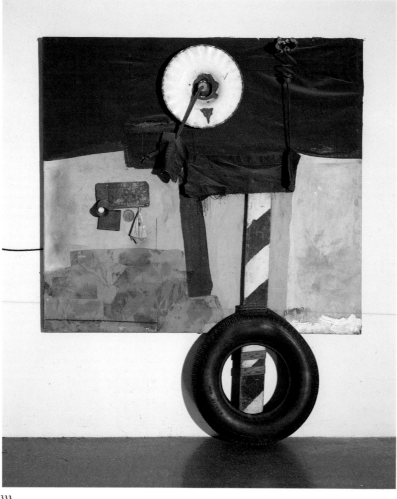

333

333. Robert Rauschenberg. *First Landing Jump*. 1961. "Combine painting": cloth, metal, leather, electric fixture, cable, and oil paint on composition board. Overall, including automobile tire and wooden plank on floor, 7'5⅛" x 6' x 8⅞" (226.3 x 182.8 x 22.5 cm). Gift of Philip Johnson

Building upon cues from Schwitters and de Kooning, Rauschenberg in his innovative assemblages did as much to transform the character of American art in the middle and late fifties as any other artist. Here, the obtrusive and blatant use of sub-aesthetic materials calls into question the traditional hierarchy of distinctions between the mediums of the fine arts and the extra-artistic materials drawn from the urban refuse heap—a rubber tire, a traffic marker, a rusted license plate, and an eerie, blue, functioning light bulb. Thrown together with Abstract Expressionist gusto, these elements nevertheless work harmoniously as color notes, compositional accents, and texture, but their material presence and identities can never be forgotten or ignored.

334. Robert Rauschenberg. *Franciscan, II.* 1972. Assemblage: fabric, resin-treated cardboard, transparent tape on plywood support, string, and stone. 7'3" x 9'8" x 47½" (221 x 294.7 x 120.7 cm) (variable). Kay Sage Tanguy Fund

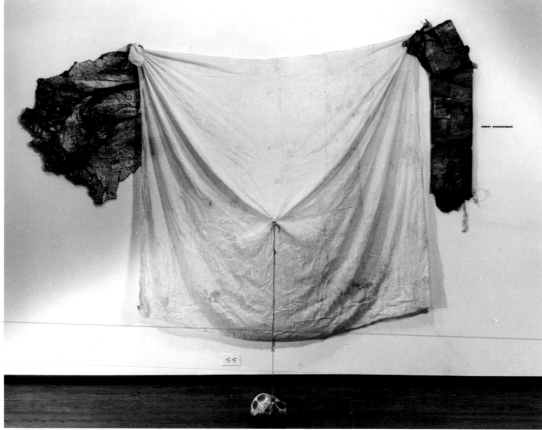

334

335. Larry Rivers. *The Last Civil War Veteran*. 1959. Oil and charcoal on canvas. 6'10½" x 64⅛" (209.6 x 162.9 cm). Blanchette Rockefeller Fund

336. Richard Diebenkorn. *Ocean Park 115*. 1979. Oil on canvas. 8'4¼" x 6'9⅛" (254.5 x 205.7 cm). Mrs. Charles G. Stachelberg Fund

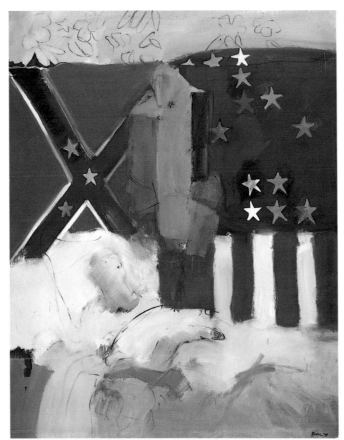

335

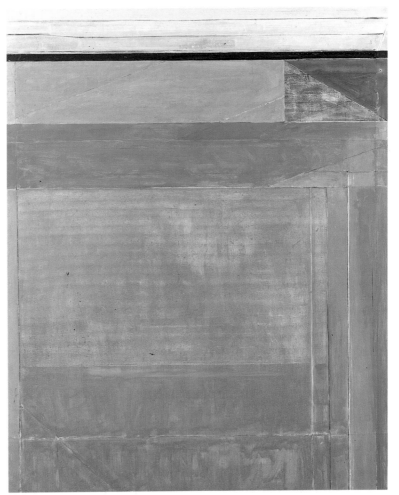

336

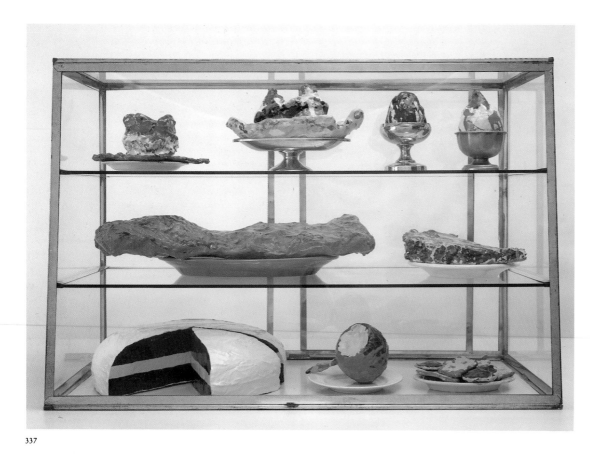

337. Claes Oldenburg. *Pastry Case, I.* 1961–62. Enamel paint on nine plaster sculptures in glass showcase. 20¾ x 30⅛ x 14¾″ (52.7 x 76.5 x 37.3 cm). The Sidney and Harriet Janis Collection

This work belongs to Oldenburg's Store period when the artist produced unlikely facsimiles of commercial products and foods from plaster, papier-mâché, cardboard, and cloth and displayed them in his storefront studio, which opened in the winter of 1962–63 on the Lower East Side in New York City. Retained in this work are elements of both Surrealism and Abstract Expressionism. The pastry case and dishes are, for example, Duchampian Readymades, but the foodstuffs are roughly modeled and spontaneously colored illusions of real and fake pastries made for display in restaurant vitrines. As Barbara Rose has pointed out, "Oldenburg completely accepted and extended the basic premise of Abstract Expressionism—which was itself a further

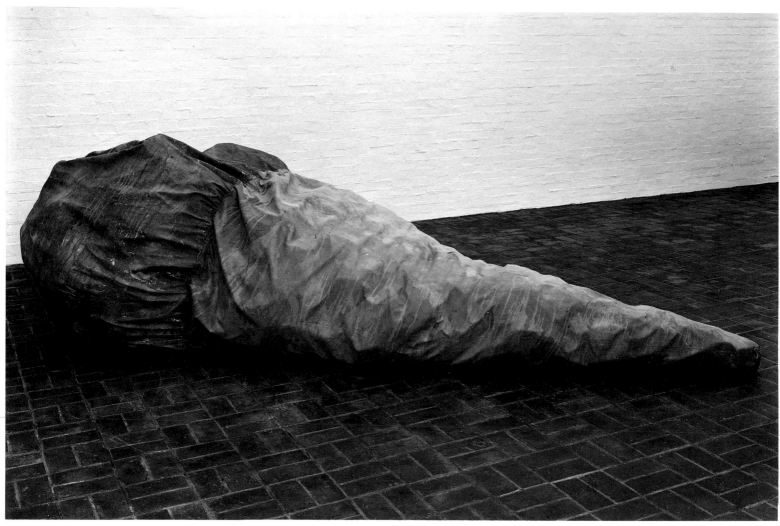

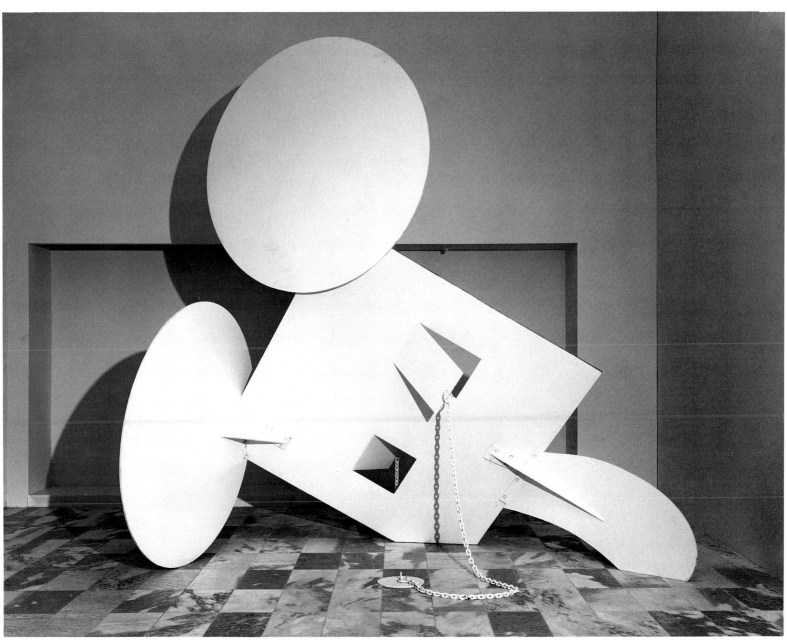

339

extension of Mondrian's literal view of the art object as a thing in itself, rather than an imitation of an object or idea at one remove from reality."

338. Claes Oldenburg. *Floor Cone.* 1962. Synthetic polymer paint on canvas filled with foam rubber and cardboard boxes. 53¾" x 11'4" x 56" (136.5 x 345.4 x 142 cm). Gift of Philip Johnson

339. Claes Oldenburg. *Geometric Mouse—Scale A.* 1975. Painted steel and aluminum. 12'1½" x 12'6" x 14'10¼" (369.6 x 381 x 452.8 cm). Blanchette Rockefeller Fund

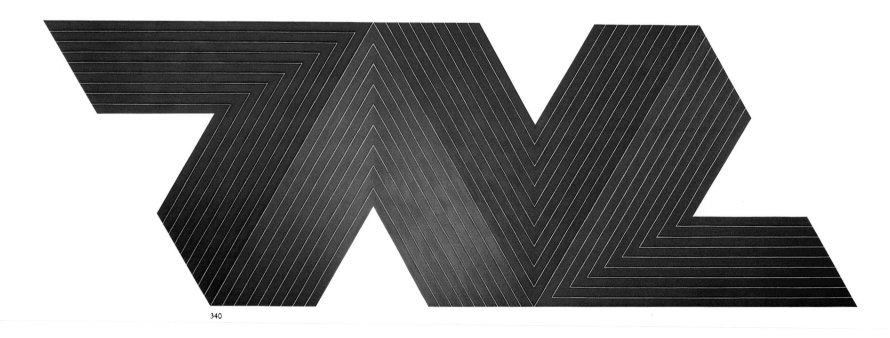

340

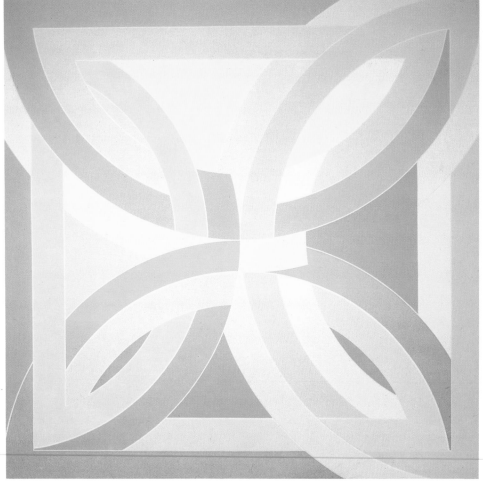

341

340. Frank Stella. *Empress of India.* 1965. Metallic powder on canvas. 6′5″ x 18′8″ (195.6 x 569 cm). Fractional gift of S. I. Newhouse, Jr.

341. Frank Stella. *Abra Variation I.* 1969. Fluorescent alkyd paint on canvas. 10′ x 9′11⅞″ (305 x 304.5 cm). Gift of Philip Johnson in honor of William Rubin

342

342. Ellsworth Kelly. *Spectrum, III.*
1967. Oil on canvas in thirteen parts.
Overall 33¼" x 9'5⅝" (84.3 x 275.7 cm).
The Sidney and Harriet Janis Collection

343. Frank Stella. *Kastūra.* 1979. Oil
and epoxy on aluminum, wire mesh.
9'7" x 7'8" x 30" (292 x 233.5 x 76.1 cm)
(irregular). Acquired through the Mr.
and Mrs. Victor Ganz, Mr. and Mrs.
Donald H. Peters, and Mr. and Mrs.
Charles Zadok Funds

This large construction in aluminum
and wire mesh is built to project well
off the wall. Its complex surfaces are
covered with scrawling paint marks
and linear signs reminiscent of sub-
way graffiti, even to the reflective
paint. While the color choices also
recall at a distance the glitz of Las
Vegas imagery, these allusions to the
emotive calligraphy of Abstract
Expressionism, to vernacular street
art, and to the Pop landscape are
under a mediating formal control
imposed by interrelating standard-
ized shapes taken from French
curves and other devices of the draft-
ing board. The overlays of free writ-
ing and color on the wildly scalloped
aluminum surfaces, moving freely in
spatial depth, create an extraordi-
nary baroque rhythm of in-and-out
movement, fragmented and then
rhythmically unified to form expan-
sive, billowing spaces in a new and
dramatic plastic mode of great
power.

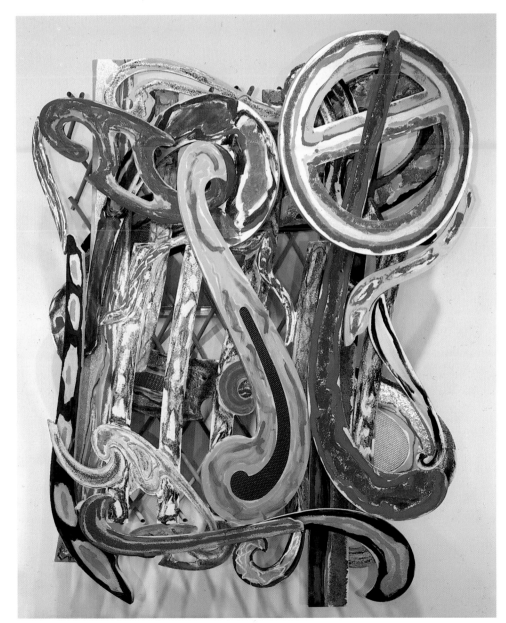

343

344

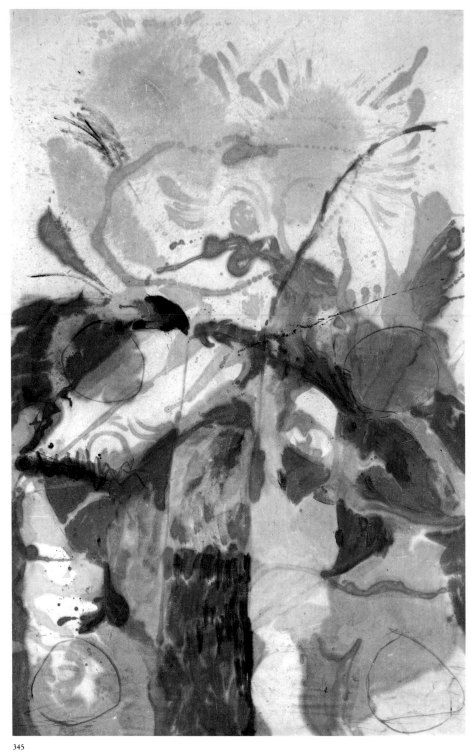

345

344. Ellsworth Kelly. *Brooklyn Bridge, VII*. 1962. Oil on canvas. 7′8⅛″ x 37⅝″ (234 x 95.4 cm). Gift of Solomon Byron Smith

345. Helen Frankenthaler. *Jacob's Ladder*. 1957. Oil on canvas. 9′5⅜″ x 69⅞″ (287.9 x 177.5 cm). Gift of Hyman N. Glickstein

346. Cy Twombly. *The Italians*. 1961. Oil, pencil, and crayon on canvas. 6′6⅝″ x 8′6¼″ (199.4 x 259.6 cm). Blanchette Rockefeller Fund

347. Agnes Martin. *Untitled No. 1*. 1981. Gesso, synthetic polymer paint, and pencil on canvas. 6′ x 6′1⅛″ (183 x 183.4 cm). Gift of the American Art Foundation

346

347

348

349

348. Roy Lichtenstein. *Girl with Ball.* 1961. Oil and synthetic polymer paint on canvas. 60¼ x 36¼" (153 x 91.9 cm). Gift of Philip Johnson

349. Roy Lichtenstein. *Drowning Girl.* 1963. Oil and synthetic polymer paint on canvas. 67⅝ x 66¾" (171.6 x 169.5 cm). Philip Johnson Fund and gift of Mr. and Mrs. Bagley Wright

Here Lichtenstein takes an image from the comics or adolescent romance-fiction and transforms it into a curiously poignant icon of Pop art. The tone of the painting is mixed, engaging our sympathies even while the parodistic style suggests irony and even social criticism. By conspicuously overstating the Benday dots, the artist compels our attention to medium and process as a significant content of his banal imagery. The latter is served, moreover, by an ornamental type of drawing that recalls Japanese prints, notably Hokusai's *The Great Wave.* Thus, despite its extremely mechanical look, Lichtenstein's work ironizes sophisticatedly about art and style.

350. James Rosenquist. *Marilyn Monroe, I.* 1962. Oil and spray enamel on canvas. 7'9" x 6'¼" (236.2 x 183.3 cm). The Sidney and Harriet Janis Collection

351. Andy Warhol. *Gold Marilyn Monroe.* 1962. Synthetic polymer paint, silkscreened, and oil on canvas. 6'11¼" x 57" (211.4 x 144.7 cm). Gift of Philip Johnson

This image offers the viewer a profane subject become almost a sacred icon, recalling Byzantine style insofar as the subject is set against an ethereal, otherworldly gold ground. This renders it almost unique in Warhol's oeuvre as his approach to contemporary imagery was to use his canvas much as he did film, as a random and continuous medium. An important part of his subject matter was the reproduction process itself. The coarse scrim of silkscreened halftone dots gives his images a visual roughness that identifies them as media products. Since his presentation of the image itself is

350

351

straightforward, even literal, the
viewer is thrown back onto the sur-
face marks, blotchy paint, and
imperfect color registration, all of
which enliven and artistically assimi-
late his alternately banal and disturb-
ing subject matter.

352

353

352. Richard Lindner. *The Meeting.*
1953. Oil on canvas. 60″ x 6′ (152.4 x
182.9 cm). Given anonymously

353. Robert Indiana. *The American
Dream, I.* 1961. Oil on canvas. 6′ x 60⅛″
(183 x 152.7 cm). Larry Aldrich Founda-
tion Fund

354. Marisol (Marisol Escobar). *Portrait
of Sidney Janis Selling Portrait of Sidney
Janis by Marisol, by Marisol.* 1967–68.
Mixed mediums on wood. 69 x 61½ x
21⅝″ (175.2 x 156.2 x 54.8 cm). The
Sidney and Harriet Janis Collection

355. Jim Dine. *Five Feet of Colorful
Tools.* 1962. Oil on canvas surmounted
by a board on which thirty-two tools
hang from hooks. Overall 55⅝ x 60¼ x
4⅜″ (141.2 x 152.9 x 11 cm). The Sidney
and Harriet Janis Collection

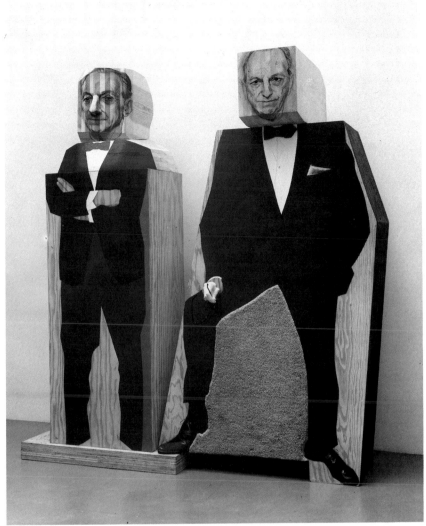

354

355

356

356. Helen Frankenthaler. *Mauve District*. 1966. Synthetic polymer paint on canvas. 8'7" x 7'11" (261.5 x 241.2 cm). Mrs. Donald B. Straus Fund

357. Jules Olitski. *Jehovah Cover—2*. 1975. Synthetic polymer paint on canvas. 7'1" x 40" (216 x 101.6 cm). The Gilman Foundation Fund

358. Kenneth Noland. *Turnsole*. 1961. Synthetic polymer paint on canvas. 7'10⅛" x 7'10⅛" (239 x 239 cm). Blanchette Rockefeller Fund

359. Anthony Caro. *Source*. 1967. Steel and aluminum, painted. 6'1" x 10' x 11'9" (185.5 x 305 x 358.3 cm). Blanchette Rockefeller Fund

In *Source*, Caro combined unexpected elements of steel remnants, metal grilles, and gently curved rods in a horizontal, sprawling, and tenuously linked composition which aimed to define and occupy lateral space. By painting the very different elements a single color, he suppressed associations to the nature of the material and its industrial origins; and by working laterally rather than vertically he eliminated those anthropomorphic and totemistic implications that regularly attached to sculpture, even in the highly abstract form they took in the work of David Smith.

357

358

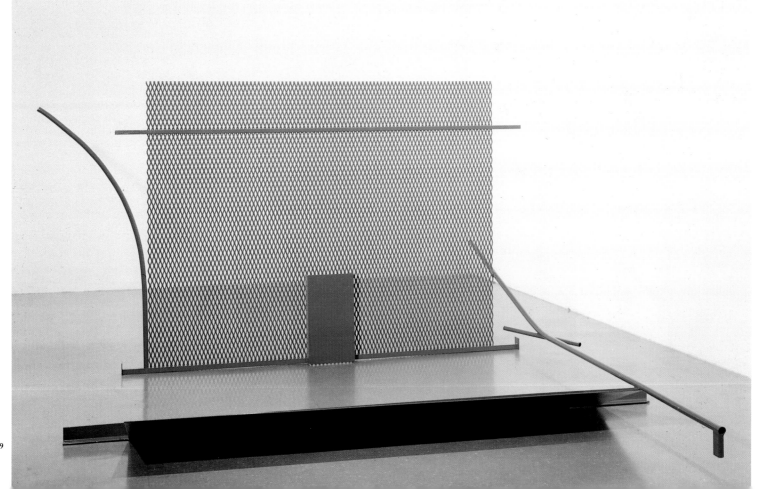

359

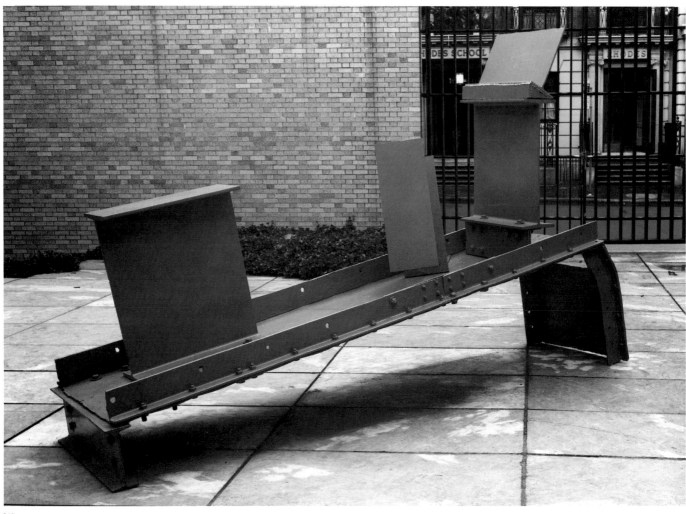

360

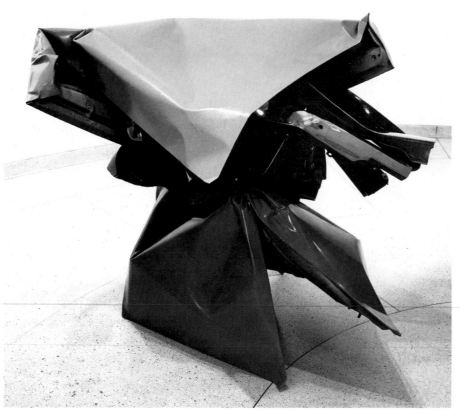

360. Anthony Caro. *Midday*. 1960.
Painted steel. 7' 7¾" x 37⅞" x
12' 1¾" (233.1 x 95 x 370.2 cm). Mr. and
Mrs. Arthur Wiesenberger Fund

361. John Chamberlain. *Tomahawk
Nolan*. 1965. Assemblage: welded and
painted metal automobile parts. 43¾ x
52⅛ x 36¼" (111.1 x 132.2 x 92 cm). Gift
of Philip Johnson

362. Tony Smith. *Free Ride*. 1962
(refabricated 1982). Painted steel. 6' 8" x
6' 8" x 6' 8" (203.2 x 203.2 x 203.2 cm).
Gift of Agnes Gund and purchase

361

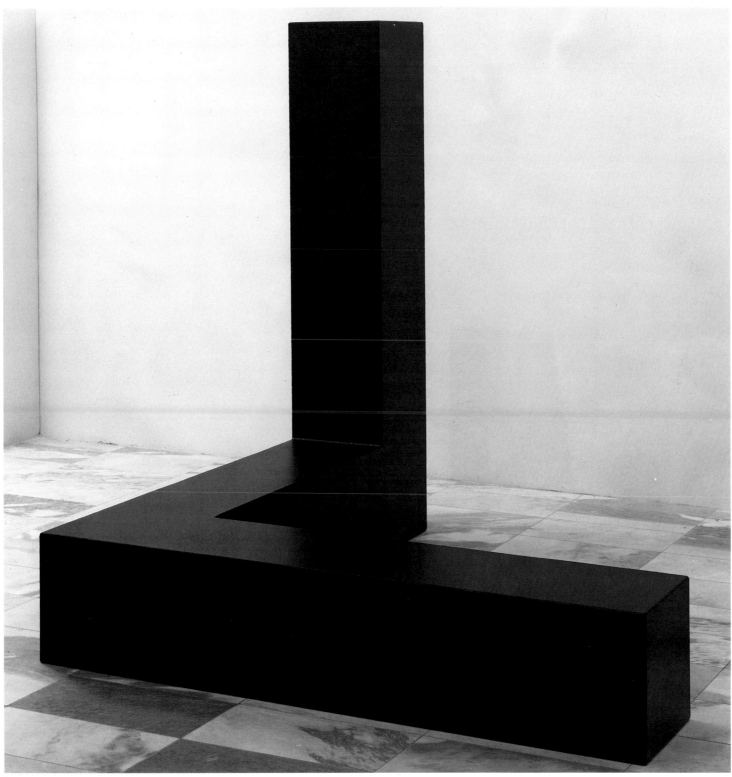

362

363

363. Chuck Close. *Robert/104,072.*
1973–74. Synthetic polymer paint and
ink with graphite on gessoed canvas. 9 x
7′ (274.4 x 213.4 cm). Gift of J. Frederic
Byers III and promised gift of an anony-
mous donor

364. Robert Smithson. *Mirror Stratum.*
1966. Mirrors on Formica-covered base.
25½ x 25½ x 10¼″ (64.8 x 64.8 x 26 cm).
Purchase

This work is, in the first instance,
comprehensible as a Minimalist zig-
gurat, but its internal contradictions
point to interests beyond formal
structure that become explicit in
Smithson's subsequent Earthworks.
Its layers of glass evoke mica crystal
structures, a kind of geological refer-
ence that would increasingly pre-
occupy the artist. There is also an
ambiguous conflict between the mir-
roring and structuring role of the
glass, only the edges of which are
visible, thus minimizing its reflective
function while nonetheless subvert-
ing the sense of sculptural mass.

365. Robert Ryman. *Twin.* 1966. Oil
on cotton. 6′3¾″ x 6′3⅞″ (192.4 x 192.6
cm). Charles and Anita Blatt Fund and
purchase

364

365

366

366. Lucas Samaras. *Book 4.* 1962. Assemblage: partly opened book with pins, razor blade, scissors, table knife, metal foil, piece of glass, and plastic rod. 5½ x 8⅞ x 11½" (14 x 22.5 x 29.2 cm). Gift of Philip Johnson

367. Richard Estes. *Double Self-Portrait.* 1976. Oil on canvas. 24 x 36" (60.8 x 91.5 cm). Mr. and Mrs. Stuart M. Speiser Fund

This picture shows the artist, a street with parked cars, building facades across the street, and commercial signs mirrored in a restaurant window. Actually, however, the artist is seen twice, reflected the second time from the interior plate glass of the restaurant's farther wall. Estes is resting his hand on one of the essential tools of his trade, a camera mounted on a tripod. Like its elaborately concealed clues of identity, the painting is a complex and fascinating study in illusionism. Deciphering image,

367

location, and logic, and making distinctions between an image source and its reflection become further complicated by the abstract pattern of the reflecting surfaces.

368. Christo (Christo Javacheff). *"The Museum of Modern Art Packed" Project.* 1968. Photomontage and drawing with oil, pencil, and pastel mounted on cardboard. Overall 15⅝ x 21¾" (39.5 x 55.2 cm). Gift of Dominique and John de Menil

369. Sol LeWitt. *Serial Project No. 1 (ABCD).* 1966. Baked enamel on aluminum. 97 units, overall 20⅛" x 13' 7" x 13' 7" (51.2 x 398.9 x 398.9 cm). Gift of Agnes Gund and purchase (by exchange)

This is a study of the relation of a horizontal grid to cubic and rectilinear geometries, open and closed. It bears a curious resemblance to an urban grid in its uniform shapes with their open cubic variants that rise like architectural forms from a schematized ground plan. LeWitt's search seems to be for the basic building blocks of form, the lowest common denominators of structure on which to build a grammar of fundamentalist spirit, not unlike the reforming spirit of Russian Constructivism or de Stijl. For all its abstract conceptual origin, it makes a remarkably compelling sculpture. In the concept's capacity for endless extrapolation, moreover, LeWitt's sculpture incorporates an irrational element that plays off against the logic of the forms.

368

369

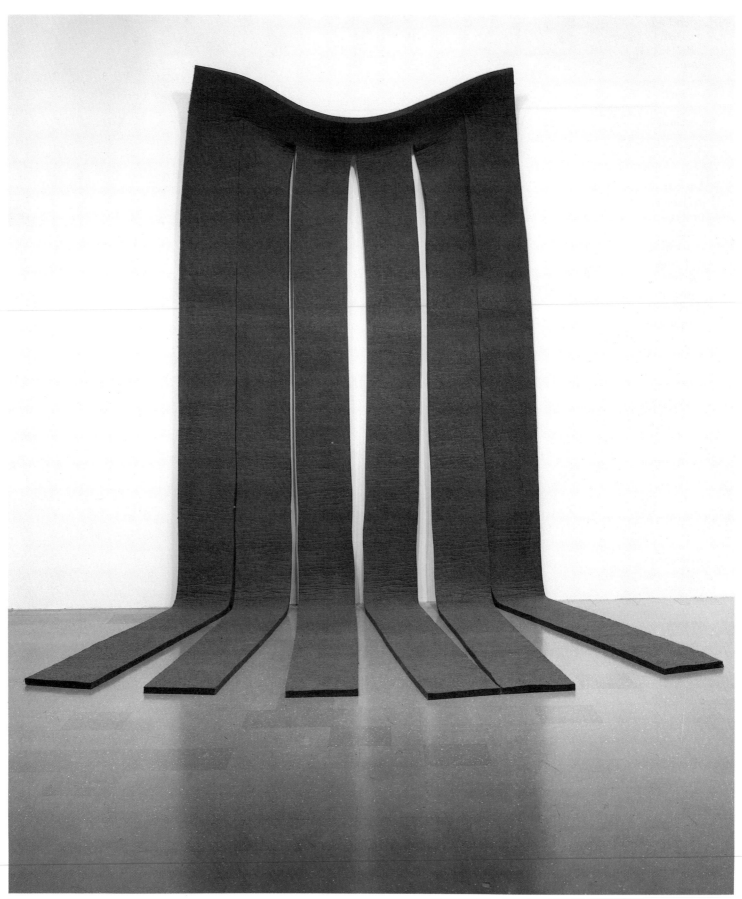

370

370. Robert Morris. Untitled. 1969. Gray-green felt, 1″ (2.5 cm) thick. 15′3¾″ x 72½″ x 1⅛″ (459.2 x 184.1 x 2.8 cm). The Gilman Foundation Fund

371. Carl Andre. *Lead Piece (144 Lead Plates 12 x 12 x ³⁄₈″)*. 1969. Lead plates, each approximately ½ x 12⅛ x 12⅛″ (1.2 x 30.7 x 30.7 cm); overall ½ x 12′7⅞″ x 12′1½″ (1.2 x 367.8 x 369.2 cm). Advisory Committee Fund

Andre's nonart materials are organized in checkerboard patterns on the floor, thus destroying any vestigial identification of his ground-hugging art with pedestal sculpture and with human scale. Instead, he forces the "viewer" into a new orientation with artistic materials, producing new sensations, as one walks over the thin slabs of lead. Andre's compositions, like those of other Minimalist artists, carried into the world of concrete "specific" objects the simple holistic devices anticipated in some of the vanguard painting of 1958–62.

372. Donald Judd. Untitled. 1968. Five open rectangles of painted steel spaced approximately 5⅛″ (13 cm) apart. Each 48⅜″ x 10′ x 20¼″ (122.8 x 305 x 51.4 cm); overall 48⅜″ x 10′ x 10′1″ (122.8 x 305 x 307.6 cm). Mr. and Mrs. Simon Askin Fund

373. Richard Serra. *Cutting Device: Base Plate Measure*. 1969. Lead, wood, stone, and steel. Overall 12″ x 18′ x 15′7¾″ (30.5 x 548.6 x 476.4 cm). Gift of Philip Johnson

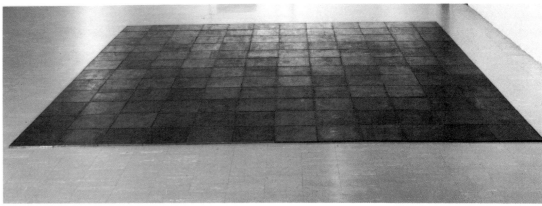

371

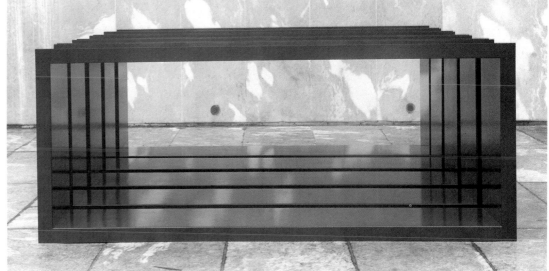

372

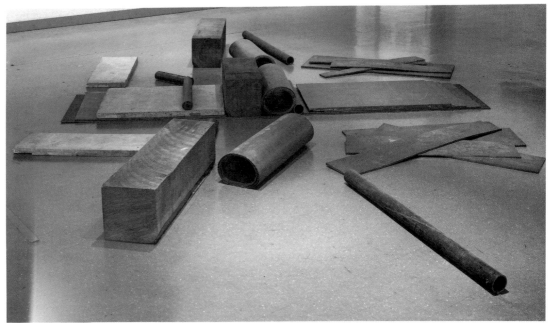

373

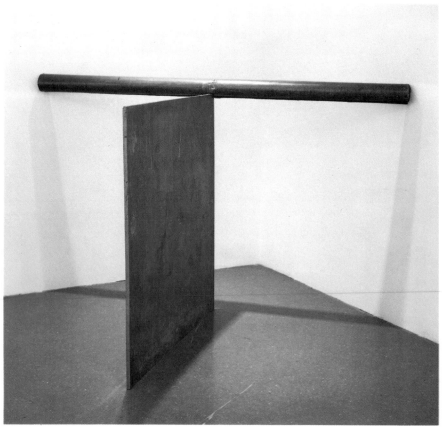

374

374. Richard Serra. *Corner Prop Piece.* 1970. Lead plate and lead tube rolled around steel core. Lead plate 48 x 48 x ¾" (122 x 122 x 2 cm); tube 7'¼" long x 4⅜" diameter (214.1 x 11.1 cm); overall size installed 52" x 7'¼" x 7'8" (132.1 x 213.7 x 233.7 cm) (variable). Gilman Foundation Fund

375. Dan Flavin. *Untitled (to the "Innovator" of Wheeling Peachblow).* 1968. Painted metal and fluorescent tubes (pink, gold, and daylight). 8'½" x 8'¼" x 5¾" (245 x 244.3 x 14.5 cm). Helena Rubinstein Fund

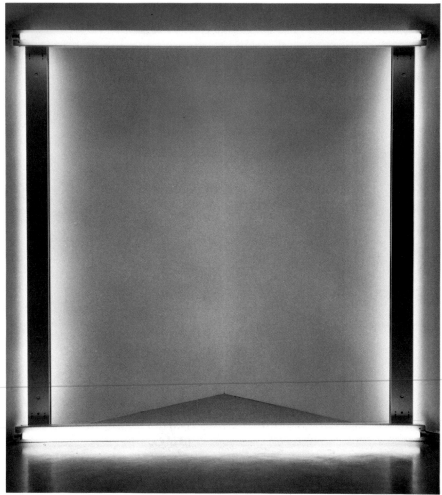

375

376. George Segal. *John Chamberlain Working.* 1965–67. Painted plaster figure with steel sculpture. Figure 69½ x 51½ x 28⅜″ (176.5 x 131 x 72 cm); overall 69½ x 53¼ x 54″ (176.5 x 135.2 x 137.2 cm). Promised gift of Conrad Janis and Carroll Janis

This work incorporates an actual unfinished sculpture by Chamberlain himself, which he had left at Segal's farm in New Jersey. When it began to rust, Chamberlain suggested that he pose for a portrait sculpture with the repainted sculpture; as always, Segal made it by starting from a plaster cast made directly on Chamberlain's body. Originally the figure of Chamberlain was unpainted plaster, and the metal sculpture was polychrome. Later, with Chamberlain's permission, Segal cut away part of the metal sculpture, and painted both it and the figure with aluminum paint, thus unifying the two-part sculpture and forcing his own identity on it as an ensemble. Segal's ghostly human replicas are invariably pieced together from worked-over casts of friends patient enough to endure the procedure. Seemingly anesthetized, they take on the metaphysical character the Surrealists had earlier discovered in inanimate objects.

377. Joseph Kosuth. *One and Three Chairs.* 1965. Wooden folding chair, photograph of chair, and photographic enlargement of dictionary definition of chair. Chair 32⅜ x 14⅞ x 20⅞″ (82 x 37.8 x 53 cm); photo panel 36 x 24⅛″ (91.5 x 61.1 cm); text panel 24⅛ x 24½″ (61.1 x 62.1 cm). Larry Aldrich Foundation Fund

A virtual demonstration piece for the definition of Conceptual art, *One and Three Chairs* juxtaposes an actual chair with its photograph and with an enlarged dictionary definition of "chair" on a placard, thus drawing our attention, in the manner of Magritte, to the way in which our conception of an object enigmatically changes nature under the pressure of its symbolic, imagistic, and semantic projections.

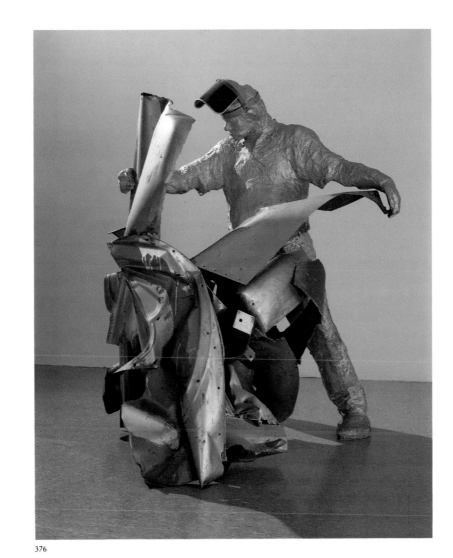

376

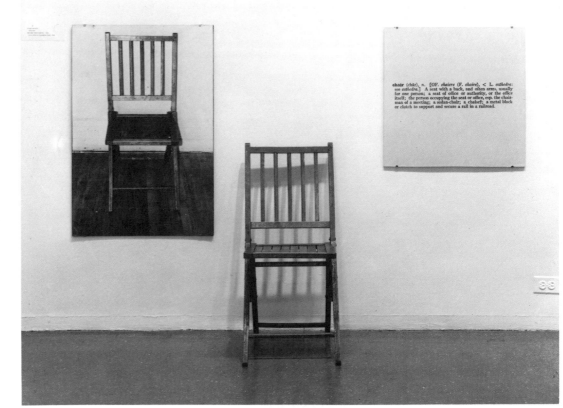

377

378

379

378. Joel Shapiro. Untitled (house on shelf). 1974. Bronze. 12⅞ x 2½ x 28⅛″ (32.5 x 6.4 x 71.5 cm). Purchased with the aid of funds from the National Endowment for the Arts and an anonymous donor

379. Dorothea Rockburne. *A, C and D from Group/And*. 1970. Paper, chip board, nails, and graphite. 13′10½″ x 21′½″ x 44⅛″ (422.8 x 641.3 x 112 cm). Given anonymously

380. Charles Simonds. *People Who Live in a Circle. They Excavate Their Past and Rebuild It into Their Present. Their Dwelling Functions as a Personal and Cosmological Clock, Seasonal, Harmonic, Obsessive*. 1972. Clay with sticks and stones. 8⅜ x 26¼ x 26⅛″ (22.2 x 66.7 x 66.4 cm). Kay Sage Tanguy Fund

381. Eva Hesse. *Repetition 19, III*. 1968. Nineteen tubular fiberglass units. 19 to 20¼″ high x 11 to 12¾″ diameter (48 to 51.1 cm high x 27.8 to 32.3 cm diameter). Gift of Charles and Anita Blatt

380

381

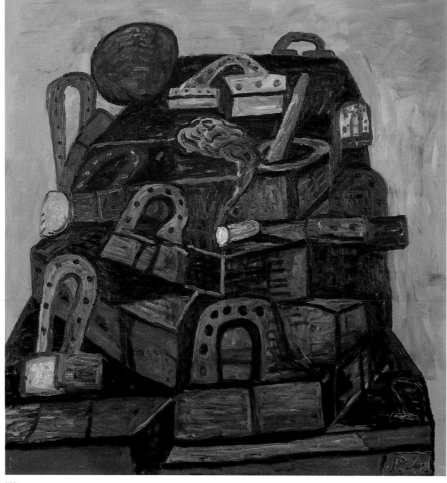

382

382. Philip Guston. *Tomb*. 1978. Oil on canvas. 6'6⅛" x 6'1¾" (198.4 x 187.6 cm). Acquired through the A. Conger Goodyear and Elizabeth Bliss Parkinson Funds, and purchase

383. Neil Jenney. *Implements and Entrenchments*. 1969. Synthetic polymer paint on canvas. 54¼" x 6'2¼" (137.8 x 178.5 cm). Gift of Philip Johnson

384. Alice Aycock. *Project Entitled "Studies for a Town."* 1977. Wood. 9'11½" x 11'7¾" x 12'1" (304 x 350 x 369 cm). Gift of the Louis and Bessie Adler Foundation, Inc., Seymour M. Klein, President

The complex surreal network of this construction suggests a visionary urban architecture that is anachronistic in contemporary social terms. Whereas architecture is a collective art, the sense of a unique, highly personalized vision is enhanced by the simple carpentry obviously realized by the artist as opposed to the precast, prefabricated, more contemporary materials from which our architecture is built. The work is thus suspended between the collective sense that inheres to architecture and the unfettered world of the private imagination of the abstract sculptor.

385. Lois Lane. Untitled. 1979. Oil on canvas. 8 x 8' (243.8 x 243.8 cm). Gift of the Louis and Bessie Adler Foundation, Inc., Seymour M. Klein, President

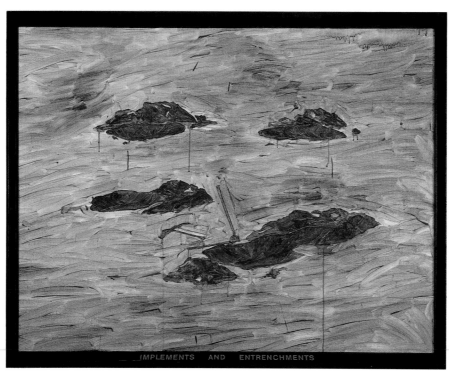

IMPLEMENTS AND ENTRENCHMENTS

383

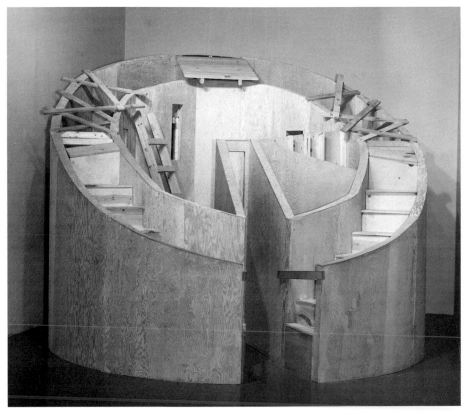

384

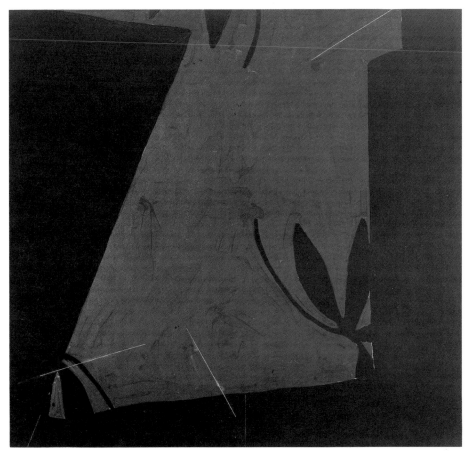

385

386

386. Yves Klein. *Blue Monochrome.* 1961. Oil on cotton cloth over plywood. 6'4⅞" x 55⅛" (195.1 x 140 cm). The Sidney and Harriet Janis Collection

387. Armand P. Arman. *Constellation Number 18.* 1976. Assemblage: ball bearings embedded in plexiglass, in attached plexiglass frame. 60⅛" x 7'1⅛" x 1⅝" (152.7 x 213.7 x 4.2 cm). Purchased with the aid of funds from the National Endowment for the Arts and an anonymous donor

388. Brice Marden. *Grove Group, I.* 1973. Oil and wax on canvas. 6' x 9'⅛" (182.8 x 274.5 cm). Treadwell Corporation Fund

389. Jennifer Bartlett. *Swimmer Lost at Night (for Tom Hess).* 1978. Two silkscreen on baked-enamel-on-steel units, each composed of 20 steel plates 12 x 12" (30.5 x 30.5 cm) placed 1" apart, hung diagonally; and two oil on canvas panels, each 48½ x 60⅛" (122.2 x 152.7 cm), also hung diagonally; overall 6'6" x 26'5" (198.1 x 805.2 cm). Mrs. George Hamlin Shaw Fund

387

388

389

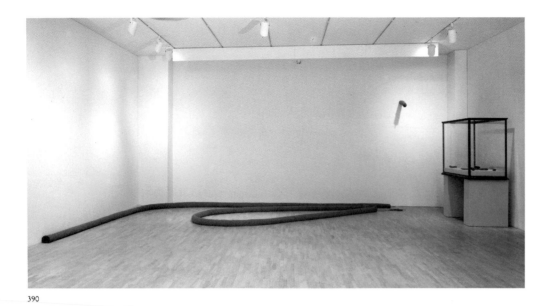

390

390. Joseph Beuys.
OSTENDE
on the beach or in the dunes
a cube shaped house
therein
the Samurai Sword is a Blutwurst
PLINTH.
1970–82. Rolled felt in three parts, dried
meat, metal, string, and vitrine. Dimen-
sions variable with each installation.
Purchase.

391. Richard Long. *Cornish Stone
Circle*. 1978. 52 stones of delabole slate.
Overall 19′8⅜″ (600 cm) diameter. Mr.
and Mrs. John R. Jakobson, Junior
Council, and Anonymous Funds

392. A. R. Penck (Ralf Winkler). *Eau
de Cologne*. 1975. Synthetic polymer
paint on canvas. 9′4¼″ x 9′4¼″ (285.1 x
285.1 cm). Mr. and Mrs. Sid R. Bass
Fund

391

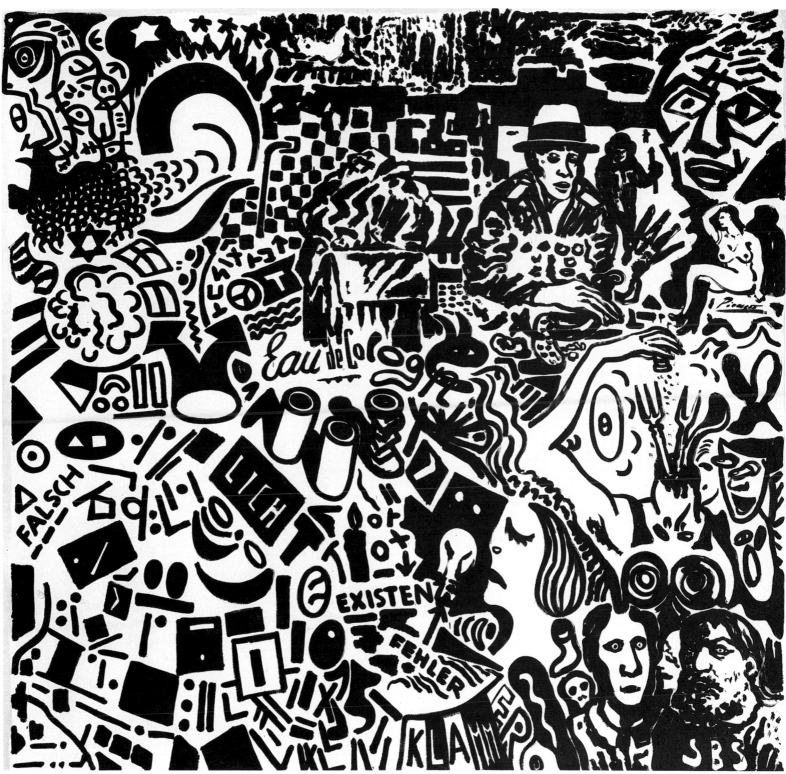

392

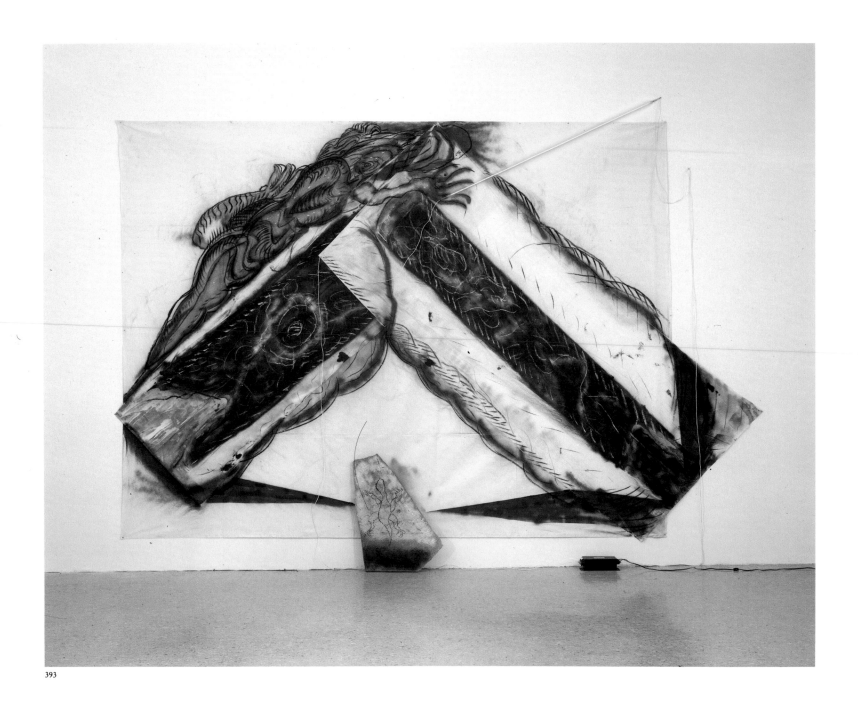

393

393. Mario Merz. *Fall of the House of Usher.* 1979. Oil, metallic paint, and charcoal on canvas with neon fixture and rock. Overall 11′8½″ x 14′5¾″ (331.1 x 429 cm) (irregular). Mr. and Mrs. Sid R. Bass Fund

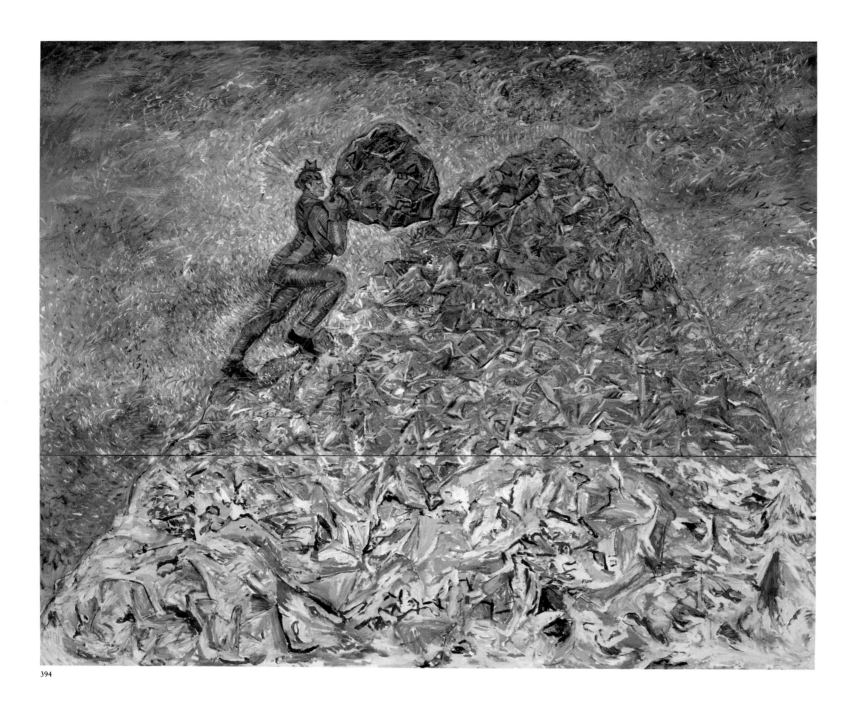

394

394. Sandro Chia. *The Idleness of Sisyphus.* 1981. Oil on canvas. In two parts: top 6'9" x 12'8¼" (205.5 x 386.7 cm), bottom 41" x 12'8¼" (104.5 x 386.7 cm); overall 10'2" x 12'8¼" (307 x 386.7 cm). Acquired through the Carter Burden, Barbara Jakobson, and Saidie A. May Funds, and purchase

Drawings

A department of drawings was planned for The Museum of Modern Art when it was founded in November 1929 as part of its conception as a museum that would serve all of the modern visual arts. That same month, a drawing (Grosz's *Portrait of Anna Peters)* was, together with a group of eight prints, the first acquisition that the new Museum made. Since that time the Museum has chiefly been responsible for pioneering the serious study of modern drawing, although, for most of its history, its own drawings have formed a virtually invisible collection. Not until 1964 were more than a handful regularly on view. Not until 1971 was an independent Department of Drawings formally established, the last of the Museum's six curatorial departments to achieve autonomy. Since the early sixties, drawings have been assiduously collected and exhibited by the Museum. However, not until completion, recently, of the Museum's new building program have there been galleries devoted exclusively to the drawings collection. The history of drawings at The Museum of Modern Art is therefore an unusual one. Only very gradually did the collection of drawings become a curatorial priority, and only over the past decade has there been established for drawings the full range of curatorial functions appropriate to them. At the same time, however, drawings have always been regularly acquired by the Museum, and when in the sixties their collection did become a priority, there was already a remarkable foundation to build on. Now the collection numbers over six thousand unique works on paper. It is widely acknowledged to be the richest and most comprehensive of its kind.

Some of the reasons for the late foundation of the Department of Drawings are entirely attributable to factors internal to the organization of the Museum. The painting and sculpture collection received absolute priority in the early years; the fact that drawings are more intimately related to painting and sculpture than are any of the other mediums the Museum collects was certainly a reason why the independent collection of drawings was delayed. And it should be remembered that while some aspects of the Museum's initial multidepartmental plan were realized quite early in its history, it was not until 1967 that the Committee on Museum Collections, which had considered acquisitions in all areas, was finally disbanded in favor of individual committees for each department. But the unusual history of drawings at the Museum is partly to be explained by the unusual status of drawing itself, especially of modern drawing. Of all the modern arts, it is the most resistant to definition. The history of the Museum's drawings collection is also the history of how modern drawing itself has gradually been acknowledged as an independent activity, and how it has been defined.

Serious commitment not only to modern drawings but to drawings of any period was very late to develop in the United States. More than any other person, the donor of the Museum's first drawing, Paul J. Sachs, was responsible for changing this state of affairs. At Harvard University, he inspired three generations of students in the connoisseurship of drawings and formed a major collection of old-master drawings at the Fogg Museum. He was part of a group that in 1916 encouraged The Metropolitan Museum of Art to seriously collect drawings and prints. As one of the founding trustees of The Museum of Modern Art, he supported its program and collection for almost three decades. His first service to the Museum, in fact, was his nomination as its founding director of one of his former students, Alfred Barr, whose chief scholarly work prior to 1929 had been in Quattrocento drawings. It was because of Barr's belief in the interdependence of the modern visual arts that drawings were valued and collected by the Museum from the start.

Initially, however, the elements of Barr's multidepartmental conception were not separately examined, and the question of a separate collection of drawings did not arise. The thirty-six works on paper, among them important Cézanne watercolors and Seurat conté-crayon drawings, that came to the Museum in 1934 as part of the Lillie P. Bliss Bequest—the cornerstone of the Museum's collection—were welcomed simply as major modern works of art. So were the over one hundred mostly American watercolors and pastels that were given to the Museum in 1935 as part of the gift of Abby Aldrich Rockefeller. And when, that same year, Mrs. Rockefeller provided Barr with his first acquisitions funds, he bought Dada and Surrealist works on paper— by Ernst and Schwitters among others—not specifically as drawings but rather for the Museum's

collection as a whole. The same is true of the Russian works that Barr acquired during his 1936 visit to the Soviet Union. It is only in retrospect that the works acquired in these early years can be seen as forming the foundation of the Museum's drawings collection. Barr was simply recognizing the fact that certain of the major innovations of modern art had been achieved in works on paper—from Cézanne watercolors to Dada collages—and that these had to be collected alongside paintings and sculptures if the Museum's collection was to become that synoptic overview of the modern movement that he desired.

This understanding of how works on paper fit into the broader history of modernism has continued to determine the growth of the drawings collection. It explains why, right down to the present, a changing selection of works from the drawings collection is hung in the painting and sculpture galleries. It also explains why, as the painting and sculpture collection began to grow, drawings were consciously sought out to support that collection, whether to add studies for paintings or sculptures the Museum owned or to fill important gaps until representative paintings and sculptures could be acquired. This sense of interrelation between works on paper and paintings and sculptures has been crucially important to the Museum as a whole. At the same time, when the drawings collection finally was made independent, it became apparent that the early acquisitions policies had produced certain imbalances in the proportionate representation of different artists' works on paper. As a result, despite the great wealth of the collection, there are a number of historical areas that require attention.

In the Museum's early years, its record for showing works on paper, and especially American works on paper, was remarkable. In 1930 there was an exhibition of Burchfield's early watercolors. In 1936 Marin, Feininger, and Demuth were given shows consisting either entirely or predominantly of works on paper. And drawings were regularly included in the early painting and sculpture shows. But it was Monroe Wheeler's 1944 exhibition, *Modern Drawings,* the Museum's first survey of modern draftsmanship and a landmark for the appreciation of drawings in this country, that most definitively signaled the Museum's early commitment to this field. It defined drawings as unique works on paper mostly in black and white. When, three years later in 1947, the Museum presented its first exhibition of its own drawings, the same definition was followed. At this date, however, the Museum—after nearly two decades of existence—owned only 227 drawings, thus defined, for watercolors, gouaches, pastels, *papiers collés,* and so on were not yet considered drawings. It would not be until very much later that the majority of the Museum's drawings—in this narrower definition—were acquired, and that the impetus created in the early years of the Museum was fully consolidated. Indeed, thirteen years went by before a second full-scale exhibition of the Museum's drawings took place, in 1960. By then the collection had increased to 530 works. Although many of the works that were acquired in the forties and fifties were crucially important ones—among them those that came to the Museum from the Katherine S. Dreier Bequest in 1953—growth was relatively slow in those decades. Only in the sixties did the collection and exhibition of drawings become a true Museum priority, for then rapid changes took place both in the collection itself and in its administration.

The collection has always been, and still is, entirely dependent on gifts, either of purchase funds or of works of art themselves. In the early sixties, 153 works from the John S. Newberry Collection, among them sheets by Kandinsky, Marc, Picasso, and Redon, were acquired by the Museum. At the end of that decade, the Joan and Lester Avnet Collection of 180 works, including sheets by Braque, Chagall, Johns, and Mondrian, was bequeathed to the Museum on Mr. Avnet's death. Both were very important additions indeed, and since the latter was formed with the Museum's collection specifically in mind, it filled many of the lacunae left by the acquisitions policies of earlier years. In addition, large groups of works by Dubuffet, Feininger, and Kupka were added to the collection as it was gradually filled out by the extensive addition both of study material and of major exhibitable works.

During the sixties, significant changes took place in the administration of drawings at the Museum. In 1960, the Department of Drawings and Prints was established, with William S.

Lieberman (a former student of Sachs and a longtime assistant to Barr) as its curator, and later director. In 1962, the Paul J. Sachs Committee on Drawings and Prints was formed to serve as an advisory body to the new department and to plan galleries for the exhibition of its works. The Paul J. Sachs Galleries were inaugurated in 1964. At this point, the Museum's definition of drawings was broadened to include pastels and watercolors as well as works in black and white. In 1966, a special subcommittee on drawings and prints was attached to the Committee on Museum Collections to review its acquisitions—which tended to concentrate more on prints than drawings. When the Committee on Museum Collections was disbanded in 1967, as part of that year's decentralization of acquisition activities, an independent Committee on Drawings and Prints was established. Four years later, it was realized that drawings and prints were better treated separately, and in 1971 the Department of Drawings was finally established, with Lieberman as its director.

At that point it had gradually become apparent that modern drawing could not be restricted to works in black and white; that while many important preparatory modern drawings were being produced, modern drawing was becoming an increasingly ambitious and independent enterprise, in black and white as well as in color; and that to many modern artists a drawing was considered to be almost any unique work on paper. When, therefore, the Museum's Department of Drawings was finally established as an independent curatorial unit in 1971, its establishment was partly a response to the changed understanding of drawing as itself an independent modern art. Similarly, the domain of the new department, expanding to include responsibility for all the Museum's unique works on paper—works in the traditional drawing mediums of pencil, ink, charcoal, and so on, but also watercolors, pastels, *papiers collés,* and other related forms—responded to the changed understanding of what the activity of drawing then comprised. By that date, certainly, modern drawing had begun to achieve such independence as even to seek at times to displace painting and sculpture from the foreground of the avant-garde. The establishment of a department devoted to drawings alone made it possible to respond properly to this new situation. But it is not only the newer works in the collection that evidence acceptance of drawing, broadly defined, as a crucial and independent activity within modern art. The older works, too, reveal the important role that works on paper have played in the development of modernism, and from the very beginning the Museum's curatorial organization recognized that such works carry a level of ambition and quality no less than in any other form of art, only different in kind.

In the sixties works on paper were for the first time prominently featured by the Museum. Although prints as well as drawings were shown in the Paul J. Sachs Galleries, the rotating installations there greatly increased the visibility of the drawings collection. From 1964 until reconstruction closed these galleries in 1982, there were presented thematic "slices" through the collection, each consisting of some fifty to one hundred works. These included exhibitions of works recently donated to the collection, such as *Rauschenberg: 34 Drawings for Dante's Inferno* and *Motherwell: Lyric Suite;* exhibitions taken from important whole collections donated to the Museum, most significantly *John S. Newberry: A Memorial Exhibition;* exhibitions of artists or movements well represented in the drawings collection, among them *George Grosz: Drawings and Watercolors, Cubism and Its Affinities,* and *The Symbolist Aesthetic;* and exhibitions devoted to more general themes, such as *Artists and Writers* and *Words and Pictures.* A number of these exhibitions were circulated to other museums after being shown in New York. And soon after the Department of Drawings had been founded, larger and more ambitious exhibitions from the collection were prepared for travel both nationally and abroad. These included *100 Drawings from the Collection of The Museum of Modern Art, Drawn in America,* and *Seurat to Matisse: Drawing in France.* Also, important loan exhibitions of drawings were arranged for the Museum, among them *Drawings from the Kröller-Müller National Museum, Otterlo; Drawing Now; Arp on Paper;* and *Jackson Pollock: Drawing into Painting.*

Organization of such exhibitions formed part of the systematic analysis of the drawings collection that was begun in the seventies under Lieberman's guidance and with the collaboration of

Bernice Rose, curator of drawings. The independence, and scope, of the department having been established, it was possible to begin to identify and correct weaknesses—as well as celebrate strengths—in the hope of creating a truly synoptic collection. As a result, carefully chosen individual works were added to previously less well represented areas of the collection. For example, two Tatlin drawings, the only examples in a Western museum collection, were added to the Museum's holdings of art from the Soviet Union through the generosity of The Lauder Foundation. When Lieberman retired from the Museum in 1979, the current director began a new review of the collection, and continued the work of filling in gaps, as well as adding to the representation of contemporary art, especially of younger artists. Recent acquisitions range from the Museum's first pencil drawing by Cézanne to a major group of Pollock drawings, some the gift of Lee Krasner, to the Museum's first works on paper by artists as varied as Diebenkorn, Dove, Frankenthaler, and Pechstein.

In recent years, the Department of Drawings program of exhibitions and publications has increased. In 1981 it initiated the *New Work on Paper* series of exhibitions to present the work of younger artists not previously seen at the Museum. In 1982 *A Century of Modern Drawing*, the most broad-ranging collection exhibition so far—organized by Bernice Rose—was shown as a preview of the Museum's new exhibition gallery before traveling to the British Museum in London. In 1983, *The Modern Drawing* exhibition, organized by the director of the department, presented one hundred of the collection's finest works, accompanied by a book that is intended to initiate a more systematic publications program on the collection. Now, with the inauguration of the expanded Museum, the first galleries devoted exclusively to drawings are in full operation, as well as the department's first adequate study center for drawings, which will allow students and scholars to inspect works in the collection that are not on public view.

The Museum's drawings collection is already extraordinary. In certain areas, especially those where works on paper were artists' principal means of expression, in Dada and Surrealism for example, it is astonishing in range and quality. Perhaps its greatest strength is in the School of Paris. But its American (both historical and contemporary) and other European holdings are also unparalleled, and the separate group of some one thousand works that comprise the theater arts collection is among the most significant of its kind. Moreover, there are many artists—among them Matisse, Ernst, Klee, Schwitters, Dubuffet, Pollock, and Rauschenberg—whose works on paper simply cannot be properly appreciated without knowledge of this Museum's drawings collection. At the same time, there are very many areas that require more attention. Boccioni is wonderfully represented, but the other Futurists only inadequately. The Matisse collection, great though it is, does not properly represent the full range of that artist's work. Representation of post–World War II art is still far from what it should be. This list could continue; no collection, of course, is complete, and none perfect. And yet it does seem reasonable to hope that a truly synoptic collection of major quality can be achieved; also, that a serious, enlightened, innovative program of exhibitions and publications can continue to be developed alongside it. This is not to say that these ambitions have been lacking hitherto—the collection itself and the record of the Museum's programs tell otherwise. It is only that the Department of Drawings is the youngest in the Museum and that it addresses a field in which there has been great endeavor, and already great achievement, but where there is very much more to be achieved.

395. Georges-Pierre Seurat. *At the "Concert Européen."* 1887–88. Conté crayon, chalk, and gouache on paper. 12¼ x 9⅜″ (31.1 x 23.9 cm). Lillie P. Bliss Collection

In *At the "Concert Européen,"* probably the most beautiful of Seurat's studies of Parisian music-hall life, one sees Seurat's invention of a new mode of drawing without the delineation of contour. One of the most extraordinary draftsmen of the modern era, Seurat used black in such a manner as to suggest all of the nuances of light and form normally accorded to color rendering. In this drawing the form emerges from the ground as the conté crayon, used broadly, reduces Seurat's drawing unit to the little particles of matter that cling to the rough surface of the drawing sheet, the densities varying in response to the pressure of his hand. Seurat's drawings return the first impression before nature to a new beginning point in art, to the origins of form coalescing out of matter. Form emerges out of the broken ground as a consequence of contrasting dense masses against lighter ones: the dark glow lighter, the light darker. In this drawing light itself is represented by highlights of white chalk. It is as though the world were formed out of little particles of matter given to our eyes as form through the reflection of light.

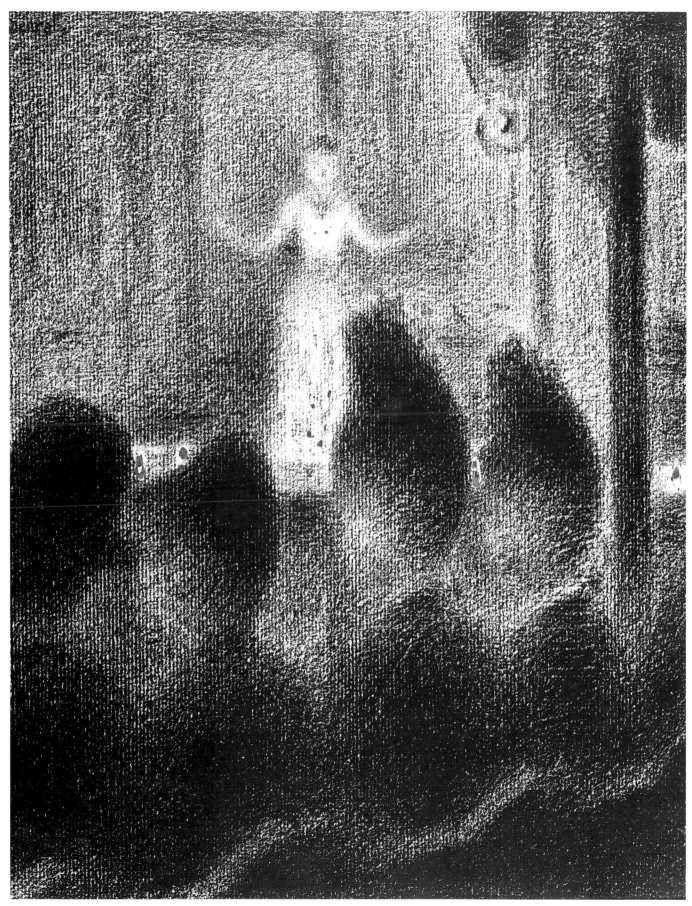

395

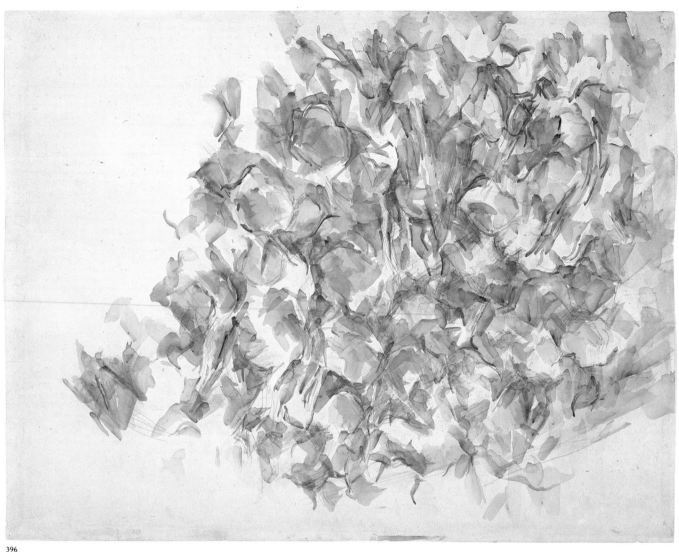

396

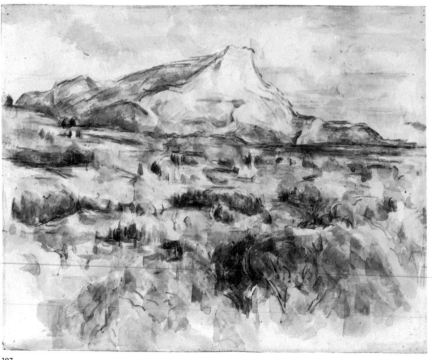

397

396. Paul Cézanne. *Foliage*. 1895–1900. Watercolor and pencil on paper. 17⅝ x 22⅜″ (44.8 x 56.8 cm). Lillie P. Bliss Collection

Cézanne's later watercolors begin the history of modern drawing. They give us two of the crucial issues of the modern movement: the release of color from conventional contour drawing and the loosening of traditional linear perspective as the means of structuring pictorial space. In the late 1870s, in his watercolors, Cézanne set about creating a system for reorganizing drawing (and painting) according to color differentiations, or modulations. Line itself was accommodated, but Cézanne felt that "pure drawing is an abstrac-

tion, drawing and color are not distinct points, everything in nature is colored.... Contrasts of harmonies and tones, there is the secret to drawing and modeling." By the late 1890s his system of organized color perceptions, his color patches and dark lines, had become his chief pictorial method. The subject of Cézanne's late watercolors became the depiction of a profuse universe in the constant process of creating itself as a unified structure; nothing is given, the space and the objects constantly discover and reconstruct one another, there is no a priori system of perspective, the transparent color patch itself usurps the place of the object so that as Maurice Merlau-Ponty wrote, each brushstroke must "contain the air, the light, the object, the construction, the character, the drawing, the style." Perceptual perspective, which had appeared at various other times in the history of Western art, now came to dominate the structure of art.

397. Paul Cézanne. *Mont Sainte-Victoire*. 1902–06. Watercolor and pencil on paper. 16¾ x 21⅜″ (42.5 x 54.2 cm). Gift of David Rockefeller (the donor retaining life interest)

398. Vincent van Gogh. *Street at Saintes-Maries*. 1888. Brush, reed pen and ink, and traces of pencil on paper. 9⅝ x 12½″ (24.5 x 31.8 cm). Abby Aldrich Rockefeller Bequest

399. Vincent van Gogh. *Hospital Corridor at Saint Rémy*. 1889. Gouache and watercolor on paper. 24⅛ x 18⅝″ (61.3 x 47.3 cm). Abby Aldrich Rockefeller Bequest

398

399

400

401

Gauguin can be said to have preserved contour drawing for the modern tradition. He left very few drawings, but in *Meyer de Haan* we can see that his style was one of radically simplified contour drawing—that is, drawing that does not stop for details—worked in concert with broad, shifting planes rendered in homogeneous, artificial color. The effect of this concentration on radically simplified contour in Gauguin's work is to establish figures and ground on the same plane, rendering figures and objects as two-dimensional, while radically foreshortening and tilting the planes, stressing surface. Gauguin's insistence on continuous decorative contour, whether established by preliminary underdrawing to indicate color contrasts or by outline drawing on top of the color as a virtually independent means of expression, set him apart technically from the so-called realists who, like Cézanne, held observation before nature as the primary task of art, and who sought to integrate line and color. Gauguin's style moves from art to nature and back. He wrote: "Art is an abstraction; I derive this abstraction from nature while dreaming before it."

401. Odilon Redon. *The Masque of the Red Death*. 1883. Charcoal on brown paper. 17¼ x 14⅛" (43.7 x 35.8 cm). John S. Newberry Collection

402. Odilon Redon. *The Accused*. 1886. Charcoal on paper. 21 x 14⅝" (53.3 x 37.2 cm). Acquired through the Lillie P. Bliss Bequest

403. Gustav Klimt. *Woman in Profile*. 1898–99. Blue pencil on paper. 16⅞ x 11⅜" (42.8 x 28.7 cm). The Joan and Lester Avnet Collection

404. Pablo Picasso. *Brooding Woman*. 1904. Watercolor on paper. 10⅝ x 14½" (26.7 x 36.6 cm). Gift of Mr. and Mrs. Werner E. Josten

402

403

404

405

405. František Kupka. *Girl with a Ball.* 1908–09. Pastel on paper. 24½ x 18¾" (62.2 x 47.5 cm). Gift of Mr. and Mrs. František Kupka

406. Oskar Kokoschka. *Nude.* c. 1907. Watercolor, crayon, pencil, and pen and ink on paper. 17¾ x 12¼" (45.1 x 31.1 cm). Rose Gershwin Fund

407. Egon Schiele. *Woman Wrapped in a Blanket.* 1911. Watercolor and pencil on paper. 17⅝ x 12¼" (44.7 x 31.1 cm). The Joan and Lester Avnet Collection

408. André Derain. *Bacchic Dance.* 1906. Watercolor and pencil on paper. 19½ x 25½" (49.5 x 64.8 cm). Gift of Abby Aldrich Rockefeller

409. Auguste Rodin. *Nude with Serpent.* c. 1900–05. Watercolor and pencil on paper. 12⅝ x 9¾" (32 x 24.7 cm). Gift of Mr. and Mrs. Patrick Dinehart

406

407

408

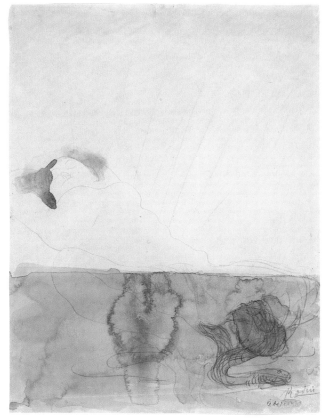

409

410

411

410. Henri Matisse. *Jeanne Manguin*. 1906. Brush, reed pen and ink on paper. 24½ x 18½" (62.2 x 46.9 cm). Given anonymously

Matisse consistently practiced drawing as a means of expression distinct from his painting. Nevertheless, contour controlled both his drawing and his painting. Though Matisse desired to break with traditional illusionism, he was unwilling to give up the human form, as he tried to depict "an inherent truth which must be disengaged from the outward appearance of the object to be represented." Contour drawing, simplified and intensified, became the primary means for this disengagement, enabling him to break with traditional pictorial illusionism, by excluding any inference of shallow illusionistic space, as in conventional perspectival rendering. *Jeanne Manguin*, an early drawing, signifies the kind of formal preoccupation that would stay with Matisse throughout his career: the accommodation of volumetric form to the flat surface of the picture plane through drawing. In this picture, the line, which remains a symbolic abstraction in itself, is juxtaposed with other lines to create a dynamic and amusing portrait of the artist Manguin's wife in a parody of high-style bourgeois dress.

411. Georges Rouault. *Woman at a Table (The Procuress)*. 1906. Watercolor and pastel on cardboard. 12⅛ x 9½" (30.8 x 24.1 cm). Acquired through the Lillie P. Bliss Bequest

412. Henri Matisse. *Girl with Tulips (Jeanne Vaderin)*. 1910. Charcoal on paper. 28¾ x 23" (73 x 58.4 cm). Acquired through the Lillie P. Bliss Bequest

412

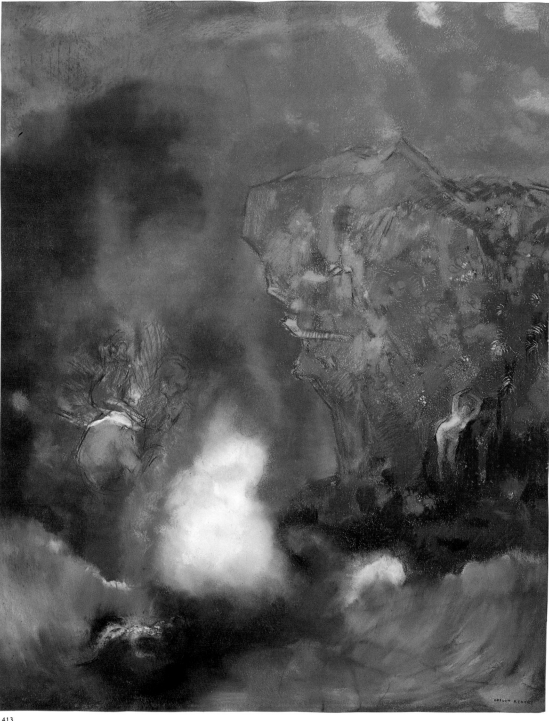

413

413. Odilon Redon. *Roger and Angelica*. c. 1910. Pastel on paper on canvas. 36½ x 28¾" (92.7 x 73 cm). Lillie P. Bliss Collection

414. Pablo Picasso. *Head*. 1906. Watercolor on paper. 8⅞ x 6⅞" (22.4 x 17.5 cm). John S. Newberry Collection

415. Pablo Picasso. *Head of the Medical Student* (Study for *Les Demoiselles d'Avignon*). 1907. Gouache and watercolor on paper. 23¾ x 18½" (60.3 x 47 cm). A. Conger Goodyear Fund

416. Pablo Picasso. *Head*. 1909. Gouache on paper. 24 x 18" (61 x 45.7 cm). Gift of Mrs. Saidie A. May

417. Pablo Picasso. Study for *The Mill at Horta*. 1909. Watercolor on paper. 9¾ x 15" (24.8 x 38.2 cm). The Joan and Lester Avnet Collection

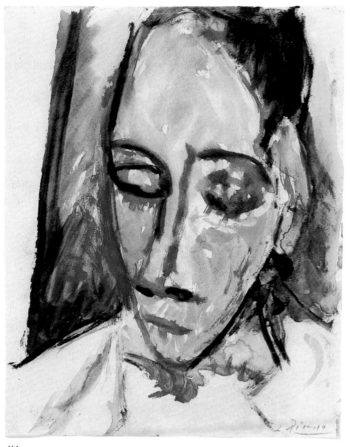

414

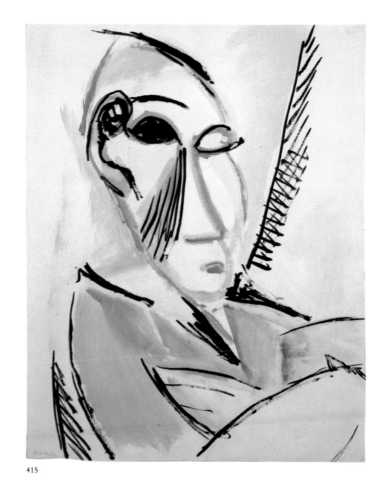

415

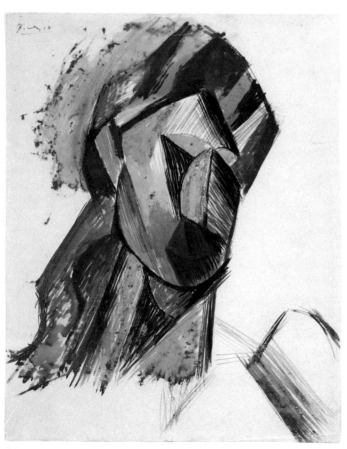

416

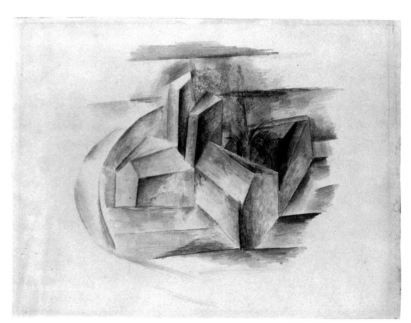

417

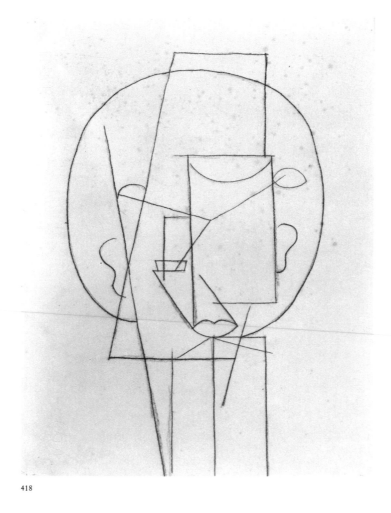

418

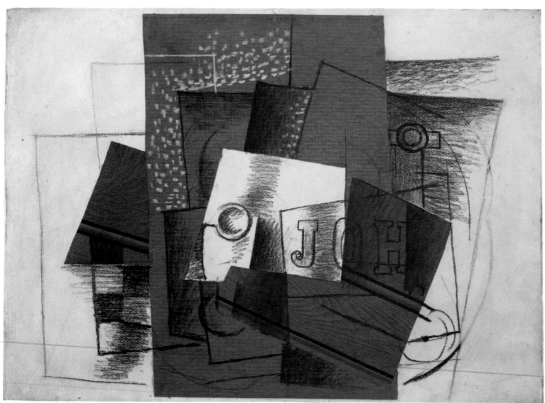

419

418. Pablo Picasso. *Head.* 1913. Charcoal on paper. 24⅜ x 18⅞" (61.9 x 47.8 cm). Alfred H. Barr, Jr., Bequest

During the first decade of the twentieth century a major problem for painters was the lack of a single unifying mechanism comparable to perspective. By 1912 Braque and Picasso had completely reorganized and subordinated the individualistic forms of perceptual perspective to a new conceptual system of linear organization. Multiple perspectives were organized by a linear armature; the attachments of the planes of the face and body became the structure and soul of the picture itself. The linear analysis of the head and the body into planar forms organized the whole surface as a system of flat planes. By 1913 Picasso dropped the shadow system with which he had maintained a minimal illusionistic space in earlier Cubist drawings. Having temporarily disposed of the space behind the picture—the space of illusionism—Picasso caused the flat surface to become the condition for a new pictorial space.

419. Georges Braque. *Still Life with Letters.* 1914. Cut-and-pasted papers, charcoal, and pastel on paper. 20⅜ x 28¾" (51.7 x 73 cm). The Joan and Lester Avnet Collection

In collage reality is dismantled and reconstructed at will. The means has become the motif, and the motif and means project their linear structures as the structure of twentieth-century art. Each element—contour, shading, texture, color—operates as an independent element or aesthetic system. Line could move toward analysis—and the armature broken apart—or it could be used synthetically to find figures in conjunction with the basic planar structure. It could be asserted in conjunction with the planes as abstractions. The basic structure accepted representational elements and was open also to metaphoric allusion and symbolic reference. Line also found abstract organic forms, and accommodated itself to impersonal handling as well as the most expressive gesturing. The

result is a continuous discourse, in twentieth-century art, among abstract, representational, organic, and geometric forms.

420. Pablo Picasso. *Man with a Hat.* 1912. Cut-and-pasted papers, charcoal, and brush and ink on paper. 24½ x 18⅝″ (62.2 x 47.3 cm). Purchase

In this work Picasso inserted an invention of Braque's, *papier collé,* or collage, into the armature of Cubism. The insertion of pieces of paper into the Cubist scaffolding changed the basis of pictorial illusionism; it became the means for reintroducing color and representation to the Cubist picture. The pictorial view was no longer intact; multiple viewpoints and planar disjunction became a new structural means whereby disparate elements were joined to create an illusion of a seamless whole. Line became a connective between the collage elements and the surface of the picture itself, as the elements of collage slid under and over one another. Elements of representation were made to coexist with constructed elements. Scale was no longer a function of notional reality, but of the construction itself. It became possible to introduce all sorts of nonart materials, to incorporate entire ready-made images from reproductions, textures from wallpaper, and newsprint, all of which served to create an optical texture previously achieved through hatching, and as the means to identify the subject. In *Man with a Hat* the device of analogy, itself basic to drawing, becomes in Picasso's hands the basic tool of Cubist formal analysis and the means to reconcile the various sensory impressions of reality: the ear and curve of the cheek echo the curves of a guitar, not simply suggesting sound, but making of the man, and by analogy the picture, an object, not a representation.

421. Pablo Picasso. *Man in a Melon Hat.* 1914. Pencil on paper. 13 x 10″ (32.8 x 25.4 cm). John S. Newberry Collection

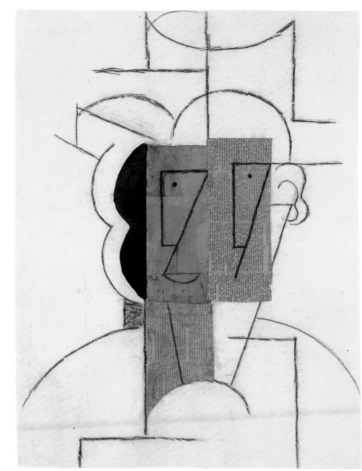

420

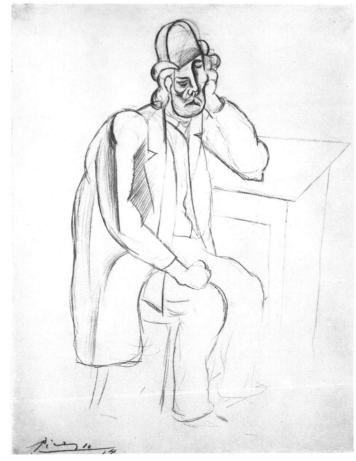

421

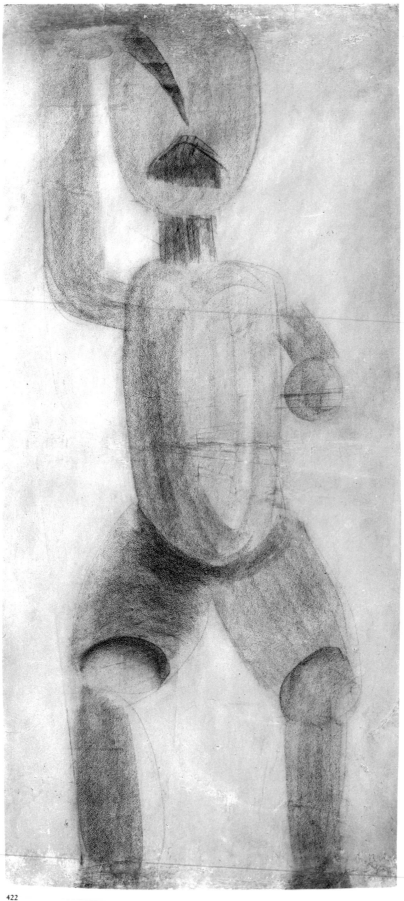

422

422. Constantin Brancusi. Study after *The First Step.* 1913. Crayon on paper. 32⅜ x 15″ (82.1 x 38 cm). Benjamin Scharps and David Scharps Fund

423. Fernand Léger. *Verdun: The Trench Diggers.* 1916. Watercolor on paper. 14⅛ x 10⅜″ (35.9 x 26.3 cm). Frank Crowninshield Fund

424. Robert Delaunay. *The Tower at the Wheel* (Study for *The Red Tower*). 1913 (inscribed 1909–10). Brush and pen and ink on paper. 25½ x 19½″ (64.7 x 49.7 cm). Abby Aldrich Rockefeller Fund

About 1910 the Eiffel Tower, built for the Paris International Exposition of 1889 as a monument to nineteenth-century pragmatism and technical utopianism, was rediscovered by artists and poets. But it was above all extolled by Delaunay, who drew and painted many views of it. In one view the Tower is seen from below, against sky and clouds, with the surrounding elements framing it drawn in different perspectives; in another, multiple perspectives of the Tower itself are penetrated by surrounding elements, thus creating a composite impression of many views. The Tower was above all a symbol of the new—of the "fourth-dimensional experience" of space-time that so interested Parisian and Italian artists of the period.

425. Robert Delaunay. Study after *Eiffel Tower.* 1911 (inscribed 1910). Pen and ink and traces of pencil on cardboard. 21¼ x 19¼″ (53.9 x 48.9 cm). Abby Aldrich Rockefeller Fund

426. Juan Gris. *Fruit Dish and Bottle.* 1917. Conté crayon and crayon on paper. 18¾ x 12¼″ (47.6 x 31.1 cm). Acquired through the Lillie P. Bliss Bequest

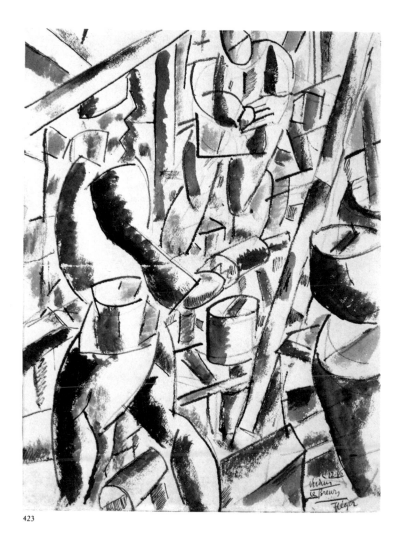

423

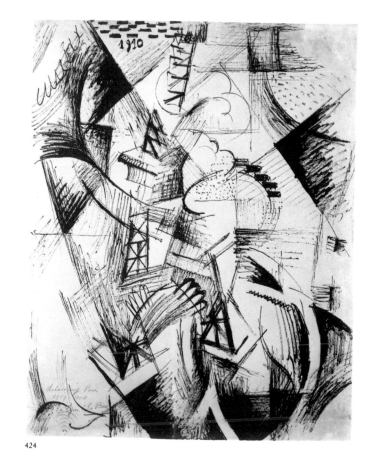

424

425

426

427

427. Umberto Boccioni. Study for *The City Rises*. 1910. Crayon, chalk, and charcoal on paper. 23⅛ x 34⅛" (58.8 x 86.7 cm). Mrs. Simon Guggenheim Fund

The City Rises is the last of Boccioni's great city subjects, completed just prior to his adoption of Cubist structure and, subsequently, of subject matter directly related to Futurist ideas concerning the interpenetration of space-time and memory. *The City Rises* represents a major synthesis of light and movement with social ideas having to do with labor and "urban issues." Although Boccioni had no academic training, he is revealed in this study as an extremely gifted draftsman. The mood is Symbolist, but while the painting is divisionist, the long repeated contour lines and hatches in the pencilwork belong to a more traditional and perhaps innocently eclectic draftsmanship. In the delineation of the rampaging horses that symbolize the wild, unleashed power of the city there is the beginning of the dynamic distortion of form and the curving baroque rhythms that would become the dominant stylistic elements seen in Boccioni's study for the sculpture *Muscular Dynamism*, drawn three years later.

428. Umberto Boccioni. Study for *States of Mind: The Farewells*. 1911. Charcoal and chalk on paper. 23 x 34" (58.4 x 86.3 cm). Gift of Vico Baer

429. Umberto Boccioni. Study for *States of Mind: Those Who Go*. 1911. Charcoal and chalk on paper. 23 x 34" (58.4 x 86.3 cm). Gift of Vico Baer

430. Umberto Boccioni. Study for *States of Mind: Those Who Stay*. 1911. Charcoal and chalk on paper. 23 x 34" (58.4 x 86.3 cm). Gift of Vico Baer

428

429

430

431

432

433

431. Umberto Boccioni. Study for *Muscular Dynamism*. 1913. Pastel and charcoal on paper. 34 x 23¼" (86.3 x 59 cm). Purchase

432. Gino Severini. Study for *Armored Train in Action*. 1915. Charcoal on paper. 22½ x 18¾" (56.9 x 47.5 cm). Benjamin Scharps and David Scharps Fund

433. Arthur G. Dove. *Nature Symbolized*. 1911–14. Charcoal on paper. 21¼ x 17⅞" (54 x 45.4 cm). Given anonymously

434. Francis Picabia. *New York*. 1913. Gouache, watercolor, and pencil on paper. 22 x 29⅞" (55.8 x 75.9 cm). The Joan and Lester Avnet Collection

434

435

435. Piet Mondrian. *Church Façade.*
1914 (inscribed 1912). Charcoal on
paper. 39 x 25″ (99 x 63.4 cm). The Joan
and Lester Avnet Collection

436. Piet Mondrian. *Pier and Ocean
(Sea in Starlight).* 1914. Charcoal
and white watercolor on paper. 34⅝
x 44″ (87.9 x 111.7 cm). Mrs. Simon
Guggenheim Fund

Pier and Ocean is one of a series of
drawings of the pier in the village
of Domberg. Recalling the series,
Mondrian wrote: "Observing the
sea, sky and stars, I sought to indi-
cate their plastic function through a
multiplicity of crossing verticals and
horizontals. I was impressed with
the greatness of nature, and tried to
express expansion, repose, unity."
Pier and Ocean is a transitional land-
mark not only in Mondrian's art but
also in the relationship of line to
delineation. It mediates between
observation and analysis, as it both
records the sensations of flickering
lights and moving patterns, as well

436

as the planar edges of forms, and reorganizes them conceptually into one coherent sign system. But the visual condensation of sign systems —the encoding of nature which began in modernism with van Gogh—is not the only system here operative. There is a secondary symbolic one: a linear system, comprising a "cosmic" dualism, in which the verticals are the masculine and spiritual, or creative, elements, spontaneously producing the planar structure; and the horizontals are the female and material elements, which are passive. Mondrian's notion of "objective" line and symbolic reference underlies his mature work, in which he moves away from all references to nature.

437. Jacob Epstein. Study for *The Rock Drill.* c. 1913. Conté crayon on paper. 27⅜ x 17¼″ (69.4 x 43.6 cm). The Joan and Lester Avnet Collection

438. Mikhail Larionov. *Rayonist Composition Number 8.* 1912–13. Brush and ink, gouache, and watercolor on paper. 20 x 14¾″ (50.8 x 37.5 cm). Gift of the artist

439. Theo van Doesburg (C. E. M. Küpper). *Composition* (Study for *The Cow*). 1916. Tempera, oil, and charcoal on paper. 15⅝ x 22¾″ (39.7 x 57.7 cm). Purchase

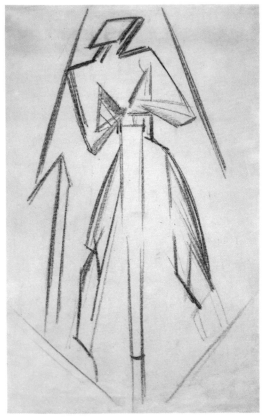

437

438

439

440

441

442

440. Kasimir Malevich. *Suprematist Element: Circle.* 1915. Pencil on paper. 18½ x 14⅜" (47 x 36.5 cm)

441. Kasimir Malevich. *Suprematist Elements: Squares.* 1915. Pencil on paper. 19¾ x 14¼" (50.2 x 35.8 cm).

442. El Lissitzky (Lazar Markovich Lissitzky). Study for page for *A Suprematist Story about Two Squares in 6 Constructions.* 1920. Watercolor and pencil on cardboard. 10⅛ x 8" (25.6 x 20.2 cm). The Sidney and Harriet Janis Collection

443. Alexander A. Vesnin. *Proposal for a Monument to the Third International.* 1921. Gouache on paper. 20¾ x 27¾" (53 x 70.5 cm). Acquired through the Mrs. Harry Lynde Bradley and the Katherine S. Dreier Bequests

444. El Lissitzky (Lazar Markovich Lissitzky). *Proun GK.* c. 1922. Gouache, brush and ink, and pencil on paper. 26 x 19¾" (66 x 50.2 cm)

443

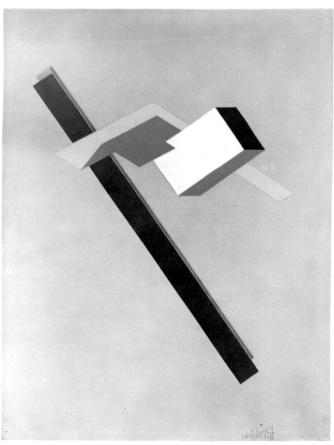

444

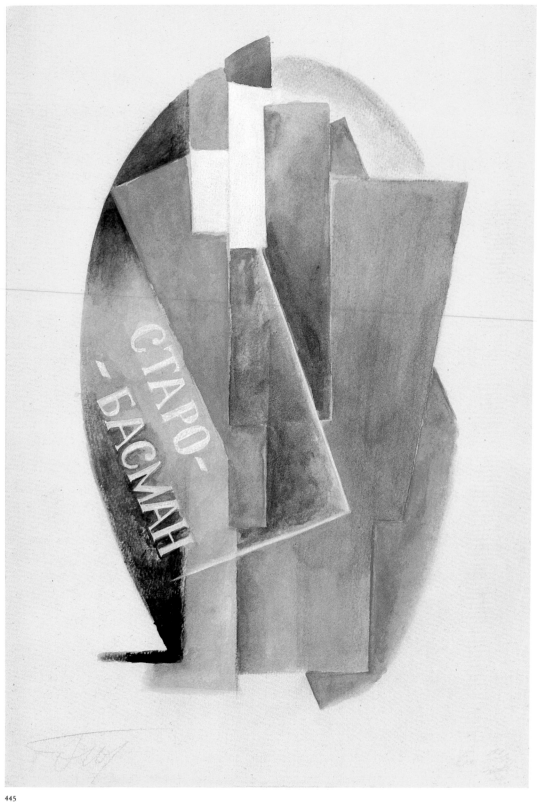

445

445. Vladimir Tatlin. Study for *Board, No. 1*. 1917. Watercolor, metallic paint, gouache, and traces of pencil on paper. 17¼ x 11⅝" (43.9 x 29.6 cm). Gift of The Lauder Foundation

446. Charles Demuth. *Stairs, Provincetown*. 1920. Gouache and pencil on cardboard. 23½ x 19½" (59.7 x 49.5 cm). Gift of Abby Aldrich Rockefeller

447. John Marin. *Lower Manhattan (Composing Derived from Top of Woolworth)*. 1922. Watercolor and charcoal with paper cutout attached with thread, on paper. 21⅝ x 26⅞" (54.9 x 68.3 cm). Acquired through the Lillie P. Bliss Bequest

448. Wassily Kandinsky. *Watercolor (Number 13)*. 1913. Watercolor on paper. 12⅝ x 16⅛" (32.1 x 41 cm). Katherine S. Dreier Bequest

The automatic line is the contour line—the line of delineation. Sometimes, in its modern guise, liberated from description, rather than delineate forms it "discovers" them. It is the peculiar vitality of the line as gesture that impels Kandinsky's watercolors. Kandinsky had sought to detach the representation of an object from its material condition because he regarded the material world as illusory and foreign to the spirit. His solution was to separate the radical contour line from a specifically descriptive function to become the vehicle of search and of aspiration, and it was this that propelled him into abstraction. Color only obliquely, and then only symbolically, referred to objects. It became, according to a theory in which color and sound are "synthetically" united in one sensation, symbolic of the spiritual, each color sounding a characteristic emotive note. Most important, line became the symbol of freedom; as color was released from material form, line also freed the "pure inner sound" of objects.

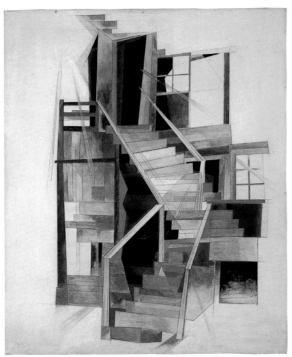

446

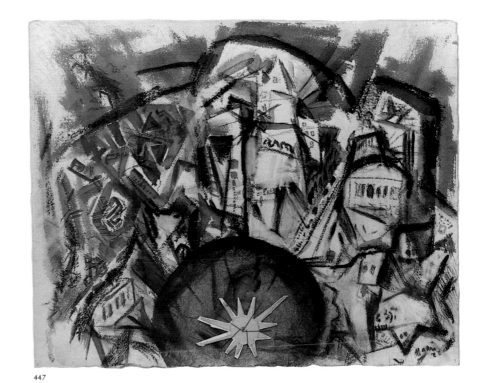

447

448

449

449. František Kupka. Study for *Fugue in Two Colors: Amorpha*. 1912. Gouache and brush and ink on paper. 16⅜ x 18⅝" (41.6 x 47.3 cm). Gift of Mr. and Mrs. František Kupka

450. Lyonel Feininger. *The Town of Legefeld I*. 1916. Pen and ink and charcoal on paper. 9½ x 12½" (24 x 31.6 cm). The Joan and Lester Avnet Collection

451. Paul Klee. *Demon above the Ships*. 1916. Watercolor and pen and ink on paper. 9 x 7⅞" (22.9 x 20 cm). Acquired through the Lillie P. Bliss Bequest

450

1916–65. Dämon über d. Schiffen

451

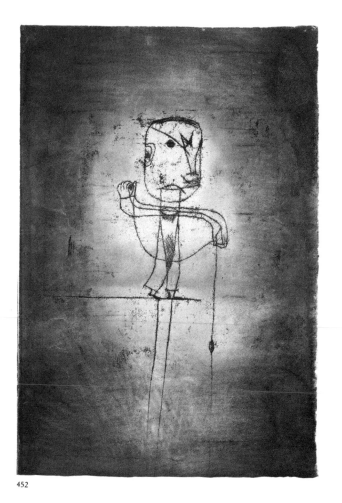

452

452. Paul Klee. *The Angler.* 1921. Watercolor on oil transfer drawing on paper. 18⅞ x 12⅜″ (47.6 x 31.2 cm). John S. Newberry Collection

453. Franz Marc. *Blue Horse with Rainbow.* 1913. Watercolor, gouache, and pencil on paper. 6⅜ x 10⅛″ (16.2 x 25.7 cm). John S. Newberry Collection

453

454. Paul Klee. *Twittering Machine.* 1922. Watercolor and pen and ink on oil transfer drawing on paper. 25¼ x 19" (63.8 x 48.1 cm). Purchase

Of this work James Thrall Soby wrote: "No one . . . can deny the importance of the title, *Twittering Machine.* The title is laughable to begin with, but to enjoy it fully we must know what manner of machine is shown. Yet once the subject is identified, visual expression takes over completely, and what is portrayed is not a literary idea but an auditory experience, as often happens in Klee's art. And note with what extraordinary subtlety the sound of the image is conveyed. The bird with an exclamation point in its mouth represents the twitter's full volume; the one with an arrow in its beak symbolizes an accompanying shrillness—a horizontal thrust of piercing song. Since a characteristic of chirping birds is that their racket resumes as soon as it seems to be ending, the bird in the center droops with lolling tongue, while another begins to falter in song; both birds will come up again full blast as soon as the machine's crank is turned. The aural impression of thin, persistent sound is heightened by Klee's wiry drawing, and his color plays a contributory part, forming an atmospheric amphitheatre which sustains and amplifies the monotonous twitter." This drawing was formerly in the collection of the National Gallery in Berlin, where it hung for five years. It was declared "degenerate" art by Hitler and subsequently acquired by the Museum.

455. Wassily Kandinsky. *Black Relationship.* 1924. Watercolor and pen and ink on paper. 14½ x 14¼" (36.8 x 36.2 cm). Acquired through the Lillie P. Bliss Bequest

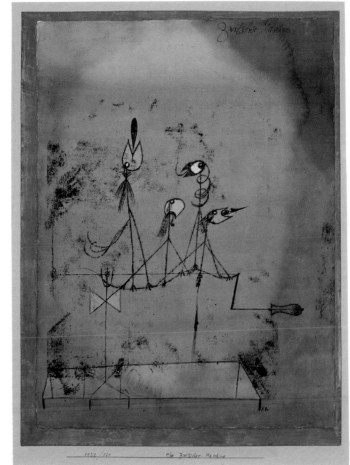

454

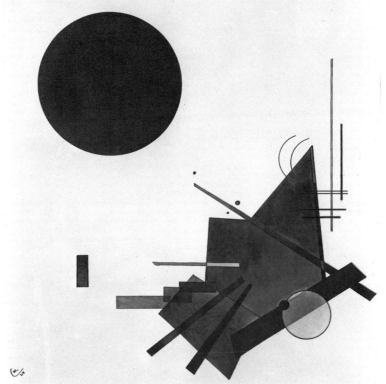

455

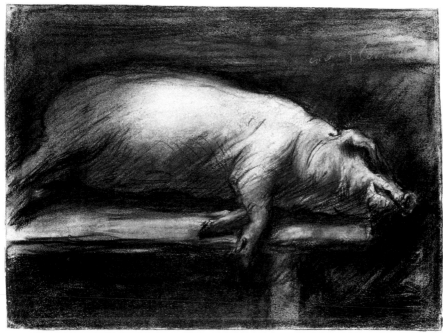

456

456. Lovis Corinth. *Slaughtered Pig.* c. 1907. Pastel on paper. 9⅞ x 13⅝″ (25.1 x 34.4 cm). Mr. and Mrs. Walter Bareiss Fund

457. Emil Nolde (Emil Hansen). *Papuan Head.* 1914. Watercolor on paper. 19⅞ x 14¾″ (50.4 x 37.5 cm). Gift of Mr. and Mrs. Eugene Victor Thaw

458. Max Beckmann. *The Feast of the Prodigal.* From the Prodigal Son series. 1918. Gouache, watercolor, and traces of pencil on parchment. 14¼ x 11¾″ (36.1 x 29.7 cm). Purchase

459. Otto Dix. *Café Couple.* 1921. Watercolor and pencil on paper. 20 x 16⅛″ (50.8 x 41 cm). Purchase

460. George Grosz. *Circe.* 1927. Watercolor, pen and ink, and pencil on paper. 26 x 19¼″ (66 x 48.6 cm). Gift of Mr. and Mrs. Walter Bareiss and anonymous donor (by exchange)

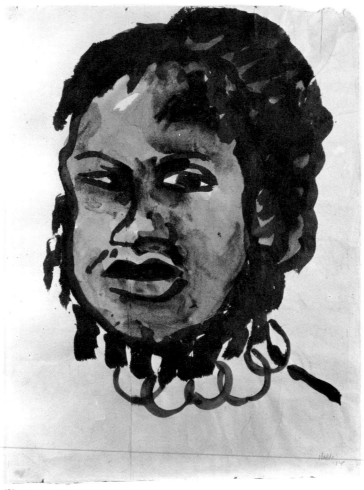

457

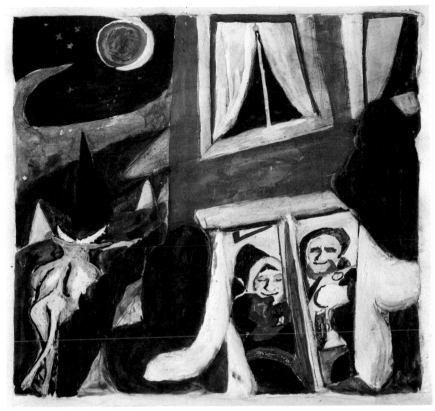

458

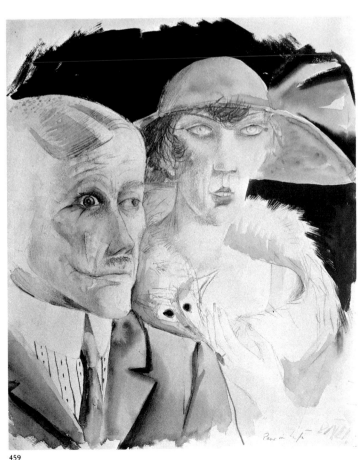

459

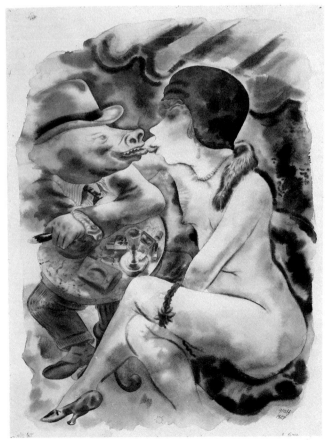

460

461

462

463

461. Man Ray. *Admiration of the Orchestrelle for the Cinematograph.* 1919. Gouache, wash and ink, air-brushed on paper. 26 x 21½" (66 x 54.6 cm). Gift of A. Conger Goodyear

462. Francis Picabia. *Dada Movement.* 1919. Pen and ink on paper. 20⅛ x 14¼" (51.1 x 36.2 cm). Purchase

463. Marcel Duchamp. *Handmade Stereopticon Slide.* 1918–19. Rectified Readymade: pencil over photographic stereopticon slide. Each image 2¼ x 2¼" (5.7 x 5.7 cm) in a cardboard mount 2¾ x 6¾" (7 x 17.1 cm). Katherine S. Dreier Bequest

464. Kurt Schwitters. *Merz (with letters "elikan" repeated).* c. 1925. Cut-and-pasted papers. 17⅛ x 14¼" (43.5 x 36.2 cm). Katherine S. Dreier Bequest

464

465.

465. Kurt Schwitters. *Merz 379: Potsdamer.* 1922. Cut-and-pasted papers, printed papers, and cloth. 7⅛ x 5¾" (18.1 x 14.6 cm). Purchase

466. Jean (Hans) Arp. *Arrangement According to the Laws of Chance (Collage with Squares).* 1916–17. Torn-and-pasted papers on paper. 19⅛ x 13⅝" (48.5 x 34.6 cm). Purchase

467. Jean (Hans) Arp. *Automatic Drawing.* 1916. Brush and ink and traces of pencil on gray paper. 16¾ x 21¼" (42.6 x 54 cm). Given anonymously

Arp had initially let chance into his art in his collages of 1915–16, letting the pieces of torn or cut paper fall to the floor, where he would then arrange them on sheets of paper more or less as they had fallen. In 1916 automatic drawing, too, grew out of a kind of chance—the deliberate release of the hand from conscious control so that its motion took over without the intercession of a preconceived subject. The hand traced extended lines which doubled back on themselves to create enclosures or configurations which intimated all sorts of life forms, provoked poetic associations; those

466

467

which "expressed his intentions," Arp filled in. The flat, biomorphic form abstracted from nature which resulted became the common iconographic element in Surrealism, as well as Arp's characteristic form; and the technique of automatic drawing itself, as a pure plastic device, became the mainspring of one branch of Surrealism. Later, in the forties in New York, it became the means to a whole new pictorial strategy.

468. Giorgio de Chirico. *The Mathematicians.* 1917. Pencil on paper. 12⅝ x 8⅝" (32.1 x 21.9 cm). Gift of Mrs. Stanley B. Resor.

The dreamlike menace of his imagery and the frozen reality of his mechanical images are but two of de Chirico's contributions to modern art. More significant perhaps is the device that renders these strange images in their strange spaces effective—his original synthesis of elements of abstraction with arbitrary perspectival space. The combination of these two elements, as in *The Mathematicians,* where the two figures—half-mechanical "lay" figures, half humanoid—seem to suggest ancient drawing machines, creates the unsettling, hallucinatory effect. Indeed, conventional perspective is the ancient art of mathematics. De Chirico's space is perhaps closer to mechanical than perspectival or Cubist space. De Chirico's composite space and his vision of the organic assimilated and juxtaposed to the mechanical had a direct impact on Ernst and on other Surrealists as well as on realism of the twenties.

469. Max Ernst. *The Little Tear Gland That Says Tic Tac.* 1920. Gouache on wallpaper. 14¼ x 10" (36.2 x 25.4 cm). Purchase

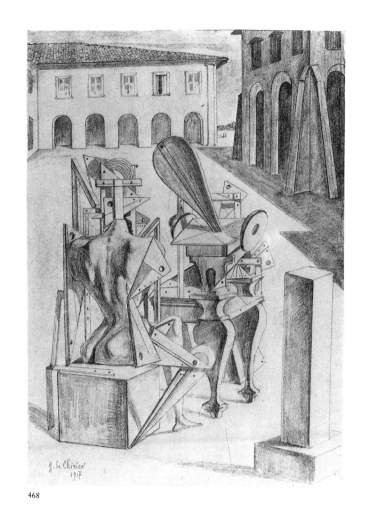

468

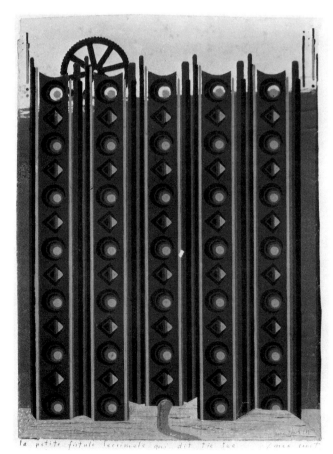

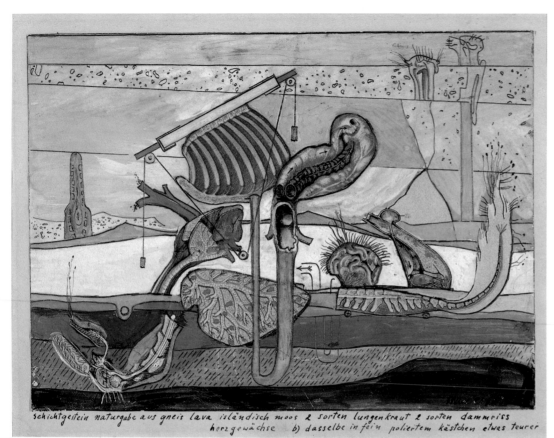

schichtgestein naturgabe aus gneis lava isländisch moos 2 sorten lungenkraut 2 sorten dammriss
herzgewächse b) dasselbe in fein poliertem kästchen etwas teurer

470

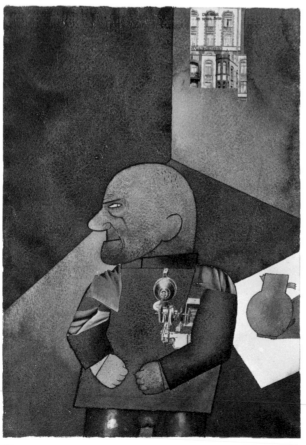

471

470. Max Ernst. *Stratified Rocks, Nature's Gift of Gneiss Lava Iceland Moss 2 Kinds of Lungwort 2 Kinds of Ruptures of the Perineum Growths of the Heart (b) The Same Thing in a Well-Polished Box Somewhat More Expensive.* 1920. Anatomical engraving altered with gouache and pencil on paper. 6 x 8⅛″ (15.2 x 20.6 cm). Purchase

471. George Grosz. *The Engineer Heartfield.* 1920. Watercolor, pasted postcard, and halftone on paper. 16½ x 12″ (41.9 x 30.5 cm). Gift of A. Conger Goodyear

The Engineer Heartfield is translated from the German, *Die Monteur Heartfield.* The change from "Monteur" to "Engineer" is a little misleading in that the work itself is meant to be a montage, that is to say, an assembly or mounting; in English "engineered" or constructed, while closest, does not quite give the sense of the technique. Here the image is made of cut-and-pasted mechanical reproductions from magazines and technical journals pasted to an extraordinarily delicate and precise watercolor, showing virtuosity as well as invention. The marriage of the mechanical and the artistic is matched by the marriage of the "real" and the constructed in the kind of strange juxtaposition of elements and pseudo-illusionistic space invented by de Chirico but here owed directly to German army photographers who placed portrait heads into idealized oleographic mounts. The antiart aspect of using mechanical reproductions is pure Dada, as is the meeting of high and low art. Pontus Hultén has pointed out that "The 'machine heart' has nothing to do with the old mechanistic interpretation of man as a machine but signifies the degree of identification with the utopian dream of what machines might achieve in the future. Those who have machines for hearts must be very special and strong men, whose spirits are ruled by no weak, sentimental organs but by instruments of rationality and logic." Here Heartfield, Grosz's colleague and friend, is

portrayed during one of his stays in prison for political activism—his beard delicately etched as if after several days' growth—still fierce and courageous, while the inscription seen out the window in the upper right wishes him "lots of luck in his new home."

472. Natalia Gontcharova. *The City Square* (Design for the ballet *Le Coq d'or*). 1914. Gouache, watercolor, and pencil on cardboard. 18⅜ x 24¼" (46.7 x 61.6 cm). Acquired through the Lillie P. Bliss Bequest

473. Marc Chagall. *Homage to Gogol* (Design for theater curtain). 1917. Watercolor on paper. 15½ x 19¾" (39.4 x 50.2 cm). Acquired through the Lillie P. Bliss Bequest

472

473

474

475

476

474. George Grosz. Costume study for *Methuselah*. 1922. Watercolor, metallic paint, and pen and ink on paper. 20¾ x 16¼″ (52.6 x 41.1 cm). Mr. and Mrs. Werner E. Josten Fund

475. Oskar Schlemmer. Study for *The Triadic Ballet*. c. 1922. Gouache, brush and ink, incised enamel, and pasted photographs on paper. 22⅝ x 14⅝″ (57.5 x 37.1 cm). Gift of Lily Auchincloss

The idea of man as a creature made of parts that could be assembled and restructured at will—as an automaton—inherent in collage, was irresistibly theatrical. The idea, in Russia, that abstract art could spread through the most popular art form of all, the theater, led to the creation of an artists' theater where drama and the plastic arts could be integrated to form the total work of art—in Germany the *Gesamtkunstwerk*. On stage the total work of art consisted of a construction of moving parts in which the actors were clad in costumes intended to make them cogs in the total machine of the production. These strange mechanistic creatures also made strange mechanistic noises and moved to music that vocalized broken, repetitive word patterns like those in Futurist and Constructivist calligraphy and typography. Numerous studies of costumes and set designs survive as fragments of these productions. This collage is a visualization of three costumes on stage for Schlemmer's production in Stuttgart of his own creation, *The Triadic Ballet*, conceived while he was a teacher at the Bauhaus in Dessau.

476. Aleksandra Exter. Costume design for *The Guardian of Energy*. 1924. Pen and ink, gouache, and pencil on paper. 21¼ x 14¼″ (51.1 x 36 cm). The J. M. Kaplan Fund, Inc.

477. Henri Matisse. *The Plumed Hat*. 1919. Pencil on paper. 21¼ x 14⅜″ (54 x 36.5 cm). Gift of The Lauder Foundation

478. Amedeo Modigliani. *Mario Varvogli*. 1920. Pencil on paper. 19¼ x 12" (48.8 x 30.4 cm). Gift of Abby Aldrich Rockefeller

479. Henri Matisse. *Reclining Nude*. 1927. Pen and ink on paper. 10⅞ x 15" (27.7 x 32 cm). The Tisch Foundation, Inc., Fund

480. Juan Gris. *Max Jacob*. 1919. Pencil on paper. 14⅜ x 10½" (36.5 x 26.7 cm). Gift of James Thrall Soby

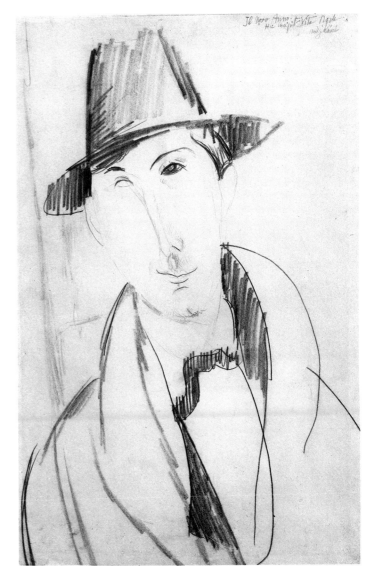

478

477

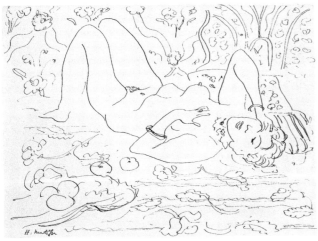

479

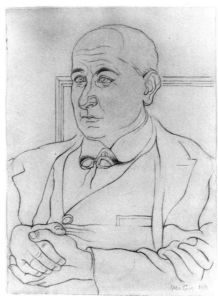

480

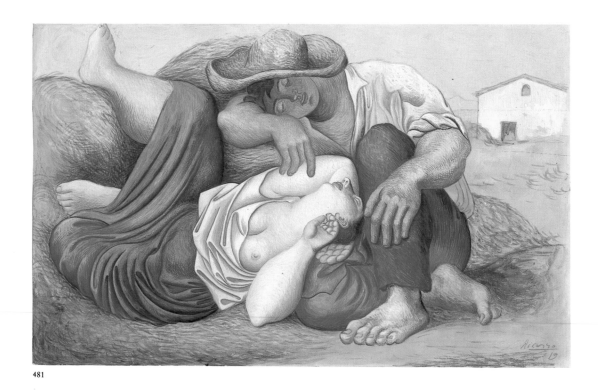

481

481. Pablo Picasso. *Sleeping Peasants.* 1919. Tempera, watercolor, and pencil on paper. 12¼ x 19¼″ (31.1 x 48.9 cm). Abby Aldrich Rockefeller Fund

482. Paul Klee. *Early Morning in Ro...* 1925. Watercolor on paper. 14⅝ x 20⅛″ (37 x 50.9 cm). Gift of Mrs. Gertrud A. Mellon

483. Joan Miró. *The Family.* 1924. Charcoal, chalk, conté crayon, scored, on sandpaper. 29¼ x 41″ (74.1 x 104.1 cm). Gift of Mr. and Mrs. Jan Mitchell

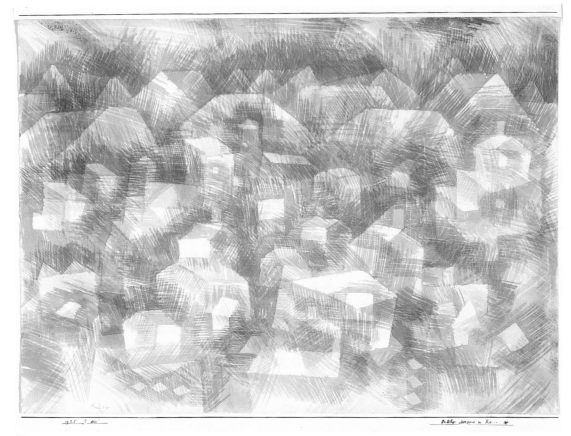

482

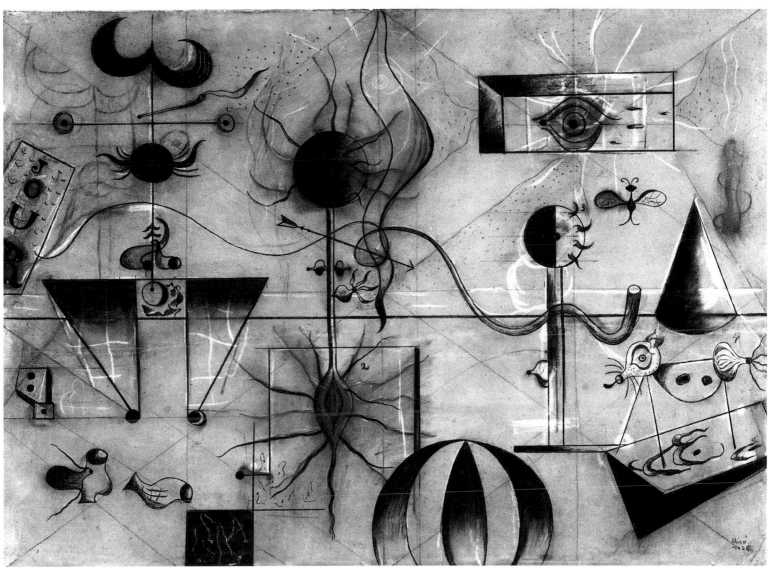

483

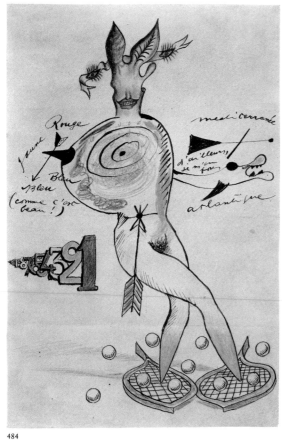

484

485

486

484. Exquisite Corpse (composite drawing, top to bottom: Yves Tanguy, Joan Miró, Max Morise, Man Ray). *Nude*. 1926–27. Pen and ink, pencil, and colored crayon on paper. 14¼ x 9″ (36.2 x 22.9 cm). Purchase

485. Oscar Dominguez. Untitled. 1936. Gouache transfer (decalcomania) on paper. 14⅛ x 11½″ (35.9 x 29.2 cm). Purchase

486. Salvador Dali. Untitled. 1927. Pen and brush and ink on paper. 9⅞ x 12⅞″ (25.1 x 32.6 cm). Gift of Mrs. Alfred R. Stern in honor of René d'Harnoncourt

487. Pablo Picasso. *Two Figures on a Beach*. 1933. Pen and ink on paper. 15¾ x 20″ (40 x 50.8 cm). Purchase

488. Pablo Picasso. Cover design for *Minotaure*. 1933. Collage of pencil on paper, corrugated cardboard, silver foil, ribbon, wallpaper painted with gold paint and gouache, paper doily, burnt linen, leaves, tacks, and charcoal on wood. 19⅛ x 16⅛″ (48.5 x 41 cm). Gift of Mr. and Mrs. Alexandre P. Rosenberg

487

488

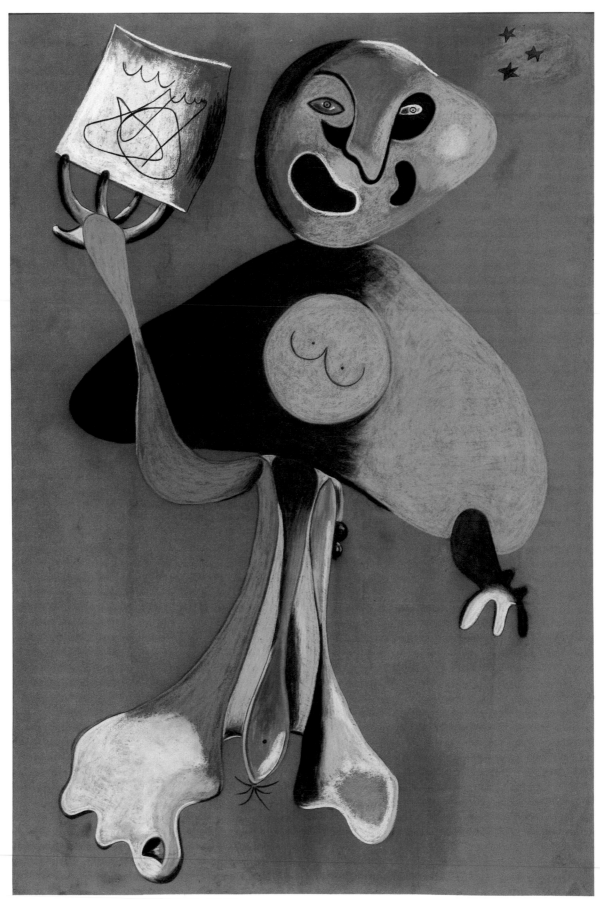

489

490

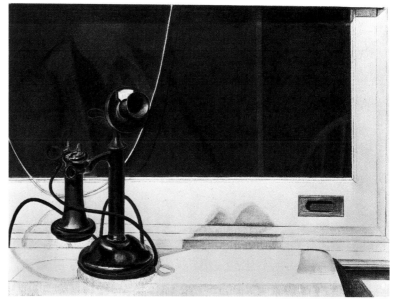

489. Joan Miró. *Opera Singer*. 1934.
Pastel and pencil on brown emery paper.
41⅜ x 29⅛″ (105.1 x 74 cm). Gift of
William H. Weintraub

490. Georgia O'Keeffe. *Banana Flower*.
1933. Charcoal on paper. 21¾ x 14¾″
(55.2 x 37.5 cm). Given anonymously
(by exchange)

491. Charles Sheeler. *Self-Portrait*.
1923. Conté crayon, gouache, and pencil
on paper. 19¾ x 25¾″ (50.1 x 65.2 cm).
Gift of Abby Aldrich Rockefeller

492. Stuart Davis. *Composition No. 5*.
1932. Gouache on paper. 22 x 29⅞″
(55.9 x 75.9 cm). Gift of Abby Aldrich
Rockefeller

493. Paul Klee. *Letter Ghost*. 1937.
Gouache on newspaper. 13 x 19¼″ (33
x 48.9 cm). Purchase

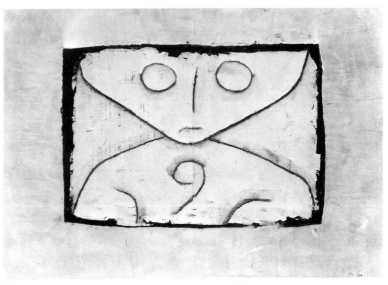

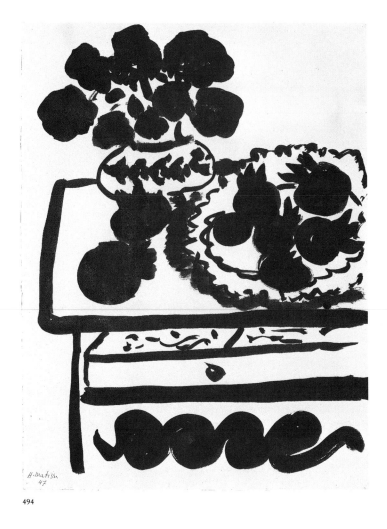

494

494. Henri Matisse. *Dahlias and Pomegranates*. 1947. Brush and ink on paper. 30⅛ x 22¼" (76.4 x 56.5 cm). Abby Aldrich Rockefeller Fund

Like Picasso, Matisse was an artist whose career encompassed the most radical innovations in the means of drawing. While less an inventor of technique, Matisse reinfused old techniques with new poetry by forcing them beyond convention. As painting came more and more to mean color, black-and-white drawing became a refuge, a means of refreshing the eye. Nevertheless Matisse's ambition in drawing was to invest black-and-white contour drawing with all the nuance of color. In 1939 he wrote, "My line drawing is the purest and most direct translation of my emotion. The simplification of the medium allows that. At the same time, these drawings are more complete than they may appear to some people who confuse them with a sketch. They generate light; seen on a dull day or in indirect light they contain, in addition to the quality and sensitivity of line, light and value differences which quite clearly correspond to color." About perspective Matisse said, "My final line drawings always have their own luminous space and the objects of which they are composed are on different planes; thus, in perspective, but in a perspective of feeling, in suggested perspective." Here we have his essential attitude and an exact description of his radical space, and the nature of his break with Renaissance linear perspective.

495. André Masson. *Pasiphaë*. 1945. Pastel on paper. 27½ x 38⅛" (69.8 x 96.8 cm). Gift of the artist

496. Henri Matisse. *The Necklace*. 1950. Brush and ink on paper. 20⅞ x 16⅛" (52.8 x 40.7 cm). The Joan and Lester Avnet Collection

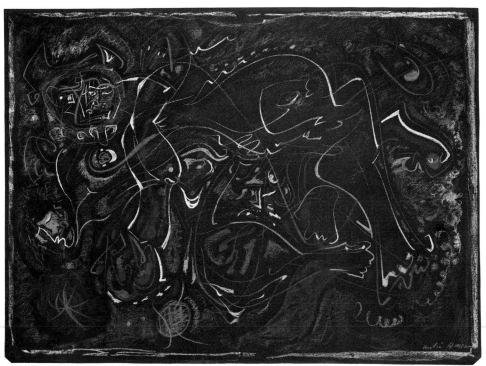

495

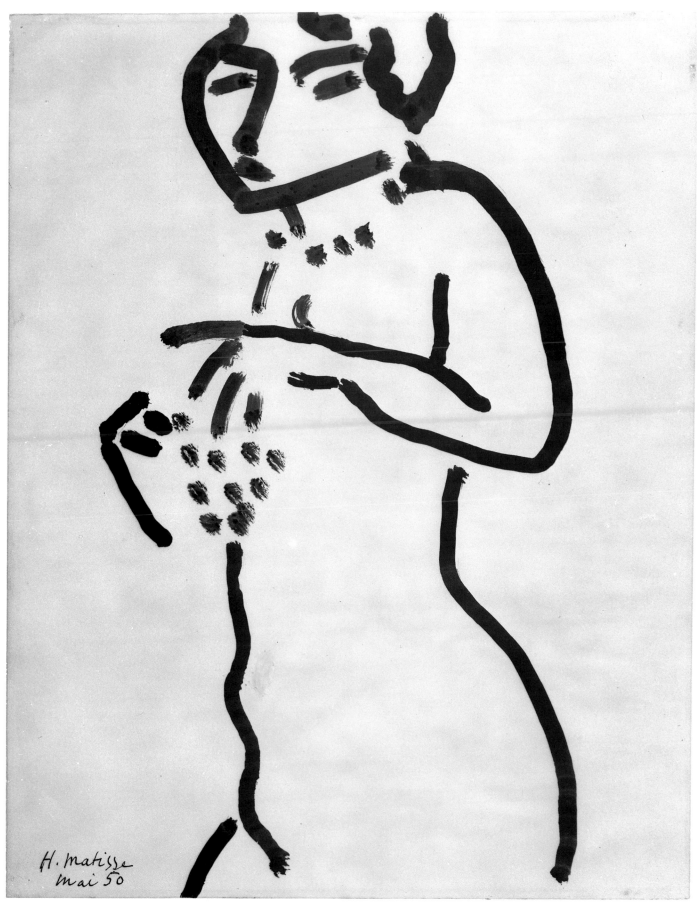

496

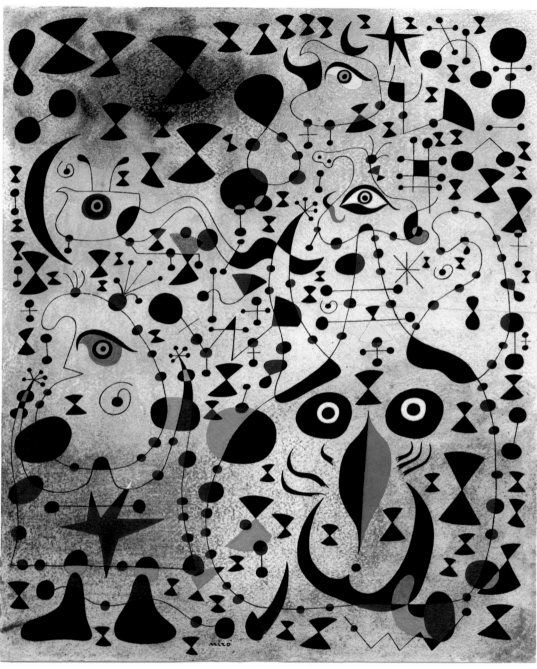

497

497. Joan Miró. *The Beautiful Bird Revealing the Unknown to a Pair of Lovers.* 1941. Gouache and oil wash on paper. 18 x 15″ (45.7 x 38.1 cm). Acquired through the Lillie P. Bliss Bequest

498. Alberto Giacometti. *Portrait.* 1951. Lithographic crayon and pencil on paper. 15⅜ x 10⅞″ (38.8 x 27.4 cm). Gift of Mr. and Mrs. Eugene Victor Thaw

499. Balthus (Baltusz Klossowski de Rola). Study for *Nude with Cat.* c. 1949. Pen and ink and pencil on paper. 11⅞ x 17¾″ (30 x 45.1 cm). Gift of John S. Newberry

500. Jean Dubuffet. *Man with Hat in a Landscape.* 1960. Pen and ink on paper. 12 x 9⅜″ (30.4 x 23.7 cm). The Joan and Lester Avnet Collection

Dubuffet has been one of the most prolific draftsmen of the postwar era and a constant technical innovator, creating new kinds of drawing and painting grounds on which to exercise his passionate draftsmanship. Reinfusing the Surrealist technique of automatic drawing with new energy, he uses drawing—particularly the scratchy, ungracious, tightly curled line—as his primary means. He structures even his largest paintings as if he were working on the drawing sheet, expanding or contracting scale as necessary to the particular format. For Dubuffet the world is made of lines crawling over themselves, finding people, finding objects. In *Man with Hat in a Landscape* both the figure and the landscape seem made of the same kind of molecular substance; the drawing meshes one into the other, differentiating them only by density. Rejecting the systematic and controlled for the spontaneous and automatic, Dubuffet seeks primitive and psychotic sources for his art, embracing the irrational as an aesthetic.

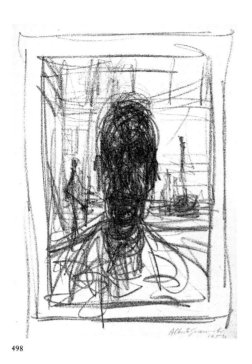

498

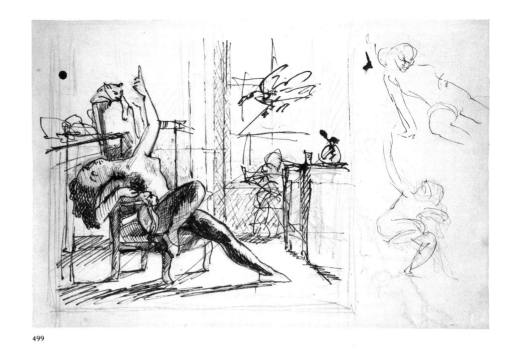

499

500

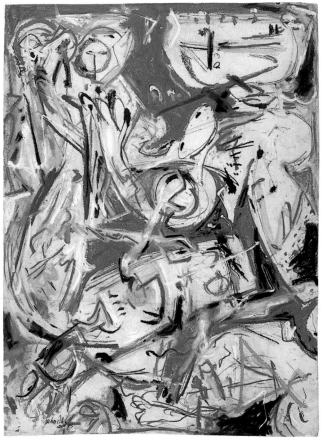

501

502. Willem de Kooning. *Standing Woman*. 1952. Pastel and pencil on two sheets of paper. 12 x 9½" (30.3 x 24.1 cm). The Lauder Foundation Fund

501. Jackson Pollock. *Painting*. 1945. Pastel, gouache, and pen and ink on paper. 30⅝ x 22⅜" (77.7 x 57 cm). Blanchette Rockefeller Fund

De Kooning derived his first notion of drawing from Ingres; though basically a contour draftsman he is also a colorist who, like Cézanne, is ambitious to integrate drawing and painting—that is, line and color. To an extraordinary sense of linear plasticity he brings an even more extraordinary sense of color that is sheerly physical and material. The marriage of these seemingly disparate approaches produces a new interpretation of contour drawing which seems to strip away layers, opening them to one another and making parts of body and landscape seem interchangeable and transparent yet still identifiable. For de Kooning the function of drawing lies in this concept of interchangeability—the "likeness" of forms, the ambiguity of identity. In *Standing Woman* it is as though one of Cézanne's seated figures has been unclothed and made transparent to its environment. The drawing shifts from top to bottom; on the top it is sliced apart so that there is a real spatial disjunction, a "jump"; on the bottom the shift is in perspective. In much the same way Cézanne's figures shift to fit the picture plane. The constant reworking, too, creates a sense of change and mutability to which our eyes constantly respond.

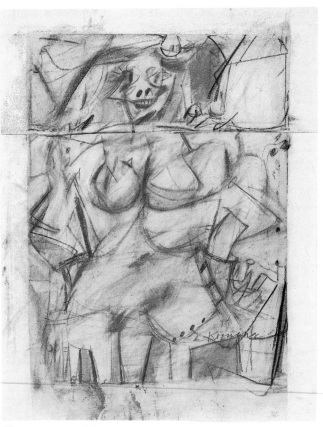

502

503. Jackson Pollock. Untitled. 1951. Black and colored inks on mulberry paper. 24¼ x 34″ (61.5 x 86.4 cm). The Joan and Lester Avnet Collection

Abstract Expressionism was based on a radical reinterpretation of drawing. Pollock's work introduced a new set of terms, extending the interpretation of the basic Cubist structure to one that seemed spatially limitless and expressively transcendent. He put together automatic drawing and painting in a new way, pouring paint directly from a can and using the brush as an extension of the movement of his body to direct its flow onto a horizontal surface without actually touching it. He created a separate linear existence for each of the three basic elements of pictorial construction—contour, color, and shadow—incorporating kinetic effects as spattered paint. In his classic works of 1947–50, these lines, layered over one another and constantly recrossing, create an evenly accented nonhierarchical division of the pictorial surface that gives the impression of a field of energy. Line in this field is wholly nonobjective; in fact, it does not even describe abstract contours, but is only the trace of its own energetic movement. This field became the condition for advanced art. Even Pollock himself later adapted figuration to it. Here, in a small work, he pours colored inks, integrating line and color, and making the broad line that results from the soaking of the ink into the paper function as its own subject removed from the description of contour.

504. Jackson Pollock. Untitled. c. 1950. Ink on paper. 17½ x 22¼″ (44.4 x 56.5 cm). Gift of Mr. and Mrs. Ronald S. Lauder in honor of Eliza Parkinson Cobb

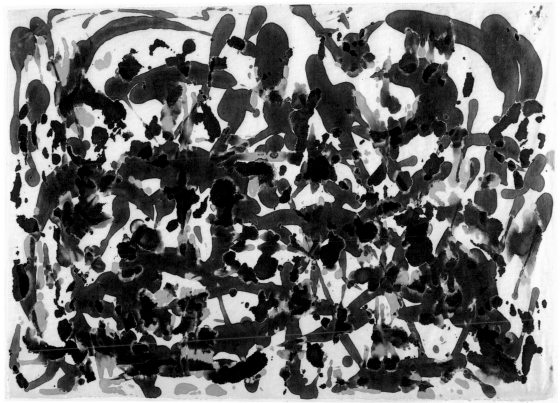

503

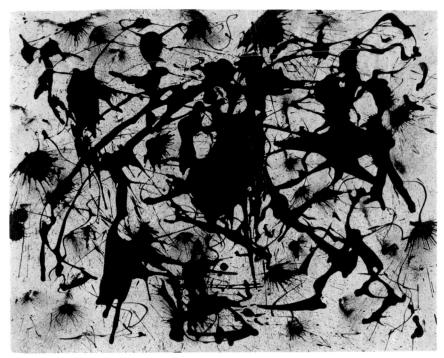

504

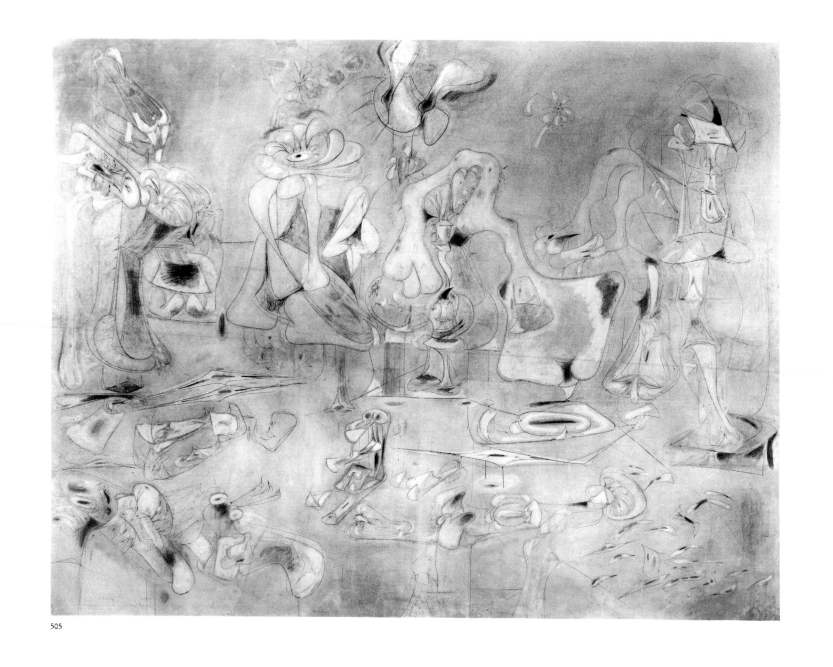

505

505. Arshile Gorky. *Summation.* 1947.
Pastel, pencil, and charcoal on paper
mounted on composition board. 6'7⅝"
x 8'5¾" (202.1 x 258.2 cm). Mr. and
Mrs. Gordon Bunshaft Fund

It has been suggested that *Summation* is a full-size preparatory cartoon for a canvas that would have been Gorky's most ambitious oil painting. The composition exists also in several exquisite smaller studies. The drawing with its velvety tones and its prolix, fluid, semiautomatic drawing that calls forth extravagant creatures of the artist's fantasy is a sufficient work of art in itself. While the title was added after Gorky's death, Gorky nevertheless did talk about the drawing in complex psychological and mythic language commenting, "this is a world, a world dominated by the ghost of the unquiet father." He usually described the "unquiet father" in terms of the progenitor, so that one may indeed think of the drawing as fecund or fertile—the line begetting images. Gorky is one of those draftsmen whose hand can seem to do no wrong, and in the painstaking transition from small to large he has not lost the essential intensity of his smaller drawings; rather, the large work has gained a dreamlike atmosphere and expansiveness, the result of the soft graphite shadows.

506. Robert Rauschenberg. *Canto XXXI.* From Thirty-Four Illustrations for Dante's *Inferno.* 1959–60. Red and graphite pencil, gouache, and transfer on paper. 14½ x 11½" (36.8 x 29.2 cm). Given anonymously

507. Joseph Beuys. *Dynamis 3.* 1960. Oil, pencil, and pen and ink on two sheets of paper. 19¾ x 13⅞" (50.1 x 35.3 cm). Purchase

506

507

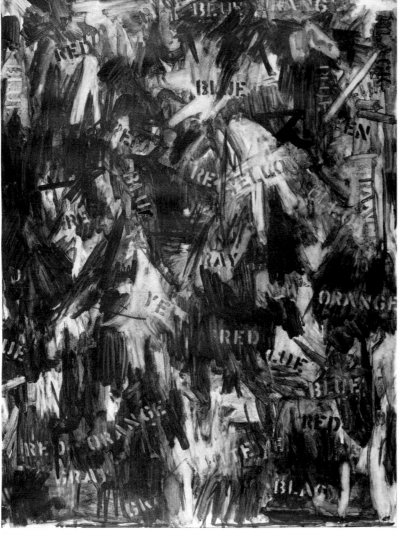

508

508. Jasper Johns. *Jubilee*. 1960. Brush and graphite wash, stencil, and traces of pencil on paper. 28 x 21" (71.1 x 53.3 cm). The Joan and Lester Avnet Collection

Following the establishment of the allover field it was Johns who restored the object, or image, to advanced art. For Johns the depicted object became the structure and soul of the picture, constructed by its internal shadows and, initially, identified absolutely with its support. About 1960 he decided that the drawing sheet represented the flattest condition for illusion, and he restored drawing, as such, to advanced art. But literal flatness was only one of the conditions of drawing: there was also the classical differentiation between line and color. Drawing is linear; as it departs from an exclusively linear mode and moves into tonal modulation, to shadow, it mimics the effects of color and becomes an analogy for color rendering. Johns makes use of the tonal possibilities inherent in loose graphite suspended in a wash, charcoal, or other soft monochromatic mediums through which ground light shines, thus binding illusion to surface. In Johns's drawing, Seurat's massing of form out of value and contrast has been accommodated to automatic line and the brushwork of Abstract Expressionism. Illusionism itself becomes the subject of the picture; its space the substance of shadow.

509. Agnes Martin. Untitled. 1960. Pen and ink on paper. 11⅞ x 12⅛" (30.2 x 30.6 cm). Acquired with matching funds from The Lauder Foundation and the National Endowment for the Arts

510. Jasper Johns. *Numbers*. 1966. Brush and graphite wash and pencil on brown paper. 26 x 21⅝" (65.8 x 54.8 cm). Gift of Mrs. Bliss Parkinson in honor of René d'Harnoncourt

511. Claes Oldenburg. *Stripper with Battleship* (Preliminary study for "Image of the Buddha Preaching" by Frank O'Hara). 1967. Pencil on paper. 30⅛ x 22⅛" (76.4 x 56.1 cm). Given anonymously

509

510

512. Sol LeWitt. *Straight Lines in Four Directions Superimposed.* 1969. Graphite on white wall. Size variable. Purchase

For LeWitt, art's primary creative aspect is that of conception. The work of art is seen as formed by a structural model that is verbally projected, a work of art made of generalized elements so basic that they can be exchanged ad infinitum within agreed rules, the rules constituting a kind of system. In LeWitt's art the visual components follow from the need to find the simplest elements with which to form a structure that would fit the most elementary description of a visual work of art. Drawing for LeWitt—the most elementary, basic work of art—was initially projected as the diagrammatic aspect of making a three-dimensional work and of placing it in three-dimensional space. Then LeWitt transferred the Cubist grid to the floor, using it as a diagram for a three-dimensional structure. One module of this structure could then be repeated as the module for structures and arrangements of greater complexity, using the grid. Drawing projected from this sculptural notation was then subjected to the same rule-making logic. In a brilliant act of intuition the artist transferred the drawing onto the wall, putting the drawing into the same kind of space as the structures occupied—the available space of the world, interpreted in each case as the given room with its given walls. The drawing here, a version of the first full wall drawing, is the simple expression of a simple concept: "Lines in four directions (horizontal, vertical, diagonal left, and diagonal right) covering the entire surface of the wall. Note: the lines are drawn with hard graphite (8H or 9H) as close together as possible (⅟₁₆″ apart approximately) and are straight." Here the statement of the basic structures of twentieth-century art is rendered in the simplest terms as a form of mediation between two- and three-dimensional concerns, between verbal and visual, a recognition of the language of drawing.

511

512

513

514

513. Gilbert and George (Gilbert Proesch and George Passmore). *To Be with Art is All We Ask*. 1970. Charcoal and wash on three partially charred pieces of paper. Triptych, overall 9′2⅜″ x 26′8¾″ (280.3 x 814.6 cm). Purchase

514. Dorothea Rockburne. *Neighborhood*. 1973. Wall drawing, pencil and colored pencils with vellum. 13′4″ x 8′4″ (406.4 x 254 cm) (size variable, work to be executed at a future date). Gift of J. Frederic Byers III

515. Richard Serra. *Heir*. 1973. Charcoal and synthetic polymer paint on paper. 9′6⅝″ x 42¼″ (291.2 x 107.2 cm). Acquired with matching funds from Mr. and Mrs. S. I. Newhouse, Jr., and the National Endowment for the Arts

515

516

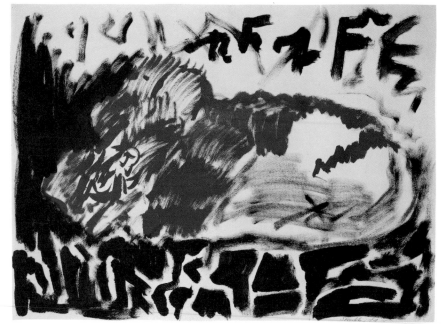

517

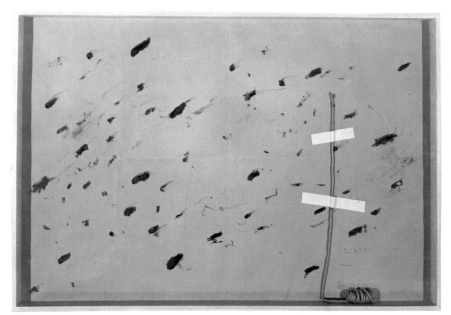

518

516. Jim Dine. *Second Baby Drawing.* 1976. Charcoal, crayon, and oil on paper. 39⅜ x 30½″ (101.1 x 77.5 cm). Gift of Lily Auchincloss

517. A. R. Penck (Ralf Winkler). *Structure T. M.* 1976. Tempera on paper. 28⅞ x 40½″ (73.2 x 102.9 cm). Gift of The Cosmopolitan Arts Foundation

518. Jannis Kounellis. Untitled. 1977. Synthetic polymer paint, tallow, and adhesive tape on brown Kraft paper. 39¼ x 58⅛″ (99.6 x 147.6 cm). Gift of Barbara Pine

519. Bruce Nauman. *Face Mask.* 1981. Charcoal, pastel, and pencil on paper. 52¾ x 70″ (134 x 177.8 cm). Acquired with matching funds from The Lauder Foundation and the National Endowment for the Arts

520. Elizabeth Murray. *Popeye.* 1982. Pastel on torn-and-pasted paper. 6′9″ x 38½″ (205.7 x 97.8 cm). Purchase

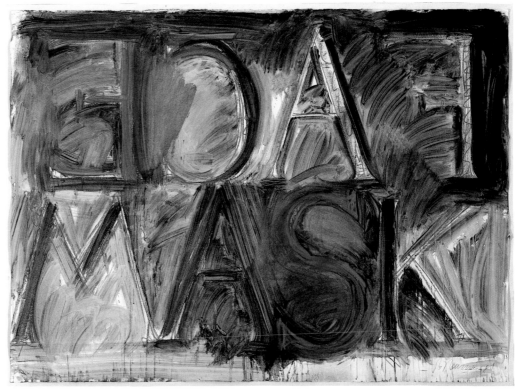

519

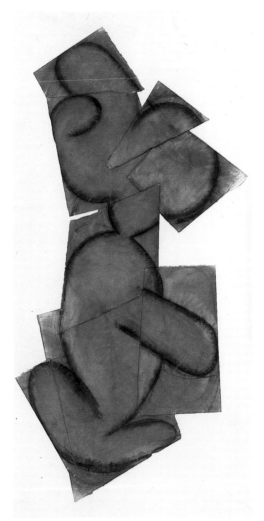

520

521

521. Brice Marden. *Card Drawing 11 (Counting)*. 1982. Ink and gouache on paper. 6 x 5⅞″ (15.2 x 14.9 cm). Gift of Mrs. Frank Y. Larkin

522. James Rosenquist. *Fahrenheit 1982 Degrees*. 1982. Pen and brush and ink on frosted mylar. 33¼ x 71¾″ (84.4 x 182.1 cm). Gift of The Lauder Foundation

523. Robert Morris. Untitled. From the Firestorm series. 1982. Charcoal, ink, graphite and pigment, and wash on paper. Eight sheets of paper, overall 6′4″ x 16′8″ (193 x 307.6 cm). Gift of The Samuel I. Newhouse Foundation

Modern artists have not often been interested in the apocalyptic, in themes of destruction or resurrection as subject. Morris, using the inspired frenzy of Leonardo's *Deluge* drawings (Royal Collection, Windsor), evokes as a point of reference the horrors of a nuclear firestorm as a parallel to Leonardo's natural disaster. Gestural drawing—used as a major expressive means, in the place of painting—has long been a central concern of Morris. But his gestural drawing is not held close to the body; it is the extension of his whole bodily movement, as he works his way across the surface (in this case working on the floor) rubbing black graphite into coloristic chiaroscuro patterns with fingers and rags. It is the trace—the record of a physical performance—and can be seen as an extension, or connection, between drawing or the object and his performances. The sense of drawing as performance is a peculiarly dynamic one; the process here gives conviction to subject matter usually regarded with distrust, as too dramatic in itself. It is from this source in bodily movement, as with Pollock's large drip paintings, that its scale too achieves its conviction.

524. Susan Rothenberg. *Untitled Drawing No. 44*. 1977. Synthetic polymer paint and tempera on paper. 38½ x 50⅛″ (97.3 x 127.4 cm). Gift of Mrs. Gilbert W. Chapman

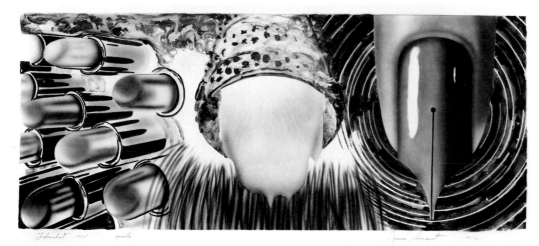

522

523

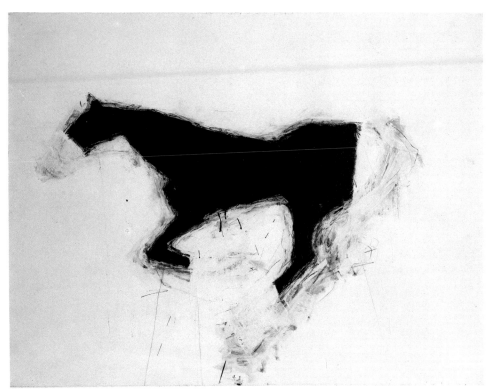

524

Prints and Illustrated Books

At a time when print collecting was rarely more than a bulkier form of stamp collecting, the new Museum of Modern Art had, as its only collection, a group of contemporary German prints. After advising the newborn Museum that it should not merely exhibit but collect the art of the modern era, Paul J. Sachs had emphasized his point by selecting and donating these prints, its first acquisitions. This extraordinary foundation for what became a pioneer public collection of major works of art represented, in a small way, the original attitude toward art mediums that the Museum was to take. Because the German prints (by Beckmann, Grosz, Feininger, and Pechstein) were recent works in 1929, they indicated that the art of the present was acceptable material for a museum's collection. As most museums were, up to that time, considered repositories for objects of value whose quality was tested by time, works that still had the fresh odor of the studio or the print shop rarely qualified. Print collections could transcend this barrier by accentuating their use as documentation. Thus, public print collections often received or acquired miscellaneous lots of newly etched views of cities and events. Sachs was fond of the drawings and prints of many periods, and he used them to teach his course in connoisseurship at Harvard. Little wonder, then, that he should present a gift that would similarly instruct. Thereafter, the prints that were chosen for the collection were those that, in and of themselves, were works of art, not representative of anything else.

The print collection grew within the protective confines of the Museum's painting and sculpture collection, usually reflecting interest in the artists whose unique works were already acquired or hoped for. Well before they founded the Museum, Lillie P. Bliss and Abby Aldrich Rockefeller had print collections: the Bliss group, largely acquired at the Armory Show in 1913, included works by Cézanne and Redon, while Mrs. Rockefeller pursued mainly contemporary American prints, although she had Gauguins and many other major European prints as well. After the Museum became a serious collecting institution, Mrs. Rockefeller added to her print collection with the Museum's needs in mind. She donated her collection of about sixteen hundred prints in 1940, when the Museum's first new building was complete and they could be housed in the new print room which she had actively promoted. However, before the facility could be used for prints, America entered World War II, and the space was given over to wartime programs.

The Abby Aldrich Rockefeller Print Room was finally opened in 1949, a year after Mrs. Rockefeller's death. At that time all the prints, from many sources, including Dada works from J. B. Neumann, Rouault proofs from the artist, French prints from Dr. Franz Hirschland, and a large collection of Toulouse-Lautrec lithographs gathered by Mrs. Rockefeller, were catalogued and made available to scholars and the public. Special funds for prints and illustrated books were donated over the years as awareness of the collection became more widespread and as associate curator William S. Lieberman took charge. Among the contributors before 1960 whose funds were used to buy the many important works available in Europe after the war were Henry Church, Mathew T. Mellon, and Victor S. Riesenfeld. The major prints donations of the period were the Curt Valentin Bequest of School of Paris prints and Samuel A. Berger's German prints.

During the decade after 1960, the Department of Drawings and Prints was established under the direction of Lieberman, who brought together the means of improving the collection of contemporary American prints through funds donated by Larry Aldrich, Celeste and Armand Bartos, and John B. Turner. The entire production of Tamarind Lithography Workshop (three thousand prints made between 1960 and 1970) was acquired, and a complete collection of the valuable publications of Universal Limited Art Editions began to be added to what had become the most significant repository of modern prints in the country. During the sixties, there were additions such as the important Louis E. Stern library of illustrated books; the William B. Jaffe and Evelyn A. J. Hall Collection of brilliant prints by Munch; the nearly complete prints and books of

Dubuffet, given by Mr. and Mrs. Ralph F. Colin; and proofs and plates of Pollock's only engravings. No print collection was richer in works by Beckmann, Feininger, Klee, Matisse, and Villon, and the selection of printed work from the mammoth production of Picasso was unparalleled.

In 1969 the Department of Prints and Illustrated Books was formed, and in 1972 the author was named curator. During the ensuing decade, emphasis was placed on acquiring contemporary works emanating from the expanded production of prints taking place in America and Europe. American prints were given to the Hermitage in the Soviet Union, The Tate Gallery in England, and the Bibliothèque Nationale in France in exchange for works from their countries. Rare prints and books by the Russian Futurists and Constructivists and many other elusive printed items by artists whose historic importance began to emerge in the seventies gave the collection more breadth and augmented the materials available for the study of modern art.

Central to the study of modern prints is the availability of trial proofs and other forms of documentation. The Abby Aldrich Rockefeller Print Room grew as the Museum did in 1964, expanding its library and files of basic information on the prints in the collection. The collection has also been thoroughly described, documented, and recorded on the Museum's computer. Portions of the computerized catalogue will be published in book form as various areas of the collection are defined for the purpose.

Many works in the collection have been exhibited and are described in books accompanying their exhibitions. Of course, the earliest Museum exhibitions devoted to prints and illustrated books, such as *Toulouse-Lautrec Prints and Posters* in 1933 and *Painters and Sculptors as Illustrators* in 1936, were made up entirely of loans. Max Weber's prints were the first shown in the Museum (in conjunction with his retrospective in 1930), and nearly every subsequent retrospective of an artist who made prints included selections in that medium. When the Bliss collection was shown in 1931 and 1934, the prints that came to the Museum in her bequest were included, but it was not until 1946 that an exhibition was devoted to the Museum's own prints, when Mrs. Rockefeller's gift of Toulouse-Lautrec prints was shown. Many exhibitions followed, particularly after the galleries were enlarged in 1964 and room became available for the regular display of the print collection in the Paul J. Sachs Galleries.

The intention to make works in the print mediums more visible within the Museum was emphasized by two exhibitions held in 1964: *American Painters as New Lithographers,* focusing on works in the collection from Universal Limited Art Editions, and *Contemporary Painters and Sculptors as Printmakers,* a pioneering survey in which Lieberman presented an extensive panorama of artistic invention in the print mediums. Important earlier exhibitions in which prints revealed some of the fundamental artistic issues of the time were *Hayter and Studio 17* in 1944 and *German Art of the 20th Century* in 1957. Lieberman was instrumental in presenting the prints of Villon and Munch in the fifties before there was widespread interest in their work. For his *Georges Braque: Painter Printmaker,* a 1954 circulating exhibition which, incidentally, was the first devoted to that artist's prints, Lieberman utilized a cache of unpublished Cubist drypoints he had discovered in Braque's studio.

The additional opportunities to use the collection for traveling exhibitions have given the curatorial staff considerable breadth of experience in assessing the subjects of modern art and selecting the most cogent works of an artist. Over four decades, prints from the collection have been sent to universities and colleges in America and to museums and galleries of all sizes abroad to provide the experience of modern art to the widest audience possible. One print in the collection, Picasso's *Minotauromachy,* has been shown in more than forty-five museums since 1948. Over the years, many of the Museum's exhibitions of works in the collection—*The Intimate World of Lyonel Feininger, Jasper Johns: Lithogra-*

pher, Picasso: Master Printmaker, American Prints: 1913–1963—were later shown in Europe, Australia, and South America. Visits abroad in connection with traveling exhibitions, sponsored by the Museum's International Program, provided the basis for acquisition and/or exhibition of the work of Japanese, Australian, and Yugoslav printmakers.

Two publications issued in conjunction with exhibitions in the seventies provided definitive data on the editions of two publishers: *Ambroise Vollard, Editeur* and *Technics and Creativity: Gemini G.E.L.* In 1980 the survey *Printed Art: A View of Two Decades* documented the vitality of print mediums as major means of expression in this era. These volumes, together with the history of prints based on the collection, *Prints of the Twentieth Century*, form a unique nucleus of information on modern prints.

Because printmaking is as much technology as craft in many instances, there has been special interest in the manners in which prints are made, and exhibitions have been devoted to the several print mediums as they have been developed by artists (*Jim Dine's Etchings*), by workshops (*Tamarind Lithography Workshop*), and as they have evolved historically (*Prints from Blocks: Gauguin to Now*). In such shows qualitative and formal comparisons are provoked by juxtapositions of works utilizing the same tools and materials, and we find different intentions and effects than are revealed in surveys of stylistic developments. Technical facility, however, is not a central issue when considering a work of art, and these exhibitions based on technique primarily provide a vehicle for the display of more wide-ranging information about art. Many factors that are less evident in selective group representations are clarified in the far simpler exhibition of a single artist's prints. The metamorphosis of formal elements in an artist's work is visible only when numerous examples are shown. In some ways, then, an exhibition devoted to the prints of a talented artist who has given serious and repeated attention to printmaking can present a full but compact view of an important expression. Among the artists whose prints have been shown in this way are Alechinsky, Beckmann, Dine, Johns, Klee, LeWitt, Matisse, Miró, Morandi, Munch, Picasso, and Stella.

The prints and illustrated books collection of The Museum of Modern Art is not the largest representation of such material in a museum or print cabinet, even considering its limitation to works created after 1885. National collections in France and America certainly exceed its size by thousands. Its particular strengths are its diversity, encompassing prints by artists from sixty-four countries, and its quality, largely due to the fact that unusually fine copies of many important prints were acquired before they became difficult to find, and due as well to continuing acquisition of significant new work by contemporary printmakers in this country and abroad. In the Museum's print galleries a selection of major examples from the collection is permanently on display, offering a historical panorama of the art since Gauguin and Cézanne. At the entrance to the galleries is a reading area where books and pamphlets on subjects relevant to the works on view are available. This area also provides a pause for the gallery visitors to accustom their eyes to the low lighting necessary for the preservation of the more fragile works on paper. The largest gallery in the complex contains a changing display of the most contemporary prints, revealing the current choices of acquisitions made by the curators. Movable walls and convertible display cases offer some of the flexibility necessary for the presentation of unpredictable forms, the possible future offspring of the traditional two-dimensional print.

Ultimately, the character of a museum's print collection is determined more by what artists do than by its policies of collecting. Reacting to a society that is more interested in and responsive to art than ever before, artists and business interests have interacted since about 1960 to extend enormously the availability of art in the form of prints. This has created a difficult situation for institutional print collections since it is not feasible to acquire every print made in a given year, or even every print made by an esteemed and prolific

artist. Another challenge is the expansion in scale of prints that has taken place since the fifties, requiring new methods of storage and handling. There are also prints made in white ink by Minimalists; such works are impossible to reproduce, as are many prints which utilize layers of ink colors that confound contemporary processes of color reproduction. Impressions on or of handmade paper offer other problems; foremost is that of caring for three-dimensional works in a collection almost totally devoted to the thinnest of two-dimensional works. Coping with the challenges to conservators and curators that artists present with their works, now physically as well as aesthetically, is a modest but vital part of the task of museum collecting. Fortunately, the aesthetic component, which is the rationale for acquiring new work, offers rich rewards that we can share.

525. Edvard Munch. *Madonna.* 1895–1902. Lithograph, printed in color. 23¾ x 17½″ (60.5 x 44.5 cm). The William B. Jaffe and Evelyn A. J. Hall Collection

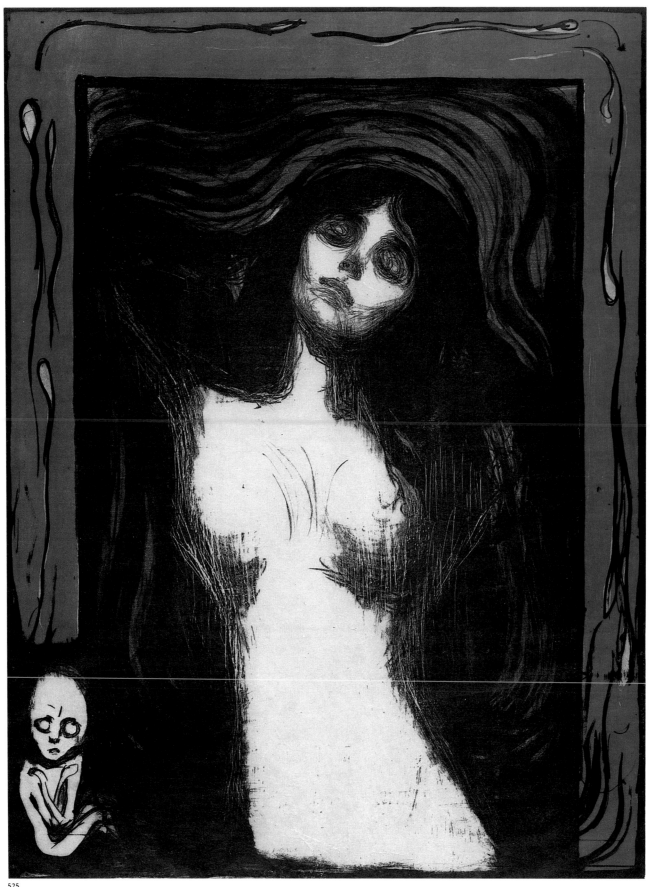

525

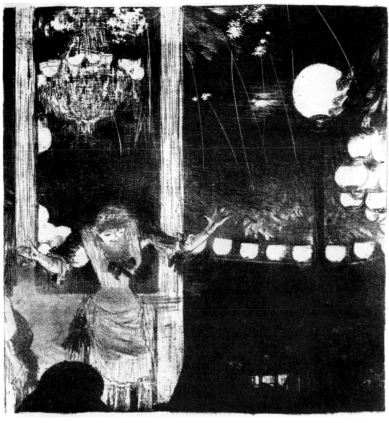

526

526. Hilaire-Germain-Edgar Degas. *Mademoiselle Bécat at the Ambassadeurs.* c. 1877. Lithograph. 8¹/₁₆ x 7⅝" (20.5 x 19.4 cm). Gift of Abby Aldrich Rockefeller

527. Paul Cézanne. *Bathers.* 1899. Lithograph. 16¼ x 19⅞" (41.3 x 50.6 cm). Gift of Abby Aldrich Rockefeller (by exchange)

528. Aristide Maillol. *The Wave.* 1898. Wood engraving. 6¾ x 7¾" (17.1 x 19.7 cm). Gift of Mrs. Donald B. Straus

529. Félix Vallotton. *Laziness.* 1896. Woodcut. 7 x 8¹³/₁₆" (17.8 x 22.4 cm). Larry Aldrich Fund

530. Pierre Bonnard. *House on a Court.* From the portfolio *Various Aspects of Life in Paris.* 1895. Lithograph, printed in color. 13⅝ x 10¼" (34.7 x 26 cm). Larry Aldrich Fund (by exchange)

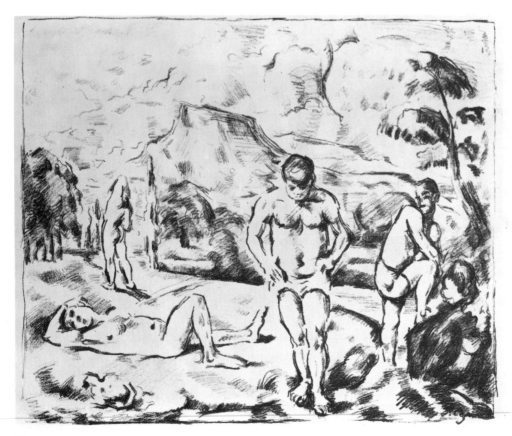

527

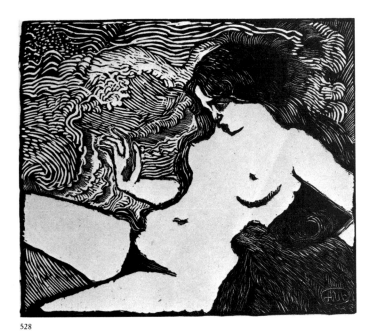

528

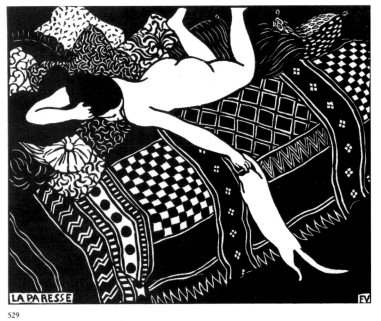

529

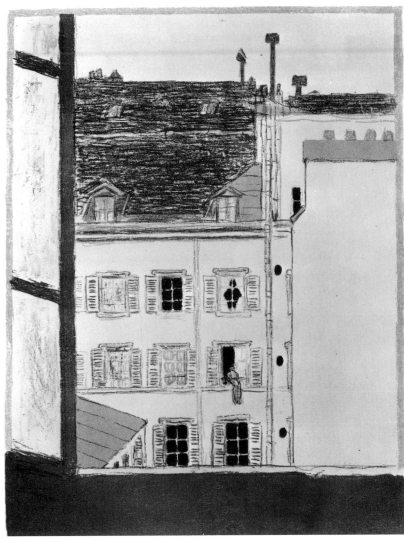

530

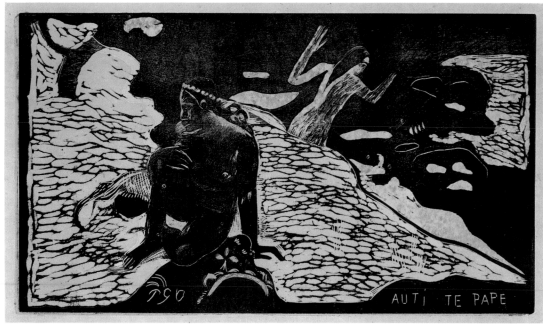

531

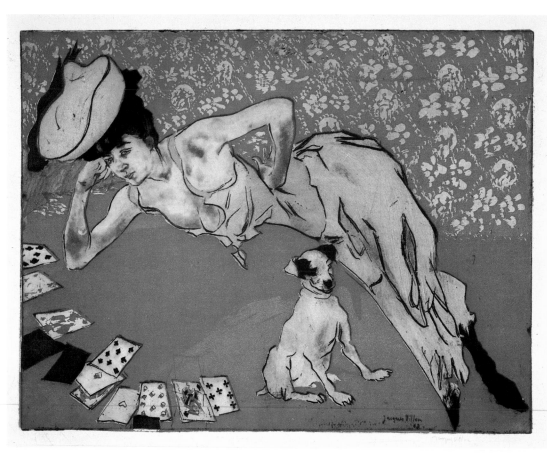

532

531. Paul Gauguin. *Auti te Pape (Women at the River).* 1894. Woodcut, printed in color. 8⅛ x 14″ (20.5 x 35.5 cm). Gift of Abby Aldrich Rockefeller

532. Jacques Villon. *The Game of Solitaire.* 1903 (dated 1904). Aquatint, etching, and roulette, printed in color. 13⅝ x 17⅝″ (34.8 x 44.8 cm). Abby Aldrich Rockefeller Fund

533. Henri de Toulouse-Lautrec. *The Seated Clowness.* From the portfolio *Elles.* 1896. Lithograph, printed in color. 20¾ x 15⅞″ (53 x 40.3 cm). Gift of Abby Aldrich Rockefeller

This print, depicting the cabaret dancer "Cha-U-Kao," is one of ten lithographs published in the portfolio *Elles.* The unidealized image embodies Toulouse-Lautrec's sympathetic honesty as he portrayed what many considered the seamier side of Parisian life. The artist's masterly use of lithography, compositionally influenced by the abstracted forms he saw in nineteenth-century Japanese woodblock prints, instigated a fruitful revival of that medium in the 1890s.

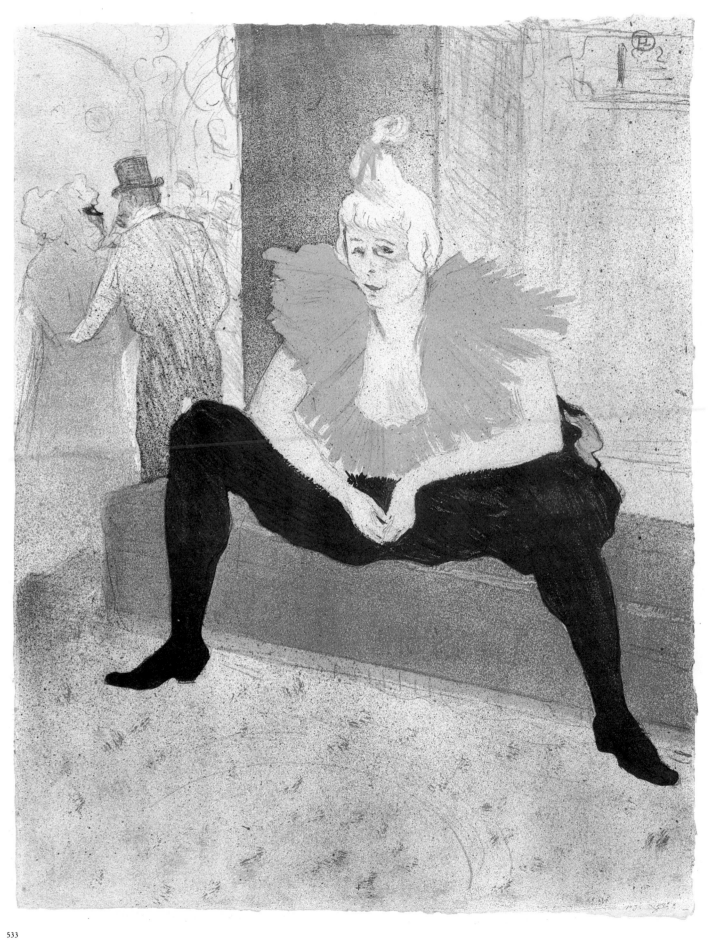

533

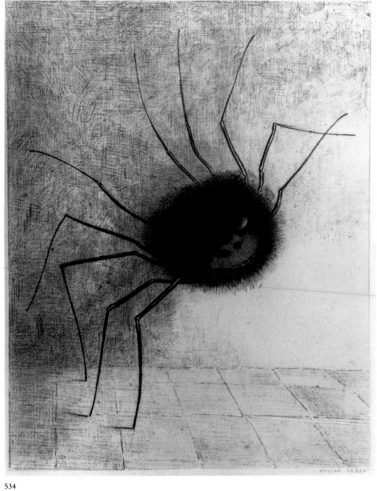

534

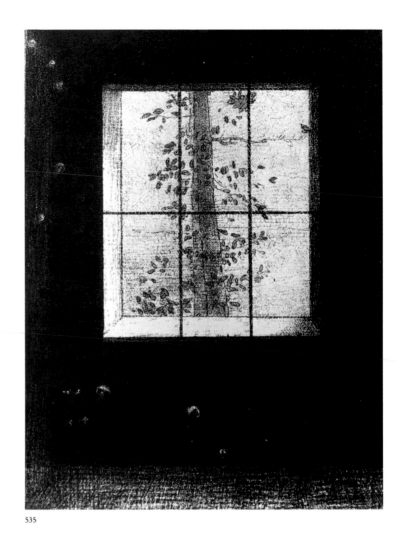

535

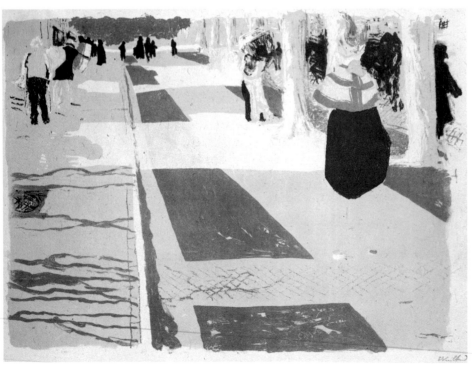

536

534. Odilon Redon. *Spider.* 1887. Lithograph. 11 x 8⁹⁄₁₆″ (28 x 21.7 cm). Mrs. Bertram Smith Fund

535. Odilon Redon. *The Day.* Plate VI from *Dreams.* 1891. Lithograph. 8¼ x 6⅛″ (21 x 15.5 cm). Lillie P. Bliss Collection

536. Édouard Vuillard. *The Avenue.* From the portfolio *Landscapes and Interiors.* 1899. Lithograph, printed in color. 12⅜ x 16⁵⁄₁₆″ (32.2 x 41.5 cm). Gift of Abby Aldrich Rockefeller

537. Vincent van Gogh. *Sorrow.* 1882. Transfer lithograph. 15⅜ x 11¾″ (39.1 x 29.9 cm). Purchase Fund

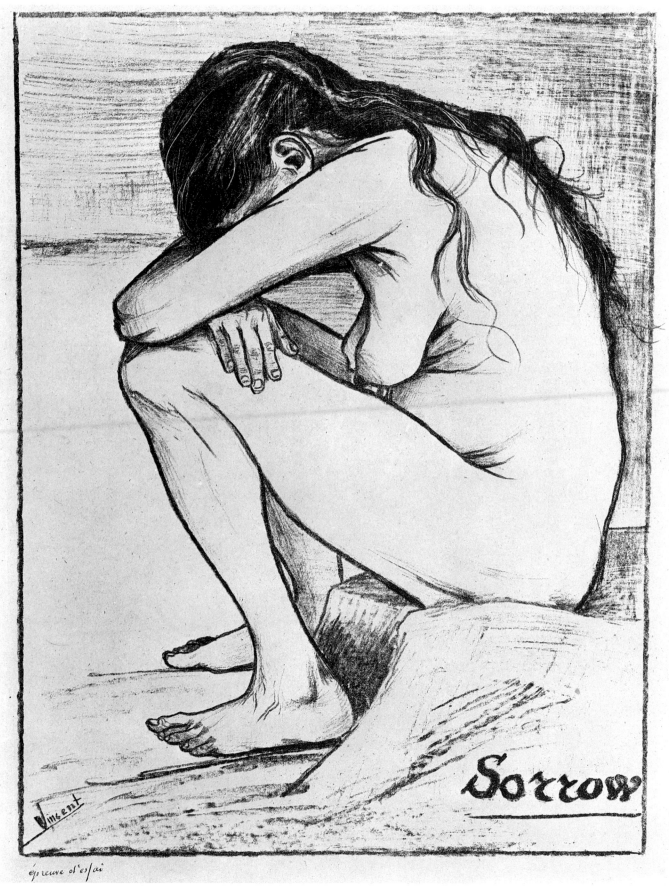

Sorrow

Vincent

épreuve d'essai

537

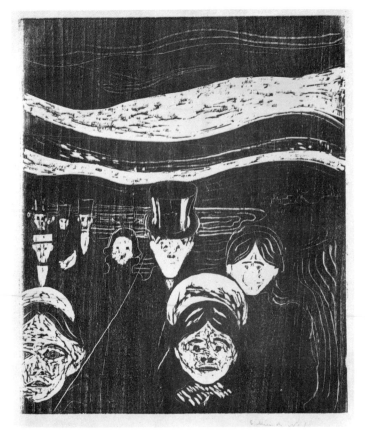

538

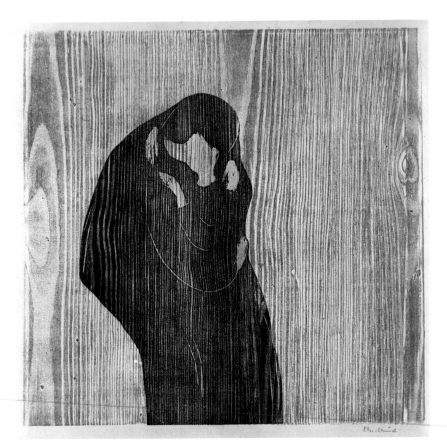

539

538. Edvard Munch. *Anxiety.* 1896 (dated 1897). Woodcut, printed in color. 18 x 14¹³⁄₁₆″ (45.7 x 37.6 cm). Purchase

Munch created more than seven hundred prints during his prolific artistic career. Influenced by Gauguin's earlier experimentation in woodcut, Munch chose to exploit its expressionistic potential as he continued to develop an imagery based on themes of isolation and sexual conflict. This blood-red version of *Anxiety,* one of three printed variations of the same subject, exemplifies the artist's compelling portrayal of universal emotion.

539. Edvard Munch. *The Kiss.* 1897–1902. Woodcut, printed in color. 18⅜ x 18⁵⁄₁₆″ (46.7 x 46.4 cm). Gift of Abby Aldrich Rockefeller

540. Piet Mondrian. *Reformed Church at Winterswijk.* 1898. Etching with charcoal additions. 14⅞ x 10⅜″ (37.8 x 26.4 cm). The Stanton Foundation Fund

This view of the church in a town where the artist spent his youth is one of two etchings Mondrian is believed to have executed, and is intriguing because of its relationship to his later work. While the print is typical in its mood and technique of late nineteenth-century etching, Mondrian's attempts at altering the vertical proportions herald his mature style based on the abstraction of forms of nature.

541. Paul Klee. *Virgin in the Tree.* 1903. Etching. 9⁵⁄₁₆ x 11¹¹⁄₁₆″ (23.7 x 29.7 cm). Purchase Fund

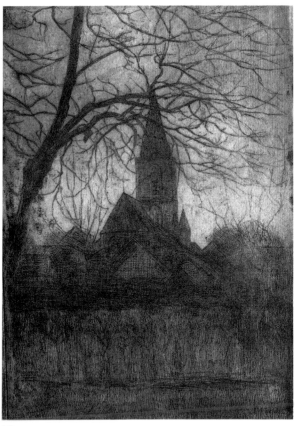

540

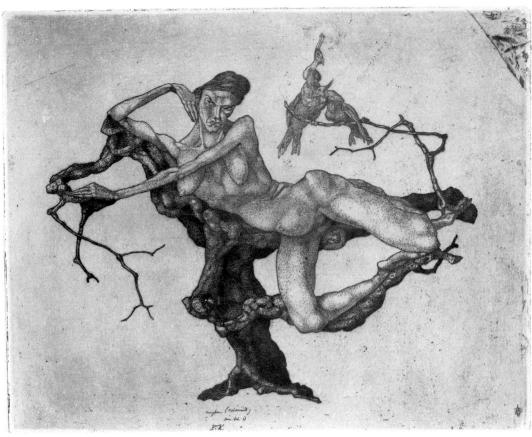

541

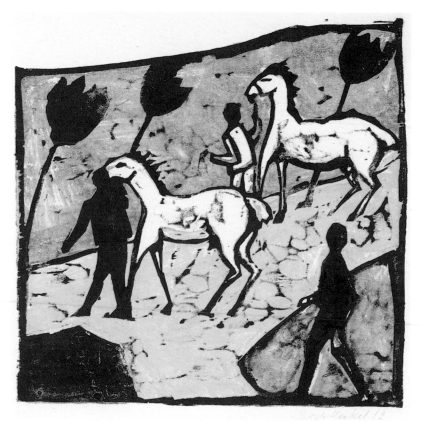

542

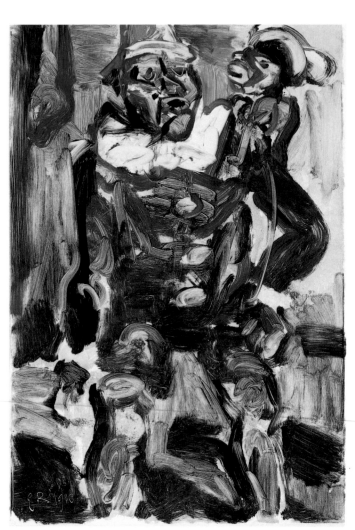

543

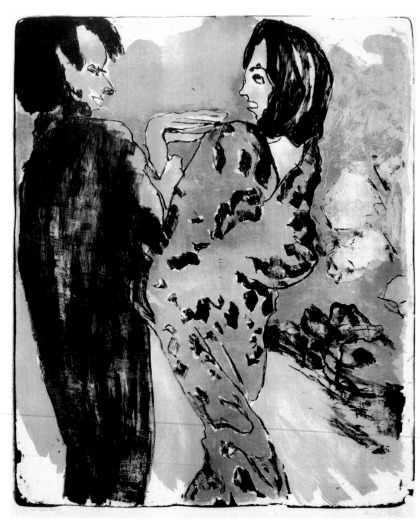

544

542. Erich Heckel. *White Horses.* 1912. Woodcut, printed in color. 12⅛ x 12⅜″ (30.8 x 31.5 cm). Purchase Fund

543. Georges Rouault. *Clown and Monkey.* 1910. Monotype, printed in color. 22⅝ x 15¼″ (57.5 x 38.7 cm). Gift of Mrs. Sam A. Lewisohn

544. Emil Nolde (Emil Hansen). *Young Couple.* 1913. Lithograph, printed in color. 24⁷⁄₁₆ x 20⅛₆″ (62.2 x 50.9 cm). Purchase Fund

545. Emil Nolde (Emil Hansen). *Prophet.* 1912. Woodcut. 12⅝ x 8¾″ (32.1 x 22.2 cm). Given anonymously (by exchange)

546. Ernst Ludwig Kirchner. *Head of Ludwig Schames.* 1918. Woodcut. 22¹⁵⁄₁₆ x 10⁵⁄₁₆″ (58.3 x 26.2 cm). Gift of Curt Valentin

547. Karl Schmidt-Rottluff. *Landscape.* 1919. Woodcut. 19⁵⁄₁₆ x 23⁹⁄₁₆″ (49.1 x 59.9 cm). Purchase Fund (by exchange)

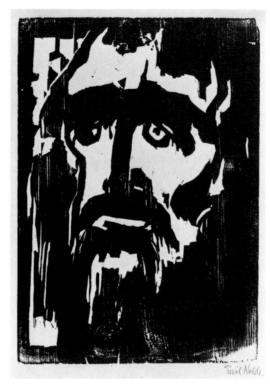

545

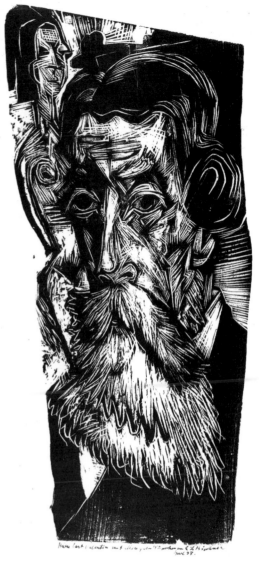

546

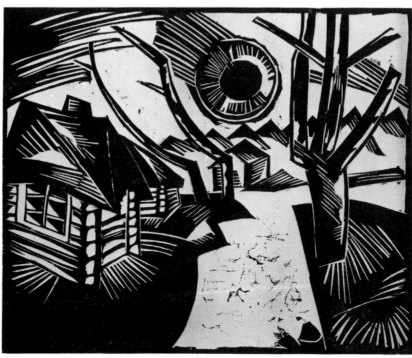

547

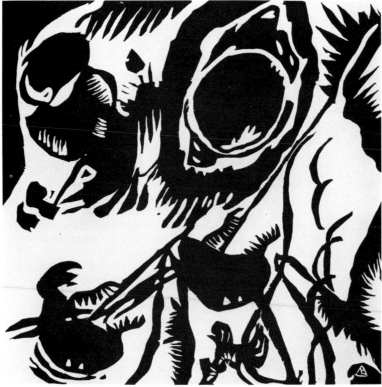

548

549

548. Wassily Kandinsky. Plate from *Klänge* by Wassily Kandinsky. Munich, R. Piper & Co., 1912. Woodcut. 11 1/16 x 10 7/8″ (28.1 x 27.6 cm). Louis E. Stern Collection

Kandinsky's book of poetry contains his most cogent and encompassing Expressionist prints. His progressive move toward abstraction clearly occurs in the illustrations for *Klänge*. In this woodcut the forms of clouds, hills, and towers have transcended their identities.

549. Franz Marc. *Genesis II*. 1914. Woodcut, printed in color. 9 7/16 x 7 7/8″ (23.9 x 19.9 cm). Katherine S. Dreier Bequest

550. Käthe Kollwitz. *Death, Woman and Child*. 1910. Etching, printed in color. 16 1/8 x 16 3/16″ (41 x 41.2 cm). Gift of Mrs. Theodore Boettger

551. Wilhelm Lehmbruck. *The Vision*. 1914. Drypoint. 7 x 9 5/16″ (17.8 x 23.7 cm). Gift of Samuel A. Berger

552. Otto Dix. *Wounded*. Plate 6 from the portfolio *The War*. 1916, published 1924. Etching and aquatint. 7 3/4 x 11 3/8″ (19.6 x 28.9 cm). Gift of Abby Aldrich Rockefeller

553. Christopher Richard Wynne Nevinson. *Troops Resting*. 1916. Drypoint, printed in color. 8 3/8 x 10 5/16″ (21.3 x 26.2 cm). Purchase

550

551

552

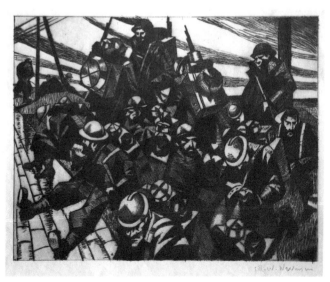

553

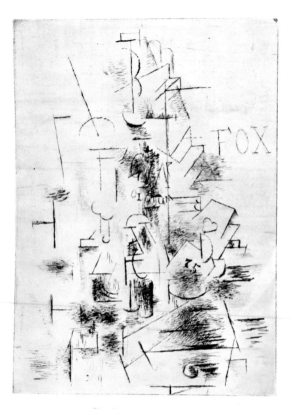

554

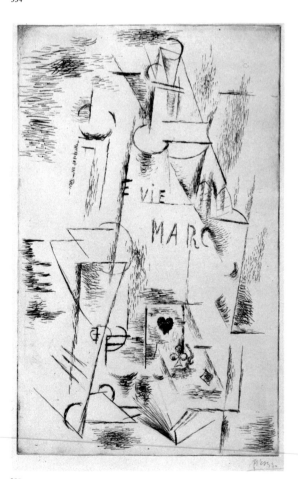

555

554. Georges Braque. *Fox*. 1911, published 1912. Drypoint and etching, printed in color. 21½ x 15″ (54.8 x 38 cm). Purchase Fund

555. Pablo Picasso. *Still Life with Bottle*. 1912. Drypoint. 19¹¹⁄₁₆ x 12″ (50 x 30.5 cm). Acquired through the Lillie P. Bliss Bequest

556. Louis Marcoussis. *Portrait of Guillaume Apollinaire*. 1912–20. Etching and drypoint. 19⁹⁄₁₆ x 10¹⁵⁄₁₆″ (49.7 x 27.8 cm). Given anonymously

557. John Marin. *Woolworth Building, No. 2*. 1913. Etching and drypoint. 12¹³⁄₁₆ x 10⁷⁄₁₆″ (32.5 x 26.5 cm). Gift of Abby Aldrich Rockefeller

558. Lyonel Feininger. *The Gate*. 1912. Etching and drypoint. 10¹¹⁄₁₆ x 7¹³⁄₁₆″ (27.2 x 19.9 cm). Gift of Mrs. Donald B. Straus

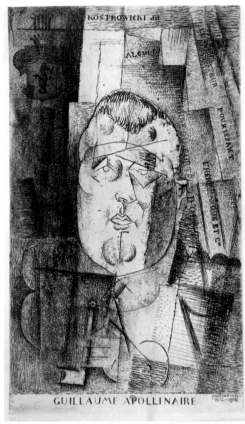

556

557

558

559

560

561

559. Robert Delaunay. *The Eiffel Tower.* 1926. Transfer lithograph. 24¼ x 17¾" (61.6 x 45.1 cm). Purchase Fund

560. Jacques Villon. *Portrait of a Young Woman.* 1913. Drypoint. 21⁹⁄₁₆ x 16¼" (54.8 x 41.3 cm). Given in memory of Peter H. Deitsch

Throughout his life Villon constructed his compositions from the arcs, wedges, and oblique geometric forms that he had perfected in 1913. Villon's distillation of the Cubist idiom can be seen in the planar definition of this portrait, one of three large drypoints of women of that year.

561. Jacques Villon. *Chess Board.* 1920. Etching. 7⅞ x 6¼" (20.1 x 16 cm). Gift of Ludwig Charell

562. Lyonel Feininger. *Cathedral.* 1919. Woodcut. 7¹⁄₁₆ x 4¹³⁄₁₆" (18 x 12.3 cm). Gift of Julia Feininger

563. László Moholy-Nagy. *Composition No. 2.* 1923–24. Woodcut. 3¹⁵⁄₁₆ x 4¹¹⁄₁₆" (10 x 11.9 cm). Katherine S. Dreier Bequest

562

563

564

564. Kasimir Malevich. *Congress of Committees of Peasant Poverty.* 1918. Lithograph, printed in color. Back cover 8¹/₁₆ x 7¹¹/₁₆" (20.5 x 19.5 cm), front cover 11⁹/₁₆ x 11⁷/₁₆" (29.4 x 29.1 cm). Gift of The Lauder Foundation

Along with its radical sociopolitical reform, the Russian Revolution fostered a new breed of avant-garde artist who searched for a vocabulary of visual forms to reflect a utopian spirit. In this cover for a pamphlet issued on the occasion of an economic conference, Malevich employed pure geometric shapes starkly set in unstructured space as an artistic language accessible to everyone. This overtly utilitarian use of art was directly informed by the revolutionary philosophy of his time.

565. Wassily Kandinsky. *Orange.* 1923. Lithograph, printed in color. 16 x 15⅛" (40.6 x 38.5 cm). Purchase Fund

566. Natalia Gontcharova. *Angels and Airplanes.* From the portfolio *The Mystical Images of War.* 1914. Lithograph. 12⁵/₁₆ x 9" (31.3 x 22.9 cm). Mrs. Stanley Resor Fund

567. Vera Ermolaeva. Design for *Victory over the Sun.* 1920. Woodcut with watercolor additions. 6½ x 7⅞" (16.5 x 20 cm). Larry Aldrich Fund

568. El Lissitzky (Lazar Markovich Lissitzky). *Globetrotter.* From the portfolio *Figurines.* 1920–21. Lithograph, printed in color. 14 x 10¹/₁₆" (35.5 x 25.5 cm). Purchase Fund

565

566

567

568

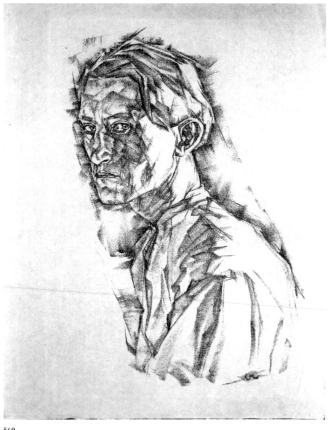

569

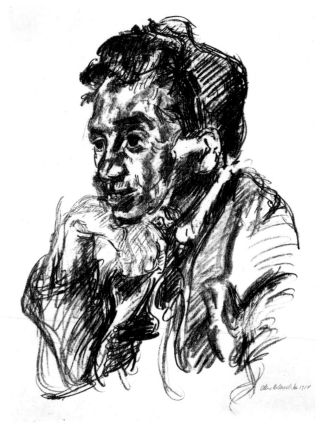

570

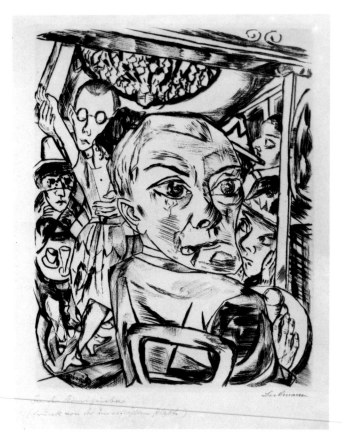

571

569. Joseph Albers. *Self-Portrait.*
c. 1918. Transfer lithograph. 18⅛ x 12"
(46.1 x 30.5 cm). John B. Turner Fund

570. Oskar Kokoschka. *Walter Hasenclever.* 1918. Lithograph. 23⅞ x 16½" (60.7 x 41.9 cm). Acquired through the Lillie P. Bliss Bequest

571. Max Beckmann. *The Queen's Bar (Self-Portrait).* 1920. Drypoint. 12⁹⁄₁₆ x 9¾" (31.8 x 24.8 cm). Gift of Mrs. Gertrud A. Mellon

The *Neue Sachlichkeit* (New Objectivity), a form of Expressionism that evolved in the twenties, held a relentless mirror to the decadence and strife of post–World War I Germany. Beckmann, one of the movement's major proponents, printed numerous self-portraits describing his own image in the context of a war-torn society. The exaggerated facial features and tightly compressed space all too effectively convey the artist's and Germany's anxiety during this tumultuous period.

572. Marc Chagall. *Self-Portrait with Grimace*. 1924–25. Etching and aquatint. 14¹¹⁄₁₆ x 10¾″ (37.3 x 27.4 cm). Gift of the artist

573. David Alfaro Siqueiros. *Moisés Sáenz*. 1931. Lithograph. 21⅜ x 16⅛″ (54.3 x 41 cm). Inter-American Fund

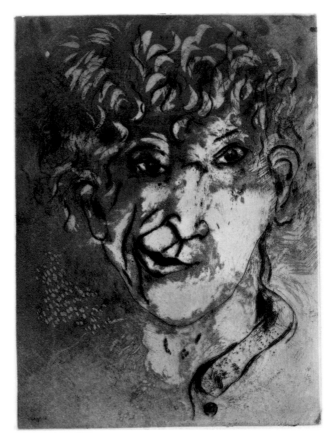

572

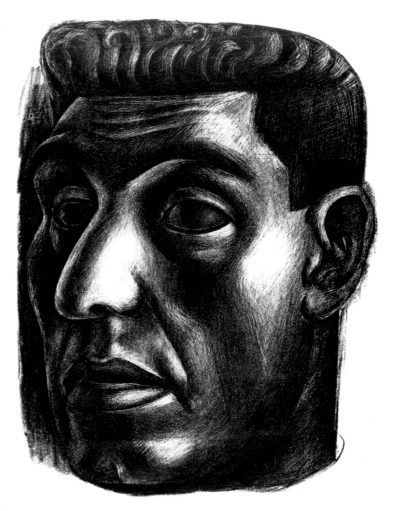

573

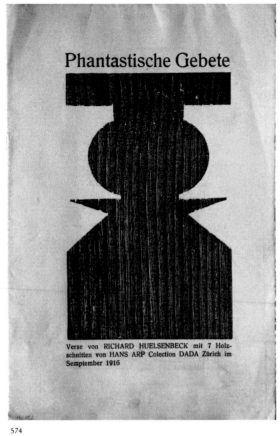

574

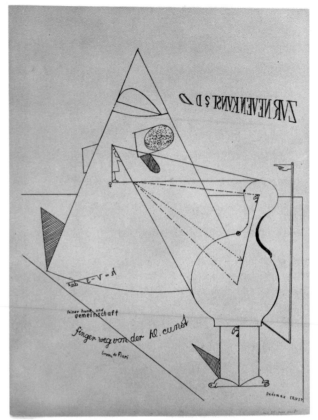

575

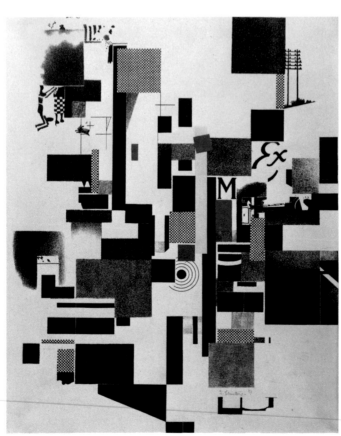

576

574. Jean (Hans) Arp. Plate from *Phantastische Gebete* by Richard Huelsenbeck. Zurich, Collection Dada, 1916. Woodcut. 9⅛ x 5¹³⁄₁₆″ (23.2 x 14.8 cm). Gift of Frank Perls (by exchange)

575. Max Ernst. Plate VIII from *Fiat Modes, Pereat Ars.* c. 1919. Lithograph. 17⅛ x 12″ (43.7 x 31.9 cm). Purchase Fund

576. Kurt Schwitters. Plate 1 from *Merz Mappe.* 1923. Photo-lithograph with collage. 21⅞ x 16¾″ (55.6 x 42.7 cm). Purchase Fund

577. Georges Braque. Plate 6 from *Theogony* by Hesiod. 1932. Etching. 14⅜ x 11¾″ (36.6 x 29.8 cm). Purchase Fund

In the early thirties Braque evolved, from the stylizations of Greek vase painting, a linear style of figuration which he used in incised plaster and etchings. Meandering lines detail the archaic-appearing figures of the gods and their symbolic borders in his etchings for Hesiod's *Theogony.* These etchings, completed in 1932, were not issued in book form until 1955.

578. Fernand Léger. *The Vase.* 1927. Lithograph, printed in color. 20¹⁵⁄₁₆ x 17¹⁄₁₆″ (53.3 x 43.3 cm). Gift of Abby Aldrich Rockefeller

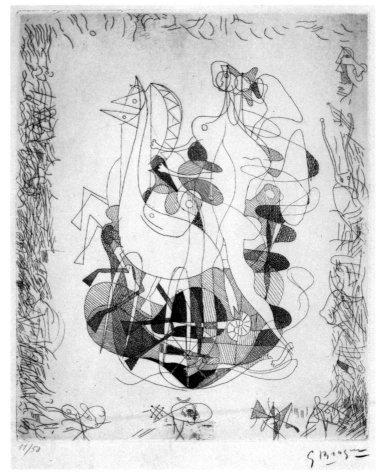

577

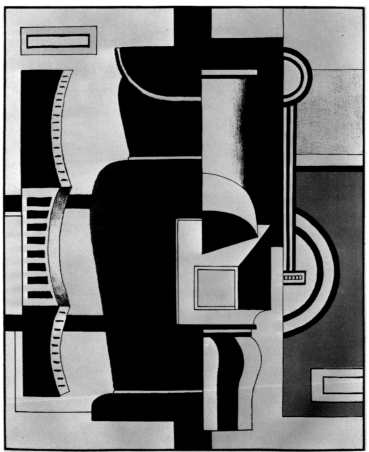

578

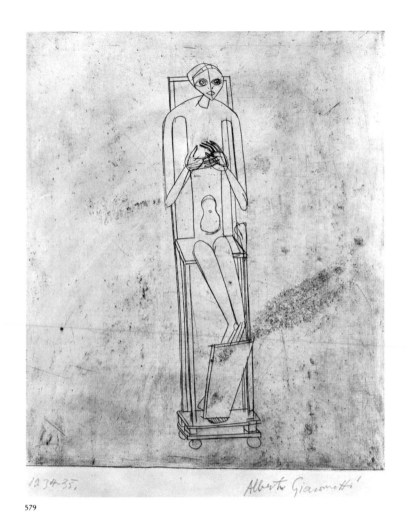

579

579. Alberto Giacometti. *Hands Holding a Void.* 1934–35. Engraving. 12 x 9⅝" (30.4 x 24.4 cm). Gift of Victor S. Riesenfeld

580. Salvador Dali. Plate XIV from *Les Chants de Maldoror* by Comte de Lautréamont. Paris, Albert Skira, 1934. Etching. 13⅛₆ x 10" (33.2 x 25.3 cm). Louis E. Stern Collection

581. Pablo Picasso. *The Diver.* 1932. Etching with collage. 5½ x 4⁷⁄₁₆" (13.9 x 11.3 cm). Purchase Fund

582. Stanley William Hayter. *Combat.* 1936. Engraving and etching. 15¾ x 19⅜" (40 x 49.3 cm). Given anonymously

When Hayter opened his printmaking workshop, Atelier 17, in Paris in the early thirties he was surrounded by Surrealists. He pursued their idea of automatic drawing in his prints by moving the copper plate haphazardly as he cut into it with his engraving tool. After these lines were established he picked out areas that suggested figurative elements and, with the addition of etching and other intaglio techniques, he completed his composition.

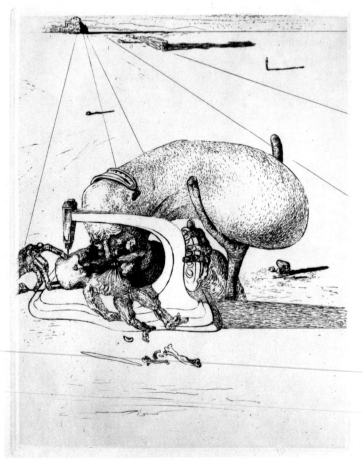

580

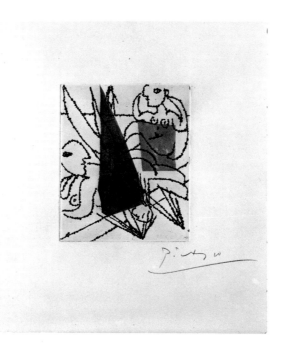

581

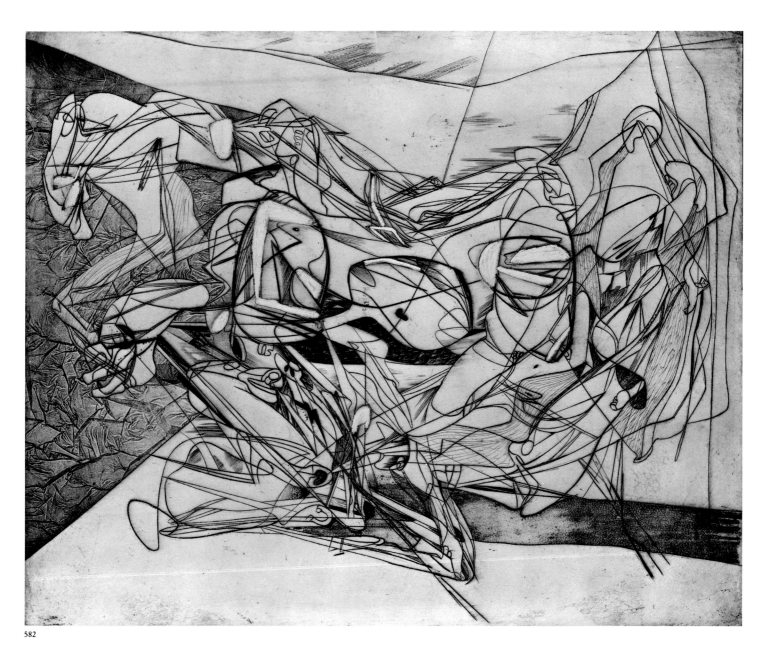

582

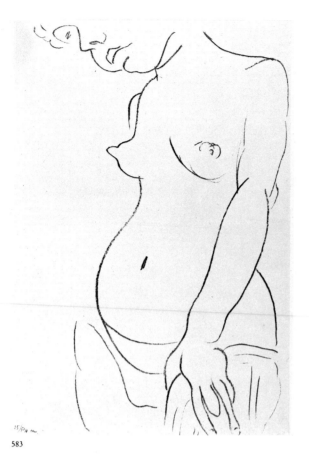

583

584

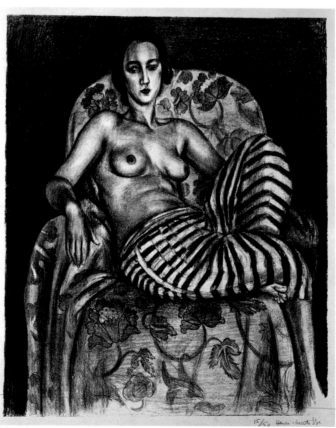

585

583. Henri Matisse. *Nude with Face Half-hidden*. 1914. Transfer lithograph. 19¾ x 12″ (50.3 x 30.5 cm). Frank Crowninshield Fund

584. Henri Matisse. *Torso, Arms Folded*. 1916–17. Monotype. 6¹⁵⁄₁₆ x 5¹⁄₁₆″ (17.6 x 12.8 cm). Frank Crowninshield Fund

585. Henri Matisse. *Odalisque in Striped Pantaloons*. 1925. Transfer lithograph. 21½ x 17⅜″ (54.6 x 44.1 cm). Nelson A. Rockefeller Bequest

586. Henri Matisse. *Reclining Nude with a Goldfish Bowl*. 1929. Etching. 6⅝ x 9⅜″ (16.8 x 23.8 cm). Gift of Mr. and Mrs. E. Powis Jones

587. Henri Matisse. Plate 24 from *Poésies* by Stéphane Mallarmé. Lausanne, Albert Skira, 1932. Etching. 13 x 9¾″ (33 x 24.7 cm). Louis E. Stern Collection

Matisse expressed the opinion that "A book should not need completion by an imitative illustration.... The drawing should be the plastic equivalent of the poem." The delicate threads of etched line with which Matisse presents his contribution to *Poésies* by Stéphane Mallarmé offer the reader a series of visions parallel to those of the poet. It is as if the artist untangled all the italic letters of the poems and realigned them into forms equally rhythmic, evocative, and beautiful.

586

587

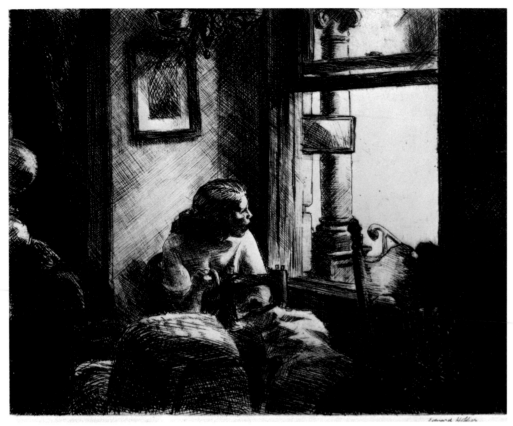

588

588. Edward Hopper. *East Side Interior.* 1922. Etching. 7⅞ x 9⅞" (20 x 25 cm). Gift of Abby Aldrich Rockefeller

589. Charles Sheeler. *Delmonico Building.* 1926. Lithograph. 9¾ x 6¹¹⁄₁₆" (24.8 x 17 cm). Gift of Abby Aldrich Rockefeller

590. Giorgio Morandi. *Still Life with Coffeepot.* 1933. Etching. 11¹¹⁄₁₆ x 15⅜" (29.7 x 39 cm). Mrs. Bertram Smith Fund

Morandi strove for a sensitive examination of form to find the myriad possibilities in still life. In such works as this Morandi used the etching needle to produce networks of tones and shadows that trapped the sharp white of the paper, filtering it or heightening it as he desired.

591. Stuart Davis. *Barber Shop Chord.* 1931. Lithograph. 14 x 19" (35.5 x 48.2 cm). Gift of Abby Aldrich Rockefeller

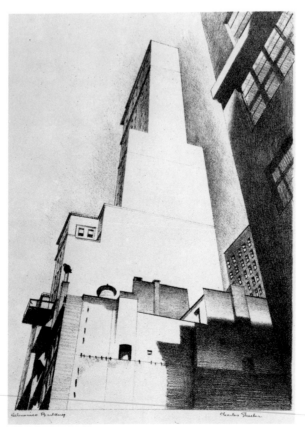

589

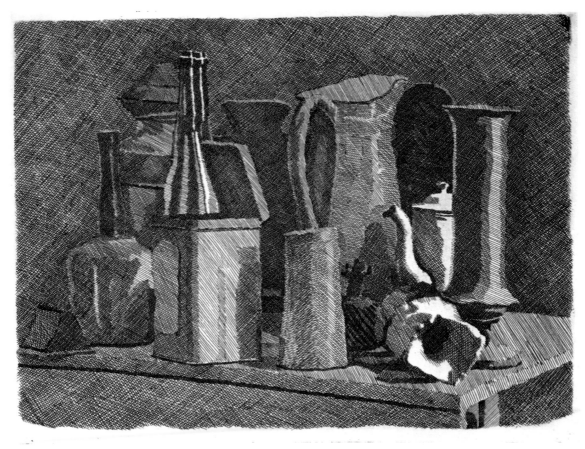

590

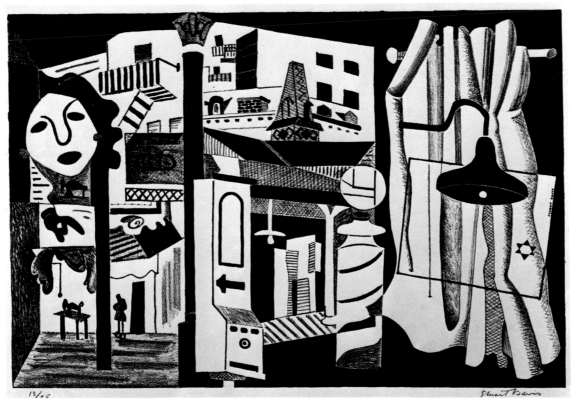

591

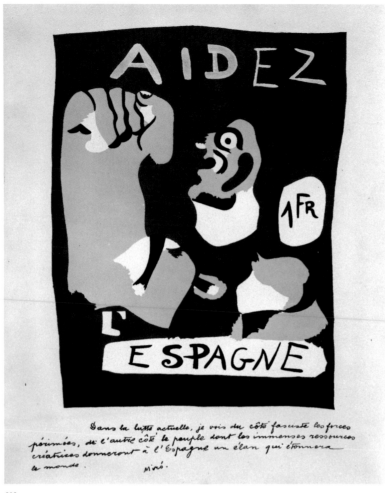

592

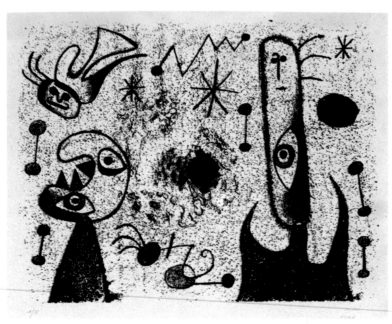

593

592. Joan Miró. *Aidez l'Espagne*. 1937. Stencil, printed in color. 9¾ x 7⅝" (24.8 x 19.4 cm). Gift of Pierre Matisse

593. Joan Miró. *Barcelona Series XLVII*. 1944. Transfer lithograph. 10 x 13" (25.5 x 33 cm). Purchase Fund

594. Joan Miró. Plate IV from *Series I (The Family)*. 1952. Etching, engraving, and aquatint, printed in color. 14¹⁵⁄₁₆ x 17⅞" (38 x 45.4 cm). Curt Valentin Bequest

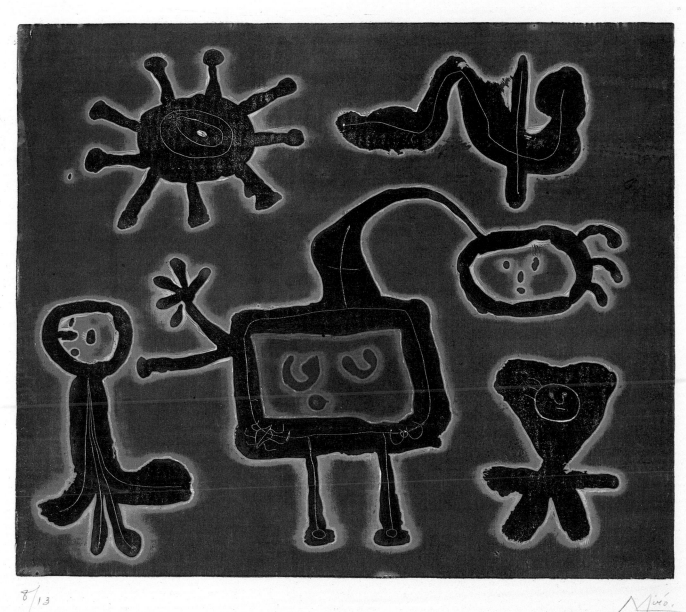

8/13

594

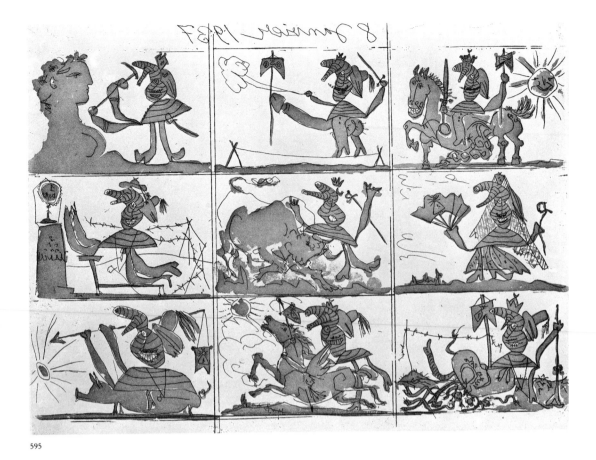

595

595, 596. Pablo Picasso. *The Dream and Lie of Franco I* and *II*. 1937. Etching and aquatint. Each 12⅜ x 16⁹⁄₁₆″ (31.4 x 42.1 cm). Louis E. Stern Collection

597. Pablo Picasso. *Minotauromachy.* 1935. Etching. 19½ x 27⁷⁄₁₆″ (49.6 x 69.6 cm). Purchase Fund

The ancient tale of Theseus and the Minotaur was transformed by Picasso into a personal allegory of such complexity that its meaning has been subjected to considerable interpretation. The combination of the Minotaur, a female bullfighter on her horse, a flowergirl holding a candle, a man climbing (or descending) a ladder, and two spectators gazing out their window past two amorous pigeons has no recognizable iconographical program. *Minotauromachy* refers to other compositions by Picasso as well as some Renaissance images that he must have known, and is considered the foundation for his greatest painting of the thirties, *Guernica.*

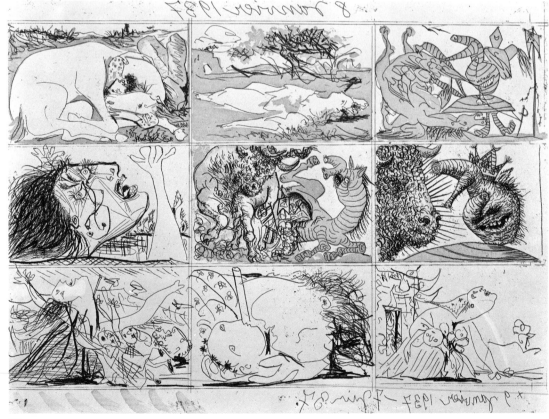

596

597

598

598. Henri Matisse. *The Cowboy.*
From *Jazz.* Paris, Tériade, 1947. Pochoir,
printed in color. Sheet 16⅝ x 25⅝″
(42.2 x 65.6 cm). Gift of the artist

599. Pablo Picasso. *Seated Woman
(after Cranach).* 1958. Linoleum cut,
printed in color. 25¹¹⁄₁₆ x 21⁵⁄₁₆″ (65.3 x
54.1 cm). Gift of Mr. and Mrs. Daniel
Saidenberg

599

600

600. Pablo Picasso. *The Bull* (State VI). 1945. Lithograph. 12 x 17⅞" (30.5 x 44.4 cm). Mrs. Gilbert W. Chapman Fund

601. Pablo Picasso. Plate 12 from *Le Cocu magnifique* by Fernand Crommelynck. Paris, Crommelynck, 1968. Etching. 11⅛ x 15" (28.1 x 38 cm). Monroe Wheeler Fund

602. Jackson Pollock. Untitled 4. 1944–45. Engraving and drypoint. 14¹⁵⁄₁₆ x 17⅝" (38 x 44.8 cm). Gift of Lee Krasner Pollock

Through the method of automatic drawing that Hayter passed on to artists in his Atelier 17 printmaking workshop, which he transferred from Paris to New York during World War II, Pollock achieved some of the first dynamic and expressive compositions of early American Abstract Expressionism. A proof of one of his larger engravings communicates the frenzy and pent-up emotion that so eloquently emerged in his drip paintings.

601

602

603

603. Willem de Kooning. Untitled. 1960. Lithograph. 42¾ x 30¾" (108.5 x 78.1 cm). Gift of Mrs. Bliss Parkinson

604. Jasper Johns. *Decoy II*. 1971–73. Lithograph, printed in color. 41⁷⁄₁₆ x 29⁵⁄₈" (105.3 x 75.3 cm). Gift of Celeste Bartos

604

41/100

605

605. Pierre Soulages. Untitled. 1957. Etching and aquatint, printed in color. 15½ x 14¼" (39.3 x 36.2 cm). Mrs. Bertram Smith Fund

606. Victor Vasarely. *Gotha*. From a portfolio of 12 serigraphs. 1959. Serigraph, printed in color. 19¾ x 13³⁄₁₆" (50.2 x 33.5 cm). Transferred from the Museum Library

Gotha is from Vasarely's third album of silkscreened prints, and reveals the kinetic effects possible in two-dimensional imagery. A linear passage is framed by geometrical forms that create an environment of opposition. This confrontation of round and angular images sets up among them wave patterns that attempt to reconcile the differences in contour.

607. Jean Dubuffet. *Man Eating a Small Stone*. 1944. Lithograph. 12¾ x 9½" (32.3 x 24.1 cm). Gift of Mr. and Mrs. Ralph F. Colin

Dubuffet's first lithographs were done in the last months of the German occupation of France. His early subjects were ordinary situations of life such as birth, eating, and so on; and an intense observation of the art of the insane, children, and primitive peoples formed the basis of his expressive figurative style.

608. Lucio Fontana. Plate 5 from the portfolio *Six Original Etchings*. 1964. Etching. 13¾ x 16¾" (34.9 x 42.5 cm). Abby Aldrich Rockefeller Fund

606

607

608

609

609. Kenneth Noland. *Horizontal Stripes (III–27)*. 1978. Artistmade paper work, hand painted. 50 1/16 x 33 9/16" (127.1 x 85.2 cm). Mrs. Gilbert W. Chapman Fund

610. Ellsworth Kelly. *Large Gray Curve*. 1974. Embossed serigraph, printed in color. 12 5/8 x 71 7/8" (32.1 x 182.6 cm). Gift of Paine, Webber Inc.

611. Robert Motherwell. *Red 4–7*. From *A La Pintura* by Rafael Alberti. West Islip, Universal Limited Art Editions, 1972. Etching and aquatint, printed in color. 25 3/4 x 38" (65.4 x 96.5 cm). Gift of Celeste Bartos

612. Barnett Newman. Untitled etching #2. 1969. Etching and aquatint. 23 3/8 x 14 11/16" (59.4 x 37.4 cm). Gift of the Celeste and Armand Bartos Foundation

In 1968 Newman was asked to make a print commemorating the death of Dr. Martin Luther King, Jr. He decided to make an etching, and this is the second of two plates he made. The dense, black aquatint on an unetched ground, wiped clean, heralds the style of printmaking practiced by Minimalist painters in the seventies.

610

4
I climb the king's purples
and descend with El Greco in the scattering draperies.

Me levanto hasta el solio de la púrpura
y desciendo esparcido—¡oh Greco!—en pliegues.

5
Purples caught through cut glass—
goblet, decanter, and cup—
in the warmth of the wine.

El púrpura a través de los cristales
—copa, vaso, botella—
calientes de los vinos.

6
The rose in the frost of Velázquez.

Un rosa con escarcha, de Velázquez.

7
I descend to the rose of the rose of Picasso.

Bajé hasta el rosa rosa de Picasso.

611

612

613

614

613. Robert Rauschenberg. *Booster.* 1967. Lithograph and serigraph, printed in color. 71⁹⁄₁₆ x 35⅛″ (181.7 x 89.3 cm). John B. Turner Fund

Booster was, in 1967, the largest lithograph ever printed on a hand-operated lithographic press (six feet long). The chair in the upper left is a personal reference to Rauschenberg's activity in the dance theater (it was a prop in a dance by Steve Paxton). A time chart for 1967 and photographic images from California newspapers surround a five-part X-ray of the artist standing nude in hob-nailed boots, all of which, through the inference of the title, may be interpreted as five stages of a rocket.

614. Jim Dine. *Black and White Robe.* 1977. Lithograph and etching. 41½ x 29⁵⁄₁₆″ (105.4 x 74.4 cm). Gift of the artist

615. David Hockney. *The Drinking Scene.* From the portfolio *A Rake's Progress.* 1963. Etching and aquatint, printed in color. 12 x 16″ (30.4 x 45 cm). Ralph F. Colin, Leon A. Mnuchin, and Mrs. Alfred R. Stern Funds

616. Richard Hamilton. *Interior.* 1964. Serigraph, printed in color. 19⁵⁄₁₆ x 25⅛″ (49.1 x 63.8 cm). Gift of Mrs. Joseph M. Edinburg

In 1957 Hamilton issued a list of characteristics underlying the philosophy of Pop art: "Popular (designed for a mass audience), transient (short-term solution), expendable (easily forgotten), low cost, mass-produced, young (aimed at youth), witty, sexy, gimmicky, glamorous, big business." *Interior,* with its humorous juxtaposition of commercially produced images, epitomizes Hamilton's acerbic parody of a consumer-oriented society.

615

616

617

618

617. Helen Frankenthaler. *Essence Mulberry.* 1977. Woodcut, printed in color. 25 x 18⅞″ (63.5 x 48 cm). John B. Turner Fund

618. Mary Frank. Untitled. 1977. Monotype on two sheets, printed in color. 35½ x 23¹³⁄₁₆″ (90.2 x 60.4 cm). Mrs. E. B. Parkinson Fund

619. Robert Rauschenberg. *Preview.* From the *Hoarfrost* series. 1974. Transfer and collage on cloth. 69″ x 6′8½″ (175.3 x 204.5 cm). Purchase

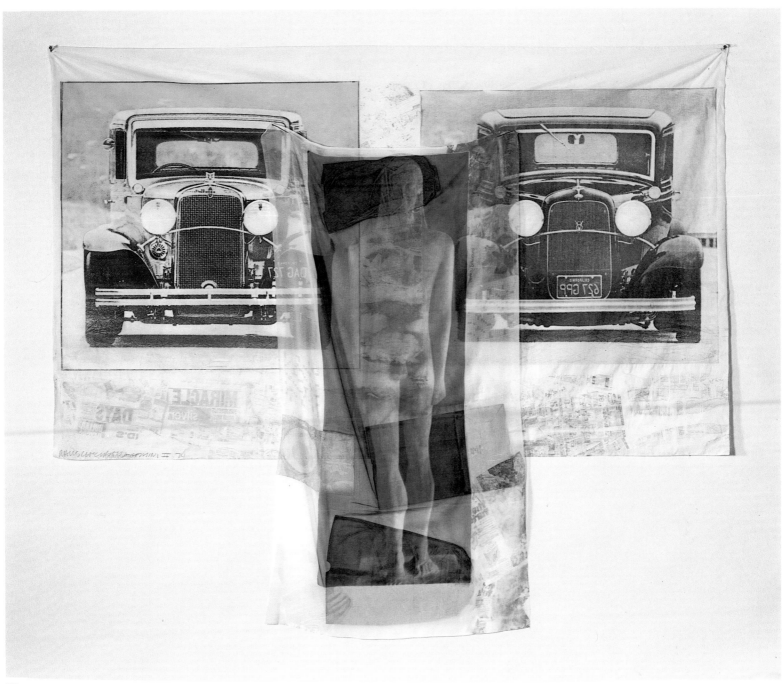

619

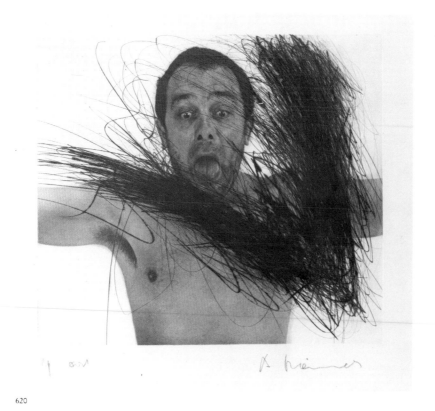

620. Arnulf Rainer. *Self-Portrait.* c. 1975. Photogravure, etching, and drypoint. 11¹⁄₁₆ x 12½″ (28.1 x 31.7 cm). Larry Aldrich Fund

621. Sol LeWitt. *Lines from Sides, Corners and Center.* 1977. Etching and aquatint, printed in color. 34⅝ x 34⅞″ (87.9 x 88.5 cm). Gift of Barbara Pine (through the Associates of the Department of Prints and Illustrated Books)

This aquatint is the byproduct of LeWitt's concept of a simple system that can be made to conjure composed space. The artist's hand is not needed to carry out the two-dimensional formation of the concept, although its purity and its limitation to certain chosen materials generally provide a brilliant aesthetic result.

622. Bruce Nauman. Untitled. From *Studies for Holograms.* 1970. Serigraph, printed in color. 20⅜ x 26″ (51.7 x 66 cm). John B. Turner Fund

620

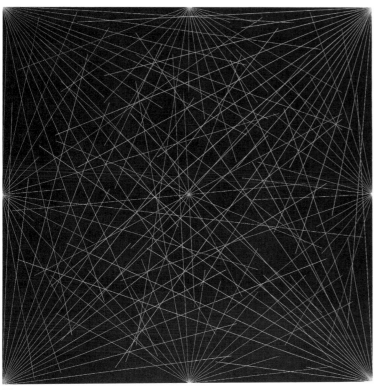

621

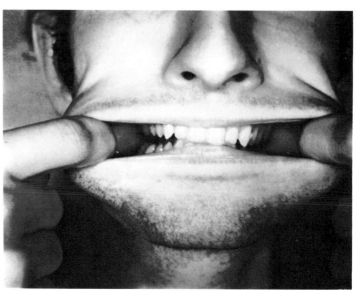

622

623. Claes Oldenburg. *Teabag*. From the *Four on Plexiglas* series. 1966. Serigraph, printed in color on felt, clear plexiglass, and plastic. 39⁵⁄₁₆ x 28¹⁄₁₆ x 3″ (99.8 x 71.3 x 7.6 cm). Gift of Lester Avnet

624. Shusaku Arakawa. *The Degrees of Meaning*. From the *Reality and Paradox* series. 1973. Serigraph and lithograph, printed in color. 27½ x 18⁷⁄₁₆″ (69.8 x 46.8 cm). Gift of Frayda and Ronald Feldman

625. Claes Oldenburg. *Screwarch Bridge* (State II). 1980. Etching and aquatint. 23¹¹⁄₁₆ x 50¾″ (60.2 x 128.9 cm). Gift of Klaus G. Perls and Heinz Berggruen in memory of Frank Perls, Art Dealer (by exchange)

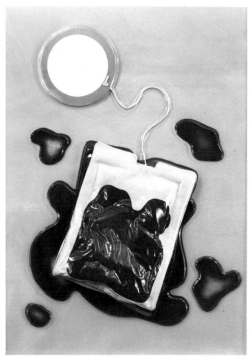

623

624

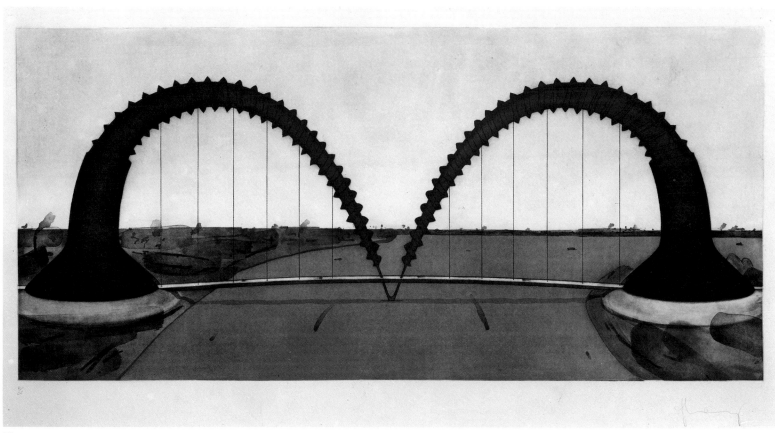

625

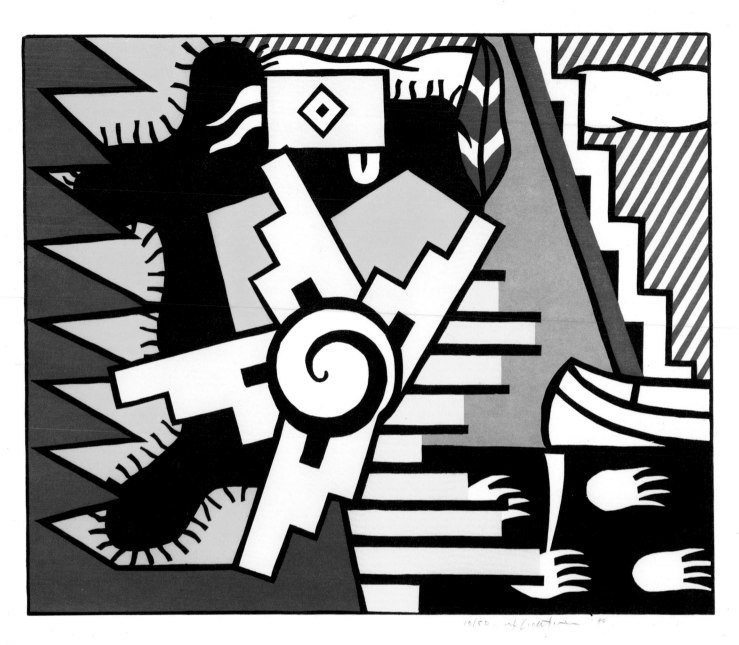

626

626. Roy Lichtenstein. *American Indian Theme II*. 1980. Woodcut, printed in color. 24 x 28⁹⁄₁₆″ (61 x 72.5 cm). Mrs. John D. Rockefeller 3rd Fund

627. Francesco Clemente. *Not St. Girolamo*. 1981. Etching, aquatint, drypoint, and chine collé, printed in color. 61⁵⁄₁₆ x 19¹⁄₁₆ (155.7 x 48.4 cm). Gift of Barbara Pine (through the Associates of the Department of Prints and Illustrated Books)

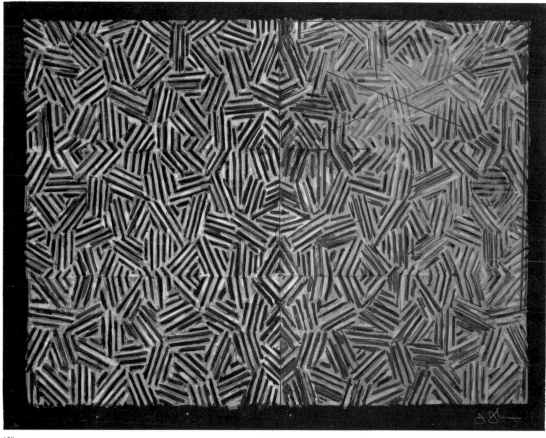

628

628. Jasper Johns. *Corpse and Mirror (Lithograph).* 1976. Lithograph, printed in color. 28¹³⁄₁₆ x 37¹⁵⁄₁₆″ (73.2 x 96.3 cm). Gift of Celeste Bartos

629. Howard Hodgkin. *Two to Go.* 1981. Lithograph, printed in color with gouache additions. 36⅛ x 48¼″ (91.8 x 122.6 cm). Gift of the artist

630. Frank Stella. *Talladega Three I.* 1982. Etching. 65¼ x 51⅜″ (165.7 x 131.2 cm). Jeanne C. Thayer and John B. Turner Funds

In 1980 Stella began work on the print series *Circuits*, named after various auto-racing tracks that he had visited in the late seventies and thematically related to his metal-relief compositions of the same period. *Talladega* (a track in Alabama) consists of an intricate network of white contour lines on a painterly black-and-white ground. The resulting tension between the implied depth and asserted flatness of the picture plane produces an image not unrelated in spirit to its iconographic source.

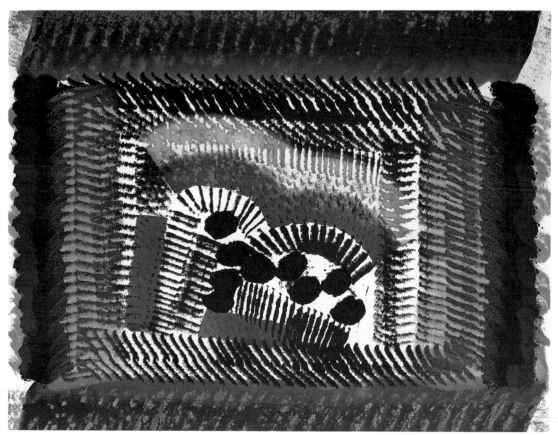

629

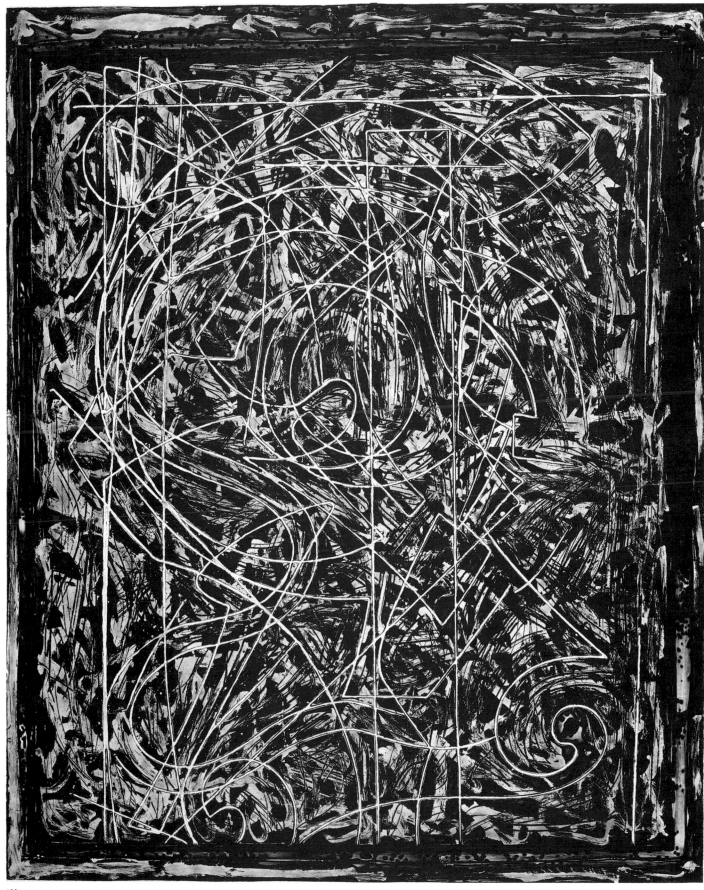

630

Architecture and Design

When the Museum was founded in 1929, it was proposed by Alfred Barr that standards be defined and history written for architecture and design just as for painting and sculpture. Still the only institution to include a curatorial department devoted to architecture and design, the Museum since 1932 has exhibited and collected material relevant to these two arts, as well as posters and typography.

Traditional collections of objects have been categorized as "decorative arts." The Museum's collection is concerned primarily with mass-produced useful objects made to serve a specific purpose, and so the term design, or industrial design, has been used instead. Buildings, of course, can be "collected" only through models and photographs, of value primarily as information, but the collection also includes architectural drawings chosen for their intrinsic quality as works of art as well as for the ideas they record.

The design collection now comprises more than three thousand useful objects representing all the arts of manufacture: household appliances and office equipment, furniture, tableware, tools, and textiles. In size and diversity they range from such mass-produced artifacts as pillboxes, typewriters, and radios, to chairs, tables, and an automobile. There are handmade objects by individual craftsmen, and even such semiarchitectural productions as the entrance arch to a Paris métro station. Graphic design—typography, posters, and other printed combinations of word and image—constitutes a separate collection approaching four thousand items. Architectural models and drawings form a third subdivision, but of much smaller quantities, except for the Mies van der Rohe Archive which numbers more than twenty thousand drawings by that great master of modern architecture.

Material for all these components of the collection is assembled by the department's staff. Their recommendations are presented to a departmental committee comprised principally of trustees. This committee must formally approve acquisitions (as do committees for other curatorial departments) before they can be added to the Museum's collection. In addition, the department maintains a separate study collection for supplementary material.

Two criteria apply in the selection of objects: quality and historical significance. An object is chosen for its quality because it is thought to achieve, or to have originated, those formal ideals of beauty that have become the major stylistic concepts of our time. Significance is a more flexible evaluation. It applies to objects that may not be entirely satisfactory for aesthetic or practical reasons but nevertheless have contributed importantly to the development of design.

Probably it is impossible, and perhaps even undesirable, to apply each of these definitions with perfect consistency. For example, "the major stylistic concepts of our time" might be interpreted to include many objects in which inane decoration and clumsy shapes substitute for balance of proportions and fitness for purpose, normally considered basic to good design. But the department's definition of quality excludes unsuccessful or ephemeral styles, no matter how numerous their examples may be. Even such popular manifestations as Art Deco and other "modernistic" furniture which, in the twenties and thirties, imitated the stepped contours of skyscrapers, are not eligible for inclusion. On the other hand, despite their limited applicability, certain design ideas of bizarre character have been welcomed into the collection because they seem related in significant ways to ideas and emotions evident in the other arts of the day. Finally, it should be noted that a good many objects in the collection, representing a generally high standard of achievement, could be replaced by others just as fine: it is not feasible to collect every work of merit produced around the world during the twentieth century.

Exhibitions at the Museum have afforded many opportunities to assemble important groups of objects. Indeed the design collection began with the *Machine Art* exhibition organized in 1934 by Philip Johnson, the department's first director. Some one hundred objects from that exhibition provided the nucleus of a collection that was intended from the beginning to document design characteristics peculiar to the twentieth century. The standards defined at that time by Barr and Johnson gave the design collection its basic character. Under the department's present director, it has since 1956 been expanded and modified but without departing from the principles proposed by its founders. In the forties and fifties the collection was administered and much enlarged by Greta Daniel, associate curator of design; and since 1976 it has been under the management of J. Stewart Johnson, the present curator of design.

John McAndrew, curator of what was then called the Department of Architecture and Industrial Art from 1937 to 1940, and Eliot Noyes, director of a separate Department of Industrial Design from 1940 to 1945, made valuable additions to the collection through exhibitions and competitions. Notable among these was a series initiated by McAndrew called Useful Objects. Successive exhibitions acquainted the public with inexpensive good design, the price range eventually being broadened so that furniture and mechanical appliances could also be shown. Noyes's competition in 1940, called "Organic Design in Home Furnishings," led to the manufacture of prizewinning designs. Well-known chairs by Charles Eames and Eero Saarinen now in the collection derive from this project. By the mid-fifties it was apparent that public acceptance of modern architecture and design was an accomplished fact, and competitions no longer seemed the best way to encourage higher standards.

After this series perhaps the most important public service and potential source of collection material was the exhibition program called Good Design. Directed by Edgar Kaufmann, Jr., Good Design exhibitions from 1950 to 1955 sought to influence the wholesale buyers who determine what furnishings will appear in stores throughout the country; to convince manufacturers of the potentially large market for well-designed objects; and to encourage designers by the example of good work and the possibility of wide recognition. In collaboration with the Merchandise Mart of Chicago, the Museum presented once each year (biannually in Chicago) work produced in the United States and abroad during the year under review. Examples were acquired for the collection from each exhibition.

In the winter of 1958–59 the Museum exhibited for the first time a major part of the design collection—an appropriate step in clarifying the origin and development of ideas that have determined the appearance of artifacts in the twentieth century—but not until 1964 was there sufficient gallery space to keep even a small part of the collection permanently on view. This fact is of considerable importance, particularly in relation to the Museum's program of design exhibitions. For example, when the collection was chronically hidden in storerooms, the public had no opportunity to measure each year's Good Design selections against the best work in a collection covering, at that time, roughly sixty-five years.

Just as the Museum's collection and exhibition programs have conditioned each other, both have been conditioned by the extraordinarily limited space to which the Museum was confined until 1984, when its gallery space was doubled. Although physically still a small museum by American as well as European standards, the enlarged galleries for the design collection now make it possible to keep key works permanently on

display, while other components of the presentation are changed two or three times a year. A separate room will allow, on occasion, the showing of interesting groups of collection material—work in glass, for example, or the fifty objects by Charles Eames—otherwise seldom seen in one place at one time.

These changes will make the scope of the design collection apparent, but a more dramatic improvement is that a gallery has now been allocated exclusively to architectural models and drawings. This will make it possible to elucidate the major ideas that have shaped twentieth-century building, and at the same time suggest the architectural context for which modern furniture and other objects were designed in the first place.

The character of the collection has evolved in response to changing circumstances both inside and outside the Museum. A significant case in point is the proportion of premodern material considered relevant to a collection meant to preserve and document the achievements of the twentieth century. When little of the collection could be shown, it was considered appropriate to include only a very few "historical" examples. These were chosen principally to illustrate the nineteenth-century beginnings of a conscious break with the traditions of Western art and design. But when, in the late sixties, it became possible to estimate realistically the amount of space that would ultimately be available to show the collection, the decision was made to increase the amount of premodern material. One consequence of that decision is to emphasize the continuity and transformation of ideas, rather than the disruption of tradition.

Until the late fifties not every work by an individual designer, no matter how gifted, was deemed eligible for inclusion in the collection proper. Only a few of many admirable designs by Alvar Aalto, for example, were acquired in the thirties, and only a few more were retained for the study collection. But by the sixties this restraint seemed too confining, if not actually misleading. Many works previously in the study collection were reassigned to the collection proper; and it was decided generally that while the collection would never strive to be encyclopedic, it would nevertheless include many more design variants than were previously thought suitable. Now that modernism itself has assumed the status of a historical event, the greater depth and variety accord well with a growing interest in the origin of ideas, and in the design alternatives that have begun to seem attractive today.

If the scope of the collection has been broadened to accommodate changing perspectives, certain contradictions continue in place. For example, from the beginning it was declared that the collection would not include fashion, jewelry, and other ephemeral forms, just because they are ephemeral. (Some jewelry was added because it resembled hardware, thus seeming to participate in the Platonic verities of machine art.) Yet the collection includes such characteristic productions of modern design as disposable packaging and computer electronics. Packages are meant to be consumed in use and could scarcely be more short-lived; electronic devices are rendered obsolete at an ever-accelerating rate, so that their intricate beauty is largely provisional.

Handicrafts present another kind of contradiction. In a collection concerned with design for mass production—or at least production of a simple design in large quantities—the craftsman's unique and varied output was thought to be of interest principally for the ways in which it reflected the dominant machine aesthetic. That the machine aesthetic itself has frequently relied on the craftsman, and on ancient craft techniques, was accepted simply as a curiosity of taste, or as a temporary limitation of machine production. Today the role of the craftsman has begun to seem worthy of more wide-ranging

examination, and the collection will undoubtedly enlarge its representation of the crafts.

Some things are inherently uncollectible, either because other museums already have the few examples known to exist, or because their functions are antisocial. Deadly weapons are among the most fascinating and well-designed artifacts of our time, but their beauty can be cherished only by those for whom aesthetic pleasure is divorced from the value of life—a mode of perception the arts are not meant to encourage.

For all its proselytizing intent, the design collection is perhaps of greatest value not for the instruction it offers but for the simple pleasure it gives: the artifacts of the twentieth century are often very beautiful. The best of them equal or surpass the greatest achievements of the past; some of them have already received continuous acclaim for a longer period of time than did comparable work in other epochs—a remarkable fact in a culture that claims to value change above all else.

631. Sven Wingquist. Self-aligning Ball Bearing. 1929. Steel. 1¾" (4.5 cm) high, 8½" (21.5 cm) diameter. Gift of SKF Industries

631

632

633

634

632. Corning Glass Works. Boiling Flask. Before 1934. Clear pyrex glass. 14⅝" (37.2 cm) high, 9½" (24 cm) diameter. Gift of the manufacturer

633. Coors Porcelain Co. Acid Pitcher. Before 1950. Glazed porcelain. 10¼" (26 cm) high. Gift of the manufacturer

634. Massimo and Adriano Lagostina. Stockpot. 1955. Stainless steel. 7¾" (19.7 cm) high. Phyllis B. Lambert Fund

635. Frank Heacox and Roy Richter. Helmet. 1957. Fiberglass-reinforced plastic and leather. 9¼ x 8⅞ x 11⅞" (23.5 x 22.5 x 30.2 cm). Gift of Bell-Toptex, Inc.

636. St. Regis Paper Company. Propeller Blade. c. 1943. "Panelyte" (plastic and paper). 62¼" (158 cm) high. Gift of the manufacturer

635

636

637

638

637. IBM Product Development Laboratory. Control Panel for IBM 305 (Random Access Memory Accounting Machine). 1950. Aluminum and plastic-covered wires. 11½ x 20¾" (29.2 x 52.7 cm). Gift of the manufacturer

638. Top to bottom, left to right: Walter von Nessen. Tray, Flower Bowl, and Plate. 1928. Copper and chromium; Baker's Bowl. Steel; Outboard Propeller. Aluminum; Boat Propeller. Bronze; Coil. Strip stainless steel; Two Plumb Bobs. Brass; Serving Tray. Copper; 1928. Bevel Protractor and Three Outside Calipers. Steel; Bearing Spring, Spring, and Two Spring Sections. Steel; Automobile Piston. Aluminum; Circular Saw. Steel. 35⅞" (91 cm) diameter; Four Hotel Sauté Pans. Aluminum; Yale Lock. Steel; Flush Valve. Chromed brass; Sven Wingquist. Self-aligning Ball Bearing. Steel; Hotel Sauce Pan. Steel. All objects are gifts of the manufacturers

The precise geometric shapes of seemingly undesigned machines and hand tools became, in the twenties, a matter of conscious aesthetic preference. Painters, sculptors, architects, and even craftsmen were influenced by these pure forms. When making objects in which utility is a secondary consideration, the craftsman is usually free to choose between geometric and nongeometric shapes. Western culture has traditionally held geometric shapes to have superior beauty, because they call into play the rational mind. Plato, in *Philebus*, declared: "I do not mean by beauty of form that of animals or pictures, but...straight lines and circles, and the plane or solid figures which are formed out of them by turning-lathes, rulers, and compasses; for these I affirm to be not only relatively beautiful, like other things, but they are eternally and absolutely beautiful." Laboratory glass, as well as propellers, coil springs, and ball bearings—all of whose shapes are dictated by their function—are beautiful in Plato's sense of the word, and it is a beauty to which the twentieth century is particularly responsive.

639. A. M. Cassandre. Poster: "L.M.S. Bestway." 1928. Lithograph. 41⅜ x 50¾" (105 x 128.9 cm). The Lauder Foundation

640. Pinin Farina. Cisitalia "202" GT Car. 1946. Aluminum body. 49" x 13'2" x 57⅞" (125 x 401 x 147 cm). Gift of the manufacturer

The Cisitalia "202" GT is the first automobile to have entered the collection of any art museum in the world and as such symbolizes the Museum's conviction that examples of industrial design can have real aesthetic value and at their best are worthy of consideration as art objects. The Cisitalia is remarkable for the aerodynamic lines of its coachwork, which suggest a metal skin tightly stretched over the chassis and which lend to the automobile an impression of speed, even when it is at rest. The doors are minimized, and the side windows and roof flow backward like a pattern of air currents in a slipstream. The fenders are cut high to emphasize the size of the wheels. Everything implies power and forward thrust.

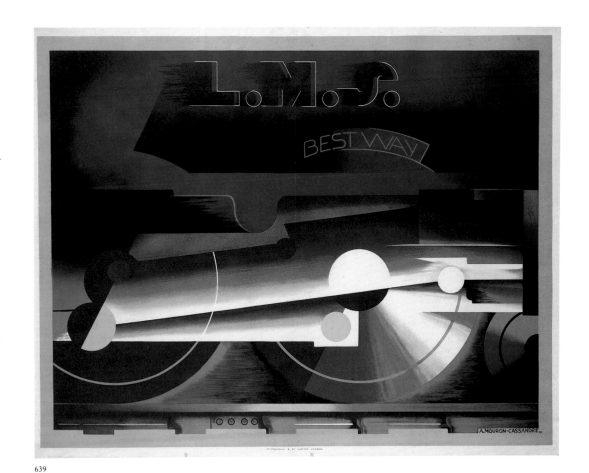

639

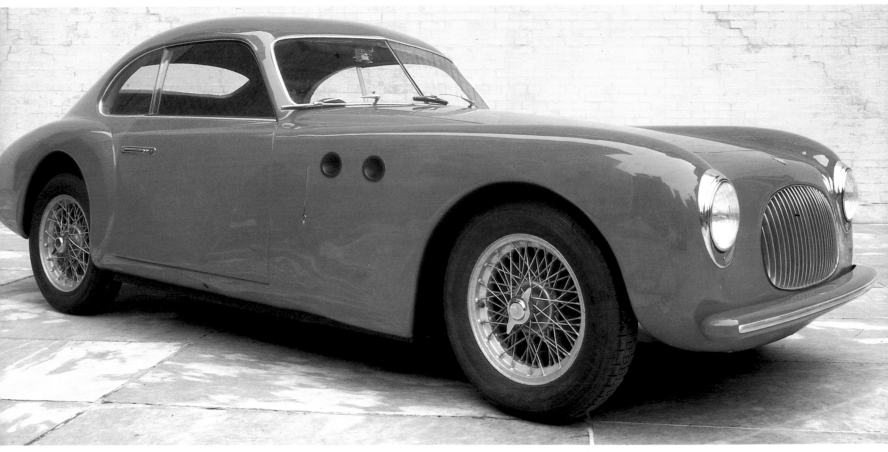

640

641

641. Hans Poelzig. Study for a Concert Hall. Interior perspective. 1918. Pencil and colored pencil on tracing paper. 14⅝ x 16³⁄₁₆″ (37.1 x 41 cm). Gift of Henry G. Proskauer

642. Frank Lloyd Wright. Carpet Design from the F. C. Bogk Residence, Milwaukee, Wisconsin. 1916. Colored pencil and pencil on tracing paper. 19³⁄₁₆ x 32⅛″ (48.8 x 81.5 cm). Marshall Cogan Purchase Fund

643. Frank Lloyd Wright. Frederick C. Robie House, Chicago, Illinois. Model. 1909. Paper, wood, and plastic. 15 x 48 x 37½″ (38.1 x 122 x 95.2 cm). Exhibition Fund

RESIDENCE MR. F. C. BOGK. DETAIL RUGS. SCALE 3·IN. 1FT. FRANK·LLOYD·WRIGHT ARCHITECT Nº 2.

642

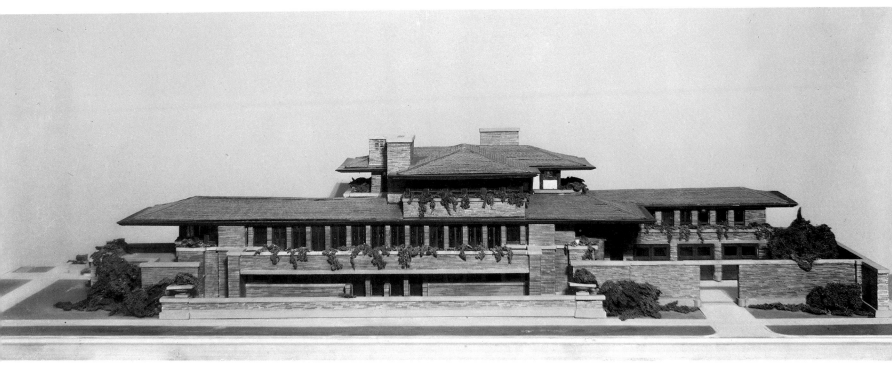

643

644. Frank Lloyd Wright. Millard House, Pasadena, California. Perspective drawing. 1923. Colored pencil on gampi paper. 20⁹⁄₁₆ x 19¹¹⁄₁₆″ (52.3 x 50 cm). Gift of Mr. and Mrs. Walter Hochschild

With this famous house Wright achieved a richness of texture related more to tapestry than to concrete blocks. This drawing, executed on Japanese rice paper, is especially successful in evoking the lush foliage of a Los Angeles site.

645. Theo van Doesburg (C. E. M. Küpper). Café Aubette, Strasbourg. Color scheme (preceding final version) for ceiling and short walls of ballroom. 1927. Ink and gouache on paper. 10¾ x 24¾″ (27.3 x 62.8 cm). Gift of Lily Auchincloss, Celeste Bartos, and Marshall Cogan

646. Gerrit Rietveld. Schröder House, Utrecht, the Netherlands. Model. 1924. Plywood and glass. 18½ x 30¼ x 21¼″ (47 x 76.8 x 54 cm). Gift of Phyllis B. Lambert

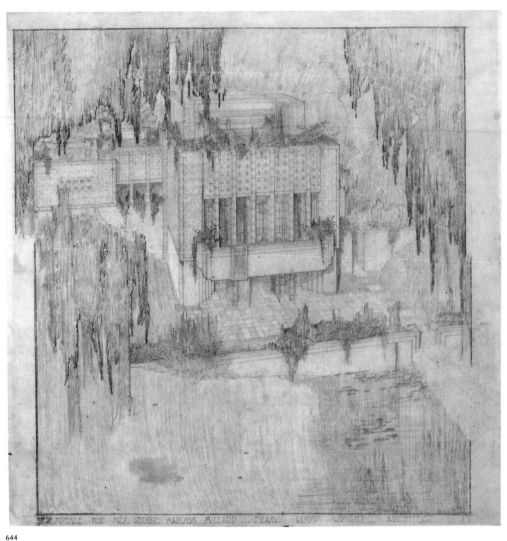

644

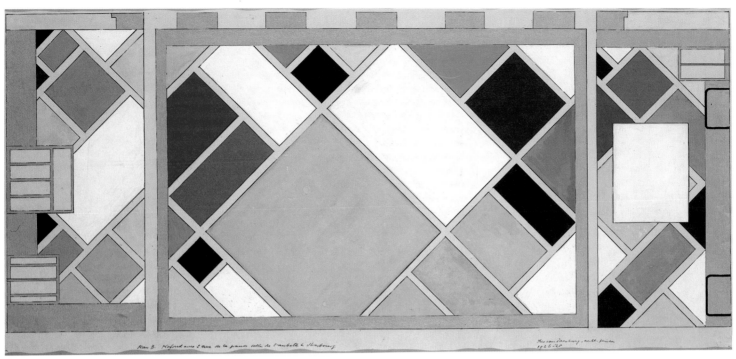

645

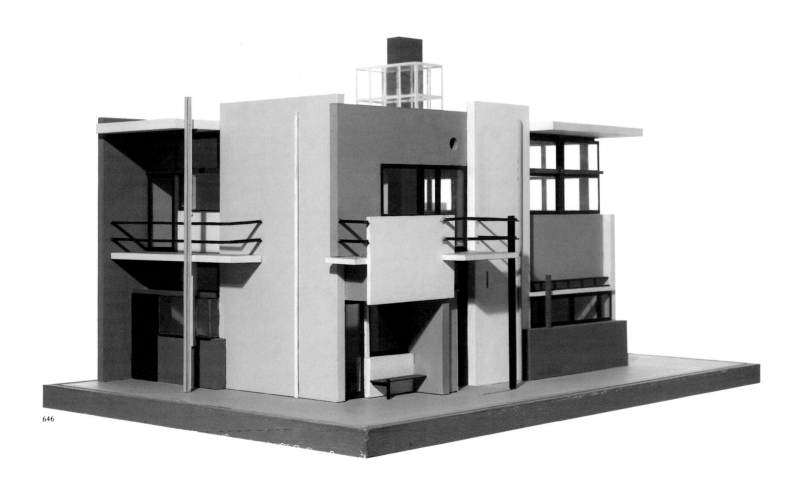

646

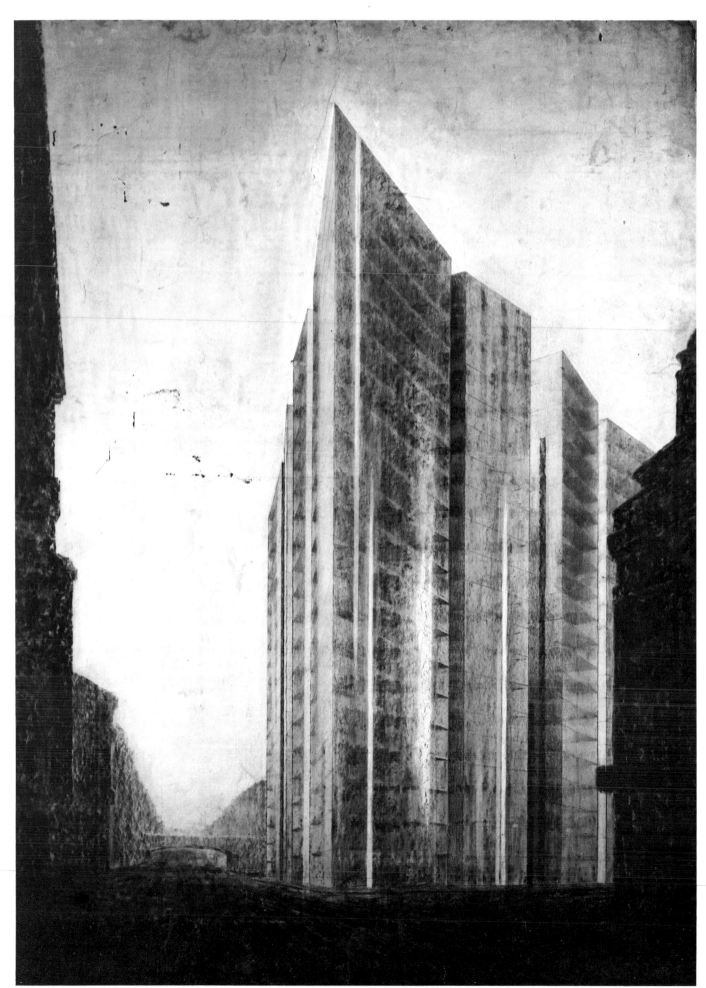

647

647. Ludwig Mies van der Rohe. Friedrichstrasse Office Building, Berlin. Perspective, north and east sides. 1921. Charcoal and pencil on brown paper mounted on cardboard. 68⁵⁄₁₆ x 48″ (173.5 x 122 cm). Gift of the architect. Mies van der Rohe Archive

In 1921 Mies van der Rohe designed the first of the five projects that would establish him as one of the pioneers of modern architecture: the Friedrichstrasse Office Building, a competition entry for the first skyscraper in Berlin. In making the facade as transparent as possible, Mies sought "to achieve beauty by revealing truth." Mies said: "Instead of trying to solve the new problems with old forms, we should develop the new forms from the very nature of the new problems. We can see the new structural principles most clearly when we use glass in place of the outer walls, which is feasible today since in a skeleton building these outer walls do not actually carry weight."

648. Ludwig Mies van der Rohe. Concrete Country House. Project, perspective drawing. 1923. Charcoal, crayon, and pencil on heavy yellow stock mounted on board. 28¾″ x 7′1¼″ (73.1 x 218 cm). Gift of the architect. Mies van der Rohe Archive

649. Ludwig Mies van der Rohe. House, Berlin Building Exposition. Plan. 1931. Ink on illustration board. 29⅞ x 40″ (76 x 101.8 cm). Gift of the architect. Mies van der Rohe Archive

650. Ludwig Mies van der Rohe. New National Gallery, Berlin. Model. 1968. Plastic, wood, onyx, and cloth. 11¼ x 63 x 36″ (28.5 x 160 x 91.5 cm). Gift of the architect

648

649

650

651

651. Richard Neutra. Philip M. Lovell House, Los Angeles, California. Model. 1927–29. Lucite. 58¼ x 34¼ x 24″ (148 x 87 x 61 cm). Best Products Company Architecture Fund

652. Le Corbusier (Charles-Édouard Jeanneret), with Pierre Jeanneret. Villa Savoye, Poissy, France. Model. 1929–31. Wood, aluminum, and plastic. 25½ x 22½ x 11⅛″ (64.8 x 57.2 x 28.2 cm). Exhibition Fund

The Villa Savoye demonstrates Le Corbusier's early preference for treating buildings as weightless volumes lifted above the ground. Its main rooms as well as a spacious terrace are all contained within the elevated rectangle. The entire composition is planned as a sequence of spatial effects. Driving out from Paris through progressively more open countryside, the owners, on arriving, first saw the building's rear elevation. The automobile was meant to drive underneath the house, circling around to the main entrance, and from there to proceed directly to the garage. From the entrance hall a stair and a ramp lead up to the first-floor hall. The ramp continues from the terrace up to a sun deck sheltered by curvilinear wind screens. The plan of this upper level particularly reveals the close relationship between Le Corbusier's architecture and his painting.

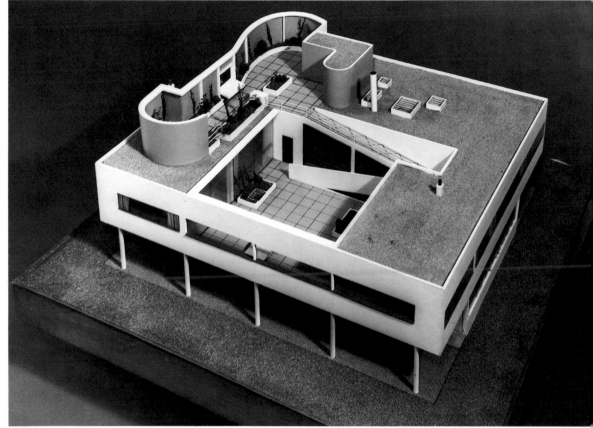

652

653

653. Louis I. Kahn. Alfred Newton Richards Medical Research Building, University of Pennsylvania, Philadelphia. Perspective drawing, preliminary version. 1957. Charcoal on tracing paper. 23⅞ x 31″ (60.7 x 78.7 cm). Gift of the architect

The Richards Medical Research Building made Kahn's reputation throughout the world. It is simultaneously a building and a manifesto. Its impact derived from its inventive and rigorous integration of form, function, space, and structural technique. Its vertical massing and broken silhouette, a somber march of towers, instantly created a new sense of form for a rising generation of architects.

654. Louis I. Kahn. Sher-e-Banglanagar, Dacca, Bangladesh. Site plan sketch. 1968. Charcoal on tracing paper. 13 x 19½″ (33 x 49.5 cm). Gift of the architect

655. R. Buckminster Fuller and Shōji Sadao. Tetrahedron City at Yomiuriland, near Tokyo, Japan. c. 1970. Photomontage. 11 x 14″ (28 x 35.5 cm). Gift of the architects

656. Hans Hollein. Highrise Building: Sparkplug. Project, perspective. 1964. Photomontage. 4¾ x 7¼″ (12 x 18.4 cm). Philip Johnson Fund

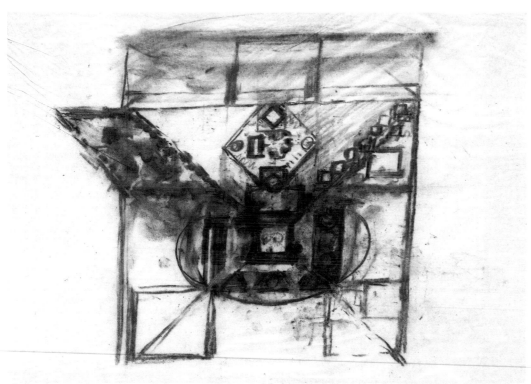

654

655

656

657

657. Michael Graves. Fargo-Moorehead Cultural Bridge. South elevation. 1977–78. Pencil and prismacolor on yellow tracing paper. 11⅞ x 11⅞" (31.4 x 31.4 cm). Lily Auchincloss Fund

658. James Stirling. Staatsgalerie Stuttgart, Germany. 1978. Pencil and colored pencil on tracing paper. 20¹⁵⁄₁₆ x 19⅞" (53.2 x 50.5 cm). Gift of the architect

In 1977 Stirling won a competition for a new gallery extension and theater for the Stuttgart Staatsgalerie, and construction was begun two years later. At the time drawings of the project were published along with remarks by the architect: "Prior to starting working drawings a number of sketches were made by the office in order to clarify materials, color, profiles, proportions, etc.; these drawings were entirely functional and for internal purposes, and were not intended for showing to the client or the authorities.... They are usually up-view frontals, with dimensions true in the vertical and horizontal plane, on tracing paper at 1:50 scale, using pencil line and shading with color crayon on the reverse." The drawings, of which this is one, are difficult to understand—even for architects—because they combine elevations, usually of travertine and sandstone walls, with segments of the plan and segments of overhead steel-and-glass canopies, both plan and canopies seen as if one were looking directly up at them from below the building. The result emphasizes the unexpected architectural juxtaposition of more or less neoclassical masonry forms with "industrial" steel structure painted in primary colors.

658

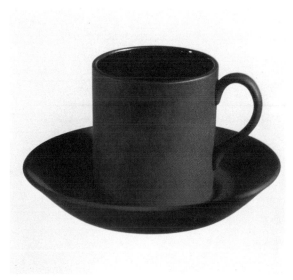

659

659. Josiah Wedgwood. Demitasse and Saucer. 1768 (manufactured 1952). Black Basalt stoneware. Demitasse 2¼″ (5.8 cm) high; saucer 4⅜″ (11.2 cm) diameter. Gift of Josiah Wedgwood & Sons, Inc.

660. Christopher Dresser. Covered Tureen and Ladle. 1880. Electroplated silver and wood. Tureen 6⅜″ (16.2 cm) high, 9¼″ (23.5 cm) diameter; ladle 12¼″ (31.2 cm) long. Gift of Mrs. John D. Rockefeller 3rd

661. Left to right: Josef Hoffmann. Wine Goblet. 1920. Hand-blown crystal. 7⅛″ (18.1 cm) high, 3¼″ (8.3 cm) diameter at base. Gift of A. J. van Dugteren & Son, Inc.; Josef Hoffmann. Champagne Glass. 1920. Hand-blown crystal. 6⅜″ (16.1 cm) high, 3¼″ (8.3 cm) diameter at base. Gift of A. J. van Dugteren & Son, Inc.; Oswald Haerdtl. Champagne Glass. 1924. Hand-blown gold luster crystal. 10½″ (26.7 cm) high, 3⅜″ (8.5 cm) diameter at base. Gift of A. J. van Dugteren & Son, Inc.

Certain pure classical shapes retained their prestige even after Art Nouveau had broken with tradition. Notable examples are the cups originally designed in England in 1768 by Wedgwood. These designs are of a classically pure perfection that has continued to satisfy twentieth-century aesthetics. Hoffmann, foremost among the proponents of Art Nouveau in Austria, at times was also greatly influenced by classical forms. His exquisitely fragile tulip-shaped wine glasses, possibly the most beautiful of their kind, are serene abstractions of plant forms with no extraneous detail. Their effect depends on the impeccable joining of the base, stem, and bowl, and the precision and clarity with which their contours are defined. Haerdtl, another Austrian, took the traditional trumpet-shaped champagne glass, blown since at least the sixteenth century, and reinterpreted it, using a fine lead crystal and drawing the stem downward to form a long uninterrupted, slightly concave line from the rim to the foot. The daring attenuation and utter simplicity of the glass give it great elegance.

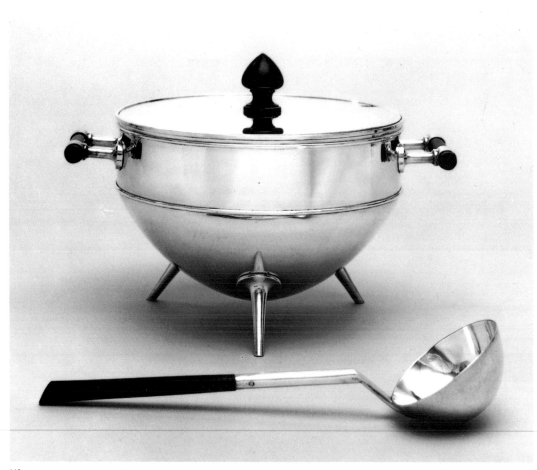

660

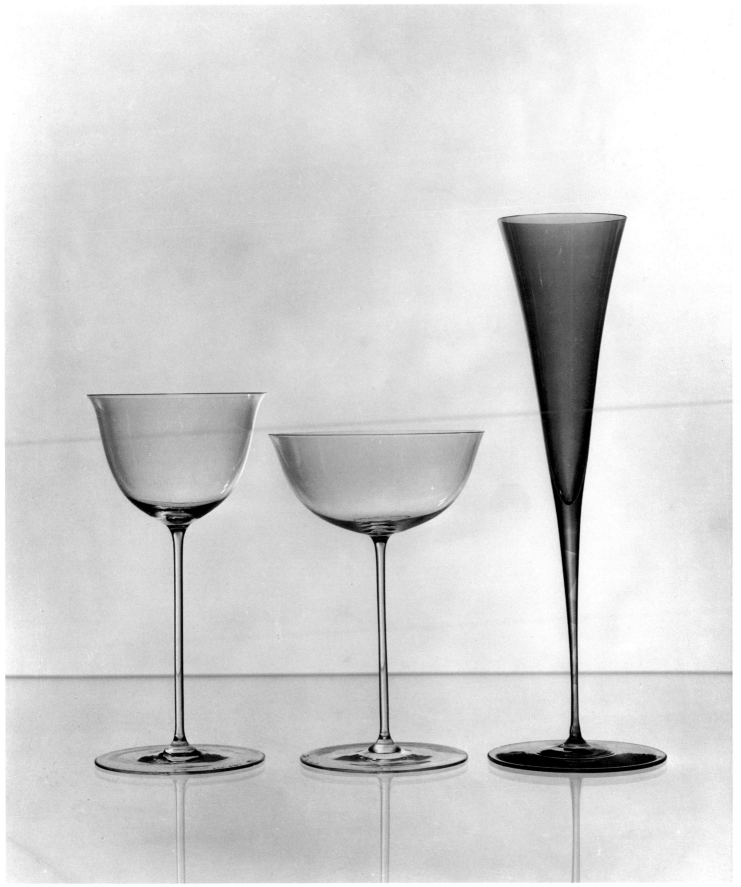

661

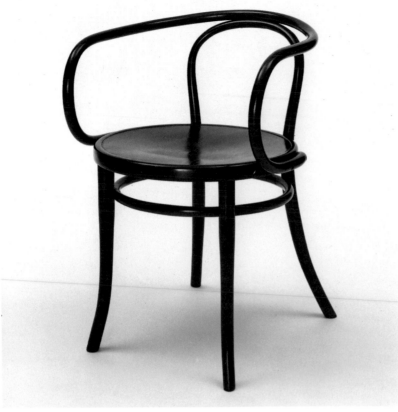

662

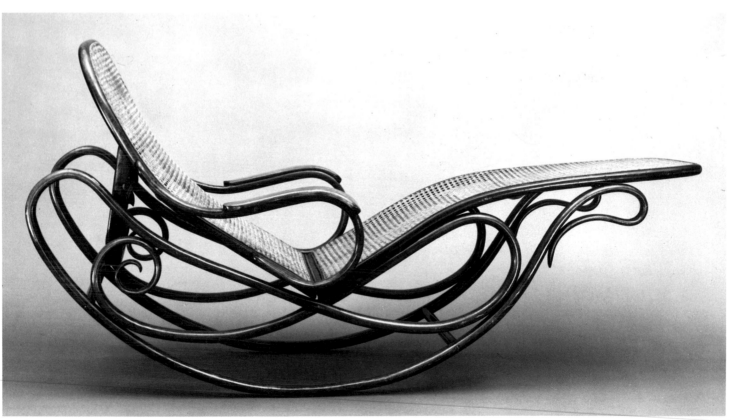

663

662. Gebrüder Thonet. Armchair. c. 1900. Steam-bent beechwood. 28¾ x 20⅞ x 21¹⁵⁄₁₆″ (74.5 x 52.7 x 55.7 cm). Philip Johnson Fund

663. Gebrüder Thonet. Reclining Rocking Chair with Adjustable Back. c. 1880. Steam-bent beechwood and cane. 30½ x 27½ x 68½″ (77.5 x 70 x 174 cm). Phyllis B. Lambert Fund and gift of the Four Seasons

In 1856 the German Michael Thonet perfected a process by which solid lengths of beechwood could be steamed and bent to form long curved rods. Before the development of this technique, the design of most furniture depended on more or less sculptural joints for the intersections of separate pieces of wood. Bentwood made it possible to eliminate intricate handcarved joints and contours, and led to the first mass production of standardized furniture. The Austrian firm of Gebrüder Thonet circulated catalogues illustrating their products, and thousands of bentwood chairs were sold throughout the world. One piece of bentwood could be made to form both the rear legs and backrest of a chair. This simplification made it particularly appealing to twentieth-century designers, notable among them Le Corbusier, who used the wood armchair in his buildings. The increased continuity of design produced by this simplification also allowed the supporting elements of a chair to be given decorative value merely by extending them in ornamental curves, as in the flamboyantly elegant rocker. The lightness of the bentwood frames is emphasized by seat and back panels of semitransparent woven cane.

664. Koloman Moser. Poster: "Frommes Kalender." 1903. Lithograph. 37½ x 24½″ (95.3 x 62.2 cm). Anonymous gift

664

665

665. Joseph Maria Olbrich. Candlestick. c. 1901. Pewter. 14¼ x 6¹³⁄₁₆″ (36.2 x 17.3 cm). Philip C. Johnson Fund

666. Daum Frères. Group of Five Vases. c. 1900. Hand-painted glass. Height, left to right: 21½″ (54.6 cm); 8⅛″ (20.7 cm); 6″ (15.2 cm); 5⅞″ (14.8 cm); 25⅛″ (63.7 cm). Phyllis B. Lambert Fund

667. Henry Van de Velde. Lobster Forks. 1902–03. Silver. Each 7⅝″ (19.4 cm) long. Marshall Cogan Purchase Fund

668. Charles Robert Ashbee. Loop-handled Dish. 1900. Silver and lapis lazuli. 2¹¹⁄₁₆″ (7 cm) high, 4⅝″ (11.2 cm) diameter. Estée and Joseph Lauder Design Fund

666

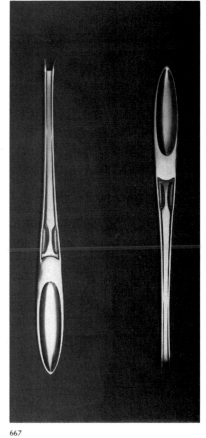

667

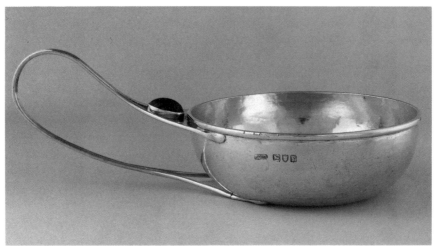

668

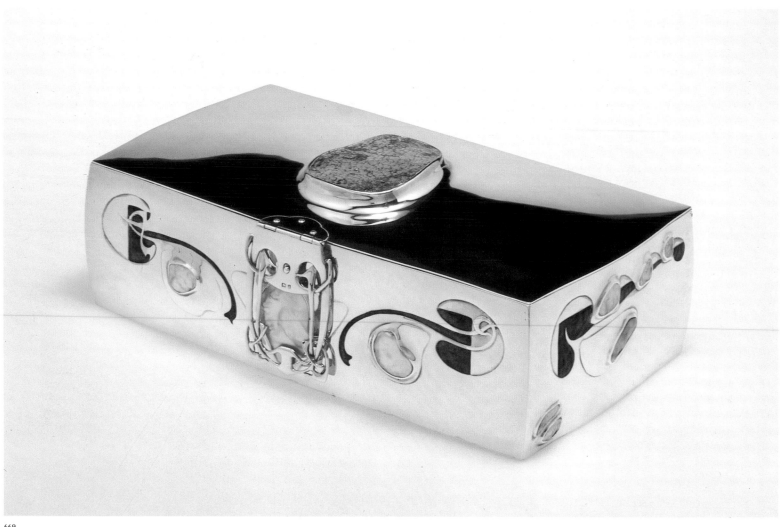

669

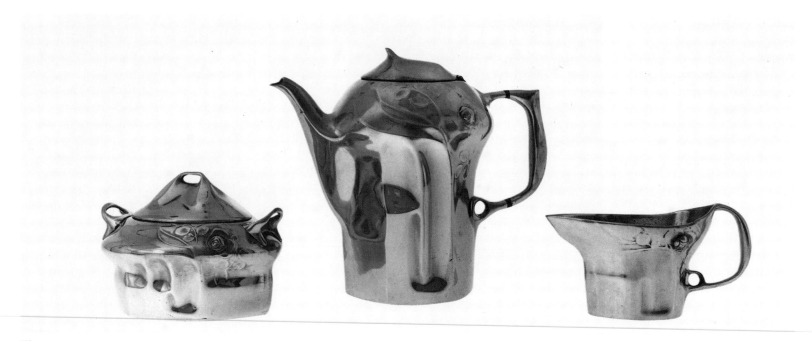

670

669. Archibald Knox. Jewel Box. 1900. Silver, turquoise, mother-of-pearl, and enamel. 3⅞ x 11¼ x 6″ (7.3 x 28.5 x 15.2 cm). Gift of the family of Mrs. John D. Rockefeller, Jr.

This jewel box was made at the height of the Art Nouveau movement for Liberty & Co., a London store that popularized the style in England by commissioning leading artists and craftsmen to design and execute a wide range of objects— among them furniture, textiles, and jewelry—in the new idiom. Art Nouveau was largely a French style characterized by the use of flowing shapes and curving lines, often reminiscent of the tendrils of plants, breaking waves, or flowing hair. In England it tended to be much less exuberant than in France. This jewel box, for example, despite its use of rich materials, is quite restrained. Its top, except for the inset stone and the upper part of the lock, is devoid of ornament; and the decoration on the front and sides is confined to the panels. A French interpretation would probably have carried the decoration over the entire surface of the box.

670. Hugo Leven. Coffee Set. 1903. Pewter. Sugar bowl 4½ x 5½ x 4¾″ (11.5 x 14 x 12.1 cm); coffee pot 8½ x 9⅝ x 5″ (21.5 x 24.4 x 12.7 cm); creamer 3⅝ x 6⅝ x 3⁷⁄₁₆″ (9.2 x 16.8 x 8.8 cm). Marshall Cogan Purchase Fund

671. Karl Koepping. Wine Glass. c. 1900. Glass. 6⅝″ (16.8 cm) high, 2⁵⁄₁₆″ (5.9 cm) diameter at base. Joseph H. Heil Bequest

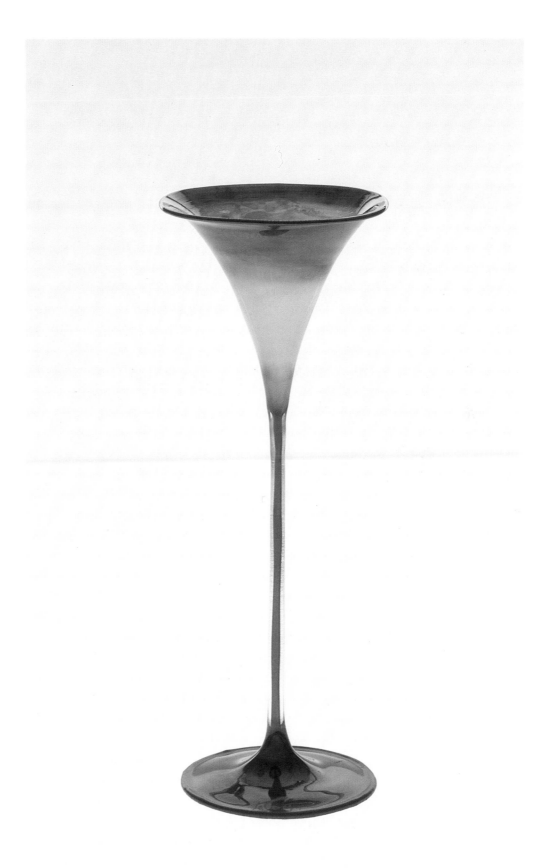

671

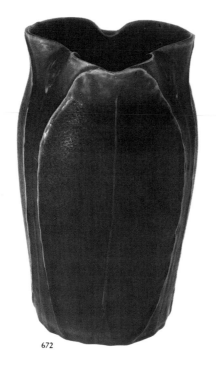

672

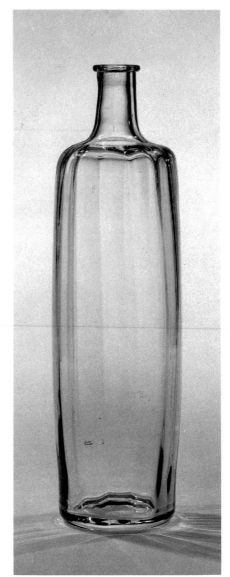

673

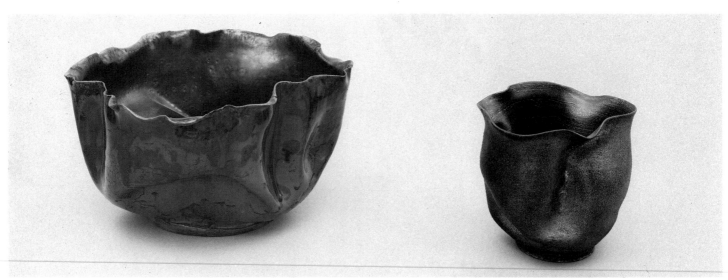

674

672. Grueby Faience Company. Vase. c. 1898–1902. Pottery with dark green mat glaze. 7¾″ (19.7 cm) high, 3½″ (8.9 cm) diameter at base. Department Purchase Fund

Grueby vases are often built up out of abstracted, broad leaf shapes, and their soft, green mat glazes are restrained and unassertively natural. This vase, with its trifoil rim, suggests a cluster of three upright leaves, punctuated by budlike forms on thin vertical stalks. Although the composition is made up of gently flowing curves, it is reserved. The thick dark green glaze runs thin at the edges of the leaves, letting light clay show through, accentuating their outline. Otherwise the vase is undecorated. Form, muted color, and texture are enough; the flash is left to the flowers for which the vase is intended.

673. Richard Riemerschmid. Bottle. c. 1899–1902. Molded glass. 11½″ (29.2 cm) high, 2¹³⁄₁₆″ (7.3 cm) diameter at base. Phyllis B. Lambert Fund

674. George Ohr. Bowls. c. 1900. Glazed ceramic. Left: 4¼″ (10.8 cm) high; right: 3¾″ (9.5 cm) high. Mrs. John D. Rockefeller 3rd Purchase Fund

675. Ludwig Hohlwein. Poster: "Confection Kehl." 1908. Lithograph. 48½ x 36⅛″ (123.2 x 91.7 cm). Gift of Peter Muller-Munk

676. Josef Hoffmann. Flatware. c. 1903–09. Silver-plated nickel silver. Knife 8½″ (21.5 cm) long; fork 8½″ (21.5 cm) long; spoon 8⅜″ (21.3 cm) long. Estée and Joseph Lauder Design Fund

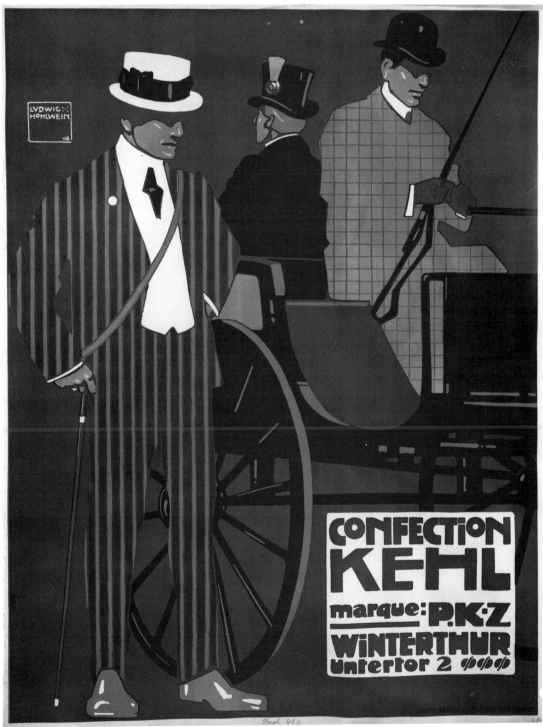

675

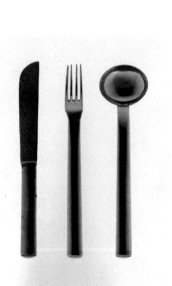

676

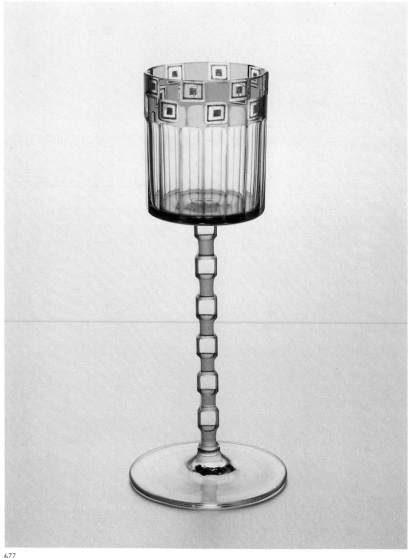

677

677. Otto Prutscher. Wine Goblet. c. 1905. Flashed and hand-painted glass. 8⅛″ (20.6 cm) high, 3⅛″ (8 cm) diameter at base. Estée and Joseph Lauder Design Fund

678. Koloman Moser. Vase. 1902. Colored glass. 5⅞ x 5⅞ x 5⅞″ (14.9 x 14.9 x 14.9 cm). Estée and Joseph Lauder Design Fund

679. Louis Comfort Tiffany. Vase. c. 1900. Favrile glass. 20½″ (52.1 cm) high, 4¾″ (12 cm) diameter at base. Gift of Joseph H. Heil

Tiffany, the son of the founder of the New York jewelry store, set up a glass factory in 1885, after having had some success as both a painter and decorator. The primary aim of the Tiffany Glass Company was to produce stained-glass windows and mosaics, and the vases and other small objects for which the firm eventually became most famous resulted from an effort to use up quantities of excess stock glass. Tiffany later said: "Stores of it accumulated; it was evident that an industry pushed so far ought to lower the annual deficit by the utilization of by-products, just like any other." The glass, which he called Favrile—a word he made up, suggesting the root of "faber" with its fashionable connotation of handicraft—was remarkable for its subtle shadings of luminous color.

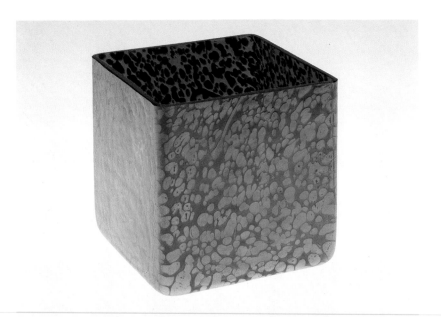

678

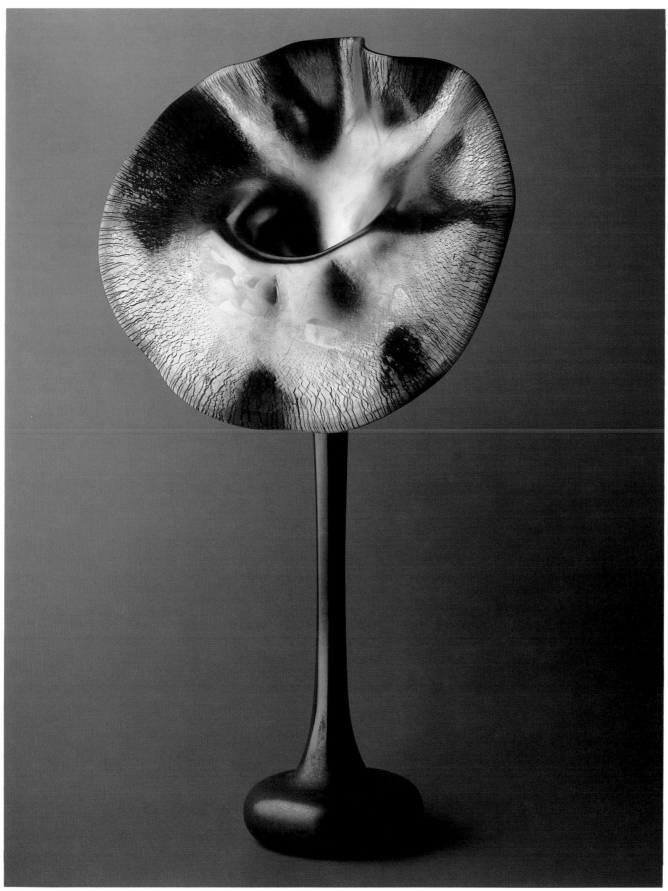

679

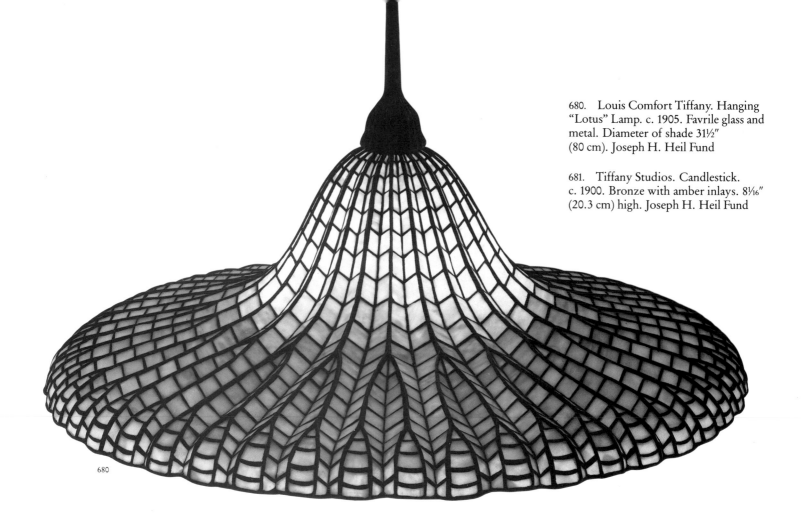

680

682. Louis Comfort Tiffany. Lava Vase. c. 1900. Favrile glass. 6½″ (15.9 cm) high. Joseph H. Heil Fund

Perhaps the most daring designs Tiffany made for glass were his so-called Lava vases. Their fluid forms suggest molten metal. Glowing as if still hot, their surfaces are shot through with veins of liquid gold and are embedded with irregularly shaped "stones" like baroque pearls. Rich and exotic, they embody many of the most admired attributes of the Art Nouveau aesthetic.

683. Hector Guimard. Desk. c. 1899 (remodeled after 1909). Olive wood with ash panels. 28¾″ x 8′5″ x 47¾″ (73 x 356.5 x 121.3 cm). Gift of Madame Hector Guimard

Art Nouveau flourished from approximately 1893 to 1910. It was

680. Louis Comfort Tiffany. Hanging "Lotus" Lamp. c. 1905. Favrile glass and metal. Diameter of shade 31½″ (80 cm). Joseph H. Heil Fund

681. Tiffany Studios. Candlestick. c. 1900. Bronze with amber inlays. 8¹⁄₁₆″ (20.3 cm) high. Joseph H. Heil Fund

681

682

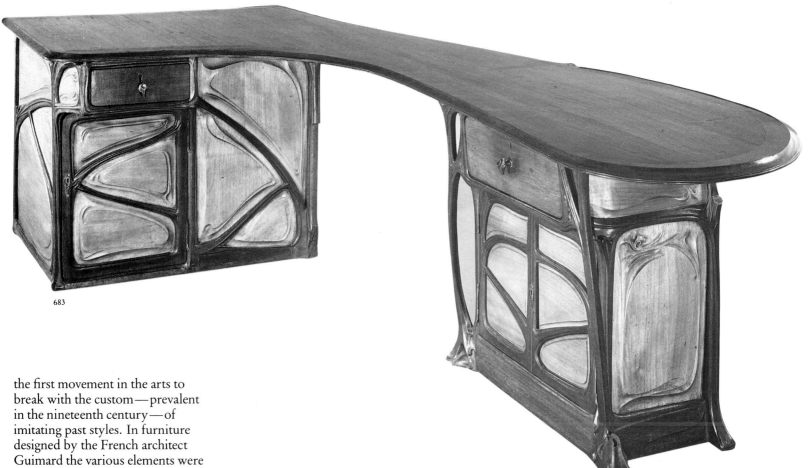

683

the first movement in the arts to break with the custom—prevalent in the nineteenth century—of imitating past styles. In furniture designed by the French architect Guimard the various elements were joined so that they appeared to flow into each other. Usually his designs were symmetrical, but in some larger pieces, and often in the applied decoration, he composed asymmetrically and somewhat in the manner of the Rococo. The large desk designed for his own use not only employs what are now called free-form shapes, but also anticipates today's practice of grouping separate storage elements in a convenient L-plan.

684. Hector Guimard. Entrance Gate to Paris Subway Station (Métropolitain). c. 1900. Cast iron painted green; amber glass fixtures. 15′5″ x 21′ (469.1 x 611.7 cm). Gift of Régie Autonome des Transports Parisiens

Guimard's famous entrance arch, mass-produced for the Paris subway system, suggests giant stalks drooping under the weight of what seems to be a swollen tropical flower—actually an amber glass lighting fixture.

684

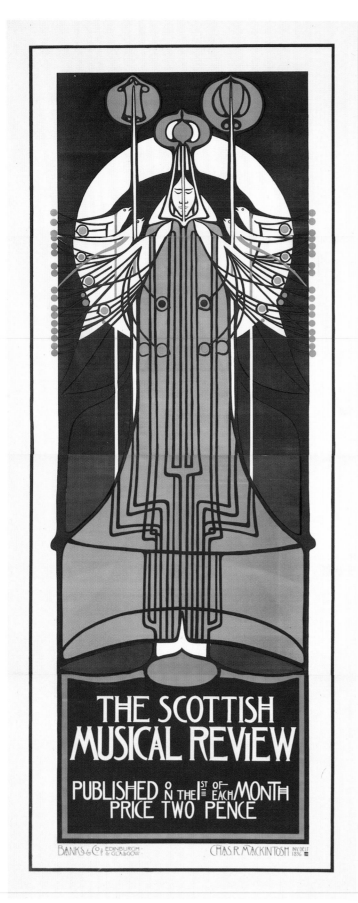

685

685. Charles Rennie Mackintosh. Poster: "The Scottish Musical Review." 1896. Lithograph. 8'1" x 39" (246.4 x 99 cm). Exchange

686. Hector Guimard. Poster: "Exposition Salon du Figaro le Castel Béranger." 1899. Lithograph. 35 x 49¼" (88.9 x 125.1 cm). Gift of Lillian Nassau

687. Antonio Gaudí. Bench. Before 1915. Spanish oak and wrought iron. 32⅝ x 43½ x 26" (82.9 x 110 x 66 cm). Estée and Joseph Lauder Design Fund

688. Richard Riemerschmid. Side Chair. 1899. Oak and leather. 30¾ x 19¼ x 18¾" (78 x 49 x 47.5 cm). Gift of Liberty & Company, Ltd.

689. Charles Rennie Mackintosh. Side Chair. 1897. Oak and silk. 54 x 19⅜ x 18" (137.1 x 49.2 x 45.7 cm). Gift of the Glasgow School of Art

As a furniture designer Mackintosh never intended his work to have broad application, since most of it was conceived as much for the dramatic effect it would have within specific rooms as for its suitability for practical everyday use. This is the first of a number of high-backed chairs Mackintosh designed in the course of his career. Made for the Luncheon Room of Miss Cranston's Argyll Street Tea Rooms in Glasgow, its design is strikingly original. The back forms a pattern of strong verticals and makes much decorative use of structural elements. The back-

686

supports, heavy and rectangular at the floor, growing thinner as they rise, become elliptical and round in section. They flank two widely spaced splats that run into the bottom of a large, oval plaque, into which is cut the chair's only decoration, the severely stylized outline of a soaring bird. The curve of the bird's wings echoes the top of the oval, reinforcing it. These curves are repeated at the bottom of the massive back stretcher and again in the front and side rails of the seat. Mackintosh's chairs are more than furniture; they are dynamic presences, and as such create an atmosphere all their own.

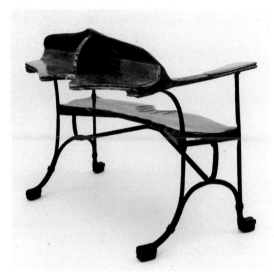

687

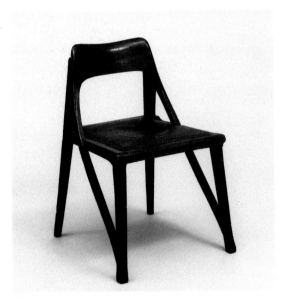

688

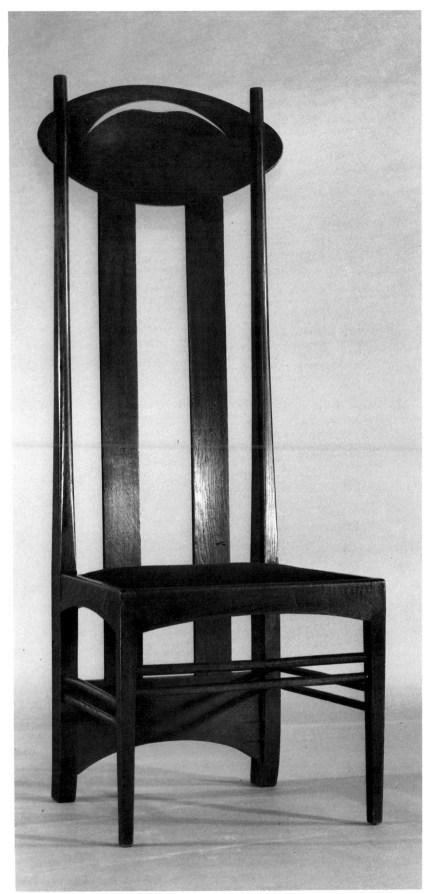

689

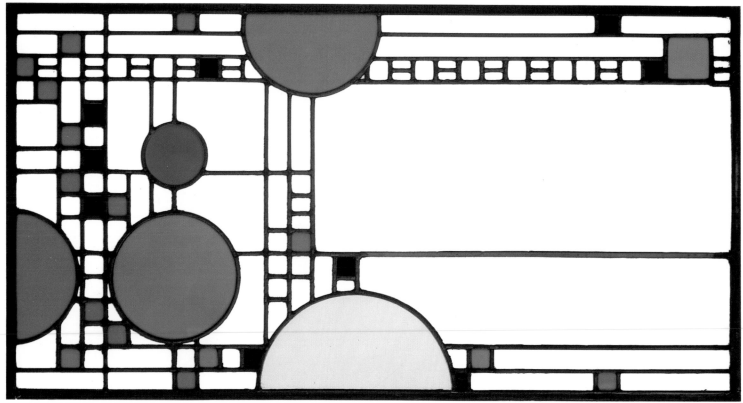

690

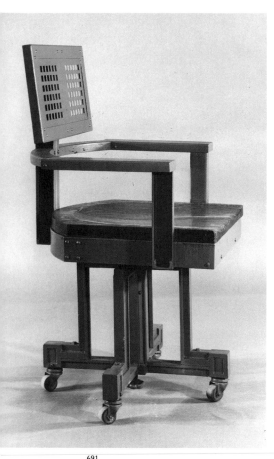

691

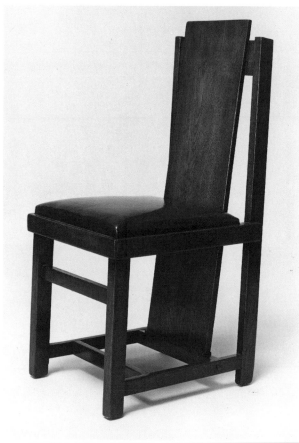

692

690. Frank Lloyd Wright. Two Windows from the Coonley Playhouse, Riverside, Illinois. 1912. Leaded clear and cased glass. Each 18⅝₁₆ x 34³⁄₁₆″ (46.5 x 86.9 cm). Joseph H. Heil Fund

691. Frank Lloyd Wright. Office Armchair on Swivel Base. 1904. Painted metal and oak. 37½″ (95.2 cm) high. Gift of Edgar Kaufmann, Jr.

692. Frank Lloyd Wright. Side Chair. 1904. Oak and leather. 35¾ x 15 x 18½″ (90.8 x 38.1 x 47 cm). Gift of the designer

693. Gerrit Rietveld. "Red and Blue" Chair. c. 1918. Painted wood. 34⅛ x 26½ x 26½″ (86.5 x 67.3 x 67.3 cm). Gift of Philip Johnson

At the same time that the Bauhaus was teaching its new principles of design in Germany, in the Netherlands a group of artists, architects, and designers who had banded together during World War I under the name de Stijl were producing works using strong, geometric

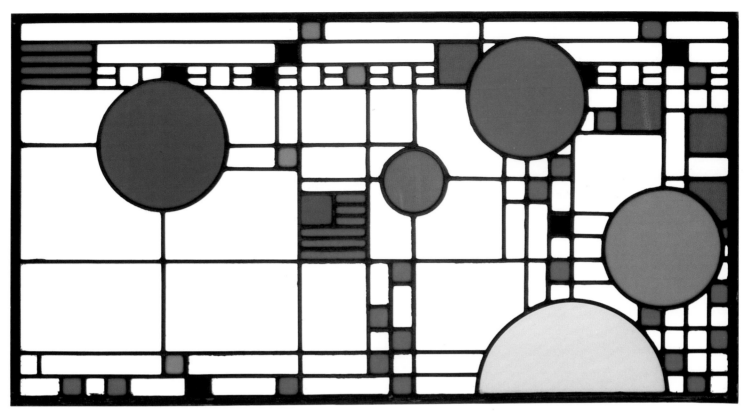

690

shapes, frequently painted in black, white, gray, and the primary colors red, yellow, and blue. At first glance de Stijl objects may resemble those made in the Bauhaus, but whereas the Germans were attempting to arrive at designs that were potentially useful and inexpensive as well as handsome, the Dutch were concerned with formal aesthetic problems more than with function. Their approach was to reduce familiar objects as far as possible to abstract shapes and pure colors. Rietveld, one of the leaders of de Stijl, was an architect and designer. His armchair is stripped to individual elements of planes and lines, the separateness of the various components accentuated by different colors. The red and blue planes of the back and seat do not meet: the whole composition appears as if the chair had "exploded," with each part distinct and seemingly unconnected to the others.

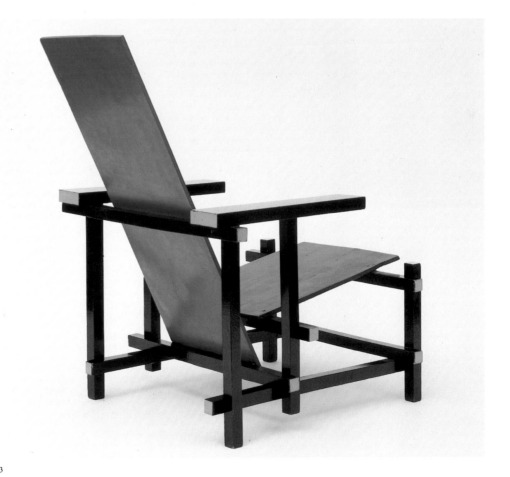

693

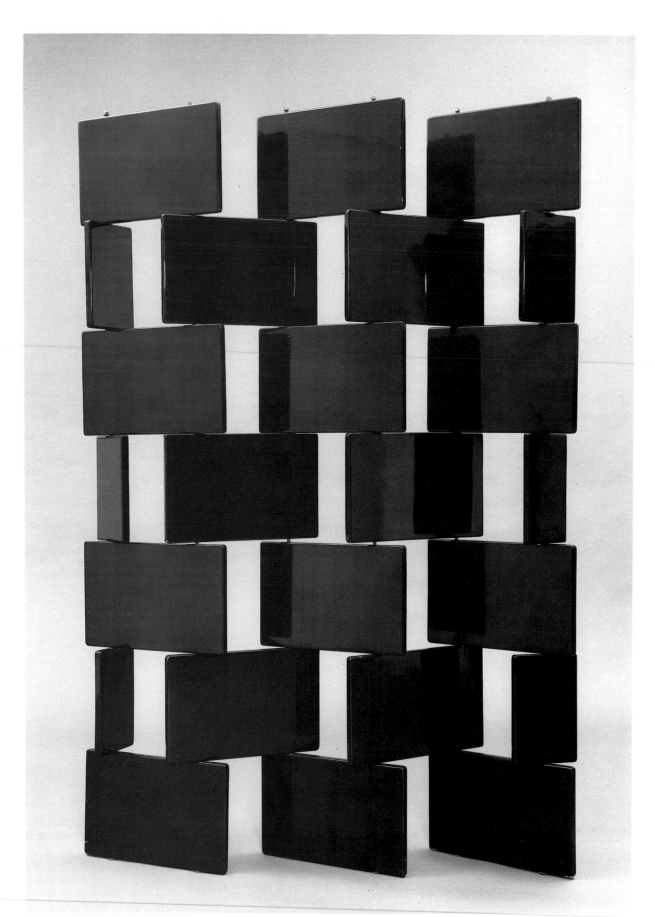

694

694. Eileen Gray. Block Screen. 1922.
Lacquered wood on metal rods. 6′2½″ x
53½″ (188.5 x 136 cm). Hector Guimard
Fund

695. Gunta Sharon-Stölzl. Tapestry.
1924. Hand-woven black and white
wool, silk, cotton, and metal thread.
71 x 44″ (180.3 x 111.8 cm). Phyllis B.
Lambert Fund

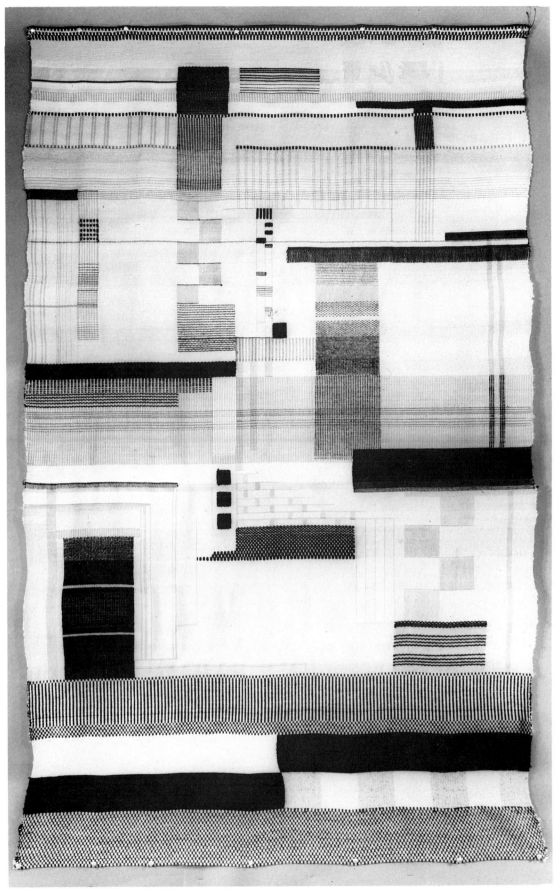

695

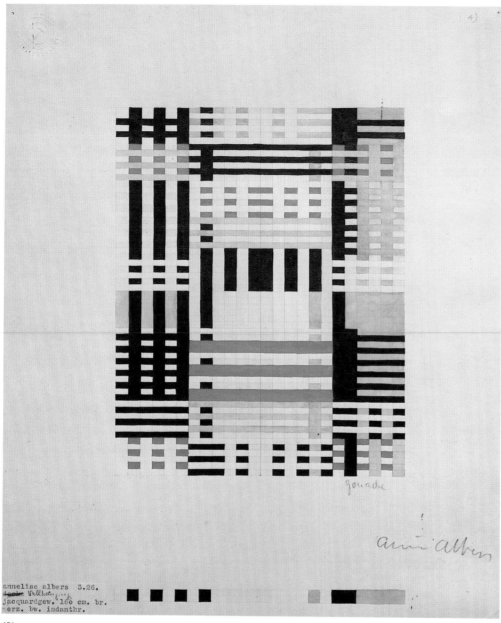

696

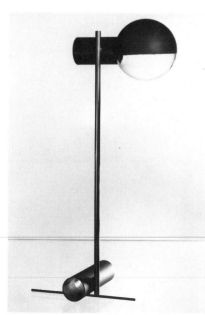

697

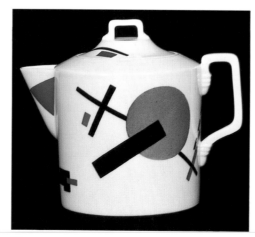

698

696. Anni Albers. Preliminary Design for Wall Hanging. Gouache on paper. 1926. 14 x 11½″ (35.5 x 29.2 cm) . Gift of the designer

697. Gerrit Rietveld. Table Lamp. 1924 (replica made by Rietveld in 1953). Chrome-plated steel, painted metal and glass. 14⅞″ (37.8 cm) high. Gift of the designer

698. Nikolai Suetin. Teapot. c. 1923. Porcelain with overglaze painted decoration. 5½″ (14 cm) high, 4½″ (11.4 cm) diameter. Estée and Joseph Lauder Design Fund

699. First row, left: Gustav Klutsis. Magazine Cover. 1931; center: László Moholy-Nagy. Book Jacket for Piet Mondrian's *New Design*. 1924; right: Frederick J. Kiesler. Exhibition Catalog Cover. 1924. Second row, left: Piet Zwart. Advertisement for NKF. 1928; second from left: Gustav Klutsis. Book Cover for *The Daily Life of Airplane Pilots*. 1928; center: Herbert Bayer. Catalog for Standard Möbel. 1927; lower center: El Lissitzky (Lazar Markovich Lissitzky). Cover for *Of Two Squares*. 1922; right: Filippo Tommaso Marinetti. Illustration from *Les Mots en Liberté Futuriste*. 1919. Third row, left: Alexander Rodchenko. Magazine Cover. 1928; second from left: Piet Zwart. Advertisement: "Hot Spots." n.d.; center: Herbert Bayer. Invitation. 1928; right: Friedrich Vordemberg-Gildewart. Envelope. n.d. Fourth row, left: Gustav Klutsis. Promotional Brochure. 1928. 11⅛ x 15″ (28.2 x 38.2 cm); center: Piet Zwart. Book Jacket for *The Comic Film*. 1931; right: Arthur Schmidt. Typography Experiment. 1927–28

About 1915, a number of young artists and political activists, reacting against conventional typography, began to experiment with lettering and type. The books and pamphlets of men like Marinetti were quickly passed from artist to artist all over Europe; and soon the Futurists were joined by the Dadaists, who added wit to political and aesthetic iconoclasm. The aesthetic that permeated the new typography might be expressed differently by Russian Constructivists or Bauhaus or Dutch de Stijl artists, but to a great extent it was shared by them all.

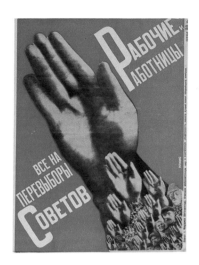

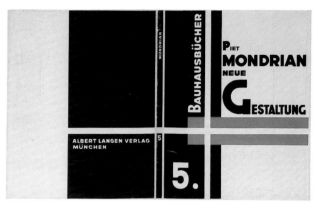

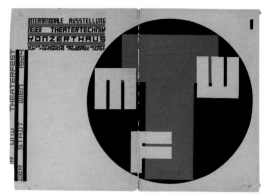

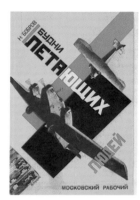

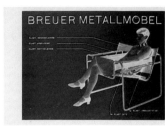

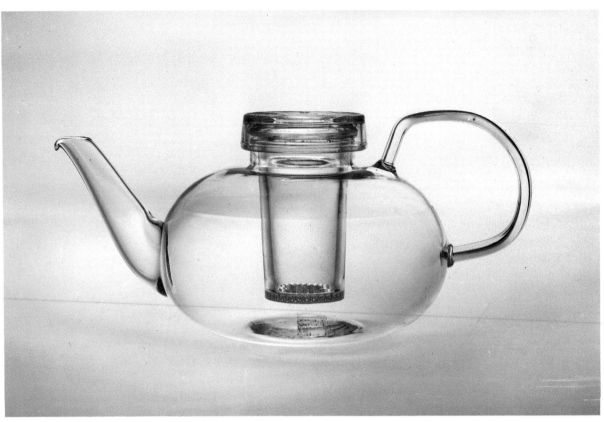

700

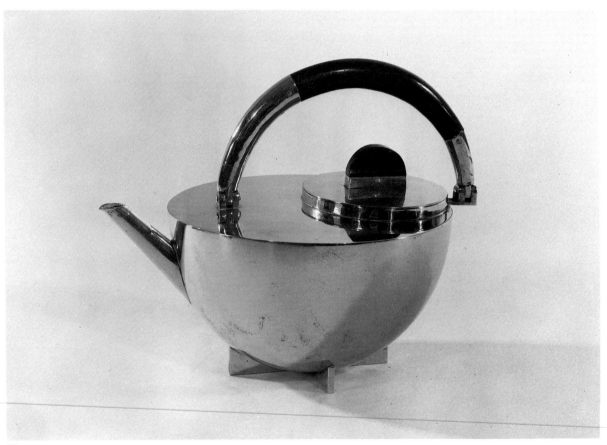

701

700. Wilhelm Wagenfeld. Teapot. 1932. Heat-resistant glass. 4½″ (11.5 cm) high, 6″ (15.2 cm) diameter. Gift of Fraser's, Inc.

701. Marianne Brandt. Teapot. 1924. Nickel silver and ebony. 7″ (17.8 cm) high. Phyllis B. Lambert Fund

The most important single design force of the twenties was the Bauhaus, a school in Germany that originated a new method of teaching designers and a new approach to the problems of industrial design. Although Bauhaus designers rigorously avoided the use of applied ornament and attempted to give their objects a machine-made look, their creations, as Wagenfeld pointed out, were "in reality craft products which through the use of geometrically clear basic shapes gave the appearance of industrial productions." This teapot, for example, with its hemispherical body, its circular lid, and its semicircular knob, is typical in that it is based on uncompromising geometrical forms. Its wood and metal handle, however, which swells gently toward the center, reveals its true craft antecedents.

702. Josef Albers. Tea Glass, Saucer, and Stirrer. 1925. Heat-resistant glass, porcelain, steel, and ebony. Tea glass 1⅞″ (4.7 cm) high, 3½″ (8.8 cm) diameter. Gift of the designer

703. Wilhelm Wagenfeld and Karl J. Jucker. Table Lamp. 1923–24. Glass and chrome-plated metal. Globe 17″ (43 cm) high, 8″ (20.2 cm) diameter. Gift of Philip C. Johnson

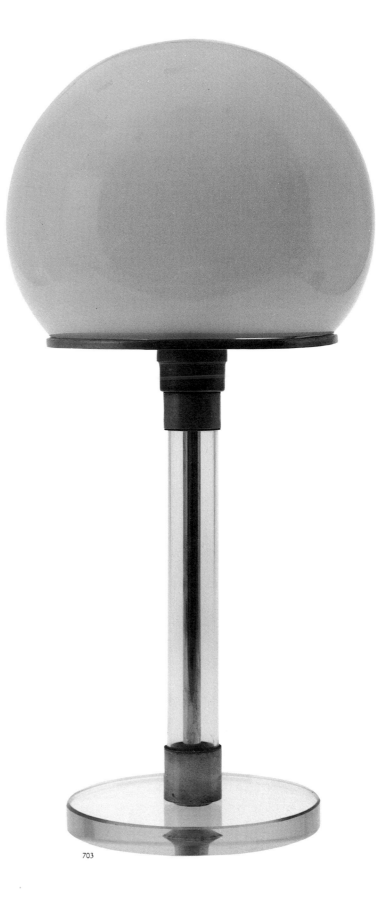

703

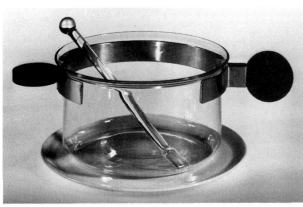

702

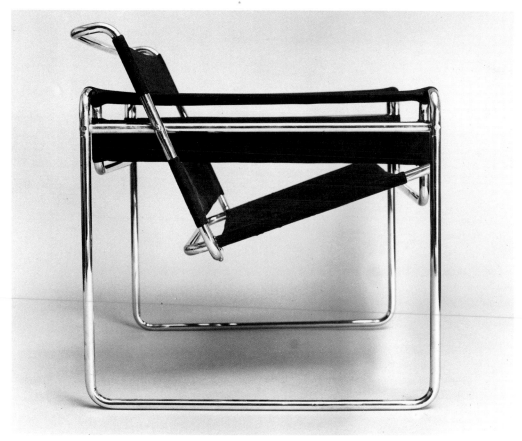

704

704. Marcel Breuer. Club Armchair.
Late 1927 or early 1928. Chrome-plated
tubular steel with canvas slings. 28⅛ x
30¼ x 27¾" (71.4 x 76.8 x 70.5 cm). Gift
of Herbert Bayer

Breuer entered the Bauhaus as a stu-
dent and later joined the faculty as
master of the furniture workshop.
While at the Bauhaus his pastime of
riding a bicycle led him to what is
perhaps the single most important
innovation in furniture design in the
twentieth century: the use of tubular
steel. The tubular steel from which
the handlebars of his bicycle were
made was strong, lightweight, and
lent itself to mass-production meth-
ods—all desirable qualities for twen-
tieth-century furniture. He reasoned
that if it could be bent into handle-
bars, it could be bent into furniture
forms. The design for this chair is
that of a traditional overstuffed club
chair; but all that remains is its mere
outline, an elegant composition
traced in gleaming steel. Later,
Breuer spoke of it as "my most
extreme work . . . the least artistic,
the most logical, the least 'cozy' and
the most mechanical." What he
might have added is that it was also
his most influential work. Within a
year designers everywhere were
experimenting with tubular steel,
which would take furniture into a
radically new direction.

705. Marcel Breuer. Lounge Chair.
1932–33. Aluminum and wood. 28½ x
21¾ x 31" (72.4 x 55.3 x 78.8 cm). Gift of
the designer

706. Marcel Breuer. Lounge Chair.
1928–29. Chrome-plated tubular steel
and canvas. 31½ x 24 x 31½" (80 x 61 x 80
cm). Estée and Joseph Lauder Design
Fund

707. Marcel Breuer. Side Chair. 1928.
Chrome-plated tubular steel, wood, and
cane. 31½ x 17½ x 18¾" (80 x 44.5 x 47.6
cm). Museum Purchase

708. Marcel Breuer. Couch. Designed
1930–31 (produced 1981 © The Museum
of Modern Art). Tubular steel and flat
steel bars, upholstered. 53¼ x 55⅛ x
28½" (135.2 x 140 x 72.4 cm). Gift of
Lily Auchincloss

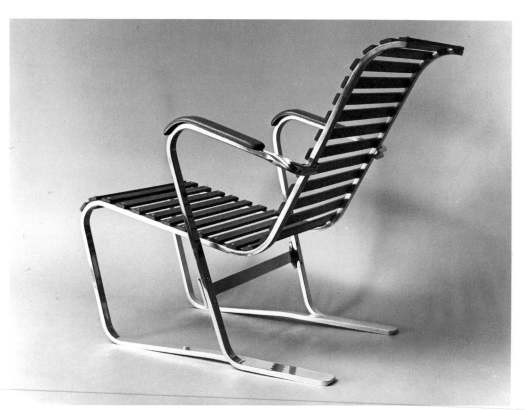

705

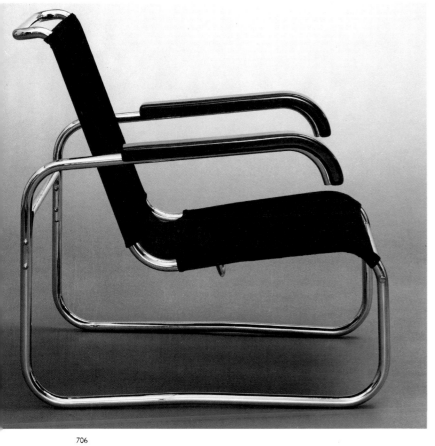

706

707

708

709

710

709. Ludwig Mies van der Rohe. Side Chair. 1927. Chrome-plated tubular steel and leather. 31 x 18½ x 28⁵⁄₁₆″ (78.8 x 47 x 71.9 cm). Gift of Edgar Kaufmann, Jr.

710. Ludwig Mies van der Rohe. Chaise Longue. 1931. Chrome-plated tubular steel with contour canvas cushion. 37½ x 23⁵⁄₁₆ x 47³⁄₁₆″ (95.3 x 59.8 x 119.9 cm). Gift of Philip Johnson

711. Ludwig Mies van der Rohe. "Barcelona" Chair. 1929. Chrome-plated flat steel bars with pigskin cushions. 29⅞ x 29½ x 29⅝″ (75.9 x 75 x 75.2 cm). Gift of Knoll International

Like Mies's highly disciplined architecture, his furniture achieves a classic serenity of line and an unparalleled elegance. He designed the famous "Barcelona" chair for his German Pavilion at the Barcelona Exposition of 1929. Generally regarded as the classic "monumental" chair of the twentieth century, it owes its imposing scale in part to its proportions, its width being greater than its depth, and to details such as the intersections of its curved legs and the proportions of its tufted leather cushions. The cantilevered side chair is perhaps the simplest and purest statement of this design theme. Like all of Mies's furniture, these designs require impeccable handcraftsmanship in order to produce, paradoxically, a machine-made appearance.

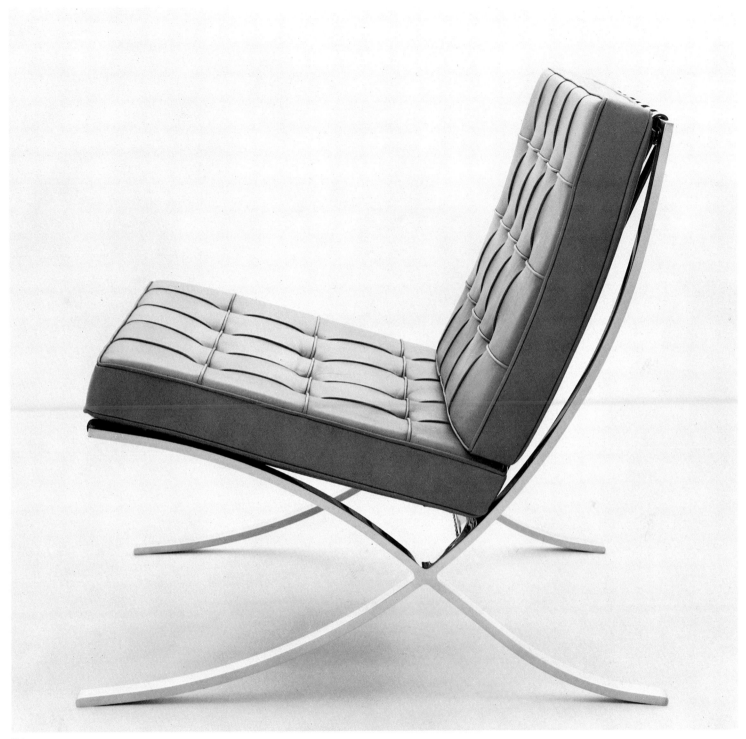

711

712

713

714

712. Jan Tschichold. Poster: "Die Hose." 1926. Linocut and gravure. 47 x 33" (119.3 x 83.8 cm). Gift of Armin Hofmann

713. Theo Ballmer. Poster: "Norm." 1928. Lithograph. 49⅞ x 35⅝" (126.8 x 90.5 cm). Estée and Joseph Lauder Design Fund

714. Herbert Matter. Poster: "Für Schöne Autofahrten die Schweiz." 1935. Gravure. 39¾ x 25⅛" (101 x 63.8 cm). Gift of Bernard Davis

715. Alvar Aalto. Vase. 1937. Amber cast glass. 5⅝" (14.3 cm) high. Gift of Artek-Pascoe, Inc.

716. Alvar Aalto. "Paimio" Armchair. 1931–32. Birch plywood. 26 x 23¾ x 34⅞" (66 x 60.5 x 88.5 cm). Gift of Edgar Kaufmann, Jr.

Aalto's earliest furniture and interiors in the twenties were conceived in an attenuated neoclassical style similar to that being practiced at the time by other Scandinavian designers. By 1930, however, he had succumbed to the fascination of bent metal, and he produced chairs and hospital furniture in this material. Although tubular steel took him from neoclassicism to modernism, he quickly grew dissatisfied with it as a material for furniture, feeling that only organic materials should come into contact with the human body. The "Paimio" armchair had a framework consisting of two closed loops of laminated wood forming arms, legs, and floor runner, between which rode the seat, a thin sheet of plywood tightly bent at both top and bottom to give it greater resiliency. The "Paimio" armchair was acclaimed from the start and is still in production.

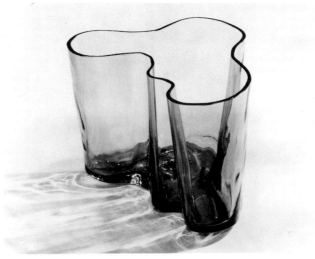

715

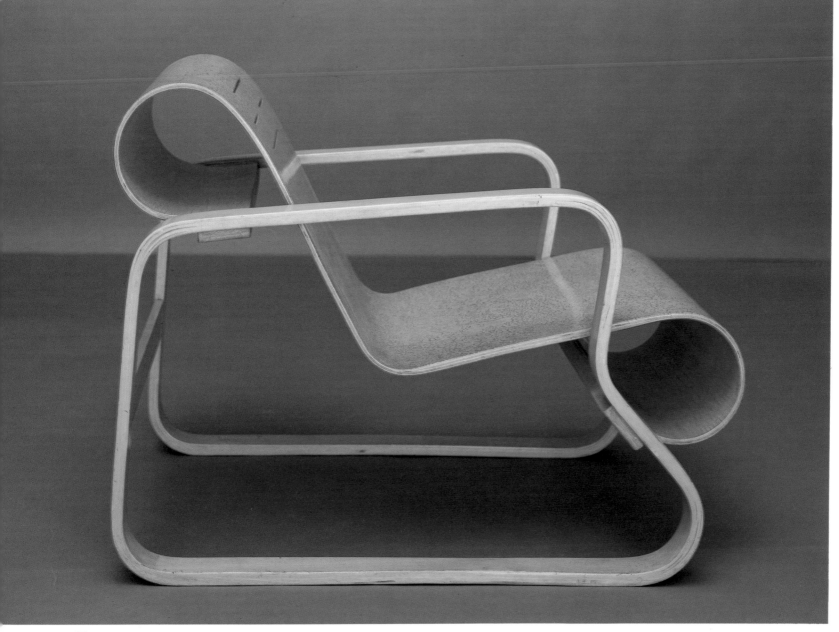

716

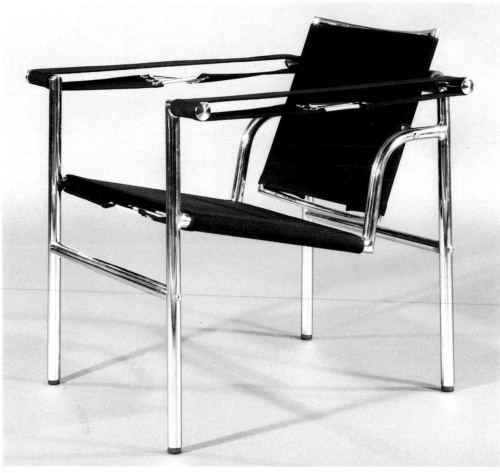

717

717. Le Corbusier (Charles-Édouard Jeanneret). Armchair with Adjustable Back. 1929. Chrome-plated tubular steel and black canvas. 26⅛ x 25⅝ x 26″ (66.3 x 65 x 66 cm). Gift of Thonet Brothers, Inc.

718. Le Corbusier (Charles-Édouard Jeanneret), with Pierre Jeanneret. "Les Terrasses" Villa Stein-de Monzie, Garches, France. Model. 1927. Plastic. 20⅞ x 35¼ x 35¼″ (53 x 89.5 x 89.5 cm). Lily Auchincloss Fund

719. Le Corbusier (Charles-Édouard Jeanneret), Pierre Jeanneret, and Charlotte Perriand. Chaise Longue. 1927. Chrome-plated tubular steel, painted steel, fabric, and leather. 24 x 19⁹⁄₁₆ x 62⁵⁄₁₆″ (61 x 49.6 x 158.2 cm). Gift of Thonet Brothers, Inc.

The revolutionary buildings Le Corbusier designed in the twenties and the polemics he wrote placed him at the center of the modernist movement. His exhortations that houses were machines for living in and chairs were machines for sitting in conjured up in the minds of most people an antiseptic world fit only for robots. He designed little furniture until 1927, when Perriand came to work with him and his cousin Pierre Jeanneret. The triumvirate's most striking seating design was this chaise longue. The tubular frame was bent to mimic the contour of the human body in repose and welded to an arc of tubes. This unit rested on a long low painted base and could be moved to a more or less horizontal position at will. The base and seating unit bear little relationship to each other; they are of different weight, of different colors and textures, and of different materials. This, as well as other Le Corbusier-Jeanneret-Perriand designs, was complicated and expensive to make, unlike the chairs of Breuer and others which were intended for mass production. Indeed, the trio seem to have been primarily attracted to the material because of its machine-like appearance rather than its potential economy.

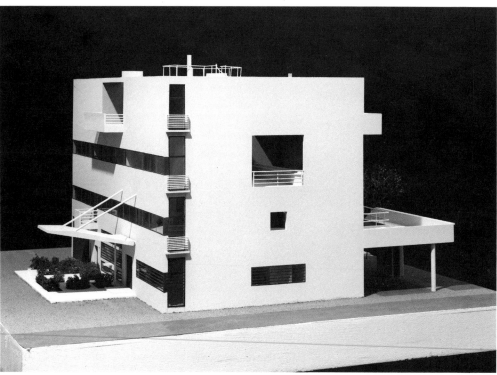

718

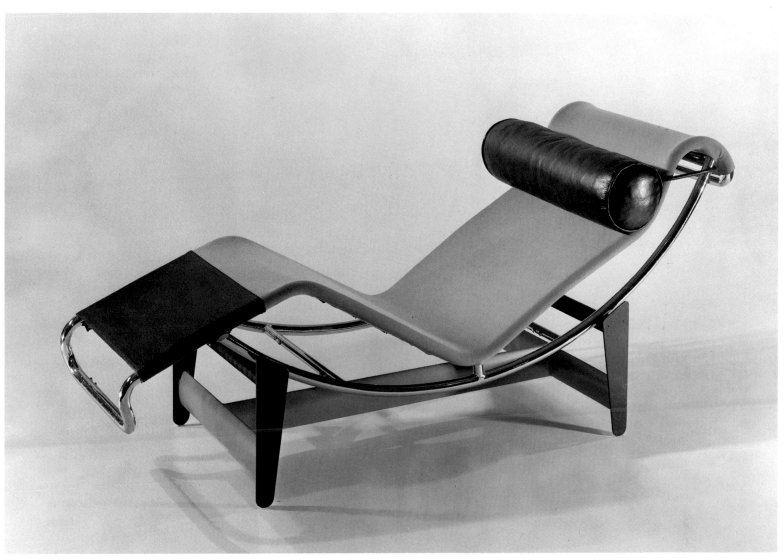

719

720

720. Max Bill. Poster: "Negerkunst Prähistorische Felsbilder Südafrikas." 1931. Linocut. 49⅞ x 34¾" (126.7 x 88.3 cm). Gift of the designer

721. Hans Wegner. Armchair. 1949. Oak and cane. 30 x 24⅝ x 21¼" (76.2 x 62.5 x 54 cm). Gift of Georg Jensen, Inc.

722. Antonio Bonet, Jorge Ferrari Hardoy, and Juan Kurchan. "B.F.K." Chair. 1938. Metal frame with leather cover. 35" (89 cm) high. Edgar Kaufmann, Jr., Fund

723. Isamu Noguchi. Table. 1944. Ebonized birch and glass. 15⅝ x 50 x 36" (39.7 x 127 x 91.4 cm). Gift of Robert Gruen

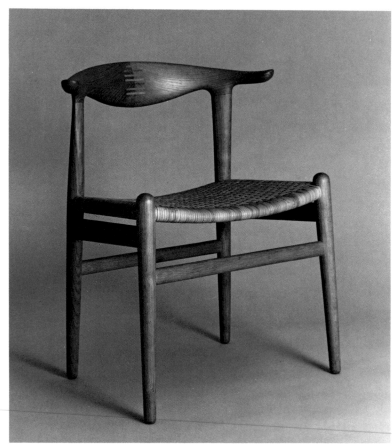

721

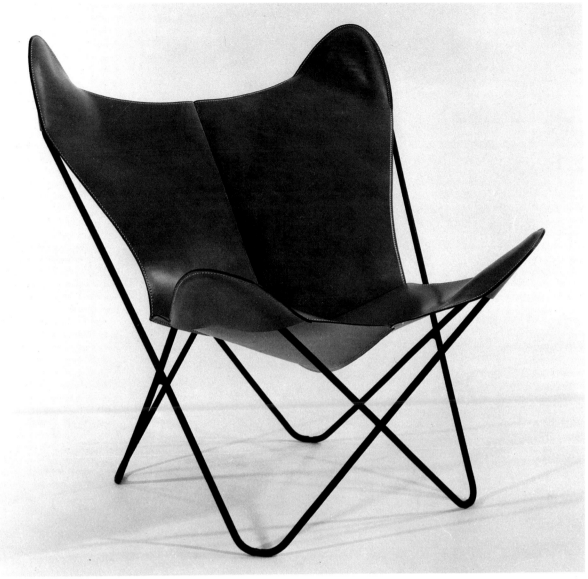

722

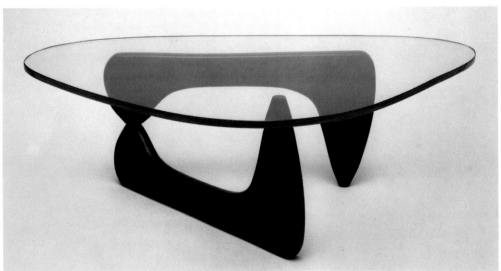

723

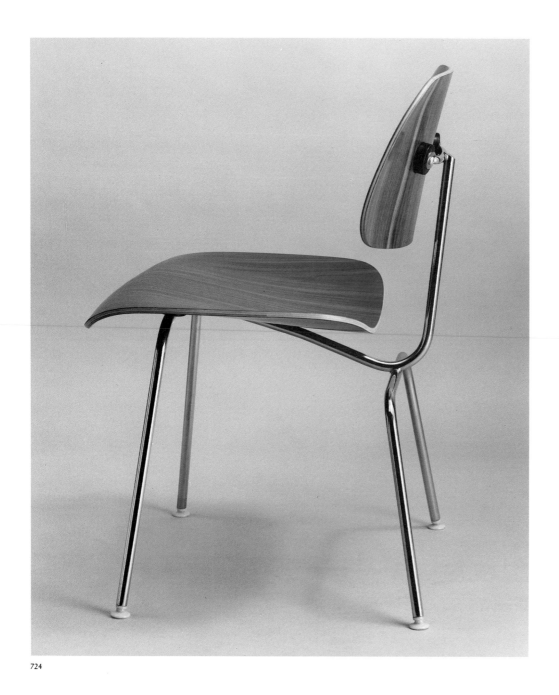

724

724. Charles Eames. Side Chair. 1946. Molded walnut plywood, steel rods, and rubber shockmounts. 29½ x 20½ x 21½″ (74.9 x 52.1 x 54.6 cm). Gift of Herman Miller Furniture Co.

The most original American furniture designer since Duncan Phyfe, Eames has contributed at least three of the major chair designs of the twentieth century. He has also given a personal and pervasive image to the idea of lightness and mobility. His work has influenced furniture design in virtually every country, and his mastery of advanced technology has set new standards for both design and production. The first of his chairs, executed in collaboration with the architect Eero Saarinen, emerged from a 1940 Museum of Modern Art competition. The Eames and Saarinen chair designs took the idea of bending plywood, which had already been done in a single direction by Aalto, a step beyond by bending the wood in multiple directions in order to produce a thin shell composed of compound curves.

725. Charles Eames. Leg Splint. 1942. Molded plywood. 4¾ x 7¾ x 41½″ (12 x 19.7 x 105.4 cm). Gift of the designer

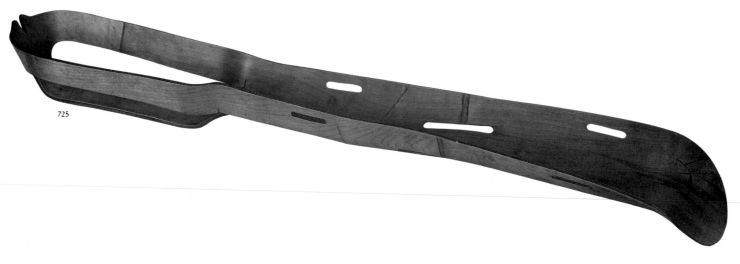

725

726. Charles Eames. Low Armchair. 1950. Molded polyester, wire, and rubber shockmounts. 23 x 24¾ x 24½" (58.4 x 62.9 x 62.2 cm). Gift of Herman Miller Furniture Co.

727. Charles Eames. Lounge Chair and Ottoman. 1956. Molded rosewood plywood; black leather cushions with foam, down, and feather filling; and black and polished aluminum base. Chair 33 x 33¾ x 33" (83.8 x 85.7 x 83.8 cm); ottoman 16 x 26 x 21" (40.7 x 66 x 53.3 cm). Gift of Herman Miller Furniture Co.

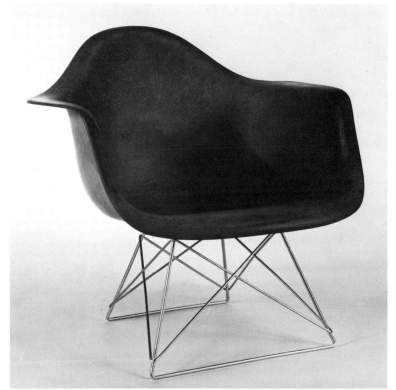

726

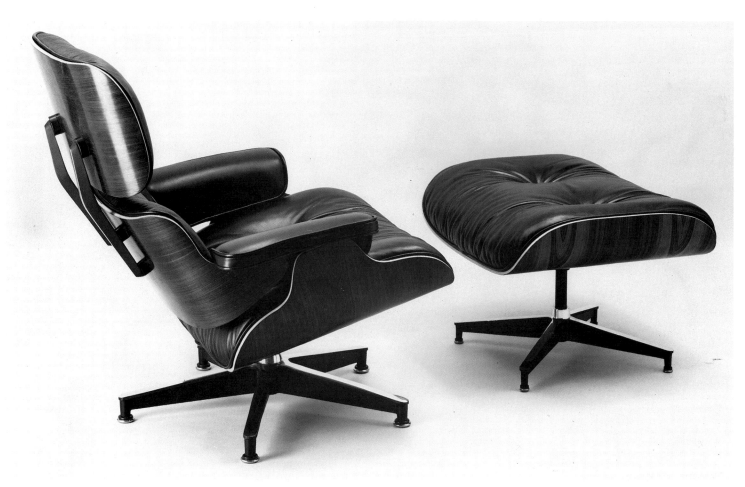

727

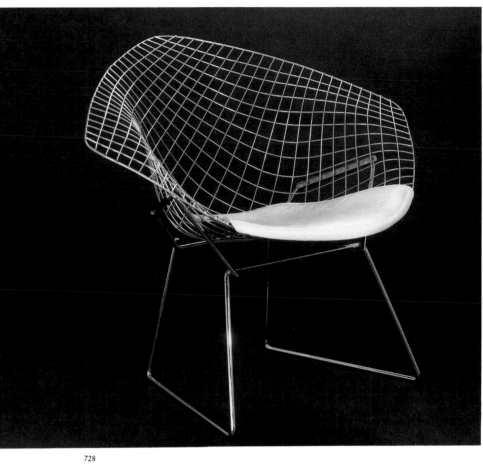

728

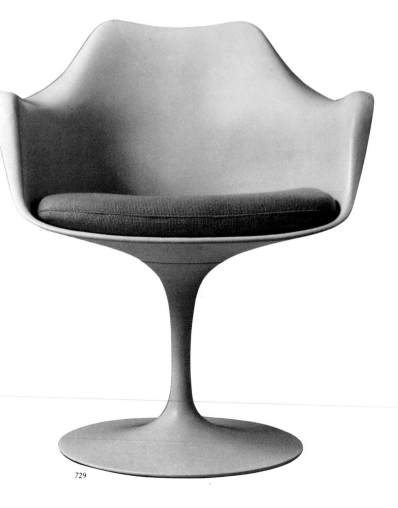

729

728. Harry Bertoia. Armchair. 1952. Chromed steel wire. 29⅞ x 33⅜ x 28″ (76 x 84.7 x 71.2 cm). Gift of Knoll Associates, Inc.

729. Eero Saarinen. Armchair. 1957. Molded plastic reinforced with fiberglass; painted aluminum base. 32″ (81.3 cm) high. Gift of Knoll Associates, Inc.

730. Verner Panton. Stacking Side Chair. 1959–60 (manufactured 1967). PU-foam Baydur. 32⅝ x 19¼ x 23½″ (83 x 49 x 59.5 cm). Gift of Herman Miller AG

Many of the great advances that took place in technology during World War II formed the basis for new approaches to design in the peace that followed. The use of injection-molded plastics, for example, made it possible to construct objects such as furniture without the slightest reference to the traditional skills and concerns of cabinetmaking. The bold, continuous curve of Panton's stacking side chair, the extreme cantilever of the seat, the lightness of the piece, and even the vibrant color and high-gloss finish, are all made possible by his use of new materials and a new technology. Rietveld's "Red and Blue" chair, although it would probably have struck someone from the eighteenth century as clumsy or contrived, would still have been recognized as a conventional chair with seat, back, legs, and arms; its roots are evident. Panton's chair, on the other hand, is entirely of the twentieth century; it would not have been manufactured—or probably even imagined—in any earlier age.

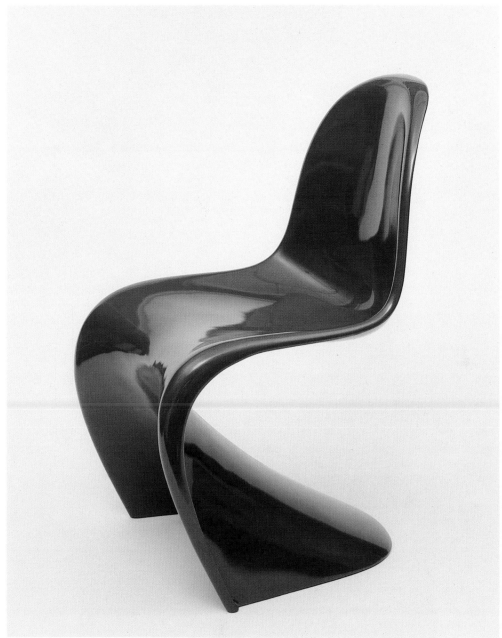

730

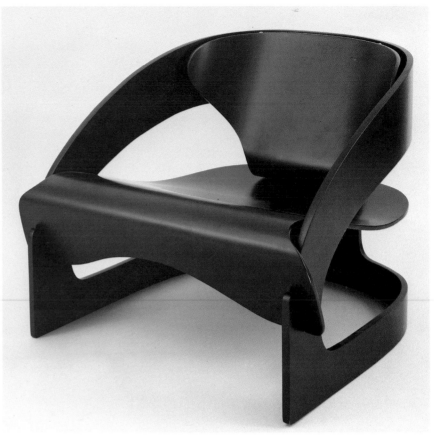

731

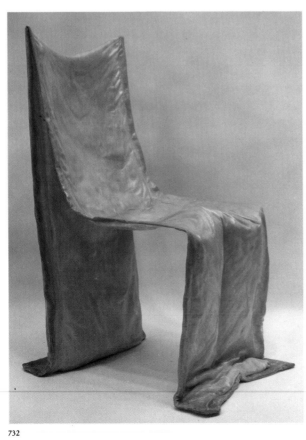

732

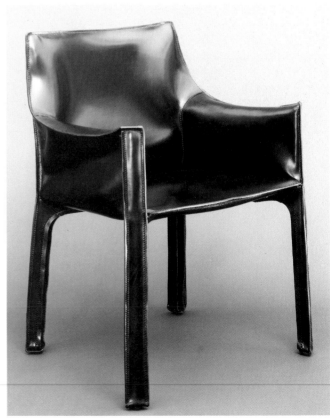

733

731. Joe Colombo. Lounge Chair. 1964. Plywood with polyester lacquer. 23¼ x 27¾ x 24⅜" (59 x 70.5 x 63 cm). Gift of Kartel S.p.A.

732. Gaetano Pesce. "Golgotha" Chair. 1974. Molded fiberglass cloth and resin. 39 x 25 x 16¼" (99 x 63.5 x 41.3 cm). Estée and Joseph Lauder Design Fund

733. Mario Bellini. "Cab" Armchair. 1977. Leather and steel rods. 32⁵⁄₁₆ x 23⅝ x 20½" (82.1 x 60 x 52.1 cm). Gift of Atelier International Ltd.

734. Gunnar Aagaard Andersen. Armchair. 1964. Polyurethane. 29½ x 44¼ x 35¼" (74.8 x 112.4 x 89.3 cm). Gift of the designer

Looking at Andersen's chair we may guess that the whim of its creator and pure chance have both played large parts in determining its appearance. We may be less aware of how much it is a consequence of the material out of which it is made. It lacks any skeleton, any covering; its shape requires no molds or any sort of shaping tools. It is constructed entirely of polyurethane, a synthetic powder which when mixed with a foaming agent greatly expands, drying into a resilient mass covered with a tough leathery skin. Design is, in fact, probably the wrong word to use in relation to this chair, certainly insofar as design implies a predetermination of form. Chemistry and gravity were the form-givers here, Andersen their collaborator, trying to hold them in check, to stop short of confusion, to impose order on accident.

735. Franciszek Starowieyski. Poster: "Iluminacja." 1973. Offset lithograph. 31⅞ x 22¾" (81 x 57.8 cm). Gift of Peter Katz

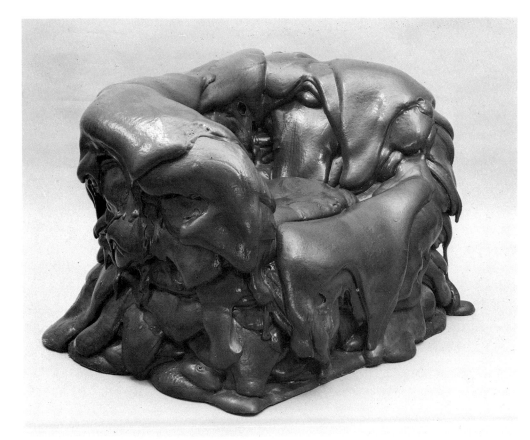

734

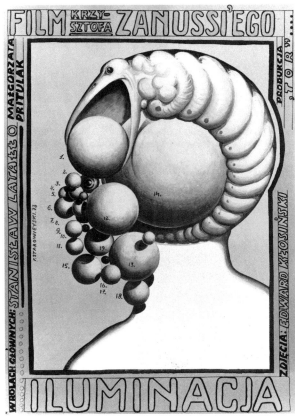

735

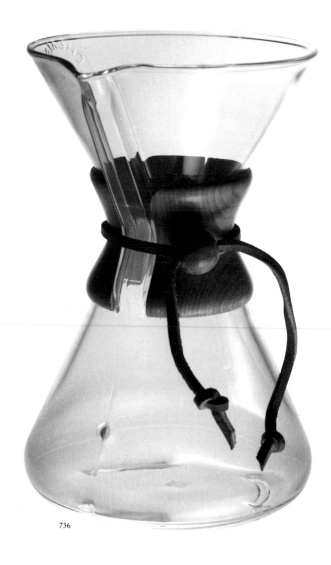

736

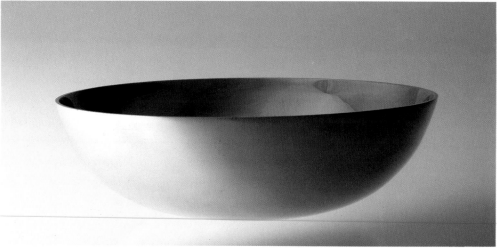

737

736. Peter Schlumbohm. Coffee Maker. 1941. Pyrex glass and wood. 9½" (24.2 cm) high. Gift of Lewis & Conger

Kitchen equipment is preeminently practical, but the variety of practical solutions to the same problem suggests that quite often the designer is decisively influenced by aesthetic preferences. In America the enterprising individual who retains complete control of his work by inventing, designing, and sometimes manufacturing and distributing his own product is exemplified by Peter Schlumbohm, a chemist, who brought to the problems of making coffee and boiling water solutions adapted from the chemist's laboratory.

737. Luigi Caccia Dominioni and Pier Giacomo Castiglioni. Bowl. 1950. Anodized aluminum. 2¼" (5.7 cm) high, 7½" (19 cm) diameter. Phyllis B. Lambert Fund

738. Left to right: Arthur Aykanian. Spoonstraw. 1968. Polyolefin. Gift of Winkler/Flexible Products, Inc.; Earl S. Tupper. Drinking Glasses. 1954. Plastic. Gift of Tupper Corporation; Gino Colombini. Pail. 1954. Plastic. 10½" (25.7 cm) high. Philip Johnson Fund; Oscar Kogoj. Aspirator. 1974. Rubber and plastic. Gift of Ciciban Shoe & Children's Ware Factory; Gene Hurwitt. Containers. 1966. Colored plastic. Purchase

739. Massimo Vignelli. Tumblers. 1956. Hand-blown colored glass. Each 4⅜" (11 cm) high, 3³⁄₁₆" (8.1 cm) diameter. Gift of William S. Lieberman

740. Saara Hopea. Stacking Glasses. 1951. Colored glass. Tumblers 3" (7.5 cm) high, 3⁷⁄₁₆" (8.6 cm) high; shot glass 1⅞" (4.7 cm) high. Gift of Barbro Kulvik and Antti Siltavuori and gift of the designer

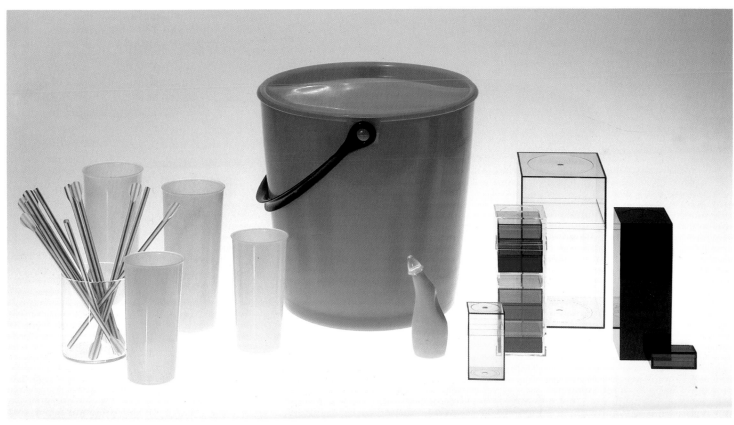

738

739

740

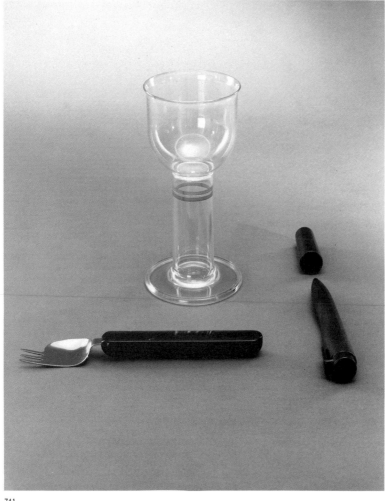

741

741. Left to right: Maria Benktzon and Sven-Eric Juhlin. Knife/fork ("Knork"). 1978. Plastic and stainless steel. 7³⁄₁₆″ (18.2 cm) long. Gift of RFSU Rehab; Maria Benktzon and Sven-Eric Juhlin. Goblet. 1978. Polycarbonate plastic. 6⁹⁄₁₆″ (16.7 cm) high, 3⁵⁄₁₆″ (8.3 cm) diameter. Gift of RFSU Rehab; Hans Tollin. Pen. 1978. Molded ABS plastic. 5⁷⁄₈″ (14.9 cm) long. Gift of RFSU Rehab

While most products are designed for the strong and able, this selection of household objects is from a series designed for the disabled, particularly those individuals with impaired hand mobility. The combined knife/fork was developed for individuals, especially rheumatics, who have the use of only one hand. The extra large grip and handle provide stability and a comfortable grip. The goblet, with its extra thick and long stem, enables the hand to clasp the stem with all the fingers and to cradle the bowl. The lifting distance is shortened as a result of the height of the goblet. All are of durable lightweight plastic. In these objects form and function have been successfully and attractively combined to solve a difficult design problem.

742. Alice von Pechmann. Teacup and Saucer. c. 1930. Porcelain. Teacup 1⁵⁄₈″ (4.2 cm) high, 3¹⁵⁄₁₆″ (10 cm) diameter at rim. Gift of Fraser's, Inc.

743. Marcello Nizzoli. Electric Sewing Machine. 1956. Metal housing and ivory and black enamel. 11½ x 18½ x 7″ (29.2 x 47 x 17.8 cm). Gift of Vittorio Necchi, S.p.A.

In the early 1900s small appliances for home and office use tended to reveal their mechanical complexity. Sewing machines, for example, would display most of their moving parts and attachments, each piece being articulated as a distinct shape. As mechanical appliances have become more complex, and as the difficulties of moving, storing, and repairing them multiply, an important functional problem the designer must solve is how to protect them. What we see today of most of our mechanical appliances is a shell or package protecting and concealing

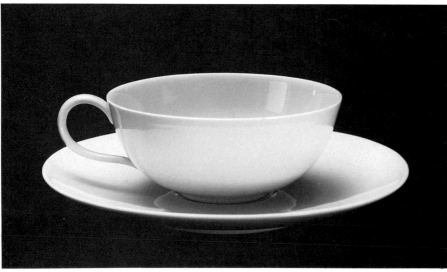

742

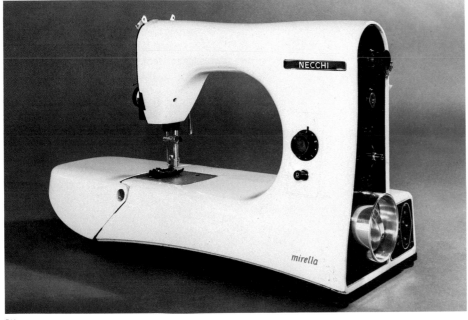

743

the machinery within. But while many refrigerators, vacuum cleaners, toasters, sewing machines, and radios have begun to resemble each other, they have not always become beautifully designed anonymous containers. Many industrial designers, however, have successfully avoided arbitrary shapes while at the same time selecting from a given object certain functions that may be visually emphasized. The Necchi sewing machine is a good case in point. Benefiting from examples of much modern sculpture, it is a sculptural shell distinguished by delicate relationships of curved and flat planes. These modulations, together with individually articulated parts, help suggest how the object performs and how it is to be used.

744. Achille and Pier Giacomo Castiglioni. Vacuum Cleaner. 1956. Red plastic housing. 15¼ x 5¾ x 5⅞″ (38.8 x 14.6 x 15 cm). Gift of R.E.M. di Rossetti Enrico

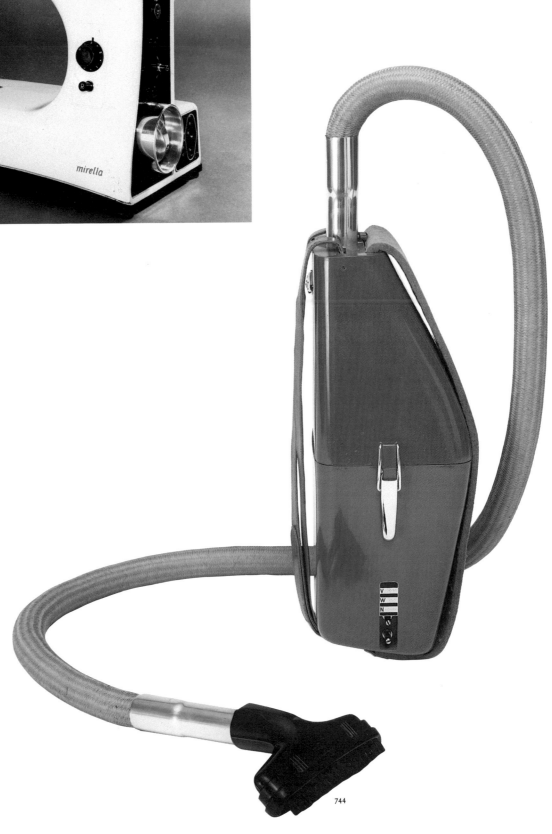

744

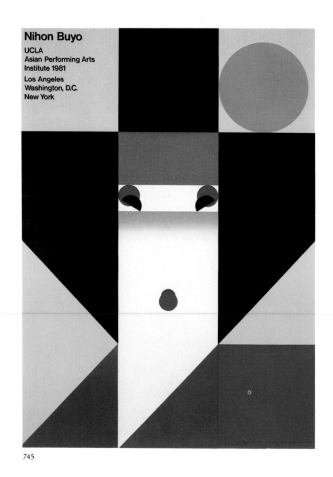

745

745. Ikko Tanaka. Poster: "Nihon Buyo." 1981. Offset lithograph. 40½ x 28¾" (103 x 72.8 cm). Gift of the College of Fine Arts, UCLA

746. Richard Sapper. "Tizio" Table Lamp. 1972. Black metal. 44" (111.8 cm) maximum height, 4½" (11.4 cm) diameter at base. Gift of Artemide

747. Vico Magistretti. "Atollo" Table Lamp. 1977. Aluminum with Nextel finish. 27" (68.5 cm) high, diameter of shade 19½" (49.5 cm). Gift of O-Luce Italia

748. Victor Moscoso. Poster: "Junior Wells and His Chicago Blues Band." 1966. Offset lithograph. 19¾ x 14" (50.2 x 35.5 cm). Gift of the designer

746

748

747

749

749. Jakob Jensen. "Beomaster 1900" Receiver. 1976. Aluminum and rosewood case. 2⅜ x 24³⁄₁₆ x 10⁵⁄₁₆″ (6 x 61.4 x 26.2 cm). Gift of Bang & Olufsen

750. Jakob Jensen. "Beogram 6000" Turntable. 1974. Steel, aluminum, and rosewood. 3¾ x 18⅞ x 14¾″ (9.5 x 48 x 37.5 cm). Gift of Bang & Olufsen

751. Marco Zanuso and Richard Sapper. "Black 201" Television Set. 1969. Metacrylic resin casing. 11⅝ x 12⅝ x 11¾″ (29.5 x 32 x 29.8 cm). Gift of Brionvega

752. Marco Zanuso and Richard Sapper. Portable Radio. 1964. ABS plastic case and metal hinges. 5¼ x 8⅝ x 5¼″ (13.3 x 21.9 x 13.3 cm). Gift of Scarabaeus, Ltd.

753. David Gammon. "Transcriptor" Turntable. 1964. Polished aluminum, brass weights, and plywood base. 4¾ x 16⅜ x 17″ (12 x 41.6 x 43.1 cm). Gift of Transcriptors

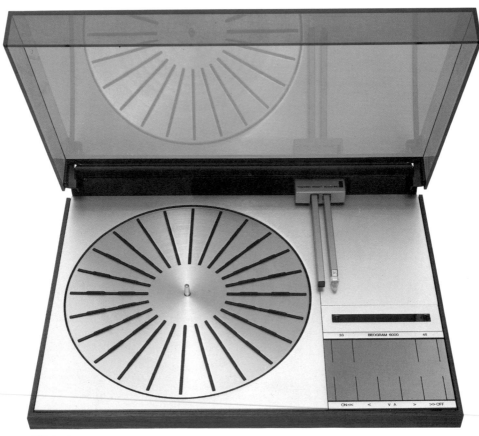

750

751

752

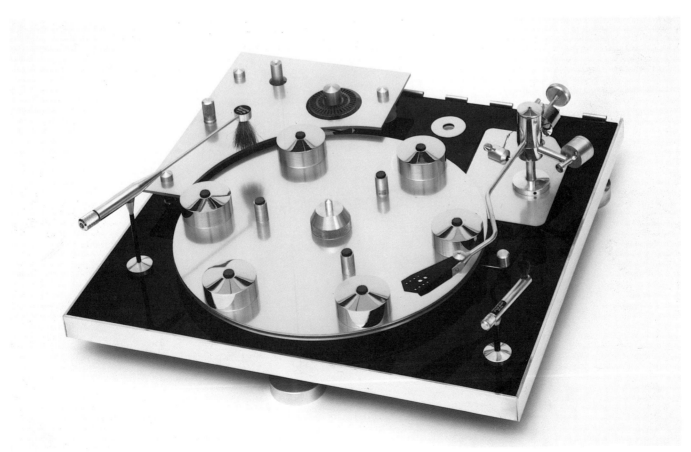

753

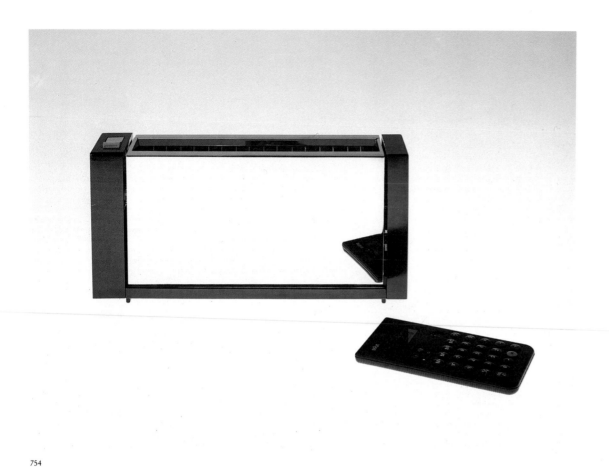

754

754. Braun Design Department, Reinhold Weiss, designer-in-charge. Toaster. 1961. Chromed metal and plastic. 5¾ x 11¾ x 2⅜″ (14.7 x 29.7 x 6 cm). Gift of Braun AG; Braun Design Department, Dietrich Lubs and Dieter Rams. Pocket Calculator. 1980. Black ABS plastic, mat finish. 5⅜ x 3¹⁄₁₆ x ⅜″ (13.6 x 7.2 x 1 cm). Gift of Braun AG

755. Mario Bellini. Portable Printing Calculator. 1970–73. ABS thermoplastic resin and flexible rubber skin. 1⅞ x 9¾ x 5″ (4.8 x 24.8 x 12.7 cm). Gift of Olivetti, S.p.A.

756. Bill Moggridge, Stephen Hobson, and Glenn Edens. Portable Computer. 1981. Magnesium and plastics. 2¹⁄₁₆ x 11½ x 15″ (5.2 x 29.2 x 38.1 cm). Gift of Grid Systems Corp.

757. Bell Laboratories. Digital Signal Processor Microelectronic Wafer. 1979. Silicon. 2 x ⅝″ (5 x 1.5 cm) (illustrated actual size). Gift of the manufacturer

758. Mario Bellini. Video Display Terminal. 1966. Sheet steel, textured ABS plastic and acrylic resin. 36⅞ x 36¹⁄₁₆ x 22″ (93.5 x 91.6 x 55.8 cm). Gift of Olivetti, S.p.A.

757

755

756

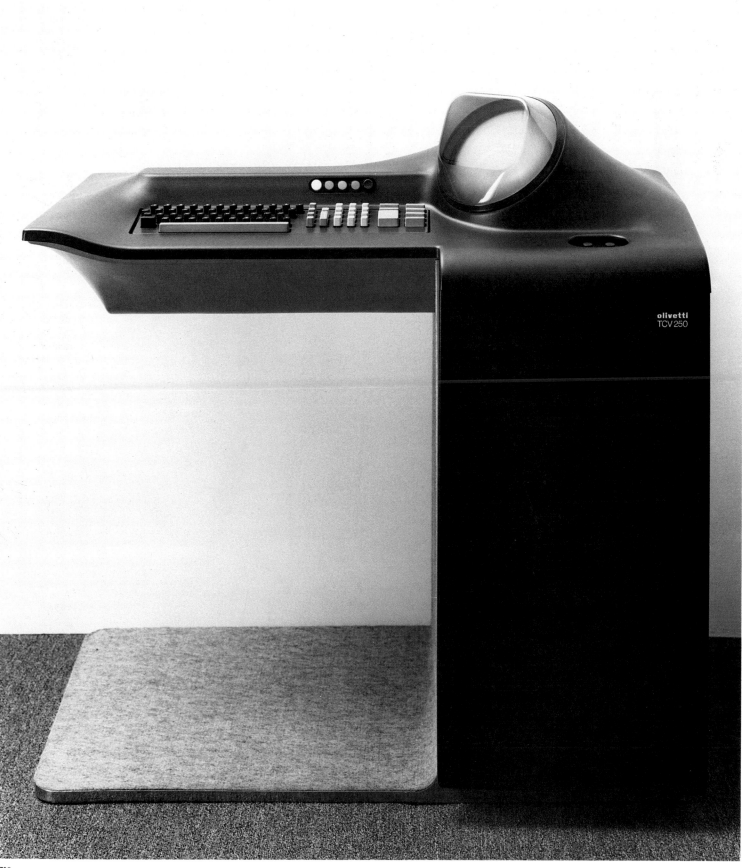

758

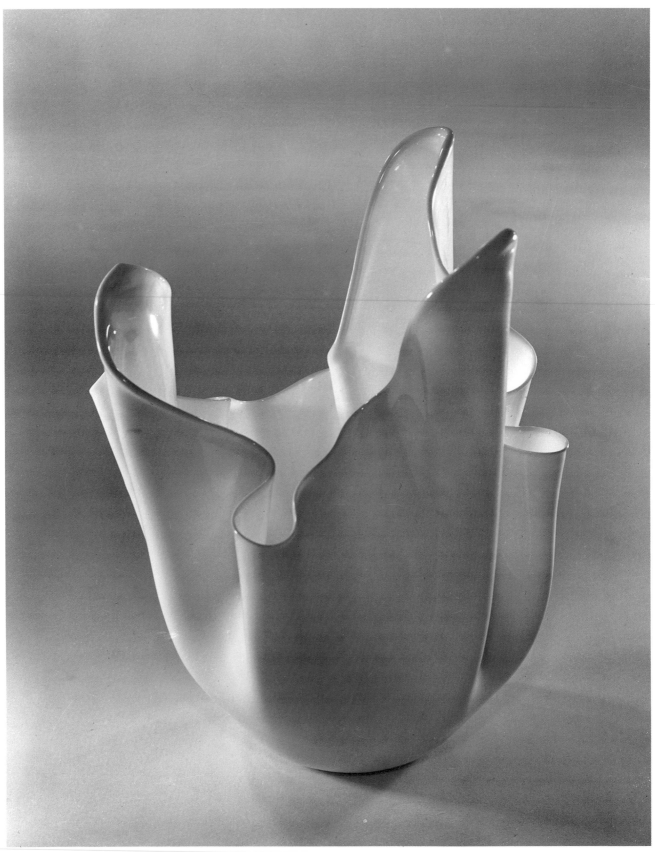

759

759. Paolo Venini. Vase. 1949. Blown glass. 13¼" (33.7 cm) high. Gift of Georg Jensen, Inc.

760. Makoto Komatsu. Pitcher. 1979. Glass. 7¾ x 4⁵⁄₁₆ x 3⅜" (19.7 x 11 x 8.6 cm). Gift of the designer

761. Harvey Littleton. Vase. 1963. Hand-blown clear glass. 9¾ x 7½ x 4⅞" (24.8 x 19 x 12.4 cm). Greta Daniel Design Fund

761

760

762

763

762. Lucie Rie. Pitcher, Teapot, and Creamer. c. 1952–54. Hand-thrown stoneware, white slip glaze, bamboo. Pitcher 3½″ (8.9 cm) high; teapot 6⅞″ (17.5 cm) high; creamer 3¾″ (9.6 cm) high. Purchase and gift of Bonniers, Inc.

Although handicrafts are no longer the chief manufacturing source of our common implements, the prototypes for many machine-made objects are first developed by the individual artisan. When not working for industry the craftsman often enriches the characteristic geometric forms of the twentieth century with his particular sensitivity to materials, fulfilling our need for objects which transcend the anonymity of mass production. Excellent examples are the ceramics of Rie and Rogers, in which subtle modulations of contour have the highly individual quality of handwriting. These ceramics, like those of the Natzlers and Chaleff, retain the personalities of their designers while reflecting the widespread influence of Japanese ceramics.

764

763. Mary Rogers. Bud Vase. c. 1975.
Bisque porcelain. 11″ (28 cm) high, 2¼″
(6.5 cm) diameter at base. Gift of Don
Page

764. Left: Kitaoji Rosanjin. Jar. 1953.
Wood-fired stoneware. 12³⁄₁₆″ (31 cm)
high, 10½″ (26.6 cm) diameter. Gift of
the Japan Society; right: Paul Chaleff.
Pot. 1979. Wood-fired stoneware. 11½″
(29.2 cm) high, 7⁷⁄₁₆″ (18.9 cm) diameter.
Mrs. John D. Rockefeller 3rd Purchase
Fund

765. Gertrud Natzler and Otto
Natzler. Bowl. 1961. Glazed earthen-
ware. 4″ (10.1 cm) high, 7″ (17.7 cm)
diameter. Gift of G. David Thompson

765

766

767

766. Left: James Prestini. Bowl.
c. 1939. Mexican mahogany. 6″ (15.3 cm)
high. Edgar Kaufmann, Jr., Fund; right:
Tapio Wirkkala. Platter. 1951. Lami-
nated hand-carved plywood. 10½″ (26.7
cm) long. Gift of Georg Jensen, Inc.

767. Nancy Guay. Wall Hanging. 1975.
Double cloth, gold gimp, Saran, and
plexiglass. 11′11″ x 36″ (363.2 x 91.4 cm).
Gift of the Louis Comfort Tiffany
Foundation

768. Charles W. Moss. Tent. 1982.
Nylon and aluminized nylon. 48″ x 6′8″
x 7′9″ (122 x 203.2 x 236.2 cm). Gift of
the designer

768

Photography

In 1929, before The Museum of Modern Art first opened its doors, Alfred Barr proposed to its trustees that in time "the Museum would probably expand beyond the narrow limits of painting and sculpture in order to include departments devoted to drawings, prints, and photography, typography, the arts of commerce and industry, architecture (a collection of *projets* and *maquettes*), stage designing, furniture, and the decorative arts. Not the least important collection might be the *filmotek,* a library of films."

In fact, the twenty-third work of art to enter the Museum's collection, early in 1930, was a photograph by Walker Evans. Arguably, the principle was thus established that photography had a rightful place in the collection of an institution dedicated to the arts of our time. But the implementation of this principle was, in the first years, not purposeful and systematic, but casual and occasional. During its first six years the Museum acquired 105 works by Evans, thirteen by Edward Weston, four by Man Ray, and one by Clara Sipprell. All were gifts of friends of the Museum, except the Man Rays, which were purchased.

It should be added that a similar hesitancy characterized the establishment of the Museum's other collections. In spite of Alfred Barr's strong and eloquently stated belief in the central importance of the collection, most of the young Museum's energies were devoted to a rapid series of exciting and often brilliant temporary loan exhibitions. There were those among the Museum's friends and supporters who felt that a modern museum was a contradiction in terms, and that concentration on a permanent collection would inevitably turn the Museum's attention away from the lively and inchoate present toward a dead and artificially ordered past.

The question, debated regularly and never quite finally resolved during the Museum's first quarter-century, had many subtly varying formulations; perhaps all versions asked in effect if an institution could best serve the art of the present by viewing it in a historical context or by considering each generation or each season *sui generis*—a new thing under the sun.

Alfred Barr thought (I think) that the problem might be solved—not in a theoretical and final way, but in a provisional and practical way—by giving an institutional authority to the argument, and hoping that neither side would win too decisive a victory. In this argument, or dialogue, the collection—or that part of the collection on public exhibition—was expected to speak for clear and distinguished achievement, which should not be read to mean immutable masterpieces. Temporary exhibitions need meet a less exacting standard, and could expose interesting ideas, brave tries, and work that seemed wonderful at first acquaintance.

If this has been in broad generality the Museum's view of the relationship between its collection and its temporary exhibitions, it should also be said that as the collection has become larger and better, as it has come more nearly to represent a synopsis of the history of the visual arts of the modern period, and as the responsibility for its preservation, exhibition, and study has claimed a progressively larger share of the Museum's resources, the collection has become the central fact of the Museum's existence, and the principal source of much of its thought and program.

The photography collection is one of the largest of the Museum's collections, and one of which only a small percentage is on public view. That portion of the collection visible in the galleries proposes a tentative, hypothetical, and changing description of photography's creative achievement; the collection in storage suggests a thousand possible revisions of that thesis. For the photographers and scholars who study it, the collection in storage is a research library of works of art, a repository within four walls of the achievement of a thousand photographers, living and dead, famous and anonymous, from many parts of the world. For the department's staff, the collection is the principal instrument of its continuing education.

The Museum of Modern Art is by definition concerned essentially with the art of the modern era, the opening date of which has not been precisely determined. In the case of the traditional arts the Museum has regarded 1880 as a plausible approximate starting point for its collections, and has thus eschewed responsibility for several millennia of earlier work. In the case of photography the same point of beginning would simplify the problem by only a single generation—photography's first generation—which has seemed too high a price to pay for consistency. In fact, it now seems widely agreed that a significant relationship exists between the development of modernism and the invention (or discovery) of photography, even though the nature of that relationship continues to be the subject of seemingly endless debate.

The history of the Museum's photography collection has followed, I should think, a pattern slightly different from that of the other collections. In the early years there was perhaps some emphasis on the acquisition of pictures that seemed to exemplify with special clarity the agenda and intuitions of the Museum, which favored the unambiguously new, and enjoyed challenging old artistic achievements. But in the case of photography, a relatively new medium with no significant authoritarian structure, it was not easy to find an academy of substance to revolt against. The situation in photography—an immense and enormously diverse agglomeration of commercial entrepreneurs, technicians, journalists, publicists, scientists, and amateurs—was in fact characterized not by restrictive academic standards but by a lack of any widely recognized standards whatever. Photographers who consciously pursued high-art ambitions could and did join the spirit of the time by revolting against pictorialism, even though the toothless remnant of that turn-of-the-century movement would seem by the thirties to have been an innocuous opponent. Of the major photographers of the time, only Edward Weston (and perhaps Imogen Cunningham) could claim to have escaped from academic pictorialism to modernism. The major living photographers of whose work the Museum had acquired ten or more prints by 1942 include Ansel Adams, Imogen Cunningham, Walker Evans, Dorothea Lange, Helen Levitt, Man Ray, László Moholy-Nagy, Eliot Porter, Alfred Stieglitz, and Edward Weston—a list which would seem to suggest no clear pattern of aesthetic philosophy, beyond a prejudice in favor of vitality and quality. Photography itself, ninety years old when the Museum was founded, was still perceived as new, a bubbling retort of untried possibilities, rather than as an ancient and honorable art that had been temporarily stifled by the forces of conservatism.

The aesthetic intuitions of the early Museum in reference to photography might be more clearly apparent from its acquisitions of nineteenth-century work. Here one might detect a preference for a plain style of cool precision and puritan economy: the American daguerreotypists, Mathew Brady and his associates, and the early photographers of the American West produced work that seemed consonant with the lean, functionalist sensibility of the thirties, and such photographs are well represented in the acquisitions of the Museum's earlier years.

The Museum of Modern Art was at its founding a museum without a collection: a museum by courtesy of terms. During the first few years the collection grew slowly. After five years, with the acquisition of the Lillie P. Bliss Collection, the Museum owned for the first time a substantial group of important paintings; with them it acquired also a sense of confidence in its own permanence and its historical function. Thenceforth its collection grew at an accelerating speed.

A coherent and systematic approach to the photography collection began in 1935 when Beaumont Newhall joined the Museum staff as librarian. When Alfred Barr learned of his special interest in photography, he encouraged Newhall to direct a broad survey of the history of that art. The exhibition, *Photography: 1839–1937*, contained over eight hundred works, and formed the first basis for Newhall's book *The History of Photography*,

now in its fifth edition and long the standard survey of the subject. In 1940 Newhall saw the Department of Photography formally established as an independent curatorial section of the Museum, and was appointed its first curator. In 1942 he joined the United States Air Force as a photo intelligence officer. He had held the title of curator for only two years, and had served the Museum for only seven. During this brief beginning of his distinguished career he established intellectual and professional standards that remain cogent for the curatorial field that he in large measure founded.

In 1947 the direction of the department passed to Edward Steichen, a photographer of great achievement and prestige. Steichen's primary concerns as a curator centered on the ways in which photographs could be orchestrated to speak with maximum emotional effect to large social and political issues. The most memorable achievement of his years at the Museum was the 1955 exhibition *The Family of Man,* which wove the work of 273 photographers from 68 countries into an eloquent and homogeneous tapestry.

When Steichen became director of the department his career in photography had spanned virtually half of the history of the medium. (Hippolyte Bayard, one of photography's several contemporaneous inventors, died when Steichen was seven.) Having collected in his own mind so much of the history and tradition of photography, he perhaps felt it was less pressing that the physical evidence—the photographs themselves—be collected. In any case the collection grew more slowly during his tenure.

Since 1962 the Department of Photography has been directed by the author. By that date the presence of photographs in museums no longer seemed a novelty, in large measure because of the initiatives of The Museum of Modern Art during the preceding thirty years. The more sophisticated visitor no longer approached a photograph in a museum as an issue to be applauded or regretted as a matter of principle, but as a particular case and an open question. The work would either prove persuasive, beautiful, and surprising, and therefore be deeply remembered, or it would fail.

In this new climate it seemed, finally, unnecessary to defend photography and not precisely to the point to proselytize for it. It seemed that photography's existing and potential audience might be served better by a simple exposition of the visual facts than by exhortation. In this spirit it seemed possible and useful to exhibit and collect photographs whose virtues were less transparently artistic, and whose beauties less handsome.

In the beginning, a collection is seen as an assemblage of exceptional and admirable objects, but as it grows in breadth and depth its individual parts, without losing their discreteness, form a pattern, and the pattern suggests the sketch for a history.

A collection is the product of two kinds of acquisitions—those that are sought and those that are found. The first are selected on the basis of consciously defined critical priorities; the second, in part, by the winds of chance. Works of the first sort form among themselves a clear and coherent historical pattern; those of the second sort complicate and enrich this pattern, and blur its sharp outlines. But a pattern, although constantly changing, persists.

It has been said that the Museum's photography collection is the best of any art museum in the world. In the absence of any agreement as to how a relative ranking might be determined, such a claim has little substance; but to the degree that it might seem justified it would be cause less for self-congratulation by the Museum than for wonder that so few institutions have (until recently) made a serious effort to preserve the essential record of this profoundly influential picture-making process.

Under these circumstances evaluations of rank are perhaps unsatisfactory, and it is perhaps more to the point to say that the Museum's photography collection is in relative terms superb, and in absolute terms inadequate. It is strong for the period since World War I, adequate for the first two decades of this century, and spotty, with areas of conspicuous weakness, for the first sixty years of photography's history. The newly expanded

Museum will allow a fuller and more rewarding exposition of those areas of the collection that are rich, and will make more clearly apparent its present weaknesses.

The achievements of the Department of Photography, and most especially the existence of its collection, have been the collaborative work of its staff and its trustee committee. Without the support of the committee the department would not have been born, and would not have survived. The faithful, generous, and disinterested guidance and generosity of its successive chairmen—David H. McAlpin, James Thrall Soby, Henry Allen Moe, and Shirley C. Burden—have been essential. Perhaps an even greater debt is owed to the thousands of photographers who have recognized the seriousness of the Museum's commitment to their art, who have been open and generous in bringing their work to the Museum's attention, and who have often been among the collection's most generous donors.

769. Roger Fenton. *September Clouds.* c. 1857. Albumen-silver print. 8⅟₁₆ x 11⅜″ (20.5 x 28.9 cm). Purchased as the gift of Shirley C. Burden and The Lauder Foundation

769

770. William Henry Fox Talbot. *Trafalgar Square, London, During the Erection of the Nelson Column*. 1843. Salt print from paper negative. 6¾ x 8⅜" (17.1 x 21.2 cm). Gift of Warner Communications, Inc.

771. Maxime Du Camp. *Temple of Kertassi*. From *Egypte, Nubie, Palestine et Syrie* (1852). c. 1850. Salt print from paper negative. 6½ x 8⁹⁄₁₆" (16.5 x 21.8 cm). Gift of Warner Communications, Inc.

Du Camp made this photograph between 1849 and 1851 during a trip financed by the French government. Together with his companion and fellow Frenchman, Gustave Flaubert, Du Camp traveled to Greece, Egypt, Palestine, Syria, and Asia Minor. This image, which is one of one hundred twenty-five selected from approximately two hundred waxed-paper negatives he produced, was published in *Egypte, Nubie, Palestine et Syrie*. It was the first travel book illustrated with original photographs to appear in France. The photograph of the Temple of Kertassi in Nubia (contemporary Sudan) is first and foremost about the temple, its size and monumentality. Its geometry echoes the frame, and its magnificent carved columnar faces animate the landscape. Du Camp has included a human being, perhaps his assistant, who stands erect, almost camouflaged against the column. Scientific in approach, Du Camp's work represented some of the earliest photographic records of such sites.

772. Alfred Capel-Cure. *Lichfield Cathedral, South Entrance.* c. 1853–59. Albumen-silver print from paper negative. 8¼ x 10½" (20.9 x 26.8 cm). Gift of Bowen H. McCoy

773. David Octavius Hill and Robert Adamson. *Master Hope Finlay.* c. 1841–48. Salt print from paper negative. 5⅞ x 8¹⁄₁₆" (15 x 20.5 cm). Gift of Warner Communications, Inc.

772

773

774

775

774. George N. Barnard. *Ruins of Railroad Depot, Charleston, South Carolina.* From *Photographic Views of Sherman's Campaign* (1866). c. 1864–65. Albumen-silver print. 10⅛ x 14³⁄₁₆″ (25.6 x 36 cm). Acquired by exchange with the Library of Congress

775. Timothy H. O'Sullivan. *Slaughter Pen, Foot of Round Top, Gettysburg.* July 6, 1863. Albumen-silver print. 6¾ x 9″ (17.2 x 22.8 cm). Purchase

O'Sullivan, or Sullivan, was born in Staten Island, or in Ireland, in 1840. He died at the age of forty-two, having slept in tents, or under the open sky, during much of his adult life. At twenty-one, after apprenticing in Mathew Brady's portrait studio, he was photographing the Civil War; after the war he worked in the American West with the geological explorations led by Clarence King and George Montague Wheeler, and in Panama with Thomas Oliver Selfridge. O'Sullivan made *Slaughter Pen* on July 6, three days after the battle had ended, but not all of the bodies had been removed from the field. The picture reminds us of the pictorial puzzles of childhood (How many faces can you see in the clouds?) or of the thoughts of the youth in *The Red Badge of Courage*: "The men of the regiment, with their starting eyes and sweating faces, running madly, or falling, as if thrown headlong, to queer, heaped-up corpses—all were comprehended. His mind took a firm but mechanical impression, so that afterward everything was pictured and explained to him, save why he himself was there."

776. James Wallace Black and Samuel A. King. Untitled (aerial view of Providence, Rhode Island). August 16, 1860. Albumen-silver print. 10 x 7¾″ (25 x 19.7 cm). Gift of Warner Communications, Inc.

776

777

778

777. Photographer unknown. *Alice E. Foh (?), Age 7.* 1860. Ambrotype. 2½ x 2" (6.3 x 5.1 cm). Purchase

778. Étienne Carjat. *Gustave Courbet.* c. 1867–75. Albumen-silver print. 3½ x 2¼" (9 x 5.7 cm) (sight). Purchased as the gift of Shirley C. Burden

779. Julia Margaret Cameron. Untitled. c. 1866. Albumen-silver print. 13³⁄₁₆ x 11" (33.5 x 27.9 cm). Purchased as the gift of Shirley C. Burden

780. Charles Clifford. Untitled. c. 1857. Albumen-silver print. 13⅝ x 9⅜" (34.6 x 23.9 cm). John Parkinson III Fund

781. Louis-Auguste Bisson and Auguste-Rosalie Bisson. *Pavillon Turgot, Palais du Louvre.* c. 1855. Albumen-silver print. 17½ x 12¾" (44.4 x 32.4 cm). Purchased as the gift of Robert B. Menschel

782. James Robertson (?). *Bas-Relief of Parthenon.* c. 1854. Albumen-silver print. 9¼ x 6⁵⁄₁₆" (23.2 x 16 cm). Purchased as the gift of Shirley C. Burden

779

780

781

782

783. Felice A. Beato. *Head Quarter Staff, Pehtang Fort.* August 1, 1860. Albumen-silver print. 9⁷⁄₁₆ x 11¹¹⁄₁₆″ (24 x 29.9 cm). Purchased as the gift of Shirley C. Burden and the Estate of Vera Louise Fraser

784. Lewis Carroll (Charles Dodgson). Untitled. Page from an unidentified album with drawings attributed to Carroll. c. 1850s. Albumen-silver print. 8⁷⁄₈ x 11⁵⁄₈″ (22.6 x 29.5 cm). Purchased as the gift of Robert B. Menschel

785. William Bradford in collaboration with John L. Dunmore and George Critcherson. *Hunting by Steam in Melville Bay.* Plate 83 from *The Arctic Regions* (1873). 1869. Albumen-silver print. 10¹⁵⁄₁₆ x 15³⁄₈″ (27.8 x 39 cm). Transferred from the Museum Library

786. Payne Jennings. *The Dargle Rock.* c. 1870. Albumen-silver print. 9³⁄₈ x 11½″ (23.9 x 29.1 cm). John Parkinson III Fund

784

785

786

787

787. Frank Jay Haynes. *Gibbon Falls, 84 Feet, Yellowstone National Park.* c. 1886. Albumen-silver print. 17¾ x 21⅝" (45.2 x 54.9 cm). Gift of Alfred Jarstzki (by exchange)

788. Carleton E. Watkins. *Arbutus Menziesii, California.* 1861. Albumen-silver print. 14¼ x 21¼" (36.2 x 54 cm). Purchase

789. William Henry Jackson. *Tower of Bable* [sic], *Garden of the Gods.* After 1879. Albumen-silver print. 21 x 17" (53.3 x 43.2 cm). John Spencer Fund

790. William Rau. *Picturesque Susquehanna near Laceyville.* 1899–c. 1902. Albumen-silver print. 17⅛ x 20½" (43.5 x 52 cm). David H. McAlpin Fund

791. Adam Clark Vroman. *Pueblo of Zuni, Sacred Shrine on Taayallona.* 1899. Platinum print. 6 x 8" (15.3 x 20.3 cm). Acquired by exchange

788

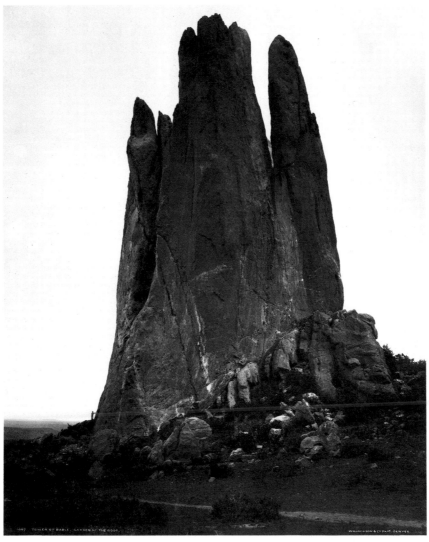

789

790

791

792

792. Peter Henry Emerson. *Snipe-shooting.* From *Life and Landscape on the Norfolk Broads* (1886). 1886. Platinum print. 7¼ x 11¼" (18.4 x 28.7 cm). Anonymous gift

Emerson, one of the foremost among Victorian photographers, was an early and influential advocate of the medium as an independent art form. He saw painting and photography as natural complements to one another, and counterparts of his photographs can be found in the work of contemporary landscape painters. With one such painter, Thomas F. Goodall, he collaborated on the portfolio *Life and Landscape on the Norfolk Broads,* with photographs by Emerson and descriptive text by Emerson and Goodall. In forty plates, it gives a comprehensive study and poetic essay on the East Anglian farmers at work, coexisting with their wild landscape. *Snipe-shooting* shows how well the platinum medium, with its wide range of tonalities, suited rendering of the atmospheric marshlands. Beautiful for its artistic description, the picture offers a visual narrative as well.

793. Frances Benjamin Johnston. *Stairway of Treasurer's Residence: Students at Work.* 1899–1900. Platinum print. 7⁹⁄₁₆ x 9½" (19.2 x 24.2 cm). Gift of Lincoln Kirstein

Johnston is known as the first woman press photographer. Born in 1864, the daughter of affluent and prominent parents, she studied art at the Académie Julian in Paris and in Washington, D.C., where her family lived. Johnston studied photography with Thomas W. Smillie at the Smithsonian and in 1890 went to Europe to study photography exhibitions. After her return she opened a photographic studio in Washington and quickly became a success. She photographed the presidents of the United States from Grover Cleveland to William Howard Taft, and other notables of Washington society. Johnston was a photographer for over sixty years. Her subjects included the Pennsylvania coal fields, Yellowstone

793

National Park, the United States Mint and Bureau of Engraving and Printing, and the Hampton and Tuskegee institutes. Although she was a member of the Photo-Secession and made pictures in the pictorial style, she is best known for her straightforward and crisp photographs. This illustration of the Hampton Institute exemplifies Johnston's careful placement of figures and sense of classical composition. In it one sees the photographer's blatant direction of her subjects, yet the grace of their positions bathed in an even flow of natural light seems to justify this artifice.

794. Lewis W. Hine. *Tennessee.* 1910. Gelatin-silver print. 4¹¹⁄₁₆ x 6⅝" (11.8 x 16.8 cm). Stephen R. Currier Memorial Fund

795. Frederick H. Evans. *Lincoln Cathedral: A Turret Stairway.* 1896. Photogravure. 7¾ x 5¼" (19.7 x 13.3 cm). Purchase

796. Gertrude Käsebier. *Rodin.* 1905. Platinum print. 12⅞ x 9¹³⁄₁₆" (32.7 x 25.1 cm). Gift of Mrs. Hermine M. Turner

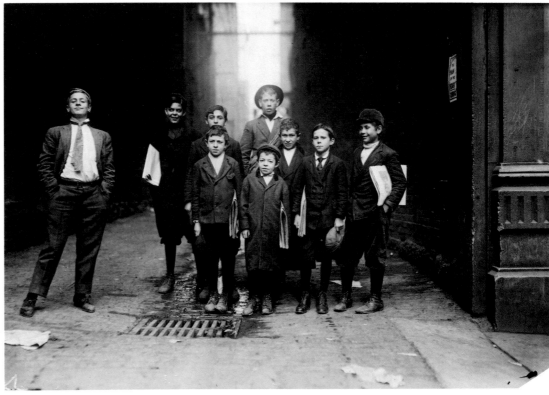

794

795

796

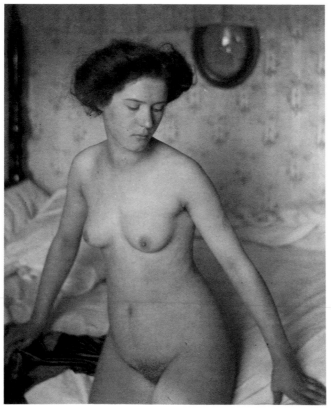

797

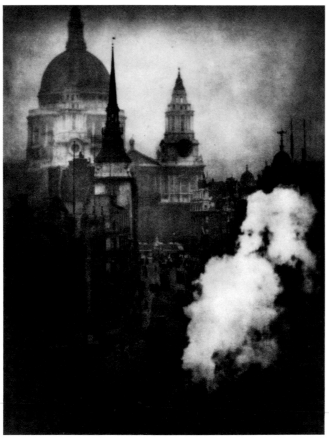

798

797. Clarence H. White and Alfred Stieglitz. *Nude*. 1907. Platinum print. 8⅝ x 6⅛" (21.9 x 17.6 cm). Gift of Mrs. Clarence H. White, Jr.

798. Alvin Langdon Coburn. *St. Paul's, London*. 1908. Photogravure. 15⅛ x 11¹⁵⁄₁₆" (38.5 x 28.8 cm). Gift of the photographer

799. Alfred Stieglitz. *Equivalent*. 1922. Gelatin-silver print. 4½ x 3⁹⁄₁₆" (11.5 x 9.1 cm). Anonymous gift

Stieglitz—photographer, champion of modern art, publisher of *Camera Work*—was at the center of aesthetic battles in the first decades of the twentieth century. In his own photography, Stieglitz sought what he demanded of all artistic production: personal expression in terms true to the given medium. In the summer of 1922, he began to photograph apple trees and clouds, not for their literal meaning, but for the congruence he found between his emotions and the discovered form. This process—to make visible the invisible, to give substance to attributes and essences that the camera could capture in no other way—Stieglitz called "equivalence." He never said what meaning this *Equivalent* had for him, but one can infer that he found symbols for life's strongest forces in the house and tree, apples and water, fruit and seed.

800. Paul Strand. *New York*. 1915. Platinum print. 10⅛ x 11¹³⁄₁₆" (25.7 x 30.2 cm). Gift of the photographer

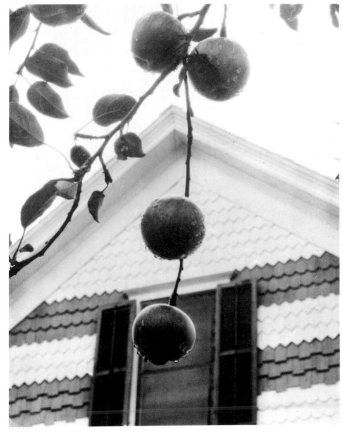

799

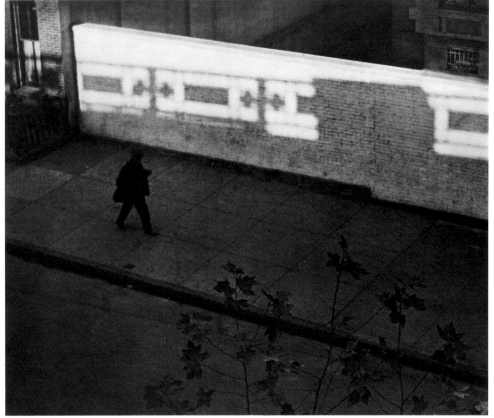

800

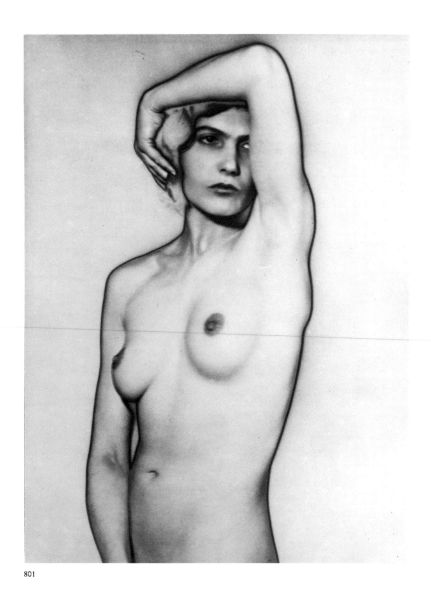

801

801. Man Ray. *Nude*. 1929. Gelatin-silver print. 11½ x 8¼" (29.2 x 20.9 cm). Gift of James Thrall Soby

802. Christian Schad. *Schadograph*. 1918. Photogram (gelatin-silver printing-out paper). 6⅝ x 4¹⁵⁄₁₆" (16.8 x 12.5 cm). Purchase

803. Francis Bruguière. Untitled. c. 1929. Gelatin-silver print. 10⅝ x 7⅝" (27 x 19.4 cm). David H. McAlpin Fund

804. Albert Renger-Patzsch. *Cherry Tree*. c. 1936. Gelatin-silver print. 8¹⁵⁄₁₆ x 6⁹⁄₁₆" (22.7 x 16.7 cm). Purchased as the gift of Paul F. Walter

802

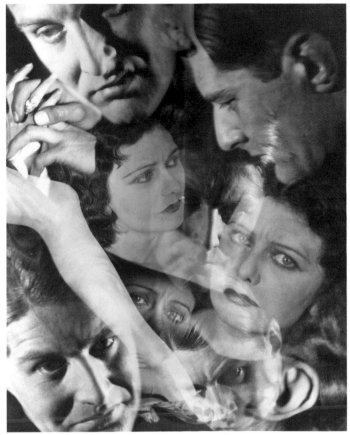

803

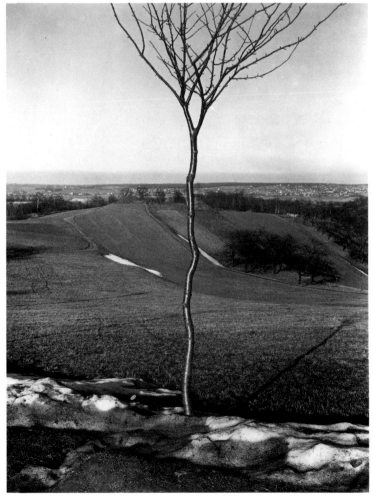

804

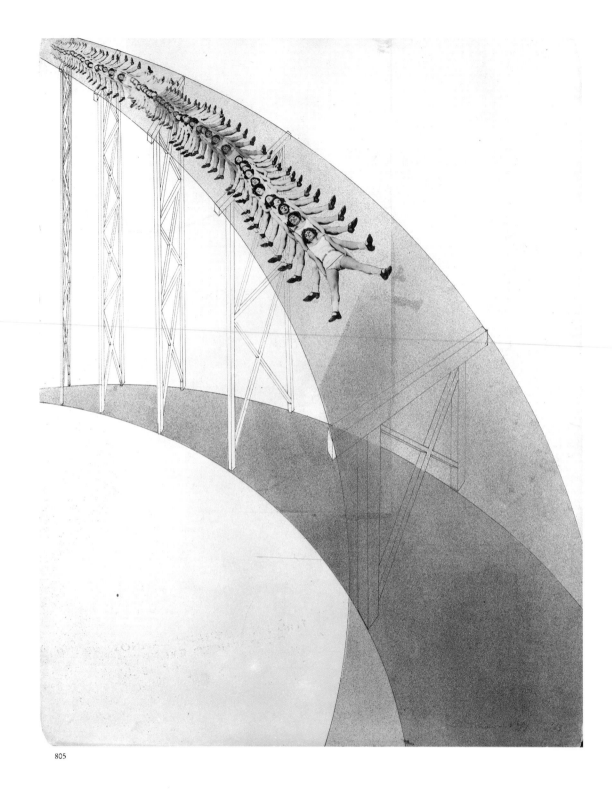

805

805. László Moholy-Nagy. *Chute.* 1923. Collage of halftone reproductions of photographs, airbrush, and pen and ink. 25½ x 19½″ (64.8 x 49.5 cm). Gift of Mrs. Sibyl Moholy-Nagy

In Berlin in the early twenties, Moholy-Nagy came into contact with Dadaism, Constructivism, Suprematism, and de Stijl. These avant-garde movements shaped the formal elements of his work and led him to integrate industrial technology with conventional artistic practice. Moholy-Nagy's free experimentation exploited the plasticity of photographs, making them available to his synthetic ambitions. In *Chute*, he deftly mixes airbrush and halftone reproduction with traditional artistic tools, pen and ink. The image projects arbitrarily from the white of the paper: the photographic reproductions of women, snipped from the context of the frame, exist in undefined space, free from expectations of logical connection to the known world.

806. Eugène Atget. *Fête du Trône.* 1925. Gold-toned printing-out paper print. 6⅞ x 8½″ (16.4 x 21.5 cm). Abbott-Levy Collection. Partial gift of Shirley C. Burden

Atget was a commercial photographer who worked in and around Paris for more than thirty years. When he died in 1927 his work was known in part to a few archivists and artists who shared his interest in the visible record of French culture. Little is known about his life, and less about his intentions, except as they can be inferred from his work. The mystery of Atget's work lies in the sense of plastic ease, fluidity, and responsiveness with which his personal perceptions seem to achieve perfect identity with objective fact. There is in his work no sense of the artist triumphing over intractable, antagonistic life; nor, in the best work, any sense of the poetic impulse being defeated by the lumpen materiality of the real world. It is rather as though the world itself were a finished work of art, coherent, surprising, and well

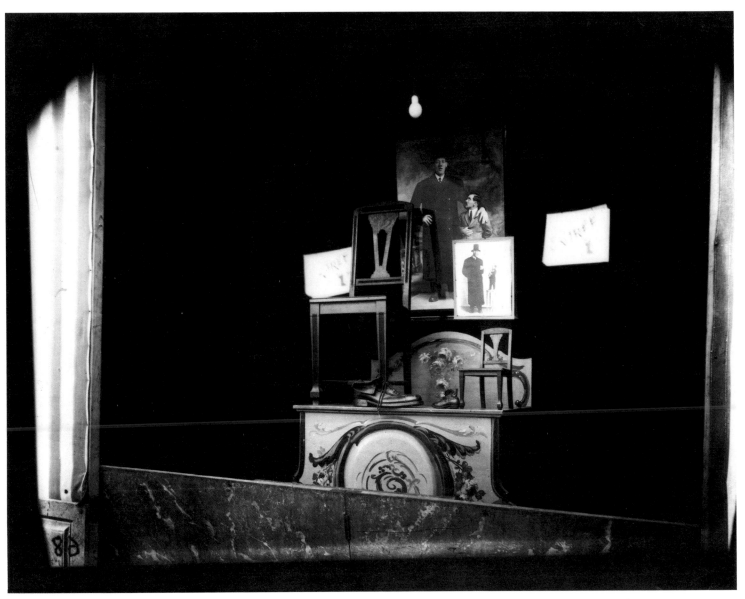

806

constructed from every possible
vantage point, and Atget's photo-
graphs of it no more than a natural
and sweet-minded payment of
homage.

807

807. Heinrich Kühn. Untitled. 1929. Bromoil-transfer print (?). 11½ x 8½" (29.3 x 21.7 cm). Purchase

808. Imogen Cunningham. *Leaf Pattern.* Before 1929. Gelatin-silver print. 9¼ x 7⅛" (23.5 x 18.1 cm). Gift of Albert M. Bender

809. Charles Sheeler. *Stair Well.* 1914. Gelatin-silver print. 9½ x 6⅝" (24.1 x 16.8 cm). Gift of the photographer

Between 1914 and 1917 Sheeler shared a house with his friend and fellow artist Morton Schamberg in Bucks County, Pennsylvania, an area whose architecture shows the influence of Quaker utility and simplicity. In his photographs of the house and the surrounding area, Sheeler applied a vocabulary derived from sophisticated European avant-garde art to vernacular American architecture. The photographs are elegant explorations of pure form, stripped of extraneous associations. In *Stair Well,* the simple arrangement of planes—the underside of steps— is animated by controlled directional lighting. As in an Analytic Cubist painting, the clues for recession are ambiguous; the image reads flat on the surface of the picture as well as in the depth we know to exist.

808

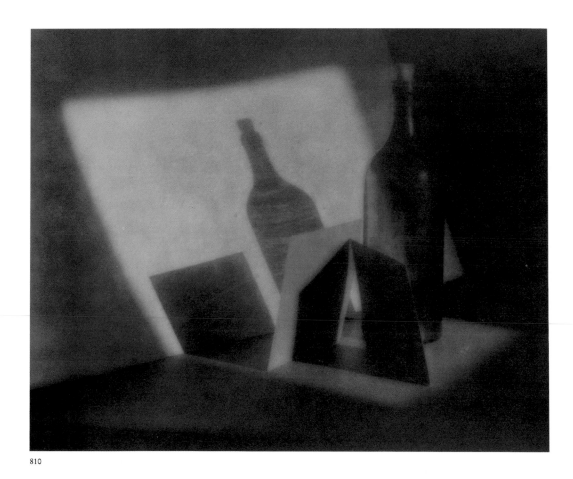

810

810. Jaromír Funke. Untitled. c. 1925. Gelatin-silver print. 9¼ x 11⁹⁄₁₆″ (23.4 x 29.3 cm). Purchased as the gift of Mrs. John D. Rockefeller 3rd

811. Ralph Steiner. *Ford Car.* 1929. Gelatin-silver print. 7⅛ x 9⅝″ (18.1 x 24.5 cm). Gift of the photographer

812. Edward Weston. *Mexico, D.F.* 1925. Platinum print. 9⁹⁄₁₆ x 7³⁄₁₆″ (24.3 x 18.3 cm). Gift of the photographer

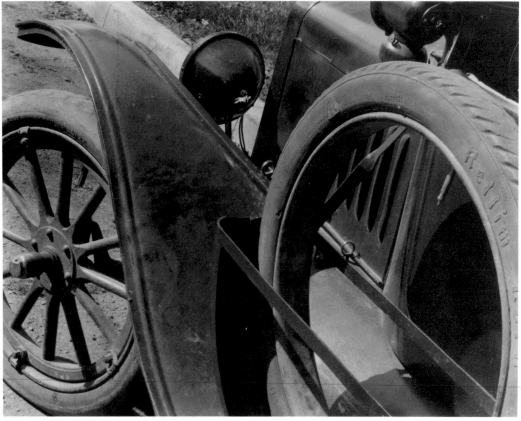

811

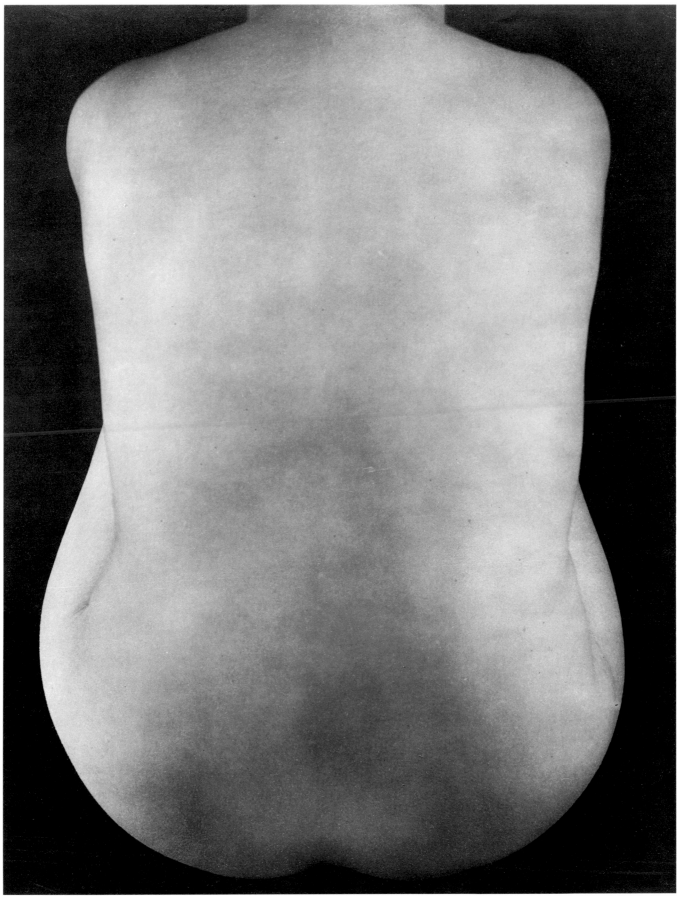

812

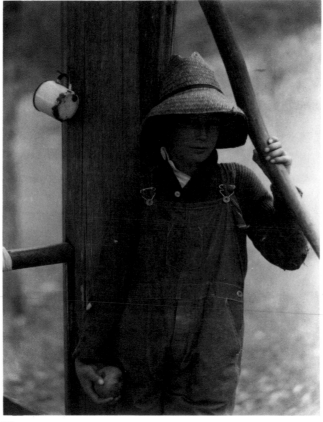

813

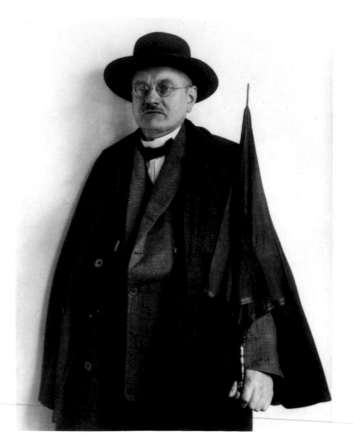

814

813. Doris Ulmann. *Portrait of a Young Boy.* n.d. Platinum print. 8⅛ x 6³⁄₁₆″ (20.6 x 15.7 cm). Purchase

814. August Sander. *Member of Parliament and First Deputy of the Democratic Party.* 1928. Gelatin-silver print. 11⅜ x 8⅝″ (28.9 x 21.9 cm). Gift of the photographer

Sander studied portrait and landscape painting at the Dresden Academy of Art and apprenticed in various photographic studios where he became proficient in portrait, industrial, and architectural photography. By 1904 he was the sole proprietor of a painting and photographic studio in Cologne. In 1929 he published *Face of the Time,* sixty plates of portraits depicting social types in Germany; however, by 1934 the Nazi Ministry of Culture had destroyed the plates for this book and prevented the continuation of other work of the kind. This portrait of Johannes Scheerer is included in a posthumous volume of Sander's photographs, *Citizens of the Twentieth Century,* under the subdivision "Politicians," and the subject is described as a parliamentarian of the Democratic Party. Typical of Sander's portrait subjects, the sitter identifies himself by his dress and manner. In addition, one sees a man with furrowed brow, uncomfortable and cramped within the frame.

815. Hugo Erfurth. *Oskar Kokoschka.* c. 1920. Oil pigment print. 14½ x 11½″ (36.8 x 29.2 cm). Gift of Fritz Gruber

816. Germaine Krull. *Étude.* c. 1931. Gelatin-silver print. 8⅜ x 6⅛″ (21.3 x 15.6 cm). Purchase

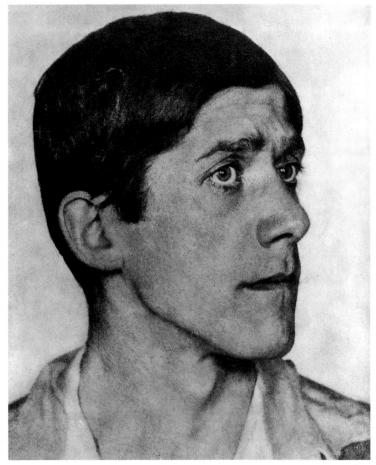

815

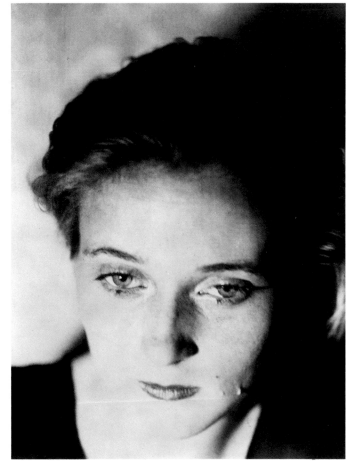

816

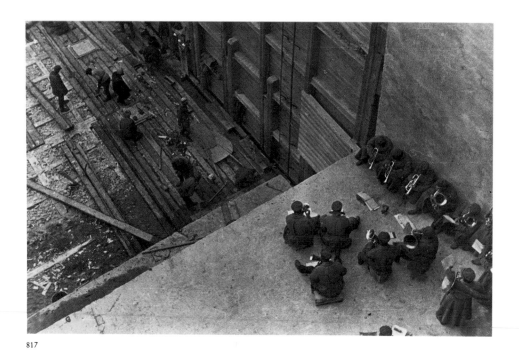

817

817. Alexander Rodchenko. *Rehearsal, Belomorsk Canal*. 1933. Gelatin-silver print. 11⅜ x 17¼" (29.8 x 43.8 cm). Purchase

818. Dorothea Lange. *Migratory Cotton Picker, Eloy, Arizona*. 1940. Gelatin-silver print. 17 x 22" (43.2 x 55.9 cm). Purchase

819. Martin Munkacsi. *Spectators*. 1928. Gelatin-silver print. 9⁵⁄₁₆ x 11½" (23.7 x 29.2 cm). Joseph G. Mayer Fund

820. Henri Cartier-Bresson. *Sunday on the Banks of the Marne*. 1939. Gelatin-silver print. 9⅛ x 13¾" (23 x 34.9 cm). Gift of the photographer

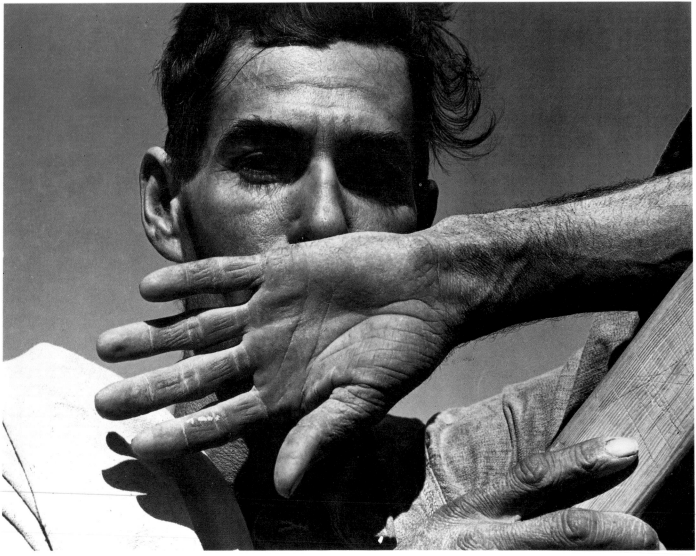

818

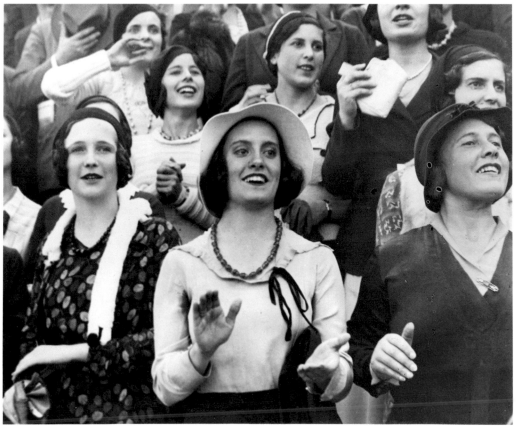

819

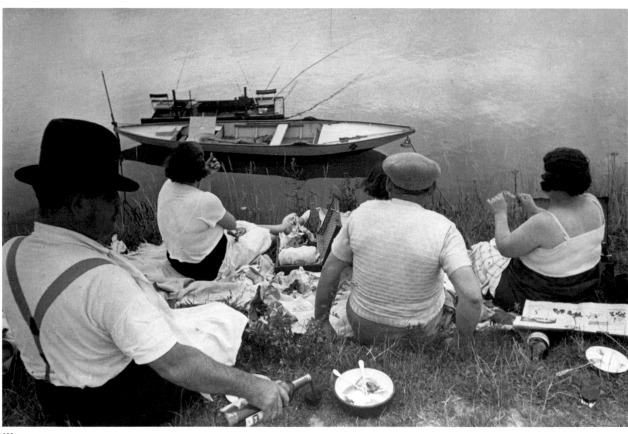

820

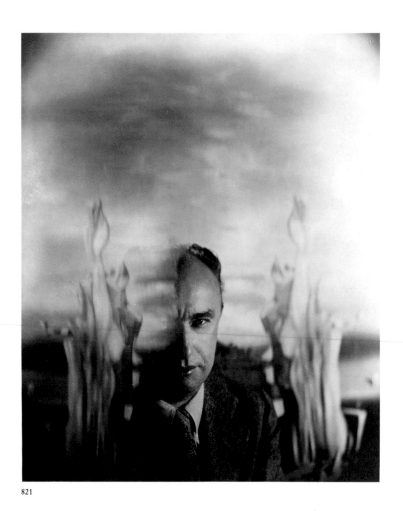

821

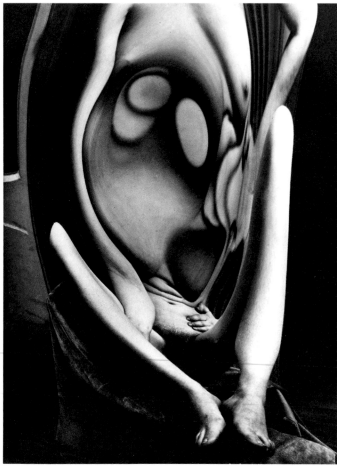

822

821. George Platt Lynes. *Portrait of Yves Tanguy.* c. 1938. Gelatin-silver print. 9½ x 7½″ (24.1 x 19.1 cm). Gift of Russell Lynes

822. André Kertész. *Distortion 117.* 1933. Gelatin-silver print. 12¹¹⁄₁₆ x 9¼″ (32.2 x 23.5 cm). Purchased as the gift of Mrs. John D. Rockefeller 3rd

823. Berenice Abbott. *The Daily News Building.* 1935. Gelatin-silver print. 13 x 10¼″ (33 x 26 cm). The Parkinson Fund

824. Louise Dahl-Wolfe. Untitled. 1932. Gelatin-silver print. 12⅞ x 9⅛″ (32.7 x 23.2 cm). Gift of the photographer

825. Russell Lee. *Hands of Old Homesteader, Iowa.* 1936. Gelatin-silver print. 6½ x 9⅝″ (16.5 x 24.4 cm). Gift of the Farm Security Administration

824

825

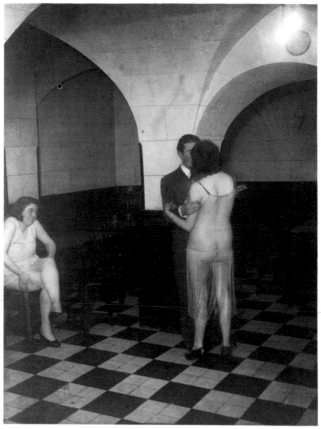

826

826. Brassaï (Gyula Halász). *Brothel.* 1932. Gelatin-silver print. 15 x 11″ (38.1 x 27.9 cm). David H. McAlpin Fund

827. Bill Brandt. *At "Charlie Brown's," London.* c. 1936. Gelatin-silver print. 12¾ x 10¹¹⁄₁₆″ (32.4 x 27.2 cm). Gift of the photographer

828. Walker Evans. *Penny Picture Display, Savannah, Georgia.* 1936. Gelatin-silver print. 8⅝ x 6¹⁵⁄₁₆″ (21.9 x 17.6 cm). Gift of Willard Van Dyke

In 1930, after having completed a brief but satisfactory flirtation with the constructivist style of the twenties, Evans told his friend Lincoln Kirstein that the possibilities of photography excited him so much that he sometimes thought himself mad. He defined these possibilities in his subsequent work: for him they hinged on the poetic uses of judiciously selected simple facts, described in a style suggesting the lean perfection of an ancient folk song or a Shaker chair. His artistic system was based on discovery (seemingly an objective, almost scientific process) rather than on invention (seemingly a matter of personal sensibility). The provincial photographer's display case, with its random sample of fellow citizens, precisely aligned by row and rank behind the gilt letters, surely seemed to Evans a marvelous object of found art, and one might say that he appropriated it.

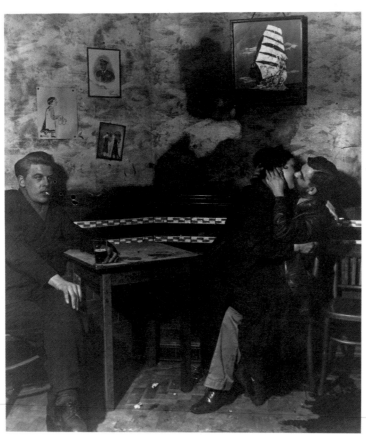

827

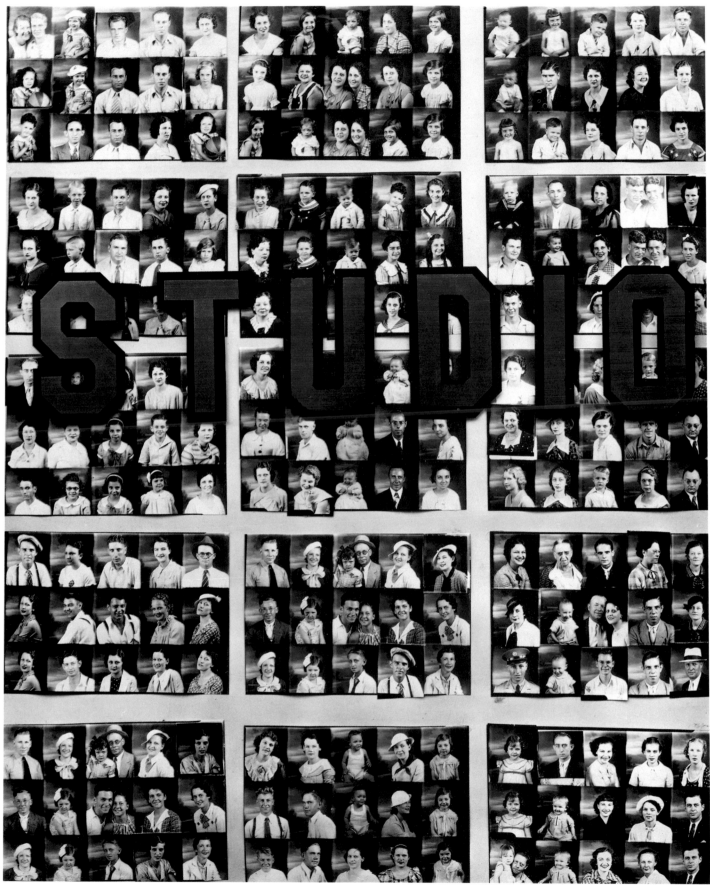

828

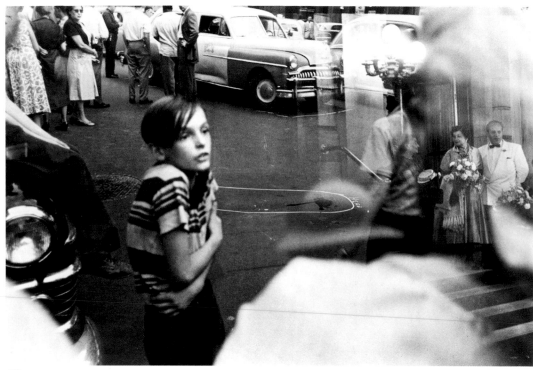

829

830

829. Louis Faurer. Untitled. c. 1951. Gelatin-silver print. 8½ x 12⅞″ (21.6 x 32.7 cm). John Parkinson III Fund

830. Manuel Alvarez-Bravo. *Workman Assassinated in Street.* c. 1940. Gelatin-silver print. 7½ x 9⅜″ (19.1 x 23.8 cm). Purchase

831. W. Eugene Smith. Untitled. 1944. Gelatin-silver print. 13¼ x 10³⁄₁₆″ (33.5 x 25.8 cm). Anonymous gift

832. Eugene Omar Goldbeck. *Indoctrination Division, Air Training Command, Lackland Air Base, San Antonio, Texas.* July 19, 1947. Gelatin-silver print. 16 x 13⁷⁄₁₆″ (40.7 x 34.1 cm). Purchase

831

832

833

833. Helen Levitt. *Women Talking under the El.* 1941. Gelatin-silver print. 10⁷⁄₁₆ x 13⁷⁄₁₆" (26.4 x 34.1 cm). Gift of the photographer

In the forties Levitt photographed in the streets of what is now Spanish Harlem in New York City. She used a 35mm camera with its lens fixed at a right angle so that she would not have to point it directly at her subjects. Her friend and mentor Walker Evans had taught her the technique of photography, but it was the work of Cartier-Bresson that influenced her the most. The human drama of the street, whose characters for her were mostly children, was revealed in a series of delicately structured and choreographed photographs. Her finely tuned intuition, combined perhaps with the bravery of her youth, showed her the poetry in the gestures, facial expressions, and human relationships of daily life. This picture, describing the strength of the taller woman's back as she rests her hand on the shoulder of her grateful and pleased friend, speaks volumes on the nature of friendship.

834. Robert Doisneau. *The Tableau in the Window of the Collector Romi.* 1949. Gelatin-silver print. 9¼ x 11⅝" (23.5 x 29.5 cm). Purchase

835. Lisette Model. *Coney Island.* 1941. Gelatin-silver print. 15⁹⁄₁₆ x 19⁹⁄₁₆" (39.5 x 49.7 cm). Gift of the photographer

836. Ted Croner. Untitled. 1947–49. Gelatin-silver print. 15⅞ x 15¾" (40.3 x 40 cm). The Family of Man Fund

837. Weegee (Arthur H. Fellig). Untitled. 1940s. Gelatin-silver print. 10⁵⁄₁₆ x 13³⁄₁₆" (26.2 x 33.4 cm). The Family of Man Fund

Fellig immigrated to the United States with his family in the early 1900s and settled on the Lower East Side in New York City. He quit school at the age of fourteen to help support his family by working in a photographic studio and soon after left home to eke out a living working odd jobs, taking anything that had to do with photography whenever possible. He joined the Acme

834

news photo service where he worked in the darkroom and covered nighttime emergencies. Scooping stories with regularity, he was nicknamed "Weegee" after the Ouija board, famous for its prophetic powers. He stayed at Acme until 1935 when he started freelancing out of police headquarters, selling his graphic, often grisly, pictures of everyday catastrophes to various tabloids and photo services. With *Naked City,* a compilation of his press pictures published in 1945, he achieved notoriety. In later years, Weegee photographed fewer murders and more bobby-soxers, barflies, and demimondaines, always retaining his macabre sense of humor. The picture of the two men trying to maintain their anonymity in the face of the intrusive photographer shows what Weegee did best—seize a moment that told a multitude of stories.

835

836

837

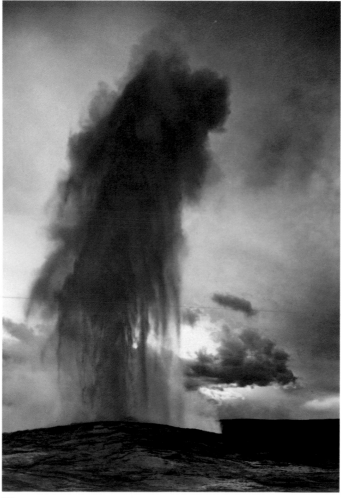

838

838. Ansel Adams. *Old Faithful Geyser, Yellowstone National Park, Wyoming.* 1941. Gelatin-silver print. 9 x 6⁵⁄₁₆" (23 x 16 cm). Gift of David H. McAlpin

In this century, the name Ansel Adams has become synonymous with landscape photography. *Old Faithful Geyser,* less well known than other works by Adams, reveals the extraordinary sensitivity of his art. John Szarkowski has observed that "Ansel Adams attuned himself more precisely than any photographer before him to a visual understanding of the specific quality of light that fell on a specific place at a specific moment. For Adams the natural landscape is not a fixed and solid sculpture but an insubstantial image, as transient as the light that continually redefines it." Surely it is true of Adams's picture of this ephemeral phenomenon of nature. The uncontrollable force of the geyser is described in relation to the incontestable solidity of the earth, while the fleeing cloud and sun serve to underline a sense of experiencing a unique moment in time.

839. Frederick Sommer. *Still Life.* 1938. Gelatin-silver print. 9½ x 7⁹⁄₁₆" (24.1 x 19.2 cm). Purchase

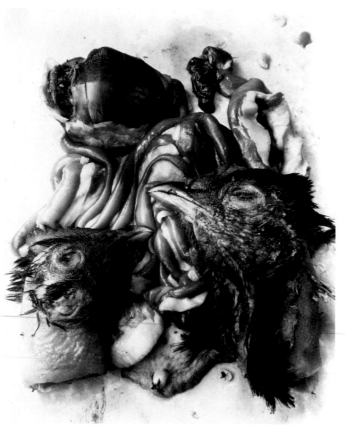

839

840. Aaron Siskind. *Uruapan, Mexico 4*. 1955. Gelatin-silver print. 13 x 16¼" (33 x 41.3 cm). John Parkinson III Fund

841. Harry Callahan. *Eleanor, Chicago*. 1951. Gelatin-silver print. 5¹⁵⁄₁₆ x 7½" (15 x 19 cm). Gift of the photographer

Callahan has come to know the world by photographing it, but his is the knowledge of life's emotions, not its events. He photographs what is familiar and close at hand—his wife and daughter, their street, and nearby parks—but excludes the narrative details of everyday life. There are no candid shots: each picture is a solemn occasion, into which nothing extraneous to the demands of art enters. We see his wife Eleanor in the bedroom or outside, places which for Callahan are not specific locations but evocative settings. Each picture is a humble meditation, limited to the objects of a man's most profound feelings: light and life, woman and nature.

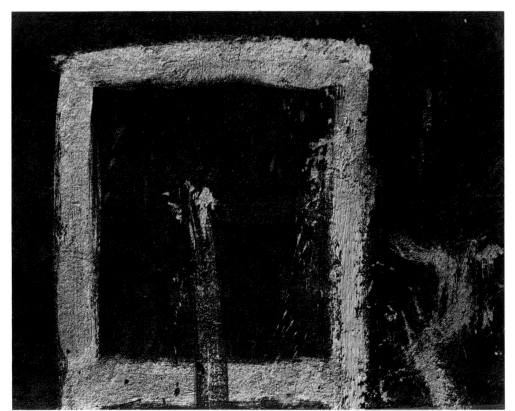

840

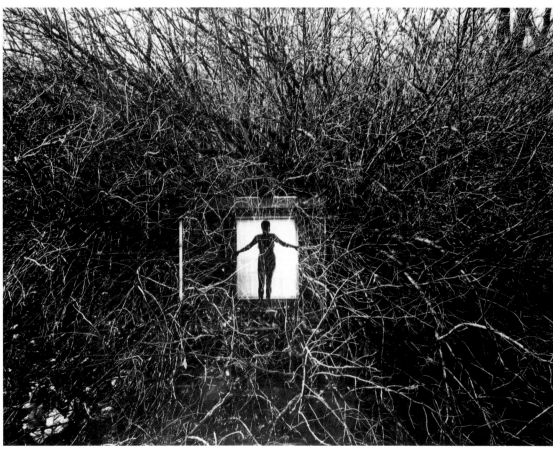

841

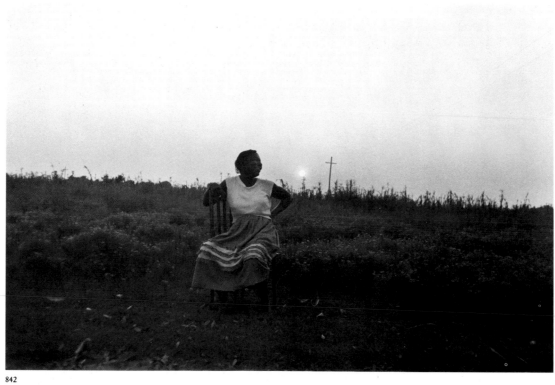

842

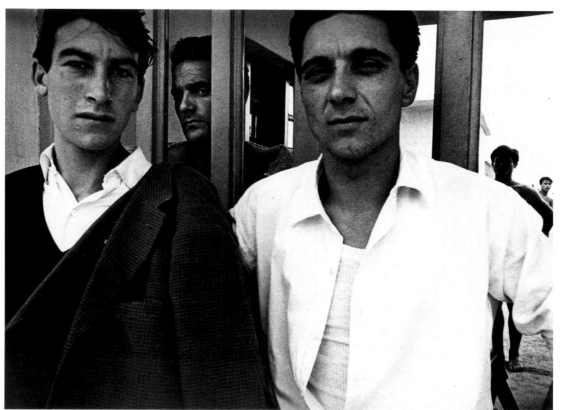

843

842. Robert Frank. *Beaufort,
Louisiana.* 1955. Gelatin-silver print.
10¹⁵⁄₁₆ x 14″ (27.7 x 35.5 cm). Purchase

Born in Zurich, Switzerland, in
1924, Frank traveled to the United
States in 1947 where he worked as a
freelance photojournalist. In 1955 he
became the first foreign-born Amer-
ican to receive a Guggenheim Foun-
dation grant in photography, which
he used over the next year to finance
a journey across the United States.
The resulting photographs were
published in Paris in 1958 in the
book *Les Américains.* The following
year the book was published in the
United States with an introductory
essay by Jack Kerouac, and within a
decade it became a kind of textbook
for young and artistically alienated
photographers. In conventional
terms, Frank's pictures were inade-
quately lighted; they had tilted
horizons and seemingly arbitrary
framing. His subject matter, seen
with the detachment of the foreigner,
was the American people and the
objects of their culture: politicians
and starlets, cowboys and laborers,
jukeboxes, pool tables, and cars. As
a portrait of America his book was
bitter and incisive, revealing aspects
of a national disaffection that had
never been so boldly confronted.
Beaufort, Louisiana is one of the
gentler pictures from *The Amer-
icans.* The setting sun on the canted
horizon tells of the turning of the
world, while the laughing black
woman sits rooted in the earth,
before the distant telephone pole,
or cross.

843. William Klein. *Ostia Beach,
Rome.* 1956. Gelatin-silver print. 12¾ x
17⁹⁄₁₆″ (32.4 x 44.6 cm). Purchased as the
gift of Mrs. Armand P. Bartos

844. Roy De Carava. Untitled. 1959.
Gelatin-silver print. 9 x 13¹⁄₁₆″ (22.9 x
33.2 cm). Purchase

845. Shomei Tomatsu. *Beer Bottle after
the Atomic Bomb Explosion.* 1960–66.
Gelatin-silver print. 15¹⁵⁄₁₆ x 14³⁄₁₆″ (40.5
x 36 cm). Gift of the photographer

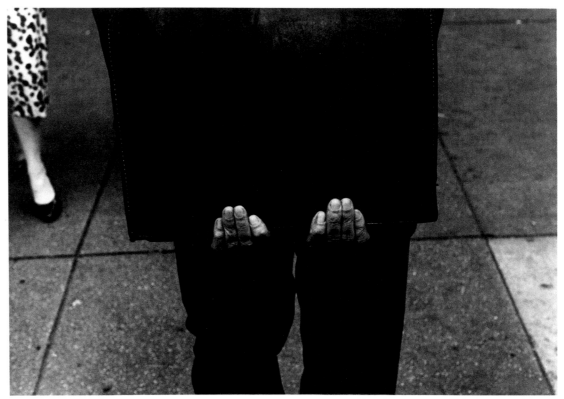

844

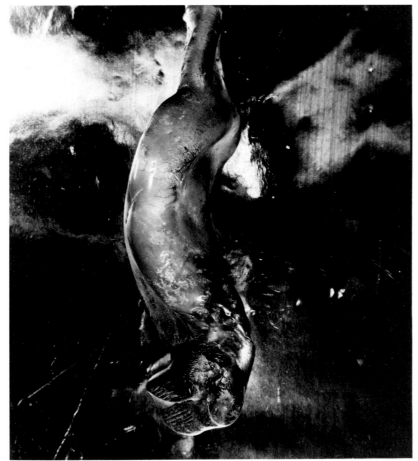

845

846

847

846. Josef Sudek. Untitled. From the Windows of My Studio series. 1954. Gelatin-silver print. 8⅝ x 11¹⁄₁₆″ (22 x 28.1 cm). Gift of Harriette and Noel Levine

847. Paul Caponigro. Untitled. 1957. Gelatin-silver print. 7¾ x 9¾″ (19.7 x 24.7 cm). Purchase

848. William Garnett. *Nude Dune, Death Valley, California.* April 15, 1954. Gelatin-silver print. 19¼ x 15⁵⁄₁₆″ (49 x 38.9 cm). Purchase

849. Minor White. *Capitol Reef, Utah.* 1962. Gelatin-silver print. 12⅛ x 9¼″ (30.8 x 23.5 cm). Purchase

White specified the way he wanted his photographs to be seen, offering them to friends and students as spiritual riddles to untangle. Some of his strongest works succeed for their ability to fend off as long as possible the mind's efforts to recognize the content—to reduce the tones and lines to known qualities. In this way he created a means of escape from ordinary perception, allowing the mind to see itself at work. The title of this work, *Capitol Reef, Utah,* obscures as much as it reveals. While we know we are looking at a geological formation of some sort, we are unsure of our spatial relationship to the picture, nor can we clearly identify scale or subject matter. We turn instead, if we follow White's intentions, to observe our own reaction to the photograph as an object of contemplation and active engagement.

848

849

850

851

850. Clarence John Laughlin. *The Insect-Headed Tombstone*. 1953. Gelatin-silver print. 13⅝ x 10⅞" (34.6 x 27.6 cm). John Parkinson III Fund

851. Jerry N. Uelsmann. Untitled. 1964. Gelatin-silver print. 13½ x 10" (34.3 x 25.4 cm). Purchase

852. Duane Michals. Untitled. 1968. Gelatin-silver print. 6½ x 9½" (16.5 x 24.1 cm). The Parkinson Fund

853. O. Winston Link. *Last Steam Locomotive Run on Norfolk and Western, Radford Division*. December 31, 1957, 11:30 P.M. Gelatin-silver print. 13½ x 10¹³⁄₁₆" (34.2 x 27.5 cm). Purchase

Within the memory of middle-aged photographers, much of the challenge and excitement of photography derived from the fact that many fascinating subjects had never been photographed because of seemingly insurmountable technical difficulties. Photographers debated the various imaginable ways to photograph black cats in coal bins at midnight, for no better reason than that it seemed a challenging problem. The black cat problem was, in fact, child's play in comparison with those encountered in Link's series on the nocturnal runs of the last great steam trains. To photograph the splendid iron horses and the dark country through which they ran, Link would prepare his set as would a film director, setting out scores of flashbulbs connected to his camera by a mile of electrical cable, each bulb timed to fire during the few milliseconds that his shutter was open. By space-age standards Link's techniques seem almost archaic. It would be much simpler to make the picture now, but for the fact that it could not be made at all.

854. Richard Avedon. *Brigitte Bardot*. 1959. Gelatin-silver print. 23 x 20" (58.4 x 51.3 cm). Gift of the photographer

852

853

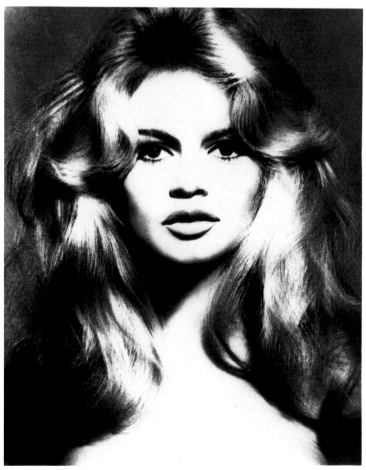

854

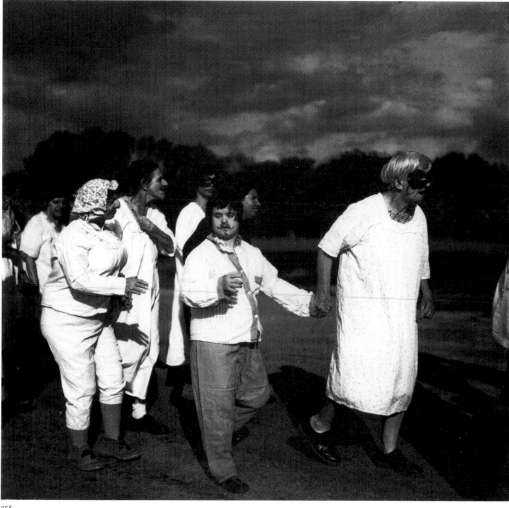

855

855. Diane Arbus. Untitled. 1970–71. Gelatin-silver print. 14¼ x 14⅜″ (36.2 x 36.7 cm). Mrs. Armand P. Bartos Fund

Arbus, born and raised in New York City, attended the Ethical Culture and Fieldston schools and married at eighteen. She and her husband Allan pursued careers in fashion photography. Profoundly influenced and encouraged by Model, Arbus began to concentrate on her own work in the late fifties. She was awarded Guggenheim Foundation grants in 1963 and 1966, and first exhibited her work in 1967 at The Museum of Modern Art in *New Documents* with Winogrand and Friedlander. The romantic idea that people are somehow liberated by what impairs them guided her vision and enabled her to engage her subjects—frequently eccentrics and freaks—on the basis of mutual respect. The picture reproduced here is from the last series she made, in a home for retarded women. It, like the rest of her work, involves the viewer in a compelling, disturbing empathy.

856. Garry Winogrand. Untitled. 1963. Gelatin-silver print. 8¹⁵⁄₁₆ x 13½″ (22.7 x 34.2 cm). Gift of the photographer

857. Lee Friedlander. *New York City.* 1964. Gelatin-silver print. 6⅜ x 9¾″ (16.2 x 24.8 cm). Purchase

858. Josef Koudelka. *Spain.* 1971. Gelatin-silver print. 9⁷⁄₁₆ x 14⅛″ (24 x 36 cm). Joseph Strick Fund

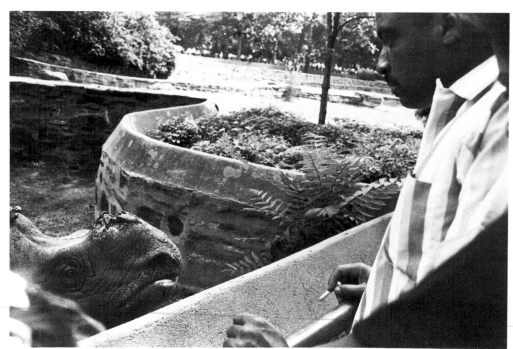

856

857

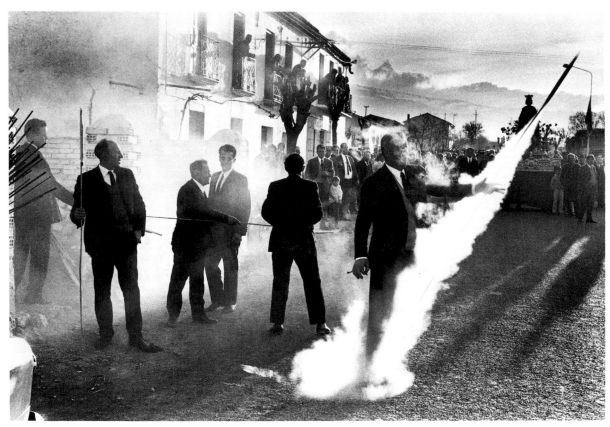

858

859

860

859. Art Sinsabaugh. *Midwest Landscape No. 64*. 1962. Gelatin-silver print. 3½ x 19¼" (9 x 48.9 cm). Purchase

860. Robert Heinecken. *The S.S. Copyright Project "On Photography."* 1978. Mosaic of black-and-white instant prints mounted with staples on two panels. Each 48 x 48" (121.8 x 121.8 cm). Purchased as the partial gift of Mrs. Armand P. Bartos

861. Ray K. Metzker. *Trolley Stop.* 1966. Gelatin-silver print. 40½ x 35" (102.9 x 88.9 cm). Purchase

A tradition of constructed photographs—as opposed to Stieglitz's idea of straight photography—entered America when Moholy-Nagy established the New Bauhaus in Chicago in 1937. Metzker sums up what he learned there in a description of his work from the mid-sixties: "Where photography has been primarily a process of selection and extraction, I wish to investigate the possibilities of synthesis." *Trolley Stop* resembles a scientific document. What at first glance seems to have the precision of a time-lapse photograph or a photo-finish record proves on inspection to obscure factual reality and present a fictitious event. From the picture it is impossible to reconstruct any sequence of events; we never know how many people were actually waiting at the stop at any given time, or where they stood, or how many trollies finally came. The work undermines the expectation that a photograph provide verifiable information and demands, instead, acceptance as an object independent of any other reality.

861

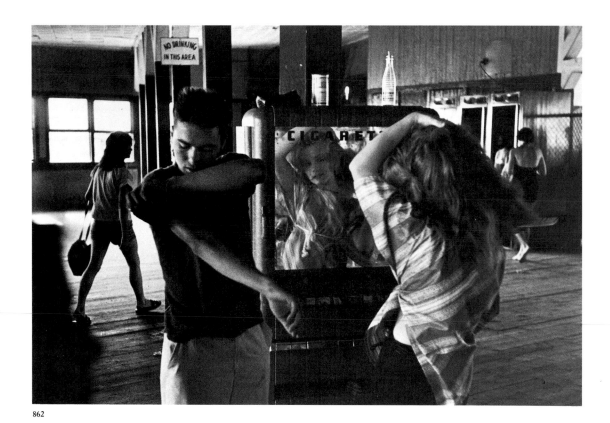

862

862. Bruce Davidson. Untitled. 1959. Gelatin-silver print. 6¾ x 10″ (17.1 x 25.4 cm). Purchase

863. Larry Fink. Untitled. 1978. Gelatin-silver print. 14¹³⁄₁₆ x 15¹⁄₁₆″ (37.7 x 38.2 cm). Purchase

864. Nicholas Nixon. *Heather Brown McCann, Mimi Brown, Bebe Brown Nixon, and Laurie Brown, New Canaan, Connecticut.* 1975. Gelatin-silver print. 7¾ x 9⁹⁄₁₆″ (19.9 x 24.9 cm). Gift of the photographer

865. Tod Papageorge. *Central Park.* 1980. Gelatin-silver print. 10⁵⁄₁₆ x 12⁷⁄₈″ (26.3 x 32.7 cm). Acquired with matching funds from Samuel Wm. Sax and the National Endowment for the Arts

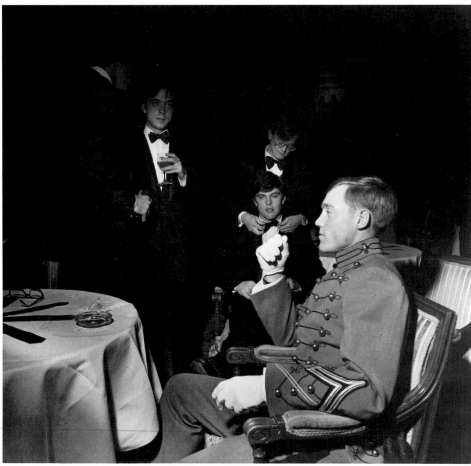

863

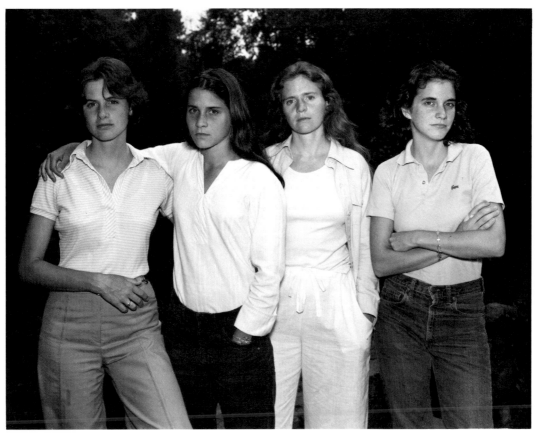

864

865

866

867

866. Ken Josephson. *Anissa's Dress.*
1970. Framed gelatin-silver print
attached to child's dress on plastic
clothes hanger. 19½ x 15⅛″ (49.5 x 38.4
cm). Purchased as the gift of Mr. and
Mrs. Ronald S. Lauder

867. Gary Brotmeyer. *#187.* 1982.
Gelatin-silver print with hand-applied
enamel paint. 5⅞ x 3¹⁵⁄₁₆″ (15 x 9.9 cm).
Purchase

868. Robert Cumming. *Two Views of
One Mishap of Minor Consequence.*
1973. Two gelatin-silver prints. Each 7⅝
x 9⅝″ (19.4 x 24.4 cm) on mount 19½ x
30″ (49.5 x 76.2 cm). Purchased as the
gift of Mrs. Armand P. Bartos

The American photographer Cum-
ming, trained as a painter and sculp-
tor, belongs to a generation of artists
whose approach to making art is
strongly identified with the Con-
ceptual movement of the seventies.
This picture, in two parts, exem-
plifies Cumming's fondness for
puzzles and for the illusions that a
photograph presents. Often his
work relies on verbal as well as visual
clues, as in the use of the caption in
this picture. The totally fictitious
quality of the event, which upon
careful inspection is seen to be
meticulously staged (the bucket and
chair being tipped by an almost,
but not quite, invisible string), is
enhanced by the pseudo-seriousness
of the caption. Cumming has pub-
lished several books of photographs,
each accompanied by a text which
is either fake-scientific or fake-
dramatic, and always witty.

869. Zeke Berman. *Still Life with
Necker Cube.* 1979. Gelatin-silver print.
10⅜ x 13⁷⁄₁₆″ (26.3 x 34.2 cm). Purchased
as the gift of the Estate of Vera Louise
Fraser

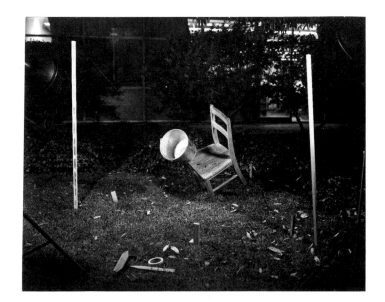

868

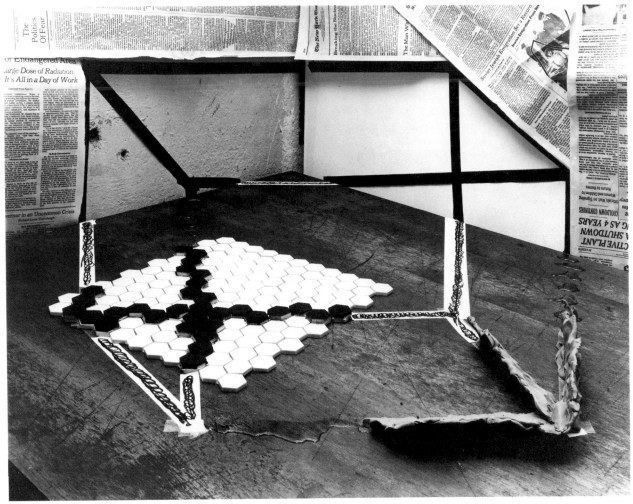

869

870

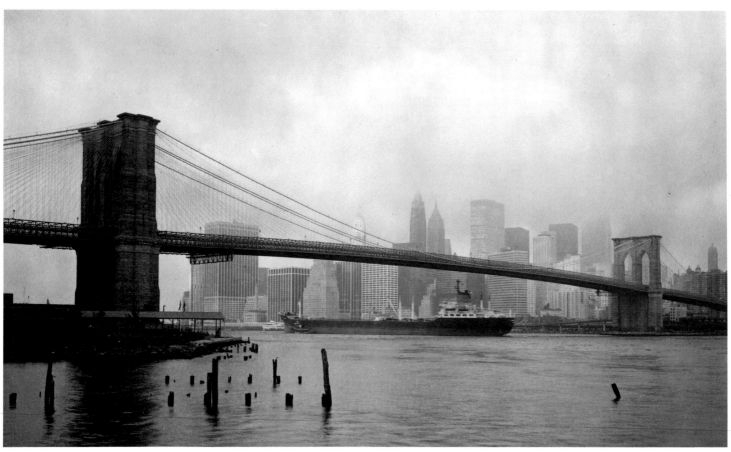

871

870. Robert Adams. *East from Flagstaff Mountain, Boulder County, Colorado.* 1976. Gelatin-silver print. 8¹⁵/₁₆ x 11¼" (22.7 x 28.6 cm). Purchase

Twenty years ago Adams stopped being a professor of English literature to become a photographer. The skies around Denver then were on most days still clear, and the rolling foothills to the west and the prairies to the east were covered with grass and wheat. As Adams set to work the skies smogged over, and the prairies and foothills were papered over with plywood ranch houses and their attendant commercial strips of concrete and acid neon. By recording the indignities to which his part of the landscape was being subjected, Adams became, in spite of his intentions, a political photographer. He has, however, noted that nothing permanently diminishes the affirmation of the sun, and that even subdivisions are at certain times of day transformed into a dry, cold brilliance.

871. Richard Benson. *Brooklyn Bridge.* 1981. Palladium/platinum print. 10⅛ x 17³/₁₆" (25.8 x 43.7 cm). The Family of Man Fund

872. Frank Gohlke. *Brick Building in the Shadow of a Grain Elevator— Cashion, Oklahoma.* 1973–74. Gelatin-silver print. 8 x 8" (20.3 x 20.3 cm). Purchased as the gift of Pierre N. Leval

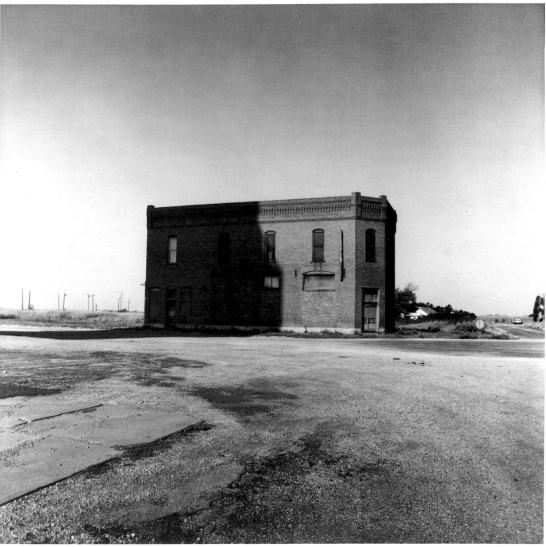

872

873

873. Edward Steichen. *Moonrise, Mamaroneck, New York*. 1904. Platinum, cyanotype, and ferroprussiate print. 15¹⁵⁄₁₆ x 19″ (38.9 x 48.3 cm). Gift of the photographer

Through the use of elaborately layered prints—this one platinum, cyanotype, and ferroprussiate—members of the pictorialist movement made photographs which were consonant with the ideals of painting. In their attempt to have photography accepted as an art form, it was the hand of the artist which they emphasized, not the duplicating abilities of the camera. Steichen was a master of printing techniques, and this picture is one of the finest works of the pictorialist movement. Borrowing from the Impressionists, Japanese painters and printmakers, James McNeill Whistler, and the Symbolists, the work of the pictorialists was atmospheric, misty, and dramatic. Steichen and Stieglitz, leaders of the movement, later abandoned such techniques to make pictures more clearly photographic in nature. Yet photographs like *Moonrise, Mamaroneck* were important, not only as unique works of great expressive beauty, but for the artistic questions they posed and the controversy they aroused.

874. Eliot Porter. *Blue-throated Hummingbird*. n.d. Dye-transfer print. 9⁵⁄₁₆ x 7¾″ (23.7 x 19.6 cm). Gift of David H. McAlpin

875. Irving Penn. *Still Life with Watermelon*. 1947. Dye-transfer print. 24 x 19⅞″ (60.9 x 50.5 cm). Gift of the photographer

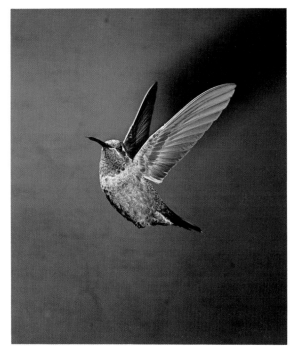

874

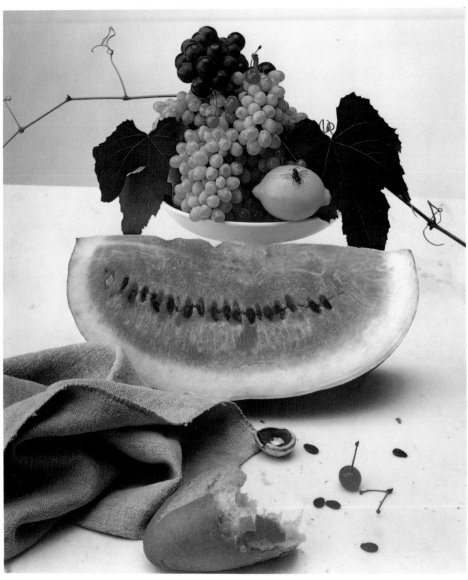

875

876

877

876. Jan Groover. Untitled. 1977. Three color-coupler prints. Overall 15 x 45¼" (38.1 x 114.9 cm). Acquired with matching funds from Mrs. John D. Rockefeller 3rd and the National Endowment for the Arts

877. William Wegman. *Elephant II.* 1981. Polaroid Polacolor print. 24 x 20" (60.9 x 50.8 cm). Gift of Irwin Schloss

878. Stephen Shore. *Castine, Maine.* July 18, 1974. Color-coupler print. 8 x 10" (20.2 x 25.3 cm). Purchase

879. Keith A. Smith. *Figure in Landscape.* 1966. Photo-etching. 9 x 12" (22.9 x 30.5 cm). Purchase

878

879

880

881

880. William Eggleston. *Memphis.* c. 1971. Dye-transfer print. 13 x 19⁵⁄₁₆" (33.1 x 49 cm). Gilman Foundation Fund

Photographers now over fifty learned their craft in monochrome. The first lesson was to blind oneself to hue, and see value; the goal was to edit the world to find a picture that was clear, and one hoped eloquent, within the limits of the photographic gray scale. Photographers who had worked so hard to inure themselves to the colors of flowers were, in general, not sure what use to make of almost foolproof color film. It was doubtless easier for younger photographers, like Eggleston, who had grown up with color snapshots and color movies, to edit the world in color, and see the red and the truck as one fact.

881. Brian Wood. *Elevator.* 1978. Four color-coupler prints. 13⁵⁄₁₆ x 42" (33.8 x 106.7 cm). Purchased as the gift of Lois and Bruce Zenkel

882. Joel Sternfeld. *After a Flash Flood, Rancho Mirage, California.* 1979. Color-coupler print. 13½ x 17" (34.3 x 43.2 cm). Acquired with matching funds from Shirley C. Burden and the National Endowment for the Arts

882

Film and Video

When in 1929 Alfred Barr proposed the idea of a modern museum devoted to all the visual arts of our time, including "a department of motion pictures," film already had a distinguished, if brief, history of some thirty-five years. But film like the automobile was an industrial product, made for a mass market, and few shared Barr's vision of cinema as art. "That part of the American public which should appreciate good films and support them has never had a chance to crystallize," Barr noted in 1932. "People who are well acquainted with modern painting or literature are amazingly ignorant of modern film. . . . It may be said without exaggeration that the only great art form peculiar to the twentieth century is practically unknown to the American public most capable of appreciating it."

The exception to Barr's premise was John Hay Whitney, then actively collecting modern paintings, whose enthusiasm for the movies led him to invest in the Technicolor process and in film production through Pioneer Pictures and Selznick International, where he later became closely involved in the production of *Gone With the Wind*. With his connections in the industry and his generous participation and support, Whitney served most effectively as chairman of the Museum's Film Library Corporation from its inception in 1935 until 1951.

The founder and first curator of the Film Library was Iris Barry, a British film critic and author, whose three decades of pioneering work in collecting films and presenting them in coherent artistic and historical contexts gained recognition for the cinema as the major new art form of our century. When Barry came to New York in the early thirties, it was rarely possible to see any film once it had completed its initial distribution. The medium was now over forty years old, the silent era had passed, and many films were lost. Barry recognized that "unless something is done to restore and preserve outstanding films of the past, the motion picture from 1894 onwards will be as irrecoverably lost as the Commedia dell'Arte or the dancing of Nijinsky."

And so Barry and John Abbott, first director of the Film Library, set out for Hollywood in 1935 with letters of introduction from Whitney, to secure the cooperation of the film industry. It was thanks to the generosity of Harold Lloyd, Douglas Fairbanks, Mary Pickford, Samuel Goldwyn, William S. Hart, David Wark Griffith, Walt Disney, and David O. Selznick, among others, that the collection had its beginnings. In the following year, Barry and Abbott searched for films in Europe. They found other people just beginning to build collections in Berlin, London, and Paris, colleagues who enthusiastically gave their cooperation and entered into exchanges of materials and information. From these beginnings, Barry and her successors have built a collection comprising some eight thousand titles today, concentrating on assembling an outstanding collection of the important works of international film art, with emphasis being placed on obtaining the highest-quality materials.

The preservation of the film collection has been generously supported since the late sixties by the Museum's board of trustees, in particular Celeste Bartos, who as chairman of the Committee on Film also has given generously of her time and her wisdom; and by the National Endowment for the Arts, the New York State Council on the Arts, and Warner Communications, Inc., among many others.

In recent years, the department has focused on the younger medium of video, through acquisition of international documentary, experimental, and narrative work from the sixties to the present. In addition to the video lecture and exhibition series, in 1983 the department added the Circulating Video Program, composed of recent tapes, to its expanded Circulating Film Library.

Several distinctions between film and the other arts have contributed to the shaping of the Museum's collection. First, as is true also for prints, photography, and industrial design objects, films may be reproduced in multiple copies and need not be uniquely col-

lected by a single institution. Nevertheless, original film negatives and prints, and copies near in generation to the original, are the most desirable, because there is a falloff in quality of image and sound that increases in proportion to the number of generations between the copy and the original. Second, film is a fragile medium, perhaps the only one other than the new medium of video that is worn out as people look at it. Even negatives from which new prints are made wear out after a number of times through the printing machines. In addition, almost all films before 1950 were made on unstable nitrate stock that deteriorates. These must be copied on modern triacetate stock. Modern color films have layers of dye that will fade. They must be copied on black-and-white separation negatives, or, at the very least, kept at extremely low temperatures and humidity levels. If the films acquired by the Museum are to be considered as part of a "permanent" collection, enormous sums must be spent in copying them and storing them.

The factor that most influences the building of a film collection is that it is at one and the same time an art form and a mass-entertainment industry. The film department seldom owns the rights to the films in its collection. Usually, the deposit of films includes the rights to show them from time to time to the general public in the Museum's own two theaters. In addition, contracts are made with the owners to permit the distribution of some of the films to educational institutions for study purposes. In all cases, the department insists on its rights under the copyright law to make such copies as are necessary to guarantee the permanent preservation of the film, and to make reference copies available for private research by qualified scholars in its film study center. Any other use usually requires the negotiation of an agreement with the owner of the rights.

Another aspect of collecting in a commercial medium is that owners have seldom been willing to allow a film to enter the collection until its commercial distribution has been completed. The department may and does collect the latest work by an independent filmmaker whose films are not destined for the mass market, but it is rare that it can obtain the most recent commercial films. Therefore, there is usually a time lag in adding to this part of the collection.

Film has always been an international medium, and the Museum's intention is to build an international collection of the important works of modern art. Nevertheless, American films have been among the most significant in world cinema in many periods of film history, and any collection of the best films will always contain a high proportion of them. In addition, film archives around the world have agreed that each has a special responsibility toward preserving its own national production. The Museum was collecting films long before there were other major national institutions to share the task. Today there are several film archives dedicated to the American cinema, and the Museum has reasserted its original role as the collector of the best films from all countries.

Among the earliest acquisitions were Fernand Léger's *Ballet mécanique* and Edwin S. Porter's *The Great Train Robbery*, demonstrating Barry's interest in acquiring works that ranged from an artist's conscious discovery of a new medium to a popular entertainment film that helped point the way to film narrative. From the start, a broad approach to what constitutes the art of the film governed the selections, and the collection is still growing in that spirit. The theorists of modern art in the twenties discovered such film artists as Chaplin working in the highly commercial Hollywood industry, and adopted them as part of their movement. The art of cinema takes many forms and may be found in popular fiction films, documentaries, animation films, propaganda films, and avant-garde and independent films.

Among the greatest treasures of the collection are all the surviving original negatives of the Biograph Company and those of the Edison Company, both major collections acquired in the late thirties, when the companies were defunct. These were two of the most important American production companies during the first two decades of the

medium—the Vitagraph Company was the third—and few of their films survive. In recent years, the department has begun to add Vitagraph productions, when they can be found. Only a very small percentage of silent films survive, and when found they are frequently in the form of worn, scratched, and incomplete projection prints. The possession of original negatives makes possible projection prints of the same quality that the first public saw. At Biograph, David Wark Griffith, the greatest director of the silent cinema, made more than four hundred short films, through which one may trace the evolution of the film style most familiar to us today, the classic American film narrative, which involves the spectator in the emotions and suspense of a story. However, recent interest has extended to the earlier Biographs and Edisons as well as to the Museum's collection of the major films by Louis Lumière, Georges Méliès, Ferdinand Zecca, Emile Cohl, Gaston Velle, all of France, not to mention the work of the pioneer filmmakers of England, Germany, and Italy. At the Edison Company, the American pioneer Edwin S. Porter did his most important work, and the collection has many excellent examples of it. Before the rise of the nickelodeon and before filmmaking became an assembly-line, factory production, the motion picture was very different from what it became in the post-Griffith period. Films then were looked at as spectacle, magic show, and recorder of daily events.

In 1937, the department acquired Griffith's own negatives and prints of his feature films (together with his papers), and now has the most extensive collection of Griffith films in existence. It includes beautiful original tinted versions of *The Birth of a Nation, Intolerance, Broken Blossoms,* and *Way Down East.* Soon after, Douglas Fairbanks contributed his own collection of original negatives and prints, constituting yet another large group of major American films of very high quality.

When Barry toured Europe in the late thirties, she not only arranged the acquisition of the classic silent films of France, Germany, Sweden, and the Soviet Union; she also brought back an astounding collection of the European avant-garde films of the twenties by Man Ray, Marcel Duchamp, Eugène Deslaw, Hans Richter, René Clair, Jean Epstein, Germaine Dulac, Louis Delluc, Alberto Cavalcanti, and Walter Ruttmann. In recent years grants from the Jerome Foundation and the National Endowment for the Arts earmarked for works by living American artists have enabled the department to build a representative collection of films by newer independent filmmakers, among them Stan Brakhage, Michael Snow, Tony Conrad, Robert Breer, James Broughton, Hollis Frampton, James Benning, Mark Rappaport, George Griffin, Anthony McCall, and David Haxton. The films of Charles DeKeukeleire, a Belgian filmmaker of the twenties and thirties only recently rediscovered, have been added to the collection, and the artist Len Lye just before his death gave to the Museum his own collection of his unique hand-painted films, which the department is engaged in copying for preservation purposes; his earlier work in England had been acquired in previous years.

In 1936, the British historian and filmmaker Paul Rotha was invited to lecture and show films at the Museum; his visit led to the creation of a major collection of documentary films from the thirties and from the World War II period, when the department was active in government projects for the war effort. In 1983, the family of the late Thomas Brandon created the Brandon Collection, donating his films and papers to the Museum. This collection is especially valuable for its labor and social documentary films, many of them rarely seen since they were first made.

The works of Soviet film artist Sergei Eisenstein were mostly acquired in the early years. In 1953, Upton Sinclair entrusted the Museum with all the surviving footage shot by Eisenstein for the famous but uncompleted *Que Viva Mexico!* After copying the nitrate negative on triacetate fine-grain master stock, the department sent the originals to Gosfilmofond, the Soviet state film archive, in exchange for a group of Soviet film classics.

Through exchanges with colleagues of the Fédération Internationale des Archives du

Film (FIAF), founded by Barry and a handful of others in 1938 and now grown to include member archives in all the major film-producing countries of the world, it has been possible to build collections of the achievements of other nations. Among these, there are groups of outstanding Polish and Bulgarian films dating from the postwar period, when the two countries' film industries were revitalized; Czech films of the thirties and the new wave of the sixties; the key films of the French Nouvelle Vague of the sixties; Italian films of the thirties and forties, including the beginnings of neorealism; a substantial collection of Soviet films of the great revolutionary period of the twenties, together with some more recent films; and a small group of early Danish films of 1907–13, when Denmark played a leading role in world cinema. During Donald Richie's tenure as curator of the department in 1969–73, he created the beginnings of the collection of Japanese film. As soon as the Chinese state film archive in Peking joined FIAF in 1980, the department arranged exchanges for a group of films from the fifties, the beginning of what we hope will be an important collection of Chinese films. Also through FIAF's cooperation, we have been able to recover for our own national heritage many American films that had been considered lost. These include such important films as Griffith's *The Romance of Happy Valley* and *True Heart Susie,* Karl Brown's *Stark Love,* and the first version of *Anna Christie,* starring Blanche Sweet, as well as a very large collection of silent American slapstick comedies.

During the seventies, the department's film-preservation program undertook to copy the major productions of Twentieth Century-Fox that still existed only on nitrate stock, including films from the silent period to 1950. This resulted in the acquisition of the early films of John Ford, Henry King, Friedrich Wilhelm Murnau, William K. Howard, Will Rogers (with substantial additions acquired from the Will Rogers Memorial), Raoul Walsh, and Tom Mix. ABC Pictures International contributed the original nitrate negatives constituting the David O. Selznick Collection, including Alfred Hitchcock's *Notorious* and *The Paradine Case* and George Cukor's *A Bill of Divorcement,* among others, and four films important for the history of early Technicolor: *The Garden of Allah, Duel in the Sun, The Adventures of Tom Sawyer,* and *Nothing Sacred,* which were donated in their original form of three-color separation negatives on black-and-white nitrate stock. These are the only color films the department has so far been able to copy by the separation method, the best preservation system for color known at the present time.

Distributors for foreign films have often been very generous in depositing prints after the term of their distribution in America, and private collectors have provided many films that often no longer existed with their production studios. Perhaps the most promising development today is that major filmmakers who grew up in the Museum's auditorium viewing their film heritage have begun to add their own films to the collection. Stanley Kubrick has already given most of his films to the Museum, and Francis Ford Coppola, as soon as he recovered the rights to his film *The Conversation,* sent the Museum a print. The new generation of filmmakers have a good understanding of the Museum's purposes and are ready to support its task of acquiring and preserving the best films as quickly as possible. We can begin to hope that some of today's films may survive in good original condition for future generations to see.

883. *A Trip to the Moon (Le Voyage dans la lune).* France. Georges Méliès. 1902

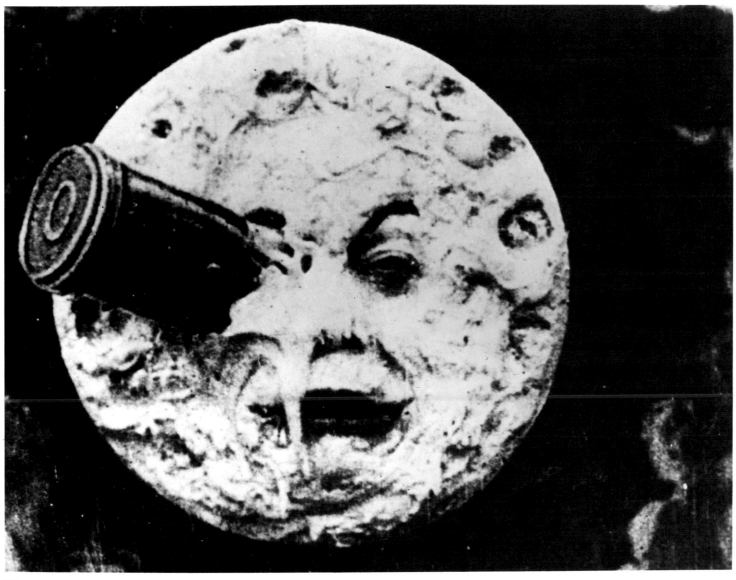

883

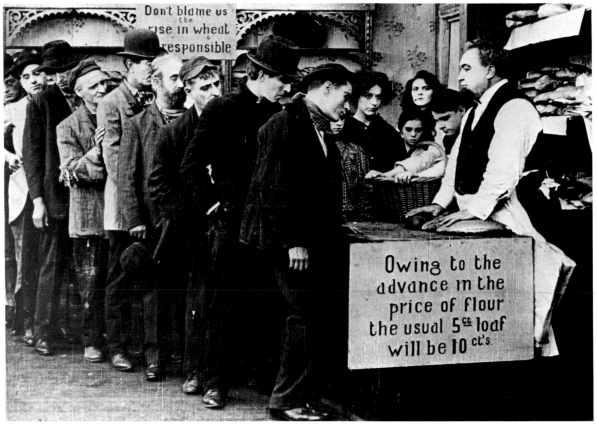

884

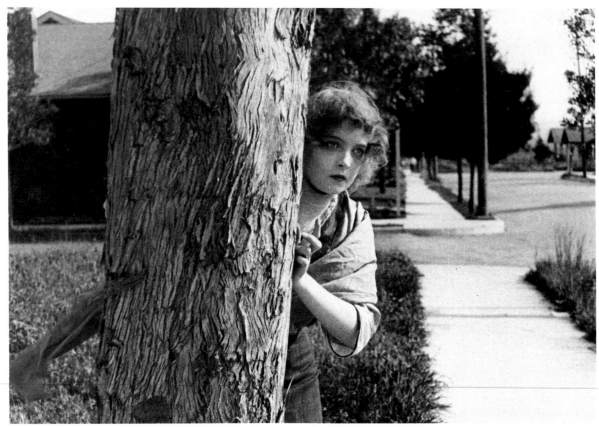

885

884. *A Corner in Wheat.* United States. David Wark Griffith. 1909

885. *The Mothering Heart.* United States. David Wark Griffith. 1913. Lillian Gish

The first films were objective and presentational in style, whether they were documents of daily life and news events, direct descriptions of vaudeville and music-hall acts, little comedies of eroticism and fantasy, or the first attempts to tell a story. Audiences were thrilled and at the same time conscious of looking at a new moving-picture device. Some of the first filmmakers were magicians who found in cinema a new tool for creating illusions. Foremost among them was the Frenchman Méliès, whose charming fantasy films still delight audiences today, especially his well-known *A Trip to the Moon.* To meet the clamor for films in the nickelodeon era, manufacturers turned to assembly-line production methods, new distribution and exhibition systems, and a new kind of film. In response to increasing demands for censorship and to attract a middle-class audience, the new businessmen turned to the morally uplifting melodrama. This, in turn, demanded new narrative systems which would involve the spectator in the emotions of a story. The audience would no longer look objectively at films, but would be drawn into them as active participants. By fragmentation and reordering of spatiotemporal reality, the films would change the spectator's vision of the world. Griffith was the leading exponent of the new style. In the short span of five years, he made more than four hundred short films for the Biograph Company, developing a narrative system that was to be the basis of the classic American style. The Museum's collection is particularly rich in Griffith's work of this period.

886. *Fantômas.* France. Louis Feuillade. 1913–14

887. *Gertie the Dinosaur.* United States. Winsor McCay. 1914

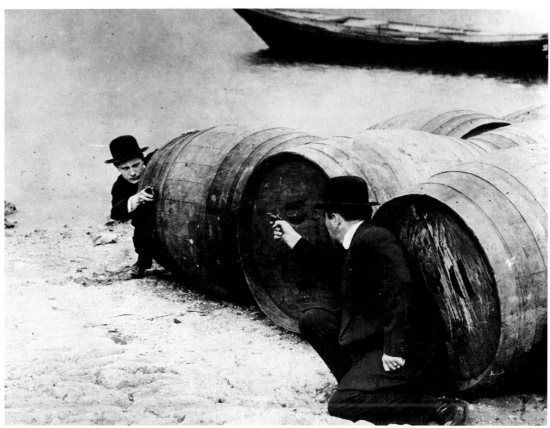

886

887

888

888. *The Birth of a Nation.* United States. David Wark Griffith. 1915. Lillian Gish and Henry B. Walthall

889. *Cabiria*. Italy. Giovanni Pastrone. 1914

890. *Intolerance*. United States. David Wark Griffith. 1916

The highly competitive international film industry looked for greater prestige with longer and more ambitious films and the use of celebrated names. Gabriele D'Annunzio wrote the titles for *Cabiria*, the most famous of the Italian historical spectacle films. Enormous solidly built sets, big battle scenes employing huge crowds of extras, and the use of the "process shot" (whereby illusory effects were introduced during the processing of the film) contributed to the grandeur of this work. The traveling shot of the pre-Griffith cinema was revived to follow action, isolate characters, and emphasize the depth perspective of the sets. This technique was considered revolutionary at the time and came to be known as the Cabiria movement. Showing the film in legitimate theaters at high prices added to its prestige. Film historians since have debated the possible influence of *Cabiria* on Griffith's *Intolerance*. Griffith had already made historical spectacle films, but *Intolerance* was something more. He interwove four parallel stories from different periods of human history; these flow nearer together as the film progresses, becoming a cascade of images, or, as Griffith expressed it, "Until in the end, they mingle in one mighty river of expressed emotion." The complexity of the structure bewildered audiences at the time, and *Intolerance* was as great a failure as *The Birth of a Nation* had been a success. With the passage of time, however, it has come to be considered among the formal masterpieces of the cinema and has exercised enormous influence, particularly in post-Revolutionary Russia, where it was closely studied.

889

890

891

892

891. *Broken Blossoms.* United States. David Wark Griffith. 1919. Lillian Gish

892. *True Heart Susie.* United States. David Wark Griffith. 1919. Lillian Gish and Robert Harron

893. *The Cabinet of Dr. Caligari (Das Cabinet des Dr. Caligari).* Germany. Robert Wiene. 1920. Conrad Veidt and Lil Dagover

Two influential films opened the aesthetic debate that dominated the final decade of the silent film: *Broken Blossoms* and *The Cabinet of Dr. Caligari.* The search for the elements of film art led filmmakers to neglect the natural world in favor of the studio-made film in which it was easier to control these elements more precisely, particularly settings and lighting. Griffith's *Broken Blossoms* is characterized by its dreamlike atmosphere and its psychological intensity. Audiences were overwhelmed by this new kind of film and especially its intimate acting style. Filmmakers were quick to note its rhythm: a slow cadence with harmonious images, shimmering lighting, and soft focus interspersed with sequences of rapid cutting, disordered compositions, sharp lens, and harsh lighting to contrast an idealistic world with a savage one. *The Cabinet of Dr. Caligari,* a fantastic nightmare film, was the first to realize the tenets of German Expressionism as it had developed in literature, theater, and the fine arts. The production design was the work of a group of artists associated with the magazine *Der Sturm.* The use of painted backdrops was a reversion to early cinema but the design was ultramodern in its deliberate distortions. The flatness is ameliorated by a perspective that destroys natural space and by the use of dramatic contrast lighting. The actors adapted stylized movement and gesture to suit the expressionist style. Later films abandoned the painted backdrops but utilized light and shadow to create similar distortions and to suggest the mystery and horror that dominated expressionist cinema. "Caligarism" entered the language.

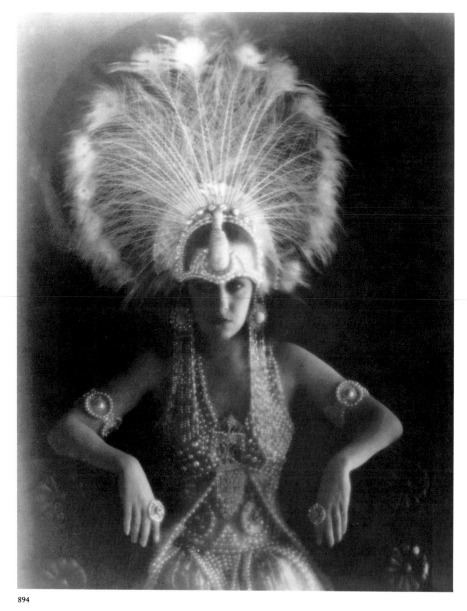

894

895

896

894. *Male and Female.* United States. Cecil B. DeMille. 1919. Gloria Swanson

895. *The Toll Gate.* United States. Lambert Hillyer. 1920. William S. Hart

896. *Tol'able David.* United States. Henry King. 1921. Richard Barthelmess and Ernest Torrence

897. *The Kid.* United States. Charles Chaplin. 1921. Charles Chaplin and Jackie Coogan

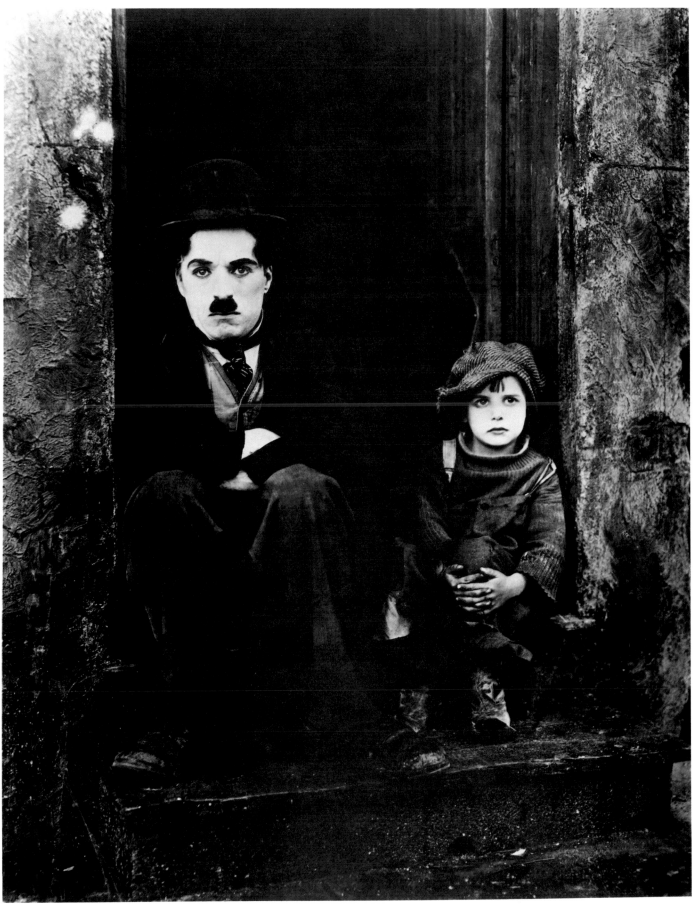

897

898

Nosferatu 33. Prana-Film.

899

898. *The Phantom Chariot (Korkarlen)*. Sweden. Victor Sjöström. 1920. Victor Sjöström and Tore Svennberg

Danish films of 1910–13 first drew international attention to Scandinavian cinema. They were known for naturalistic acting, developed characterization, adaptation of settings to psychological purposes, and featurelength production. They were followed by an extraordinary flowering of cinema in Sweden, particularly in the work of Sjöström and Stiller. Swedish films emphasized the natural world, using its light and shadow to intensify atmosphere and deepen psychology. However, *The Phantom Chariot*, like *Broken Blossoms* and *The Cabinet of Dr. Caligari*, was made almost entirely within specially built studio sets. It was made by Sjöström at the peak of Sweden's greatest period in film. The story is taken from a Swedish legend in which the last person to die each year must drive the chariot that collects the dead. When a drunken brawler dies at midnight on New Year's Eve, the driver decides to take him back to life and give him the chance to correct his errors. The unusual beauty of the ghostly multiple superimpositions and the complex flashbacks of this poetic allegory won great critical admiration all over the world. The film was seen by Murnau before he made, in Germany, *Nosferatu*, a darker and more chilling fantasy.

899. *Nosferatu*. Germany. Friedrich Wilhelm Murnau. 1922. Max Schreck

900. *Nanook of the North.* United States. Robert Flaherty. 1922

901. *The Covered Wagon.* United States. James Cruze. 1923

The practice of making films inside the studio, where craftsmanship reached great heights of skill in illusionism, became so widespread in the twenties that it meant a break in tradition when some filmmakers were able to insist on traveling to the location of their films. King went to his native Virginia hills to make *Tol'able David,* the universally admired American film classic later to be dissected by Pudovkin in *Film Technique* as a case study of the cutting on movement and the means whereby characterization is achieved through externally expressive action. Flaherty went to the far north to re-create the Eskimos' vanishing way of life in *Nanook of the North,* the documentary feature that encouraged a movement to depict people as themselves in their natural environments and to find beauty in such subjects. Cruze revitalized the Western genre by going on location for his epic Western *The Covered Wagon.* Its love story was secondary to the majestic sweep of the westward movement of the pioneers. The covered wagon-trains and the horses and cattle moving in clouds of real dust across a rugged landscape became images permanently ingrained in Western mythology.

902. *Greed.* United States. Erich von Stroheim. 1925. Gibson Gowland and Jean Hersholt

900

901

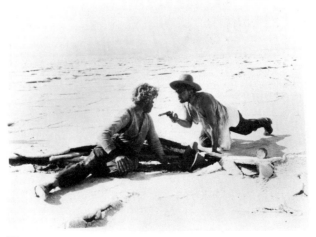

902

903

904

905

903. *The Story of Gösta Berling (Gösta Berlings Saga)*. Sweden. Mauritz Stiller. 1924. Greta Garbo

904. *The Last Laugh (Der Letzte Mann)*. Germany. Friedrich Wilhelm Murnau. 1924. Emil Jannings

905. *The Joyless Street (Die Freudlose Gasse)*. Germany. Georg Wilhelm Pabst. 1925. Greta Garbo and Valeska Gert

906. *Metropolis*. Germany. Fritz Lang. 1926

907. *Manhatta*. United States. Charles Sheeler and Paul Strand. 1921

Images of the modern urban landscape and the machine abound in the art of the twenties, but nowhere more than in the motion picture. *Manhatta,* by photographer Strand and painter-photographer Sheeler, celebrated the dynamics of the modern city, its stunning verticals and diagonals, its dramatic contrasts of light and shadow, especially evident in the skyscrapers of downtown Manhattan. The two photographers had been working together in "direct photography," trying to avoid any artifice yet through a rigid selection of elements to capture the intensity of experiences. In a press release for the first showing of *Manhatta,* Strand described their intentions: "[We] have tried to do in a scenic with natural objects what in *The Cabinet of Dr. Caligari* was attempted with painted sets." *Metropolis,* on the other hand, called for all the resources of artifice that the German studio could provide. Eugene Schufftan's mirror-matte process was used here for the first time. Inspired by Lang's first view of Manhattan, *Metropolis* is a science-fiction film about a future urban society in which mechanization has resulted in the dehumanization of the population. Its images are filtered through Expressionism, but it was Erwin Piscator's theater craft that inspired the geometrical patterns and massed architectural compositions of the crowds of workers. The designers were particularly

906

interested in the form and movement
of machinery, in pistons and gears,
not for their function but for their
abstract design.

908. *Ballet mécanique*. France.
Fernand Léger. 1924

907

908

909

910

911

909. *Safety Last.* United States. Sam Taylor. 1923. Harold Lloyd

910. *Big Business.* United States. J. Wesley Horne. 1929. Stan Laurel and Oliver Hardy

911. *The General.* United States. Buster Keaton and Clyde Bruckman. 1926. Buster Keaton

912. *Potemkin (Bronenosets Potemkin).*
USSR. Sergei M. Eisenstein. 1926

With *Potemkin*, the new Soviet cinema took its place on the world scene. The effects of its revolutionary style are still felt wherever revolutionary movements look for a cinematic means of expression. To characterize the meaning of the Soviet Revolution, Eisenstein used the events of the 1905 rebellion in the port of Odessa. There are five major sequences: the rebellion of the *Potemkin*'s sailors over the rotten food; the mutiny on the quarterdeck; the display of the martyr's body on the quay; the massacre on the Odessa steps; the triumphant sailing of the battleship to meet the fleet. Each of these merits study for Eisenstein's newly conscious manipulation of film materials. His brilliant editing; his use of details, repetition, and contrast; his compression or expansion of time; and the collision of images for shock value all ran counter to the trend toward creating a seamless illusion of reality. The film *Mother*—with its simple theme of a working-class mother growing in political consciousness through participation in revolutionary activity—established Pudovkin as another major figure of the new Soviet cinema. A student of Lev Kuleshov and an admirer of Griffith's films, Pudovkin was already writing his first book on film theory when he made *Mother*. The expert cutting on movement, the associated editing of unrelated scenes to form what he called a "plastic synthesis," is amply demonstrated in it. In opposition to Eisenstein's shock montage, Pudovkin developed a linkage method which went far beyond Kuleshov's theories. The variation in cutting rhythms for the various sections in this film comes to a climax in the famous rush of images comparing the spring thaw and the breaking up of the ice to the coming of the Revolution.

913. *Mother (Mat').* USSR. Vsevolod I.
Pudovkin. 1926. Nikolai Batalov and
Vera Baranovskaya

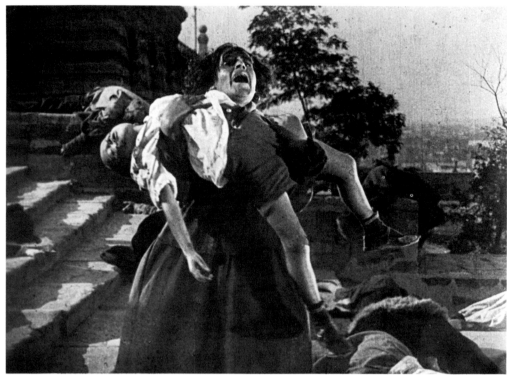

912

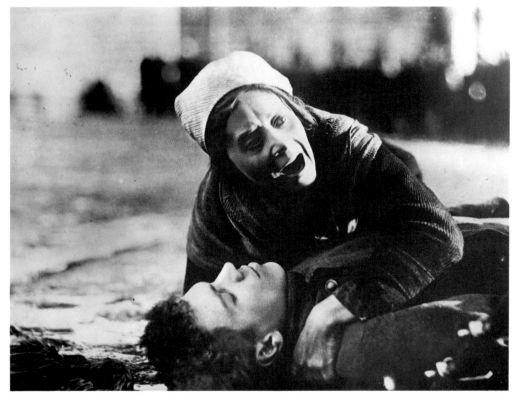

913

914

916

915

914. *Storm Over Asia (Potomok Chingas-Khan)*. USSR. Vsevolod I. Pudovkin. 1928

915. *Bed and Sofa (Tretya Meschanskaya)*. USSR. Abram Room. 1926. Ludmilla Semyonova

916. *Man with a Movie Camera (Chelovek S. Kinoapparatom)*. USSR. Dziga Vertov. 1928

917. *The Loves of Jeanne Ney (Die Liebe der Jeanne Ney)*. Germany. Georg Wilhelm Pabst. 1927. Fritz Rasp

917

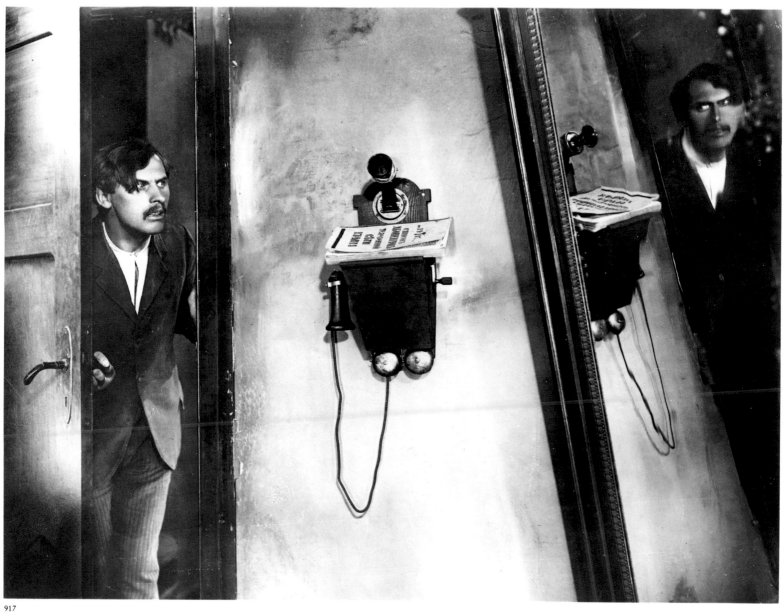

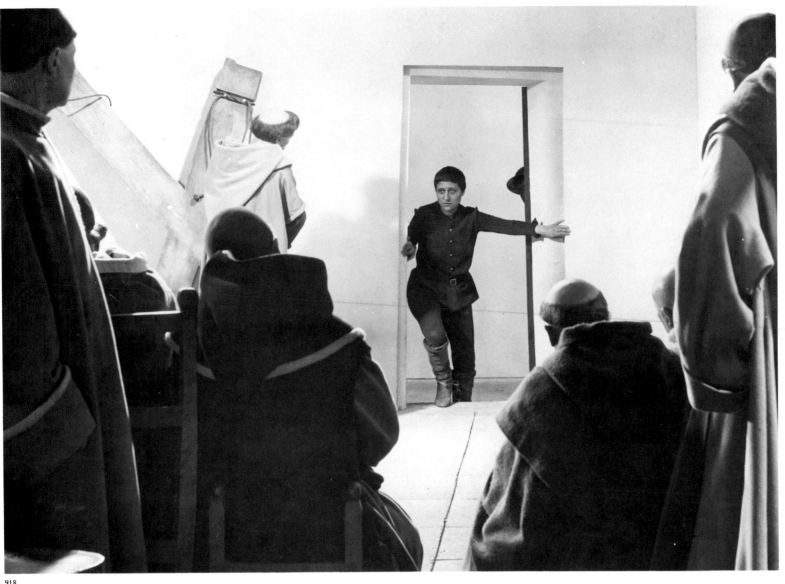

918.

918.	*The Passion of Joan of Arc (La Passion de Jeanne d'Arc)*. France. Carl Theodor Dreyer. 1928. Marie Falconetti

The various currents of national styles flowed together at the close of the silent period to form a European international style. Ideas and filmmakers moved freely across borders. Certain films appeared at the conflux of currents, summing up the contributions of a decade of vigorous investigation into the art of film. Many of the greatest achievements of the period were doomed to be seen by comparatively few, as the sound film began to change the nature of the film-going experience for the general public. In the years since, however, *The Passion of Joan of Arc*,

made by the Danish director Dreyer in France, has proved its lasting power. The trial and death of Joan of Arc, based on contemporaneous records of her trial, her sufferings, and her ecstasy, form the subject. The pace is slow and relentless. Huge closeups dominate, sometimes without the context of establishing shots. Oblique camera angles distort facial expressions and reveal a subjective point of view. The textures of human skin, of hair, cloth, and metal are explored by the camera, and disembodied mouths and eyes are emphasized. Marie Falconetti's intense portrayal of the main character is one of the most famous performances in all of film history. The flight of birds at Joan of Arc's death releases her spirit and that of the audience held captive by the spell of Dreyer's film. *The Passion of Joan of Arc* pushed the art of the silent film to its utmost in expressiveness. It is a fitting monument to mark the end of the silent era.

919. *Stark Love*. United States. Karl Brown. 1927 . Helen Munday and Reb Grogan

920. *Sunrise*. United States. Friedrich Wilhelm Murnau. 1927. George O'Brien and Janet Gaynor

921. *The Docks of New York*. United States. Josef von Sternberg. 1928. Betty Compson and George Bancroft

919

920

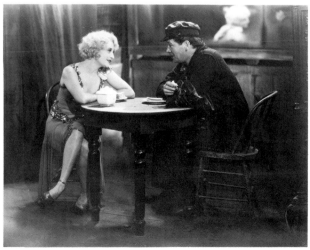

921

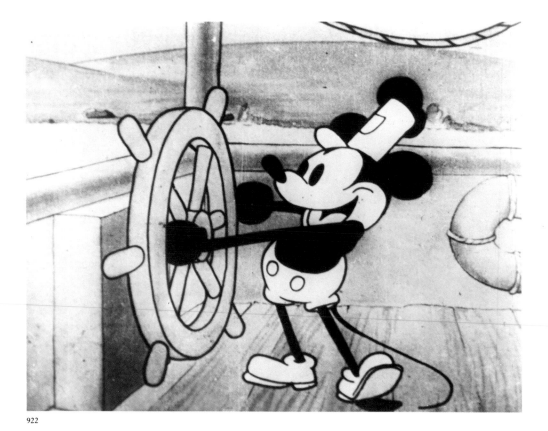

922

922. *Steamboat Willie*. United States. Walt Disney. 1928. Mickey Mouse

If the sound film's popular success can be traced to the opening of *The Jazz Singer* in October 1927, its creative potential was to be explored in other films. Mickey Mouse's little animated figure captured the sound medium while human characters were still struggling under the limitations imposed by the placement of microphones and the camera, rigidly enclosed in its soundproof box. Mickey had an immense advantage—he could move freely, which was more than actors were able to do at that time. In *Steamboat Willie*, the first animated cartoon with sound and also the first Mickey Mouse cartoon to be shown publicly, sound effects are matched to the action on the screen; for example, the pulling of pigs' tails produces squeals which become an integral part of the musical score. Lubitsch's *The Love Parade* freed the musical from the limitations that characterized many film adaptations from the Broadway stage. Even before the sound engineers learned to free the camera from its heavy box, Lubitsch achieved a fluidity in its use. He makes use of off-screen speech or has a conversation take place silently behind a window. In other places he employs words for their sound value as much as for literal content. It matters not whether we understand either the French spoken in the opening scene or the gibberish spoken by the foreign ambassador at the wedding or that they be "translated" for us; the words are used as sound effects and not to advance the narrative. The musical fantasy of operetta is played in luxurious and spacious sets designed by Hans Dreier and used to the full in extreme, long, overhead, and trucking shots, the work of the photographer Victor Milner.

923. *Three Little Pigs*. United States. Burt Gillett. 1933

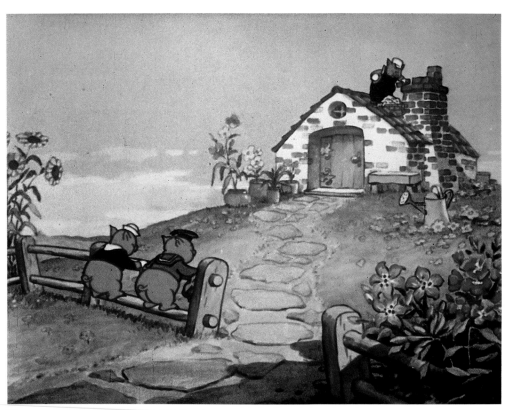

923

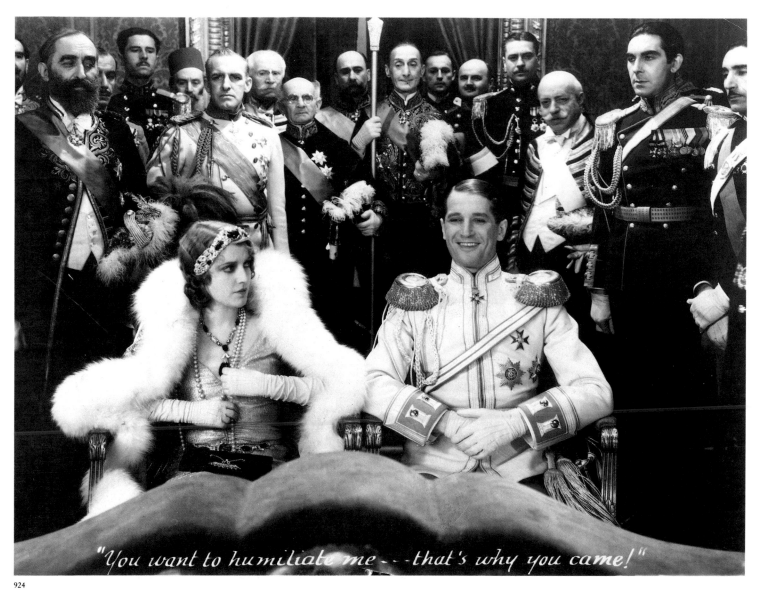

"You want to humiliate me---that's why you came!"

924

924. *The Love Parade*. United States. Ernst Lubitsch. 1929. Jeanette Mac-Donald and Maurice Chevalier

925. *Hallelujah*. United States. King Vidor. 1929. Daniel L. Haynes

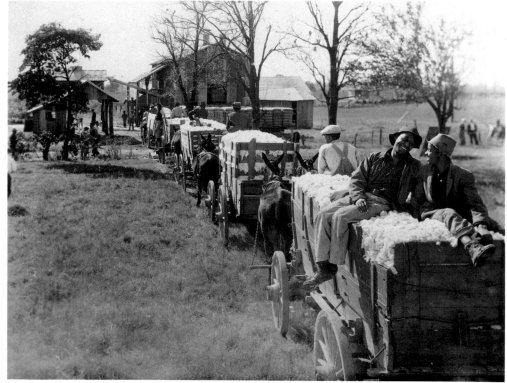

925

926

927

926. *Little Caesar.* United States. Mervin LeRoy. 1930. Edward G. Robinson

927. *Blackmail.* Great Britain. Alfred Hitchcock. 1929. Anny Ondra

928. *The Blue Angel (Der Blaue Engel).* Germany. Josef von Sternberg. 1930. Marlene Dietrich

929. *All Quiet on the Western Front.* United States. Lewis Milestone. 1930. William Bakewell and Lew Ayres

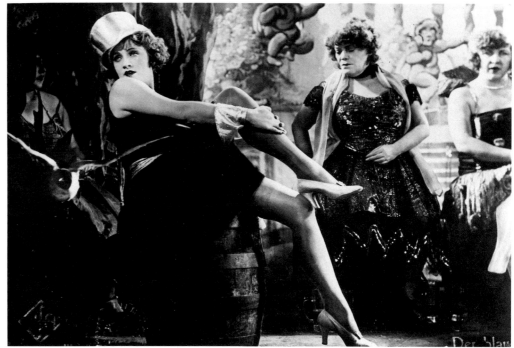

928

929

930

931

930. *L'Age d'or.* France. Luis Buñuel. 1930

931. *M.* Germany. Fritz Lang. 1931. Peter Lorre

932. *Que Viva Mexico!* United States. Sergei M. Eisenstein. 1932

The Department of Film seldom collects unedited film material, but *Que Viva Mexico!* is a special case, a cause célèbre of film history. Eisenstein was invited by Paramount Pictures to make a film in Hollywood, but all his projects came to naught. However, outside the industry, he found a backer in the radical socialist novelist Upton Sinclair for a project to make a film in Mexico. Eisenstein had met the Mexican painter Rivera in Moscow in 1926 and thereafter developed an interest in Mexico's folk culture as well as its modern artists. Eisenstein shot an enormous amount of footage in Mexico but never completed his film. Sinclair and his investors in the Mexican Motion Picture Trust, alarmed by mounting costs and Eisenstein's working methods, finally called the project to a halt and seized the film material; and Eisenstein went back to Moscow. In an effort to recoup costs, Sinclair authorized the making of several films by others from Eisenstein's material: *Thunder over Mexico, Time in the Sun,* and a group of travelogues, over the objections of a highly vocal group of Eisenstein's admirers and friends. Campaigns were mounted, in a hostile atmosphere, to get the footage from Sinclair and into Eisenstein's hands, but funds to purchase it were never raised. In 1953, Sinclair gave up all hope of getting back his investment and agreed to deposit all the existing material with the Museum. It was too late for Eisenstein, who died in 1948, but his assistant, Grigori Alexandrov, was still eager to try to cut the film. Only after copying the entire original nitrate negative on triacetate fine-grain master stock to ensure its preservation did the Museum finally send the originals to the Soviet state

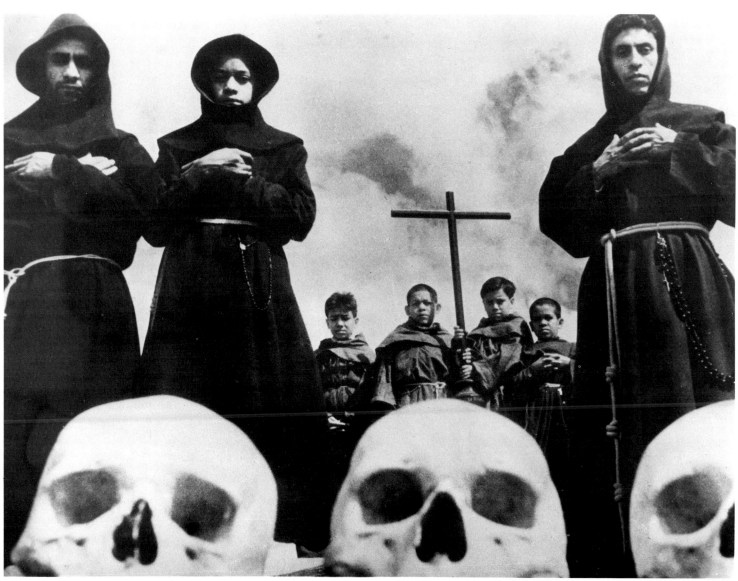

932

film archive, in exchange for a group of Soviet films. The film department produced a study version of the material—not an edited film but a demonstration showing Eisenstein's working methods—prepared by the noted Eisenstein authority Jay Leyda.

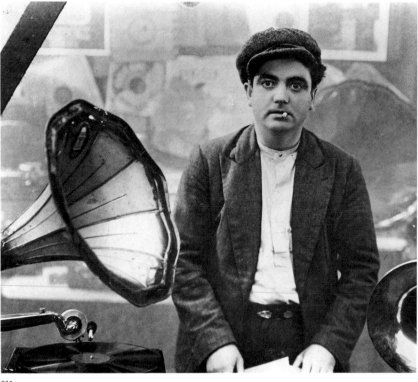

933

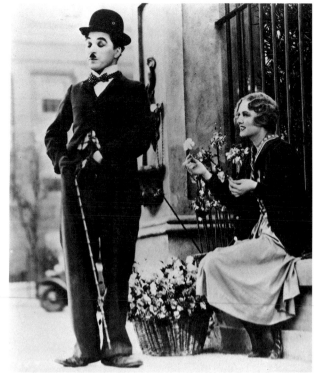

934

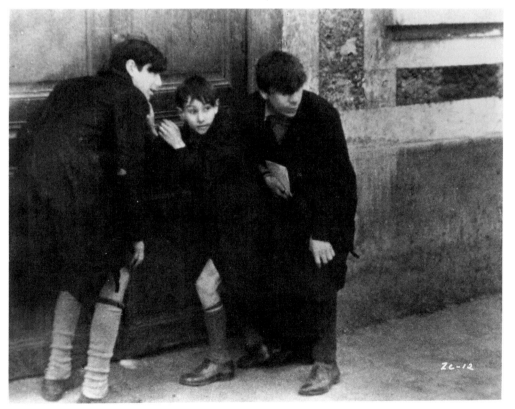

935

933. *A Nous la liberté*. France. René Clair. 1932. Raymond Cordy

934. *City Lights*. United States. Charles Chaplin. 1931. Charles Chaplin and Virginia Cherrill

935. *Zero for Conduct (Zéro de conduite)*. France. Jean Vigo. 1933

936. *Our Daily Bread*. United States. King Vidor. 1934. Tom Keene

937. *Alice Adams*. United States. George Stevens. 1935. Ann Shoemaker, Fred MacMurray, Hattie McDaniel, Katharine Hepburn, and Fred Stone

938. *Dodsworth*. United States. William Wyler. 1936. Walter Huston and Mary Astor

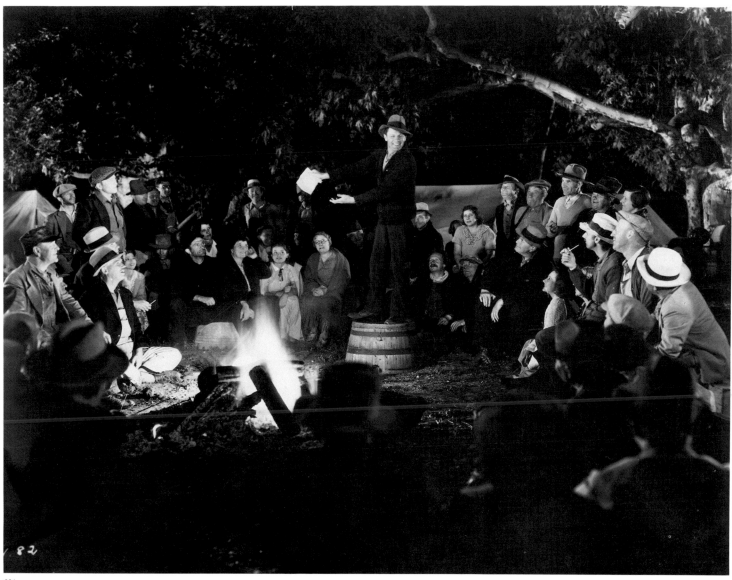

936

937

938

939

939. *Ruggles of Red Gap*. United States. Leo McCarey. 1935. Mary Boland and Charles Laughton

Among the several film genres born of the Depression era was one known as Americana, a genre which celebrated the old-fashioned virtues of American democracy, rural life, rugged independence, individualism, self-sufficiency, and a way of life that had long since vanished. McCarey's *Ruggles of Red Gap* returned to the first decade of the century, the period of the original novel which had already furnished material for a play and two earlier movies, for this comedy about a proper British manservant transplanted to a rowdy frontier town. McCarey had been a director of slapstick comedies in the silent period and made such sound comedies as *Duck Soup* and *The Awful Truth*. In *Ruggles of Red Gap*, he uses comedy underlined with seriousness to denigrate American pretensions to European culture and to celebrate the glories of our democratic institutions. Charles Laughton is brilliantly cast as the stolid embodiment of British tradition. In the set piece in the frontier saloon, having learned to admire the rough-and-ready ways of American democracy, he recites the Gettysburg Address in its entirety to a ragged gang of illiterate Westerners. The moving scene works well not only because of Laughton's great recitative powers, but also for its counterpoint of sound and image: there is a leisurely and accurate pacing of alternate shots as the speaker, beginning quietly, gradually gains the courage of his words and the listeners are slowly drawn to them, the shots adding content not to be found in the speech itself.

940. *Swing Time*. United States. George Stevens. 1936. Ginger Rogers and Fred Astaire

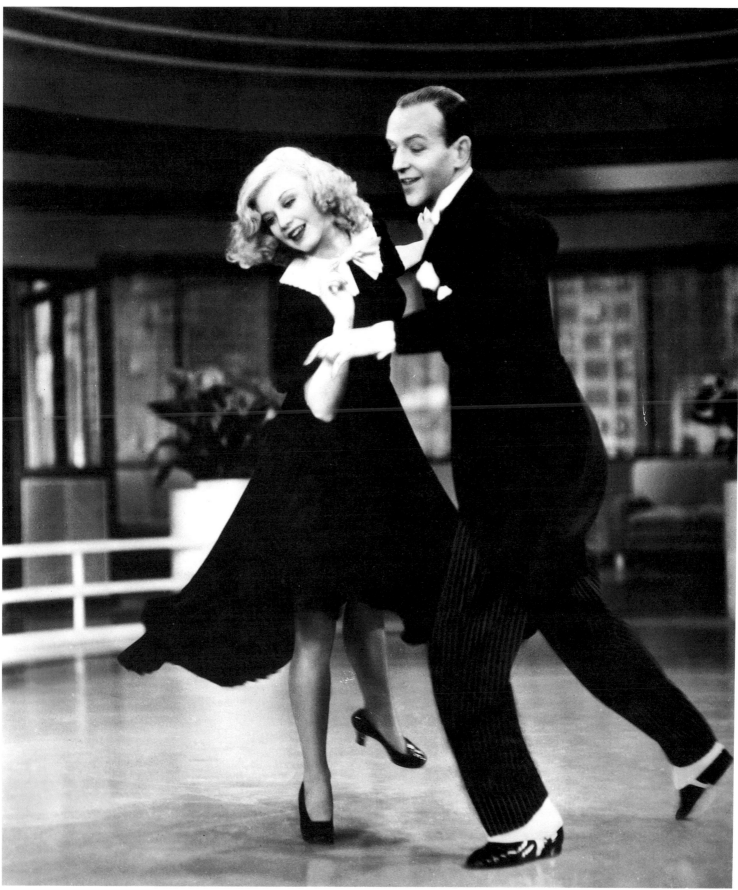

940

941

941. *Man of Aran.* Great Britain. Robert Flaherty. 1934

942. *The Plow that Broke the Plains.* United States. Pare Lorentz. 1936

The concept of film as a force for social change was alive in America from the end of the nickelodeon era, but its major forward impetus came as a result of the devastating conditions of the Great Depression. Radical, militant, and independent filmmakers, many of them inspired by the new Soviet films, created a ferment in the early thirties; but with little money and no access to commercial distribution, their efforts had small chance of making an impact on the general public. *The Plow that Broke the Plains* did reach a mass audience after some initial difficulties, and changed the course of the documentary film movement. It was made for the Resettlement Administration by Lorentz, a young film and music critic and political activist, as part of the RA's task of documenting the effects of the midwestern dust storms on the nation's farmland. It combined the talents of three photographers from the New York Film and Photo League, Strand, Steiner, and Hurwitz, and the modern composer Virgil Thomson, whose score, closely worked out with Lorentz during the editing, added important dimensions to the film's haunting images. *The Plow that Broke the Plains* and *The River,* the subsequent film made by Lorentz for the RA, are still effective today in the campaign to protect our environment. The popular and critical success of these two documentaries led to the setting up of the United States Film Service, with Lorentz at its head.

942

943. *The City.* United States. Willard Van Dyke and Ralph Steiner. 1939

944. *The Spanish Earth.* United States. Joris Ivens. 1937

945. *Native Land.* United States. Leo Hurwitz and Paul Strand. 1942

943

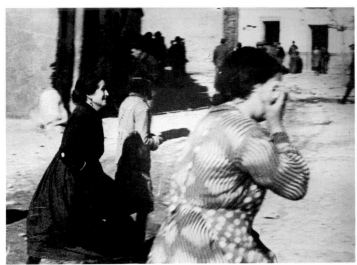

944

945

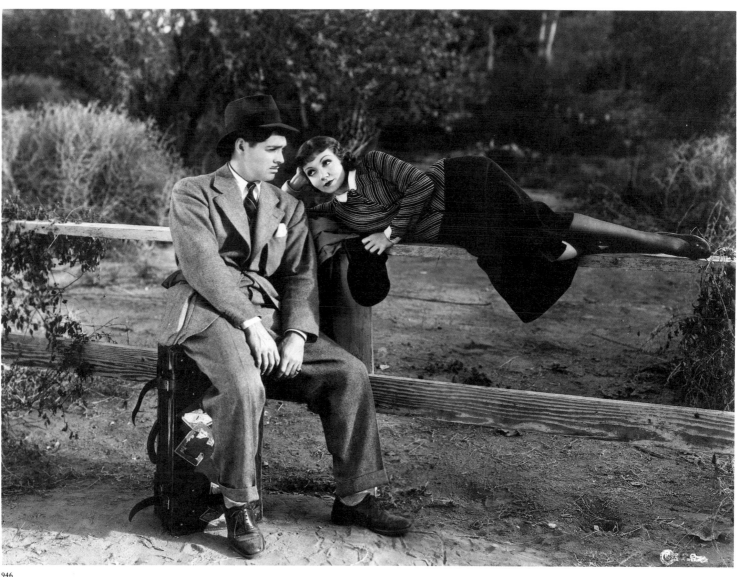

946

947

946. *It Happened One Night*. United States. Frank Capra. 1934. Clark Gable and Claudette Colbert

The American "screwball" comedy of the thirties exemplifies the smooth and polished style, expert pacing, and wit for which Hollywood films were known the world over. The genre satirized American ideals and conventions, continuing the tradition of the silent slapstick film and combining it with witty dialogue, wisecracks, and more believable characters. The direct and unsentimental heroines played by Claudette Colbert, Carole Lombard, and Jean Arthur gave credence to the suggestion that absurd behavior was the sane and healthy

reaction to a society gone crazy in the wake of the Depression. Energy and toughness, imagination and wit, were useful qualities for survival in hard times. In the screwball comedy, the unexpected, the unlikely, and the accidental events that propel the semblance of a plot forward show that the poor may become rich overnight and the rich become poor—but that the rich have more fun. The origins of the genre are usually traced back to *It Happened One Night,* a modest low-budget production of a conventional romantic comedy directed by the then little-known Capra, which found unexpected popular success. What seemed new about it was its mood, its charged energy, its defiant nonsense, and the memorable characters who turned conventional romance upside down. Many of the qualities of the screwball comedy can be found earlier, in Lubitsch's brilliant exercise in style and amoral sophistication *Trouble in Paradise,* but it was the overnight success of *It Happened One Night* that launched a whole series of crazy comedies, culminating in the glorious *Nothing Sacred, Easy Living,* and *The Awful Truth,* all appearing in 1937.

947. *Nothing Sacred.* United States. William A. Wellman. 1937. Carole Lombard, Walter Connolly, and Fredric March

948. *Easy Living.* United States. Mitchell Leisen. 1937. Jean Arthur, Esther Dale, Edward Arnold, and Mary Nash

949. *The Awful Truth.* United States. Leo McCarey. 1937. Cary Grant and Irene Dunne

948

949

950

950. *Quai des brumes*. France. Marcel Carné. 1938. Jean Gabin and Michèle Morgan

951. *La Grande Illusion*. France. Jean Renoir. 1937. Erich von Stroheim, Pierre Fresnay, and Jean Gabin

952. *Mr. Smith Goes to Washington*. United States. Frank Capra. 1939. James Stewart

953. *Jesse James*. United States. Henry King. 1939. Slim Summerville, Tyrone Power, and Henry Fonda

951

952

953

954

954. *The Grapes of Wrath*. United States. John Ford. 1940. John Carradine and Henry Fonda

The Grapes of Wrath marks the culmination of the socially conscious cinema of the thirties. Ford's ability to define character through environment is vividly illustrated by the opening sequence showing Tom Joad (Henry Fonda) in an extreme long shot, a tiny figure walking endlessly along a flat ribbon of highway. It is an image that speaks of the immensity and desolation of the Oklahoma landscape and the persistence of the lone individual thrust against it. In another expressive sequence, Muley (John Qualen) tells Tom about the "tractoring out" of the tenant farmers in a flashback composed of a long slow pan that follows a tractor past a group of watching farmers and into the shack that they call home; a cut back to the watchers that continues in a slow tilt down to the ground and then pans across to the demolished building and the departing tractor, and finally another cut back to the standing group and a slow tilt down to their elongated shadows on the ground. Using the kinesthetic power of the moving camera, Ford makes us share in the emotions of the farmers. In the night scenes, his poetic approach to the American landscape seeps through cinematographer Gregg Toland's camera in filtered skies and figures silhouetted against the horizon, but it is in the sun-baked sequences, the extreme long shots of the landscape, the highway snaking across vast distances, the desolate shacks, the ungainly poor in their overloaded old cars and trucks, the rural gas stations, and the small-town cops that *The Grapes of Wrath* is most faithful to the spirit of John Steinbeck's novel, Horace Bristol's photographs or those of Lange's *An American Exodus,* or Lorentz's *Plow that Broke the Plains.* These are the images we remember as the look of the Depression years.

955. *Citizen Kane*. United States. Orson Welles. 1941. Orson Welles

Citizen Kane, the first film by the notorious young prodigy Welles, ripped across the fabric of the well-made studio film as it existed at the end of the thirties. Its flamboyant theatricality was designed to excite attention. It was as though Welles wanted to remake the established conventions of filmmaking by purposely discarding the smooth and seamless narrative designed to make the spectator forget he was watching a movie. *Citizen Kane*'s expressionist camera angles and contrast lighting; the deep-focus photography and multiplane compositions; the long takes, with camera movement substituted for cutting; the sharpness of the image in depth; and the special effects, the overlapping dialogue, and the noncontinuous narrative, were not new in the history of cinema. But many of them had become de-emphasized, especially those devices which might call attention to the process by which a filmmaker manipulated an audience. Welles exuberantly highlighted this process. In this, he was ably abetted by his cinematographer, Toland, who had been experimenting with similar ideas in some of his other films, but had not found real enthusiasm for them until Welles, who was eager to do something sensational. While the style was upsetting to some of Welles's Hollywood colleagues, it was really the scandal of the thinly disguised portrait of William Randolph Hearst that caused the film to be withdrawn after a short and troubled run. Ten years later it was revived with great success and remains one of the most widely admired works of the cinema. The more films changed, as they did during the dark years of the forties, the more *Citizen Kane* seemed fresh and vigorous.

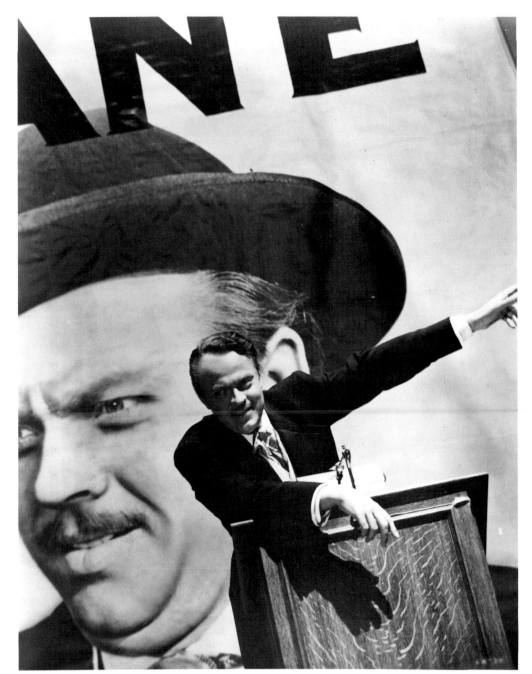

955

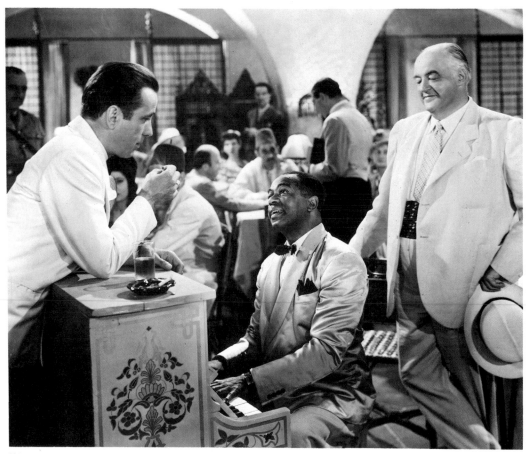

956

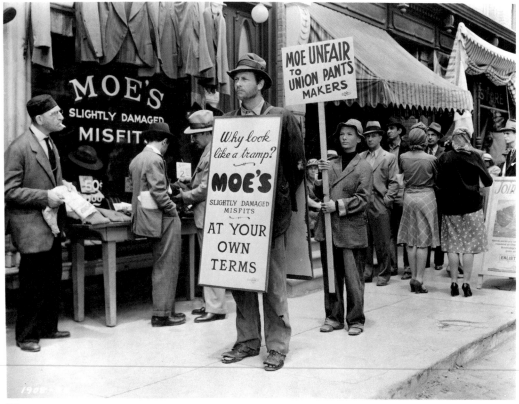

957

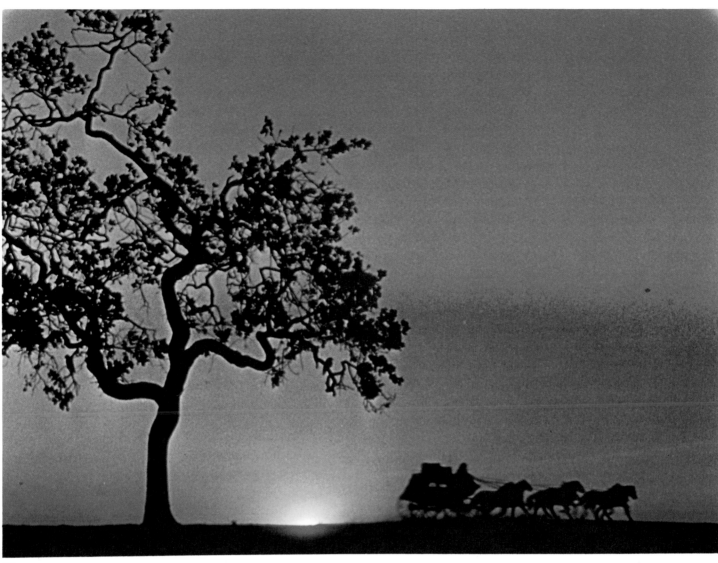

958

956. *Casablanca.* United States. Michael Curtiz. 1942. Humphrey Bogart, Dooley Wilson, and Sidney Greenstreet

957. *Sullivan's Travels.* United States. Preston Sturges. 1941. Joel McCrea and Veronica Lake

958. *Duel in the Sun.* United States. King Vidor. 1946

959. *My Darling Clementine.* United States. John Ford. 1946. Henry Fonda

959

960

960. *Day of Wrath (Vredens Dag).*
Denmark. Carl Theodor Dreyer. 1943.
Lisbeth Movin, Preben Lerdoff, Albert
Hoeberg, and Sigrid Neiiendam

961. *The Lost Weekend.* United States.
Billy Wilder. 1945. Ray Milland

962. *The Snake Pit.* United States.
Anatole Litvak. 1948. Ruth Donnelly
and Olivia De Havilland

963. *Notorious.* United States. Alfred
Hitchcock. 1946. Cary Grant, Ingrid
Bergman, Madame Konstantin, and
Claude Rains

964. *The Cage.* United States. Sidney
Peterson. 1947

961

962

963

964

965

966

965. *Open City (Roma, Città Aperta).*
Italy. Roberto Rossellini. 1945. Marcello
Pagliero

It is the raw immediacy of *Open
City* that gives it its emotional
power. The Germans were just pull-
ing out of battle-scarred Rome
before the American troops' arrival
and chaos reigned when Rossellini
went into production with a story of
the resistance movement, filmed in
the very streets and bombed-out
buildings where the events had just
taken place. Many of the people
involved had lived the story they
were now putting on film. Only the
principal actors were professionals,
the rest ordinary people of Rome.

With the use of hidden cameras, even the departing Germans were captured on film. The shortage of film stock, the lack of electricity for studio lighting, and the strong emotions of the time contributed to the rough-edged character of this moving testimony to the work of the resistance. *Open City* marked the rebirth of the Italian film industry, which had been under the domination of the Fascists since 1934. The tenets of Italian neorealism were based on this film and those that immediately followed. The new Italian cinema would avoid the artifice and the polish of the well-made studio film and the forced optimism of the state-dominated production, replacing it with socially significant films and nonprofessional actors in actual locations, reenacting their own lives. There would be organic plot development and it would feature ordinary people, working people, and the poor. The proponents of neorealism aspired to nothing less than the truth of life as it is really lived. In fact, it was a short-lived aesthetic but a powerful one, with echoes reaching around the world.

966. *San Pietro*. United States. John Huston. 1945

967. *Shoeshine (Sciuscia)*. Italy. Vittorio De Sica. 1946. Franco Interlenghi and Rinaldo Smordini

968. *Bicycle Thief (Ladri di Biciclette)*. Italy. Vittorio De Sica. 1949. Lamberto Maggiorani

967

968

969

970

969. *The Set-Up.* United States. Robert Wise. 1949. Robert Ryan

970. *On the Waterfront.* United States. Elia Kazan. 1954. Marlon Brando

971. *East of Eden*. United States. Elia Kazan. 1955. James Dean

972. *Bus Stop*. United States. Joshua Logan. 1956. Marilyn Monroe

973. *La Ronde*. France. Max Ophüls. 1950. Danielle Darrieux and Daniel Gélin

971

972

973

974

974. *Rashomon.* Japan. Akira
Kurosawa. 1950. Toshiro Mifune and
Machiko Kyo

With the end of World War II the
international distribution of cinema
spread with a vigor it had not known
since the end of the silent era.
Although some Asian countries,
especially India and Japan, had had a
long and very active history of film
production, their films were but lit-
tle known in the Occidental world.
Distributors in both East and West
thought that the cultural differences
were too great to make such dis-
tribution viable. Kurosawa's
Rashomon opened everyone's eyes.
To be sure, the Japanese were said to
consider this film "less Japanese,"
and some of its appeal to Western

eyes may have been as a result of its
exoticism. Its style is closer to the
West's than other Japanese films of
the same period, in its more rapid
cutting and in its use of the moving
camera. Nevertheless, its appeal is
universal. Set in medieval Japan, a
brutal rape and murder is recounted
by four characters who either wit-
nessed or participated in it, each
telling in turn a conflicting story,
in a complex series of flashbacks.
Kurosawa underlined the irony of
Ryonosuke Akutagawa's grim sto-
ries on which the film is based, by
adding the so-called uplift ending, in
which the woodcutter, the ordinary
man, is given humanitarian motives
in addition to petty selfish ones.
("Rashomon" has entered the
English language as a word for the
relativity of truth.) What one
remembers most strongly are the
rich performances of the actors and
the vivid sensory impressions of the
natural world. In Japanese culture
aspects of nature have symbolic
meanings as well, but for the West-
ern viewer the steady downpour of
summer rain at the ruined gate or the
camera moving sinuously through
the forest, brushing aside leaves in
dancing sunlight and shadows, exist
for their own sakes, remaining in the
mind's eye.

975. *The Lavender Hill Mob.* Great
Britain. Charles Crichton. 1950. Stanley
Holloway and Alec Guinness

976. *Umberto D.* Italy. Vittorio De
Sica. 1952. Carlo Battisti

975

976

977

978

979

977. *Ugetsu Monogatari.* Japan. Kenji Mizoguchi. 1953. Masayuki Mori and Machiko Kyo

978. *Tokyo Story (Tokyo Monogatari).* Japan. Yasujiro Ozu. 1953. Chieko Higashiyama and Setsuko Hara

979. *Pather Panchali.* India. Satyajit Ray. 1955. Karuna Banerjee

980. *The 400 Blows (Quatre Cent Coups).* France. François Truffaut. 1959. Jean-Pierre Léaud and Patrick Auffay

The youthful revolutionary spirit of the sixties found its first deep expression in the cinema, beginning in France and spreading through much of the Western world. In 1959, the unexpected success of Truffaut's *The 400 Blows* and Alain Resnais's *Hiroshima Mon Amour* at the Cannes Film Festival announced a rebellion against "establishment" cinema, followed the next year by Godard's *Breathless,* in which Truffaut and Claude Chabrol also participated. These filmmakers were intellectuals, film critics, and film buffs dissatisfied with the classic well-made film and the French literary tradition, which they considered to be stagnant. Not since the twenties was there so significant a reexamination of the art of the film. *Breathless* replaced the unity and logic of classic cinema with spontaneity, hand-held cameras, flowing pans, and disorienting jump cuts. On the surface it follows the genre of the American "B" gangster movie of the forties, which French filmmakers greatly admired, but its real subject is the genre itself. The characters are not so much people as film images, romantic memories of films seen and loved. Jean-Paul Belmondo, thumb on his lip, is a living memory of Humphrey Bogart. So influential and imitated was *Breathless* that it no longer shocks and surprises: its elliptical style took over filmmaking in the sixties, and we are no longer even very much aware of jump cuts. The new films changed our way of seeing. The new filmmakers, con-

980

trary to their predecessors, wanted
to call the spectator's attention to the
fact that they were looking at a film
and not life itself.

981. *Breathless (À Bout de souffle).*
France. Jean-Luc Godard. 1960. Jean-
Paul Belmondo and Jean Seberg

981

982

982. *NY, NY.* United States. Francis Thompson. 1957

983. *Wild Strawberries (Smultron-stallet).* Sweden. Ingmar Bergman. 1957. Victor Sjöström

984. *Ashes and Diamonds (Popiol i Diament).* Poland. Andrzej Wajda. 1958. Zbigniew Cybulski and Eva Krzyzewska

985. *The Red Desert (Il Deserto Rosso).* Italy/France. Michelangelo Antonioni. 1964. Xenia Valderi and Monica Vitti

983

984

985

986

986. *Knife in the Water (Noz w Wodzie)*. Poland. Roman Polanski. 1962. Zygmunt Malanowicz, Jolanta Umecka, and Leon Niemczyk

987. *8½ (Otto e Mezzo)*. Italy. Federico Fellini. 1963. Marcello Mastroianni

988. *Bonnie and Clyde*. United States. Arthur Penn. 1967. Michael J. Pollard, Faye Dunaway, and Warren Beatty

989. *Scorpio Rising*. United States. Kenneth Anger. 1963

990. *Dr. Strangelove: Or, How I Learned to Stop Worrying and Love the Bomb*. Great Britain. Stanley Kubrick. 1964. Peter Sellers

987

988

989

990

991

991. *2001: A Space Odyssey.* Great Britain. Stanley Kubrick. 1968

992. *Text of Light.* United States. Stan Brakhage. 1974

992

993

993. *Wavelength*. United States. Michael Snow. 1966–67

In America outside the commercial Hollywood cinema, young artists and intellectuals of the sixties began to reexamine the nature of film, in the spirit of those who constituted the French avant-garde of the twenties. The form these explorations took was as varied as the individuals who made them, but for most the cinema as mass entertainment was no longer the goal. Independently made films such as Snow's *Wavelength* were shown to small but dedicated audiences in museums, universities, and other cultural institutions. The work done by this group of independents, however, tended to concern the basis of all filmmaking, everywhere. *Wavelength* challenged many of the concepts of classic cinema: for example, that the short shot is the basic unit of expression and its combination in groups of shots is the means of manipulating feelings. *Wavelength* consists of one very slow forty-five-minute zoom shot across a room, accompanied by an insistent sound track that increases in volume, until the zoom ends at a still photograph—a photograph of waves—fastened to a wall. The room is empty but people enter and four events do take place in front of the camera, but they do not form a connected narrative. Snow began with the concept that a film consists of a cone of light on a flat screen, and rediscovered the basic film element of space and time. This is not only an intellectual exercise. In the end it is compelling to the senses, as the spectator is steadily pushed into the changing space of the room on the flat space of the screen.

994

994. *Golden Positions*. United States. James Broughton. 1970

995. *Heavy Traffic*. United States. Ralph Bakshi. 1973

995

996. *Citizens Band* (a.k.a. *Handle With Care*). United States. Jonathan Demme. 1977. Ann Wedgeworth, Marcia Rodd, and Paul LeMat

997. *Five Easy Pieces.* United States. Bob Rafelson. 1970. Jack Nicholson

998. *The Conversation.* United States. Francis Ford Coppola. 1974. Gene Hackman

999. *McCabe and Mrs. Miller.* United States. Robert Altman. 1971. Warren Beatty

998

996

997

999

1000

1000. *Chott el-Djerid (A Portrait in Light and Heat).* United States. Bill Viola. 1979. Gift of Catherine V. Meacham

The Museum has kept abreast of developments in the experimental, narrative, and documentary uses of video since the sixties, when artists began working with the medium as a form of expression. Videotapes and multimonitor installations are included in the Museum's collection and exhibitions. A major example of artists' video, Viola's *Chott el-Djerid* reflects a sophisticated understanding of electronic technology. Based on the recording of natural sounds and images, the videotape begins in the snowy plains of Illinois and Saskatchewan before it quickly switches to the desert of Tunisia. Through the subtle editing of recorded materials, which center on the illusive qualities of distant mirages, the work becomes an extraordinary exploration of perception, light, and scale.

Photograph Credits

The Museum and the Publisher wish to thank the following individuals and organizations, who have taken or supplied the photographs for this book.

INTRODUCTION (pages 8–41). Numbers refer to pages.

AP Photo: 14; Harry Benson: 35 below, © 1973 Conde Nast Publications, Inc.; Paul Berg: 25 above; Dan Budnik: 28, 35 above; Robert Damora: 21; Alexa Darrow: 22 below; Alexandre Georges: 25 below, 32–33 above; D. Haar: 36 below; Wolfgang Hoyt (ESTO): 40 both; Koshiba: 10 below; Laffont: 34 below; Long Photography: 39 below; Sharon McIntosh: 36 above; Constantine Manos: 19; Helaine Messer: 35 center, 37 above; Joan Miller/Magnum Photo: 30 below; Paul Parker: 12; James Thrall Soby: 26 below; Ezra Stoller: 30 above; Soichi Sunami: 15 above; Jonathan Wenk: 38; Wurtz Brothers: 16–17 above.

THE COLLECTION (pages 42–588). Numbers refer to plates.

Ansel Adams: 222; David Allison: 9, 10, 27, 107, 255, 329, 385, 396, 565, 573, 601, 680, 750; Art Institute of Chicago: 49; George Barrows: 632, 634, 652, 659, 661, 673, 683, 689, 691, 695, 697, 700–702, 715, 717, 719, 722, 736, 743, 759, 762; Ira Bartfield: 233; Rudolph Burckhardt: 286, 294, 345, 361; Geoffrey Clements: 24, 195, 258, 260, 295, 534; Colten Photos: 223, 310; © 1979 Imogen Cunningham Trust: 808; Alexa Darrow: 271; Bevin Davies: 363; Charles Eames: 726; Yukio Futagawa: 710, 711; William Garnett: 848, copyright © 1954 William Garnett; Gemini G.E.L.: 610 © Gemini G.E.L. 1974, 613 © Gemini G.E.L. 1967, 619 © Gemini G.E.L. 1974; Wolfgang Hoyt (ESTO): 651; Jacqueline Hyde: 245; Scott Hyde: 708; Seth Joel: 631, 640, 663, 669, 671, 677, 682, 690, 693, 696, 698, 723, 730, 733, 742, 744, 746, 751, 753, 765; Peter Juley: 19, 416, 527, 584; Kate Keller: 4a–c, 28, 30, 31, 35, 36, 58, 67, 72–76, 80, 82, 83, 101, 108, 121, 136, 142, 152, 154, 156, 171, 186, 189, 202, 204, 215, 216, 239, 240, 242, 250, 253, 254, 270, 277, 292, 293, 300, 302, 306, 327, 333, 336, 339, 342–44, 355, 357, 360, 362, 369, 370, 373, 376, 387, 389, 390, 392, 393, 397, 400, 408, 409, 414, 415, 417, 419, 426, 435, 440, 443, 445, 450, 453, 467, 477, 479, 481, 486, 497, 503, 512, 515, 519, 524, 525, 540, 542–44, 550, 551, 553, 557, 564, 568, 574, 580, 581, 585, 592, 598–600, 604, 612, 614, 620–22, 624, 628, 644, 655, 658, 660, 668, 688, 694, 747; Kate Keller: 626, printed and published by Tyler Graphics, Limited, © copyright Roy Lichtenstein/Tyler Graphics, Limited 1980; Norman McGrath: 752; Phil Marco: 679; Joseph Martin: 413; James Mathews: 45, 47, 77, 78, 89, 116, 135, 150, 159, 161, 167, 192, 193, 221, 238, 259, 262, 267–69, 274, 288, 308, 309, 315, 346, 354, 365, 368, 371, 372, 375, 377, 381, 403, 410, 412, 442, 476, 496, 510, 511, 513, 536, 545, 558, 560, 571, 593, 602, 607, 648, 718, 720, 732; Herbert Matter: 87, 125, 638; Al Mozell: 521; Hans Namuth: 139; Mali Olatunji: 6, 17, 33, 40–43, 53, 55, 61, 91, 95, 100, 109, 122, 134, 143, 144, 177, 178, 182, 184, 188, 203, 211, 213, 217, 229, 231, 272, 276, 285, 291, 297, 304, 321, 322, 337, 347, 351, 356, 358, 364, 367, 374, 378, 380, 382–84, 386, 388, 391, 394, 399, 405–7, 420, 433, 436, 437, 441, 444, 446–48, 454, 464, 470, 473, 482, 489, 490, 495, 501, 502, 504, 507, 509, 516–18, 520, 522, 531, 533, 547, 548, 566, 567, 575, 594, 609, 618, 627, 629, 642, 662, 667, 687, 706, 716, 741, 749, 768; Mali Olatunji: 611, courtesy Universal Limited Art Editions, Inc.; Mali Olatunji: 625, copyright © 1980 Multiples, Inc.; Mali Olatunji: 630, printed and published by Tyler Graphics, Limited, © copyright Frank Stella/Tyler Graphics, Limited 1982; Victor Parker: 692, 704, 705, 707, 709, 721, 763; Kira Perov: 1000; Rolf Petersen: 162, 205, 301, 366, 460, 484, 498–500, 562, 569, 577, 606, 608, 641, 647, 653, 654, 656, 665, 675, 684, 731, 734; Eric Pollitzer: 48, 71, 105, 219, 261, 273, 289, 298, 303, 312, 334, 338, 353, 379; Nathan Rabin: 514; Percy Rainford: 37; Stan Ries: 724, 725, 727–29, 766; Sandak, Inc.: 1, 2, 7, 15, 18, 22, 23, 29, 34, 38, 39, 50, 51, 56, 57, 60, 65, 79, 92, 93, 96–99, 102–4, 110–15, 120, 129, 141, 145, 146, 148, 153, 155, 163, 164, 170, 172, 176, 179, 183, 187, 212, 218, 225, 228, 246, 247, 256, 264, 265, 275, 278–84, 290, 296, 305, 307, 311, 313, 314, 319, 335, 340, 348, 349, 359; Shunk-Kender: 341; Steve Sloman: 299; Edward Steichen: 873, reprinted with the permission of Joanna T. Steichen, photographed by Malcolm Varon; Glenn Steigelman: 332; Paul Strand: 800, copyright © 1976, The Paul Strand Foundation, as published in Paul Strand, *Sixty Years of Photographs* (Millerton, New York: Aperture, 1976); Adolph Studly: 62, 130, 505, 587, 615; Soichi Sunami: 5, 8, 11–13, 20, 21, 25, 26, 32, 44, 46, 52, 54, 59, 66, 68, 69, 81, 85, 86, 88, 106, 118, 119, 123, 124, 126, 127, 131–33, 137, 138, 140, 147, 149, 151, 157, 158, 160, 165,

166, 168, 169, 173–75, 180, 181, 185, 190, 191, 194, 196–201, 206–10, 220, 226, 227, 230, 232, 234–37, 241, 243, 244, 249, 251, 252, 257, 263, 266, 287, 316–18, 323–26, 328, 352, 395, 398, 401, 402, 404, 411, 418, 421–25, 427, 431, 432, 438, 439, 449, 451, 452, 455–59, 461–63, 465, 466, 468, 469, 471, 472, 474, 475, 478, 480, 483, 485, 487, 488, 491–94, 506, 526, 528–30, 535, 537–39, 541, 546, 549, 552, 554–56, 559, 561, 563, 570, 572, 576, 578, 579, 582, 583, 586, 588–91, 595–97, 603, 605, 636, 643; Tyler Graphics, Limited: 617, printed and published by Tyler Graphics, Limited, © copyright Helen Frankenthaler/ Tyler Graphics, Limited 1977; Charles Uht: 117, 428–30, 434, 508; Malcolm Varon: 3, 14, 16, 63, 64, 70, 84, 90, 94, 128, 214, 224, 248, 320, 330, 331, 350, 532, 616, 623; James Welling: 633, 635, 637, 639, 645, 646, 650, 657, 664, 666, 670, 672, 674, 676, 678, 681, 685, 686, 699, 703, 712–14, 735, 737–40, 745, 748, 754–58, 760, 761, 764, 767; Edward Weston: 812, copyright © 1981 Arizona Board of Regents, Center for Creative Photography; Alan Zindman: 523.

FILM ACKNOWLEDGMENTS

The following plates appear courtesy of the companies and individuals listed below.

ABC Pictures International, Inc.: 958; Columbia Pictures Corporation: 946, 949, 952, 970, 990, 997; Samuel Goldwyn, Jr., and The Samuel Goldwyn Company: 938; Janus Films: 979; MCA Publishing, a Division of MCA, Inc.: 894, 901, 919, 921, 924, 929, 931, 939, 948, 957, 961; MGM/UA Entertainment Co.: 902, 925, 991; Paramount Pictures: 996, 998; RKO General Pictures: 937, 940, 955, 969; Hal Roach: 910; Warner Brothers Inc.: 971, 988, 999.

FILM COPYRIGHTS (listed by plate number)

Biograph Co.: 884, 885; British International Pictures: 927; Carrosse Production: 980; © 1921 Charles Chaplin: 897; © 1931 Charles Chaplin, renewed 1959 United Artists Associated, Inc.: 934; Copyright © 1934, renewed 1962 Columbia Pictures Corporation: 946; Copyright © 1939, renewed 1967 Columbia Pictures Corporation: 952; Copyright © 1954, renewed 1982 Columbia Pictures Corporation: 970; Daiei Motion Picture Co.: 974; © Ealing Studios, Ltd.: 975; © Embassy Pictures Corp.: 987; Epoch Producing Company: 888; © 1919 Famous Players-Lasky Corp.: 894; © 1923 Famous Players-Lasky Corp.: 901; Film Polski: 984, 986; © 1973 Films Creations Limited, released by American International Pictures Limited: 995; Filmsonores Tobis: 933; Copyright © 1970 Five Easy Pieces Productions, Inc.: 997; © Foremco Pictures Corp. and Massau Films, Inc.: 931; © 1927 Fox Film Corporation, all rights reserved: 920; Frontier Films: 945; © 1936 Samuel Goldwyn, Jr.: 938; Sacha Gording: 973; Government of West Bengal: 979; © 1919 D. W. Griffith, released by United Artists Associated, Inc.: 891; Copyright 1963 Hawk Films, Ltd.: 990; Lambert-Hillyer Productions: 895; © Metro-Goldwyn-Mayer Distributing Corporation, renewed 1957 Loew's Incorporated: 925; © 1968 Metro-Goldwyn-Mayer Inc.: 991; © 1924 Metro-Goldwyn Pictures Corporation, renewed 1952 Loew's Incorporated: 902; Palladium: 960; © 1927 Paramount Famous Lasky Corp.: 919; © 1928 Paramount Famous Lasky Corp.: 921; © 1930 Paramount Famous Lasky Corp.: 924; © 1937 Paramount Pictures, Inc.: 948; © 1941 Paramount Pictures, Inc.: 957; © 1945 Paramount Pictures, Inc.: 961; Copyright © 1974 by Paramount Pictures Corporation, all rights reserved: 998; Copyright © 1977 by Paramount Pictures Corporation, all rights reserved: 996; © 1935 Paramount Productions, Inc.: 939; © Pathé Exchange, Inc.: 900, 909; Copyright © 1929, renewed 1956 Pathé Exchange, Inc.: 949; Prana Film: 899; Produzioni De Sica S.R.L.: 968; Prometheus Pictures: 944; Rank Film: 941; Rizzoli Film S.p.A.: 976, 985; © 1946 RKO Pictures, released to Selznick International Pictures, Inc.: 963; Copyright © 1936 RKO Radio Pictures, Inc.: 940; Société Nouvelle de Cinéma: 981; Sofar Film: 905; Svenskafilmindustri: 898; Svensk Filmindustri: 903, 983; Paolo W. Tamburella: 967; Francis Thompson: 982; © 1939 Twentieth Century-Fox Film Corporation, all rights reserved: 953; © 1940 Twentieth Century-Fox Film Corporation, all rights reserved: 954; © 1946 Twentieth Century-Fox Film Corporation, all rights reserved: 959; © 1948 Twentieth Century-Fox Film Corporation, all rights reserved: 962; © 1956 Twentieth Century-Fox Film Corporation, all rights reserved: 972; UFA: 904, 917; U.S. Government: 942, 966; © Universal Pictures Corp.: 929; © 1934 King Vidor, released through United Artists Associated, Inc.: 936; © 1979 Bill Viola: 1000; © Walt Disney Productions: 922; © MCMXXXIII Walt Disney Productions: 923; Wark Producing Company: 890; © 1955 Warner Bros. Inc.: 971; © 1971 Warner Bros. Inc.: 999; © 1967 Warner Bros. Inc., Fatima: Hiller Productions: 988; © 1930 Warner Bros. Pictures, Inc., renewed 1958 Associated Artists Production Corp.: 926; © 1943 Warner Bros. Pictures, Inc., renewed 1970 United Artists Television, Inc.: 956.

The first two quotations on pages 9–10 are reprinted from *The Nelson A. Rockefeller Collection: Masterpieces of Modern Art* by permission of the publisher, Hudson Hills Press; that appearing on pages 11–12 is reprinted from *Arts Quarterly*, January-February-March, 1983, New Orleans Museum of Art; and the quotation on pages 24–26 is © 1953 The New Yorker Magazine, Inc., reproduced by permission.

Index

In the index works of art are listed by artist. Page numbers in *italics* refer to illustrations. Biographical data are given for artists whose work is illustrated.